George

A DOUBLE LIFE

Cukor

OTHER BOOKS BY PATRICK McGILLIGAN

Cagney: The Actor as Auteur

Backstory: Interviews With Screenwriters of Hollywood's Golden Age

Backstory 2: Interviews With Screenwriters of the 1940s and 1950s

Robert Altman: Jumping Off the Cliff

A BIOGRAPHY OF

THE GENTLEMAN DIRECTOR

George

A DOUBLE LIFE

Cukor

PATRICK McGILLIGAN

ST. MARTIN'S PRESS

NEW YORK

GEORGE CUKOR: A DOUBLE LIFE. Copyright © 1991 by Patrick McGilligan. All rights reserved. Printed in the United States of America. No part of this book may be used or reproduced in any manner whatsoever without written permission except in the case of brief quotations embodied in critical articles or reviews. For information, address St. Martin's Press, 175 Fifth Avenue, New York, N.Y. 10010.

Design by Judy Dannecker

Library of Congress Cataloging-in-Publication Data

McGilligan, Patrick.
 George Cukor: A double life / Patrick McGilligan.
 p. cm.
 ISBN 0-312-05419-X
 1. Cukor, George Dewey, 1899– . 2. Motion picture producers and
directors—United States—Biography. I. Title.
PN1998.3.C8M34 1991
791.43'0233'092—dc20
[B] 90-48352
 CIP

First Edition: December 1991

10 9 8 7 6 5 4 3

Grateful acknowledgment is made to the following publisher for reprinted material:

Passages from *Audrey: The Life of Audrey Hepburn* by Charles Higham reprinted with permission of Macmillan Publishing Company. Copyright © 1984 by Charles Higham.

Grateful acknowledgment is made to the following individuals and organizations for use of previously unpublished material:

Zoë Akins's correspondence quoted courtesy of James D. Akins, administrator of the Akins estate.

Interview excerpts from Charles Brackett, Ben Hecht, Anita Loos, and Nunnally Johnson oral histories courtesy of the Oral History Research Office of Columbia University, City of New York.

Louis Calhern's correspondence excerpted with permission of Marianne Stewart Dirksing.

James Hilton's letter quoted courtesy of Mary D. Porterfield, copyright owner. All rights reserved.

Sidney Coe Howard's letters from the Sidney Coe Howard Papers, The Bancroft Library, University of California, Berkeley. Quoted with permission of Margaret Howard and the family of Sidney Howard.

Garson Kanin's letters and memoranda quoted with permission of Garson Kanin.

Fredric March's note to George Cukor cited courtesy of Penelope March Fauvalli.

All material from the Metro-Goldwyn-Mayer files quoted with permission of Turner Entertainment Co.

Joel Greenberg's oral history with Walter Reisch, conducted under the auspices of the American Film Institute, quoted courtesy of Joel Greenberg and Mrs. Elizabeth Reisch.

David O. Selznick's memos and letters quoted courtesy of Lewis Jeffrey Selznick.

Donald Ogden Stewart's letters quoted courtesy of Donald Stewart and the Donald Ogden Stewart estate.

The correspondence of King Vidor is cited courtesy of Suzanne Vidor Parry.

Salka Viertel's correspondence quoted courtesy of Peter Viertel and the Salka Viertel estate.

All material from Warner Brothers production files copyright © Warner Brothers Inc. and quoted with permission.

Special acknowledgment is made to the following individuals and organizations for use or loan of illustrations:

Section 1: Robert E. Gross, Stella Bloch/Deborah Offner, Benny Baker, Edward Eliscu, USC Cinema-Television Library and Archives, Museum of Modern Art, British Film Institute, Marcella Rabwin, Photofest.

Section 2: Photofest, British Film Institute, Stella Bloch/Deborah Offner, Museum of Modern Art, Academy of Motion Picture Arts and Sciences/The Margaret Herrick Library, USC Cinema-Television Library and Archives.

Section 3: Photofest, Garson Kanin, British Film Institute, Elizabeth Reisch, Museum of Modern Art, Academy of Motion Picture Arts and Sciences/The Margaret Herrick Library, Robert Wheaton, USC Cinema-Television Library and Archives, Charles Williamson.

To Eddie and Stella

and everybody else

I got to know

George

A DOUBLE LIFE

Cukor

CHAPTER ONE

*G*eorge Cukor believed that his life story actually began before he was born—in genes and chromosomes, in the tangled roots of his ancestry, and in the essential traits of his immediate family.

"You'd like to think you're pretty much an original," the world-famous film director was fond of saying, in a reflective mood, "everything about yourself distinctive and individual. But it is surprising to realize to what extent you echo your family, and how, from childhood, you have been shaped and molded. . . ."

Cukor made a point of surrounding himself with literary lions, the pantheon of the theater, the social elite of Hollywood, and minor European royalty. Lineage was extremely important to this director of motion pictures about rootless orphans and waifs, aristocratic gate-crashers, and nobodies transformed into somebodies by luck and love. The Cinderella/fella theme was touched on in some of his best films: *What Price Hollywood?*, *Dinner at Eight*, *Camille*, *David Copperfield*, *Holiday*, *The Philadelphia Story*, *Born Yesterday*, *A Star Is Born*, and *My Fair Lady*.

The origin of the name Cukor was, among family members, a source of wry speculation. Although at times Cukor kidded about his Hungarian heritage, the film director was not uninterested in his family's geneaology. He spent time and money tracing official records

1

and family trees; he consulted the opinions of national experts and kept in touch with distant relatives who might provide clues to the enigma of the past.

Cukor wanted to believe in a good lineage for himself, at the same time that he made jokes about coming to the United States by steerage. Although there was some opinion that in Hungary the Cukors were related to the Kallays—a family line that included parliament members and rabbis—Cukor had to accept the fact that he wasn't highborn. He settled for positioning himself as a member of the world's cultural aristocracy.

At one time, in the early 1900s, his paternal grandfather, Joseph Cukor, had laboriously typed a long manuscript that purported to chart the ancient family odyssey of the Cukors. There was some doubt about the veracity of the inscribed facts, but Cukor kept and cherished the document. The film director liked its snobbish implications, deciding it conveyed "approximate accuracy."

According to this questionable document, the Cukors were descended from sons of the tribe of Joseph who journeyed to India some three or four hundred years before the birth of Christ. Chukor, which was the name of an Indian hill, was the family name adopted by this bloodline that boasted not only the usual contingent of shepherds, farmers, and warriors among its relations but also orators, scholars, writers, and poets. Chukor translated as "partridge" in Hindi and Sanskrit; the family coat of arms was decorated with the image of a partridge, which was said to guide their destiny.

In approximately A.D. 669, members of the family set out and resettled around the Caspian Sea. Chukor became Magyarized as Czukor sometime in the eighteenth century, and Americanized to Cukor upon family immigration to the United States in the nineteenth. Responsibility for dropping the z was claimed by grandfather Joseph Cukor, who complained that "two consonants in succession is a slavish habit." George Cukor liked to say that because of his last name he suffered amiable confusions when he directed films in the early sound era for Paramount, whose president was the phonetically kindred Adolph Zukor, also Jewish and Hungarian-born. (Though otherwise they were unrelated; perhaps, said Cukor jokingly, he would have had "an easier time" at Paramount altogether if the C had been dropped instead.)

From an early age, Cukor had a powerful sense of identity. His name was pronounced CUE-kor, and he would insist on correcting that pronunciation, saying, "CUE-kor, as in CUE-cumber." That was one of Garson Kanin's pet names for him, "Mr. Cucumber," although behind his back the film director was also dubbed by Kanin "God Damn Cukor," a wordplay on his initials, GDC, and an allusion to

2

the fact that when in an irritable mood Cukor tended to scream like his partridge namesake and overflow with expletives.

Cukor's great-grandfather had been a countrified gentleman with a landed estate in Napkov, Hungary. Some family misfortune induced his son to leave the Old World behind. Grand, humorless, exceedingly handsome, Joseph Cukor made ship passage from Europe to New York City in 1884, his arrival predating the massive Hungarian migrations of the 1900s by at least a decade.

With Joseph Cukor came his wife, Victoria, and their four children—Victor, the eldest, Bertha and Irene, the two sisters, and Morris, the youngest. Victoria spoke Slavic and German, as well as Hungarian, for Hungary in the nineteenth century was part of Transleithania, which was tucked into the Austro-Hungarian monarchy. Though she lived in the United States for thirty years, Cukor's grandmother never did learn much English.

His grandmother was the predominant family character, and Cukor always recalled her vividly—as personable and witty, if ugly and a bit deaf. She carried an ear trumpet, which did not affect her dignity in the slightest, although it gave her a comical aspect. Her hearing could fade when convenient, and she was especially oblivious when doing her morning shopping, the shopkeepers cursing her as she patted and squeezed the tomatoes. A rabid housekeeper, every morning she would glide down the stairs of her brownstone with a handkerchief, wiping the banister. Cukor observed and absorbed. Such fastidiousness was carried over to his own home in Hollywood, and to an extent in his approach to filmmaking.

The Cukor saga was typical of many immigrants'. At first, life in the United States was hard for the family. They worked and scrimped. They were Hungarian—they always wept when they heard Hungarian songs—but they were also patriotic new Americans. The two sons, Victor and Morris, stuck through law school and were admitted to the bar. However, their sister Irene died suddenly, in 1904 when she was only in her early forties, and her loss left a void in the household that resonated throughout Cukor's boyhood. For many years thereafter, his grandmother would sit alone in the afternoons and shed tears over Irene's memory.

Partly because of this early period of struggle and tragedy, the Cukors were close-knit and proud, no doubt—as Cukor put it—prouder than they ought to have been. The Cukor aunts and uncles used to assemble for dinner practically every night at their parents' house on East Sixty-eighth Street. Cukor always remembered the setting: On the walls hung the Stuart portrait of Washington; a rendering of Betsy Ross, sewing the American flag; a picture of the Lincoln family; and

a steel engraving of Lajos Kossuth, the Hungarian statesman, at the massive reception for him held on lower Broadway.

From these family dinners, Cukor acquired the lifelong habit of urging people to have a second helping, because that is what his grandmother always did. Cukor was canny about it, however: When he was directing Judy Holliday, who had a tendency to gain weight, he would discipline her to make sure she didn't overeat. When that actress was working with another director and dining with Cukor, on the other hand, he would revert to his childhood training and ladle it on.

The other relations from the old country would be invited on Sundays. Sundays were special. The covey of Cukors would show up in weird outfits exhibiting bizarre—at least from a young boy's point of view—mannerisms. A big meal would be shared, and as the food was passed, there would be several languages loudly spoken—always Hungarian, but also English and German, and a smattering of French. So Cukor grew up speaking several languages, often in the same conversation.*

After the meal, the Cukors would stand up, clasp hands, and wish each other *Gesegnete Mahlzeit*, from the German for "Blessed mealtime." (It was not like a scene from the sentimental Fannie Hurst play *Humoresque*, which Cukor saw in 1923, starring Laurette Taylor. *Humoresque* was about noble, downtrodden Jews; his family, Cukor always emphasized, was thoroughly middle-class.) Toward the end of the long Sunday get-togethers, Cukor, as a boy, would fall asleep at his grandparents'—and mysteriously awaken the next morning at his own place, up the block, on the same side of the street, also on East Sixty-eighth Street.

Cukor's mother, Helen (Ilona) Gross, hailed from a different part of Hungary—Tokaj, vineyard country, where her father was governor of a prison. She was one of six children, all of whom immigrated to the United States. If anything, the Gross family was more literate and more cultured than the Cukors. One of Helen Gross's cousins became a well-known New York advertising copywriter who also wrote books on prayer. One of her brothers was a portrait photographer who roamed the West—à la *Heller in Pink Tights*—taking photographs of rowdy frontier types. When he settled down in Toledo, part of the Cleveland branch of the Cukor family tree, he started up a reputable photo-supply house whose success continues today.

*Although fluent only in English, Cukor never lost this boyhood knack for picking up and spewing out foreign phrases. "Cukor had a gift for the spoken word," noted Edward Eliscu. "His speech never showed a trace of New Yorkese."

Helen Gross immigrated to America in 1887, and married Victor Cukor in 1894. A pretty brunette with fine features and a soulful warmth in her eyes, she was decidedly plump. Her restrained temperament meant that she was all but swallowed up by the more vivid Cukors. Yet she was a dutiful daughter-in-law, who deferred to Victor's family, and the Cukors embraced her lovingly.

Helen and Victor were blessed with two children: first a girl, Elsie, who was four and a half years older than her brother; then George Dewey Cukor, who arrived in this world on July 14, 1899, when the family still listed its address downtown on East Fourth Street.

From the hero of the Spanish-American War, Admiral George Dewey—not the progressive educator or the decimal systemator—Cukor received his patriotic christening. Cukor trotted out his unlikely and stolid middle name in letters and at festivities for the unfailing chuckle that it warranted. He and Elsie were the only grandchildren of Joseph and Victoria to carry the Cukor name, for Uncle Morris remained childless. So they were brought up, the center of family gatherings, pampered and smothered with affection.

All of the Cukors—the grandparents, Uncle Morris, Victor's family, and the two aunts—shortly congregated near each other in residences on tree-dotted East Sixty-eighth Street. Hunter College for girls, at Sixty-eighth and Lexington, was nearby. Cukor always remembered the malt smell of a brewery wafting up from the East Fifties. As a boy, he went tobogganing on his Flexible Flyer down Pilgrim's Hill, just as did Claudette Colbert, growing up at about the same time in the same neighborhood. Later, they would joke about how they must have passed each other on the slope.

East Sixty-eighth Street was not a particularly Jewish neighborhood, nor was Cukor raised in devout religious fashion. Although many non-Jewish New Yorkers—James Cagney, among Hollywood personalities, for one—could speak fluent Yiddish, the common tongue of most European Jews, it was never spoken among the Cukors. Cukor himself viewed it as the province of poor Jews. (It was only later, from actor Paul Lukas, that Cukor learned all the Yiddish phrases he really got a kick out of, the vulgar and suggestive ones.)

When Cukor went to temple, sponsored by his grandfather, he learned the more scholarly language of Hebrew phonetically, without a clue as to the meaning of the words. Pork was perfectly acceptable on the Cukor dinner table; Jewish holidays were principally an excuse to get out of school.

Like many Jews from immigrant families, Cukor was ambivalent from boyhood about his Jewishness, sensitive about his social status, and dismissive of old-world tradition. In this respect, he followed a trend of some American Jewish immigrants—especially the German

5

Jews—to treat the Jews of Eastern Europe with indifference or contempt. The assimilated Jews were often socially ambitious and more well-to-do, their only connection with those who, like themselves, had come over by steerage, philanthropic.

Self-effacing Jews were no rarity in Hollywood, as is detailed in Neal Gabler's compelling social chronicle *An Empire of Their Own*. And Cukor did not stand alone in Hollywood among those who compensated with fervent Anglophilia—in his case adopting English spellings and the English style of personal salutation. Some Hollywood people, like screenwriter Leonard Spigelgass, went so far as to affect accents; Spigelgass's Yiddishisms, a main source of wit, were set surrealistically against elaborate British speech.

Being Hungarian could be quite amusing, but Jewish beliefs and rituals gave Cukor an uncomfortable twinge. When in 1958 Cukor attended the orthodox Jewish funeral of his onetime agent, Bert Allenberg, he was offered a skullcap but would not don the customary head covering. He was scolded by his companions, Katharine Hepburn and Sara Mankiewicz (the widow of screenwriter Herman Mankiewicz). Still he refused. He told Hepburn he wouldn't wear the damn thing. If he was in a Catholic Church, maybe he'd behave accordingly, he said, but in most ways he had never practiced his own religion. Then actor Spencer Tracy, hefting one corner of the casket, entered the room with the other pallbearers. Tracy, a staunch Roman Catholic (and Cukor's good friend), was wearing a crepe paper yarmulke. Instantly, Cukor felt ashamed and reached for a skullcap. Immediately after the rites, however, he made a point of taking it off.

After all, Jewishness could be an impediment to assimilation. The submergence of his religious background, and to a lesser extent the downplaying of and humor about his Hungarian ancestry, were part of Cukor's camouflage.

Early in life Cukor made a vow to himself not to be a "hyphenated American" like his grandfather and uncle. Joseph Cukor and Uncle Morris were both well-known figures in the Hungarian-American immigrant community. Cukor recalled that there was always much entertaining of "hyphenated" groups and organizations at his Uncle Morris's house. He was horrified at the extent of the political finagling and chicanery. He felt certain that his beloved uncle would have risen as far as the U.S. Supreme Court if only he had integrated himself into the broader community.

As a film director, Cukor carried out this boyhood determination. At the same time that he was a unique, highly individual person, there was about Cukor the paradox that no one in Hollywood was more anxious to blend in.

East Sixty-eighth Street was a comfortably middle-class, melting-

pot neighborhood. If Cukor had such a tremendous sense of *attainment* in life, that impulse may have been spurred by the fact that his parents' branch of the family, in contrast to Uncle Morris, lived in relatively modest circumstances in a small flat on the corner of the block, not the most desirable location. The entrance itself was on East Sixty-eighth, but the flat bordered on Third Avenue, and the elevated train rattled by noisily a few feet from the windows.

Indeed, Victor had achieved only humble status as an assistant district attorney, whereas Morris had become a civic notable and a "distinguished" (one of Cukor's most complimentary words) lawyer. Both had graduated from New York University Law School, yet Morris had earned honors. Victor seemed permanently lodged in the city bureaucracy, while Morris (an officer of the Hungarian cultural societies, an adviser to the Austro-Hungarian consulate, the president of the Municipal Civil Service Commission) had an enviable income and social recognition.

A bachelor until late in life, Morris, like his parents, could afford a nearby brownstone. Although Cukor recalled that he and his family lived without any deprivations, they were aware—and grateful—that it was dear Uncle Morris who provided the cushion of comfort in their lives.

Understanding the relationship between the two brothers was a matter of some concern to Cukor, who was never quite sure how well he knew his father. In the man's as well as the boy's eyes, Victor existed in the shadow of the eminent Morris. Victor did not look much like a Cukor—he was taller and thinner, swarthy, like a Spanish grandee. Victor did not even say much, whereas Morris was—like Cukor himself—outgoing and full of mischievous charm, very funny, a gifted extemporaneous speaker and the life of any crowd. Victor was older, but the youngest, Morris, was the favorite son, the family role model.

Some who knew him could attest that, in private, Victor was not without a twinkling sense of humor. The family had an affectionate nickname for him: Farkash (or Farkas—a nickname in Hungarian, translating as "wolf"). But compared to Morris, Cukor's father seemed colorless, the original two-dimensional man. At large gatherings, Victor seemed to shrink into himself.

Cukor never spoke much about his father, not even to close friends. Later, after he moved to California, the film director bought his father and mother a house in Beverly Hills. His parents rarely visited the motion-picture studio where Cukor was filming. After Cukor's mother died, remembered one Cukor acquaintance, his father just sat on his front porch all day long. Unlike Cukor's mother—who was fluent in German, Hungarian, and English—Victor's knowledge

7

of English was limited, so father and son would converse sparsely in Hungarian. "George said his dad spent most of the day smoking his pipe and watching the flow of traffic," recalled the acquaintance. "He hadn't the vaguest idea how famous his son was."

That may be an exaggeration, but it emphasizes the silence and uncertainty that stretched between them. When Cukor consulted a handwriting specialist in the 1940s, he made a point of displaying a sample of his father's scrawl. He took some solace in the analysis: "This man had a brother to whom he was devoted and of whom he felt no envy. . . ."

To his mother, Cukor was more raptly devoted. She was terribly protective of him, and her sweet and gentle disposition gave Cukor one side of his personality. She composed and recited potery, and was teased by her two sisters for being a highbrow. Most of the time, at family get-togethers, she was docile, but Cukor felt in her an unrealized aesthetic yearning. The film director often talked about his mother, and artist Don Bachardy remembered Cukor telling of the time his mother donned a costume at a family party and began to clown and entertain the guests. In an instant, she was transformed in the boy's eyes—in an instant, and for a lifetime in memory—into a magical and glamorous creature. "The family beauty" is how he always described his mother. Cukor's eyes always lit up when he spoke about her.

A boyhood friend, artist Stella Bloch, said she felt certain that Cukor's close attachment to his mother stimulated his understanding of female characters and his deft directorial handling of actresses in his films. "I think it [his skill directing women] derived from his love for his mother, and his keen observation of her mannerisms and her reactions, which became a part of him," Bloch said. "He lived with her, she adored him, and she was very kind to him always. I think she gave him some kind of touchstone for other women."

Rarely disciplined, the boy became extremely independent and clever at getting along. He was good at playing one parent against the other, or the parents against the grandparents. The extended Cukor family supplied much love and laughter—and Cukor's memories of growing up were fond and happy ones of treats and gifts, vacations and parties, going to the beach and to the theater.

When Uncle Morris went on one of his excursions to Hungary, he returned with perfume and toys (instilling in his nephew a lifetime habit of generous gift giving). There were annual family summers at Bath Beach, with all the Cukors—aunts and uncles and grandparents—sharing a house. Thanks largely to Uncle Morris, Elsie and the only male Cukor grandchild did many of the things wealthier people did.

It was a childhood characterized by a spirit, if not the reality, of plenty. The seeds were sown for a lifetime of personal and professional generosity. As an adult, Cukor refused to economize, and on principle he urged using and enjoying whatever one was fortunate enough to have. No one in Hollywood threw more parties or hosted more dinners. And people in need who went to the film director—behind closed doors in Hollywood—discovered he was an angel of charity. He never hesitated about an appeal for a loan, or a handout.

At work, likewise, Cukor had the reputation of being *too generous* with time and the studio's money. Producers felt that he could not be relied upon to correct a drastic situation with hurry-up measures—and they were not entirely wrong. Whether with regard to household or film production, budget was always somebody else's worry. In any case, Cukor didn't think of moviemaking strictly in terms of costs and profits, as some producers did.

If there was a blight on Cukor's youth, it may have been that he was vulnerable about his looks. To Cukor the director, beauty in an object, in art, was a sublime abstraction, and ugliness of any category repellent. Although Cukor felt he had been good-looking as a young boy, he loved rich cooking and Hungarian sweets too much, he was never athletic, and he was inclined to chubbiness. He was nearsighted, too, and had to be fitted with glasses. He looked bookish. He did not grow particularly tall—five eight and a half; he always stressed that extra half-inch. (He recalled a neighborhood play where he was playing a prince. He was shorter than the princess, so the love scenes were played with her elbow at his shoulder.)

There is a scene in *The Actress*—the film version of actress Ruth Gordon's autobiographical play, one of Cukor's more revealing projects—in which Spencer Tracy (playing the father) tells Jean Simmons (playing the Ruth Gordon character) that she will never make it in the theater because she is too much the ugly duckling. After playing the scene, Tracy told Cukor that when he had spoken to his own father about going on the stage, his father had expressed disappointment that he hadn't chosen a business career, and then told him that it was too bad he didn't look like an actor. Tracy—a plain, stocky boy with big ears and squinting eyes—was wounded with hurt. Tracy was crushed even more when his girlfriend seconded the opinion that he was no matinee-idol type.

Tracy's confidence moved Cukor. That shared sense of "ugliness" was an important subtext of their friendship.

In some respects, Cukor was a typical boy. He pored over *Popular Mechanics;* the boy who would one day almost be the director of *Gone With the Wind* read avidly about the history of the Civil War. But in other respects he was different; he found that he was not interested

in sports or flirting with girls. What he was interested in were books and plays.

The personality that was developing as an armor for his secret self was already an unusual one, as outwardly mannered as it was inwardly aesthetic. People remember how courtly Cukor was even as a teenager—extraordinarily courteous, a bringer of gifts and profferer of ingratiating compliments, someone whose kindnesses were always capped by a small joke that was a kind of camping. He emanated enormous self-confidence. His enthusiasm about things could bowl people over.

From his earliest years, Cukor's interest in the theater was tied up with the idea of family—not only theater, but art, dance, music, literature, the developing motion-picture field, and all show business.

When Cukor was growing up, his entire family would go to the Irving Place Theatre, managed by Rudolf Christians (whose Viennese-born daughter Mady was to become a well-known actress) to see the classic German plays. Many in the audience were Hungarian—bilingual in German. Cukor did not understand everything that was happening, but somehow that just added to the sense of drama and excitement.

(Although he has been accused of being the director of talky scenes, Cukor from boyhood always had this deeply felt appreciation for scenes with abundant dialogue. Other screen directors became known for their poetic scenery. But the unusual vitality of a Cukor film often stemmed from effervescent dialogue sequences in which the conversation might not even be important—might be trivial—might as well be in German.)

Uncle Morris had more Philistine tastes. He would take his young nephew to the spectacular Hippodrome, at Sixth Avenue between Forty-third and Forty-fourth streets, and they would sit close to the stage, where Cukor could gaze up, enthralled, at the wardrobe and makeup of the hundreds of permanent chorus members, the amazing lights and props, the revolving stage, the giant water tank, the trained horses and elephants, and the farrago of ballet and circus acts.

The eager youth was able to sample the spectrum of public entertainment in New York City in the pre–World War I era of peak vaudeville, vaunted classical performances, and Broadway shows. Cukor sat through the Hungarian operetta *Sari*. At age twelve, he was smitten by the delectable Ina Claire, a vaudevillian who had made the leap to musical comedy and was beguiling audiences with her singing of "Come to the Ball" in *The Quaker Girl*. He enjoyed a noisy revival of *Ben Hur* replete with horses and chariots at the New Amsterdam Theatre.

Don Bachardy said whenever Cukor talked about his boyhood, he gave the impression that it was his mother who took him along to the more high-toned productions. But hidden among the vast number of letters and autobiographical jottings that Cukor left as part of his memorabilia is this nugget of a fact: Victor, his father, gave up Sundays to take his son to photoplays.

In his career, Cukor would borrow elements equally from the well-made plays and the more commonplace musical revues that he loved so much as a child. And as a screen director, he was to marry both influences—a kind of blending of the vulgar and the sublime, an approach that, at its best, could be artistic as well as entertaining. Cukor wanted both, artistry and entertainment, without one drowning the other.

Before he was a teenager, Cukor had joined in a couple of neighborhood plays; he had jotted down the fragments of stories that he toyed with in his mind; and he had taken dancing classes from Neuberger's at Fifty-eighth Street and Lexington Avenue. Annually, Neuberger's put on a school gala at the Terrace Garden. All the boys wore coats and dancing pumps. One year, Cukor played Neptune and sang a song.

Interestingly, even way back then Cukor saved practically everything. In his Hollywood home, there was a trove of programs, letters, photographs, family treasures, mementos, and whatnot, which composed an archive of the passions and passing fancies of his life.

Decades later, when Cukor pored over a program of his Neuberger's appearance at the age of seven, he was astonished to discover that David O. Selznick appeared on the bill of the same recital. But Selznick—his old friend, a mentor of moviemaking—had already died by the time Cukor discovered that coincidence. (Not to mention that there had been a certain coolness between them ever since their rupture during the production of *Gone With the Wind*.)

When Cukor grew older and entered high school, the romance and rewards of a theater life began to beckon to him as an escape from more humdrum reality. Two friends, Mortimer (Mortie) Offner and Stella Bloch, came to symbolize for Cukor the choice between Art and the Mundane. Beginning with his teenage years, he said with candor more than once, they influenced him far more than his own family.

Offner and Bloch were first cousins, with the closeness of a brother and sister. In about 1913, Offner's parents bought a house on East Sixty-eighth Street. As it happened, Cukor's grandparents had just died within a year of each other, and Cukor was about to start high school: a turning point. From that time on, he spent more time at the Offners' than he did with his own family. He, Offner, and Bloch

11

saw or spoke to each other every day, and the Offner home became a haven away from his own.

The Offners were an especially cultivated family, up-to-date on trends in fashion, photography, art, literature, theater, and motion pictures. The mother was an inveterate picturegoer; she subscribed to movie magazines, and Cukor loved to sit and talk to her about the best new photoplays. The older brother Richard, an expert on Florentine art, was writing a huge book on pre-Renaissance Italian painting. Olga, Mortie's sister, was a schoolteacher and Mortie—a slender, handsome youth with a shock of dark blond hair—had ambitions to become a photographer.

As a teenager, Stella Bloch was already proving exceptionally talented. She played the piano, wrote extremely well, studied dance, and was sketching and painting with serious intent. A willowy creature with green eyes and a stream of long dark hair, she was lyrical and dreamy. Although Bloch lived in a brownstone down on Fifty-fourth Street, she, Offner, and Cukor were an inseparable trio.

Like Cukor, Mortie was enrolled at De Witt Clinton—one of the very best public high schools, dating from 1897. Then located at Fifty-ninth Street and Tenth Avenue, De Witt Clinton, over the generations, has boasted an alumni list of high achievers, many from the arts and show business—including author James Baldwin, playwright Neil Simon, film star Burt Lancaster, jazz legend Fats Waller, actor Martin Balsam, composer Richard Rodgers, and photographer Richard Avedon. In Cukor's day, there was a full program of stimulating activities—athletics and languages, debate, sketch, and camera clubs, literary societies and publications. The drama department was noteworthy, and when Clinton produced its annual show, some of the boys had to dress up as girls—because De Witt Clinton, like all city schools of the era, was segregated by gender.

Cukor, from the graduating class of 1917, is not photographed individually in the school yearbook. He is listed as a member of only one school organization—the Dramatic Society. From records, it appears that he acted in only one school show, in 1915; both he and Offner were part of the soprano "girl" chorus of the school production of *The Mikado*. Surviving classmates recall only that during the other annual productions Cukor might have been busying himself doing something of vague significance backstage (though not directing—that was the province of the drama coach).

One of Cukor's classmates was Edward Eliscu, a dapper whirlwind who played Puck in the school production of *A Midsummer Night's Dream* and was voted "cutest" of the class of 1917. Eliscu, a good friend of Mortimer Offner's, who later came to know Cukor quite well in another context, scarcely remembered the film director as

even being at De Witt Clinton at that time. "At least his potential was not evident," Eliscu said.

It is surprising that such a vivid and effusive character as Cukor should be considered inconspicuous by his high school classmates. But that may have been because Cukor's colorful personality had not yet developed fully, at least outside the view of family and neighborhood. Or, more simply, it may have been just that Cukor was skipping classes—with his new boon companions.

At least once a week, Cukor remembered, they played hookey. Cukor initiated the routine. The signal was that when Cukor picked up Offner in the morning, he would be carrying only his lunch, no books. They would take their lunch to Central Park, then go to a Broadway show afterward. They had to get up early the next morning to intercept the enemy postman, who would bring the inquiry from school concerning their absence. Offner and Cukor would try to snatch away the card, while the postman, who suspected their shenanigans, tried to outwit them.

Through Offner and Bloch, according to Cukor's recollection, he was exposed to the more adventurous talents of the day—among them, the Brazilian piano prodigy Guiomar Novaës, the diseuse Yvette Guilbert, and immortal dancer Isadora Duncan.

Although she had been sketched in her youth by Toulouse-Lautrec, Yvette Guilbert was now a thin and homely older woman. But such was the power of her performance that she seemed able to put the audience in a trance, transforming herself into a young and seductive creature. She roamed the stage, singing medieval and childish songs; her presence had a profound effect on Cukor.

Many times, Bloch, Offner, and Cukor watched Isadora Duncan dance from standing room in the back of an auditorium, which is all they could afford on their allowance. They waited by the stage door to catch a glimpse of her. Duncan was an especial favorite; Bloch practiced dance with one of her disciples, and wrote magazine articles praising the dancer's artistry.

Half a century later, Cukor could remember with astonishing clarity his brief contact with these legendary figures. At one point, he made a stab at following up his youthful enthusiasm with an Isadora Duncan screen biography, but like some other ideas close to his psyche, this project came to naught.

In turn, Cukor took Offner and Bloch to the vaudeville shows at the Palace, the flagship of the Keith circuit. Although Cukor was to outgrow his boyish zeal for the Palace, he always recalled warmly the merry entertainers who reigned there around the time of World War I.

If the three friends liked a play, they might see it two or three times, repeatedly. They memorized lines and practiced line readings.

Cukor, in particular, discovered he had a photographic memory for theater lore and stage business. That was to serve him well.

These were the years of the incandescent female stars, and Cukor had many personal favorites, including Ethel Barrymore, Laurette Taylor, Emily Stevens, Pauline Lord, Mrs. Pat Campbell, and Elsie Ferguson. The three friends could buy their tickets at reduced prices at Gray's Drug Store. From the safe remove of the second balcony—all they could afford—the future film director fell in love with the stage beauties of that generation.

Again and again throughout the history of Hollywood, there are instances of people who grew up to make motion pictures centered on the enthusiasms and preoccupations of their youth. Joel McCrea, a California surfer, rose to star stature in the movies of the Western dime novels he had enjoyed as a boy. Clarence Brown, the director, chose to film *Intruder in the Dust* as an apologia for a racial atrocity he had witnessed growing up in the South. The screenwriter Norman Krasna channeled his humiliating stint as a Macy's salesman into the script for the comedy *The Devil and Miss Jones*. The examples go on and on.

Something practical—it is what they know best—as well as something ineffable draws creative people back to the earliest wellspring of their experience.

The actresses whom Cukor adored—the lives and careers he scrutinized—formed the basis for the finely etched showgirls and cabaret performers of *Rockabye* and *Zaza*, the theater animals of *A Double Life* and *The Actress*, the has-beens and hopefuls of *What Price Hollywood?* and *A Star Is Born*. In these, and many other Cukor films, show business is a sanctuary for the misfit, bathing all in a beautiful and forgiving light. His deep feeling for all show people was one that complemented his own interior psychodrama—as someone who (like an actor playing a role) was to live one life onstage and another behind the curtain.

When the teenaged Cukor made up his mind to meet these women and to befriend them and if possible to work with them one day, that must have seemed an astounding germ of ambition. Yet as a testament to his willpower, that is precisely what transpired. Cukor met and wooed many of the luminaries of his boyhood (sometimes pathetic figures offstage); he helped them out charitably or otherwise; he cast them in small or showcase parts in motion pictures. They came to dinner at his Hollywood home.

These great ladies were flattered that the young director could quote from their heyday on the stage—their most famous parts, precise line intonations, memorable reviews. They were flattered, even if they were flustered sometimes, to be reminded that they were ten or twenty or thirty years older. Cukor liked to tell an anecdote about

14

Broadway headliner Fanny Brice. When informed that he used to see her quite often at the Palace when he was a boy, the comedienne glared at him and said, "You son of a bitch . . ."

For Cukor, these adolescent years—years of friendship with Offner and Bloch, of immersion into show business—especially 1916 and 1917: They were the "delicious days" of his youth.

In his senior year at high school, he and Offner became supernumeraries (fifty cents a show, one dollar for blackface) for the Metropolitan Opera. They strolled about in the square during *Carmen* as the chorus sang *"Sur la place, chacun passe, chacun vient, chacun va . . ."* They were permitted to stand in the wings and watch Geraldine Farrar sing her arias. The coquettish lyric soprano became another idol of his, and Cukor saw her in *Madame Butterfly, Tosca,* and as the Goose Girl in *Königskinder.* He always remembered his glimpses of her backstage—talking with Caruso, or wafting by in a cloud of perfume with her mother one time after a curtain call. Bouquets of flowers were being tossed from the audience, and her mother was advising her in a whisper, "Pick this one up . . . now that one. . . ."

With Offner and Bloch, while still in high school, Cukor plunged into his first real attempt at putting on a show for the public.

The three friends put on a harlequinade one Sunday at New York's Temple Beth-El. Offner, Bloch, and Cukor were the three characters in a skit that Bloch and Cukor wrote together. Offner played the dashing hero, Bloch the simpering ingenue, and Cukor a skulking villain called Liccoricio. Cukor, the budding director, devised the action, blocked the proceedings, and helped paint the backdrop created by a De Witt Clinton classmate who later became an artist by profession, Howard Kuh. Olga Offner played the piano. "We had a large audience," remembered Bloch, "and they seemed to like it very much."

Although Cukor had been well behaved until high school (he claimed to have finished as valedictorian of his grammar school class), truancy took its toll and he barely made passing grades at De Witt Clinton High. (Another of the three friends, Stella Bloch, was to quit secondary school altogether without having graduated.) Any further education would have to come from the life Cukor boldly planned for himself in show business.

His nostalgic memory of an idyllic youth must be qualified by the reaction of Cukor's parents—and of Uncle Morris—to Offner and Bloch taking up so much of Cukor's time. Ironically, the Cukors, who had done much to foster an interest in the theater, now thought the teenager was squandering time and money on plays. The family

made wisecracks and raised complaints, but they stopped short of telling Cukor to stay away from his two friends. And as he recalled many years later, it wouldn't have mattered, anyway. Long before, he had stopped listening to his family.

One reason the Cukor family complained about his constant companions had nothing to do with show business. They were simply envious, according to Cukor.

This was particularly true of Cukor's mother, who saw in Stella Bloch—in her refinement and intellectualism—someone she herself might have wished to be. "She saw me as a rival for her son's devotion," said Bloch.

Bloch, Offner, and Cukor spent hours together, discussing art and music and literature, recommending to each other this new book or that most recent photoplay. Bloch's ideas, to some extent, became Cukor's own. Together, they discussed the serious plays. Together, they devoured Schnitzler and other dramatists. Together, they championed D. W. Griffith as the master of the cinema.

Griffith was a pronounced hero among the three. Indeed, Bloch wrote an article for the prestigious literary journal *The Arts,* in the mid-1920s, in which she eloquently defended Griffith, whose reputation was then on the wane. If Cukor never professed much admiration for other American directors, he never lost his fascination with Griffith, a poet and a dreamer—a man who wore his complexes on his sleeve—an independent-minded, self-destructive film artist who in many ways was the antithesis of the more sensible studio craftsman Cukor.

When, while still a teenager, Cukor took a series of photographs of Bloch in costume with her cousin Offner, the photographs were posed in a sentimentalized D. W. Griffith style—soft-edged, artificialized. The negatives of this early, fumbling camera experiment were inadvertently scratched by Cukor, whose technical expertise as a Hollywood director later was sometimes called into question, after he attempted to develop the photographs himself. However, Cukor insisted he would get better with practice. He had a good exemplar in Offner, who even as a youth was developing into an accomplished photographer.

Just for his own contemplation, Cukor put together an album of photographs he took of Bloch dancing evocatively in a diaphanous costume. After a time, he decided to give her the album because, he said, it would upset his mother. "In fact, he also gave me some of my own letters back," said Bloch, saying it was because "she [his mother] would be apt to read them and they would disturb her."

There were already more than a score of letters from Cukor to Bloch by the end of 1917. The three friends kept in touch with each

other over school vacations—with the Cukors sequestered summers at his grandparents' on Far Rockaway, Bloch away in Massachusetts, and Offner earning money as a counselor in boys' summer camps.

Cukor was already an inveterate letter writer, and over his lifetime he wrote (usually dictated) literally thousands of letters, many of them duplicated and saved in various drafts in his files. Producer David O. Selznick, a prolific memo sender (it was one more aspect of their kinship), had nothing on his director in that category.

From the earliest, Cukor's letters followed a pattern, and reflected the psychology of someone who revered good writing but felt, intrinsically, unable to express himself. He was something of a "frustrated writer" from youth, yet to his credit he channeled that frustration into a reverence for writers. In his career, he was to prove meticulously faithful to the words of the script, and in private life, a great friend of scriptwriters—and writers in general. In this respect, he was unusual, if not unique, among Hollywood directors, who in general were more likely to have hostile or uneasy relationships with the writers whose skills they envied yet were dependent upon.

Invariably, over the span of decades, Cukor's letters touched on points that arose in the earliest known example—to Stella Bloch—dating back to the summer of 1915. In that letter, mostly gossip and joking and recommendations of books to read, the sixteen-year-old Cukor apologized profusely for his spelling and composition, which he allowed were a poor substitute for his verbal fireworks in person.

This inability to evoke himself in writing was a weakness he exaggerated for effect. He must have felt it deeply, however, for his letters some sixty years later are coated likewise with apologies for spelling and clumsy construction. In reality, of course, the spelling was pristine, the tone natural, and the construction sound—Cukor's letters were often delightful, humorous, casual-seeming gems. If only, he said many times to himself and to friends, he could write fiction, or his autobiography, as unselfconsciously as he dictated letters. . . .

The letters to Stella Bloch—from the high school years until well into the mid-1920s—have one other distinguishing quality. They are studded with endearments, flirtatious language, professions of love, and playful intimations of sex. Some of that language was just Cukor's characteristic effusiveness; some of it was clowning and teasing. But it is impossible to read a stack of these letters without coming to the belief that they are also evidence of his first painful and deep-seated attraction.

Bloch herself was not sure of the boundaries of their relationship. There was mystery about Cukor—not only a genuine but put-on air of mystery. He was very slippery about himself. His letters were full

of chatter about other people but superficial about his own emotions.

He would express enormous affection for Bloch. He would ardently flatter her (he had a way of isolating and observing details—a piece of clothing, jewelry, a new hairdo—that was to serve him in good stead in Hollywood). "'Even,' he said, 'the way you handle a book, or turn the pages,'" recollected Bloch. "I thought, Oh, that's lovely!" But Cukor was also evasive and ambiguous when Bloch tried to pin him down about his feelings.

Bloch sensed that Cukor felt a deep attraction to her cousin Mortie. Cukor was *influenced* by Offner, and he laughed harder than anybody at Offner's jokes. In turn, Offner, who could be awfully funny, found Cukor hilarious. Much of what the three did together, much of their bond, was laughter, the basis for many a Cukor friendship.

Because they had been extras in the chorus, Offner and Cukor could entertain friends by singing in French large portions of the opera *Carmen* with great ease. Or they would adopt Italian accents and launch into elaborate, uproarious pantomimes.

Even in those days, Stella noticed how much of Cukor's humor was centered on homosexuality. He was always camping and making fun of homosexuals. Cukor was scathing about their weaknesses, and referred to some men (in the parlance of the day) as "she" and to homosexuals in general as "girls." He was already an avid collector of vulgar stories and foul expressions; from him Bloch learned the word *schwel*, a variant on *schwul*, which roughly translated from the German as "homosexual."* They used it among themselves as a code word.

Bloch wondered. As she and Cukor grew older, she pondered whether he had an infatuation with her—or with her cousin. "I did think he was in love with my cousin Mortie, and it's possible that he was," recalled Bloch. "I don't think he would have told anybody that." Cukor's mother, in her preoccupation with Bloch, may never have considered that possibility.

Cukor's lifelong affection for Offner was to be a "totally frustrating experience" for the film director, according to Bloch. The letters penned to Bloch inevitably signed off with a postscript message to her cousin Moische (Cukor's pet name for Offner) to get in contact.

*"Homosexual" is probably too bland a translation—*schwul*, then as now, had the force of "queer" or "faggot." In West Germany, for example, the present-day Green Party has attacked the use of "schwul" in parliamentary proceedings, because of its negative connotation. Christian Democrats have countered that the Greens want to revise German into (according to one reference source) a "feminist Esperanto without any character."

But Cukor could never get Offner to write or even to answer his letters.

Bloch had a feeling that Cukor was more fervent about Offner than vice versa. For one thing, Offner, witty and striking, was a magnet to women, "totally interested in women, and such a thing [as a homosexual relationship] would have been unthinkable to him," in Bloch's words.

When Cukor graduated from De Witt Clinton in the spring of 1917, he was not yet eighteen. At his parents' bidding, he entered college in pre-law. Some sources indicate Columbia University—but, if so, it wasn't for long. His college charade was destined to be a halfhearted one.

World War I was ongoing, and able-bodied young men were enlisting in droves. Cukor enrolled in the Student Army Training Corps (SATC) of the College of the City of New York, but during his brief stint, from October through early December of 1918, Germany surrendered. That duty was done with, so with his friend Mortimer Offner, he took a temporary job working for a publisher on a translation of *Le Voyage de M. Perichon*, a standard French text.

Cukor's secret ambition, he confided to Stella Bloch, was to earn a half million dollars—a fortune—to become wealthy and famous. He informed his mother that he had decided on a life and career in show business. He wanted to be a director of Broadway plays.

The reaction from the family (especially Uncle Morris) was vehement. Cukor was expected to follow family tradition and become a lawyer, a safe bourgeois occupation. The profession of stage director was from the family point of view, according to Cukor, equivalent to a drug pusher or a bookie. With the resoluteness that was such a hallmark of his life, Cukor turned a deaf ear to objections and decided to follow his heart.

In any case, Cukor harbored the impression that his mother was secretly pleased with his artistic impulses. Though Uncle Morris was vastly disappointed, it was he who provided his nephew with helpful connections.

Uncle Morris knew someone from his law school class who was the attorney for a partner of director Arthur Hopkins, one of the most distinguished Broadway producers. Hopkins's signature was good taste, the well-knit play, the introduction of new talent, and—something revolutionary for the times—a laid-back approach to steering the performers toward truth in acting.

"He [Hopkins] used to sit around a table with all the actors reading the script," commented Katharine Hepburn, who was directed by Hopkins for the stage as well as by Cukor for films. "Most directors get the actors on to their feet almost immediately. Hopkins, on the

other hand, had them sit around the table for about two and a half weeks until they knew it. I worked for Arthur and found this an excellent system, as I always learned a script before I went into rehearsal. Some people were very thrown by this method. Frankly, I always thought Hopkins was on the right track—as walking around with a script in your hand is quite different from knowing what you're talking about and saying it spontaneously."

Cukor was given an introduction to Hopkins, and awarded a job interview. Nothing came of the meeting—Hopkins merely advised Cukor he had to get some workaday experience under his belt—but the important theater director was very open and friendly. He permitted Cukor to visit him in his office, glass-walled so that he could observe the stage, in the balcony of the Plymouth Theatre.

Watching Hopkins discreetly at rehearsals, Cukor was struck by his disconcerting technique. Hopkins would sit out front as the play was run and ask the players to perform the scenes again and again, never commenting.

Gradually, Hopkins's system had this effect: The actors forgot that the director was out front, all of their sham and artificiality dropped away, and the integrity of the play would emerge. Certain critics thought Hopkins was inept when it came to managing crowd scenes and violent action, but no one, Cukor felt, served the actors and the script better. Cukor tried not to miss a Hopkins production. He would never forget certain shows: Marjorie Rambeau in Zoë Akins's *Daddy's Gone A-Hunting,* John Barrymore in his Shakespearean triumphs, *Richard III* and *Hamlet,* Laurette Taylor and Louis Calhern in Philip Barry's *In a Garden.* Although Cukor's methods were antithetical to Hopkins's in many respects (not for him such a resolutely laissez-faire approach), in terms of directing no single person exerted a more subtle and far-reaching influence.

CHAPTER TWO

\mathcal{W}ith the pretense of law school and his military obligations out of the way, the eighteen-year-old Cukor began to do what he really wanted— scouting talent agencies and stage doors, looking for his first job in show business.

The Better 'Ole was a droll musical entertainment based on Captain Bruce Bairnsfather's World War I cartoons. The show had originated in London and proved such a hit that it was playing in England, Canada, and Australia, with four concurrent road companies in the United States. Klaw & Erlanger, the theatrical producers with a stranglehold on much of the touring circuit, needed someone as a backstage man and to play a bit part for the Chicago company. Cukor answered an advertisement and was hired.

In late February of 1919, *The Better 'Ole* opened its tour at the Illinois Theatre in Chicago. From there, the production zigzagged around the Midwest, playing Kankakee, St. Louis, and Cincinnati—among other whistle-stops—usually for one-week stands, but interspersed with occasional one-nighters.

Cukor had never been to Chicago—indeed, he had never been outside of New York City, except to Bath Beach, Far Rockaway, and once to a farm upstate, where, incongruously, he had been a farmer's helper during a school vacation. The train trips (the company traveled by private car) were rambunctious, and local accommodations not al-

ways commendable. Landladies swindled him. In St. Louis, a convention forced Cukor into a room at a hotel for burlesque performers. There, he complained in a letter to Bloch, he tripped over empty beer bottles in the hall, and heard a chorus of "Ja Da" shouted all night from open windows. Shrieking women and seductive ladies, he wrote, beckoned to him from across the courtway.

The letters flowed—to his parents, to Bloch, and to others in their circle of acquaintances. The family letters were typically brief, written with some difficulty on the jolting train. The theater novice promised to save a little money from his paycheck, and asked for his favorite marble cake with nuts to be mailed ahead to the next destination.

His letters to Bloch ran to several pages and in them Cukor waxed poetic, commenting on the smell of the city streets, the beauty of the lakes and rivers. Cukor made note of photoplays he had seen (always, the latest Griffith) and commented upon the various eccentrics in the *Better 'Ole* troupe: a Russian Jewish lady who pretended to have had a Christian mother; the Christian Scientist cum spiritualist who would cure any ailment for two dollars.

Interestingly, in these early letters from "the front" (as he put it), Cukor took a dim view of these and other "strange creatures" of show business. Theater people, he realized close up, were a special breed. Their magnified personalities included magnified faults and frailties. One of the irrepressible fans of actors and actresses, Cukor also had, from this earliest experience, a profound skepticism about actors. At times, that skepticism verged on contempt; in private, Cukor was known occasionally to quote Alan Jay Lerner's adage "Never underestimate the stupidity of actors." What seemed a double-edged attitude gave uncommon depth and virulence to his most powerful films about the profession, *A Double Life* and *A Star Is Born.**

In one letter to Bloch, dating from *The Better 'Ole* tour, Cukor itemized his complaints about actors—how "insinuating" they could be (daring to embark on a first-name basis with him only minutes after making his acquaintance), yet lazy and undependable, devoted to bickering and gossiping. Actors lived, Cukor wrote Bloch, only for the spotlight, the world of exaggeration, and offstage they exhibited

*That double-edged attitude never left Cukor. "I often dined with George," said the playwright and screenwriter John Patrick, who worked with Cukor in the 1950s and 1960s, "and we went to the theatre a couple of times. Sitting beside him, he was very critical of some of the actors, but when we went backstage he was very flattering—which was part of his personality. He didn't like to hurt or offend anybody, though he might say awful things about them behind their back."

little subtlety, little humanity. Onstage, they pretended to be honest and have deep feelings, but backstage they were shallow people.

In this revealing letter, though, Cukor felt obliged to gild his complaints by adding that many of the actors he had met were handsome indeed and knew some excellent vulgar jokes besides—which jokes he promised to remember and tell to Bloch when he saw her next.

One *Better 'Ole* actor Cukor unabashedly admired was the veteran comedian De Wolf Hopper, who enjoyed top billing as the soldier Old Bill.

Hopper's Broadway career had peaked, and he was relegated to touring shows. He was notoriously slow to memorize his lines (although Hopper's memorization improved nightly, Cukor said he thought it was a good thing the Chicago critics had a habit of skipping opening nights). Even so, in his letters Cukor said he found the trouper so deft and ingratiating an actor that he called to mind Yvette Guilbert. Hopper's curtain-call speeches Cukor found particularly diverting, because the actor—a shameless raconteur and crowd pleaser (in his deep basso voice, he would tirelessly recite "Casey at the Bat")—altered his monologue every night in order to keep from boring the regular company.

As for Cukor's own acting in the play: He felt that he rendered his small part admirably.

At this fundamental stage of his career, interestingly, the future film director seems to have been as concerned with the idea of *writing*—a letter, an essay, a play, *anything*—as directing.

Cukor made the acquaintance of Percy Hammond of the Chicago *Tribune* and persuaded the well-known drama critic to publish in the allotted space of his column a brief article Cukor had drafted praising the showmanship of De Wolf Hopper. Cukor wrote to Bloch that, while writing the piece, he had tried consciously to imitate the style of one of her essays about Isadora Duncan.

More ambitiously, Cukor devised a couple of treatments of dramatic material for stage consideration—only he could not bring himself to finish the actual writing, so he left the typing and polishing of the material to a private secretary back in New York City.

Cukor had a fund of ideas, in those years, for plays that one day he intended to write. They were not always ideas for comedies; they were usually sophomoric "boy meets girl"–type romances, recalled Bloch, typical of the period and of Cukor's youth.

One of them, which Cukor described in some detail in a letter while on the road with *The Better 'Ole* company, was a tragic drama that he said had been haunting his imagination for years: about an empty-headed girl, age about twenty-nine, who tries hard to be unconventional, and is treated shabbily by a callow young man.

Cukor must have realized that his trivial-sounding plot might seem unimpressive to Bloch, so he added that the scenario was more coherent than his breathless recounting might imply. He said he had great belief in its potential. Significantly, for a film director who became known for his high-society milieus, Cukor said he felt that he was on solid ground with his story because it had a middle-class family basis much like his own.

As he became drawn further into the intrigues of backstage existence, Cukor decided that writing about the life he was leading—the theater life—would be even more important. He informed Bloch in a letter that he had experienced amazing insights about show business, and that a play about a touring company of actors was taking shape in his mind.

This was a lifelong goal: Off and on for fifty years, Cukor would make noises about filming an autobiographical backstage story. The memories of his early-on road-show experiences would stimulate the director, especially when he came to film *Sylvia Scarlett* and *Heller in Pink Tights*. But his writing efforts, for complicated reasons, were doomed to frustration. In 1919, some of those reasons were evident already: Cukor hated to work or be alone (and writing is such a solitary act); and autobiography stymied him particularly. It always remained for someone else to come along and do the hard work of honing Cukor's stream-of-consciousness ideas.

"I don't think he had a word on paper," Bloch said of Cukor's ideas for stories in those years. "He talked to me about them. I encouraged him to write them down. But he never did. Finally he said to me, 'Why don't *you* write them down?'"

All told, Cukor found that he was intoxicated by life in the theater. He loved the community and camaraderie, the overlapping of onstage and offstage drama. He felt as if he *belonged*, one of the show-business family. (It cannot have been incidental to him that so many of the cast were homosexual, that homosexuality was relatively acceptable, or at least overlooked, behind stage doors.)

He was surprised that the actors listened to him—seemed to trust in him—he was proud to tell Bloch that the show people he met predicted a bright, shining future for the stagestruck young man. In his own clodhopping way, he was advancing in his knowledge, he wrote Bloch, predicting that in time he would make a name for himself in show business.

His duties as assistant stage manager were lowly but vital to operations. Cukor posted the call sheets, organized the props and the protocol of the dressing rooms, gave light and curtain cues, handed out the pay envelopes, and did whatever errand or favor was asked of

him by members of the company. Part of his job was to assist the stage manager in keeping each player on time, on cue, and in good humor.

The actors and actresses who met Cukor during this crucial phase of his apprenticeship were struck by him. His energy was abundant. He was helpful in organizing chaos and taming crisis. He was patient with silliness or vulnerability. Profusely charming, endlessly buoyant, he had a store of funny stories—vulgar and otherwise—for every occasion. He seemed at ease in the intimacy of hotel rooms, in taverns and restaurants, and at the many social occasions that enliven a long, arduous tour.

To anyone who would listen, the personable young man would proclaim his love for the theater and vow that one day he would be a director of high-minded plays. They had no impulse to doubt such aspiration, and as they got to know him better, they had more reason to believe.

The stint with *The Better 'Ole* was followed by another assistant stage managership with a company performing Mark Swan's *A Regular Feller*. After playing East Coast venues, *A Regular Feller* was also launched into the Midwest from the hub of Chicago. (Cukor arrived in Chicago again in the fall of 1919, in time for the World Series, which was of no consequence to him.) No matter that his onstage duty required driving a vehicle—it was an automobile comedy, about the invention of a puncture-proof tire—and Cukor had never gripped a steering wheel.

"The first thing they asked him [Cukor] was whether he could drive a car," recalled Bloch, "He said, 'Oh yes, of course.' He had never driven a car in his life. So he went from the office to a place where he learned to drive. And he had a rather difficult job of it, because the car came on to a rather shallow stage, had to make a turn, and come right down to the footlights. One press of the foot too much, and . . . I remember that distinctly."

When *A Regular Feller* ended its cycle, Cukor was dispatched by Klaw & Erlanger to Baltimore to participate in a lighthearted doughboy musical called *Dere Mable*. Cukor was promoted to stage manager, and played the minuscule part of Toni, billed in the program as George D. Cukor. He became chums with the tall, vivacious ingenue, George M. Cohan's protégée, Elizabeth Hines. The production played one-week engagements in Baltimore, Wilmington, Chicago, Rochester, and Boston, but never reached a Broadway pinnacle.

While on the road with *Dere Mable*, Cukor made the acquaintance of a theatrical manager in Syracuse by the name of Howard Rumsey. Rumsey, who was affiliated with the Belasco organization, operated a stock company during the summer months that shuttled plays be-

tween Syracuse and nearby Rochester. His wife, the leading lady of his troupe, the Knickerbocker Players, was actress Florence Eldridge. Rumsey needed a backstage man for the 1920 season.

The sensible Cukor saw the offer as an opportunity to stay in one place for a couple of months. But to his surprise, Cukor found that he liked summer stock—with its variety and velocity, its nurturing, family-style closeness among the cast and townies. What is more, he liked the smallish cities of Syracuse and Rochester. The summer of 1920 passed enjoyably.

Back in New York City, Cukor again found himself looking for a foot in the door. For a while he had one, literally—as doorman of the Criterion Theatre, bedecked, in this era of theater opulence, in an admiral's uniform, gold epaulets and all. It was a somewhat unlikely Cukor getup, with his tortoise-shell glasses and by now undeniably pudgy physique.

When Cukor was approached by Rumsey for the 1921 summer season, he signed on once again as stage manager of the Knickerbocker Players.

In the spring of that year, the personnel assembled for an introductory meeting at Tuxedo Hall, on Madison Avenue and Fifty-ninth Street in Manhattan. Apart from Eldridge, the group included Clarke Silvernail and Charles Halton, who played parts and doubled as directors, the actor-writer Richard Taber, Ralph Murphy, who had a substantial career later on as a Hollywood director, Mabel Colcord (grandes dames and character women), Donald Foster (juveniles), and Margaret Cusack (second women).

The season's fresh-faced ingenue was the slender, red-haired nineteen-year-old Frances Howard McLaughlin. When she arrived at Tuxedo Hall and announced to the group "I'm here," she struck Cukor, he later recalled with some hyperbole, as "the prettiest girl I had ever seen—a beautiful figure, lovely face, and beautiful skin. And there was something very respectable about her, very elegant. She was soignée."

McLaughlin was susceptible to Cukor's chivalric charms. He took her under his wing—one of the first actresses for whom he was a Svengali—coaching her in roles, suggesting a name change for billing purposes to Frances Howard, and advising her, as he so often did with female acquaintances, on makeup, hairdo, and wardrobe. They found they shared a malicious sense of humor.

The schedule started with rehearsals upstate in late May, but most of the plays—one a week through early August—were performed also at the Lyceum Theatre in Rochester, where the Knickerbocker Players were billed differently, for civic purposes, as the Manhattan Players.

26

Cukor did not direct, but he had to organize the hectic schedule of rehearsals and performances in both cities. At the same time, he had to master the occasional walk-on, such as his impersonation, in that season of 1921, of a red-bandannaed Indian named Mak-a-Low, a Siwash, who squatted and grunted in one corner of the stage in Willard Mack's *Tiger Rose*.

But Howard Rumsey was a difficult man and was not liked by most of the company, including his own wife. (Most of the company did not much like his condescending wife, either.) When, during the summer, marital tensions between Rumsey and Eldridge reached fever pitch, the situation became unbearable for Cukor and others.

By chance, that was also the summer—1921—that the longtime proprietor of Rochester's Lyceum, Martin E. Wollf, died. The theater was bequeathed to his widow, who, it was whispered, was investigating the viability of another summer-stock company, exclusive to Rochester. Cukor had cultivated his friendship with Mrs. Wollf, who shared his dislike of Rumsey.

Not coincidentally, therefore, the next summer the Manhattan Players found themselves without their customary lease on the playhouse, while Cukor rose up to become the general manager of the newly formed Lyceum Players. The Manhattan Players were dislodged and forced into other quarters (Rumsey's operation lasted only one more season). The only other Knickerbocker to bolt Howard Rumsey's ensemble was the ingenue Frances Howard, who joined the upstarts for the summer season of 1922.

The city of Rochester was to echo fortuitously, almost magically, throughout Cukor's long life and career. The Lyceum Players provided his first cosy niche in show business. Frances Howard was an honorary native with socially prominent Rochester relations. And born and raised in that upstate metropolis, by coincidence, were Clare Boothe Luce, Philip Barry, and Garson Kanin, three who contributed much in the way of sparkling comedy to Cukor's oeuvre.

In Rochester, too, was Eastman House, producer of all raw film stock and photographic equipment of the period. Mint-condition prints of the latest photoplays were always screened in Rochester, and a steady stream of motion-picture executives and luminaries visited the city. Motion pictures, then, were very much part of the civic identity.

In 1922, Rochester was "a small city, very American, very Yankee and so much fun," in Cukor's recollection. It had a bustling downtown, excellent theaters and moviehouses, fine restaurants and speakeasies, chic hotels, a nearby amusement park, and many Finger Lakes, plus Lake Ontario, within driving distance. With its sizable

middle class and well-to-do bloc, Rochester citizens had a tradition of turning out in goodly numbers for all of the major touring productions and revues.

The first-class Lyceum, downtown, east of the river, was considered the city's best playhouse. A twin to the Casino in New York City, its architecture was Moorish, its stage one of the most commodious in the country. There was an expansive balcony and also a good-sized second balcony, or "peanut gallery" as it was called. "You could whisper [on stage] and hear it in the balcony," said one of the Lyceum ensemble, Benny Baker, in awe of the acoustics.

The newly constituted Lyceum Players were not alone on the Rochester summer scene. They were rivaled by the more veteran crew of Vaughan Glaser, a fading Midwestern matinee idol who had once promoted Ty Cobb in a touring production of *The College Widow* (Glaser stoically maintained that the baseball slugger was a perfectly adequate thespian). Starring in and directing his own light touring fare, Glaser and company were in their second decade of returning to Rochester for the profitable summer engagement. The Lyceum troupe looked down their noses at Glaser's inferior ham productions—across the street at the newer Temple. After hours, Cukor used to regale everybody with his slashing mimicry of the rival company's manager.

One of the ways in which Cukor gained the upper hand was to exploit the local angle. Glaser was an outsider whose company (many from Portland and San Francisco stock organizations) did not mix in Rochester society, whereas the Lyceum Players seemed to be, more or less, genuine "Rochesties" (a nickname for the local populace). "They [Cukor's company] *related* to the town," explained Rochester newspaperman Henry W. Clune, "Local theater buffs gathered round them, members of the audience entertained them, stage-struck young men beaued the young women of the company."

The Lyceum chorus members were picked from Rochester debutante circles and from among the student ranks at the University of Rochester. Most were nonprofessionals, but some townies, like baby-faced character player Benny Baker, who gained his first acting stripes under Cukor, went on to have solid careers on Broadway and in Hollywood.

One of the bit performers that first season of 1922 was Walter Folmer, a Rochester native who had played female leads in productions for Princeton's celebrated Triangle Club, and who, more importantly perhaps, was the son of the owners of the Graflex Corporation, manufacturers of high-grade photographic apparatuses, a business affiliated with Eastman. Another early conscript was George "Junie" Kondolf, Jr., also from Rochester, who was tight with dollars

and cents, and who knew, for publicity purposes, all the area scribes.

The first two years—1922 and 1923—were modest ones for the Lyceum Players, with playbills consisting of comedy, romance, bedroom farce, and the occasional murder melodrama. Nothing of the classics; no originals; indeed, many of the productions had already played Rochester during the preceding months, assuring their audience familiarity and reception.

The leading players of the fledgling company in 1922 were Ann Andrews, a statuesque blonde with airy poise—she became Cukor's first big inamorata—and Ralph Morgan, a versatile actor, not as well known as his brother, Frank Morgan, was to become well-known in Hollywood later on by playing the Wizard in *The Wizard of Oz*. In 1923, the returning company included Andrews and the lanky, debonair Louis Calhern, who began to cut his local swathe, according to one Rochester newspaper column, as "command performer to thousands of fluttering feminine hearts."

Despite his grand-sounding title of company manager, Cukor still was not entrusted with directing the plays. In 1922, the Lyceum shows were guided by two stage veterans, Carlyle Moore and Charles Kennedy, and in 1923 by Kennedy and Harry Plimmer, with Cukor relegated to subordinate duties ("Mr. Cukor will . . . look after technical points of production as well as act," reported a Rochester newspaper).

Yet Cukor was crucial to the success of the Players. The energetic company manager put in long hours behind the scenes, he had a finger in every phase of the operation, and he circulated widely around town at dinners and parties. Long before he became famous in Hollywood, Cukor was already on his way to being "famous in Rochester."

Back in New York City during the regular season, Cukor could flaunt good references now. It wasn't long before he was positioned advantageously as the stage manager of the Empire Theatre, across from the Metropolitan Opera House, near Fortieth Street, which was the showcase of the Charles Frohman organization and one of Broadway's most prestigious playhouses.

In those days, a Broadway stage manager was second in importance only to the director. Among Cukor's duties were drilling the understudies and supervising touch-up rehearsals in the absence of the director. In effect, as a stage manager for the Frohman organization, Cukor himself was *rehearsing* to be a director.

Many of the tryouts began on the road, furthermore, and the young stage manager was traveling regularly between cities on the Eastern Seaboard, caretaking plays, meeting show people and making new

29

friends, and attending to a list of growing and complicated responsibilities.

As a stage manager for the Frohman organization, Cukor first met so many of the theater and literary nonpareils who would exert such an impact on his life and career.

It was in 1923, for example, that Cukor first met the playwright and novelist W. Somerset Maugham while on a fall tour of Maugham's farce *The Camel's Back*. Although Maugham's reputation was well established—indeed, he was at an early peak of his fame—he and the young untried stage manager had an immediate affinity. They found they had much in common: Both were sons of lawyers, both refugees from the middle class. And although it was to come much later in Cukor's case, often Maugham wrote—and Cukor directed—stories about social double standards.

Of course, as homosexual gentlemen, both lived in the shadow of social reproof. Though he was—as Cukor was to become eventually—a highly self-disciplined professional who had conquered his field, Maugham always felt himself to have certain personal inadequacies: a shyness linked with his stuttering, and an ugliness that wounded his vanity. That physical sense of inferiority was another thing Maugham and Cukor shared.

When they first met on the tour of *The Camel's Back* (an unsuccessful Maugham play that never made it to Broadway), the stage manager was upset about changes in the text being made without Maugham's knowledge. Cukor approached the world-renowned author and cautioned him, behind the backs of the producers, about the dastardly cuts. "When you write easily," Maugham replied stutteringly, "you don't m-m-mind cuts."

(Cukor always remembered and was impressed by that philosophy. In a different context, as a screen director, he tried to follow Maugham's advice: When the work was basically solid, never mind the irritating cuts.)

Helen Hayes was another of the illustrious people Cukor met during his period as a stage manager. At the time, Hayes was in an early, flapper phase of her career. She was playing a leading role in the 1924 Frohman production of *Dancing Mothers*, a comedy cowritten by Edgar Selwyn (who also directed) and Edmund Goulding (before he made his name as a writer-director in Hollywood). The cast included David Manners, one of Cukor's circle many years later; in a small part, Frances Howard's sister Constance; and inconspicuous in a café scene, Walter Folmer.

"At that time," remembered Manners, "we didn't know if he [Cukor] was talented, but he was lots of fun. He always had quips and funny remarks to make about people, that sort of thing. He was vital

to the show and everybody liked him. He was like the mother hen, taking care of her chickens; every night he'd come to the dressing room to see how you were and if you were Johnny-on-the-spot."

Hayes found the stage manager of the play to be a boon companion, always "up" and ebullient. She and he used to go dancing a lot together after rehearsals and performances.

"His laugh was enough to send you flying high," Hayes remembered. "It was a wonderful, merry, infectious laugh. We laughed a lot and we danced a lot and we palled a lot. Danced together and palled together. He [Cukor] was a good dancer! We had a good laughing relationship."

Perhaps the reigning queen of the stage, "the most glamorous actress of her day," in Arthur Hopkins's words, was Ethel Barrymore. One of Cukor's idols, she appeared in 1926 in Maugham's *The Constant Wife* (Cukor's second Maugham play—he was already on close terms with "Willie"), a Frohman production about a wife indifferent to her husband's philandering. The comedy had a long road gestation in the Midwest, with Cukor as stage manager, before its presentation on the Great White Way.

On opening night in Cleveland, the actress's mind went blank and the First Lady of the American Theater could not remember her lines (not a single line of dialogue, exaggerated Cukor). She was prompted from all sides, including Cukor crouching behind the fireplace, and at best it was a ragged performance. Afterward, Maugham marched backstage, looking grim-faced. Barrymore threw her arms around him and said, "Willie, darling, I've ruined your play—but, never mind, it'll make a million dollars!" (Cukor liked to dramatize one of his favorite theater anecdotes, by adding that, on the following night, by some sorcery that was known to only the best actresses, Barrymore knew every "if" and "but," and cruised through her performance.)

By the time *The Constant Wife* arrived at Maxine Elliott's Theatre, in November of 1926, Cukor had risen up to become Barrymore's director. Or at least Cukor always *claimed* that he directed Barrymore on Broadway, although the program and *The New York Times*'s reference book on the subject omit his name; Barrymore herself, in her memoirs, identifies Cukor only as the "stage manager." Maybe it is just a question of semantics—for the stage manager certainly would have done some de facto directing.

More to the point, Cukor and Barrymore had become inseparable. Every night during the run of the show (some twenty-nine weeks), he, Mortimer Offner, and Stella Bloch would pick up Barrymore and squire her to her apartment. They would sit and talk night after night until the sun came up. Practically every weekday night! Frank Conroy, the British actor from the cast, might be there, and other theater

people, such as Zoë Akins or the actress Jobyna Howland, would drop in. Ruth Gordon lived in the same building, and she was another who stopped in and said hello, on her way upstairs late at night after one of her own performances.

Weekends, after the Saturday-evening performance, Offner, Bloch, and Cukor would all travel in a limousine out to Mamaroneck and spend Sunday at Ethel Barrymore's country house, driving back on Monday morning. Cukor seemed to make Ethel Barrymore his whole life. His zeal for her was total and genuine. But since she was theater royalty, sometimes others suspected it was self-serving.

One Sunday, Bloch took a walk in Mamaroneck with Zoë Akins. Akins, the author of *Déclassée* and other acclaimed plays, asked her, "What do you think about George?" Bloch replied cautiously, "What do you mean?" Akins said, "Don't you think he's rather a *climber?*" Bloch was surprised, and assured her, "No, if George behaves in this rather extravagant way, it is because he really feels it." Akins shook her head in consternation. She could hardly believe that Cukor was such a totally sincere creature.

Barrymore immensely liked this young man who behaved as a devoted son to her. She sent her own son, Samuel Blythe Colt, up to Rochester to Cukor's stock company to be seasoned as an actor. Colt was an indifferent, monosyllabic actor—he preferred to drink and play golf. But he and Cukor became chummy, too, and they stayed friends to the end of their lives.

Somerset Maugham, Helen Hayes, Ethel Barrymore, Zoë Akins— these and other luminaries Cukor met and assiduously cultivated while still a stage manager in the Frohman organization. Yet there is evidence that he was just as friendly and helpful to the lesser lights and up-and-comers.

In a 1924 dramatization of Olive Higgins Prouty's *Stella Dallas* that never congealed on Broadway, a young actor was playing opposite Mrs. Leslie Carter. The legend past her prime unnerved the actor by flirting with him during rehearsals and, during previews in Boston, by overplaying scenes (as was her wont) and upstaging him. No matter how good his performance, the great lady was the one to receive the imperishable notices. The stage manager seemed to understand the actor's frustration, and reported to him in his dressing room, talking about plays and distracting him with his banter and good humor.

The young thespian whose name was not yet famous—Edward G. Robinson—was struck by the kindness and theater lore evinced by the stage manager, whose name was George Cukor.

Sometime after the 1923 summer season ended, Mrs. Wolff's financial advisers convinced her to cancel her investment in the Lyceum Players.

Her advisers focused on Cukor, among other liabilities. They accused him of frivolity and of spending too much time and money on entertaining and parties. Ironically, this was one of his strong points as a ringleader—his tireless, exuberant personality and the way he collected people around him. He *did* have fun, he *was* extravagant: Throughout his career, that worried more sober-minded producers, and not for the last time were such criticisms to be leveled against him.

Stung by Mrs. Wolff's decision, Cukor directed a personal plea to the theater owner. The complaints against him amounted to an accusation that he had been concentrating on parties and entertaining to the detriment of his work, he wrote her in a letter. But everything he did, Cukor insisted, *even the parties and fun*, benefited the Rochester company.

Writing from a Baltimore hotel, where he was on the road as stage manager of *The Camel's Back*, he reminded Mrs. Wolff that he devoted himself to casting actors and choosing the plays for the Rochester summer seasons, and that once he arrived in Rochester, he did everything that was asked of him—painting scenery, even acting!—not to mention functioning as the resident peacemaker. The undeniable popularity of the company, he argued, was proof of his diligence.

Mrs. Wolff was not swayed by Cukor's letter, however. She withdrew her backing. All of a sudden, Cukor and his stock company were without a patron or premises. The Lyceum Theatre was leased for the 1924 season to, of all people, the rival Cukor had ridiculed, Vaughan Glaser. Cukor still had his Frohman job, but that summer, he did not return to Rochester. At the time, it was a most crushing blow.

One quality about this gentleman director that is sometimes overlooked is the tenacity Cukor prided himself on, the tough resilience and inner determination that enabled him to rebound, again and again, from the many professional failures that pockmarked his career.

Determined to return to Rochester under better circumstances, Cukor schemed throughout 1924 in order to lay the foundation for his comeback.

One of the people he consulted was Louis Calhern. Calhern had been approached by Vaughan Glaser with a leading-man contract for the 1924 summer season, but Calhern and Cukor were friends, so Calhern was hedging his reply. Because Calhern was so phenomenally popular with Rochester audiences, his loyalty to Cukor would prove crucial.

Cukor told Calhern that he was considering starting up his own Rochester troupe. In prospect, he was going to call it the Rochester Theatre Guild, an honorary nod to the Theatre Guild of New York

City, whose influential productions Cukor attended faithfully. Calhern replied that the words *Theatre Guild* conjured up "such weighty stuff as *Joan of Arc* and *Back to Methuselah*" and "may be too heavy for the Rochesties in search of summer entertainment."

Writing to Cukor in the spring of 1924 from his quarters at The Lambs, Calhern advised: "Why not the Cukor Company?—or the Cukor Comedy Co.? Think I prefer the latter. Don't be afraid to tack the Cukor name on it—might as well start not to get it attached to programs as 'presenting.' Keep on your toes—you can cut it, young feller."

The difficulty was financial backing. Cukor made a tentative approach to George Eastman. In a letter to the photography magnate, Cukor invoked the example of the Theatre Guild and described a highly evolved program of "distinguished" plays run in conjunction with the Eastman School of Music, the University of Rochester, and high schools of the city. It would be a first-rate repertory program, he wrote, emphasizing the civic value of such a proposal. There would be comic operas produced in association with the School of Music, classical plays for the sake of the university students, and for the public schools, such children's staples as Robert L. Stevenson's *Treasure Island* and James M. Barrie's *Peter Pan*. On nonmatinee days, the theater could be used for photoplays and recitals.

But Eastman was already in the midst of preparations for his own, more high toned program of Sunday-night musicales at Eastman House. He was not well acquainted with Cukor, nor especially impressed by his résumé. When Eastman said no, Cukor turned to Walter Folmer, offering to make him his partner, and asking Folmer to persuade his father to put some money into an altered setup.

Now Cukor wrote to Folmer's father. The civic benefits were downplayed and the box-office prospects stressed. Complaining that Rochester was stuck with tattered road-show thespians performing recycled plays, Cukor recommended a cachet of reputable New York actors—some visiting stars re-creating their original roles (such as Mrs. Leslie Carter in *The Circle* and Pauline Lord in *Anna Christie*)—an ambitious play list, including some bona fide Broadway-bound tryouts. With good publicity and showmanship—and he allowed that he had plenty of ideas in both departments—Cukor could guarantee success.

Meaningfully, Cukor added that such a company would spell a great opportunity for his friend Walter, who could exercise his acting prowess while dabbling on the ledger side of show business.

Folmer's father agreed to invest money, but it was too late to get things going for the summer of 1924. And Cukor was tied up from August to April with *Dancing Mothers* and other Frohman duties.

So it wasn't until the summer of 1925 that Cukor returned to Rochester. Once again, the company was installed at the Lyceum Theatre, whose management had revolved in the meantime.

The revitalized Lyceum Players were officially incorporated as "The C.F. and Z. Producing Corporation," for Cukor was too self-effacing—and the timing not propitious—to adopt Calhern's suggestion that his name be emblazoned as part of the company name. The *C* was Cukor, the *F* was Folmer, and the *Z* was John Zwicki, the treasurer of the Players, who was also a business manager for the Selwyns. The publishing family, the Knopfs, also may have had some capital in the enterprise; their representative on the scene was the younger brother of Alfred A. Knopf, Edwin H. Knopf, general manager of the Lyceum Players and a director of at least one production that first season of 1925.

The new Lyceum Players looked suspiciously like the old Lyceum Players. Louis Calhern and Ann Andrews (who had made a name for herself on Broadway the previous season in Vincent Lawrence's *Two Married Men*) were back as the leading man and lady. Harry Plimmer was doing character roles. The ingenue for the season was Frances Howard's younger sister, Constance. Walter Folmer's roles were stepped up in importance. ("He [Folmer] played the derelict in *White Cargo*," remembered Henry W. Clune, "but never allowed a hair of his head to be out of place. He was hardly sensational.")

Cukor made good his boast of a season of classy yet popular plays. He had used his contacts to forge the necessary arrangements with the most powerful theatrical producers, Klaw & Erlanger, Arch and Edgar Selwyn, George M. Cohan, the Frohman organization and Gilbert Miller. Some of the plays were indeed untested; six of the fourteen Lyceum plays of 1925 were premieres (though not all made the later transition to Broadway). This was a novelty for summer stock, which typically suffered the stigma of being the "bush leagues" of Broadway. So much so that Cukor's play list warranted mention and condensed critiques, reprinted from the local dailies, in *The New York Times*.

Rochester audiences responded. People crowded into the hot theater on sweltering summer nights, even though the resorts on nearby lakes promised much more comfort and relief from the heat. *Theatre* magazine reported that the Lyceum Players of 1925 had set "new records in a town commonly designated as 'dead' theatrically."

Cukor did not direct all of the plays that first season, or in succeeding seasons. Louis Calhern directed sometimes; there were occasionally important guest directors (Percival Vivian, from the Belasco organization, like Ariel in *The Tempest*, running up and down the stairs in his ballet slippers, sprinting to the back wall of the balcony to

consider an angle) as well as novice ones (a Broadway stage manager by the name of Irving Rapper directed his first play in Rochester in 1928).

After 1926, the Lyceum Players moved across Clinton Avenue to the Temple Theatre and became the Cukor-Kondolf Stock Company. As often as not after 1926, as part of his agreement with Cukor, Kondolf was credited with codirecting. Kondolf was more the front-office type, however, and even though Cukor did not follow Louis Calhern's suggestion, Rochester's summer stock became known very quickly as "Cukor's company."

It is surprising how often Cukor described himself in conversation as "not especially attractive"—particularly as a young man. That seems to have been the prevalent opinion of others, as well. Among the dozens of friends and associates interviewed for this book, many volunteered comments about Cukor's lack of physical beauty. *Ugly* is the word that frequently cropped up, unprompted.

Yet in photographs, Cukor appears really quite beautiful in his early twenties. He had fine, curly black hair, a sharp nose and chin, searching brown eyes. Though Cukor was fat indeed, his skin was smooth and creamy, and there were a few—Stella Bloch was one—who preferred the sensuous plump Cukor to the haggard one after so many desperation diets years later in Hollywood.

Cukor still had a deep fondness for Bloch. They saw each other often when Cukor was in New York, or sometimes in Boston or up in Rochester.*

When Cukor and Bloch were separated, there were always letters between them, with theater gossip, news of mutual friends, and litanies of endearments. Cukor made up funny nicknames: Bloch was "Otille"; he called himself "boychick" or "the little ogre." He teased her about their passionately chaste relationship. Cukor said he thought about her "amorously," and round the clock.

When Bloch made a long trip to the Orient in 1920 to 1921, studying dance and the arts, there occurred a dividing point of sorts in

*Bloch visited Cukor in Rochester in July of 1923, at the behest of the Russian-born director Rouben Mamoulian, who was then organizing the Eastman School of Music. A versatile dancer was needed to head the dance department. The Isadora Duncan School of Dance in New York, to which Mamoulian had turned for a recommendation, chose Bloch, its star pupil. She gave a series of concerts at the Eastman Theatre and won the position. Unwilling to be tied to Rochester for a whole year, however, she declined the job. In the end, that position was awarded to a modern dancer and choreographer who was to become the foremost experimenter of American dance, Martha Graham.

their relationship. There was a forced hiatus in their communications. Cukor himself had sorely wanted to travel to foreign lands—especially to London. But for a decade, he would be forced to stall his plans until he could afford the expense. Not until Hollywood provided him with a cushion of income did he travel overseas.

Also, Bloch traveled in the company of a man: Ananda Kentish Coomaraswamy, Curator of Indian Art at the Boston Museum of Fine Arts, though perhaps that post was the least of his distinctions. Coomaraswamy was known through his publications as a scholar, philosopher, archaeologist, historian, and critic. (He became internationally famous, posthumously, when the youth movement of the 1950s embraced his views as the teachings of a guru.)

In his letters to Bloch, Cukor grumbled about her shipboard romance. He said he was mystified by her attraction to "Coom," and opined that it could only be rationalized by the fact that they were jungle beasts with an uncontrollable urge. Cukor joked about his jealousy gone amok, but it seems clear from his letters that he was bothered.

When she returned, they resumed their friendship. One night in 1921, Bloch and Offner stayed up all night talking to Cukor, indicating to him "in very Aesopian language" that he ought to be frank with them about his sexual preferences. Cukor was unwilling to be honest, and at the end of the long discussion, he dismissed their curiosity by saying, "You'll find out about me ten years from now. . . . The mystery will be solved!"

In 1922, Bloch got married to Coomaraswamy. An unconventional marriage: She continued to reside in New York City, while Coomaraswamy lived in Boston. Yet her marriage did not seem to faze, but to enthuse, Cukor. In Hollywood, the director was to become widely known for his knack of sustaining friendships with both spouses in a marriage, maintaining his close personal ties with dutiful wives while invariably maintaining professional rapport with their powerful husbands. Likewise, Cukor had decided he approved of Bloch's marriage.*

By 1922, anyway—with his career picking up momentum—there were indications that Cukor, after a period of seeming ambiguity, was

*He was good friends with (among others) the two daughters of MGM's Louis B. Mayer, Edith Goetz and Irene Selznick, both married to prominent producers (William Goetz and David O. Selznick, respectively); with Warner Brothers mogul Jack Warner's second wife, Ann; with Universal executive Jules Stein's wife, Doris; and, of course, with Frances Howard, who married Sam Goldwyn in 1925, becoming Frances Goldwyn.

becoming more comfortable with his emergent homosexuality. Most friends, including Bloch, do not believe there was ever any real doubt in his mind; never any option—just a normal period of self-discovery.

Hans Kohler, a dermatologist who was one of Cukor's close friends for nearly forty years, said he could not remember having discussed the subject with Cukor. But, Kohler said, Cukor had to be aware "of the strong bid for heterosexuality by society, to which the individual is exposed from early youth on: Boy Loves Girl in literature, in the movies, in the arts, et cetera, wherever one looks. In spite of that, if it [homosexuality] still comes out, it must be in one's nature. It is definitely not a matter of choice."

In any case Bloch did not have to wait ten years for revelation of the mystery—even though Cukor remained extremely guarded with her and others. Up in Rochester, according to Curt Gerling, who as a "townie" member of the chorus first met him in 1921, Cukor was "definitely in the closet. . . . There were no obvious attachments. He epitomized circumspection." If anything, the director spent more time with the ladies of the company— "discussing their views, reactions, and lifestyles," according to Gerling.

Although he may have been especially secretive with straight men such as Gerling, Cukor offered no surer signals to the Rochester ladies. "I'm sure he [Cukor] was homosexual, but I never saw any of it," agreed Esther Fairchild, one of the townies who was a small-part actress in the company.

Cukor's discretion, as it was later on in Hollywood, could be formidable. Yet as the company manager—an eligible bachelor whom all the women thought charming and witty—Cukor was a natural focal point for people's curiosity up in Rochester. His secretiveness had the perverse effect of teasing their interest. As his local status grew, they zeroed in on the clues he dropped about himself, or, at least, what passed at the time as clues.

For one thing, the "Rochesties" noticed that Cukor was incessantly curious about whether *other people* were homosexual, always eager to pry into other people's sex lives. Not that he confined himself to homosexuality in that regard: He used to pump Gerling for explicit details of Gerling's own prolific lovemaking. "Took delight in asking any of the ladies I comported with as to what kind of lay I was," recalled Gerling. "*Unabashed* was the word for George. Probably had a lot to do with his development as a woman's director."

For another, Cukor's foulmouthed language could be extreme. And many of his obscene anecdotes, people in Rochester noticed, tended to be about "faggots," a word Cukor used with impunity. Unlike Cukor, many of his friends were flagrant "faggots" and did not make any pretense at *not* being. Walter Folmer, for example, was elabo-

38

rately made up much of the time offstage, with fey mannerisms that were unmistakable. They—especially Folmer—were often the butt of Cukor's sarcasm. Much of a social evening would be spent camping and making jokes at the expense of the homosexual men that predominated among his circle.

Cukor never encouraged any such camping—or illusions—about himself. One story that made its way around the company was that Cukor was going to become the fiancé of the Lyceum Theatre owner's daughter. But Cukor didn't think that preposterous joke was very funny.

If there was no revelation, up in Rochester there was eventually a Cukor who was more pronounced in his proclivities. At least once there was an overt episode that seconded people's impressions that their director was a "confirmed bachelor."

There was no mistaking Cukor's attentions in 1926 toward a wavy-haired actor in the company by the name of Edward Crandall. Crandall had an escalating career on Broadway. His appeal to Cukor was enhanced by the fact that he was educated at Oxford (his clipped accent belied his Brooklyn origins) and that in his spare time he dabbled at writing. People took note when the company manager employed Crandall for a second season and installed him in quarters across the hall from himself at the Hotel Sagamore on East Avenue.

"That was the one time he [Cukor] ever what we used to call 'dropped a spangle,'" said Bloch. "It's a campy expression meaning he let his hair down."

From 1925 through 1928, these were the summers that always glowed in Cukor's memory. They, too, were "delicious days" of friendship and fun. But Cukor always remembered, too, how hard he worked up in Rochester.

The summer stock schedule could be grueling, especially in the July and August torpor, with a new play every week, six nightly shows, and matinees on Wednesdays and Saturdays.

On Mondays, the day of opening night, they would have scene and dress rehearsal all day. Cukor would start early in the morning with rehearsals of the third act, then they would rehearse the second act, followed by a break for lunch. In the afternoon, they would rehearse the first act last, so that the scenery would be standing when the audience arrived for the opening curtain.

In Rochester, Cukor was already well known for his unusual willingness—his insistence—to talk to actors about their parts.

"He was wonderful with actors," remembered Benny Baker, who was in the stock company for two seasons. "They knew what he wanted and gave it to him. I worked with a lot of directors [in my

career], and a lot of directors are traffic cops. They're not directors. They just say, 'Go over there to the couch, turn, and say the line.' But they never come up with any reason why, or a way to say the line. Cukor would talk to you, tell you what he wanted. Make you believe his whole theory."

Cukor was very firm, even then. He would yell, *scream*, at the actors if they didn't do it the way he wanted them to. If they happened to be friends of his, so what? Anderson Lawler—one of his close chums—and Cukor had a tremendous argument about an interpretation one day, which ended, in front of the entire cast, with a typical torrent of Cukor vulgarity. The defiant Lawler announced, "You can't talk that way to me, I'm a Southern gentleman!" Cukor raised his voice a notch above Lawler's and shouted, "Well, I'm a New York Jew and I'm gonna talk to you any way I want to, until you do it my way!"

The actresses were not immune to his tantrums. He might call a veteran actress an old biddy or worse if she didn't cooperate. Nobody seemed to mind, however, for Cukor was *funny* besides being charming, and he had an adorable way of being insulting. The bawdiness was his eye patch. Profanity at the crucial impasse—the "supplementals" of direction, in Cukor's terminology—was always part of his technique.

Up in Rochester, people already recognized that Cukor had a talent for bringing something special, something *individual*, out of an actor or actress. He talked to actors. What's more, he was willing to *listen* to them. What was gleaned in the exchange became part of the actor's performance, so that the characterization became more *personal*, the part more comfortable, until, eventually, the part and the actor were blurred.

Already in Rochester, Cukor had many of the trademarks of direction for which he became famous in Hollywood—even his standard line of modesty, or "exaggerated modesty," as Garson Kanin put it.

About Phyllis Povah, for instance, a titian-haired actress from the Theatre Guild, one of Cukor's leading ladies in Rochester (she had a long Hollywood career and appears in Cukor's *The Women* and *The Marrying Kind*, among other films), Cukor was modest. He would pooh-pooh his own contribution. He'd say he was just about to give Povah a direction when she did exactly what he was thinking of—*before* he gave her the direction. This was something Cukor repeated often, almost verbatim, in his career, in Rochester and in Hollywood, about Phyllis Povah and about many others.

There were many future motion-picture players who passed through the ranks of the Cukor-Kondolf Stock Company. Among those who had parts in the schedule, and then later turned up in

Hollywood in Cukor films, were Phyllis Povah, Louis Calhern, Ilka Chase, Frank Morgan, Reginald Owen, Elizabeth Patterson, Genevieve Tobin, and Douglass Montgomery.*

At one point, Robert Montgomery was getting paid twenty-five dollars a week while living with Miriam Hopkins, another stock company member, yet Cukor had to give Montgomery small roles because the young actor had trouble remembering his lines.

Another year, a doe-eyed hopeful named Bette Davis played a minor role in the chorus of the musical *Broadway*. When one of the cast sprained her ankle, Davis stepped into the small part of a girl who shoots the villain onstage during an elborate dance number. Although her performance was said to be exceptional, Davis was not rehired the following summer season.

(Over the years, Davis persistently mentioned the Rochester episode in interviews and books. The origins of the decision not to rehire her were fuzzy, and the director wearied of being reminded of his "mistake." In any case, Cukor did not particularly like Davis as an actress. For one reason, her few comedy outings were shrill.)

Cukor also kept his vow to lure the genuine marquee names of the era to the upstate city for summer engagements. Helen Menken, Dorothy Gish (with husband James Rennie), Billie Burke, Louis Wolheim, Wallace Ford, Elsie Ferguson, Ruth Gordon, and Helen Hayes—these were among the glittering stars inveigled to Rochester for what was usually a reprise of some Broadway hit. (It helped that Rochester was only an easy sleeper jump from New York City, and that the sizable stage "allowed room to experiment with stage and business and scenic and property arrangements," according to Henry W. Clune.)

Cukor gravitated to stars and ingratiated himself with them. The only weakness he had as a director—"and you couldn't really call it a weakness," playwright and screenwriter John Patrick commented in an interview—was that Cukor had no vanity before the stars—"he had a great pride, but no vanity"—and was willing to kneel before an actress as she sat imperiously in a chair, awaiting his directions.

"Up in Rochester, when Cukor found a star," noted Benny Baker, "he gave them the star treatment."

There was the red carpet that ran from the stage door to the star's dressing room. There were the opening-night flowers for the leading lady, never mind the expense, bestowed with a flourish by the company manager, who dramatically swept down the center aisle during

*Douglass Montgomery was used by Cukor repeatedly in the *Gone With the Wind* screen tests.

the curtain call. Helen Hayes played for Cukor in Rochester once, and she recalled being astonished by the luxuriousness of that gesture (typically Cukor), and no less so by what happened next (typically Kondolf).

"I felt as if I had just won an Oscar," said Hayes, "My arms were just loaded with sprays of roses. I was stunned. After the curtain closed, George came up to me sheepishly and said he had to have them back. 'We have to return them,' he said. 'They are rented.' He opened the stage door and handed them to a man who stood there waiting for them with his cart."

Cukor's company may or may not have been the best summer-stock company in the United States in the mid-1920s—Jessie Bonstelle's Detroit organization would rate pretty high—but none could boast more publicity and showmanship, greater prestige, New York proximity, or more favorable word of mouth.

The summer programs presented by the Lyceum Players were heavily weighted toward comedy. The plays included the most popular titles of the era, *Rain, The Guardsman, Peter Ibbetson, The Green Hat, The Butter and Egg Man, No, No, Nanette, The Spider*—but Cukor wasn't above the occasional "storm and stress" melodrama, or blackface chorus. There were plays by Zoë Akins, John Van Druten, Sidney Howard, William LeBaron, Leon Gordon and other people with whom the director would work in Hollywood.*

When the scripts arrived, moreover, they were usually replete with instructions from the playwright—explicit blocking, notes on characterizations, and advice on scenes that had already been audience-tested in London productions or on Broadway. In the case of premieres (although the percentage of tryouts dipped after 1926), the authors themselves would visit Rochester to sit in on rehearsals with pointers and suggestions. Often they were billed as codirectors. Some of the plays, furthermore, Cukor had already stage-managed for the Frohman organization, so he would have had ample opportunity before Rochester to observe them, to discuss them with the authors, and to learn them by rote.

At this pivotal stage of his career, the director could not help but be reinforced in his instinct that the script was sacrosanct, and that it was the job of the director to implement the writer's intentions.

*Akins, Van Druten, and Howard wrote scripts for Cukor films. Onetime playwright LeBaron was an executive at Paramount when Cukor was at that studio in the early 1930s, and Leon Gordon was another ex-writer who became a producer, functioning behind the scenes at MGM on Cukor's *Keeper of the Flame.*

The inviolability of the script was a theater tradition that set Cukor apart from other Hollywood directors of the studio system who did not have that background. In Cukor's case, moreover, it was tradition added on to a genuine respect for writers and a personal love of good writing.

There is some truth in Jean-Luc Godard's remark—made when he was writing as a critic for the French film journal *Cahiers du Cinema*—that if Cukor had not been a film director, he might have become an exceedingly good press agent. By this, Godard meant that enthusiasm radiated from the best Cukor films, as if Cukor was selling *himself*. This was always an element of Cukor's success, this *positive attitude* or *showmanship*—up in Rochester, too.

In Rochester, Cukor was as beloved for his extroverted personality—his extravagant wit and stories, his kindness and courtesies, his notorious temper, and ring-mastering of occasions—as for his plays.

Cukor's personality existed independent of the work, as well as being part and parcel of it. Cukor directing was just like Cukor hosting a party, and Cukor hosting a party was just like Cukor directing. As he had written to Mrs. Wollf, the parties and fun were necessary to the way he worked, and to the atmosphere he tried to engender.

Get-togethers—of all sorts, usually over edibles—were already a factor in his professional as well as personal life (and one might note how often dinners, teas, and party scenes crop up, with effervescence, in his films). Usually, Cukor lived at the Seneca or Sagamore, but he also kept a summer house up at the Genesee River, three or four miles south of town, expressly for the purpose of hosting soirees—for which he was already famous years before Hollywood.

Ilka Chase, a onetime Rochester stock-company player, commented in her autobiography that the Hollywood "pasha-Cukor" was not so very different from the "pasha-Cukor" she had known in less palmy Rochester days. "The only difference is that now [in Hollywood] he is rich and gives Sunday luncheons which are eaten by Ina Claire and Billie Burke and Aldous Huxley, and in the old days the luncheons were sometimes Dutch, but they were also eaten by Ina and Billie."

Cukor worked hard at creating an atmosphere of enjoyment. He organized group outings after rehearsals and performances: to nightclubs and restaurants; to a local speakeasy, country clubs, and hotel parties; to the Sea Breeze Amusement Park on Lake Ontario ten miles away.

At dinners, he would sit at the head of the table and throw out a subject for everybody to pounce on. Just like a director, he orchestrated the conversation and cued the laughs.

There is a body of local legend about Cukor from those days: About the time he told Florence Eldridge, loud enough for everyone else to hear, that the audience's attention would be less divided—and her own nightly performances vastly improved—if only she would deign to wear some undergarments while emoting onstage.

About Cukor and Mamoulian: Cukor's company intermingled somewhat with Mamoulian's more highbrow company, which put on Sunday-night programs at the Eastman School of Music. Mamoulian's staging of such operas as *Carmen*, *Boris Godunov*, *Faust*, *Tannhäuser*, *Rigoletto*, and *Pélléas et Mélisande* for the American Opera Company tried to integrate dialogue, music, and dance with poetic stylization. They were the opposite of Cukor's more conventional summer-stock shows and did not really siphon off downtown audiences.

But Mamoulian—not Cukor, after all—was the beneficiary of Eastman's cultural largesse, and these directors, who for the rest of their lives had this time in common, maintained a distinct coolness about each other. At Rochester parties, they would try to top each other with their respective Hungarian and Russian vignettes.

About the time the entire company got into cars and went out for hot dogs after a rehearsal. They stopped at a beach and changed into swimsuits on the sand. One of the actresses went in the water wearing her bra and panties. Only she didn't know how to swim, so Cukor had to wrap his arms around her and heft her into the waves. Afterward, the actress covered herself with a towel and handed her underwear to the director. After waving them in the breeze for several minutes, Cukor handed them back. "Are they dry?" she asked. "As dry now as they ever were!" was the memorable riposte.

About Cukor and Louis Calhern, who was almost as brilliant a rakehell as he was an actor. One night came 8:15, show time, Calhern absent, Cukor fidgeting. All of a sudden, the drunken Calhern lurched through the stage door, clinging to the wall, pulling himself along, speaking gibberish. The play had already started. Cukor consoled Calhern, propped him up in the wings, and when his cue came gave the actor a forceful push in the direction of center stage. Calhern played the scene and delivered all of his lines—perfectly, they say—before collapsing back into Cukor's arms after his exit.

(Calhern returned again and again to his summer sinecure in Cukor's company. His popularity in Rochester did not wane. He had a male retinue of goggle-eyed imitators, as well as a female one of cooing admirers. He caused a civic pit-a-pat and outpouring of press coverage during the summer season of 1926 when he up and married Ilka Chase, actress daughter of a *Vogue* editor, after a whirlwind courtship that culminated in a late-night visit to a local justice of the peace. They were divorced within a year.)

Even if the plays had not been good, even if Cukor had not gone on to Hollywood and such a remarkable film career, his summers in Rochester would have been remembered. He gave the Rochesties "badinage, camaraderie, laughs," in Curt Gerling's words. A mother hen/father figure of a director, he succeeded at quality, but according to Gerling, he also succeeded in transforming his stock company into "a sort of a wonderful big substitute family."

CHAPTER THREE

*W*hile Cukor was establishing himself upstate, summers in Rochester, he was also making headway on Broadway.

The 1920s were Broadway's heyday, a decade in which the glorious past and optimistic future of show business rubbed up against each other and threw off sparks. It was a decade of innovation and promise in the theater, as well as of vanishing forms and emotional last hurrahs of turn-of-the-century legends. A phenomenal influx of talent from England and Europe filled the stages. Eugene O'Neill and Philip Barry exploded on the scene. Edna Ferber and George S. Kaufman formed a collaboration. Other new playwrights included Elmer Rice, Sidney Howard, Maxwell Anderson, Thornton Wilder, and Moss Hart. La Duse, Mrs. Pat Campbell, and Mrs. Fiske gave magical farewell performances.

Cukor tried to see everything. But his favorites were often the plays molded around characterization and the genius of an exalted performer. Other theatergoers might remember a first-rate play. Cukor tended to recollect the "memorable moments" of lesser plays illuminated by the volatile inspiration of a great actress.

He saw the subtle comedic actress Mrs. Fiske in a rather shoddy vehicle, but when she began to sob and cry in one scene, it was so moving that all of a sudden Cukor, too, began to sob and cry. And he saw the niece of Mrs. Fiske, Emily Stevens, in Zoë Akins's *Foot-*

loose, playing a disagreeable blackmailer. Cukor was moved by a scene where the actress surprised herself, it seemed, by abruptly bursting into tears. Watching her, he surprised himself, too, by bursting into tears.

He feasted on Ina Claire as she developed into one of the finest high comediennes of the era, in *Bluebeard's Eighth Wife* (1921), *The Awful Truth* (1922), *Grounds for Divorce* (1924), *The Last of Mrs. Cheyney* (1925), *Our Betters* (1928), and *Biography* (1932). He attended Philip Barry's comedies, but the Barry play he often talked about was the highly charged and more cerebral drama *In a Garden*, with Frank Conroy, Laurette Taylor, and Louis Calhern. Cukor vividly recalled a romantic scene with Calhern in the foreground and Taylor half-obscured in shadow, yet Taylor riveting the audience with only her voice.

He saw a magnificent production of Buechner's *Dantons Tod*. It was one of Max Reinhardt's mass spectacles, and Cukor was there to spot Rosamond Pinchot—whom he doted on (she was one of his Rochester leading ladies)—in a small role.* Cukor was with Laurette Taylor's son, the playwright and latterly screenwriter Dwight Taylor; neither of them minded that they could not translate the German fast enough.

Cukor followed the arc of Alla Nazimova's career, and went to see her in a smouldering Hungarian drama, *Dagmar*. Although it was not a particularly good play, he and Stella Bloch attended it three times because they so admired the dark, intense Russian-born star.

Cukor preferred the actresses who were enormously self-possessed. Their behavior was always sincere and genuine, purely individual. They were seemingly indestructible. Yet at surprising moments, they unexpectedly revealed their vulnerability by sudden "curious movements" of the heart that attacked the nerves and flooded the senses of the audience.

These were the memorable moments that were deathless in his psyche. He knew he was forever influenced by and indebted to these actresses. And although he said he didn't draw on them consciously, the director knew there were borrowings from them in his films.

*Pinchot had starred for Cukor in Rochester. Beautiful and elegant, she was one of his true loves, a frequent guest at his home in California. After some featured roles in Max Reinhardt productions, her career stalled, however. She became a mistress of Jed Harris's. Cukor was shaken by her suicide in January of 1938, at age thirty-three. According to *Variety*, Pinchot was found dead in her automobile in her garage at Old Brookville, Long Island. "In evening dress and an ermine wrap," the show-business paper reported, "she had left the motor running after leading a hose from the exhaust pipe into the closed car."

* * *

Katharine Hepburn once made the comment that one of the most amazing aspects of George Cukor's life was the "tremendous continuity" that he built into it. One can detect this continuity in the work, dating back to Rochester and Broadway years, as well as in the network of his acquaintances and relationships—a network that, like much of Cukor's life, was consciously nurtured and impressively ordered.

Relationships are important to some degree in every person's life, but Cukor gave relationships the total enthusiasm that he gave to directing. And they gave much back to him—not only a degree of personal satisfaction but many professional contacts and a circle of friends that was always widening and looping off and spiraling into related circles.

In this period of time, Cukor was making close friends in theater circles in New York City that he would keep for the rest of his life. His friends usually had certain qualities in common: wealth, education, or good breeding, which Cukor always looked up to; an interest in theater and the arts; an abiding sense of humor. The closest of them, the people he felt most comfortable around, were very often like him, gentlemen whose homosexuality was discreet.

Two friends that he met in the early 1920s were Alex Tiers and Whitney Warren Jr., both handsome, delicate-featured, independently rich young men who made halfhearted stabs at acting careers on the stage. Both moved to California after Cukor did, and they kept in contact with the director until his death. They phoned one another regularly, and arranged to rendezvous at social events and other occasions. Cukor's letters to them always had a rare candor that revealed aspects of his psychology that he kept shielded from others.

Tiers had inherited a fortune from sulfur mines, while Whitney Warren Jr., was the only son of the architect of Grand Central Station, who also rebuilt Belgium's Louvain Library and designed many fancy New York hotels.

Both had the kind of social connections that Cukor envied. Quite in his own right, well before Cukor, Warren was friendly with many show people: Ruth Gordon, Tallulah Bankhead, Ina Claire. And Warren traveled abroad a good deal—he lived in Sri Lanka (then Ceylon) for a period of time in the 1930s—where his international connections, especially on the homosexual circuit, proved a vital overlap to Cukor's own.*

*For example, Warren's college chum Jeffrey Holmesdale neé Lord Amherst, was Noël Coward's traveling companion for a spell in the 1920s and 1930s.

Among actors, Cukor counted two close friends who were also to follow him to California: Anderson (Andy) Lawler and Tom Douglas. Both were from the South, Lawler from Virginia aristocracy, Douglas from Kentucky.

Lawler was tall, thin, freckled, with a choirboy's face and plentiful wavy red hair. Unlike a choirboy, he had a foul vernacular that rivaled Cukor's own—and a rippling laugh that he tended to wield at others' expense. But he took Cukor's own merciless ragging meekly; it was a characteristic that seemed to endear people to Cukor.

While Lawler had extensive experience in stock and small Broadway parts, Tom Douglas was a theater celebrity who had created a sensation on the London stage early in the 1920s playing opposite Tallulah Bankhead. The blond, blue-eyed Douglas was legendarily handsome. In his memoir *George*, Emlyn Williams wrote that as a young man he was infatuated by Douglas, browsing stage alleys and actor's hangouts for a glimpse of the devastating actor.

"The boy, twenty-one, slim as a reed, with a look of a vulnerable school-stripling," wrote Williams, "made every woman in the audience, the mothers and the childless, want to cradle that perplexed tousle of straw; but with his short nose and a wide soft mouth that seemed not to know its potency, he cast a spell over his own sex, as often as not in unexpected quarters."

One of Broadway's foremost producers, Gilbert Miller, was in the early 1920s the manager of the Frohman organization, with his offices in the Empire State Building. Miller's cachet rooted from his father, the much-respected leading actor Henry Miller, and not everyone liked the overbearing producer. But Cukor worked easily with him.

Miller was appreciative of Cukor, grateful to such an organized, responsible, and energetic stage manager. The producer helped pave the way for the unusual contractual arrangement of Broadway tryouts during Cukor's summer seasons in Rochester. And it was Miller who gave Cukor his first directing assignment on Broadway.

Cukor's opportunity came in 1925. He did not direct many Broadway plays—eight or nine, depending on the credit source—and his stage résumé was not a particularly auspicious one. Rather the opposite: None of Cukor's plays ran more than four months; only a couple received especially positive notices; and none of the plays are of such timeless merit that they need fear revival today.

Already, with Arthur Richman's adaptation of *Antonia* in October of 1925, however, the director had begun to weave the patterns and themes of his screen career.

Antonia had been planned originally for a Rochester summer tryout, but the details could not be ironed out in time. It was based on a

Hungarian play by Melchior Lengyel, who in fact had directed *Antonia* in Hungary and was credited, on the New York program, as Cukor's codirector.

About a lusty country wife seeking a fling of romance and nightlife in Budapest, the play was designed to spotlight the stock and stage veteran Marjorie Rambeau, in those days (before her Hollywood tenure as a blowsy character actress) a beautiful leading lady of the footlights. *Antonia* was all her show and—as in some Cukor films—the male characters did not amount to much.

At the time, Rambeau was married to the Canadian-born actor-writer Willard Mack, a heavy drinker, and she herself had taken up the bottle. "She [Rambeau] had such a low saturation point that one drink and she'd be just as good as soused," recalled Ruth Hammond, an actress in the cast of *Antonia*. "All through rehearsals, here she was just a little bit teetering, not quite drunk and not quite sober."

Cukor was frustrated in his efforts to cope with Rambeau, though according to Hammond he tried various crafty measures. For example, he would schedule an early rehearsal and advise working straight on through, skipping the jeopardy of lunchtime. But hearing that, Rambeau would pester him for a twenty-minute break "just to grab a bite." Eventually the beleaguered Cukor would feel constrained to give in.

"She would come back in twenty minutes," reported Hammond, "just soused. Her little calories were evidently all wet."

Cukor could have cheerfully killed his female star. But the smile with its hint of cunning, and that extraordinary forebearance, were already part of the work ethic of a director who, many decades hence, would endlessly adjust to the self-destructive behavior of, among others, Judy Garland and Marilyn Monroe.

The producer finally put the fear of God in Rambeau, threatening to sue her, so she sobered up in time for Broadway. "But it was too late," recalled Hammond, "because she'd gone through these two or three weeks [of rehearsals and tryouts] drunk, and she didn't know what the play was about. In fact, when we went to open for an out-of-town tryout—in Philadelphia—she called me into her [dressing] room and said, 'Darling, what is this goddamn opera all about?' Consequently, she wasn't any good in it, where it should have been a perfect role for her."

Nor could the reviewers comprehend *Antonia* any more than Rambeau. A musical comedy with a paucity of music, according to *The New York Times* reviewer, it had a negligible first act, a moderately amusing second act, and an obligatory concluding one. Even at that, *Antonia* lasted fifty-five performances.

Richard and Mortimer Offner and Stella Bloch were sharing an apartment at the corner of Madison Avenue and Thirtieth Street. After studying with one of America's foremost photographers, Clarence White, Offner was beginning to make a name for himself, while Bloch was already established in art and dance circles.

Bloch, Offner, and Cukor threw a party on New Year's Eve 1925, which might have been taken, in part, as a celebration of Cukor's first Broadway play, as well as of auld lang syne.

Because Cukor still lived with his parents, the party was at Mortie and Stella's. Bloch performed East Indian dances a couple of times during the party as entertainment. They collaborated on the guest list of over one hundred people, which reflected their expanding horizons: partygoers included titled ladies, opera singers, publishers, journalists, Rochester veterans (such as Ilka Chase, Louis Calhern, Ann Andrews), and such people instantly recognizable over sixty years later as actress Helen Hayes, playwright Zoë Akins, artist Gerald Kelley, abstract filmmaker Stella Simon (who financed *Ballet Mécanique*), composer George Gershwin, and violinist Jascha Heifetz.

Cukor was coming up in the world as a party giver, too.

The Great Gatsby, based on F. Scott Fitzgerald's novel with its corrosive depiction of wealthy Long Island society, was Cukor's next and better-known Broadway play in February of 1926.

This time, the producer was William A. Brady, Jr., notorious for his florid curtain speeches on opening nights. James Rennie played Jay Gatsby, the first big Broadway part for the actor who was perhaps better known at the time as Dorothy Gish's husband. The rest of the line-up consisted almost entirely of actors with some connection to Cukor's summer seasons: Florence Eldridge (Daisy Buchanan), Eliot Cabot (Tom Buchanan), Catherine Willard (Jordan Baker), and Charles Dickson (Meyer Wolfsheim).

Fitzgerald was not involved in the production (he was in Europe at the time). Nobody anticipated such a shrewd adaptation of Fitzgerald's book by the veteran playwright Owen Davis, who—before winning the Pulitzer Prize for drama for *Icebound* the previous year—was best known for his hundreds of cheap melodramas and Hippodrome extravaganzas.

Davis stuck to the book but kept the play from being talky. His years of practical theater experience were a benefit to Cukor. As was customary on Broadway and as happened with all of Cukor's plays, the playwright was present at all rehearsals and performances, giving notes and suggestions alongside the director.

More than *Antonia*, *The Great Gatsby* was Cukor's breakthrough. Zoë

Akins, for one, was struck by the "heat" the director generated in his romantic scenes ("without cameras or anything visual"), and it made her regard Cukor more seriously. Moreover, the run of the play was a substantial one (113 performances).

Drama critic Arthur Pollock wrote in *The Brooklyn Eagle* that someone by the name of George Cukor had raised "with surprising suddenness the standards of William A. Brady, producer. It is an unusual piece of work by a director not nearly so well-known as he should be."

Her Cardboard Lover was the first of two Laurette Taylor vehicles that Cukor was associated with on the stage, the Americanization of a modish French play that posited the wholesome heroine of *Peg O' My Heart* as a liberated Parisian lady who engages a penniless young fellow to masquerade as her lover.

Taylor was an actress whom Cukor revered. She was one of the theater's poignant creatures, consumed with neuroses, intermittently downed by alcoholism, yet utterly beguiling in her best parts. It was indicative of his new status that, after the success of *The Great Gatsby* (which followed the Rochester summer season of 1926), he was picked to work with her.

But the actress had never smoked, kissed, or sat on a bed in a play before, according to her daughter Marguerite Courtney's biography *Laurette*, and she was uncomfortable in a chic bedroom farce. Added to Taylor's discomfort was the antagonism between her and producer Gilbert Miller, and the wrangling between French author Jacques Deval and adapter Valerie Wyngate, both on the spot for rehearsals and tryouts.

Taylor's leading man in this instance was one of the future stars of the film of *Gone With the Wind*, the Englishman (by way of Hungarian parentage) Leslie Howard. Both Howard and Taylor were friends with F. Scott Fitzgerald, and during the Wilmington, Delaware, previews an invitation to supper was arranged at the Fitzgerald mansion, so that the director of the play *The Great Gatsby* could meet the celebrated author of the novel.

Many years later Cukor recalled that the occasion was "mad and fraught," with somewhat of a Bohemian atmosphere. "I remember," he said, "that Mrs. Fitzgerald's way of calling the servants was to honk an auto horn. It all seemed very gay and giddy, and at the same time very staged."

On the road with *Her Cardboard Lover*, a sympathetic Cukor was attentive to Taylor's vulnerabilities, and took pains with the lighting to protect her vanity in scenes where she had to disrobe. The long preview tour in the fall of 1926 was an ordeal, however. Although Cukor thought Taylor's performance was "comic, distraught, light as

a feather, and heartbreaking all at the same time," the out-of-town critics disagreed—they thought the play licentious, and Taylor woefully miscast.

The play had to be shuttered for script revisions after its Atlantic City preview, and Taylor was reported to have been dismissed. No one could be sure whether Gilbert Miller would be able to resurrect the production.

But another theater goddess of the period, Jeanne Eagels, was persuaded to take over the role, and the doctored *Her Cardboard Lover* eventually had a respectable, if not particularly long, run on Broadway beginning in March of 1927. Ironically, the problem-plagued play was the only stage comedy Cukor, one of the paragons of screen comedy, ever directed.*

Cukor was already busy with *The Dark,* which opened at New York's Lyceum Theatre in February of 1927. This was another William A. Brady, Jr., production, written by Martin Brown and transplanted from the 1926 Rochester summer season. The cast was drawn from Cukor's regulars: Louis Calhern, Ann Andrews, and others.

An overwrought, symbolic drama about a woman saddled with a blind husband, *The Dark* went dark itself after only thirteen performances.

The Dark was followed by an even more daunting failure, of a type that would happen again in Cukor's career. For the director to be fired from directing *Coquette* in the fall of 1927 was every bit as disastrous on Broadway terms as it was to be fired in Hollywood many years later from *Gone With the Wind.*

If he was fired—he may, in fact, have walked away. In memoirs by Helen Hayes, George Abbott, and Jed Harris, the versions are every bit as complicated and interwoven as the *Gone With the Wind* history. Cukor himself was always deliberately hazy on the details.

About a Southern flirt who receives her comeuppance in a torrid love affair, *Coquette* was the first and only play by Ann Preston Bridgers, a minor player from the cast of *Broadway.* It originally had been submitted as a comedy (*Norma's Affair*) with a happy ending. With writer-director-producer George Abbott's help, Bridgers revised her play as a drama.

*Cukor directed Eagels's out-of-town workup, but again he is not credited in *The New York Times Reviews/Index* or other sources as having directed the Broadway play. Some reviews credited the direction to Gilbert Miller, who sometimes fancied himself a director, and was not above taking the credit.

Helen Hayes, who had conquered Broadway with her "radiant averageness," in drama critic John Mason Brown's words, agreed to play the female lead. In part because of his close relationship with Hayes, Cukor was hired as director by producer Jed Harris. George Abbott might have been the more obvious candidate, but Abbott and Harris were perpetually feuding.

Early in rehearsals, it became clear that *Coquette* was in trouble. The script was uneven and Cukor, emphasizing the humor, was floundering. Producer Harris wanted Abbott to repair the script, but Abbott would not agree to do so unless he could also direct the play.

Hayes, who then was being courted by fledgling playwright Charles MacArthur, had strong notions about what constituted a well-made play. So did Cukor. But neither of them was able to cope with the inadequacies of the show. Both, according to Hayes, felt trapped in a laughable tearjerker. "The two of us were scornful of the writing," admitted Hayes.

One day, Harris was in the theater where they were rehearsing, observing things, and he caught Hayes and Cukor with their heads together, giggling—it would not be the last time Cukor's instinct was to giggle over Deep South dialogue. The next thing Hayes knew, Cukor had vanished and Abbott had replaced him as director. "I was too cowardly, I guess, to stand up and say I wouldn't have anyone else but George," said Hayes. "He [Cukor] disappeared from view, poor darling."

Once rewritten and as directed by Abbott, *Coquette* became a tenderly moving character tragedy. It was hailed by drama critics as one of the dramatic highpoints of the 1927–1928 season (Hayes delivered "an immortally ingrained performance," wrote J. Brooks Atkinson of *The New York Times*), and named by Burns and Mantle as one of the ten best plays of the annum.

Cukor hadn't really "disappeared from view." Because of experiences like *Coquette*, his credo, long before failures in Hollywood, was: On to the next thing.

He quickly rebounded as the director of *Trigger*, as obscure in Broadway history as *Coquette* is famous. *Trigger* was written by a pioneer of the folk play, also from the Deep South, Lula Vollmer, and was produced by the gentlemanly Richard Herndon, who had presented Pavlova and Nijinsky in the United States. Although it managed to keep afloat for fifty performances, in late 1927 and early 1928, *Trigger* was hokum about a Bible-quoting mountaineeress (Claiborne Foster) with nothing vital to recommend it.

(In 1934, *Trigger* became the basis of the film *Spitfire*, which starred Katharine Hepburn—yet another link in her career to Cukor.)

In January of 1928 came *A Free Soul* by the prolific Willard Mack, an implausible murder mystery based on a quasi-autobiographical novel by Adela Rogers St. John. St. John's drama was about the free-spirited daughter of a San Francisco lawyer who gets mixed up maritally with a big-time gambler. Melvyn Douglas, who would later costar with Greta Garbo in the Cukor film *Two-Faced Woman*, was among the large cast directed by Cukor. *A Free Soul* received fair notices and ran for one hundred performances.

In the spring of 1928, Cukor got involved with an operetta called *The Dagger and the Rose*, which warrants attention.

Lyricist Edward Eliscu (Cukor's former high school classmate), dramatist Frances E. Faragoh, and composer Eugene Berton had been working on a musical that they were unable to convince anyone to bankroll. When they learned of publisher Horace Liveright's willingness to produce a musical based on the play *The Firebrand* by Edwin Justus Mayer—just so long as the production also boasted a chorus of beautiful girls—they hastily modified their book and score to accommodate the subject of that opus, the Florentine Renaissance man Benvenuto Cellini.

Cukor was an eleventh-hour addition as director. His first musical inaugurated a curious career-long trait: As was not atypical of Broadway directors, he staged the book only (not the song-and-dance numbers). The musical routines of *The Dagger and the Rose* were choreographed by one Seymour Felix. This stage custom of deferral to the specialists was a tradition that the director continued in Hollywood, notably on *A Star Is Born*, where Cukor stayed away from the lauded musical numbers.

A part in the operetta went to Cukor's friend Walter Folmer, though Folmer's career in show business was doomed to be a limited one, largely confined to Rochester and his father's money. (Folmer was good company, however, and made them all laugh when he insisted on supplementing his period costume for *The Dagger and the Rose* with padded muscles.)

Playwright Mayer, writers Faragoh and Eliscu, and choreographer Felix—like Cukor—all went on to considerable Hollywood careers. But nobody is making any great claims for *The Dagger and the Rose*. Cukor's operetta lasted precisely one week in early 1928, before succumbing in Atlantic City. He never mentioned it in interviews, and one would be hard-pressed to find citation of it in theatrical references. It was another instance—of many in Cukor's career—of the personal allegiance triggering the professional association.

Zoë Akins wrote *The Furies* expressly to boost Laurette Taylor's sagging career, and in the spring of 1928 Cukor directed the actress in this stage whodunit about a wife accused of killing her millionaire husband.

This time there could be no faulting of Taylor's performance. "He [Cukor] knew her vanity, capriciousness, her high and mighty airs covering the pitfalls of her ignorance and insecurities, and that once in harness these things dropped from her as though they had never existed," wrote Marguerite Courtney in *Laurette*.

But *The Furies* was not an exceptional play—the best plays never came Cukor's way—and despite the marquee attraction of its star, *The Furies* collapsed after forty-one performances.

In October of that year, Cukor imported *Young Love* from its late-summer Rochester tryout. A risqué comedy about a trial marriage by the up-and-coming playwright Samson Raphaelson, *Young Love* was noteworthy for starring Dorothy Gish (making her Broadway debut), her husband James Rennie, and Cukor's handsome friend Tom Douglas.

But there was little else noteworthy about it. The critics did not think much of *Young Love* ("the worst play of the new season," complained the Chicago *Herald and Examiner*), and even with the combination of Gish and Rennie to lure audiences, it lasted only eighty-seven performances.

Gypsy, next and last, was written solo by Maxwell Anderson (his second play since splitting up with *What Price Glory?* collaborator Laurence Stallings). Claiborne Foster, whose mannish name was publicity-rich during her brief Broadway vogue, played the title character, while Louis Calhern was succeeded as the male lead, late in the touring stages, by Donald Cook.

Yet another Cukor stage melodrama about a restive female (the title refers to her "gypsy heart"), *Gypsy* was panned by critic George Jean Nathan, who wrote, "The play doesn't ring true; its purely theatrical tinkle is constantly apparent." *Gypsy* ran for only twelve performances before slamming the door on Cukor's Broadway career in January of 1929.

Five years earlier, Cukor had been a backstage man for hire. By 1929, he had one of the most exciting summer-stock companies in the United States, and was directing two plays a year on Broadway. And the parade of Broadway entries that began with *The Constant Wife* and continued on up through *Gypsy* had earned him a modest—and surprisingly specific—reputation as a director.

Much later on, in Hollywood, Cukor used to complain about his typecasting as a "woman's director," and he had a point: Such a label had its subtle, pejorative meaning, its obvious unfairness. Yet way before Hollywood, as a Broadway director, Cukor was to develop something of a mystique as a "woman's director"—with a knack for ladies' characterizations and female star parts, and for coping with difficult or intuitive actresses.

Beginning on Broadway, Cukor had begun to be typecast (and self-typecast) in his directing career as someone at his best dealing with stories about women—free-willed women, victimized women, amorous women, but always (with the exception of *The Great Gatsby*) women.

The best actresses asked for Cukor—Ethel Barrymore, Laurette Taylor, Helen Hayes. Everyone in New York knew that the renowned screen star Dorothy Gish, nervous about her stage debut, had *insisted* on having him as her director.

(And everyone knew this anecdote about *Young Love*: Gish, who was cognizant of the Stanislavski system, asked Cukor to explain her "motivation" for crossing the stage in a particular scene. The director explained to this superlative actress, "Just motivate your ass over there and sit in that chair.")

People who worked with Cukor on the stage felt, as did some people in Hollywood later on, that the director had a certain affinity with actresses.

"He did seem more in touch with women's emotions," stated Helen Hayes.

"He had a great empathy for women characters," agreed Ruth Hammond, "and of course women all loved him, they were crazy about him, so he was always at ease with them. He really understood women, and their characters in plays, and got wonderful successes out of them."

According to Helen Hayes, Cukor's outstanding trait as a director was his enthusiasm. Working with him on the stage was exhilarating because he was able to transmit his enthusiasm. It was contagious. Consequently, said Hayes, there was an "alertness" about people who acted under Cukor. Especially women, who seemed to *relate* to him.

"He was a very intimate person to work with," Hayes commented. "One sympathized with him very well. He seemed to get inside an actor and get their personality in hand. I don't know that many directors had that much feeling for actors. I wish I would have had him as a film director in Hollywood. Maybe my film career would have gone better."

58

Yet by 1929, Cukor was through directing for the stage. Indeed, before the first of the year, he could be found at the Astoria Studios in Queens, learning to make motion pictures while under contract to Paramount.

Plays were so fragile, the work so arduous, the money evanescent; as a practical man above all, Cukor was obliged to consider the alternatives. Movies, by comparison, were an easy shot.

Since boyhood Cukor had sneered at the quality of most photoplays. Movies were commerce and entertainment, not Art. This was ingrained, the attitude of a generation, really (especially that generation of New York show people), and Cukor never completely shed it.

Later in life, when Cukor was interviewed by important French film magazines, he would gripe about the other directors they were extolling, such as Howard Hawks. ("I'd be more flattered to be in your magazine," he'd say, "if I didn't know you also interviewed Howard Hawks. Christ, Howard Hawks!") Cukor had affection for D. W. Griffith and for the film poet of Americana, John Ford, but he found most of the other directors—even the best of them, such as Hitchcock—to be clever but empty. At least, not to his liking.

When asked what films he personally admired, Cukor would ransack his memory and never, but never, name a motion picture that had been made in Hollywood. Once or twice, he came up with an obscure Russian film based on Chekhov's *The Lady With the Dog* ("the most exquisite picture I ever saw") or an early Fellini (*I Vitelloni*). "I wish I'd directed both of them," he'd say wistfully.

Like most of the stage directors hired by the motion-picture industry in the late 1920s and early 1930s, Cukor was not so much embracing film as abandoning a field of diminished prospects. Broadway was endangered—it would take a nosedive after the Wall Street crash—and Cukor was not a major Broadway director by any means.

Also he had been hinting weariness of the summer-stock grind. He was through with Rochester. Kondolf and Folmer would limp on for a couple of years as the Kondolf-Folmer Stock Company, but without Cukor the thrill was gone.*

Cukor was not really sold on the idea of making films—not quite. Curt Gerling, for one, recalled having lunch with him at the St. Regis

*Kondolf became an occasional Broadway producer—including one Louis Calhern vehicle in the 1930s—and, later on, a higher-up with the Federal Theatre Project. For many years, Folmer stayed in Rochester; he did not act again on Broadway, and he never acted in films.

two days before Cukor was supposed to leave for California in early 1929. Cukor said he couldn't ignore the salary, six hundred dollars, "a princely sum in those days," in Gerling's words. "Curt, I know I am going to hate California," Cukor told him. "I'll be back in New York in six months."

There were exciting lightning-bolt developments in the motion-picture industry. At the same time that Cukor was directing Samson Raphaelson's *Young Love*, a free adaptation of an earlier Raphaelson play, *The Jazz Singer*, was making screen history as the first successful talkie. Now, as a result of the technical innovation of sound, there was propitious opportunity for newcomers in the film business.

There was also chaos. Soundstages were novel. Camera noise—the slightest noise—was picked up by the giant unwieldy microphones. The cameras were placed in heavy, shrouded booths, insulated for sound. For further insulation, the crew hung huge blankets from the roof of the stage to the floor of the set. There was no air conditioning, the soundstages would become suffocatingly hot, and after two or three takes, everyone had to step out and get some air. The obstacles to perfection were many. Indeed, film crews might labor three days and three nights continuously to achieve technical satisfaction. (The biggest meal of the working schedule would be the midnight dinner, served free by the studio at the commissary.)

Into this frenetic atmosphere, directors from Broadway were being recruited by the trainload to rehearse the "titles," as the dialogue was still being called by the old-timers.

The more auspicious theater directors, such as Rouben Mamoulian—who had graduated from Rochester to acclaimed Theatre Guild productions, such as *Porgy*, in New York—were given free rein, but these could be counted on one hand. Most other stage-trained directors, such as John Cromwell, William Keighley (who was married to Genevieve Tobin), or Irving Rapper, were given introductory stints as dialogue directors, a kind of apprenticeship—as well as false insurance for senior directors who might be unsure of dialogue situations or uneasy about the newfangled technology.

There were all kinds of theories in those days about how one might speak "naturally" and come across on the screen. The dialogue director was not only an apprentice but one of the competing experts. His job was to polish the enunciations and calm the quavering voices, while learning the ropes of the business. It was a situation made for advantage, especially for someone quick-witted like Cukor.

Most of the major Broadway producers for whom Cukor had worked had motion-picture-industry ties. Gilbert Miller, for one, was an executive of Famous Players–Lasky. And Frances Howard had married Samuel Goldwyn, one of the independent titans. (It was

Goldwyn's second marriage; Cukor had strongly advised Frances to marry the already rich and powerful producer, because she certainly was not going to have much of a career as an actress.)

Yet in all of the hundreds of interviews and books about Cukor, there is no clear indication of who it was that hired Cukor into films. Some believe it was Goldwyn, but Cukor never worked for Goldwyn. Jesse L. Lasky made a claim the director might not have cared to emphasize: that it was a Rochester comrade, Rouben Mamoulian, who preceded Cukor to Paramount and recommended him to Lasky, head of the company.

In the week before Christmas of 1928, Cukor signed a contract with Paramount. Though he claimed "a considerable reputation" (in Cukor's own words) as a stage director, the contract stipulated a six-month period of servitude, "enabling me to observe the manner in which motion pictures are made and of learning the mechanical and those sides of motion picture direction with which I was not familiar."

During this six-month apprenticeship, according to his contract, Cukor would receive no credit on the screen or in advertising. His initial salary amounted to six hundred dollars for six working days each week, plus round-trip train fare to Los Angeles.

Cukor's arrival in Los Angeles was heralded by an item generated by the studio publicity department in the Los Angeles *Times* of February 13, 1929. "Still another Broadway stage director has come to Hollywood to conquer new worlds in the realm of talking pictures. He is George Cukor, director and manager of many New York successes, who has been signed to a contract."

Cukor checked in at the Villa Carlotta, furnished apartments across the street from the faded grandeur of the Château Elysée. The director might have felt instantly at home because of the presence in California of old friends: Zoë Akins, for one, was already working at Paramount; Andy Lawler was in Los Angeles appearing in the Western road company of *Her Cardboard Lover*.

Cukor's first assignment was a brief and impersonal one. His task was to coax a Southern accent, though he could only manage a bogus one himself, from the cast of *River of Romance*, an adaptation of the Booth Tarkington novel *Magnolia*. Unimportant in most respects, *River of Romance* served to introduce Cukor to the Paramount team who began to teach him the fundamentals: editor Cyril Gardner and director Richard Wallace, himself a former editor.

As one aspect of the confusion of the early sound era, editors—technical personnel in general—had ascended in mystique. The art of cutting sound to image had not been mastered; there were no numbering or sync machines, and the films were spliced on a silent Moviola; edit-

ing, therefore, was the crucial step in postproduction. It was part of the Paramount system—in general, it was widespread in the industry—that the editor would be on the set constantly to monitor the continuity.

Charming and low-key, director Wallace had attended medical school in Chicago before dropping out to roam with a carnival and land in California. He had begun as a comedy cutter for Mack Sennett, and eventually directed for Sennett and Hal Roach. His oft-partner Cyril Gardner was Paris-born, also well educated, a former child actor and protégé of Thomas Ince. The two had just finished working together on the original version of *The Shopworn Angel* filmed as a part-talkie in late 1928.

Cukor felt warm toward Gardner and Wallace, both relatively refined souls. Their collaboration was intimate from the beginning.

From Gardner and Wallace, Cukor learned about the importance of editing, which was the prevailing language of film. Both former editors preached "coverage," which meant, simply, the practice of shooting different setups of a scene, or alternate angles on a scene, so that there would be meaningful options when the film was assembled. Long shot, medium shot, close-up—over and over again, from different angles. That was the Hollywood way of rehearsing (if at all). "Coverage" for many directors was a kind of editing, and in Cukor's film career, it was a technique he would be known to carry to extremes.

By Gardner and Wallace, Cukor was introduced to the camera in the period of clumsy equipment and the massive camera booths. Those large cameras certainly didn't move much, and that may be one of the reasons why Cukor, especially early in his film career, did not find much excuse to force camera movement.

The unmovable camera may have dictated another unusual aspect of Cukor's approach. Throughout his career—as he did in the days of codirecting—Cukor often relied on someone else to "suggest" the camera setups. It was not unusual to find a Hollywood director who did not peer through the camera lens; many, astonishingly, never did. However, it was certainly unusual to find a director who delegated the actual placement and camera angles to someone else as regularly as Cukor did.

Cukor always had the last word, but from the beginning in Hollywood, he preferred to let the camera specialists worry about the camera while he worried about the people. The rhythm in his films would come from *within* the scenes, primarily, not from camera movement or the cutting. That is one of the reasons why Cukor preferred rehearsals and long takes—so that the actor, not the camera, would dominate. That is why he spent most of his time talking to the actors, not the cameraman.

"Generally, in *River of Romance*, he [Cukor] worked with Richard Wallace," said Mary Brian, one of the cast members of *River of Romance* and of Cukor's later *The Royal Family of Broadway*. "But the thing is, it was never like a novice coming out here for the first time. It was more of a collaboration. All he didn't know was the technical side of things, the camera and the editing. But he had great authority nonetheless. And great humor.

"It was a three-way collaboration, really. Most of their discussions were not in front of the actors, although once in a while, we observed them. We had a wonderful editor for *River of Romance* named Cyril Gardner, and he was part of it. After we had finished shooting for the day and gotten out of our costumes, ready to go home, lots of times if we went by the stage they would still be conferring. And you could hear Cyril saying that he needed this cut and that angle."

Cukor *was* back in New York within six months—to sign a new contract option with Paramount, increasing his salary to one thousand a week, which was much more than he could have ever hoped to make directing plays on Broadway.

His agent, by this time, was Myron Selznick, and he had acquired a new friend in Myron's brother, the driving and driven David O. Selznick, executive assistant to Paramount general manager B. P. Schulberg on the West Coast. Many people considered Myron Selznick's younger brother (or "DOS," as he was sometimes called, in deference to the initials of his memos), who also lived at the Villa Carlotta, to be one of the most brilliant of the aspiring young producers. The fact that Selznick was married to Irene Mayer, one of the daughters of MGM executive Louis B. Mayer, was additional reason to believe that "DOS" was going places.

In October of 1929, Cukor was informed by "DOS" that he would be loaned to director Lewis Milestone and Universal Pictures as dialogue director of the upcoming *All Quiet on the Western Front*. Selznick was a close friend of Milestone, and Cyril Gardner had edited *Two Arabian Knights*, which won the Academy Award for Milestone as Best Comedy Director of 1928.

The screen adaptation of Erich Maria Remarque's international best-seller about World War I was in prospect one of the most ambitious and important—not to mention exorbitant—productions of the year. The Russian-born Milestone, one of Hollywood's hard-charging young turks, had vowed to re-create his own World War I experience; he had served in the Army Signal Corps along with fellow screen directors Victor Fleming, Josef von Sternberg, Wesley Ruggles, and Richard Wallace. At the point that Cukor's help was enlisted, preproduction had bogged down while the script was progressing fitfully.

Behind the scenes, George Abbott and Maxwell Anderson had been called in to work alongside Del Andrews, a Universal cutter whose know-how as an editor had elevated him to scriptwriter status. In Milestone's house on Catalina Island, next door to a bungalow inhabited by colleague John Ford, Milestone and the assorted writers were hammering at the screenplay of the futility-of-war novel, trying to achieve the proper blend of action and ideas.

In some way, the slowly formulating script was just a delay tactic for Milestone. The casting of the pivotal role of Paul Baumer had yet to be finalized, even though the production was supposed to begin filming, with publicity hoopla, on November 11. Universal was pushing for contract player John Wray to play the sensitive young protagonist of *All Quiet*. Director Milestone had Douglas Fairbanks, Jr., in mind for the part, however, and was stalling for time while he tried to negotiate a loan-out for Fairbanks's services from United Artists.

Meanwhile, actor Lew Ayres had read the book and envisioned himself as Baumer. For months Ayres had been trying to get an audience with Milestone. MGM producer Paul Bern urged Milestone to test the twenty-year-old newcomer—who was no novice, having acted opposite Greta Garbo in her last silent picture, *The Kiss*. But Milestone, his mind set on Fairbanks, was unresponsive.

With Cukor's arrival in late October, the testing of young men for the many speaking roles began in earnest. All the hopeful males of Hollywood were showing up in droves for the casting calls. Finally, Ayres managed to get scheduled for a test by Cukor; he was handed some pages of dialogue for memorization, and told to come back the following day.

His test consisted of two scenes from the film—one, a close-up of soldiers complaining about the brutality of war. Ayres gave the pages his all, but he felt that he didn't get much of a reaction from Cukor.

Yet it happened that his test, along with those of several other young men, took place on the day that it was confirmed to Milestone that United Artists would not release Douglas Fairbanks, Jr., from his contractual obligations. The disconsolate and now rather desperate Milestone showed up to watch a batch of the latest test results. When Ayres came on the screen, the director perked up noticeably and announced to Cukor, "I think this is our man."

Cukor, Ayres was told later on, protested to Milestone that he was not at all convinced. He wanted to make another test of Ayres. Milestone was very positive in his attitude, however, and the young actor was given the part.

As Ayres recollected: "Milestone told me time and again that if I had made the tests earlier I probably never would have been chosen. It certainly wasn't because of my acting, which Cukor made plain

many times. He was used to polished theater actors and I was just a nobody from nowhere. He was perfectly frank about saying I didn't have the polish. All I had was this tremendous desire and I was the type. But it was too close to the picture starting, and we never took another test."

Ironically, screen tests were to become an aspect of Cukor's mystique, and one of the ways the director made himself valuable to the studios. It may be that no Hollywood director conducted as many screen tests throughout his career. Cukor enjoyed such work, even if many other top directors refused to squander time on so much nothing.

Even discounting the months of *Gone With the Wind* testing, Cukor screen-tested hundreds in his career, people as diverse as opera singer Rosa Ponselle, screenwriter Ring Lardner, Jr., future First Lady Nancy Davis (Reagan), athlete Frank Gifford . . . the list goes on and on. No other director had quite that intriguing track record of discovery: after the (qualified) discovery of Ayres—Katharine Hepburn, Judy Holliday, Angela Lansbury, Shelley Winters, Jack Lemmon . . .

After the screen tests were through, Cukor's job was to rehearse the more intimate dialogue scenes. The ensemble of young men had to speak the dialogue over and over, with Cukor challenging them to dig deeper into themselves. That kind of rehearsal was anathema in Hollywood—and it bothered the less experienced players.

Cukor went further: He strutted and gestured, mouthed the lines, gave precise readings. ("His line readings were always on the mark," said Mary Brian.) Some movie directors did this occasionally, but very few old-timers did, and few ever as much as Cukor. Such a technique could be inhibiting as well as stimulating.

From Ayres's point of view, Cukor was *too* authoritative, *too* cerebral for motion pictures, at this early point in his Hollywood career. The dialogue director wore his "theater orientation" like a badge. That "theater orientation," said Ayres, was particularly unnerving to men without formal stage training, who had the "personality orientation" of screen acting.

"I became immediately aware of his [Cukor's] approach to directing," said Ayres. "It was very difficult for me, as it has been for many men [in Hollywood]. Milestone was more or less a 'man's director.' He had a method not unlike many directors. They don't give you a great deal of direction. They may remind you of the script or the scene. They give you a general mood. But Cukor—and I think this is one of the things that made him so attractive as a director to ac-

tresses—tried to motivate his players into the mood of the scene, or the caliber of the characterization.

"Cukor was the most prolific motivator I have ever known. Much of it was good, but there was too much to hang on to. Not just every scene, but every line of dialogue and every emphasis of the line. He had an incisive insight into his conception of the nature of the scene and of the personalities involved, and he was so articulate that he, to some extent, bound you to his thinking, to the degree that you couldn't really be free. You couldn't be yourself.

"I'll say this, George didn't try to act it. That's one nice thing. Sometimes we would challenge him and say, 'Show me what you mean.' He never descended to that. He knew he overacted if he tried to explain; his facial gestures, his mannerisms were too broad. Other directors liked to have a peep of a role themselves. Milestone let himself be seen in *All Quiet*—he is the hand at the end of the film. That would be a little corny, and George was a supersophisticate.''*

One day, in these rehearsals, Cukor had a problem with a hulking young contract player who didn't like his approach. The man yelled at him and refused to accept a direction. Cukor yelled back, "Either you will accept it or I will step down from my position!" It was a tense moment in front of the crowd of actors. But Cukor stood his ground, and indeed the actor was obliged to leave the picture.

"Let me tell you, George had a certain courage and determination," said Ayres. "He was very strong-willed as a director."

"It's interesting, though, he disdained the camera. They'd say, 'We have to move the camera here. . . .' He'd say, 'I don't know anything about that.' None of us could imagine him becoming a film director. We knew he had the brilliance and the background, but he seemed not to care anything about the mechanical aspects."

Cukor was there throughout the production, nearly twenty-three weeks, working mostly with the young, unschooled novices. But, said Ayres, the actors all breathed a sigh of relief when Cukor's task was done on a particular scene, and the more casually in command Milestone materialized to supervise the actual filming.

"It was a bit of a burden sometimes," said Ayres. "George had all the specifics in a way that I had never beheld. What could we say in

*Even up in Rochester, Cukor had shied away from acting. The other directors of the Lyceum Players had tended to augment their importance by acting key roles in productions, whereas Cukor always limited himself to one-liners or cameos. After the 1923 summer season, in fact, Cukor, the actor's director, never again acted on the stage—and not once in motion pictures, not even for one of those "in-joke" Hitchcock walk-ons.

contrast to what he could say back? We were kind of glad when he stopped rehearsals and Milestone took over. Milestone was the sort who breezed by. He was the supreme boss."

In later years, director Milestone, whose career proved uneven after *All Quiet on the Western Front*, could bristle when Cukor's contribution was mentioned. *All Quiet* is very much a Milestone film as well as a milestone film—an early sound masterwork—with all the stench, disorder, and terror of war choreographed with gripping ferocity. Yet at the core of the visceral effect is something that was missing from many subsequent pictures directed by Milestone, something affecting in the group portrait, and something ghostly in Ayres's central performance.

When *All Quiet* was released, the film bore George Cukor's first screen credit, as dialogue director.

Back in New York, Cukor took a penthouse suite on Lexington Avenue in the upper Forties, which he shared for several years with Andy Lawler, using it on East Coast trips. The decorator was James Reynolds, a friend of Cukor's. A dominant figure in stage design equally known for his interiors, Reynolds had a trademark not unlike George Hoyningen-Huene's, later on, for Cukor's films—the sensational juxtaposition of colors. Reynolds's decor for Cukor's penthouse apartment was impressive, highlighted by good oil paintings and splashy cretonne curtains.

Cukor matriculated into the Paramount codirecting rotation, resulting in three quick proscenium-oriented features: *Grumpy*, codirected with Cyril Gardner; *The Virtuous Sin*, codirected with Louis Gasnier, and *The Royal Family of Broadway*, again codirected with Gardner, all in 1930.

Grumpy was from a venerable English play about a jewel robbery, which had been filmed once before, as a silent, by Cecil B. De Mille. Cukor's version featured the British veteran Cyril Maude in a barn-burning performance as the doddering old lawyer ("Grumpy") who solves the crime.

The Virtuous Sin was taken from a stilted Hungarian costume drama about a woman (Kay Francis) who sacrifices her honor to a haughty hussar (Walter Huston) in order to save her imprisoned husband (Paul Cavanagh). Not that bad—and Walter Huston's performance outshone Kay Francis's.

Only *The Royal Family of Broadway*, of the three, is of any enduring interest to Cukor followers. From the Edna Ferber-George S. Kaufman hit play, a send-up of the Barrymore dynasty, its bald satire had offended Ethel Barrymore to the point that at one time she considered a lawsuit against it.

Ann Andrews had played the leading role on Broadway. Cukor had quarreled with Andrews, however, and for this, his first screen comedy, Cukor called on one of the deities of his youth, Ina Claire, to play the Ethel Barrymore prototype. Unfortunately, the refined performance of Claire doesn't really register. And in most ways, Cukor's first screen comedy dates to the Stone Age of talkies: the camera unswervable, the posturing florid and exaggerated. The consolation is meager and comes in the form of Fredric March, hamming it up in an unruly takeoff on John Barrymore.

By *Royal Family*, though, it was clear who was in charge on the soundstage. "With *Royal Family* it was Cyril and Cukor," recalled Mary Brian. "But by this time he [Cukor] was really doing all the directing [of actors], and Cyril was doing all the technical things."

Edward Dmytryk, a Paramount editor, was also on the *Royal Family* set, the first of three Cukor films that he edited before becoming a director (the other two were *Girls About Town* and *Zaza*). In an interview, Dmytryk recalled the experience of working with Cukor for the first time.

Dmytryk remembered how the director always asked his opinion, after each take, each scene, and after dailies. Unsure himself sometimes, Dmytryk preferred to act tough, noncommittal. That was a typical editor's attitude, and Dmytryk said Gardner understood implicitly. However, Cukor resented Dmytryk's lack of enthusiasm and treated him brusquely.

"What I didn't realize is that directors too are insecure," Dmytryk recalled. "You have to pat them on the back, just like anyone else."

One day, Cukor and Dmytryk were in the splicing room, and the director commented that the editor had forgotten to hold for a laugh at the tag end of a scene, as they do in the theater. Dmytryk, who did not have a theatrical background, explained to Cukor that in motion pictures the custom is to cut away swiftly to the next piece of business because you can never be quite sure where—or if—the laugh is going to fall.

"But [Cukor] learned to have a good sense of pace," said Dmytryk, "which a lot of those theater directors never did learn. . . ."

Indeed, he did learn to have a good sense of pace. But contrary to Dmytryk's advice, one of the hallmarks of his direction was that, in his finest films, he was not afraid to leave room for laughter. *Royal Family* flies by a little too swiftly, as if, in that era particularly, everyone was afraid of the gaps. Cukor's later comedies usually did exactly the opposite: instead of quick cutaways after the punch line, his camera held fast, again and again, long after the jokes. The humor in a Cukor film feels more luxurious, in part because the audience is left

to savor the subtleties of human behavior just a little longer than was customary in Hollywood.

Cukor was bolstered by a new contract, in advance of his option date of February 1931, and a salary hike to fifteen hundred dollars weekly.

From *Royal Family*, someone had finally figured out that this director—whose career up to this point had been mired in drama—had a biting sense of humor. His first two solo directing assignments were to capitalize on this revelation: *Tarnished Lady*, with a script by Donald Ogden Stewart and starring Tallulah Bankhead, and *Girls About Town*, based on a story by Zoë Akins, with Kay Francis, Lilyan Tashman, and Joel McCrea.

Both were uneven. *Tarnished Lady* featured la baritone Bankhead, one more Cukor idol, in one of those romantic mix-up comedies that never quite captured her free-slugging stage appeal, while *Girls About Town*, about a pair of lovestruck gold diggers, boasted one of the most engaging screen performances of Lilyan Tashman, another Cukor friend, whose career was abbreviated by her sudden tragic death three years later.

Both were screen originals, not adaptations, used exterior locations freely and interestingly (*Tarnished Lady* was filmed in New York City; *Girls About Town* in Los Angeles), and could boast intermittent charm as well as some insight into feminine wiles.

Back in California, Cukor was awarded the direction of *One Hour With You*, a tuneful soufflé to star two of Paramount's hottest names, Maurice Chevalier and Jeanette MacDonald (with Rochester summer-stock veteran Genevieve Tobin as the flirt who tries to break up their romance), and to be produced by Ernst Lubitsch.

Director Lubitsch had prepared this production, an informal remake of his 1924 *The Marriage Circle*, with scriptwriter Samson Raphaelson, but found himself overextended and obliged to drop out to concentrate on the editing of *The Man I Killed*. One of the imperial names among Hollywood directors, Lubitsch chose Cukor to take his place and carry out the production blueprint, under his personal supervision.

Because of what transpired during this production, the arc of Cukor's career was altered dramatically—in the long run for the better. Much of what happened was swept under the rug over the years in the manner in which, publicly at least, Cukor swept all adversity and bitterness aside.

Ironically, Cukor and Lubitsch had much in common: a background in the theater; the habit of directing by enunciating the dialogue and coaching scenes down to the tiniest nuance; a reputation,

in the course of their respective careers, for witty, sophisticated comedies that often revolved around the motif of marital infidelity. Early in his motion-picture career, in fact, Cukor was hailed by some reviewers as "the American Lubitsch."

After less than two weeks of filming, however, their affinity began to unravel. Cukor was summoned to a conference in B. P. Schulberg's office with Schulberg and an obviously uncomfortable Lubitsch present.

Diplomatically, Schulberg asked whether Lubitsch could spend more time or the set and be in closer contact with the production, now that Lubitsch had speeded up completion of *The Man I Killed*. Unhesitatingly, Cukor agreed. Schulberg admitted that it was an unusual situation and thanked Cukor for being such a good sport about it.

Lubitsch's frequent presence on the set quickly accelerated to continuous attendance for rehearsals, discussion of photography, and actual filming of scenes, always with Cukor present and assenting. Even so, according to court documents of the time, Cukor felt that he remained in charge.

When *One Hour With You* was completed, in fact, it did bear Cukor's credit as director on the screen. With that credit, it was shown to "thoroughly delighted" Paramount executives on the lot. And when *One Hour With You* was previewed for the industry at the Uptown Theatre in Los Angeles, reviewed in the *Hollywood Reporter*, and advertised in *Variety*, preview prints, advertising, and the glowing advance reviews carried Cukor's name—and only Cukor's—as director.

At which point, Lubitsch underwent a startling reversal. Concerned that the picture "stands a chance to be rated as the best directed Chevalier picture, surpassing all my previous efforts," Lubitsch sent a memo to Schulberg, threatening to take his name as producer and "supervisor" off *One Hour With You* unless Cukor's name was forthwith removed as director. The implicit threat, of course, was that Lubitsch's name was more important to the box-office prospects, not to mention that he, Lubitsch, was imminently due for renegotiation of his contract.

A concerned Schulberg telephoned Cukor and asked Cukor's consent to drop his directorial credit. Partly as a sop, Schulberg offered to let Cukor direct the next Chevalier-MacDonald film, *Love Me Tonight*. Cukor was disturbed by the conversation, though, and said he would not make up his mind until he had slept on the issue.

The next day, Cukor telephoned Schulberg and said he had decided that he was the legitimate director of *One Hour With You*, and would take legal means if necessary to guarantee his credit. Schulberg warned him that he would be the "laughingstock" of the profession,

going up against the famous Lubitsch. Cukor said that he was willing to take that bet. Schulberg responded that a man who showed so little judgment and sanity about screen credit ought not be entrusted with the direction of any future Paramount production, to which Cukor responded that he could see no logic in this statement and that "one had nothing to do with the other. . . ."

Schulberg concluded by declaring that Cukor's credit would be removed no matter what, and he repeated his assertion that if Cukor attempted to enforce his contractual rights, he would become the industry laughingstock.

Schulberg must have been astonished when the relatively obscure and insignificant director—under contractual obligation to Paramount for three more years—nevertheless filed suit against the studio, demanding that his deserved credit be restored.

The suit attested that Cukor's name was on "every single take" of every scene as director. Though Cukor acknowledged Lubitsch as a "master of his craft and one of the most outstanding directors of the industry," he, not Lubitsch, Cukor insisted, was the actual director of *One Hour With You*. Any statement to the contrary was a "subterfuge" intended "to serve his [Lubitsch's] own interests."

Cukor was stubborn, and it might be that he had already made up his mind to leave Paramount for RKO, where David O. Selznick had set up production.

For at first, in the late 1920s and early 1930s, Paramount had seemed like a "college campus," in the words of Joseph L. Mankiewicz, who like Cukor was one of the many New York emigrants to the studio. For these New Yorkers transplanted to Hollywood, there was a convivial atmosphere of esprit de corps, pranks and parties, and exuberant movie-making on the Paramount lot.

Now, in just a short time, thanks to bad studio management, there was financial instability, producer interference, and constant executive reshuffling. Cukor was willing to use the stalemate over *One Hour With You* to his advantage. The deal that was struck enabled him to tear up his Paramount contract and to sell his services elsewhere in Hollywood. And in the end, he settled for a subsidiary credit on *One Hour With You*.

In most sources, Cukor is described as either assistant director or dialogue director. All the most authoritative Lubitsch and Cukor books ascribe the direction of the film, without much qualification, to Lubitsch. The court documents of the lawsuit reveal that Cukor felt otherwise at the time, however, and some people think *One Hour With You* is, in fact, the first real Cukor film, a funny little ode to the pangs of love.

"It's a kind of masterpiece," said director Paul Morrissey, a fan of

Cukor's work, who became Cukor's friend during his Warhol period of filmmaking in the 1960s. "When you watch it [*One Hour*], what you see is the energy and pacing of Cukor, not the deadly pauses of Lubitsch."

One should not make great claims for Cukor's fledgling features. They sometimes plod and creak, like other early talkies. But they had memorable moments, scintillating star turns, and an increasingly assured and refreshingly individual tone.

Cukor was just over thirty. This fresh commodity from Broadway—this dark, European sort of man with his quick, liquid smile and air of nervous preoccupation—had demonstrated that he was not intimidated by the camera. He could win over actors and writers. He was in his element, intensely and irresistibly in command of a motion-picture set.

He was also patently homosexual, a fact that set him apart from most other Hollywood directors, who made a tremendous show of being the very opposite: swaggering, cigar-chewing, polo-playing, deep-sea and safari-adventuring manly men who notched their leading ladies on their belt. Yet as the Lubitsch lawsuit indicated, Cukor was gutsy and uncompromising, in this way, too, not anyone's preconceived idea of a soft, malleable dialogue director from back East.

In three short years, the director had made the transition, psychologically as well as professionally, from theater to movies, and he had established himself as one of the charismatic names in Hollywood.

"To watch him work, oh, it was like a miracle," recalled writer Adela Rogers St. John.

"Tremendous presence—and presence of mind," Lew Ayres said.

"Full-blown," stated Mary Brian.

"Quickly he [Cukor] became top of the roost," recalled Joseph L. Mankiewicz. "I met George when most people met George. He was young and pudgy—just another bright young Jewish director who had a stock company up in Rochester, I think. But I didn't know what George did in New York, really. Whereas, out there, almost within six months it seems, he became a legend. He seemed to have *arisen* in Hollywood."

CHAPTER FOUR

*A*part from everything else, Cukor was unusual among stage directors from the East Coast enticed to Hollywood for talkies, in that he found moviemaking—indeed California itself—immensely stimulating.

He had arrived with the usual New York mental resistance, sporting a black overcoat and matching fedora—very fashionable back East—which he insisted on wearing despite the warm climate. Cukor was chagrined by the distances between places, and had to take driving lessons. (He had his usual mechanical nonchalance when it came to handling an automobile, and when he was not being chauffeur-driven, then as later on, Cukor was a demon driver.) His friend Ilka Chase was in Los Angeles at the same time, and she accompanied him on his rounds in a new Buick sedan. As they drove around the city, they were agape at the signs with initials that seemed to preface everything—L.A. First National Bank, L.A. Figueroa Market, L.A. this and that. At first, they thought L.A. was a sort of charming French pretentiousness, until they realized it stood for Los Angeles.

Within weeks, Cukor had shed not only his coat and hat but many of his trepidations and preconceptions. He quickly decided he loved the weather, and wondered how he had ever survived the dreary and chilly winters of the East. He realized how much he had hated bundling up against the elements. His wardrobe changed dramatically, and Cukor was one of the first in the movie colony to don the

73

light silk lounging suits, almost like pajamas, that were fashionable for indoor informality.

He decided he loved the distances, as well as the proximity of things. Cukor organized day trips to the ocean, up and down the coast, to the mountains and the desert. Though he didn't play polo or tennis as did many in the film colony, he was not at all sedentary. When he wasn't working, or attending a party, the director loved to get out and explore the newness, the variety, the strangeness of California.

Most surprising of all, Cukor found that he loved picture making. He loved the slow, complicated, and sometimes torturous collaborative process that stymied so many others. He was *good* at the collaborative process. He enjoyed solving the problems, negotiating the egos. He enjoyed delegating. He didn't mind that the cameraman knew more than he did. He didn't care to inhabit the editing room. He delegated so well, so much—he used the studio departments so fully—that sometimes it seemed he was doing nothing, living it up, while getting paid for the easiest job in the world.

That is what he told scriptwriter Walter Bernstein when Bernstein asked for advice about directing his first film: "Don't give away the secret. It's the easiest job in the world." Unlike so many other directors, Cukor wasn't threatened by collaboration. As long as he could make the final decision, he encouraged input—from anybody.

Earl Bellamy, his assistant director on *A Star Is Born* and other pictures, recalled: "There's a great bit [in *It Should Happen to You*] when Peter Lawford is nuzzling Judy Holliday, and she's trying to fend him off, but she takes off her earring so he can nibble her ear. That was an idea that came from the property man, Blackie, and Mr. Cukor thought it was great, so it's in the film. But that's the way he was, very receptive to people's contributions toward making a good film."

There was still a producer at the top: a vital necessity to Cukor, even if he often had trouble in his career finding the right producer. But there was always going to be a producer, back East, too. Cukor not only accepted that but welcomed the producer and tried to get along with him. Unlike a handful of directors, Cukor had no desire to be that independent—that much in charge—to be his own producer. It was a flaw in his professional makeup that he did not wish to remedy.

Cukor found, moreover, that he didn't have any intellectual angst. He had none of the guilt of having left the theater and literary circles of New York behind. Certainly guilt of any kind was not in him.

Already, in the early 1930s, Cukor was giving newspaper interviews in which he declared that Broadway was in the doldrums and that its

new crop of players lacked the spark and inspiration of run-of-the-mill Hollywood hopefuls. The New York *Herald Tribune* profiled the transplanted Broadway director and reported with amazement, "He has none of the attitude of the highbrow who berates [film] producers for leveling pictures at wholesale audiences."

For several years as he shuttled back and forth between coasts, Cukor lived in residential hotels when in California. In the summers, he and Alex Tiers—still wistfully thinking of an acting career—shared a house in Malibu, in those days when the film colony was smaller and more closely knit, near the beach houses of B. P. Schulberg, Herman Mankiewicz, Edwin Knopf, and others. Cukor and Tiers went around with actress Gloria Swanson, and Tiers threw some memorable parties.

By 1932, Cukor had his own new house—and a valet, a cook, a secretary, and servants. To a man who so valued creature comforts, this was no small factor in his love affair with Hollywood and movies.

His six-acre hillside estate, on a narrow street twisting uphill, Cukor purchased for only ten thousand dollars early in the year that he signed his new contract with RKO. Three years later, the original development house on the grounds was extensively renovated by J. R. Dolena, landscaped by Lucille Council and Florence Yoch, then interior-decorated by the former silent screen player Bill Haines, one of Cukor's new friends.*

For half a century, Cukor's place was one of the most distinctive and personal among famous residences in Hollywood.

Behind a twenty-foot brick wall were situated courtyard steps, terraces blooming with oleanders and camellias, an elaborate garden with marble statues from Italy and Greece, and one of the most talked-about swimming pools in Hollywood—there is no end to the anecdotes about Greta Garbo, Tallulah Bankhead, and others enjoying their privacy by swimming in the buff there.

The original house was remodeled along the lines of an Italian villa—preserving the Regency details. It became two levels, consisting of a main floor of seven rooms (including a living room, the library, a formal dining room, and the oval room) and one master bedroom, rising above the ground-floor guest and servants' quarters over the kitchen. In addition, there were three houses remotely situated on the grounds that were rented out individually.

*Florence Yoch also landscaped David O. Selznick's house—among many others in the screen colony. She consulted on film sets for *Romeo and Juliet* and details of the Tara mansion for *Gone With the Wind*.

Inside, the house reflected its master's preferences, in its formal beauty as well as its idiosyncratic ostentation.

One of the most extraordinary rooms in the house was the oval lounge, which was the intimate room for friends and guests. French doors opened onto gleaming parquetry. The walls were covered in natural suede. The ceiling was smoke blue, the fireplace copper and pewter, with a cornice that made a quiet clicking sound when the indirect lighting was turned on and the metal expanded with the heat. An enormous curving sofa, also covered in beige, was set against a floor-to-ceiling circular bay window overlooking the gardens. The pillows and side chairs were in bottle green and coral.

Cukor's art collection started in the early 1930s with the gift of a Grant Wood from Katharine Hepburn and a small painting by Emile Bernard from Stella Bloch. As it grew, his collection tended toward the modern: Cukor built up quite a gallery of sketches, paintings, and sculptures by Picasso, Toulouse-Lautrec, Matisse, Renoir, Georges Braque, Grant Wood, Juan Gris, Graham Sutherland, and Stella Bloch.

(Art was regarded as a good investment in Hollywood, and Cukor was not alone in the film colony to buy and sell pieces. Particularly among Cukor, the Selznicks, and the Goetzes, there was a flow of art tips, and swapping of items.)

The furniture that accumulated over the years was generally exotic or antique and on the rococo side: Victorian set alongside Orientalist, Derbyshire, Dutch, or Moroccan. Cukor had a weakness for shiny things, he haunted antique shops and flea markets, so that the house was filled with unusual gilt, velvet, lacquer, mother-of-pearl, and turquoise pieces—decorative Nubians, coral figures, Empire bronzes, paintings on glass, samovars, and miniatures. "Baubles and bibelots," in Kenneth Tynan's phrase.

There was also Cukor's vast and ever-expanding store of show-business memorabilia—some noteworthy items (John Singer Sargent's pencil sketch of Ethel Barrymore as a young actress in 1903, which she bequeathed to him; Charles Dana Gibson's portrait of the actress Lucile Watson); others of private significance but equally treasured—framed letters, scrolls, awards, programs. These flecked the walls and the corridors.

One short hall leading to Cukor's office was covered floor to ceiling with portraits autographed by the actors and actresses with whom he had worked, and by the famous personalities with whom he was acquainted and who regularly stayed with him when visiting California.

Part of the reputation of Cukor's house lay in people's varying reactions to it. Not everyone appreciated its strange harmony, the decorative blend that echoed the owner's bravura personality. There were

dissenters among the visitors, people who did not feel comfortable there, people such as Gottfried Reinhardt, who thought the house "a mixture of good and very tacky taste," or Pulitzer Prize–winning playwright and screenwriter Sidney Howard, who found its effect oddly disconcerting.

After visiting it for the first time in 1937, Howard confided in a letter to his wife: "Cukor's house is like nothing I have ever seen. Never has anything been so done by decorators. It is, I think, as beautiful as any interior I have ever seen but each room is, in the most nance sense, a perfect show window rather than a room; so much that when I saw Cukor himself in his own library he seemed to belong there no more than a shop saleslady belongs in a perfectly dressed shop window."

Cukor was forever tackling home improvement projects at 9166 Cordell Drive (Aldous Huxley made a quip about it, paraphrasing Psalms 69, Verses, "For the meal of mine house hath eaten me up . . ."). But all the changes over the years were cosmetic, really, and nothing about the Cukor domicile truly changed. Cukor lived there for fifty years, until the end of his life, by which point the famous house seemed to be preserved as if in a kind of time warp. It was one of the few homes that could be said to exist essentially as it had—always had—in the Golden Age of Hollywood.

In early 1932, in the midst of the Lubitsch lawsuit, Cukor wrote to Elsa Schroeder, inviting her to come to California and work for him. He sounded the refrain that he would repeat again and again over the years to friends and journalists: California was wonderful. His house was wonderful. He loved everything about his new life.

"When I arrived in California," he liked to tell friends, "I knew I was lucky."

Schroeder was to prove a Rock of Gibraltar for Cukor. She had worked for Gilbert Miller back in New York, and when she left that producer's employ in the early 1930s, Cukor convinced her to become his household manager. Their relationship, as with so many of Cukor's staff over the years, was intense, part love (Cukor confided in and trusted her) and part hate (at the same time as he fought and belittled her constraints).

Unprepossessing to look at, nondescript in personality, she lived her own life apart from the Cukor house, residing with and taking care of her mother. For thirty years, until her death at the time of *My Fair Lady*, she managed the income, the investments (especially the stock holdings and Beverly Hills real estate), and the expenses of Cukor's profligate lifestyle.

His income in 1932 alone amounted to $73,500.00. Under advise-

ment from Uncle Morris, Schroeder invested Cukor's earnings. The screen director purchased some California property, American Telephone and Telegraph stock, and municipal bonds. In addition to these holdings, by 1938 Cukor had a trust fund of $100,000 as well as several bank accounts for different purposes.

Yet he lived lavishly and couldn't keep track of his spending, so part of Schroeder's job, always, was to hold him back.

By comparison with Paramount, a first-class studio, RKO was small and financially shaky, headquartered on an almost shabby lot. If Paramount claimed the importance of directors, at RKO there was more of a collaborative spirit, with everyone—writers, directors, producers, and the technical craftsmen—working more as a team on any given project. For better or worse, there were no Ernst Lubitsches running loose. In part because of its perennial also-ran status among the studios, at RKO the atmosphere was more modest and relaxed, friendly, almost the ideal of family atmosphere to which every studio liked to pretend.

Louis B. Mayer's son-in-law had preceded Cukor to RKO, as head of production, in 1931. Along with Merian C. Cooper—an ex-adventure documentarist who had gained his footing in Hollywood as the codirector and producer of such sensational pictures as *The Four Feathers* and *King Kong*—David O. Selznick was revitalizing the studio. Taking advantage of the Lubitsch situation, Selznick cleared the way for his best friend to come over from Paramount.

"When I say they [Selznick and Cukor] were best friends," said Marcella Rabwin, Selznick's secretary and executive assistant in those years, "I mean there was love between them, there was mutual dependence, there was respect. . . . They were both such charmers. They were both witty. They were both bright. They understood each other. Things were unspoken between them. They were always laughing together. That was an important part of their friendship."

One thing they shared in common was the New York Jewish background, although Selznick had the more dynastic family history, as the son of one of the early film moguls who became very rich before going very broke.

Ironically, Cukor and Selznick resembled each other physically—the wire rims, the combative noses, the kinky black hair, that slightly doughy look. So much so, in fact, that acquaintances were forever mistaking Cukor and Selznick for each other, in part because they seemed inseparable at the studio, on the set, at previews, and at each other's parties in the evenings.

"You got to associate one with the other so that you almost uncon-

sciously made that mistake," said Edward Eliscu. "If you expected to see George, and then David Selznick walked by . . ."

The resemblance wounded their vanity and annoyed them both. "It's curious," wrote Selznick, "because, although probably we bear some facial resemblance to each other, George is about six inches shorter than I am. In this connection, my mother once protested violently in Cukor's presence, when the subject came up, that we didn't look like each other at all. George replied, 'It's all right, Mrs. Selznick. My mother doesn't like it either.'"

Selznick was tough but soft-centered, a man of sensitivity as well as of bright, courageous instincts, those qualities that Cukor esteemed in himself. Not only was Selznick's integrity unimpeachable, when he wasn't being too demanding or quick-tempered, he could be an immensely fun person with whom to work.

Selznick did things with style—and Cukor liked that about him. Business was always mixed with pleasure. There would be week-long boat excursions to New York through the Panama Canal, during which present and future film scripts would be mulled over. There would be trips to gambling lodges in the desert, and all-male hunting and rejuvenation weekends at mountain lodges (Myron Selznick kept a house at Lake Arrowhead). Improbably, on these hunting and fishing trips, Cukor would be dragged along in the company of such other nonmachos as Ernst Lubitsch and King Vidor.

At these many occasions, it might be said, Cukor was as much the shining star as Selznick.

"George was the most socially acceptable guest in Hollywood," recalled Joseph L. Mankiewicz. "If you could bring George to your dinner party, you were in. First of all, he was a wonderful speaker, very funny. Told marvelous stories. George could take a whole evening with his Ina Claire stories—or stories about Goldwyn's wife [Frances Howard], who was in [summer] stock with him. He knew all these women and men from way, way back and he had these wonderful stories to tell."

"Irene [Selznick] gave the best parties," said Marcella Rabwin, "and if you were on the Selznick party list you were made in Hollywood. George was at the top of her list, always. She loved having him there, number one, because any extra man is valuable. But any wit is worth his weight in gold because you can keep a dinner table laughing. And she could depend on him to be witty."

David O. Selznick was the right producer for Cukor, if ever there was one. Selznick sincerely believed Cukor was one of the finest young directors in the motion picture industry, and Cukor predicted Selznick was going to achieve great things.

Their first two pictures together, both in 1932, confirmed their professional chemistry.

One of the producer's pet projects, *What Price Hollywood?* had been pushing along, already in development, by the time Cukor joined the RKO payroll. Selznick was the one who steered the original concept through the thicket of half a dozen credited and uncredited writers. Adela Rogers St. John received the eventual story credit, Jane Murfin and Ben Markson the screenplay card, but others, including Gene Fowler and Rowland Brown, were around and pitching in.

This was a theme about which Selznick felt deeply, his precursor to the more full-blown *A Star Is Born* in 1937—which, in turn, became Cukor's musicalized version in 1954. Purely as an original story, *What Price Hollywood?* is Selznick's most enduring contribution to screen literature. Its tough storyline about the pressures of Hollywood stardom has been stolen from and remade many times.

Selznick had "a very romantic view of Hollywood, a real love of it," according to Cukor. Yet at the same time, the producer viewed himself as a perennial outsider, a maverick of the studio system. Although he was surrounded by vivid examples of fickle fame, he also had the more personal role model of his father—whose trajectory of wild success and a dismal, sputtering end Selznick himself was doomed to repeat.

For Cukor, this was his first show-business movie *about* movies, and about Hollywood and California, his happy new life—not Broadway and New York. In that sense, the director met *What Price Hollywood?* at a crossroads, which to a certain extent resulted in a jumble of styles and attitudes in the film itself.

In the screen story, a young Brown Derby waitress (Constance Bennett) is elevated to stardom by an old-time director (Lowell Sherman) whose habitual drunkenness spurs his downfall. In spite of gossip-column scandal and domestic strife—she is married to a tedious playboy character, acted by Neil Hamilton—the actress stays loyal and helpful to her mentor. Guilty over burdening her, the broken-down director commits suicide.

Interestingly, Cukor treated the behind-the-scenes picture-making apparatus with a curious wonder, mixed with humor. At times, the humor was worse than dumb, as when a black maid makes an "idiotic suggestion" (Cukor's words) after a script conference and is thrown into a swimming pool. There is little offense in the studio portrait (the character of the blowhard producer is patently cartoonish), and Cukor's real scorn here is reserved for people on the outside peering in—nosy fan-magazine writers poking into stars' bedroom habits.

The Maximilian Carey character was said to have been patterned,

roughly, after silent director Marshall "Mickey" Neilan, whose career, despite early promise, had declined into drinking and scandal. Cukor may have had feeling for those the parade passed by, but he also liked the fact that the actor playing the part had "a slightly odious quality." That unleashed his ambivalence. Playing Carey, Lowell Sherman, the onetime matinee idol turned director, turned in an edgily affecting performance.

Cukor poured his compassion into the Constance Bennett character, Mary Evans. Cukor always defended this actress—who could be mechanical and cloying—whom he directed in an early 1930s informal trilogy. "Constance Bennett had one kind of romantic, Scott Fitzgerald look about her," stated Cukor in one interview. "It was the look of the 1930s—or perhaps the 1930s looked like her."

Yet Bennett was never as natural and compelling as she was under Cukor's direction here. Before the sappy-happy ending, there was little formula in her character's behavior. The director could wear his heart on his sleeve for such a character: Mary Evans was the first of the shrewdly observed gutsy females in Cukor films who refuse to knuckle under to slander and adversity.

What Price Hollywood? may have been "a mixed bag," as Cukor himself admitted, later in life, in interviews. However, its dose of Hollywood verisimilitude was bracing, its highlights as original and incisive as anything Cukor—or Selznick—had done in motion pictures. In this, their first genuine collaboration, the producer and director had made a quantum leap.

A Bill of Divorcement, also in 1932, was based on a 1921 British play that had been a New York showcase for Katharine Cornell. Considered risky screen material, it focused on a mentally unstable man who returns home, revitalized, on the day his ex-wife is about to remarry. His daughter is torn between her mother's fiancé and her love for her natural father.

Slated to play the rehabilitated father was the stage and screen star John Barrymore. The choice of the daughter was narrowed down to Jill Esmond—married to Laurence Olivier at the time—and Anita Louise. Only Cukor was holding out for a fresh face, someone different and new.

One of the candidates was a twenty-four-year-old actress with only stage experience to her name. Katharine Hepburn had acted, earlier, for Edwin Knopf's stock company in Baltimore, and in Broadway plays. At the time, she was appearing in New York in *The Warrior's Husband,* and Stella Bloch and Edward Eliscu—married to each other now, after Bloch's divorce from Coomaraswamy—went to see her and filed a report with Cukor, at the director's request.

At Cukor's urging, Selznick scheduled Hepburn for a screen test in New York, opposite a young actor who intrigued them both: Alan Campbell, the handsome young husband of Dorothy Parker, who was in the midst of a modest thespian career (he had had a small part in one of Cukor's Broadway plays) that was destined to deviate into scriptwriting.

Not everyone liked the test results: Hepburn had the Philip Barry high style of acting, "too high," Cukor said. She looked like a gargoyle, her hair all spiked back. Mannish and mannered. She seemed to bark through her nose.

But the director noticed a gesture that eluded the others. Those who were in the screening room with him said it seemed to electrify him, though it meant little enough to them, even after it was pointed out. It was one of those tiny surface abberations that, to Cukor, suggested hidden depths.

In the test scene, Hepburn swooped to pick up a highball glass, moving with enormous feeling. Though the camera was behind her, it captured something—Cukor described it as "a sad lyric moment"—enigmatic yet somehow emblematic.

Cukor was hardly infallible when it came to casting (nor did he often have a free casting hand), but he did throughout his career have such revelations about people. When he screen-tested Judy Holliday, he was struck by her unexpectedly poignant reading of a most uninteresting line. For some reason he could not pinpoint, Holliday reminded him of Garbo—though she was entirely herself, not like Garbo at all.

"Can you do that again?" he asked her. "Yes," Holliday said, and she got the part.

With newcomers, the director liked to say, you go for the glints and grab the gold later on.

Selznick was not particularly impressed by this newcomer's screen test, but Cukor and writer Adela Rogers St. John spent a night beseeching and haranguing him, walking up and down the Malibu beach with the producer. Selznick liked that process of endless, sometimes all-night debate, which tested the faith and endurance of his retinue. Sometimes, the winner of the argument was the person still on his feet at the end of the shouting.

This time, Selznick told the mule-headed Cukor to go ahead and take a chance. Indeed, Cukor's insistence on casting Hepburn was to become a trump in the relationship between him and Selznick, just as it was an eternal bond between him and Hepburn. The discovery first of Lew Ayres and then of Hepburn certainly gave Selznick reason to believe in Cukor's casting genius.

Soon enough, accompanied by her friend Laura Harding, a most

82

un-Hollywoodish-seeming Hepburn arrived by train. She wore a gray silk suit designed by the New York couturier Elizabeth Hawes; her coif of hair was swept priggishly under a pancake hat. The looks that greeted her were startled ones. People had to stifle their laughter.

To make matters worse, one of Hepburn's eyes was sore and reddened as a result of a cinder that had flown into it on the train, so that the new Selznick investment—horrors—appeared to squint.

Accompanied by agents Leland Hayward and Myron Selznick, Hepburn was delivered in a Rolls-Royce to the unprepossessing RKO setup. Adela Rogers St. John was sitting with Selznick in the RKO commissary when Hepburn appeared in the doorway. Selznick took one look at her, and turned the table over, dispersing food in everyone's lap. Then he sent for Cukor.

Selznick's assistant, Pandro Berman, took Hepburn to meet her Hollywood patron. Cukor looked her over apprehensively. When she asked to see a doctor about the irritation in her eye, her complaint did not register with the director. In the corridor. Hepburn chanced to meet her costar, the fabled Barrymore, who was more sympathetic than Cukor when she mentioned the stabbing pain in her eye. Barrymore offered Hepburn a vial of eye drops and confided with a wink, "I also hit the bottle occasionally, my dear."

Shortly thereafter, Cukor took Hepburn to see her wardrobe sketches. Under Cukor's piercing gaze she looked at them, her face betraying a distinct lack of enthusiasm. She thought they were much too flouncy for the character, an English girl of fortunate circumstances.

"What do you think of these?" Cukor asked challengingly.

"Well, I don't really think that a well-bred English girl would *wear* anything like that," Hepburn is said to have replied.

Cukor was perturbed by her response. "What do you think of what *you* have on?" the director demanded.

"I think it's very smart," she said defensively.

"Well, I think it stinks. Shall we proceed from there?" the director said.

To himself, Cukor was wondering at how remarkably self-possessed the young actress seemed to be, and how the chiding appeared to roll off her. Later on, he learned that Hepburn's father had been a stern disciplinarian, and she was used to tough remarks directed at her. Also, when they became closer friends, he realized that indeed his barbs had upset her, only she was too poised to let on.

"The first thing we have to do," Cukor announced to Hepburn, "is something about your hair." He took her to the hairdressing department, where she had her baby-fine hair fashionably shorn. That seems remarkable, but it is like that scene in *A Star Is Born* where

James Mason pulls off Judy Garland's wig, nose putty, and makeup—revealing the organic Esther Blodgett—and the real beauty inside her. Cukor often gave his leading ladies new hairdos; Judy Holliday got a quick haircut, too, after her first screen test.

The studio makeup people advised him to leave Hepburn's freckles and high cheekbones alone, so he did.

Now it remained for Cukor to guide Hepburn's performance. They rehearsed for a week, Hepburn, Barrymore, and Billie Burke (playing the Barrymore character's wife), in the RKO commissary. Selznick encouraged rehearsal—that was one of the differences between him and other Hollywood producers.

By this time in his life, it may be that Hepburn's costar had a slightly tarnished air, with a slur, a paunch, and milky complexion. The aging Barrymore still had charisma, however, and was not at all as broken down or dissolute as he would become just a few years later.

Barrymore was cooperative; he took direction gently and behaved sweetly. Under Cukor's cloak of admiration, the actor felt at ease and was moved, more than he was at other times in Hollywood, to contribute nuances.

In the first scene they filmed, Barrymore had to come in with a hat and raincoat on, then turn around to gaze at Hepburn, standing outside audience view, while he fiddled with some pipes on the mantelpiece. As she watched him go through his paces, the young actress thought to herself that Barrymore was "overdoing it a bit," but of course she didn't say so. All the while, Hepburn herself—though she was offcamera—was acting to the hilt, tears streaming down her face, "doing a little too much myself."

When the take was over, Barrymore seemed to notice her rapt visage for the first time. He went over to Hepburn and took her chin in his hands, then announced to Cukor, "I'd like to do it again." Cukor said fine; he always said fine. Barrymore did another take and this time his performance was *charged*, entirely different, thrilling.

"I think," Hepburn remembered, "he just saw a kid to whom it meant a tremendous amount and he thought, 'Well, the poor thing, I better do a little better here.'"

The pleasure of *A Bill of Divorcement*—in most ways a dated family melodrama—was the delicately balanced scenes between the two of them, the "common ground" (in the words of the director) that is achieved in the performances of the young colt and the old smoothy.

In interviews in later years, Cukor said that Hepburn was instantly at home in front of the camera, naturally photogenic—though he had

to fight the sound department to keep that New England inflection in her voice.

Her real distinction, Cukor theorized on more than one occasion, was the way she walked and talked, her brash personality. Hepburn refused to soften herself—unlike Cukor, she wasn't trying to assimilate; she wasn't afraid to go against the audience. Cukor liked that about her: that she was willing to risk audience acceptance.

"At first, the public was taken aback," Cukor said. "As the character, she was very sure of herself, and the audience was not quite certain how to take her. But then there was a moment when she flashed this warm, radiant smile for her mother, played adorably by Billie Burke, and the audience could see how very attractive she really was. Then, when she picked up some cushions and lay on the hearth rug, they noticed that she moved beautifully. They realized that something fresh and exciting was happening on the screen."*

The new star—the film—was released to acclaim. Every woman who saw it wept a flood of tears, crowed studio head Merian C. Cooper in a memo.

The experience of A Bill of Divorcement cemented the friendship of Cukor and Hepburn, and launched one of the unique director-star relationships in Hollywood history—one that was not predicated on sex, money, studio whim, or picture trends. One that was to endure for fifty years, with nine other films starring Hepburn and directed by Cukor.

Cukor could be surprisingly severe about his friend's faults: On more than one occasion, he said in interviews that her screen mannerisms ought to be tamped down. But, according to people in his close circle, to bring up her name in a truly snide fashion privately was to be dismissed forever from his presence. Hepburn was one of the few who was excepted from nasty gossip behind Cukor's closed doors. The director was intensely protective of the actress and saw her in an unassailable glow, not unlike the way his camera trained on her.

Cukor said once that he couldn't get very excited about directing most of the Hollywood people, such as Cary Grant. He said he

*Interestingly, in the book of his studio memorandum, Memo from David O. Selznick, Selznick is quoted on that scene with similar wording. "But very early in the picture," Selznick said, "there was a scene in which Hepburn just walked across the room, stretched her arms, and then lay out on the floor before the fireplace. It sounds very simple, but you could almost feel, and you could definitely hear, the excitement in the audience. It was one of the greatest experiences I've ever had. In those few simple feet of film a new star was born." Who said it first? Was Cukor reading Selznick's memos, or was Selznick listening closely to Cukor?

couldn't get weak-kneed at the idea of Cary Grant. The remote stage beauties he gazed on from the second balcony had a "prestige" with him that the newcomers could never have. Only a few motion-picture personalities affected him as deeply.

As for Hepburn, he wasn't daunted by her, not exactly, but she did affect him more mysteriously and profoundly than the others.

It was the same with Olivier: Cukor saw Laurence Olivier perform in *Macbeth* once, and was scheduled to have dinner with the actor afterward. Only, suddenly, after absorbing the performance, he felt that Olivier was no longer his friend, but a stellar figure with extraordinary genius, and the director found it difficult to speak to his friend across the dinner table.

Once a fan, always a fan. Many times over the span of five decades, for weeks or months at a time, Hepburn stayed with Cukor in the guest room of his house; she could wax rhapsodic about the pillows, the hangers, the soaps, the convenient bed light. (She kept a stack of valuable paintings and sketches in a storeroom over Cukor's garage: Toulouse-Lautrec, Vlaminck, Bellows, Robert Henri.) After Spencer Tracy died, Hepburn rented his house on Cukor's estate, and lived there, off and on, for years. Film critics gush over the collaborations of Josef von Sternberg and Marlene Dietrich—or William Wyler and Bette Davis—but here was a director-star relationship that cut closer, ran deeper, and lasted longer than any other in Hollywood, off as well as on the set.

She and Cukor took lunches and dinners together, walked through the hills together on Sundays, and consulted each other on scripts and projects. Their circle of friends mingled and overlapped. Quite apart from their close friendship, however, Cukor remained in her thrall.

Hepburn might be staying with him at the house, and they would be having a conversation. She would excuse herself to make a change of clothes, and then after some minutes she'd return, walking into the room, where Cukor was waiting. Her friend the director would have to catch his breath. Only a half hour before, they had been together in the same room. Now, seeing her anew, she struck him as a "thrilling apparition."

One of Selznick's abilities was in knowing how to mine the studio departments. With Selznick, Cukor was—for the first time in his career—immersed in all production areas *before* filming.

Perhaps the most important category was the script, the rock upon which every Hollywood movie stood or foundered. Until now, with plays and films, Cukor had only been consulted belatedly about the stories he was going to direct, but under Selznick's command he was

given more of an opportunity to get to know the writers and to help shape the scripts.

Hollywood scriptwriters as a breed were very different from the Broadway playwrights with whom Cukor had been used to working, even if they were sometimes the very same individuals the director had known back East.

For one thing, writers in Hollywood could be overruled or replaced with startling abruptness. The producer's opinion was of paramount importance. The director, under the producer's umbrella, had more leeway in dealing with writers and scripts—whereas a theater director was not brought in until *after* a play was written, and even then had strictly limited authority where the text of the play was concerned.

Selznick worked closely with writers. Everywhere they trailed after him, and when Selznick wasn't available for consultation, his memos took up the slack. Like Cukor, Selznick professed to love writers, and was uncommonly skillful at the give-and-take with them. Selznick writers (and directors—*all* Selznick personnel) were expected to be on twenty-four-hour call. The producer had a habit of convening all-night story conferences, which could, in fact, go on for several nights in a row.*

Like Selznick, Cukor was already adept at *talking* ideas, only now, in the Hollywood system—with the writer low on the totem pole—he had a captive audience. Ideas "spitballed" at midnight, or at high noon in the commissary, could be exceedingly helpful to writers, though the habit might also drive them to distraction. Selznick "could think of twenty different permutations of any given scene without stopping to catch his breath," in Ben Hecht's words. The two of them, Selznick and Cukor, were usually more likely to be helpful when the structure was already manifest and the arc of the story clear. Otherwise, the scriptwriter might have the problem of trying to make a thoroughly implausible stream-of-consciousness idea fit in.

The important thing was that Cukor, at last, had a direct outlet for his love of writers and writing. And as important as were Selznick and Hepburn to Cukor's career in the early 1930s, equally important were the relationships the director formed in Hollywood with fluent and first-rate writers.

The director had continuing relationships with some playwrights he

*Unlike Cukor, who knew when to draw the line, Selznick fancied himself more of an actual writer. Much later, more than once, the producer found himself in conflict with the Screen Writers Guild over a script credit he claimed for himself. Selznick took script credit on three of his films: *Since You Went Away*, *Duel in the Sun*, and *The Paradine Case;* Cukor, never.

had known from earlier days, who gravitated to Hollywood in the early 1930s. But Cukor was also alert to new writers who might have a future in motion pictures and who, coincidentally, might be friends.

He suggested to Selznick that the producer bring out to Hollywood Edward Eliscu, who had proven himself on Broadway over ten years as an actor, songwriter, and director. A short-term Selznick directorial contract was arranged for Eliscu, who wrote a tune for Cukor's *Rockabye* before settling down to a Hollywood career as a song- and screenwriter.

Eliscu's wife, Stella Bloch, also went to California, and Cukor's boyhood friend began working for Selznick on a script that never came to fruition, an adaptation of a Thomas Hardy novel.

Mortimer Offner also went west with a considerable reputation as a professional photographer; in Hollywood, he took portraits of Katharine Hepburn and Irene Selznick, among others. Knowledgeable about the theater, Offner was drafted as a contributing scriptwriter of such Hepburn films as *The Little Minister*, *Alice Adams*, and Cukor's *Sylvia Scarlett*.

Cukor invited the novelist and drama critic Charles Brackett to Hollywood. The aristocratic Brackett, whom the director knew from his days as a Broadway columnist for *The New Yorker*, arrived for a false start on a Selznick picture and sat in on a conference with Selznick, Adela Rogers St. John, and Cukor. Brackett could not discern the matter under discussion ("I got no clue from him [Cukor] whatever," recalled Brackett), and quickly hopped a train back to New York. Still, Brackett was to return to Hollywood to make his eventual mark, not only as a one-time Cukor screenwriter (*The Model and the Marriage Broker*) but as the preeminent writing partner, for many years, of Billy Wilder.

Also from *The New Yorker*, by way of England, came the poet, novelist, and writer of witty, macabre stories, John Collier, whose most recent acclaim was for a satirical novel, *His Monkey Wife*, about a gentleman who marries a monkey. Collier's maiden voyage as a scriptwriter was to be Cukor's allegorical *Sylvia Scarlett*. In a long, distinguished career, Collier also helped write the script for Cukor's *Her Cardboard Lover*, besides collaborating on the film version of John Van Druten's *I Am a Camera*. (A man of diverse literary gifts, Collier also won an Edgar for his collection of short mystery stories, and published a screenplay based on John Milton's *Paradise Lost*.)

Cukor collected writers like he collected books, not only the famous ones who came to dinner but the lesser-known Hollywood scriptwriters with whom he worked, if amicably, then usually more than once. It is striking how many of them, throughout his career, were women—in a Hollywood where the paucity of female scriptwrit-

ers is often remarked upon by present-day film historians, six out of ten Cukor pictures have a female scriptwriter listed among the credits.

They were there, in part, to ensure the truthfulness of the female characterizations—even, in contemporary terms, to see that the women in his films were as strong and self-reliant as possible.

"Even when we were beginning to taper off seeing him that frequently, because we were involved in other things and becoming more political," said Stella Bloch, "even then, when George got a script, he used to send it to me and ask me what I thought about it. He'd say, 'I have a script I'm supposed to direct and I'd like your opinion on it—whether any of the scenes are demeaning to women.'

"Sometimes I had objections on feminist grounds, which he wouldn't have been able to see himself. But he was very sympathetic, and seemed very ready to accept my objections. I think he thought I had a better contribution to make on that level than any of his friends who were not particularly radical. I don't know if my suggestions were always used, but George always gave a person the feeling that they made some contribution for which he was grateful."

From early on in Hollywood, Cukor's lady scribes included Jane Storm, a Paramount contract writer; Selznick writer Jane Murfin (who was married to actor Donald Crisp); Adela Rogers St. John, the ex-Hearst columnist whose Broadway play had been directed by Cukor; Anita Loos (*Gentlemen Prefer Blondes*); Frances Marion, highly regarded for her Wallace Beery and Marion Davies vehicles; Salka Viertel, Garbo's confidante; and Sonya Levien, a prolific MGM scriptwriter.

First among the female writers whose contributions he valued, until her death from cancer in 1958, was Zoë Akins. She worked for Selznick, too (on 1930s *Sarah and Son*), and kept pace with Cukor at Paramount, RKO, and for many years at MGM.

Some thirteen years older than Cukor, Akins was from Missouri, the child of well-to-do, bedrock Republican parents. She had fallen in love with the touring stage, written her first play at the age of twelve, and produced her initial professional work in New York in April of 1919, roughly simultaneous with Cukor's first road-company tour and assistant stage managership.

Her writing, critics felt, owed something to Elinor Glyn and Saki, with its flowery style, its hint of verse, and its scandalous wit and romance. In her time, she was noted for highly dramatic plays about writers and artists, about show business and British upper-class society, and about women ahead of their time. Among the latter are *Declassée*, starring Ethel Barrymore, and a string of hits during the heyday of Cukor's theatergoing, the 1920s, including *Daddy's Gone A-*

Hunting, The Varying Shore, The Moon-Flower, The Furies, and *The Greeks Had a World for Them.* Akins capped her playwrighting reputation in 1935 with a dramatization of *The Old Maid,* from the Edith Wharton novella, which won the Pulitzer Prize for drama.

By 1929, however, Akins was living mainly in California in the interest of her health, and shuttling between studios on motion picture jobs. Homely, "kind of an erratic fat lady," in MGM story editor Sam Marx's words, she was made fun of in some Hollywood circles. Even more of an unregenerate Anglophile than Cukor, Akins lived snobbishly in Pasadena in a mansion staffed with liveried servants. She spoke with a decidedly ersatz British accent.

In motion pictures, she toiled primarily for actress Ruth Chatterton and director Dorothy Arzner, one of the few female directors of the era. At RKO, Akins had credits on two early Katharine Hepburn films, *Morning Glory* (based on her play, which was said to be inspired by Tallulah Bankhead) and *Christopher Strong* (about a spitfire British aviatrix). She was important to Cukor's career, with a story contribution to *Girls About Town,* script work on *Camille, Zaza,* and, though no director is credited, *Desire Me.* Often, without credit, she consulted with Cukor on the scripts of his films.

She could be a nuisance, calling him up on the phone and reading an entire new play to him. (Although the director didn't really mind: He was addicted to the phone, and decades before it was trendy he had hookups in his bathroom, bedroom, and at strategic points around the house. Bill Haines, his phone-obsessed interior decorator, was something of a pioneer in the realm of intercoms.) But when her credits dropped off, Akins remained a regular dinner guest, and Cukor stayed loyal to their friendship, encouraging her ceaseless plans for short stories, novelettes, plays, and screenplays.

Cukor liked to quote Akins: "I submerge myself, as in water, and the writing is automatic."

The editor Edward Dmytryk remembered an incident that occurred on the set of *Zaza.* The actress Claudette Colbert didn't feel comfortable with one of her lines—a short line, ten or twelve words. Cukor telephoned Akins. They had to stop filming and send a limousine out to Pasadena for the scenarist and bring her back to the studio. "She thought about it for a moment, and suggested a new line," recollected Dmytryk. "That was about a two-hour delay. Normally, a motion picture director would have done that [himself] in about ten minutes."

Cukor's script dependency, in general, was almost palpable. On the set, he would clutch the pages of a script so tightly, or stick them in his pants, that they would become crumpled and have to be replaced constantly. He was even known to chew on them in his agitation. He had no impulse in such situations to contribute modifications

90

to the sacred text. Even for trivial scenes, he needed people like Zoë Akins, and to feel that bond with a writer.

"He [Cukor] never liked to play around with the dialogue," added Dmytryk. "It was probably his theatrical training—because in the theater you can't change anything without a writer's consent. But there was an insecurity about it, too. There must have been, there always is—otherwise he would have just done it himself."

If Akins was a kind of vaguely old-fashioned writer, Cukor's other principal resource of this period was an exceedingly up-to-date, funny, and sophisticated fellow by the name of Donald Ogden Stewart, the other, really more significant "DOS" in Cukor's career.

Stewart was, in Hollywood, the voice of playwright Philip Barry, one of the outstanding talents of the American theater, who wrote plays about the born-rich that were acclaimed for their razor-sharp dialogue and keenly observed situations, often family folly tinged with sadness.

Close personal friends, Stewart and Barry had attended Yale together and were part of the same social set. They shared the same drawl, the same Eastern Seaboard accent. They wore the same kind of clothing and drank the same kind of cocktails. "They understood each other," in the words of Donald Stewart, Donald Ogden Stewart's son.

With this crucial difference: Stewart was from a humbler background than Barry, who was at least one generation further entrenched in the American upper class. Stewart had had to work his way through Exeter and Yale after his father died, and for a long time he was dependent on the largess of his sister's husband. His acceptance into Yale's privileged club, Skull and Bones, brought him into well-to-do society, but Stewart never forgot that he was not to the manor born.

"My father did learn about how the American upper class moved, spoke, dressed, drank, smoked, enjoyed themselves—even dreamed—through his terribly successful career at Yale," said Donald Stewart. "He became one of them. But he always remembered how nice he had to be to people he saw through pretty easily."

There was also this difference: Stewart, in person, was more of an entertainer. At home, in the theater, in a restaurant or bar—wherever he was—Stewart was known for his quips and repartee, while Barry was more shy and straightforward. Stewart was likely to have too much to drink at a party, and, glassy-eyed, stand on a center table and spout a hilarious toast poking fun at pretension.

One would have taken Stewart for a schoolteacher—lanky, almost fragile; even his spectacles were unobtrusive. He was one of the be-

loved personalities of his era, universally admired, as thoroughly congenial and humorous in person as one of his scripts.

Originally, Barry wrote the part of Nick Potter in *Holiday* for Stewart, who took time off from writing humorous essays and parodic novels to play that role on Broadway in 1928 (Katharine Hepburn was an understudy in that original cast). When Barry's plays began to be filmed in Hollywood, Stewart, as his friend as well as his adapter, had the playwright's utter trust.

What's more, and what always mattered, is that Stewart was also compatible with Cukor; they spent much of their time together laughing at each other's jokes. Being from similar middle-class backgrounds, being similarly self-made, they had the same perspective on the high society they aspired to and kindly mocked.

If anything, Stewart was more the keen arbiter of that world—the world of the Paysons and the Whitneys, to which Stewart thoroughly belonged. When, for example, Cukor asked Philip Barry for some advice on the appearance of the Lord mansion for the film of *The Philadelphia Story*, Barry simply advised the director to consult Stewart, who often enough had been a guest at many of the famous upper-crust residences that MGM was considering as models. Just ask Don, Barry wired Cukor, what it's like inside the Montgomery house in Villanova, the Bigger Mouse Hole in Manhasset, or the Plunkett Stewart residence in Unionville. "He will know. . . ."

Stewart met Cukor at Paramount's studio in Astoria, Long Island, in 1930. Both were doing films with Fredric March. Cukor was directing *The Royal Family of Broadway*, while Stewart was finishing his first motion-picture scenario, *Laughter*. Producer Walter Wanger got the idea of introducing Tallulah Bankhead to movie audiences, and brought Stewart and Cukor together with the idea of doing an "original" for Bankhead, which in short order became *Tarnished Lady*.

"He [Cukor] was considered by my father an unusually perceptive and prepared director," said Donald Stewart. "I think part of this respect came from a complex appreciation of Cukor's homosexuality, of the fact of his being a Jew, and of his success—to have Cukor directing your script was emblematic of your importance, like having Vuitton luggage or that table at Ciro's."

In Hollywood, after the "original" of *Tarnished Lady*, Stewart specialized more in adaptations of other people's material—especially the Philip Barry plays. Stewart was always generous about other writers and self-effacing about his own touches. His talent was so reliable, his company so pleasurable, that he was the "rescue writer" of choice for many people—including David O. Selznick.

In all, before the political climate in Hollywood broke up their "partnership," Cukor and Stewart worked together on seven notewor-

thy films—*Tarnished Lady, Dinner at Eight, Holiday, The Philadelphia Story, A Woman's Face, Keeper of the Flame,* and *Edward, My Son.* Like Akins this other "DOS" was there on other Cukor pictures, too, polishing without credit.

"Many directors had favorite authors who they kept in close contact with personally," noted Sam Marx, "and who they brought in on pictures.

"Between Zoë [Akins], in a stolid kind of way, and compared to Donald Ogden Stewart, who was a very lively and outgoing man, George had two of the top-grade authors [at his beck and call]. Zoë had more of a dramatic quality and Don had a sense of humor that covered everything they wrote. Between them they were to give a kind of flavor to George's films."

Two other Constance Bennett vehicles, directed by Cukor and produced by RKO in quick succession in late 1932, did not measure up to *What Price Hollywood?*

The first, *Rockabye*, was the better of the two. Actually, it was the first of many rescue jobs in Cukor's career, for a version that had been filmed by another director, with Phillips Holmes in the male lead, was dreadful and had to be scrapped entirely. Joel McCrea was put opposite Constance Bennett, and Cukor was brought in to direct again the whole megillah.

The story was a heart-tugging romance about a Broadway headliner who is denied adoption papers because of her underworld ties. Her salvation appears to lie in a love affair with an earnest, budding playwright, until it is revealed that he has been married all along.

The star-crossed leads were good, and there is some earnest emotional interplay (and some unusually rough physical passion, in the kitchen!) between them. Yet as well done as the film is, everything smacks of contrivance. And this director found it difficult to weep for a female character who sacrifices her happiness for a man. Cukor could usually express more conviction the other way around.

A Somerset Maugham farce about a free-spirited American social climber who marries British nobility might seem to be an ideal Cukor subject. However, *Our Betters*, the only Maugham play that Cukor ever filmed—it had been Ina Claire's showcase on Broadway—came off as distinctly cold and brittle. It may be that the director was beyond believing in such outdated, politely scandalous comedy.

This was still stage-bound Cukor, with the actors playing to the camera, not vice versa. The presentation was slick, pseudo-English, and Constance Bennett (who knew the international jet set well, having married into it in the 1920s) gave a mannered performance. Her real-life second husband, Gilbert Roland, did duty as her costar.

Yet these Cukor films were well received at the time, and played a part in his mounting reputation. After seeing *Our Betters*, fellow director King Vidor wrote the director a complimentary note: "As for myself, I would never have tackled a subject with so little locomotion but you have a faculty of keeping it interesting in spite of this obstacle. I feel that the picture is on the border edge of being static but you get away with it beautifully."

Selznick was still in the midst of preproduction for his film of Louisa May Alcott's *Little Women* when, at Christmas in 1932, it was widely reported that Irving Thalberg, his counterpart at MGM, had suffered a heart attack. Louis B. Mayer, to some extent Thalberg's rival in the MGM bureaucracy, prevailed upon his son-in-law to leave RKO and come to MGM. Selznick was torn, but he went to MGM in early 1933, setting up an autonomous production unit. Shortly thereafter, he was able to make an offer to Cukor to follow him to the studio and direct *Dinner at Eight*.

MGM was the pinnacle of the Hollywood system—a studio with peerless camera, editing, sound, scoring, costume, sets and design departments. Working there appealed to Cukor's snobbery, and he authorized Myron Selznick to negotiate his immediate departure from RKO.

With the civility that existed between studios in those days, RKO agreed to release Cukor if he would return to the studio for the filming of *Little Women*—after completing *Dinner at Eight*—and direct one additional RKO film, later on, at everyone's scheduling convenience. In exchange, MGM would arrange a loan-out to RKO of Lionel Barrymore; again and again, the Barrymore family played quite the pivotal role in Cukor's early stage and screen career.

Cukor's contract negotiations with MGM raised some concerns. One consideration was MGM's standard "moral turpitude" clause, which the studio inserted into the contracts of its employees. The straitlaced and Republican Mayer regarded himself as a protector of traditional American values, so any MGM "family member" could be dismissed if they committed any act adjudged by the front office to "shock, insult, or offend the community, or ridicule public morals or decency, or prejudice the producer, or the motion picture industry in general. . . ."

This clause was challenged by the director's lawyers, who knew that Cukor was vulnerable to attack because of his homosexuality. Indeed, the "moral turpitude" clause was challenged every time Cukor's contract came up for renewal through the 1940s. But MGM never yielded much on the wording.

Yet the advantages of the MGM contract outweighed any qualms.

Cukor's two-year pact boosted him to $1,750 per week, making him one of the highest-paid contract directors in the motion-picture industry. Curiously, according to the contract, Cukor was expected to complete at least six photoplays in two years, with bonuses (thirty thousand dollars plus) written in for the seventh and eighth completed pictures!

That was typically wishful MGM thinking. Perhaps the speedster of the MGM lot, W. S. Van Dyke, dubbed "One-Take Woody" for his picture-making velocity, could manage five directing assignments in 1934, and an astounding thirty-four over the span of the decade. This was not the case with Cukor—whose method and standards were different, and who could barely maintain a one-per-year average during his long off-and-on tenure at MGM.

Even so, this initial MGM contract may have been the beginning of an institutionalized feeling that Cukor—under Selznick's wing first, then Thalberg's—was something of a luxury for the studio.

By early February 1933, Cukor was ensconced at MGM, working on the film of George S. Kaufman and Edna Ferber's play *Dinner at Eight,* about the intermingled lives of a group of status-conscious dinner guests. The screen adaptation was by Herman J. Mankiewicz and Frances Marion, with additional dialogue by Donald Ogden Stewart.

Selznick had already lined up the actors. Marie Dressler was to play the aging Broadway courtesan. John Barrymore would play the ham actor on the final downward spiral of his career. The nouveau capitalist, Wallace Beery. Jean Harlow, the ex-hat-check girl who is his unfaithful mistress. Lionel Barrymore would act the shipping magnate whose financial empire and personal health are failing. Madge Evans, his daughter, unwisely in love with the broken-down actor. Lee Tracy, a glib show-business agent. And as the flighty hostess whose dinner party triggers the story, Billie Burke.

Screenwriter Mankiewicz kidded Cukor about the casting. "What a challenge!" "Mank" told the director. "I can't imagine how you will ever get Jean Harlow to play a tart. And I sympathize with you, trying to take the edge off Wallace Beery's sophistication. Although nothing can compare with your problem in getting Jack Barrymore to understand the part of a fading matinee idol. . . ."

There was only one weak performance in the batch, from Madge Evans—Cukor could have little tolerance for such a sincerely mistaken female—while from several of the other MGM stars Cukor extracted career high-water performances. The smooth handling of John Barrymore, in particular, continued to be part of the director's mystique.

Barrymore, who could be intransigent with other directors, was again cooperative and good-natured with Cukor, his sister's staunch

friend. They had a kind of winking conspiracy between them. One day, George Bernard Shaw was at the studio, and planning to visit the set. Barrymore sidled up to Cukor and suggested, "Why don't we dumb it up? Then you come in and correct us and you'll look good. . . ."

The part of the cheap actor was eerily close to a self-portrait, odious like the character of the director in *What Price Hollywood?* yet poignant. Barrymore told Cukor he was playing him as a combination of his father-in-law (Broadway matinee idol Maurice Costello), his brother-in-law (Lowell Sherman, married to Helene Costello, sister of one of Barrymore's wives), and himself. Barrymore's bleak study of a drink-doomed Lothario anchored the film somberly.

The film was certainly atypical for Selznick, probably a property already under MGM ownership. Nothing in his career rivals its topical punch. For the director, too—though many critics consider it quintessentially Cukor—it was unusually "relevant." The director expressed scant fondness for the handsomely mounted film in later years, though ironically, *Dinner at Eight* would rank among his most revived and most familiar titles on television and in theaters.

For one thing, the director faulted Marie Dressler's casting (as one of the stagestruck himself, he said he could not believe that she was ever a young theater beauty besieged by beaux); and he often criticized the superficiality of the play. Cukor felt there was no truth to the characters, unlike *The Philadelphia Story*, for example, and that playwright Kaufman was "quite an astringent writer, not very profound. . . ."

No doubt, Cukor was offended by the very thing that sets *Dinner at Eight* apart from other social satires of its era: its uncompromising bitterness. There was very little sweetness or uplift in this caustic comedy. All the people have crumbling fortunes or facades. The dissolute actor commits a bumbling suicide (Cukor films abound in the honorable demise). His mistress plans to save face after his death by marrying someone she doesn't really love. The rest of the characters are vain, crass, fraudulent, or scatterbrained. The only dinner guest with an honorable vita has a weakened heart and is dying by degrees.

All these blemishes of the privileged class are seen, subtly, against the backdrop of the more widespread and genuine misery of the Depression downtrodden. Cukor was too envious of the wealthy to feel comfortable complaining so stridently of their vapidity and smugness.

In his other films, Cukor tended to mute any criticism of the rich. In *On Cukor*, Gavin Lambert mentioned to Cukor that in *The Philadelphia Story*, "more openly than *Holiday*," playwright Philip Barry seemed to think the rich were "the most marvelous people on earth."

Cukor responded with amusement. "Maybe so do I. Let's face it—don't you?"

Likewise, the director once admitted he was embarrassed by the scene in *The Philadelphia Story*, where George Kittridge, the would-be groom played by John Howard, declares, ". . . you and your whole rotten class . . . you're on your way out . . . the lot of you . . . and good riddance!" If there is any weak link in that almost perfect film, it is that that character, and the ineffectual way he is presented, makes for such a dummy target.

So *Dinner at Eight* may not have been a particularly personal project for Cukor—nor profound nor compassionate. But what a hilarious movie! At least it is as hilarious as any that Cukor ever directed. Especially considering that it is all dialogue and repartee, *Dinner at Eight* fairly rockets across the screen, even by today's standards fast and furious.

During filming, Cukor had asked his editor "to drive him crazy by insisting that every scene was too slow while he was actually shooting it." But the breakneck pacing of *Dinner at Eight* might also be attributed to the whirlwind production calendar. Because photography was already scheduled to begin by the time Cukor had arrived at the studio, ironically *Dinner at Eight* was to be the director's only "quickie" ever under MGM contract, begun and finished in twenty-eight days.

Little Women, the Louisa May Alcott adaptation, with Katharine Hepburn as Jo, the tomboy who yearns to be a writer, began filming at RKO in July of 1933.

The younger sister of Constance Bennett, Joan Bennett was a good friend of Lilyan Tashman's, and Cukor was being thrown into her company constantly. One night, at a party, Cukor noticed that when she got slightly "tight," she became unexpectedly "sweet and funny." He championed her to Selznick, and Bennett got the part of Amy. The bady-faced actress, stuck in her career in between studio contracts, was considered adventurous casting, according to the director.

The rest of the cast included Jean Parker (Beth), Frances Dee (Meg), Spring Byington (Marmee), Douglass Montgomery (Laurie), Paul Lukas (Fritz Bhaer), and Edna May Oliver (Aunt March).

In later years, Cukor admitted he hadn't read the book before the filming (he thought it was probably too sticky-sweet). Hepburn liked to kid him that he probably never did read it (and he confessed she was probably right).

There had been at least half a dozen versions of the script before Victor Heerman and Sarah Y. Mason, married show-business veterans, were brought on the film to structure the awkwardly episodic novel. The Heermans labored over several additional drafts and were

present on the set, banging on typewriters and delivering pages to a fretting Cukor. The husband and wife scenarists earned the writing Oscar that year for their streamlined adaptation of a literary classic.

One of the film's virtues is its shimmering pictorial design. Cukor had long been fascinated by elements of decor. Stella Bloch recalled discussing George Hoyningen-Huene's fashion photographs with him, back when they first appeared in *Vogue,* in the early 1920s. Up in Rochester, Cukor was friendly with Claude Bragdon, the Rochester architect who did some work for the Cukor-Kondolf Stock Company and later became a stage designer for Walter Hampden. The director stayed in touch with James Reynolds, and avidly followed the career of stage designer Robert Edmond Jones, who often worked with Arthur Hopkins.

The *Little Women* set designer was a close friend, Hobe Erwin, half of Jones and Erwin, a leading interior decorating concern of the era located on Fifth-seventh Street in New York City. A quiet man with violet eyes and long lashes, very kindhearted, Erwin was not a studio regular, not part of the old and established court, since he kept up his business in New York. In that sense, he was the first in a long line of Cukor art directors who operated more as an extension of the director than as part of the industry. This—employing an outsider for a key purpose—was one of the small ways in which Cukor declared his independence from Hollywood, at the same time that he was one of Hollywood's most loyal creatures.

Indeed, according to Gene Allen, Cukor's longtime aide-de-camp, the director's method of going outside Hollywood channels for his pictorial consultants was a stubbornness that sometimes put him at odds unnecessarily with studio department heads. Often the studio people, bound to be offended by Cukor's preference for an outsider, were in reality just as good.

Beginning with Hobe Erwin, Cukor's set designers were to function as much more than just that. It was they who would orchestrate the visual design—freeing Cukor to deal with the actors. Just as it became part of Cukor's mystique—though it was not so unusual among directors—that he rarely looked through a lens, so it was that the art director, with Cukor's blessing, often laid out the camera setups.

At some expense to RKO, Erwin was sent up to the Alcott house in Concord, Massachusetts, for research. (The exteriors were filmed on the Civil War sets at the RKO ranch.) The gamble on Erwin paid off: His exquisite taste and passion for the mid-Victorian made for the first Cukor film where the design was significant, and whose meticulous beauty was quite unlike any the director had done before.

According to all reminiscences, *Little Women* was one of Cukor's happiest experiences. Cast and crew picnicked during filming. Every-

one was certain of the value and quality of what they were doing.

It was a carefree atmosphere, in part because Selznick was gone from their midst—his fussiness could be nerve-wracking. Ultimately, the producing responsibility was shared more by Cukor, Merian Cooper, and Kenneth MacGowan (who worked easily with Cukor, having produced his play *Young Love* on Broadway). Even Selznick conceded, in a memo of the time, that under the circumstances of the film's success he was "embarrassed by the inclusion in the pictures I produced of the title *Little Women*."

To general surprise, the film proved a box-office sensation when it opened at the newly built and cavernous Radio City Music Hall in New York City, and at hundreds of lesser moviehouses across the country. Critical notices were laudatory. The Academy of Motion Picture Arts and Sciences nominated Cukor for the first time as Best Director.

It remains one of Cukor's enduring films, popular among revival audiences today—albeit a period gem, a marriage of the period of the book and that period of Hollywood. As good as the film is, it does seem (as Cukor suspected of the novel) saccharine, lacking the shrewdly adult sensibility of Cukor's later films.

How the director wanted to believe in its precious nostalgia! Hepburn was his window onto Louisa May Alcott's world, and it is interesting how the ensemble recedes as the story progresses, and the camera shifts intensely to Jo. Cukor demonstrated a powerful identification with girlhood, with the perfect mother who is Marmee, and, most of all, with the aspiring artist who is Jo, the latter breathed into life by his ideal actress. Other directors might have done a fine job with *Little Women*, but here were story elements that showed Cukor's own wonderfully complicated psychology.

Cukor lost the Best Director Oscar to Frank Lloyd for the less-well-remembered *Cavalcade*. Yet with *Dinner at Eight* and *Little Women* released in the same year, Cukor vaulted into the front ranks of screen directors, and embarked on his first great run of films.

While Cukor was making this heartwarming film—unusual in his canon—about a close-knit family, he was gathering his own family around him.

Already by 1933, Cukor was supporting his sister, Elsie, in a house he had bought for her in Hollywood. Elsie constantly borrowed and overspent, and her daughter Evelyn, who suffered from spastic paralysis, had to be under the constant care of nursing professionals. (Cukor had taken care of his sister's expenses since 1926, the year after he directed his first Broadway play and the time from which he dated his success. It occurred to him once, many, many years later, that she had never thanked him.)

His parents had left New York and moved to Los Angeles to be near their prosperous son, and though they had some savings, he had bought them a house and now he was taking care of them financially, too.

Helen Cukor was his Marmee, and meant more than anything to him. Coming out of the premiere of *Dinner at Eight*, it occurred to the director as he gazed at his mother that she had grown older, even matronly, while he had not been paying attention.

Helen and Victor were at Cukor's house many Sundays, often in the company of aunts Bertha and Rose, and Uncle Morris, too, when he was visiting California. Briefly, at such times, they recreated the family togetherness of Cukor's boyhood.

The family mixed freely with old friends of Cukor's from boyhood and New York, with the prominent people who came to lunch and dinner, and with the director's circle of homosexual friends.

The MGM version of Charles Dickens's *David Copperfield*, next on Selznick's agenda in 1934, was the antithesis of *Little Women*—a vast social landscape with a tenderhearted boy at its core; a story as much exterior as interior; as British as *Little Women* was Yankee; dramatic, yet throbbing with comedy and sentiment.

Yet there was a similarity to *Little Women;* Selznick had both on his list of classic novels that interested him as possible motion pictures. (The producer's predilection for adolescent classics prompted Ben Hecht to quip once that Selznick probably hadn't read anything after the age of seventeen.) Dickens's autobiographical masterpiece, the author's own favorite story, had a personal relevance for Selznick. As a boy, then a Russian immigrant living in Great Britain, his father, Lewis J. Selznick, had read the book repeatedly in order to learn English. In time, it had become one of his son's favorite books, too.

Nagged by Selznick, MGM was persuaded to bankroll the production—as expensive and drawn out as *Dinner at Eight* was dashed off—because of its inherent appeal to the British market.

Foreshadowing *Gone With the Wind*, the script went through numerous unacceptable drafts, while Selznick and Cukor busied themselves in a publicized quest for the perfect boy actor to impersonate young Master Copperfield. Naturally, they had to go to England to endeavor to find the right Copperfield, just as later on Cukor had to roam Atlanta and the Deep South on his producer's behalf, scouting up possible Scarlett O'Haras.

Since youth, Cukor had been hankering to go to England, which was his idea of a civilized country. This would be his first trip outside the United States. In time, he would become the most widely traveled of all Hollywood directors.

Traveling overseas opened up a new chapter in Cukor's life, per-

sonally as well as professionally. He loved to *see* the actual places where his films were imaginarily set. Never mind that everything learned might be discarded in the filming, Cukor loved these experiential crash courses; for him, it meant observing customs and soaking up atmosphere, excursions into history and geography, new pleasures and new friends, in general a broadening of horizons. Ideally, location preproduction was a practical preparation for filming. But for Cukor, it was also a valuable psychological workup.

For a month, Cukor toured England with the Selznicks ("DOS" and his wife) and scenarist Howard Estabrook. Visiting the historical sites encouraged the impulse toward authenticity: the Cedric Gibbons sets that reproduced mid-Victorian London, and the costumes and details that evoked Phiz or Cruikshank illustrations.

"The slightest things gave me ideas," Cukor declared about his trip to England in a newspaper interview at the time.

They did not discover their boy Copperfield. The sensitive, curly-haired Freddie Bartholomew, age ten, a veteran of the British stage from the age of three, was visiting Hollywood with his aunt when he was ushered into Cukor's presence.

More important, from the director's point of view, in England he made the acquaintance of Hugh Walpole, the tall, impressive poet and novelist who was president of the Dickens Society. Walpole was a friend of Somerset Maugham, although he had been cruelly caricatured by the writer in his portrait of the sycophant Alroy Kear in the novel *Cakes and Ale*.

Walpole struck up a rapport with Cukor and was invited back to Hollywood to police the Dickensian dialogue and to carry a cameo as the Vicar in the film. As the writing progressed in Hollywood, Estabrook was bypassed; the writer more friendly to Cukor, Walpole, submitted the satisfactory final draft of the screenplay.

Apart from Bartholomew, the top-flight MGM cast included Lionel Barrymore (as Dan Peggotty), Maureen O'Sullivan (Dora), Madge Evans (Agnes), Edna May Oliver (Aunt Betsy Trotwood), Lewis Stone (Mr. Wickfield), Elizabeth Allan (Mrs. Copperfield), Roland Young (Uriah Heep), Basil Rathbone (Mr. Murdstone), Elsa Lanchester (Clickett), Jessie Ralph (Nurse Peggotty), John Buckler (Ham), Florine McKinney (Little Emily), Hugh Williams (Steerforth), and Frank Lawton (David Copperfield as a man).

Charles Laughton was originally supposed to play the part of the eccentric Mr. Micawber, but after early photography, that highly regarded actor decided he did not feel comfortable in Dickensian surroundings. So Laughton was relieved of the part, and W. C. Fields was rushed into the role, a rare out-of-character (serious) acting job for the bulbous-nosed comedian.

101

Cukor had little need to offer pointers to the stage revue veteran (not that Fields would have listened even if he had). Fields had the vagarious Micawber spirit, and in his scenes he improvised wantonly. In the midst of one hemming and hawing soliloquy, the comedian dipped his quill pen into his tea and stuck his foot into a wastebasket. The director—as if he was back watching the two-a-day performers at the Palace—was delighted.

"George would let the camera roll whenever he [Fields] started saying something that wasn't in the script," recalled Michael Pearman, Cukor's personal assistant on *David Copperfield* and several other films. "He [Fields] was such a character—he would start to juggle fruit on the table. George thought it was all terribly funny."

Fields's highly idiosyncratic performance—true to life but with theatrical embellishments—set the tone for the rest of the ensemble. *David Copperfield* was certainly an acting feast, bursting with vignettes and memorable moments of character flourish.

The completed film was rather shamelessly overlong for its day, at 132 minutes. After previews with mixed audience reaction, some studio executives wanted to snip away at the film, or to release it in two parts. Selznick was defiant, insisting on its length.

Selznick was right. There is nothing ponderous about his and Cukor's version of *David Copperfield;* like *Dinner at Eight*, it seems to hurtle across the screen, to be as visually cinematic as the other was stubbornly talky. Selznick used montage expert Slavko Vorkapitch for the special effects, including the stormy shipwreck that dooms Steerforth. Vorkapitch had also executed the slow-motion suicide montage of Max Carey in *What Price Hollywood?* These were dynamic touches that were an example of the producer's embroidery. Their ilk would not be seen in a Cukor film again until the late 1940s, when the Kanins urged him down similarly adventurous "cinematic" roads.

Cukor always said that if the first half of the film was better than the second half, that was because the first half of the book was better than the second. That is also because the first half of *David Copperfield* was more anguishingly focused by Cukor's feeling for the luckless Copperfield—a boy he could identify with, an innocent wrested tragically from his mother's love.

David Copperfield was nominated for an Oscar as Best Picture of 1934, but lost to *Mutiny on the Bounty*. It remains, however, the most sublime Hollywood adaptation of Dickens. The highpoint of the Selznick-Cukor alliance, the film evidenced how perfectly the overcompensating producer and his favorite director were partnered on such an ambitious undertaking. Incredibly, too, the high point of *David Copperfield* was to be their last fulfilled collaboration.

* * *

Despite the warm publicity and the photographs of the two of them embracing at movie premieres, Cukor's relationship with Selznick was hedged by his feeling that Selznick was egotistical and self-destructive—and his belief that Selznick needed him more than he would ever need the producer.

"Cukor was another of David O. Selznick's avenues to literacy and class," commented Joseph L. Mankiewicz. "George could talk about 'the drama.' George could talk about the plays David Selznick used to make believe he read.

"But George, I think, played David. George saw through David almost immediately. When [later on] he was let go from *Gone With the Wind*, I think George quite expected that. I don't think David fooled George very much. George could act as though he were fooled. But George played those studios beautifully, and he gave them their money's worth."

Selznick's presence at MGM, it had been rumored, was a cog in Louis B. Mayer's plotting to undermine Irving Thalberg, the intuitive force behind the best of the studio's films. Selznick unabashedly admired Thalberg, however, and he did his best to float free of studio intrigues. And Thalberg's precarious medical condition took the edge off a rivalry that never materialized in such a way as to benefit Mayer.

When, in 1936, Selznick announced that he was going to leave MGM and set up a new independent production company, Selznick International Pictures, it was expected that his friend and director, Cukor, whose contract was up for renewal, would join him. But Selznick may have been surprised to learn instead that the director was tempted to stay at MGM and work under the stewardship of Thalberg.

For Cukor as for F. Scott Fitzgerald, who depicted Thalberg as the character Monroe Stahr in his unfinished Hollywood novel *The Last Tycoon*, Thalberg was "a prince, a hero . . . a marker in the industry like Edison and Lumière and Griffith and Chaplin." As supervisor of such "distinguished" (that favorite Cukor word) MGM films as *The Big Parade, Ben-Hur, Flesh and the Devil, The Crowd, Anna Christie, Freaks*, and *The Merry Widow*, Thalberg seemed to embody the "Ars Gratia Artis" motto that was emblazoned on the company logo.

Moreover, on a personal level, Cukor found Thalberg spellbinding—physically frail, mentally tough. Basically uneducated, but with elevated instincts. Thalberg was a shrewd, demanding perfectionist, yet he gave his directors a great deal of creative leeway. He seemed never to intrude himself, his ego or his power. He seemed a man of lonely dignity.

All of a sudden, Cukor introduced a charade that was to work for him throughout his Hollywood career. When he wanted to play hard to get,

he got very picky. He began to turn down all of Selznick's projects.

The producer could have inveigled Garbo or Tallulah Bankhead to star in *Dark Victory,* except that Cukor seemed lukewarm about the idea. Then Selznick had the idea of Cukor directing the three Barrymores in an adaptation of John Galsworthy's *The Forsyte Saga.* True, there was staunch opposition in the MGM executive ranks, where there was still raw memory of the only other production to star the three Barrymores, *Rasputin and the Empress,* which was rife with troubles. But Cukor chose not to be persuasive with the clan. Try as he might, Selznick could not find a property that boasted Cukor's wholehearted endorsement.

Meanwhile, in the weekly MGM story meetings at which Thalberg presided, the director's name kept coming up. Thalberg usually had a specific director in mind before he even purchased a story. "George had a reputation for high-class direction," recalled Sam Marx, who was in on those conferences (directors were never, *ever* present). "You would think of [Woody] Van Dyke if you were going to do *Eskimo* or *Trader Horn.* You would think of George if it was a high-quality story. In between you had a marvelous staff of directors who did not care what they were assigned."

One of the high-quality stories that Thalberg had in mind was a motion-picture version of William Shakespeare's *Romeo and Juliet,* to star Thalberg's wife, actress Norma Shearer, publicized by MGM as the "First Lady of the Screen." To guide Shearer in the storied role of Juliet, and to shield her against the inevitable brickbats of critics, Thalberg needed someone quite unlike "One-Take Woody" or any of the other rough-and-ready contract directors. He needed someone for whom he had a growing appreciation and liking. He needed the gentleman director: Cukor.

While Selznick was busy inaugurating Selznick International Pictures, Thalberg was busy wooing Cukor. The rivalry over Cukor grew to the extent that in the summer of 1935 the director became the object of an unusual negotiating war between MGM and Selznick's newly constituted company. Perforce, Cukor had to choose between Thalberg and Selznick. Contract files reveal that Cukor leaned in favor of not his supposed good friend but Thalberg, the "boy wonder" of motion pictures.

Cukor's agent, Selznick's brother Myron, hit on a unique solution: Cukor signed with Selznick International Pictures in August, becoming the first employee of the new organization, and its only contract director. According to the deal, Cukor was to receive a munificent four thousand dollars a week with option raises.

Simultaneously, however, Cukor signed a new, improved contract with MGM. His MGM salary, too, made the jump from $1,750 to

$4,000 weekly, with built-in hikes for overlong schedules, up to $5,000 weekly after the eleventh week of a protracted production. According to his MGM agreement, Cukor had to deliver at least one picture a year to Thalberg, an arrangement that would take precedent over any Selznick obligations.

An extraordinary clause was inserted into Cukor's MGM pact: "Services to be assigned by and rendered under supervision of [Irving] Thalberg. If Thalberg incapacitated or severs relations with us, we advise Cukor in writing promptly and on condition Cukor advises us within 30 days after Thalberg incapacitated or severs relations, he may cancel agreement, except such cancellation [sic] not to become effective until completion of services in connection with photoplay under production at such time."

Preoccupied as he was with launching his new enterprise, Selznick did not seem to mind the compromise. Now, in effect, Cukor had not one but two directing guarantees with financial terms as good as any director in the industry.

First, Cukor owed a picture to RKO: *Sylvia Scarlett*.

Then—as 1935 stretched into 1936—the director went to work for Irving Thalberg on two of MGM's most prestigious productions.

Though he was regarded as the studio's most "cultural" director, in fact Cukor had no experience with, or special claim on, Shakespearean literature. If he was going to direct Shakespeare, probably something such as the acid-etched *Taming of the Shrew*, a battle royal of the sexes, would have better piqued his sensibility.

From the outset, MGM's production of *Romeo and Juliet* was burdened with its own significance. With "important" casting, unusual expenditure, and a studied approach to the time-honored text, the studio aimed to impress audiences and critics with its artistry. Not only did Thalberg camp out on the set, but script conferences were overseen by a Harvard professor—Elizabethan theater authority John Tucker Murray—and rehearsal and filming monitored by Cornell scholar William Strunk, who apart from being a Shakespearean authority was the author of a definitive book about principles of literary editing. (Cukor liked to quote Strunk's favorite axiom "Less is more" as a philosophy that would improve some never-ending film scenes.)

At first, Thalberg had had half a notion to shoot the film on location in Italy, but a horrified Louis B. Mayer said no, firmly no. Therefore much of the $1 million plus budget went into the opulent settings erected on the MGM back lot by studio art director Cedric Gibbons, one of Hollywood's design geniuses. Gibbons—who had also done the job on *David Copperfield*—created an imaginative Renaissance Verona that included the Capulet garden, constructed in a massive glass

hothouse, with pools and sculpted shrubbery, and a three-story Romanesque tower.

The ornate period costumery, for a sum total of twelve hundred cast members, according to the publicity department, was jointly attributed to MGM's vaunted costume designer Adrian—Gilbert A. Adrian—and to Oliver Messel, who was brought from Britain, at the director's insistence, to serve the occasion.

Although he had designed clothing and decorated homes for British royalty, and although he was preeminent in London stage circles, Messel was a marked man in the competitive bureaucracy of MGM. Cukor's handpicked outsider was sabotaged by the studio department heads, who claimed that his drawings could not be executed. The unfortunate hostility between Messel and MGM, though Cukor set it in motion, contributed to a tension behind the scenes during filming, and a sense, on the screen, that the design elements had run rampant over the rest of the film.

The producer's wife, playing the teenaged Juliet, was in her midthirties, while MGM's lovestruck Romeo would be played by an actor who was in his early forties. Selznick had urged Cukor to test Douglas Fairbanks, Jr., but Thalberg preferred Leslie Howard, and that was that.

Shakespeare veteran John Barrymore would act the high-spirited Mercutio. The remainder of the cast, drawn from MGM contract reliables, included Basil Rathbone as Tybalt, Edna May Oliver as Juliet's nurse, and the exceedingly unlikely (breath-of-fresh-air) Andy Devine as the servant Peter.

The notable choreographer Agnes de Mille supervised dance scenes that were much ballyhooed and too briefly glimpsed. The veteran scriptwriter Talbot Jennings (Harvard graduate, Yale Drama School postgraduate) abridged, where convenient, the text of the Bard.

Whatever his own instincts might have been, Cukor seemed overwhelmed by the swollen prestige of it all. The sets tended to dwarf the actors, and in any case Cukor was not one to let his camera linger on scenery; he preferred the architecture of the human body. The expensive costumes were flossy and not a little bit ridiculous. The visual decor seemed a garish jumble, most of the "spectacular" stuff cold and stiff.

The acting scenes were much better, the two leads surprisingly plaintive and moving.* The film was borne up not by action or spec-

*Where Cukor's luck ran out, ironically, was with Barrymore. Though he was famous for his inspired interpretations of Shakespeare on the stage in the 1920s, here, as the pivotal Mercutio, Barrymore gave a sour, bombastic performance. By now, the great

tacle but by the simpler moments between the two principals, the soliloquys and love scenes, where, as Thalberg must have calculated, the humanity of the director was ignited.

On the whole, however, *Romeo and Juliet* seemed a noble failure, its effect oddly and dully earnest. It became another Cukor picture nominated for (and losing) the annual Academy Award as Best Picture.

Two pictures to star Greta Garbo were in the advanced planning stages at MGM, and Clarence Brown, her usual director, would be directing only one of them. Thalberg offered Cukor his choice of the two.

One was a remake of Alexander Dumas's *La Dame aux Camélias*, popularly known as *Camille*, and the other was the love story of Marie Walewska and Napoleon.

Perhaps *Camille* was the safer choice—Cukor had a weakness for material with tried-and-true antecedents (as did the studios), not to mention for tragedies involving courtesans and doomed love affairs (as did the studios). The director—as well as Oliver Messel, who was to do the sets—also had a weakness for that nineteenth-century French period, which had been the backdrop for some of his favorite plays of youth.

As it happens, Cukor did not meet the divine Garbo until shortly before his name was brought up as her possible director in Thalberg's story conferences.

The two met in the living room of Salka Viertel's home, a beach house on Mabery Road in Santa Monica. A Polish-born actress of some repute in Europe, Viertel had come to the United States and was in the midst of a thriving career as a Hollywood scriptwriter, mostly of Garbo's films. Viertel was Garbo's closest confidante, without whose counsel, it was said, the aloof, impenetrable star, then at the peak of her international celebrity, did not choose to make a professional commitment.

Viertel's Sunday salons were a respite for Hollywood cultural and literary figures, and for the increasing number of political refugees

profile was in obvious decline, and he was reduced to residing in a private sanitarium near MGM. Cukor insisted, over the years, that Barrymore stayed "absolutely on the wagon" throughout the picture, but the actor was nonetheless difficult to handle, and held up photography with his "gaga" antics. At times, Thalberg had to be summoned to the set to intimidate Barrymore into speaking the lines as written.

Cukor did not give up on Barrymore. The downfall of a great artist always aroused the samaritan in him. Indeed, the director considered Barrymore for a part in *Camille;* and within a year, partly on Cukor's advice, Selznick would cast Barrymore—and fire him—as the lead in the William Wellman version of *A Star Is Born*. By then, Barrymore's lifestyle had taken its toll, and at times the fading star was reduced to reading his dialogue from cue cards.

from Europe—"a kind of pantheon for the gathered artists, musicians and writers," in the words of S. N. Behrman, who often collaborated with Viertel on scripts. The food was superior, the conversation always stimulating.

(Cukor learned from parties, as he learned from everything. No doubt the ambience, the intimacy, and the selectivity of guests became a model for his own parties—although it is hard to picture Brecht, or even Chaplin, as a guest at Cukor's.)

Cukor was there, as were other Hollywood people, to meet and greet the European artist émigrés. Especially with the Hungarian film people, the director was always generous and helpful with introductions.

At first, Cukor did not think much of the Swedish-born actress, who was to become another of his trousered female stars. She seemed to him too dour and lesbian. Nice as she might be, Cukor confided in a letter to Hugh Walpole, her nobly suffering attitude depressed him.

But he warmed up to Garbo. He could see that, beneath the facade, she was high-strung and nervous, her droll patter of conversation and jokes a smoke screen for her insecurity. She needed reassurances, and Cukor could have had REASSURANCES printed on his business cards.

She was perfect to play the gay Parisienne courtesan whose romance with a penniless lover is doomed because of her tuberculosis. Dumas's novel had been a celebrated play (as well as the basis of Verdi's opera *La Traviata*). There had been three films of *Camille*, starring Clara Kimball Young in 1915, Theda Bara in 1917, and Nazimova and Rudolph Valentino in 1921. The trick, in 1930s Hollywood, was to satisfy the censorship qualms while updating the love story for increasingly sophisticated audiences.

The able MGM writers who converged on the script included Carey Wilson, Mordaunt Shairp, Tess Schlesinger, Ernest Vajda, Vicki Baum, and Mercedes de Acosta. The eventually credited threesome included Frances Marion, James Hilton (the British author of *Goodbye, Mr. Chips* and *Lost Horizon*) and the inevitable Zoë Akins.

Akins was summoned by Cukor to write the final draft. The director always credited her knack for argot, and her underplaying of the pathos, for the final satisfying result.*

Cukor's respect and liking for Garbo really began on the set. Although she teemed with ideas, Garbo kept her own counsel and had

*"I regard it as a real honor to have had my name associated with such a beautiful piece of work," wrote the self-effacing Hilton to Cukor after the film was released. ". . . Whoever wrote the script (who was it, by the way?) . . ."

a working method unique to herself. Her rehearsals were sketchy; her real acting was saved for the camera. No one knew precisely what she was going to do when the camera was turned on. She insisted there be no visitors or unnecessary personnel around while she was acting a scene. Cukor was impressed when on one occasion the head of production paid a visit to the set, and she pointedly ignored Irving Thalberg.

Between scenes, Garbo would always sunbathe in a little screened-off place on the back lot. She quit every evening precisely at 5:00 P.M. in order to go home, have dinner, and rest her muse. She never viewed rushes.

She was practically rude to Robert Taylor—the prettily handsome actor playing the vulnerable Armand. She said she wanted to save all her emotion for the character of Armand. If she felt any liking for Robert Taylor off the set, she believed it would drain her performance.

Like a host at one of his dinner parties, Cukor's principal role was to do as little as possible, to establish a relaxed and friendly (yet intensely concentrated) mood on the set. Garbo did the rest. She liked to say that her favorite directors were the ones that left the set after the cameras began to roll.

Indeed, Garbo asked Cukor to get out of sight during one of the sad scenes of *Camille.* The director had a peculiar habit of elaborately mimicking his actors as they played a scene; more than mimicking, carried away, he would act the scene silently along with them, his face changing expression almost violently. She said he distracted her, and his grotesque expressions unnerved her. Cukor, one of Garbo's favorite directors, did just what was asked of him: He got out of sight.

"I asked her why she minded people coming on the set of *Camille,*" the director recalled once. "She said, 'You know I don't think acting is all that wonderful; I am not so proud to be an actress.' She said that when she was acting she had some sort of an ideal picture in her mind—something she was creating—and she never saw the rushes because she was always disappointed in what she saw. But she said while she was acting she could imagine certain things and if she saw people just off the set staring at her, she felt like an ass, like somebody with a lot of paint on her face making faces. It stopped her imagination."

Selznick had produced a stretch of six pictures with Cukor. Now Thalberg was producing his second in a row. Only once again in his career—with Garson Kanin, who was a de facto producer for him—would Cukor work on successive pictures with such harmonious producers.

109

At Metro, the joke went, pictures were not made, they were *re-made*, filmed and refilmed until they had achieved a standard studio gloss. There was always second-guessing of the directors. Cukor was used to retakes—Selznick insisted on a lot of them, too—but unlike Selznick, Thalberg seemed to know more precisely what it was he wanted.

As the filming of *Camille* continued, Cukor's respect for Thalberg grew. He marveled at the producer's insights and ingenuity. In a story conference one day, Akins, Cukor, and Thalberg were discussing the scene where Marguerite (Garbo) and Armand (Taylor) are planning to get married. The producer cautioned him, "They should play this scene as though they were plotting a murder!" Cukor agreed, and that is the way it was filmed—to avoid any excess of sentiment.

When Cukor filmed Marguerite's death scene, Thalberg did not like the way it was done. He persuaded the director and scriptwriter Akins to cut down the scene's length and move it from the bed to the chaise longue. When Cukor filmed it again, Thalberg's way, it made all the difference. Thalberg seemed a fount of such good ideas.

It may be that Thalberg's death at an early age factored sentimentally in Cukor's memory, for in interviews the director always paid particular tribute to the producer he worked so closely with on *Romeo and Juliet* and *Camille*.

Cukor was careful never to disparage Selznick publicly. Certainly Cukor was better friends with Selznick than with Thalberg. However, Cukor would often speak of Thalberg as having "the beginnings of taste," and insist that "in his own way he [Thalberg] was an artist himself." Cukor often praised Selznick as a producer, but especially after what happened on *Gone With the Wind*, he never spoke of Selznick, as he did of Thalberg, as being an artist.

CHAPTER FIVE

\bigcircn the scores of published interviews and the newspaper and magazine articles about Cukor, the first one to take stock of his "woman's director" reputation occurs just as he arrived at MGM. That was MGM's publicity thrust. But Cukor went along with it.

At times, especially in the early 1930s, the "woman's director" advertising was to serve the director well. Other times—when it typecast him, when its meaning was narrow and demeaning—it hurt him, professionally as well as psychologically.

The initial article was in *Screenland*, in April of 1933; interestingly, it was written by Ida Zeitlin, a fan-magazine writer who knew Cukor, having grown up in the same neighborhood as he, Mortimer Offner, Stella Bloch, and Edward Eliscu. Cukor introduced Zeitlin to Katharine Hepburn, Tallulah Bankhead, and Constance Bennett, who were able to expound on the theory that Cukor, better than other Hollywood directors, was able (in Bankhead's words) "to bring out the best in any woman."

There was a progressive flurry of articles on this theme when Cukor settled in at MGM in the mid-1930s. Thalberg, like Selznick, had a maximum opinion of Cukor's creativity, but at the same time he saw the director linked closely with the future of MGM's female stars—Garbo, Joan Crawford, and his own wife, Norma Shearer. The publicity department promoted Cukor accordingly. Sometimes the ar-

ticles were obvious flack concoctions—as with a long syndicated column that went out to fifty newspapers in 1936, declaring that "Cukor likes to direct women. He believes they try harder than men. . . ." Yet Cukor himself was interviewed often, coyly confessing to his specialty.

One article that had the authentic ring of Cukor, one of the most extensive and revealing pieces on the subject, came out in May of 1936, during the filming of *Romeo and Juliet*.

"I suppose it is foolish to admit you like to direct women more than men," Cukor was quoted as saying to Mary Moffitt, a columnist for the Kansas City *Star*. "But I have a fundamental reasoning back of it. I think that nothing is more ridiculous than a pretty man going on the stage just because he is handsome. A man must, in my mind, have great talent before he has any business on the stage or in movies. But a pretty woman should, I believe, be on the stage whether she has any tremendous talent or not. She needs no more excuse than her beauty to have a reason for being before the public. Therefore, having this belief, I can overlook stupidity in a woman with far more ease than in a man."

The rest of the Kansas City *Star* article is worth quoting practically in full. A thousand and one times in his life, Cukor was asked the secret of his skill at directing women, and he had several stock replies, as well as a thousand and one variations. He might literally strike an actress if necessary, he'd say with a gleam, as he did once with Hepburn on the set of *Little Women* (she had spoiled a dress necessary to a scene they were filming). "I feed 'em dope!" he shouted another time at a reporter persistent with the trite question.

Nowhere in the Cukor file, however, is there a more thoughtful or thorough reply than this one, published in 1936, before he had been asked the question so repeatedly:

Lord yes, I've plenty of theories about how to handle temperamental stars. If I think the heroine should say a line casually and my star insists on "emoting" it to the house-tops, I have to do something. It depends on her type what I do. I call the routine my eight acts. Number one is the most universally successful. It is "Flatter her into it." The next most successful is my "lulling technique," then there is the "sane reasoning method," and the "hurt, but not angry." Occasionally it is necessary to use the "Whoever told you you were an actress," but that is apt to bring on a tantrum. The "Belasco flying into a rage" is a standby. So is the "My dear child, you must have confidence in me, I know best."

112

Of course, one of the fundamental reasons why Cukor was so good at directing women was that he was homosexual, a man who "understood" women, a man who in some ways could identify with female feelings and desires. This could not be stated. Yet wasn't that the coded translation of his publicity?

Many people who knew Cukor or worked with the director were blithely unaware of his homosexuality, entirely uninterested in his sexual orientation, while to most others in Hollywood it seemed obvious, a kind of open secret. "George Cukor never disguised his sexuality," said Joseph L. Mankiewicz, producer of *The Philadelphia Story*, "yet he never carried it as a pin on his lapel."

Cukor's sexual orientation was manifest in his lifestyle and personality, but it was also, in the collective psychology of the film colony, linked to his work. The belief was, in producer Pandro Berman's words, that "women were his [Cukor's] specialty, and perhaps because of his lifestyle he didn't seem to have much interest in the male characters." The ability to cope with actresses, the knack with screen stories attuned to women, the attention to costume, hairdos, and decor—according to even the professional people who knew him best, these had their basis in Cukor's homosexuality.

"My father said that coaxing a memorable performance out of an actress was Cukor's specialty," recalled Donald Stewart. "George knew how a woman would react in a particular situation and how to help an actress get that reaction on film. I heard this remark a number of times: 'George was good with women because he was a fairy.' My father explained to his ten-year-old son that 'fairies are trusted by women because they're gentle and they aren't going to jump on them.'"

Other, more macho directors in the film industry seemed to foster an atmosphere of sexual foreplay and antagonism on the set; many were not great authorities on the subject of acting, either. Some of the more sensitive—as well as some of the more hard-boiled—actresses, wary of that combination, warmed to Cukor, relaxing before the camera and cooperating famously during filming.

"The women adored him, simply because they felt at ease," concurred Joseph L. Mankiewicz. "And women by and large did not feel at ease [in that era]. For example, you had directors like Billy Wellman, Victor Fleming, and George Stevens. William Wellman, for example, had a wooden finger made just so he could goose women [on the set]. That would get a big laugh from the gaffers and the crew high up [on the scaffolding]. I think women, in the earlier days, before they became important, had a pretty tense time with the very masculine directors.

"George fulfilled that need. A woman could come on his set and

be absolutely safe. And safe—meaning, a director was going to make no demands on her other than [the movie]. With the other directors, there was always that moment. Is he going to make a pass at me? Is George Stevens going to fall for me? George Stevens had a helluva list of conquests . . . Cukor had a helluva list of friends."

Nothing was too personal or too nitty-gritty for the friendship between Cukor and actresses. In the *Screenland* article, Tallulah Bankhead makes an allusion to his understanding her moodiness during her menstrual cycle, to his not behaving "as if you've contrived the complete female anatomy as a personal affront to him."

Mankiewicz recalled that Cukor made a strategic point of becoming friends with actresses' mothers. Suddenly, ladies who had never baked anything in their lives were bringing cookies to the set.

"George's taste in clothing was better than most of them [the actresses'], too," said Mankiewicz. "They could relax on that score. Fleming wouldn't know an attractive new dress from nothing. George watched things that were important to the actress.

"I don't know if you should quote me on this," Mankiewicz added, "but I mean it kindly. In a way, George Cukor was the first great female director of Hollywood."

The early part of the 1930s was an unusual period in Hollywood history, relatively open and unrestricted in terms of sex on the screen.

Before the curtain of censorship rang down on the movie industry in the mid-1930s, there was a quantum change in the nature of love scenes—the suggestive slang and double entendre, the degree of nudity—as well as the brisk violence that became acceptable in motion pictures. Partly, the new screen excitement reflected the influx of newcomers from the East, as well as the turbulence of swiftly changing technology and times.

To some extent, offscreen life in Hollywood mirrored the onscreen freedoms. Lifestyles seemed more undisguised and public—whether it was drinking or drugs, cohabitation, political radicalism, lesbianism or homosexuality.

Hollywood was a haven for all sorts of artistic people, but for those among them who happened to be homosexual it was a vaguely hospitable oasis in a distinctly antagonistic world. Just as in New York, the California laws were prejudiced against homosexuality, and so were the predominant religions of show-business people (Catholicism and Judaism). The media and the censorship organizations enforced the conventional morality. There were vice sweeps and morals arrests, and there were also, on several occasions, incidents of Los Angeles police officers brought up on charges of blackmailing Hollywood people lured into compromising circumstances.

Homosexuals were still discriminated against off the screen and often stereotyped on the screen. Cukor, too, made harsh sport of prissy homosexuals in films, as he did behind closed doors—in life. There is, for example, a limp-wristed dance instructor, played by Harold Entwistle, in Cukor's film *Our Betters*, who makes for some cheap laughs.

Many film people, however, especially those with theater backgrounds, recognized and accepted homosexuality. There was a continuation of the tradition of show business as an open door for all types of humanity.

And homosexuals could get rich and famous working in movies, just like anyone else. While the sunshine and outdoor culture—the upheaval of talkies and the waves of newcomers from the East—seemed to augur a new era of lifestyle freedoms.

What needs to be understood is that Cukor's standing in this context was unique. There were certain pockets of the movie business where homosexuality thrived; among the creative crafts—sketch and design, decoration and sets, costume and makeup—it was almost ghettoized. However, at the top of everything in Hollywood, in creative authority, stood the director, among whose first rank there was only one homosexual—this "woman's director."

Other homosexual directors, distinctly second rank, were more flamboyant about their sexual orientation: The horror specialist James Whale was "obvious," widely dubbed "The Queen of Hollywood." The versatile Mitchell Leisen, a former costumer turned director, carried on openly for many years with a top cameraman.

Cukor must have felt that he had to protect his stature among the first echelon. He didn't want to be typecast as a director who wasn't virile enough to direct Westerns or tough guys (not that he was eager to direct Westerns or tough guys). He had to beware of malicious gossip that could affect not only what kinds of properties he was offered as a director but which stars he would handle, and how much he would be paid. And of course, from boyhood, Cukor always had been obsessively secretive about himself—determined to blend in, not to be perceived as any kind of "hyphenate"—at the same time that, perversely, he enjoyed throwing out clues.

The secretiveness had to be partly shame. Even among the most enlightened Hollywood people, the liberal opinion of the era—an opinion that to some extent prevails today—held that homosexuality was a kind of psychological deficiency, an abnormal, perhaps "curable" condition. Many Hollywood people of the era went—people still go—to psychiatrists and therapists to "cure" themselves of homosexuality. For even the highest-paid, most reputable, civilized, and charming Hollywood homosexual, as for all homosexuals, there was

always—no matter appearances—the underlying social stigma.

The cruel practical jokes and "anti-faggot" jibes by such "manly" directorial colleagues as Victor Fleming and John Huston were part of whispered industry lore.

Ben Hecht's stated view of Cukor as a film director, for example, was that "he didn't know anything, except one thing. He didn't know anything about stories, he didn't know anything about directing, sets, technique. He had a flair for women acting. He knew how a woman should sit down, dress, smile. He was able to make women seem a little brighter and more sophisticated than they were, and that was about the only talent they had. . . . There are some men who identify themselves with women, and they are so interested in the identification that everything a woman does is more important than what they do, and they are able to express themselves through a woman more than through any other medium." Hecht's spurious assessment crops up in more than one book and documentary about *Gone With the Wind* nowadays, as justification of Cukor's firing; no doubt it was uttered sotto voce in the 1930s.

Heartrending is the story, revealed in an interview for this book, of a young boy at the birthday party of another screenwriter—one who had never worked in any capacity with George Cukor. This boy was one of the many children in Hollywood who claimed the director as a godfather. In the general hubbub of conversation, someone mentioned Cukor. "That faggot!" exclaimed this Oscar-winning screenwriter, who was equally famous as a liberal crusader. The boy was shocked and saddened although it was something—being a "faggot"—he couldn't understand. But he understood the tone. George Cukor was a "faggot." It seemed to be a big secret that everyone in Hollywood knew.

Although the director always claimed to eschew publicity, he was very much the public figure in the Hollywood of the early 1930s—photographed and set down in the columns, while out and about at night in the "café society" that was springing up, often in the company of one of his male friends whose homosexuality was even less of a secret.

Apart from being strikingly handsome, charming, and humorous, his friends were usually well-heeled "confirmed bachelors." Bill Haines was one of the piping voices whose career was abridged when sound was ushered in. Andy Lawler and Tom Douglas had trailed Cukor out to Hollywood. The South African–born James Vincent was a studio dialogue director who had been a stage manager for Katharine Cornell. Rowland Leigh was a clever British writer who had worked with the cabaret performer Rex Evans. John Darrow had

116

been in Hollywood since 1926, trying to improve on small parts.

Haines was the most outrageous personality, and undoubtedly one of the most well-known homosexuals in the screen colony. The breezy silent star was Cukor's introduction to a world that had existed before his arrival—to people like bit actor Louis Mason, who became a good friend, as well as, later on, to the interior decorators, real estate agents, antique and art dealers, and architects who would augment the director's new circle of friends after the 1940s.

A rugged, domineering man, Haines had a personality that blazed with mischief and confidence. Everyone liked him so much that after Haines's last screen appearance in 1934, the film colony helped to launch his new career—interior decorating. The actress Joan Crawford was one of his first clients, and her showpiece mansion became his calling card. Crawford's friendship with Bill Haines was one of the implicit bonds between her and Cukor.

Initially, Haines, Lawler, Douglas, and Darrow had grouped at Paramount, where Cukor was directing in the early 1930s. The December 1931 issue of *Motion Picture* magazine featured photographs and biographies of the new crop of handsome "flaming youth" that included Douglas and Darrow—no matter that their thespian careers, once bright with promise, were effectively over.

Andy Lawler's age and receding hairline already exempted him from the "flaming youth" category. In Hollywood, he managed to obtain low-level studio contracts at Paramount and RKO, and later he coached Gary Cooper's southern accent for *The Virginian*. In time, the jobs dried up, however, and by 1936 Lawler was known around town as a "fourth for bridge"—he was famously expert at bridge—or glimpsed in the gossip columns at Trocadero, Ciro's, or the many parties.

Tom Douglas's looks were also waning—where once he was willowy, now he was fleshy—and with them his screen prospects. As a young man, Douglas had appeared in some silent films (costarring with Dorothy Gish in *The Country Flapper*, 1922; opposite Estelle Taylor in *Footfalls*, 1921), before hitting his stride in London on the stage. By the mid-1930s, though, he could not find substantial work as an actor. "Poor Tommy Douglas always seemed to be killed in the first scene," friends would say about the sweet-natured actor.

Unlike Lawler or Douglas, John Darrow never had had much of a show-business profile, and his biggest parts were fleeting ones in films such as *The Racket* and *Hell's Angels*. A red-cheeked, swarthy-looking fellow, Darrow was quieter than the rest of the group, who tended toward boisterous and foulmouthed humor. Paramount publicity declared that he was "one of the most promising of the younger actors,

with a brilliant future," but by the mid-1930s, Darrow, too, had decided to get out of acting.

Of them all, only Rowland Leigh's screen career did not depend on a perpetually youthful face. The slim, curly-haired British writer had been a lyricist and stage director in England, and in the United States he was accepting regular screenwriting assignments on such noteworthy vehicles as *Charge of the Light Brigade, Tovarich,* and several *Tarzan*s.

Cukor's place was the magnet for these people, and they collected around him there. They were all endlessly amusing, and that was important. One of their functions was to make Cukor laugh, or to laugh at his jokes. "He liked these people very much," remembered Cukor's friend Elliott Morgan, a studio art director. "They were sort of court jesters."

Outside the circle, people wondered which of the friends was sexually involved with the other. For a time, Haines, Douglas, and Cukor seemed to form a sort of Three Musketeers, but Cukor and Lawler were also inseparable. In any case, that kind of question indicated a fundamental misunderstanding of the homosexual milieu. Nobody was with anybody, at least for very long, in those days. If they ever had been interested in each other, which was unlikely, now they were primarily interested in ever-younger men.

Frequent sexual activity without emotional attachments was part of their bond. By the 1930s, if Cukor ever had been hesitant or shy about his homosexuality, he pursued sexual gratification with the same fervor he applied to his career.

"He [Cukor] said something once that kind of shocked me," said agent Bob Raison, a longtime Cukor friend. "I thought about it for years. He said only two things really interested him: sex and his work. They were the two things he liked best."

No one who knew Cukor well disputes that his appetite for sex was "healthy," in one friend's words. And there were plenty of young men in and around the fringes of the motion-picture industry, in and around Los Angeles. He and his friends made forays to the beach, to the desert communities—especially to Long Beach, where sailors roamed the streets—to pick up their sexual tricks.* Cukor rarely went

*Various subtly differentiated meanings apply to the word *trick* in homosexual parlance. According to *The Language of Sex from A to Z* by Robert M. Goldenson and Kenneth N. Anderson (New York: World Almanac, 1986), *trick* is "a slang term for a prostitute's client" and "the word also is used by homosexual males to distinguish a temporary sex partner from a 'lover.'" *The New Dictionary of American Slang* by Robert L. Chapman (New York: Harper & Row, 1986) defines it further as a "sexual transaction" or "a casual homosexual partner."

alone. The group afforded not only security but facilitated the approaches, at which Cukor was notoriously clumsy.

Part of the function of the group—informally, but a function—was to pass the tricks around, and to keep Cukor supplied with sexual partners. Andy Lawler, for example, was notorious in the circle for cruising practically every night, and for being Cukor's procurer—passing on tricks to Cukor, who had no compunction about passing on his tricks afterward to someone else.

One of the legendary tricks was Bob Seiter, a would-be actor, the brother of director William Seiter, as much a "cockhound" as his brother was a cocksman. Seiter, from St. Petersburg, Florida, is spoken of fifty years later as one of the all-time legendary lookers. Everyone in the circle had a chance at him. After Cukor, Seiter went up to Santa Barbara for a fling with Alex Tiers.

Seiter was so well liked—quite apart from his being so handsome—that he was one of the few tricks that graduated into the circle itself. This was rare. Even the popular tricks had a transient appeal. But Seiter stayed in Hollywood as a film editor, and became everyone's friend—no longer a trick.

Cukor himself preferred heterosexual masculine men. He did not like his lovers to be effeminate or blatantly homosexual. He could discover beauty in all types of women in his films, but his ideal of male pulchritude was a strict one: young men who were invariably tallish, muscular, with broad shoulders and sculpted faces. Never Jewish. The guardsman type—preferably in a uniform of any kind. Cukor had a predilection for young sailors, whom his friends, in amusement, dubbed "seafood."

Most of the young men were anonymous, just passing through. They never stayed in his life very long—a week, a month. After a while, a new boyfriend bored him, he said. According to close friends, there was never any emotional intimacy between Cukor and his partners—never any confidences—just sex, usually paid sex. The director of some of the screen's most stirring love stories relinquished the idea of true love in his own life. He didn't harbor any romantic illusions.

For one thing, Cukor couldn't help but suspect that his pickups were attracted to him only because of his status as an important director. For another, Cukor's friends were, if not leading men, then handsome, dashing, and (unlike him) athletic, as well as wealthy. All things considered, they were among the most desirable homosexual men in Hollywood. By comparison, Cukor had to feel, more than ever, fattish and ugly.

One of the ways that Cukor compensated was by a meticulousness that struck some of his friend, themselves rather meticulous, as ex-

treme: frequent changes of clothing, regular manicures, the habitual application of perfumes and ointments, the calculated cleanliness.

"He [Cukor] was hipped on being absolutely immaculate," said Michael Pearman. "He was always terribly clean. I think he probably took two showers a day. Part of it, I think, is that he was a bit more scared than others of disease."

"He [Cukor] always smelled wonderful," agreed Bob Raison. "He reeked of being especially clean. He was no beauty, and that was part of his determination to be always presentable."

The secretiveness, the deeply felt ugliness, and the ridicule of swishy men meant that as a homosexual Cukor was living a double life that, to some extent, bothered him. There would always be sex, but there would never be companionship or shared feelings between him and another man. Cukor told one friend that he had decided early on to live an essentially lonely life. His joy would be in his work, in his films, where he celebrated beauty (even ordinary beauty) and defiant, unconventional women.

Many of Cukor's male friends and many—it is impossible to say how many—of his fleeting tricks appeared in his films.

Among the former—the "cronies," as they sometimes referred to themselves, there was Andy Lawler, who played in a couple of early Cukor films before his acting career was abbreviated. He has a striking bit as the conniving ex-husband of Kay Francis in Cukor's *Girls About Town*. Louis Mason and Grady Sutton appear in several Cukor films, spanning their decades of friendship—both are in Cukor's version of *A Star Is Born*. And Harris Woods, a nonprofessional neighbor and architect who was a longstanding friend, shows up with one line in *Camille*.

Rex Evans appeared so often, and so conspicuously, that it was a kind of in-joke among the cronies. Six foot three, about three hundred pounds, the entertainer was well known in England as the creator of naughty and topical song and piano drollery (with lyrics often by Rowland Leigh). In the United States, however, his career fluctuated, and he never got much work in Hollywood, except in Cukor films—many of them, including briefly spotted parts in *Camille, The Philadelphia Story*, and *A Star Is Born*.

So many briefly spotted parts, in fact, that among Cukor's acquaintances the story was told, no doubt apocryphally, that after viewing several scenes of *Camille* and seeing the same actor appear—for no logical reason—in several different scenes, Garbo asked Cukor, "Who is that big man and what part is he playing?" "That man is Rex Evans," the director is said to have replied. "And he's playing the part of a friend who needs a job."

In the case of the tricks, film appearances were a variation of the sexual patronage that was widespread in Hollywood, and considered, if not really talked about or admitted, one of the rewards of the game. Cukor scarcely went overboard, as many straight directors and producers did, making movies that starred (or "featured") their wives, lovers, and mistresses. However, it might be astonishing for people to learn that this heralded director of impeccable good taste was not above such a thing. It was just one of his appetites (work, food, sex) that Hollywood so agreeably gratified.

If Cukor's cronies usually had small parts, walk-ons, the tricks got quick bits—for the most part unbilled. That was enough to impress these young men, who were thrilled to be given even a moment of screen time. Only those "in the know" knew why someone got that crowd-reaction shot or fleeting close-up.

Once a friend asked Cukor why the camera seemed to linger on such a handsome young man during one of the swordfights of *Romeo and Juliet*. There didn't seem to be a very good reason, the friend speculated. "Oh," replied the director teasingly, "there was a *very good* reason!"

Another Cukor crony told, in an interview for this book, a story about having been flagged down by a traffic cop. This crony gazed disconsolately at the policeman as he made out the speeding ticket, slowly realizing what a hunk the cop was. He offered to get him into motion pictures. One thing led to another and shortly thereafter the crony was in his living room engaged in his ultimate fantasy—having sex with a cop!

Later on, he introduced the trick to Cukor, lost track of him, and the next thing he knew he was watching a Cukor film and there was the trick up there on the screen, bigger than life. According to the crony, this particular trick was in more than one film directed by Cukor—usually just a glimpse of him, at least once playing a cop!

In the early 1930s, a kind of innocent winking about Cukor and his friends prevailed in the newspapers and magazines, the gossip columns, and the publicity items churned out by the studio flacks.

Some of Hollywood's best-known homosexuals were considered the ultimate escort for leading actresses who were man-shy, or for the wives of studio executives whose husbands couldn't be bothered with attending an evening occasion. Celebrated Hollywood hostess Jean Howard, who published a book of her photographic memoirs, made the point in one interview that after a big screenland party, when all the stolid, important men would retreat behind closed doors with their smelly cigars and their studio buzz, Cukor and his friends would twirl the women out onto the dance floor.

More than once, men in Cukor's circle were romantically linked with one of their "beards" in the press. Andy Lawler, for one, was rumored in the gossip columns to be the fiancé or romantic attachment of (at one time or another) Tallulah Bankhead, the Countess Dorothy de Frasso, Helen Menken, and Ilka Chase . . . Lawler seemed to be one of the most eligible and elusive Lotharios in town.

Cukor escaped much of this silliness, but he was not immune. A 1936 newspaper item "revealed" Cukor as Garbo's private "Romeo," and many newspapers reported him that year as her mysterious "romantic connection." It seems incredible that anyone would take such nonsense seriously, and possibly no one did.

But Cukor was shrewd about the press. Although he discouraged fatuous news items about himself—he was discreet, not dishonest—he knew that the studio press departments could not always be restrained, and he tried not to let such "hollers" bother him. The press could be neutralized by cooperation.

This was the heyday of the gossip columns, and of those two rival and all-powerful snoop queens, Hedda Hopper and Louella Parsons, both notoriously straitlaced, homophobic, and not above making damaging insinuations in print. Indicative of his ability with the press, Cukor tamed these two tough ladies adeptly, flattering them with all the charm and diplomacy with which he soothed actresses on the set.

Hopper had known Cukor since the 1920s and her marriage to De Wolf Hopper. In the 1930s, he made the gesture (really it was MGM's gesture) of directing her in a small part in *The Women*. The director stayed in regular communication with both Hopper and Parsons (the latter's rigid views on Communism and homosexuality stemmed from her orthodox Catholicism), feeding them on- and off-the-record tips, innocuous but useful. He and his friends (who like Cukor, it must be said, were genuinely popular) were always assured a warm mention in their columns.

An inveterate gossip himself, Cukor kept the spiciest Hollywood prattle for behind closed doors, and he never repeated it for books or newspapers. He liked to say, only half-jokingly, that he always read the Hollywood gossip first in the morning papers. To the end of his life, he rarely read about himself there, except in the most complimentary terms.

It was really in 1936, with the completed renovation and decoration of his house, that Cukor began to come into his own as one of the fabulous hosts of the film colony.

No one turned down an invitation to Cukor's house. "The appointments were wonderful, the flowers were pretty and the furniture was all interesting," explained Kitty Carlisle Hart, who with her husband,

writer Moss Hart, attended lunches and dinners there. "He liked distinguished, famous people—and you always expected good food. You accepted his invitations with alacrity because he made everyone feel important. He made everyone feel as though they were the most welcome guest."

Not everyone could expect an invitation. If Cukor did not always control the casting of his films, he certainly commanded his own guest list. Excepting Selznick, none of the studio heads were ever invited, although their presences might have been mandatory at other parties in town.

After all, Cukor's guests were, in the words of one press account of the era, the "interesting people" of Hollywood—invariably literary or cultural personalities.

The atmosphere was decidedly more intimate than the punch-bowl and mariachi-band setups elsewhere in the partygoing community. Guests were expected to contribute intelligent conversation or witticisms, or, at the least, to listen attentively. The conversation was not about contracts and box office, nor so much about the specter of fascism and impending war that was all the headlines in the mid-1930s. It was Cukor's opinion that a discussion of politics ruined the digestion of good food. Therefore, the conversation was more likely to be about books, music, art and architecture, theater . . . even sometimes, the best (and worst) new films.

The lunches were more informal occasions, the dinners elegant. The regulars would sit at the end of the table. The new people would sit close to Cukor, who would gently—or forcibly—steer the conversation just the way he had as the head of his summer-stock family in Rochester.

He would assiduously plan every last detail of his dinner parties. There might be improvisation in the dialogue but not in the general scenario of a Cukor dinner, which was carefully thought out—and over the years routinized. "We always used to say he went on directing at home," said Elliott Morgan.

"He was so meticulous and fastidious about every detail in his entertaining," said his personal secretary for nearly forty years, Irene Burns. "Everything was quite formal. To the point that, with the housekeeper and the cook and me, he would spend a day or so in preparation of the menu. He would even go with us to his linen closets and select everything himself that was to be put on the table—the china, the crystal, the silverware. He would select everything himself. He didn't leave that to anyone else."

To some people who had known Cukor back in less conspicuous New York days, the newly important film figure was different from the eager, boyish stage manager of the early 1920s—more showy and

exterior, more on his guard with people. Always now, there was the sense that he was under pressure to act the image. To these people, Cukor seemed *too much* the director—truly no different at home than on the set.

To actor David Manners, who first became acquainted with Cukor when he was the stage manager of *Dancing Mothers* in 1924, the older, more established Cukor, was "George plus." He was not as free and natural in conversation as he once had been. Manners was cast in the supporting part of Kit Humphrey in *A Bill of Divorcement*, and the actor remembered thinking, at the time, how there was now a difference in status between him and Cukor.

"George was very important by that time, and I was just an actor," recalled Manners, "so I always felt *under* him. But it wasn't until then, too, that I realized what a wonderful director he was. He took great pains with Kate and me in our scenes together. I had found that directors were not so hot in Hollywood. Most of them were careless about the actors."

Cukor had always been self-disciplined, remarkably self-controlled, in personal as well as professional habits. He never smoked, rarely picked up a drink. Now, to some old acquaintances, and to new ones as well, he seemed wound tight by the front he had to maintain, even in his own house.

There were times—just as on the set—when Cukor startled people by erupting with epithets, seemingly out of nowhere, throwing tantrums when guests trespassed on one of his rules that they didn't realize was inviolate. He didn't listen to much music, but he prided himself on knowing certain popular songs, and he had some habits—such as playing one song over and over monotonously during a dinner party, harping on the lyrics—that made people ill at ease, for such compulsive behavior seemed to hint at a commotion beneath the surface.

"He always seemed to be *on*," commented fellow MGM employee Gottfried Reinhardt. "He was always aflutter, always. Some people liked that. It stimulated them. Not me."

Once Cukor's residence was completed in 1936, it seemed that—more than ever—the director was always surrounded by a crowd. "We never saw him alone anymore," remarked Stella Bloch. "He was always with an entourage. And he was so totally social that personal relationships seemed nonexistent."

At Cukor's house would be gathered literary titans, such as Sinclair Lewis, Theodore Dreiser, Aldous Huxley. There were foreign film personalities, passing through Hollywood. British ladies of vague royal derivation seemed to be abundant. There were often illustrious

theater people, such as Fanny Brice, Lucile Watson, or Mrs. Patrick Campbell, in Los Angeles for the climate or the vague prospects of work (often prospects nurtured by Cukor). There was the faithful cadre of famous actresses who were friends: Bankhead, Garbo, Hepburn.

Even if most of Hollywood was excluded, word got around of these privileged gatherings—of the Hungarian dramatist Ferenc Molnár and Garbo at a Cukor dinner where they discussed Empress Elizabeth and Krakow pianos; of the great ladies Dorothy Gish and Ina Claire, whose stories were all about themselves; later, of author Henry Miller, basking in the company of Vivien Leigh and Simone Signoret.

Part of the cachet of the house, implicitly and explicitly, was Cukor's homosexuality. That was part of what made it unique: There was a flow of distinguished homosexual guests from around the globe, and particularly from England: the author Somerset Maugham, playwright and actor Noël Coward, the noted *Vogue* photographer George Hoyningen-Huene, the photographer and designer Cecil Beaton . . . and many others.

The more itinerant visitors may or may not have stayed at Cukor's; he was always helpful in arranging other accommodations. However, like Tennessee Williams, who was guided by Irene Selznick to stay with Cukor on his first sojourn to California in 1947, they knew that they could find a haven at Cukor's—in a place (the figurative as well as literal Hollywood) that otherwise has confused, alienated, or betrayed many an intellectual, many an artist, and certainly many a homosexual.

"They [homosexual visitors] all flocked to George," said Joseph L. Mankiewicz, "because George was their access to the crème of Hollywood. George was really queen of the roost."

In turn, if his guests were interested (and, invariably, they were), Cukor would take his famous friends (whether homosexual or not) to the studio for visits to the sets, publicity photographs, lunches with studio executives, and autographs. Someone like Somerset Maugham, whose literary reputation was at its acme, proved to be amazingly generous with his Hollywood time, and more than once he would appear at a studio, at Cukor's behest, to offer his analysis of the strengths and weaknesses of a best-seller that a producer had just purchased.

Not everyone in Hollywood who was homosexual was invited to Cukor's house, of course. If Cukor didn't like someone, he couldn't be convinced otherwise. And his judgments were snap, often made with an arrogance that offended people. The exclusivity of his club bothered many people who were left out, heterosexuals as well as homosexuals.

"They thought they were the elite," said Marcella Rabwin, Selznick's secretary and assistant, somewhat enviously, of Cukor's circle of homosexual friends. So they did and so they were: an elite within an elite, living, in the 1930s, their own pocket variation of the Golden Age.

One of the signposts of the era for Cukor was *Sylvia Scarlett*, owed to RKO and filmed before *Romeo and Juliet* between June and October of 1935.

Sylvia Scarlett was unique in the director's filmography, an offbeat—not to mention brave and experimental—film that was also, to some extent, a humorous as well as serious personal allegory about sexual awakening.

Although this time Cukor suspected *her* of not finishing the book, it was Hepburn who promoted the filming of Scottish writer Compton Mackenzie's picaresque novel *Early Life and Adventures of Sylvia Scarlett*. The job of scripting the unusually digressive novel was turned over to the veteran Gladys Unger and the British author John Collier, newly arrived in Hollywood. Cukor's boyhood friend Mortimer Offner was brought in to add some highlights.

The screen story (dedicated in a preface "to the adventurer, all who stray from the beaten track . . .") focused on an embezzler and his daughter, disguised as a man, who escape from France and join up with a con artist, roving the English countryside. Hidden implications abound in the script. A housemaid wants to daub a mustache on the curiously feminine Sylvester, and kiss her. The con artist wants to cuddle up to him/her "like a hot-water bottle." An artist, whom the trio meet along the way, finds himself oddly attracted to the handsome lad, which gives him a "queer feeling."

Besides Katharine Hepburn (as Sylvester/Sylvia Scarlett), Edmund Gwenn and Cary Grant were chosen to play the delinquent father and cockney con man, respectively. Playing the thankless ingenue's role was heiress Natalie Paley, in her first American film. (She was part of the Cukor social circle; her husband was Broadway producer John C. Wilson.) The British romantic leading man Brian Aherne rounded out the company as the bohemian artist.

This was Cukor's first film with Cary Grant, who, though he had not yet hit his stride as a leading man, had been in films since 1932. Cukor never talked much about Grant—about whether they had known each other back in New York. It seems they were not particular intimates; not really friends, more like professional friends. But they knew each other well and stayed in touch over the years through a common friend, Grant's longtime personal secretary, Frank Horn—a hillside neighbor of Cukor's with a legendary collection of

male pornography and extensive contacts in that field. For fifty years, Horn was part of Cukor's closest circle.

The emanations from the set were reminiscent of *Little Women*. Cukor's company was a happy group conspiracy carrying off its private joke, on idyllic locations, away from prying studio dictates. In Malibu, where they filmed exteriors (substituting for England), they swam and sunbathed and had picnic lunches on the cliffs above the sea. "Every day was Christmas on the set," recalled Cukor in one interview.

But Christmas on the set can be deceptive. There was some private soul-searching and the feeling from the outset that they were out on a limb with the material. At one point, Hepburn confided to her diary: "This picture makes no sense at all, and I wonder whether George Cukor is aware of the fact, because I certainly don't know what the hell I'm doing." Especially toward the end of the filming, Hepburn suspected that, like her, the director had to realize they were floundering.

At the first preview in San Pedro, in December of 1935, Hepburn and Cukor suffered humiliation when the audience did not laugh at the symbolic comedy; at intervals, they walked out in droves. The head of RKO, B. B. Kahane, left his seat, too, and paced nervously in the rear.

The audience was probably just bewildered by the ellipses of relationships and a whimsical plot line that lacked the expected linear drive and climax. If the coded motifs escaped most audiences and reviewers, however, some people in Hollywood, aware of the director's predilections—and of Cary Grant's widely whispered homosexuality as well—thought *Sylvia Scarlett* indulgent and an embarrassment. "Very fey, and very wrong," was how Joseph L. Mankiewicz recollected the film decades later, "and no contact with humanity at all."

After the screening, Hepburn took a ride with Cukor back to Beverly Hills for a meeting with producer Pandro Berman. She was contrite and pleaded with the producer, "Pandro, scrap this and we'll do another picture for you for nothing." He was fuming, and is said to have replied, "I never want to do a picture with either of you again." (He would, in fact, eventually do other pictures with both of them.)

Years later, Berman would recall with uncharacteristic bitterness that *Sylvia Scarlett* was "a private promotional deal of Hepburn and Cukor; they conned me into it. . . ."

The moral guardians of Hollywood picked up on the allusions of *Sylvia Scarlett*, and it became the first film by the director of good taste to be condemned by the Legion of Decency. It was considered RKO's worst box-office failure of the year.

Said the *Variety* review: "The story is hard to get. It is puzzling in

its tangents and sudden jumps plus the almost poetic lines that are given to Miss Hepburn. At moments the film skirts the border of absurdity and considerable of its mid-section is downright boresome."

Said *The New York Times* critic: "A sprawling and ineffective essay in dramatic chaos."

Only Cary Grant transcended the reviews, for his role as the devious Jimmy Monkley was widely regarded as his most successful—his most comfortable—role to date. Cukor always said that was because Grant, who came to epitomize masculine charm and sophistication on the screen, was this time playing a raffish cockney pretender, someone very close to himself. Cukor directed him as he knew him, and suddenly Grant "burst into bloom," the director liked to say.

As for Hepburn, *Sylvia Scarlett* made plain the emerging pattern of Cukor's work: The director identified with the actress deeply and powerfully—through her he saw himself. For him she functioned on the screen as an idealized alter ego. Between himself and the actress, Cukor always referred to *Sylvia Scarlett* as their misbegotten love child.

As sweet and swashbuckling as her performance is, though, *Sylvia Scarlett* was a disaster for Hepburn. She had a share of the profits, but the film cost $641,000 to produce and showed a loss of $330,000 on the ledgers. Its dismal reception set in motion Hepburn's denunciation and boycotting by the nation's film exhibitors as "box-office poison."

In interviews later on in life Cukor was to call the experience of *Sylvia Scarlett* a personal watershed and professional catastrophe. The reaction to the film hurt him, the director said, and made him more cautious and conservative about future film choices.

Though both of them might have liked to forget *Sylvia Scarlett*, Hepburn and Cukor were haunted, decades later, by its recurrence at film festivals. When, in 1970, Cukor's 1936 film was chosen to open a Museum of Modern Art retrospective of the director's oeuvre, Cukor raised objections, and asked that another film, *Holiday*, be subsituted.

Not only did modern audiences better appreciate the sex-role interplay that offended Hollywood decades earlier, but many found the mercurial mood, the sinuous rhythm, and the visual shimmer (the result of Joseph August's expressive photography) of *Sylvia Scarlett* to be preferable to more staid studio films of the era.

When, thirty years after its initial failure, his pet film would be showered with love and admiration, Cukor might confess a grudging pride in the only motion picture of his career that was perhaps too revealing of his secret self. "I suppose there was *something* about that picture," he would admit, "something brave as well as foolish."

CHAPTER SIX

Che filming of *Camille* was clouded by two events: the deaths of Cukor's mother and Irving Thalberg.

Helen Gross Cukor succumbed after complications that arose from surgery for stomach cancer in June of 1936. Her decline was swift, and Cukor was devastated by the loss. He telephoned Stella Bloch on the day of his mother's death and asked to go over and visit with her. Cukor arrived alone and stayed for several hours, unusually subdued.

"For him to call up and ask to come over, by himself, without his entourage," said Stella Bloch, "indicated to me how deeply grieved he was by his mother's death."

His love for his mother could never be matched by his feelings for anyone else. Ironically, his life was filled with women—actresses and others—whom he doted on, telephoned daily, and helped out financially or otherwise. Because of his mother, perhaps, he was quite capable of *love* for women—not of physical love but profound caring and compassion. Whereas she spoiled him for men, whom he seemed only to *like*.

Somehow Cukor would recycle everything, even his mother's death, into work. He liked to say that some part of himself was always acting the director—observing, storing away information and detail that he would put to use as grist for scenes in films. "I use

everything," he would say. "My mind is always taking notes."

Many times, he told interviewers the story of how, the last time he visited his mother on her deathbed, she looked at him and whimpered pathetically, something he had never seen her do. Then she turned her head toward the wall, as if willing herself to die and to spare her son any more anguish.

It so happened that the scene of Marguerite's death was being filmed shortly after his mother's, and thus the director was shunted from the real to the imagined tragedy.

Directing that climactic scene, Cukor liked to tell interviewers, he was overwhelmed with the memory of his last visit with his mother. Somehow he managed to transmit the gist of that experience to Garbo—though in actuality he uttered no words to the actress—so that in the film Marguerite, too, sighed in agony and turned her dying face to the wall.*

How could Cukor communicate such a thing without speaking? If this marvelous directorial anecdote seems a little too perfect, it is. A close watching of the film reveals that what Cukor remembered taking place on the set does not, in fact, occur on the screen. It occurred primarily in the director's imagination, so completely did he associate the character of the dying Marguerite with his stricken mother. So completely did the self identify with the work.

Irving Thalberg died, also, three months before the end of production—on September 14, 1936. He was the same age as Cukor, thirty-seven. Though the MGM producer was spoken of in his own lifetime as sickly and doomed, his passing, from "lobular pneumonia complicated by a cardiac condition," in the words of *Variety*, seemed nonetheless sudden and shocking.

His death proved a hammer blow to Cukor, which would alter the director's future, a death every bit as significant and unfortunate, on a professional level, as his mother's was on a personal one. Only Selznick and Thalberg, at MGM, had a complex appreciation for Cukor's talent.

"He [Cukor] had that taste that, aside from Thalberg, nobody at [MGM] understood," said Anita Loos. "And after Thalberg died, I think Cukor was more or less thrown to the wolves."

*"My mother had just died, and I had been there during her last conscious moments," said Cukor in one published interview, "and I suppose I had a special awareness. I may have passed something on to Garbo, almost without realizing it. You don't tell her how to say 'I'm strong,' but somehow you find yourself creating a climate in which she can say it that way."

A staff producer named Bernard Hyman was assigned to watchdog the production of *Camille,* and he showed up on the set, along with his then-assistant Gottfried Reinhardt. Hyman became the first of many MGM staff producers to come to a standoff with Cukor.

One of Mayer's loyalists, Hyman was convinced that Cukor was slow and expensive, and had been pampered by Thalberg. To Hyman, an old-style movie producer, Cukor was a theater man without any instinct for the camera. The producer surrounded Cukor with people who could second-guess him: Vienna-born Fred Zinnemann, to monitor the camera composition, and MGM supervising editor Margaret Booth, to ensure optimum continuity. None of this was too unusual for MGM, and people like Margaret Booth *always* seemed to be around. But Hyman was tactless and wore on the director's nerves. There was constant tension between them as filming dragged on in the fall of 1936.

Since Cukor's MGM contract was directly tied to Thalberg's health, he was duly informed that he was legally entitled to break it within thirty days of Thalberg's passing. Not that MGM was eager to let him go: From the studio's point of view, there was no one better than Cukor at costume dramas and with leading actresses. The studio made him a generous renewal offer: a five-year contract at the salary of four thousand dollars weekly.

Selznick was waiting for Cukor to join him at Selznick International Pictures. Everyone expected that Cukor would go with Selznick. Yet Cukor had his doubts about Selznick. He wasn't sure what the studio setup would be like at MGM without Thalberg. But the fact was that Cukor *liked* MGM, its family feeling and first-class status. He could work quietly and effectively there, disappear into films, and it seemed that he had his pick of the most appealing projects on the lot. At least, those that appealed most to *him.*

The immediate effect of the MGM offer was to raise the bidding for Cukor. Selznick, who was already under heavy obligation to the bankers underwriting his production company, was forced to counter with a revised contract package for the director, the same high salary padded by annual escalations.

As *Camille* went into its final weeks of filming, Cukor stalled and equivocated, while Selznick and MGM waited for his decision.

There was another significant factor in the situation. The moral climate, in general, was changing. Censorship was tightening as the Depression eased up. Cukor's private life was more vulnerable than before.

One hears a lot of different rumors about Cukor in Hollywood during this period, most of them impossible to substantiate, and all of

them indicating the general atmosphere of titillating and hurtful gossip that ruled the day.

However, according to Cukor intimates, there had been several arrests on morals charges in Cukor's circle: Bill Haines, Andy Lawler, James Vincent—all more than once. Always, the charges were dropped, or cleared up by the studios.

Sometimes Cukor himself got involved—with phone calls, or (in the case of James Vincent) by spearheading a letter-writing campaign, and by rallying the help of Tallulah Bankhead's father, Speaker of the House of Representatives William Brockman Bankhead.

Usually, these incidents were hushed up, but Bill Haines had the bad luck to be newsworthy when he got into trouble. One of Haines's more publicized arrests was typical of the scandal that nipped at the heels of Cukor and his circle.

The front page news in Los Angeles newspapers in June of 1936 was that Haines and a group of companions had been driven out of El Portos Beach by an angry mob that had chased them, abused them verbally, and tossed tomatoes at them.

One of the group, Jimmie Shields, who was knocked down by the mob, was said to have provoked the melee by an unspecified action toward a young boy on the beach. A person named Mason (probably Louis Mason) was reported to be one of the group, as was a local antique dealer. A mysterious "Sullivan" was also identified as one of the group, whose actual number varied according to accounts. There was speculation around town that Cukor was "Sullivan" or one of the unidentified others.

There were front-page photographs of Haines being grilled by detectives, as well as murky—yet tantalizing—details of the episode.

Of course, the alleged offense might well have been a figment of someone's overactive imagination, not to mention the overactive imagination of an entire mob of people (who in more contemporary language might be called gay bashers). In any case, all of the charges were dropped, and noted as such in the newspapers, within forty-eight hours.

One of Cukor's choice stories for intimates was about the night of the Haines headlines. Tallulah Bankhead happened to be invited to a Cukor dinner party that night, along with Robert Benchley and Bill Haines. Bankhead was going on and on about the negative reviews for one of her shows while Benchley listened patiently and a disconsolate Haines sat with his head cupped in his hands. Bankhead said she was particularly incensed to have had her performance compared by one reviewer to that of a circus acrobat.

Finally, the former silent-screen actor could stand no more of Bankhead's self-absorbed monologue. "Oh, for God's sakes, Tallu-

lah!" exclaimed Haines. "It's not the same as being called a cocksucker on the front page of the Los Angeles *Times*!" Bankhead paused a moment and seemed to consider this remark. Benchley raised his head and murmured, "Oh, I'd much rather be called a cocksucker than an acrobat."

Although Haines could weather the notoriety of a front-page arrest, to Cukor that would have been a living death. The reality of such a thing would go against everything he stood for in his work, and the gentlemanly image he had adopted for himself.

That is why, when Cukor himself was arrested on vice charges, it was crucial that the arrest be squelched at "the highest possible executive level" at MGM, and that word of the incident never leak out. Although it has proven impossible to pinpoint the date, sources indicate that Cukor was arrested, at least once, during roughly this time period—during the filming of *Camille*, somewhere around the time between his mother's and Thalberg's deaths.

Details of the episode are cloudy. Charges were quietly erased. No arrest files can be located at this remove in time. Cukor never spoke about his arrest afterward, even with his most intimate friends.

Interviews with people who were in a position to know leave no doubt as to the occurrence, however. The consensus is that nothing actually criminal transpired. Indeed, one reliable version has it that Haines and Cukor were themselves haplessly assaulted by navy personnel in Long Beach when they became too aggressive in their flirtations, and that it was the navy men, not Cukor and Haines, who should have been arrested.

"I remember hearing about it [the arrest]," said Katharine Hepburn in an interview. "It was just the shadow of a thing. Most unfortunate. Most undeserved."

According to Joseph L. Mankiewicz, the upshot of the arrest was that Cukor was sternly advised, in the high offices of MGM, to be more prudent about his sexual activities in the future. There was no attitude of punishment at MGM, only sympathy. Cukor's embarrassment was such that he resolved never to blunder into a similar transgression.

His indiscretion would have meant little to the sophisticated Selznick or even Thalberg, if it could be kept out of general circulation. It might have signaled some concern at MGM, however, with its "moral turpitude" clause. And perhaps Mayer himself would have had to know about Cukor's arrest and made the phone calls to rescue the studio's publicized "woman's director."

So, in the wake of all these dramatic events, it happened that MGM ceded Cukor to Selznick International Pictures for an indefinite period.

Cukor's agent, David O. Selznick's brother Myron, once again performed one of the negotiating miracles that established him at the forefront of Hollywood deal making.

After Thalberg's death, Cukor signed concurrent contracts with MGM and Selznick International Pictures. The MGM contract held Cukor to a three-picture deal at $75,000 apiece, of which *Camille* was accepted as the first obligation. After which, oddly, MGM agreed to an immediate option loan-out of Cukor's services to Selznick International Pictures.

It was understood, though, that Cukor owed MGM at least two future pictures. His agreement with Selznick stipulated that he would be employed for precise one-year intervals, and that Selznick would be obligated to renew Cukor's agreement annually. Otherwise, his services would revert to MGM.

Myron Selznick obtained a further hedge for Cukor: "unquestioned control" of any loan-out of his services by Selznick International Pictures. That specific language was kept out of the contract, but the gist of it became a gentleman's agreement between Cukor and David O. Selznick.

The contracts looked, to all interested parties, like a good compromise, especially after the release of *Camille*. This was an indisputable achievement, the director's romantic testament, a love story according to his lights, reckless and merry and doomed. A movie about breaking society's rules, brimming with parties and laughter and jubilant love scenes, as well as the most radiant tragedy at the end.

Garbo was nominated for a Best Actress Oscar.

The New York Times's notice of *Camille* called her performance brilliant and eloquent, subtle and ethereal, full of strength and dignity, poignantly sad, delicate and moving. Yet even as that film critic, Frank S. Nugent, was hailing her director as "the classicist of the Metro studios," Cukor had left MGM and was working someplace else.

On July 8, 1936, Selznick International Pictures had paid out a record fifty thousand dollars for the story rights to a first (and only) novel by a southern newspaperwoman. Although Selznick himself had not read it, Margaret Mitchell's *Gone With the Wind* was urged on the producer by associates in New York who had seen the galleys. The published book swiftly achieved best-seller status; it would win the Pulitzer Prize in 1937. Public opinion polls reported tremendous anticipation for the Hollywood interpretation.

David O. Selznick was going to have to risk a lot of money and time and ego on the film of *Gone With the Wind*, and his choice as director was his friend George Cukor.

By October of 1936, Sidney Howard had been engaged to adapt the sweeping Civil War–era saga of thwarted and obsessive love into a filmable screenplay. Howard, an ex-Hearst reporter, had been recognized as one of Broadway's foremost playwrights ever since his Pulitzer Prize–winning 1924 play, *They Knew What They Wanted*. For motion pictures, Howard had toiled admirably, if intermittently, as a scriptwriter since 1929, usually from the safe haven of Tyringham, the location of his farm in Massachusetts.

It was not until December of 1936 that Cukor finished the last retakes for *Camille* and it was not until after Christmas—a holiday he always celebrated munificently—that he traveled east. He had a personal agenda—he was having belladonna put in his eyes for medicinal purposes, and gold in his teeth—and he was booked to sail to Europe. His itinerary began in Hungary, where he had always wanted to visit.

While on the East Coast, Cukor met with Sidney Howard for the first time. They spent several afternoons together at the writer's farm in early January. Their conversations about the book were general. Selznick's instructions were that they must remain "rigidly faithful" to the novel so as not to disappoint the great numbers of people who were familiar with it. Not that either Cukor or Howard, high-minded about literature, thought much of the popular novel. Cukor hadn't actually read it (he probably never did), while Howard thought it, tactfully, "a series of islands" that would need a lot of shaping into a motion picture.

Although Howard had already completed a summarized treatment, Cukor's immediate interest in *Gone With the Wind* was such that he had misplaced his copy. Fortunately, Selznick had mailed in his reactions, and Cukor could translate Selznick's dictums, so everything was fine.

In any case, Selznick was more concerned, temporarily, with the casting of the two leads.

The press was clamoring for Clark Gable—the character of Rhett Butler seemed to cry out for his virility and manliness. Gable's casting seemed a foregone conclusion, except that Gable was under exclusive contract to MGM, which made a practice of never loaning him out. Meanwhile, the "King of Hollywood" was rumored to have trepidations about playing a part with so many built-in expectations.

There were the fallback options of Errol Flynn or Gary Cooper or Ronald Colman . . . Selznick had to sort them all out.

The role of the willful Southern vixen, Scarlett O'Hara, was more crucial, for she was the focal point of the romance and tragic sweep of the novel. Although Selznick vowed publicly to discover a new personality to play Scarlett, privately much of his time was spent with

assistants and agents, pondering more important and familiar ladies in the business.

By February, Cukor was back from Europe, on the Selznick payroll, and temporarily headquartered in New York City, at the St. Regis Hotel, where he liked to stay. New York was no longer home; now it was the place he loved to visit. There were lunches and dinners with friends and nightly forays to the theater. The director began to meet with hopeful actresses and to conduct screen tests. He communicated fitfully with Howard, who was ensconced in Tyringham and immersed in the first draft.

Selznick, absorbed with his slate of other pictures, indicated no great urgency, so the script drafts, the casting rigamarole, and plans for costumes and settings proceeded at a snail's pace. Cukor was the perfect point man for Selznick, and he put in effort and advice in all areas—some of it significant groundwork for the film, and some of it highly irrelevant to the eventual outcome.

Sometimes the publicity angle seemed to be the most important thing of all.

Dispatched to Atlanta in the spring of 1937, Cukor was absolutely the right person to greet Margaret Mitchell and assuage a regional press that was perhaps nervous (in a subliminal way) about the fate of the great Southern novel in the hands of a Yankee producer and director, who also happened to be Jewish.

The respecter of writers charmed Mitchell, and gave her a selection of Mary Chess perfumes. She did not care to be consulted about the script or the casting, and was frankly overwhelmed by the success of the book and the mounting national anxiety over the film version. But she found Cukor "a grand person and a brilliant one," and her approval paved the way for his warm reception in the Deep South.

Traveling with Cukor were production designer Hobe Erwin and John Darrow, who was temporarily on the Selznick payroll and identified as a talent scout.

After spending a week in Atlanta, the trio made flying visits to Marietta, to nearby scenes of the Battle of Kennesaw Mountain, to Milledgeville and Savannah, to Charleston (to isolate the "coast accent" referred to in the novel), and to the James River region, where Erwin was studying and photographing the aristocratic cornices and antebellum balconies of the old houses. Selznick was as determined to have the right house for Scarlett as he was to have the right Scarlett.

All of this scouting and research was in keeping with a verisimilitude that Cukor had been moving toward slowly in his filmmaking—away from the artifice of theater, toward the true-to-lifeness that is manifest in the best of his later films. (It must be said, too, that

little of that authenticity is evident in the eventual film of *Gone With the Wind*, with the back-lot and soundstage artifice that Selznick ultimately preferred.)

Despite the good publicity, the cost of it all nagged at Selznick. He figured carrying Darrow on the payroll was a "fruitless expense." Although Cukor saw Southern women and pored over submitted glossies, there was little real hope that anything would come up in the casting.

Like Cukor, Selznick read his notices diligently, and he had to flinch at newspaper commentary such as the one by a *New York Times* interviewer: "It is, we think, a proof of the increasing mellowness of this age that Mr. Cukor has been doing this sort of thing [touring Southern locations] for several months now . . . calling it work." To this newspaper writer, as well as to Selznick, the adventures of Cukor, Erwin, and Darrow began to look suspiciously like a "hedonistic" boys' night out.

In California, Selznick could keep closer tabs on Cukor—not that there was actually much to do on *Gone With the Wind*, other than screen-testing and more screen-testing. But Cukor was summoned back to Hollywood, and by the summer of 1937 he was commuting between New York City and Los Angeles, where he coached the screen tests of the up-and-coming as well as established actresses that Selznick had lined up.

The endless hours of repetition, of setting lights, of perfecting hairdos and makeup, of calming jangled nerves, this Cukor did not mind. He was in his element, coping with the high-voltage outbursts of a Tallulah Bankhead, who was embarrassed perhaps by having to submit to the indignity of a screen test. He was the right man to reassure the big Hollywood stars for whom the auditioning process was suspect.

Selznick seemed to be obsessed with the screen-testing—the famous memos churned forth—but it was an obsession that his director did not mind, at least at first. Besides, the script of *Gone With the Wind* was not ready, nor the sets, nor anything else—certainly not the producer. And Cukor *enjoyed* screen tests.

In time, Cukor would screen-test dozens of actresses, including Susan Hayward (a.k.a. Edythe Marrener), Lana Turner, Frances Dee, Anita Louise, Jean Arthur, Joan Bennett, and Paulette Goddard. The last-named three were the inside favorites. Especially Goddard—Chaplin's leading lady, in films and in life, and Selznick's Summit Drive neighbor. Cukor said he liked Goddard's flirtatious quality in successive testing. However, Goddard was believed to be living in unwedded bliss with Chaplin (actually they were secretly married); and it was typical of the moral climate of the era, and of Selznick's

sensitivity to it, that the potential outcry was said to be the factor that kept the producer from closing the arrangements.

In any case, part of Cukor's tact—with Selznick as well as the actresses—was to avoid expressing any actual preference. "Cukor talks as though his mind were made up [about the casting]," Sidney Howard wrote his wife skeptically after one Hollywood visit, "but I doubt if Selznick ever makes up his."

It may be that all along Cukor was quietly rooting for the dark horse, his friend Katharine Hepburn. That was the line in the gossip columns that has been recapitulated in many books about *Gone With the Wind*. Only Selznick, worried about "box-office poison," would not consider Hepburn as Scarlett O'Hara without a screen test. And Hepburn refused to stoop to such a thing.

The year 1937 dragged on with preproduction on *Gone With the Wind*, while Selznick paid attention to his other, more pressing projects.

Sidney Howard completed a rough draft, then a shooting script. He traveled west to meet with Selznick, then back east again to meet with Cukor. In early summer, he managed to find them both in the same place at the same time, in Hollywood, where, at Cukor's house, story conferences between the writer and the director would begin at noon, and the producer could join them in the afternoon.

Despite their pruning of dialogue and whole sequences, the shooting script was swollen by many emendations and grew to four hundred pages—which would demand an estimated six hours of screen time. Selznick was stubbornly refusing to cut or condense. In fact, he demanded constant additions. Selznick could not always make up his mind, he was rarely punctual, and he would disappear on trips suddenly, leaving Cukor and Howard cooling their heels waiting for his input.

Selznick informed the writer that he might as well plan on staying in Hollywood until September. Howard despaired of ever finishing. "I had so much rather be eaten by a shark than by Selznick," he wrote to his wife.

In some ways, these two years of *Gone With the Wind* preproduction were the least fruitful period in Cukor's career. In small ways he kept active, though; he did direct two films for other studios, and did other work that went uncredited.

Around town (and this was true throughout his career), Cukor made himself available to screen-test actors and actresses. His advice was sought on stories and scripts, especially the edifying ones that worried producers and needed some early encouragement from a respected source.

Cukor was perfectly willing to discuss the challenge of a screen libretto of Bizet's *Carmen* to star the Metropolitan Opera soprana Rosa Melba Ponselle; to hobnob with Theodore Dreiser over a film of *The Stoic;* or to have lunch around the pool with Aldous Huxley and Salka Viertel at Bernard Hyman's beach house, discussing a treatment of the life of the scientist Madame Curie to star the elusive Garbo.

Unlike most of the top-flight directors, Cukor busied himself in small and unseemly ways, and was content to have a finger in where others might demand obeisance and wide authority. Cukor loved a project of any size. Until the end of his life, the worst thing of all for him was to sit around and do nothing. Many Hollywood producers were grateful to him for some favor, at one time or another. Professional generosity—as much as personal generosity—was part of his reputation.

More than once in his career, Cukor stepped in and took over for a director who took sick on the job. He also seemed perennially available for someone else's retakes—the least of all directorial jobs. When three days of additional coverage were deemed necessary for *I Met My Love Again*, a 1938 romantic weeper with Joan Bennett, Cukor stepped in, unsalaried, on behalf of codirectors Josh Logan and Arthur Ripley. Cukor received for his effort a marble mantelpiece that set off his drawing room, not to mention Logan's lifelong gratitude.

Selznick used Cukor in the same way. In mid-1937, the producer needed a revised renunciation scene, with Ronald Colman, for *The Prisoner of Zenda*, after its director John Cromwell had moved on to another obligation. Sidney Howard, who happened to be in California for *Gone With the Wind* discussions, was pressed into writing the dialogue for the scene that Cukor eventually directed.*

It was a point of contention between Cukor and Selznick that the director repeatedly turned down the opportunity to direct in their entirety any of the pictures on Selznick's schedule.

Cukor fought against assignment to the first production of *A Star Is Born*, saying he didn't want to do another Hollywood picture so soon after and so similar to *What Price Hollywood?*. He declined *Intermezzo*. When H. C. Potter was yanked off Selznick's adaptation of *The Adventures of Tom Sawyer*, the producer entreated Cukor to step in. The director refused; he was working on something he preferred

*"The best of recent Hollywood stories happened to me last night," Howard wrote his wife in April of 1937. "They asked me, some days ago, to write a ballroom love scene for the *Zenda* script, and I wrote one. Last night Selznick said to me: 'Could you let me see a rewrite on that ballroom scene?' 'Sure,' says I, 'how do you want it rewritten?' 'I don't know,' says he. 'I haven't read it yet.'"

to do, with Garbo. (He did deign to shoot one scene—the cave scene.)

Where Cukor seemed free and available with others, to Selznick he seemed curiously inflexible. Selznick was in the paradoxical and humiliating position of having to employ other directors because his only long-term contract director refused his bidding. Though Cukor continued to work on preparations for *Gone With the Wind*, it began to dawn on Selznick that Cukor was being paid a lot of money for little enough work.

"The situation is utterly ridiculous," Selznick complained in a memo held confidential from Cukor, "and what it amounts to is that we pay George $4250 weekly as a retainer for him to select what pictures in the industry he would like to direct."

In early 1938, Katharine Hepburn was approached by Columbia to star in Philip Barry's *Holiday*. Barry's comedy had been filmed once before, in 1930. Hepburn was going to play Linda, the nonconformist and youngest sibling of the stuffy upper-crust Setons.

Hepburn asked for a director she would feel absolutely comfortable with—Cukor. Selznick could not talk his contract director into any films that he wanted to make, but Hepburn was another matter. At least Selznick was able to make some money loaning his contract director for ten thousand dollars weekly.

The first of two Barry plays that Cukor was to film so well, *Holiday* featured that subtle interplay of wit and despair that was the playwright's stock-in-trade, the stinging criticism of the upper class that turned, at precipitous moments, into a toast of their sterling virtues.

With Sidney Buchman, one of the most erudite Columbia scenarists, Donald Ogden Stewart adapted the play for filming. There was some speculation that Stewart might turn actor again and reprise his Broadway role as Ned Seton, drink-addicted scion of the Setons, but Cukor preferred to explore the casting of Robert Benchley, the commonsensical humorist.

Opposite Hepburn, Cary Grant was cast as Johnny Case, the societal outsider whose professed love for lofty Julia Seton (Doris Nolan) upsets the tenuous harmony of the Seton household. Edward Everett Horton and Jean Dixon were the two free-spirited fuddy-duddies who enter the story now and then to bolster Case's instincts and puncture pretensions.

In the end, it was Lew Ayres who memorably portrayed Ned Seton. Ayres was taken aback to receive a casting call from the director who had tested him, without much enthusiasm, for *All Quiet on the Western Front* in 1930. In the intervening years, however, Ayres had

readied himself for Cukor—proven himself in some thirty motion pictures.

"I was surprised and grateful that he thought of me as the drunken brother," Ayres recalled. "Gee, it was a cute role. It was an opportunity to do something with big, stellar figures. Cukor was still the same but by now I was a different person. I could take him in stride. I didn't try to carry the load. I wasn't bothered by the long exegesis of the characterization."

In his supporting role, Ayres gave off wistful glints, but center stage was Hepburn and Cary Grant's tango. The world of the Setons is seen through the starry eyes of Johnny Case, but the idealism of Case is filtered through Linda, who longs to escape that suffocating world. Necessary to their slow glide was someone—a director—who could identify with both people and feel their desperate yearning for truth and adventure.

As one of Barry's sympathetic rich people, who stores her dreams "upstairs," Hepburn comes on subtly, so understated and integrated into the diverting ensemble as to be at first almost invisible. Hepburn was playing a part she knew well, having understudied Linda Seton on Broadway a decade earlier, and, four years after that, having borrowed a scene from *Holiday* to audition for Cukor and *A Bill of Divorcement*.

Here she was the perfect dance partner, who hung back until the right moment—and then she was there, miraculously, for the step and whirl. By the bravura ending of the film, the audience may be as surprised as Johnny Case to discover themselves ready to run off with her.

Grant's performance, in counterpoint, is robust, as nimble and ebullient as the handsprings he demonstrates at appropriate intervals in the comedy. Cukor was the first director to spot the antic gleam in Grant's eyes, and while Grant was always amusing and sexy in films, he was not as often the way Cukor saw him—not only amusing and sexy but miserable and conniving. He gets the girl here, but—as in *The Philadelphia Story*—no one should think they are going to live happily ever after.

Cukor's ambivalence about Grant, his deeper insights, helped set the actor up as Hepburn's best foil. With Tracy and Hepburn, it was "5-oh, 5-oh." With Cary Grant and Hepburn, it was more a game of dare and double dare. In their best films together, Tracy and Hepburn tended to get comfortable with each other. Any truce between Cary Grant and Hepburn could be safely assumed as temporary.

In many a Barry comedy, as in many a Cukor comedy, there are dark shadings. Real crises: divorce and infidelity, chronic drunkenness, self-destructive tendencies. These are considered an inevitable

part of the social fabric. Neither playwright nor director believed in panaceas or the clichés of a Hollywood happy ending. *Holiday* is not a carefree film; no Cukor film is. It is funny as well as deep, however, the first of his fully realized contemporary adult comedies.

Zaza followed, later on in 1938, another loan-out to justify Cukor's cost to Selznick International Pictures.

An old New York friend, producer Albert Lewin, had invited Cukor back to Paramount. The director was attracted to the project because it was supposed to feature Isa Miranda, the international star from Italy, who was preparing a stab at a Hollywood career. By the time her accent was deemed too thick for American audiences, and Claudette Colbert had become the eleventh-hour replacement, Cukor was already committed to Zoë Akins's script.

The sentimental romance between a music-hall performer and an unscrupulous married man, set in turn-of-the-century France, had the antecedents that Cukor esteemed: It was the third film version of a play that Mrs. Leslie Carter had made famous, on the stage, as a leading lady in 1899. The first film of *Zaza*, in 1915, had been a showcase for Pauline Frederick, while the remake, in 1923, had boosted the career of Gloria Swanson.

Cukor's idea was to enlist Fanny Brice to coach Colbert in music-hall mannerisms, although Brice is uncredited and the results of her coaching not particularly evident. Alla Nazimova was another incarnation of the past for whom a job was created, as technical adviser.*

After *Holiday*, *Zaza* was a sentimental reversion. Cukor's most emblematic films side eloquently with women's flirtations and infidelities. This one, however, adopted a victimized tone, and the Romeo, played by Herbert Marshall, was a drearisome character who didn't seem worth the grief.

The backstage and revue numbers are the highlight: the shrill rivalry between Zaza and Florianne (Genevieve Tobin), and the shtick of Zaza and her faithful consort, Cascart, played with flair by Bert Lahr.†

*Another familiar name in the credits was Edward Dmytryk, editing his third Cukor film. Continuing the early-sound Paramount tradition, Dmytryk, who had directed his own first film in 1935, said he acted as virtual codirector of *Zaza* and did many of the camera setups.

†It was Lahr's first important role in motion pictures. "Cukor edited me," said Lahr. "He would take me aside and say, 'Simple, Bert, simple. Cut it down to half. Give me half of that. You've got a microphone above you. You don't have to kick it out to an audience of a thousand people. Let the camera do the work. You don't have

Although to a contemporary viewer *Zaza* might seem tame and dated, at the time of its completion, the Hays Office found the dance sequences and the infidelity story line prurient and offensive—after *Sylvia Scarlett*, Cukor's second film to encounter concerted moral opposition.

Zaza was denied a purity seal, and there were retakes and re-editing, particularly to temper the cancan sequences. The conventional wisdom among Cukor enthusiasts is that this somehow eviscerated the film as it exists in the present day. But it would be going out on a limb to contend that there was anything outstanding there in the first place.

The publicity-conscious Selznick could not have been heartened by *Zaza*, especially after even the reconstructed version was condemned by the American Legion Auxiliary as "vulgar," by the California Congress of Parents and Teachers as a "cheap and tawdry story," and by the California Federation of Business and Professional Women's Clubs as "outmoded," "distasteful," "cheap," and "disgusting."

At least two of the principal roles in *Gone With the Wind* had been settled.

Forty-five-year-old Leslie Howard could not be convinced that he was still young and romantic enough to play the idealistic Southerner Ashley Wilkes, until Selznick tossed in a promise to let Howard produce his next picture (*Intermezzo*). So Howard signed his *Gone With the Wind* contract "in a spirit of complete indifference," according to one definitive history of the production.

Although Selznick had been preoccupied by the possibility of Joan Fontaine for the part of Melanie, the actress shrugged him off and recommended her sister, Olivia de Havilland—a spirited player whose offcamera love life and court battles against studio contract peonage belied her gentle-hearted screen persona.

The first time de Havilland read for Cukor alone; a few days later she read for David O. Selznick. "This time, while I played Melanie, George played Scarlett," de Havilland told a television interviewer years later "He did this with such passion, such fervor, such dynamism that David was beside himself with enthusiasm. And to this day I think I got the part because of George's performance.

"The biggest problem I had then, or the biggest decision I had to make then, was how Melanie should look. And here again, George Cukor was wonderfully helpful. He said, 'Olivia, there are hairdress-

to reach out to an audience and hand it to them.' He was the first man to try and adapt me to films."

ers that are true to the period which will make you look pretty. And there are hairdressers that are true to the period which will make you look plain.' And I said, 'It's the plain one I want.' And that's the one we used."

Sidney Howard was at his wit's end. The writer had satisfied his professional obligations and delivered a final draft of the screenplay in March of 1938. But Selznick wanted *more* changes and Howard, who couldn't figure Selznick out, had no interest in continuing on what seemed to be an endless job.

A succession of more than a dozen writers, including F. Scott Fitzgerald at one point, labored on portions of the script. Still, Selznick was dissatisfied.

By now, the designated director was only half-interested in the story conferences. For better or worse, Selznick had taken over the script. Cukor had venerated Sidney Howard, though, and it was painful for him to witness Selznick flogging the script, and to realize, finally, that Selznick was a kind of frustrated writer.

The director had grown as weary of the Scarlett O'Hara quest as Howard had of the script. The producer had painted himself into a corner by vowing publicly to discover a newcomer. Selznick had declared in a memo to his staff, "I feel that our failure to find a new girl for Scarlett is the greatest failure of my entire career." Actually that had been Cukor's principal task—and, by implication, Cukor's failure.

There were other things that gnawed at their friendship. Selznick's marriage was on thin ice, and most people close to him knew of his incessant womanizing. Cukor wasn't moralistic about such things, but he had a habit of siding with the wives, especially at divorce time. Cukor was good friends with Irene. And Selznick wasn't being discreet about his affairs.

Selznick was also binging on drugs—Methedrine, barbiturates, whatever was handy. Cukor told intimates, with revulsion, of Selznick crushing Benzedrines and licking the pieces from the palm of his hand, a grain at a time. What once seemed to be Selznick's tireless energy and driving ambition Cukor now perceived for what it was—neurosis, egomania, the seeds of self-destruction. It was no longer fun to keep pace with the producer: his overnight meetings, his ceaseless memos, his professional sloppiness, and his impulsive decision making.

Cukor was precisely the opposite—fastidious about everything, personal and professional, someone who, unlike Selznick, not only esteemed the writer but kept an early bedtime!

While Cukor accepted all kind of excesses from the temperamental

actresses he adored, he did not appreciate bad behavior from the men in his life, either cronies or associates.

To Selznick, *Gone With the Wind* had become the most important production of his career, Margaret Mitchell's novel his bible.

To Cukor, *Gone With the Wind* was (increasingly) an overblown, almost purple melodrama, lacking a speck of truth. As with *Coquette*, the director's impulse was to chuckle at the solemnity of it. All drama, Cukor thought, ought to be tinged with comedy. That was how he viewed life. Where was the comedy in *Gone With the Wind*?

All of these tensions between director and producer were aggravated by the financial crisis of Selznick International Pictures as the months dragged on, the costs escalated, and the personal and professional differences mounted to a showdown.

Meanwhile, Cukor was one of the umpteenth directors brought in by MGM in the fall of 1938, during the making of *The Wizard of Oz*, to consult and advise, embellish, and direct scenes.

Cukor considered L. Frank Baum's children's story "a minor book full of fourth-rate imagery," as compared to the grander things he was brought up on—Tennyson, for example. Cukor was a team player at MGM, however, and after one of the directors, Richard Thorpe, was fired, Cukor responded to an SOS by producer Mervyn LeRoy and agreed to review some of the early footage.

He did not direct any photography in the one week he was on the job. His principal contribution was to remove Judy Garland's blond wig and then to remind her, pointedly, that she was playing just a little girl from Kansas, so she ought not to act in a "fancy-schmancy" way. It was one of Cukor's favorite pieces of advice—and it worked not only for Judy Garland in *The Wizard of Oz*, but for other people in Cukor films.

Meanwhile, Cukor continued to look for another project to cultivate for Greta Garbo. Perhaps he squandered as much time in his life questing after material for Garbo as Selznick spent looking for his Scarlett O'Hara.

His Hungarian colleague Melchior Lengyel told him a story that Cukor liked immensely, about a humorless Russian agent, female, who falls in love with a carefree bachelor in Paris. The idea was sketchy, however, so Cukor introduced Lengyel to Sam Behrman and Gottfried Reinhardt, who began to work together on a draft of *Ninotchka*.

Finally, MGM agreed to loan Clark Gable to play Rhett Butler. However, to seal the bargain, Selznick had to relinquish the distribution rights of *Gone With the Wind* to his father-in-law and MGM, thereby

diminishing his independence and his eventual share of the profits.

Gable did not care to adopt a southern accent, but Cukor insisted that he give it a try. So Gable had some coaching, from a dialect tutor, on the set of the MGM picture he was filming, *Idiot's Delight*, in October of 1938.

The art director William Cameron Menzies, one of the unrivaled visual talents of the era, superseded Hobe Erwin, coordinating all color and design. He was laying out the big setups, the process shots, and the montage sequences. Certain sets had been erected, and most of Walter Plunkett's costumes were now ready. The expensive decision had been reached to film in Technicolor.

The remaining key roles were assigned to Thomas Mitchell, Hattie McDaniel, Ann Rutherford, Evelyn Keyes, and Butterfly McQueen.

Apart from their wavering friendship, several other factors were spurring Selznick to doubt Cukor.

First and foremost, there were the economic considerations. By September of 1938, Selznick was complaining to Selznick International Pictures executive Dan O'Shea, in a confidential memo, that Cukor had proven "a very expensive luxury" to his production enterprise.

Reviewing the history of Cukor's two-year inactivity as a Selznick International Pictures director, Selznick conceded, "There is a large measure of justice in George's statement that this is not his fault. . . ."

However, the producer complained that as a result of Cukor's guaranteed compensation, "We are in danger actually of winding up paying him about $300,000 for his services on *Gone With the Wind*," which would make Cukor the highest-paid director per picture in the business.

"In any event," Selznick concluded, "I think the biggest black mark against our management to date is the Cukor situation and we can no longer be sentimental about it. . . . We are a business concern and not patrons of the arts. . . ."

For the first time, at least as recorded in one of his memos, Selznick wondered aloud whether it might be more advantageous to have someone like Victor Fleming ("a contract director of importance") rather than Cukor come aboard for the actual filming.

At MGM, meanwhile, there was vehement opinion in the legal department that the MGM and Selznick contracts were in distinct conflict (legally "invalid" and practically speaking, "unenforceable"), anyway, and that Cukor's services belonged, properly, to MGM.

For its own program, the studio wanted Cukor back, and in exchange was not at all averse to loaning Fleming out. If there is any

logic to this, it may be that directors like Fleming—brisk, action directors—were a dime a dozen, while directors like Cukor—a dependable "woman's director"—were rarer.

Figuring into Selznick's psychology was L.B.'s warning that Cukor might concentrate on the nuances and intimacies of *Gone With the Wind*, favoring the women in the story line while neglecting the scope and the spectacle. Now that MGM was a partner, Mayer had to be heeded.

Fleming began to loom as Selznick's savior. A former race-car driver who had begun his Hollywood career as a cameraman under Allan Dwan and D. W. Griffith, Fleming was handsome, imperious, authoritative—a flag-waver, skirt-chaser, Jew-hater. He was MGM's undisputed master of male-oriented pictures, including several starring his buddy Gable.

To Selznick International associates, Selznick began to sound like someone who believed all the worst criticisms other people uttered about Cukor. To F. Scott Fitzgerald, during one script conference, the producer vented a warning: "Look, don't let Scarlett romp all over Rhett Butler. George will try to throw everything to her. You and I have got to watch out for Clark." Editor Hal Kern was advised to force the pace of the cutting when filming began and to urge Cukor to speed up scenes.

But Selznick was more or less reconciled to Cukor and his big weekly retainer, until his annual renewal date, at least until early 1939.

When Cukor talked about directing *Ninotchka* with Garbo, that was a last straw for Selznick, who had lost Cukor to Garbo—for months on end—once before. That, plus the financial pressure he was feeling from his friend, John Hay ("Jock") Whitney, a key investor in Selznick International Pictures.

Though the casting was not complete and the revised script was riddled with gaps, Selznick scheduled the burning of Atlanta, with all sorts of attendant publicity, for December 10, 1938.

Director Ernst Lubitsch was once more the beneficiary of a Cukor contract dilemma. Lubitsch took over *Ninotchka*, temporarily abandoning the direction of another studio project that, much against his wishes, he had been asked to superintend: a filmization of Clare Boothe's play *The Women*. (Ina Claire, in one of her infrequent screen appearances, was to survive Cukor's original casting scheme in Lubitsch's film of *Ninotchka*.)

Even as the cameras were set to roll for the first time, recording scenes for *Gone With the Wind*, muted reports of the breach between producer and director had begun to filter to the press.

The New York Times reported on December 19, 1938, that a "closely

guarded battle" was in progress between Selznick and MGM over certain aspects of the production. According to the *Times* account, Gable had been demanding Victor Fleming from the outset, while Cukor might yet be switched to *Ninotchka*, which he had been nursing behind the scenes. Garbo had declined to proceed without him.

The first scene of *Gone With the Wind* to be directed would be a most un-Cukorish one: Actually, William Cameron Menzies would direct the burning of Atlanta, while Cukor peered over his shoulder.

Atlanta—which was in actuality a clever hodgepodge of old movie architecture—was indeed in the process of being burned on the back lot of the Selznick (Pathé) Studio when Selznick's brother, Myron, bustled into view and introduced one of his companions, the British actress Vivien Leigh. Although one would think Cukor must have known of Leigh—if not through his agent, then through Laurence Olivier—he never indicated in interviews whether he had the least foreknowledge of her visit to the set.

Selznick had already viewed some of her films, including *A Yank at Oxford*, and rejected her as a possibility for Scarlett. When the producer turned to greet her for the first time, however, he found himself transfixed by the loveliness of her gaze.

At this point, the routine was for Cukor to run hopeful actresses through certain pivotal scenes. The director had stacks of such scenes in his office, and that evening he and Leigh went over the script in his office. He made light of her British accent and precise manner. "You sound just like Nova Philbeam!" he exclaimed. The humor was a common bond; so was her no-nonsense attitude. From the first, he too was captivated by her.

At last, there was something on which Cukor and Selznick could agree. There were more tests, and hairdo and accent questions, and weeks of negotiation with British producer Alexander Korda before the arrangements could be agreed upon and the announcement made. However, Vivien Leigh was cast—really on the spot, by Selznick—as Scarlett O'Hara.

Not only was he pleased to have her as Scarlett O'Hara but, for Cukor, Leigh became a lifelong symbol of beauty and artistry, and a precious friend.

Gable was not happy. He had arrived on the set unhappy and he grew progressively more unhappy as tests and filming progressed.

Gable was used to being pampered at MGM in vehicles that were contemporary and tailor-made for his masculine personality. A Gable movie did not depend on costumes, accents, or best-selling novels. Gable was haunted by the memory of *Parnell*, one of the few pictures

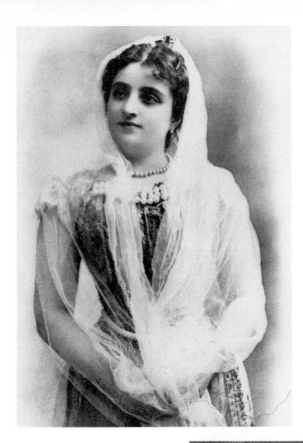

Cukor's mother, Helen, costumed for a family party, in a photo taken some time between his sister's and Cukor's birth.

Teenagers Stella Bloch and Mortimer Offner, in costume for a harlequinade, one of the first Cukor productions.

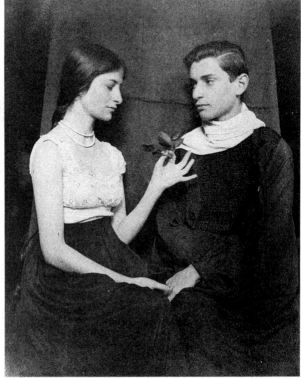

Just out of high school: the budding Cukor, setting out on the road to his career. He was photographed by his friend Mortimer Offner.

Members of Temple Theater Company Arrive for Inauguration of Stock Season Monday

Above: "Cukor's Company." A newspaper photograph of the 1928 stock troupe, arriving to launch the Rochester summer season. From left to right: Benny Baker, Samuel Blythe, Walter Folmer, Wallace Ford, Bette Davis, Helen Gilmore, Mary and Russell Wright (the stage manager), and Irma Irving.

Left: Sheet music for the Cukor musical that never made it to Broadway. *The Dagger and the Rose* mercifully closed in Atlantic City, but Cukor began his career-long habit of leaving the song-and-dance scenes to the professionals.

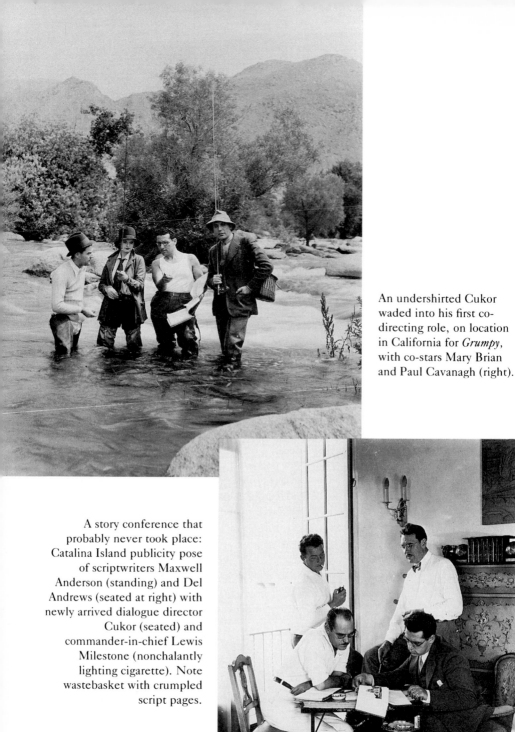

An undershirted Cukor waded into his first co-directing role, on location in California for *Grumpy*, with co-stars Mary Brian and Paul Cavanagh (right).

A story conference that probably never took place: Catalina Island publicity pose of scriptwriters Maxwell Anderson (standing) and Del Andrews (seated at right) with newly arrived dialogue director Cukor (seated) and commander-in-chief Lewis Milestone (nonchalantly lighting cigarette). Note wastebasket with crumpled script pages.

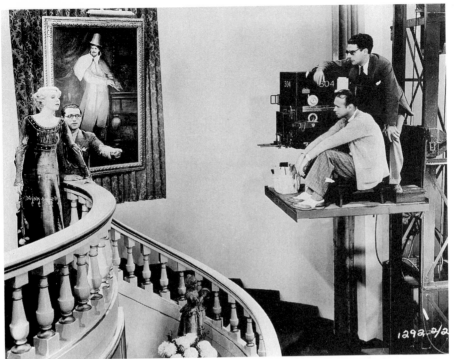

Cukor directs one of his boyhood idols, actress Ina Claire, in a scene from *The Royal Family of Broadway*. With such cumbersome equipment, no wonder camera movement was kept to a minimum.

With Helen Hayes, another Broadway refugee, at one of Lionel Barrymore's parties in the early 1930s. Photograph by Mortimer Offner.

Small talk and big cigars: From left, producer David O. Selznick, writer Ben Hecht (back to camera), directors Ernst Lubitsch (hatted), King Vidor (back to camera), and Cukor. Photograph by Mortimer Offner.

Selznick did things with style. Here, the producer and his retinue sail through the Panama Canal in October 1932, on their way from Los Angeles to New York. At the table are scriptwriter Jane Murfin (who wrote several Cukor films), Cukor, actor Donald Crisp (Murfin's husband), Selznick's assistant Marcella Rabwin, Selznick, his wife Irene Mayer Selznick, and Bea Stewart, Donald Ogden Stewart's first wife. Stewart probably took the snapshot.

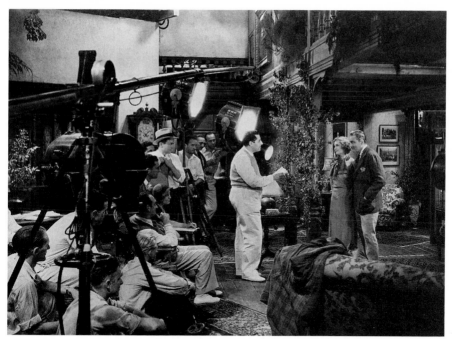

On the set of *A Bill of Divorcement*, with John Barrymore, whom Cukor managed to tame (he had a knack with Barrymores), and actress Billie Burke.

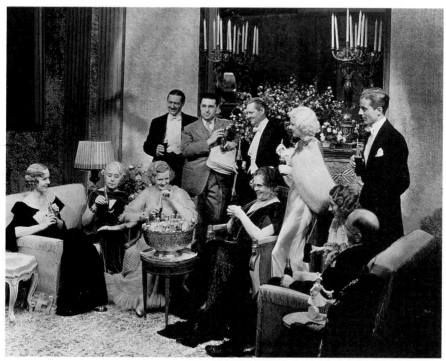

A Coca-Cola break during the filming of *Dinner at Eight*. Left to right: (seated) Madge Evans, Louise Closser Hale, Billie Burke, Marie Dressler, Karen Morley, and Grant Mitchell; (standing) Edmund Lowe, Cukor, Lionel Barrymore, Jean Harlow, and Phillips Holmes.

Lunch and clowning on the set of *Little Women:* from left, Cukor's favorite actress, Katharine Hepburn, her stand-in Adalyn Doyle, Cukor, Mortimer Offner, an unidentified person, and assistant director Eddie Kilroy.

Professor William Strunk of Cornell University, literary adviser to MGM's version of *Romeo and Juliet,* being welcomed to Hollywood (for publicity purposes) by a casually dressed Cukor, producer Irving Thalberg (second from right), and Talbot Jennings, who collaborated with Shakespeare on the screenplay.

that had dared to place him in the nineteenth century, in Ireland: a film notorious in the industry as a flop.

By the time of filming, Gable was refusing altogether to invoke his decidedly ersatz southern lilt. No doubt Cukor had pushed him a little too hard on the subject. The balloon of doubt that floated over Gable's head was reinforced by his friends—and his soon-to-be wife, Carole Lombard.

Lombard, with whom Gable was living in flagrante delicto—during their separate divorces—was one of Cukor's detractors on the Hollywood scene, and he of her.

Ironically, Lombard was quite friendly with Andy Lawler and Tom Douglas, among other people in Cukor's circle. However, the director thought Lombard foulmouthed and uncouth, decidedly vulgar, and friends told the story of the time she came weaving up the walkway to his house, arm in arm with Tom Douglas. Both of them had had too much to drink, and Cukor called Lombard a drunk, barring the door to the shouting and gesticulating actress. Lombard did not hesitate to make known her preference for someone she liked a lot better, Victor Fleming.

Gable felt completely comfortable with Fleming, and distinctly uncomfortable with Cukor. Not only was Fleming Gable's closest friend among the ranks of directors but they shared a lot of the same enthusiasms—hunting and motorcycling—not to mention the same beliefs and prejudices.

"He and Victor Fleming were very macho people and they had great intolerances," said Marcella Rabwin, "One of the intolerances was for gays, and one was for Jews. They always referred to Mr. Selznick and Mr. Cukor in very unflattering terms. They always referred to David Selznick as 'that Jewboy up there' and Cukor was 'that fag.'"

This is a part of the saga that has never been reported.* Nor did Cukor ever speak candidly about this aspect of the differences between him and Gable.

In late January, filming officially began. Cukor started on some of the all-female scenes—grist for Gable, who complained that Cukor was throwing the film to the women. Cukor's attention to costumes and hairdos bothered him. The director's intense mugging behind the camera as scenes were acted also annoyed him. Cukor's ingrained

*According to Rabwin, Fleming and Gable's anti-Semitism was left out of the recent Turner Network documentary about the making of *Gone With the Wind*—even though she reported it in her interview—because such charges were considered distasteful to the image of all concerned.

habit of calling his actors and actresses "darling" bothered Gable even more.

There were conferences with Selznick, and phone calls from Gable to his agent and Louis B. Mayer, but nothing was resolved. Selznick seemed ambivalent, as if he was waiting for Gable to make the decisive move.

There was one additional factor: Gable had been one of Bill Haines's tricks one night many years before, dating back to their meeting when Gable was one of the crowd in a Haines silent film of the 1920s. Versions of this story circulate among old-timers; only Gable and Haines knew the precise circumstances. However, Cukor's friends say that Gable wasn't "trade"; it was a drunken moment.* Sex between Haines and Gable happened once and only once.

In privacy, Cukor would swear to the veracity of this story, and people who knew Haines believed he wouldn't lie about such a thing, either.

In any case, that story was gospel in Cukor's circle, and part of the gospel was that one night Andy Lawler remarked loudly at a big party, "Oh, George is directing one of Billy's old tricks!" That comment went around Hollywood in an instant, and ignited Gable's fury.

Gable went to Bill Haines and said if he ever heard such a thing again, he would beat him within an inch of his life.

Then a most harrowing thing happened. The director was on the set soon after, preparing a shot after a series of awkward moments with Gable. Selznick was there too, as always. Suddenly, Gable muttered audibly, "I can't do this . . . I can't do this scene. . . ."

Everyone was dumbfounded. Because whatever else he was, Gable was an absolute professional. Somebody asked, "What's the matter with you today?" And suddenly, Gable exploded. "I can't go on with this picture! I won't be directed by a fairy! I have to work with a *real man*!"

The atmosphere was deeper than silence. Footsteps echoed on the soundstage. Cukor had walked off. He was beaten. This was a story Cukor told, on rare occasions behind closed doors, against himself.

The next day, Gable simply did not show up for work.

*According to *The New Dictionary of American Slang, trade* has several sexual connotations, including "a person regarded merely as a sex partner," and among male homosexuals specifically, "a man, usually heterosexual, who takes gratification from homosexuals without reciprocation, identification, etc. . . . a man of masculine build attractive to homosexuals. . . ."

For months, Cukor had been proceeding much the way he always had whenever things had gone wrong for him. He had set his jaw with determination and continued to work as if nothing was awry. As ever, he was seemingly full of energy and optimism.

He had found it difficult to subscribe to the script that Selznick had patched together from the final draft by Sidney Howard and contributions by numerous others. He had found it equally difficult to behave as if Selznick wasn't gazing apprehensively over his shoulder. Selznick had become impossible, hovering around the set, second-guessing his every move. Cukor was asked to rehearse and direct scenes in the producer's presence. It was another situation like the one that the director had found himself in with Lubitsch and *One Hour With You*. Not for the first time did it occur to Cukor that Selznick was not only a frustrated writer but a frustrated director, and not equipped for either task.

Cukor tried to muddle through, the way he had during the crises of *Coquette* and *One Hour With You*. Inferior scripts and interfering superiors were familiar to him; he would find no solution to either of them during his long career.

Every indication is that Cukor anticipated a disaster, in some fashion, and to some extent had resigned himself to it.

Selznick, unable to face his friend, dispatched an associate, Henry Ginsberg, to the production site the second week of February. A meeting took place in a small office adjoining the set.

The director's annual one-year contract was due to come up for renewal in February. And so it happened that the timing of Selznick's bombshell announcement to the press had an underlying motivation: The producer of *Gone With the Wind* discharged the director in time to give the required sixty days' notice for exercise of option.

Critic Kenneth Tynan, who profiled Cukor for the magazine *Holiday* many years later, wrote that the blow to the director's pride was "thunderous."

His lifelong friend Frances Goldwyn said Cukor did not yell or scream but that he ate a great number of cakes.

The whitewashed account of Cukor's firing given to the press has reigned in chronicles and histories to this day. The producer's official statement read: "As a result of a series of disagreements between us over many of the individual scenes of *Gone With the Wind*, we have mutually decided that the only solution is for a new director to be selected at as early a date as is practicable."

Louella O. Parsons quoted Cukor's own version in her column as "a refusal [on his part] to continue directing" because the script was inadequate.

Cukor's version was embellished: The director told Susan Myrick, Margaret Mitchell's friend and a technical adviser for the film, that the director and producer had had a showdown over the script. Cukor insisted upon returning to the Sidney Howard version of the screenplay. Selznick told Cukor he was a director, not an author, and that he, Selznick, was the best judge of whether a script was sufficient or not. Cukor said he would not let his name go out over a lousy picture. Selznick's supposed reply: "Then get out."

No doubt they did have more than one conversation about the inadequacies of the script. People who viewed early rushes said the acting was "terrible" (in the words of Ben Hecht) because of the script. Cukor could hardly direct a good scene if the script was bad.

The production would benefit from a shutdown while Selznick concentrated on the problems of the script. And Cukor could be made a scapegoat for the delay and the financial headaches.

In an interview for this book, one of Selznick's close associates related the too-perfect anecdote that the producer wouldn't make a move against Cukor until he went in the other room, telephoned Louis B. Mayer, and got his friend a good job at MGM directing *The Women*. The news accounts were all to this tidy effect.

In reality, *The Women* was dangling without a director, and MGM was plotting to have its best women's director back for the aptly named assignment.

Apart from the personal implications of his differences with Gable, it was not in Cukor's character to whine or rationalize. Yet how could the director explain his firing to the countless interviewers who brought it up over the years?

His conventional reply, at times, was that it happened because Gable felt ill at ease with him. Gable, said the director, thought Cukor didn't understand that he was a screen personality who didn't need much direction, who was all macho behavior, yet effective within his limits.

Other times, Cukor would blank on the memory. He would claim to have no understanding or recollection of what, precisely, triggered his firing. "I don't *know* why I was fired," he would say. It could just be a convenient memory block, he would plead.

Other times still, Cukor would bring up the subject compulsively—to relative strangers, as well as to friends in the close circle—for it was a psychic as well as a professional wound, lodged deep in his soul. He knew the reasons for the firing were complicated. But he also believed that he had been wounded in the place of his worst vulnerability. How to explain that?

When fellow director Jean Negulesco was fired from *The World of Suzie Wong*, he was surprised and touched by a telephone call from

Cukor, who told him, "If it is any comfort, I was fired from the biggest picture ever made."

British director Ronald Neame was a newcomer to Hollywood in the 1950s, and he had never met George Cukor. When Neame was taken off the filming of a W. Somerset Maugham story called *The Painted Veil* (retitled *The Seventh Sin*), he was astonished to receive a phone call from Cukor, who said to him, "I'm phoning to tell you not to worry. It's not going to make the slightest difference to your career, and I should know, because I was the man that was taken off *Gone With the Wind*."

Once there had seemed only friendship and mutual respect between Cukor and Selznick. Now, despite all polite appearances, there would always be the bitterness of this act of cowardice and betrayal.

When the news of Cukor's dismissal from *Gone With the Wind* hit the newspapers, actor Fredric March, whose wife Florence Eldridge had started out with the director nearly twenty years before in summer stock, clipped one of the newspaper items and sent it along with a hastily scribbled note to the director.

The clipping indicated that Cukor was let go because he had "favored the female character over the male."

"Hope you've learned your lesson—F," joked March, one of many male stars who had benefitted from Cukor's direction and knew that he was more than just a "woman's director."

No one should claim that the picture didn't turn out more than just all right—this most enduring and popular of all Hollywood movies.

No one would dare fault Victor Fleming's strong, sensitive direction of *Gone With the Wind*, even if the indomitable female presence who is the backbone of the picture—Vivien Leigh's Scarlett O'Hara—owed much to the original director who moulded it.

The female performances in general—from Hattie McDaniel as Mammy to Laura Hope Crews as Aunt Pittypat to Olivia de Havilland's Melanie—were part of the film's remarkable quality, and so unlike anything else ever credited to director Fleming.

In the end, although there was copious refilming of scenes, there were "several very important" sequences of *Gone With the Wind* that had been directed by Cukor that stayed in the picture, according to Selznick.*

*Gavin Lambert, in his book *The Making of Gone With the Wind*, estimates 5 percent of the actual footage was directed by Cukor, including: "Mammy lacing up Scarlett for the barbecue, Rhett arriving at Aunt Pittypat's with the hat for Scarlett, Scarlett and Prissy delivering Melanie's baby, and Scarlett shooting the Union deserter at Tara."

When Ben Hecht was called in to salvage the script, he met with Selznick and reviewed the drafts. His suggestion was that the producer go back to Sidney Howard's script, which is what was eventually filmed, with Selznick's touches.

Behind the scenes, the two leading actresses—Vivien Leigh and Olivia de Havilland—continued to consult with Cukor.

After the firing, Vivien Leigh and Laurence Oliver spent most Sundays with Cukor. After Olivier went to New York to costar in a play with Katharine Cornell, Leigh would go alone to Cukor's and run over her lines with him.

She was working very hard, harassed by Victor Fleming, always at the point of exhaustion. One afternoon, she dropped off to sleep in a wet bathing suit on a chaise by the pool. Cukor felt nothing but compassion for her. Rather than wake her, when the sun went down, he draped her with a blanket, and she dozed on.

At the Academy of Motion Picture Arts and Sciences ceremony, *Gone With the Wind* won a record eight Oscars. A special achievement citation went to William Cameron Menzies; apart from the big category, Best Picture, the film won the annual awards for Best Editing (Hal C. Kern and James E. Newcom), Best Interior Decoration (Lyle Wheeler), Best Color Cinematography (Ernest Haller and Ray Rennahan), Best Screenplay (Sidney Howard), Best Supporting Actress (Hattie McDaniel), Best Actress (Vivien Leigh), and Best Director (Victor Fleming). Clark Gable, nominated for Best Actor, lost to Robert Donat, the star of *Goodbye, Mr. Chips.*

After the awards dinner, Vivien Leigh and Irene Selznick found themselves alone together in the ladies' room. They gazed into each other's eyes and then exclaimed in unison, ". . . and *he* isn't here"—meaning Cukor. They surprised themselves by collapsing into each other's arms, weeping copiously. "Incidentally," Cukor liked to add when he told this, one of his favorite anecdotes, "on most other occasions there was no love lost between these two ladies."

CHAPTER SEVEN

*A*lmost one month to the day after he was fired from *Gone With the Wind* (he always put it that way—*fired!*), Cukor's contract with MGM took effect, and the director reported to the set of *The Women*.

The first thing he did was pose for stills with the auspicious lineup, which included Norma Shearer, Joan Crawford, Rosalind Russell, Paulette Goddard, Joan Fontaine, and others—largely castoffs, Hollywood wags noted, from the *Gone With the Wind* talent quest. One of the publicity gimmicks was that there was not a single man in the cast.

Cukor and his women were photographed, arms linked, strutting on the MGM lot, a confident smile blazing on the director's face.

The publicity was in keeping with MGM's narrow view of Cukor.

At MGM in the 1940s, beginning with *The Women*, Cukor's reputation as a "woman's director" became, to some extent, a straitjacket. What Ephraim Katz, in his *Film Encyclopedia*, describes as the director's period of "creative drought" was a personal and professional crisis brought on by the death of his mother and Thalberg, Cukor's arrest, Gable's ultimatum during the filming of *Gone With the Wind*, and, more broadly, by the changes in Hollywood from the more freewheeling decade of the 1930s to the more restrictive 1940s.

As much as the studio wanted him, the paradox is MGM wasn't

155

quite sure what to do with him. Cukor liked to joke, rather lamely, that when any outside producer asked for his services from MGM on a loan-out basis, the director was usually handed over with embarassing swiftness. It is no coincidence that most of Cukor's best, most ambitious pictures after 1939 were done for outside producers, and studios other than MGM.

Few of the MGM producers were as admiring of Cukor as Joseph L. Mankiewicz, who worked with the director agreeably on his greatest MGM picture, *The Philadelphia Story*—a property that, in fact, came from outside the studio with all kinds of strings attached.

Among most staff producers, according to Gottfried Reinhardt, Cukor had the reputation of being difficult and contrary. The director seemed to make a point of being "persnickety" (one of Cukor's favorite words). Once such an amiable collaborator with Selznick, now Cukor was thought to be anathema to some producers on the studio payroll who did not want to battle his insistent ideas about script, decor, costume, or casting.

"Not every producer wanted to work with George," Reinhardt said.

There were many times in the coming decade when Cukor would be in studio executive Benny Thau's office haggling with the company men over irreconcilable differences. The respected producer Arthur Hornblow, Jr., it was said, was ordered off the set of *Desire Me* and told by the director to make his future appointments with him in his office by phone. Partly as a result of Cukor's intractability, that film ended as a fiasco.

MGM's inability to comprehend Cukor began at the top of the hierarchy, with the producer of producers, the company patriarch, Louis B. Mayer, whose behavior and attitudes informed everyone else's at the studio. Mayer had a distinctly wary attitude toward Cukor, a man whose films the critics prized (they were not Mayer's favorites) but whom the studio head did not understand or like personally.

Mayer himself had let Bill Haines go when sound was ushered in and all the obviously gay leading players purged from the screen. (Late in life, Haines gave published interviews in which he called the sanctimonious studio executive "a liar, a cheat, despicable.") Unlike his more broad-minded sons-in-law Selznick or Goetz, a staunch Democrat, Mayer, a flag-waving Republican and friend of the Roman Catholic prelate Francis J. Spellman, had little grasp or tolerance of homosexuality.

Mayer was bewildered that Cukor was such good friends with both of his daughters. He didn't understand the nature of their relationship. Mayer was irritated, too, that Cukor was so much the opposite

of his conventional idea of a homosexual—so adamant about his point of view, so defiant and proud, so rhino-hided.

In his book, *Let Me Entertain You,* producer David Brown tells an anecdote about a meeting between Mayer ("who was somewhat to the right of Attila the Hun") and Cukor. According to Brown, Mayer had discovered that this "distinguished director of memorable earth-moving love scenes with the most glamorous actresses in the world, might himself not like women." Cukor was summoned to Mayer's sanctum sanctorum, wrote Brown. In a near whisper, Mayer said, "George, this is a very important matter. A very serious matter. You must answer me truthfully because I must know." Cukor said, "But of course, L.B., what is it?" "George," stammered Mayer, "tell me are you a . . . homosexual?" "Dedicated," Cukor is said to have replied without hesitation. Without a word of reproach, Mayer turned his back and began reading his mail. "Even Louis B. Mayer's homophobia," concluded Brown, "gave way to the higher needs of business, money and stockholders."

A revealing anecdote—mainly for what it reveals about Cukor's wishful storytelling, for it certainly came from Cukor and is just as certainly apocryphal. No one should imagine such a conversation actually taking place.

More to the point may be the tale of a birthday party for Irene Selznick at the Mayer residence, at which Cukor and other noteworthy MGM people gathered. Mayer was host. At one point in the festivities, the head of the studio stood up to make a toast and began by mentioning everybody at the table, offering effusive flattery to each of the important directors by name—except when he came to Cukor. Despite the fact that Cukor was the highest-paid MGM contract director, Mayer felt himself at a loss for words. He hemmed and hawed, and finally said, "And George Cukor, who is also a fine director . . ."

Cukor spoke up sharply, "I beg your pardon! I am a lot more than a 'fine director.' I am an extremely good director, and I am as good as anybody else at this table!" Irene said nothing, while everyone else in the room expected some kind of reaction from Mayer. Yet the imperious studio head appeared to be somewhat chastened, and without comment he passed over Cukor's remark.

The director knew that Mayer didn't regard him as "his man." He realized, somewhat forlornly, that Mayer didn't think much of him as a director. That bothered Cukor. He could be surprisingly wistful about the studio head whose rigid notions about "public morals" were written into the standard "moral turpitude" clause of MGM contracts; the studio head whom, in interviews, he always described as a "wise showman."

157

(Indeed, Cukor was susceptible to all of the studio father figures—not only Mayer but Darryl Zanuck, Harry Cohn, and Jack Warner. Throughout his career, he sought their approval. He confessed to *liking* them.)

Cukor liked to tell a story about himself, dating back to the early 1930s. A producer on the MGM lot, impressed by *Dinner at Eight*, tried to interest the director in one of his projects. He wined and dined Cukor, he sweet-talked him, he coaxed him. Cukor simply wasn't interested. Cukor told the producer the picture-to-be was "a piece of shit." The producer changed his tack. He threatened to have the director fired unless he started behaving like a "company man." "Sir, you have stiffened my resolve," Cukor liked to quote himself. "Go fuck yourself!"

Now—after what had happened on *Gone With the Wind*—Cukor was more eager to please. The director was of particular value to MGM, at this point in time, for purposes of handling actresses with studio sinecures, especially a trio of them who were approaching middle age and mid-career crises—Norma Shearer (adrift without Thalberg to guide her career), Joan Crawford (considered past her prime), and Greta Garbo (increasingly picky about projects).

With these three actresses especially, Cukor was to be relegated to tricked-up melodramas, stage froth, and mannered comedies that were pegged as star vehicles and women's stories. Such films were throwbacks for Cukor, at a time when he ought to have been expanding his horizons. The director's "resolve" was broken down, however. To prove himself a company man he did a number of penitent pictures that he bemoaned privately in letters to friends.

Based on Clare Boothe's Broadway hit about a pack of women who gush and gossip about each other's romantic tribulations, *The Women* is one of those Cukor films that boasts an inflated following nowadays.

A former sports reporter, who had been on the MGM staff since the 1920s, was the producer. Hunt Stromberg was profit-minded, never artistically inclined. His prevailing trait was interminably reworking his films in the editing room, hardly a Cukor characteristic. Stromberg was easygoing, however, and he and Cukor established an accord. *The Women* was the first of two films directed by Cukor with Stromberg as producer.

According to scriptwriter Anita Loos, censors had whittled away at the racy dialogue of the script even before Cukor arrived to take charge. Loos was summoned to the set by the director and assigned the job of "putting the laughs in where the censors had take them out. . . ." Donald Ogden Stewart was also on the sidelines, pitching in humor.

Despite its much-publicized all-female ensemble, *The Women* was, when stripped to its core, a Norma Shearer vehicle, with Irving Thalberg's widow cast as the virtuous wife rejected by her masher of a husband. The husband is never seen, only talked about.

Because the director found it difficult to shed tears for the sanctity of a marriage under stress, the central story has little emotional pull, while all of the comedy—and entertainment—is on the periphery. The banter is caustic, the lines oozing with double meaning.

For anyone closely studying Cukor's career, *The Women* bears evidence of the director's haste, his eleventh-hour arrival, and his general disinterest. Scenes are unusually choppy, elaborate tracking shots serve no purpose; backdrops and decor are unimaginative. A superfluous fashion-show interlude—in color, easy to snip out—was filmed by someone else. At 132 minutes, the picture is, to put it kindly, overlong.

Even the performances, acclaimed in their day, seem overripe by today's standards. Tearful outbursts alternate with dueling-eyebrow repartee. Joan Crawford (as the social-climbing shop clerk) is all bristle and thorns. Rosalind Russell (a troublemaker) is arch fun, but Joan Fontaine (badly treated by a man) is just kind of whining and terrible.

Cukor got his best results from Dennie Moore, as a beautician (he used the actress again and again in small, effective parts in his films), and from two old-timers, Lucile Watson and Mary Boland.

When Watson, playing the Shearer character's mother, gives her daughter the sensible advice to forgive and forget her husband's womanizing, the moment is surprisingly genuine. Typical of the elder great ladies in Cukor's life and films, Boland plays an oft-married dowager. Swept off her feet once too often, she nonetheless takes her marriage failures philosophically. "Oh, l'amour, l'amour, how it can let you down!" is her refrain, a sentiment that Cukor could endorse.

At the time, there was a freshness to the all-woman story line, and—considering what had just happened to Cukor and *Gone With the Wind*—an appreciation for the film's latent context. Modern audiences enjoy the barbs and interplay between the women as much if not more—those scenes that mirror the bitchery among friends that went on in Cukor's suede-walled drawing room.

Next, in short order, was *Susan and God*, from a script by Anita Loos, based on a Rachel Crothers play. It starred Joan Crawford and Fredric March, along with one of those quintessential Hollywood supporting casts that seemed to have all the best lines.

Cukor and Crawford's professional relationship dated back to the filming of *No More Ladies* in 1935, when he took over the direction,

uncredited, from an ailing E. H. Griffith, who had collapsed with pneumonia. Cukor gave Crawford what she called the "roughest time" she ever had from a director.

On their first film together, Crawford liked to say, Cukor barely tolerated screen stars and felt quite certain at the outset that his leading lady was artistically inept. Crawford had one speech in the film that she delivered as a trumpet blast. She said she never forgot how the director took her aside and told her, "You've remembered the words, now let's put some *meaning* into them. . . ." The actress said she was raked over the coals until she gave every word "meaning."

Cukor had a soft spot for Crawford, a weakness, although she never measured up to his other female stars: His four pictures with her, taken together, would add up to a dull retrospective. The director was loyal to their friendship, and his public attitude toward her, and their films together, was fondness. Yet in private, he ridiculed her acting, and his letters were sprinkled with jibes at her expense.

Susan and God was the least of the three pictures that Cukor was obliged to make with Crawford in the early 1940s. As the society lady who discovers religion while misplacing her family, she runs her voice up and down the register but achieves neither the comic spirituality nor the hoped-for stirring catharsis.

The film can be recommended only for the contrasting intensity of Fredric March, her costar. March, with his pork-chop face, plays her alcoholic husband, trying to win the heroine back for the sake of their daughter (Gloria De Haven). Cukor's films are full of sympathetic alcoholics—curious, for a teetotaler. However, March's haggard believability is at odds with the dreary comedy, as if he had stumbled through the door of the wrong soundstage.

While Cukor was in the latter stages of his *Gone With the Wind* ordeal, Katharine Hepburn had been busy touring the nation in a play of Philip Barry's that the high-society playwright wrote—and rewrote extensively during rehearsals and tryouts—expressly for her.

The comedy revolved around a tintype of Hepburn. The character, Tracy Lord, is an egocentric socialite whose plans for the perfect second wedding are rocked by the arrival of some unwelcome guests—including her ex-husband.

The national tour and Broadway run (415 performances) of *The Philadelphia Story* were so successful that the play was widely regarded as having reestablished Hepburn with audiences. Hollywood was not convinced, however. Warner Brothers wanted to purchase the film rights for actress Ann Sheridan. MGM wanted the vehicle for Joan Crawford. Twentieth Century–Fox wanted it for anyone they could

get. Everyone wanted *The Philadelphia Story*, but nobody wanted Hepburn.

At the time, in late 1939, Joseph L. Mankiewicz was producing MGM pictures (Louis B. Mayer wouldn't let him be a director, because he considered directing a lesser function). One day, Mankiewicz received a summons to appear in Mayer's office, where stood, in front of Mayer's desk, the tall, rather thin, and shambling Howard Hughes. The reclusive inventor-aviator-industrialist, it turned out, owned the rights to *The Philadelphia Story*, somehow in conjunction with Hepburn.

Billionaire Hughes declared he would sell the play to MGM only if Hepburn could play the part she had created on stage opposite not one but two top male stars presently under contract to the studio. Hepburn wanted more than one leading man, Hughes explained, to ensure her comeback. She preferred Clark Gable and Spencer Tracy, added Hughes, but that part of the arrangement was negotiable.

Mayer was intrigued that Hughes would make a personal plea on Hepburn's behalf. He sent Mankiewicz east to take a look at the play again (Mankiewicz had seen it once already). Mankiewicz took the unusual step of making a tape recording of a performance so they could monitor where the laughs came. He spoke with Philip Barry about perhaps writing the screenplay, and creating an equal, second male lead. But Barry asked for a "solid gold train" in payment (Mankiewicz's words), and consequently MGM shunned the playwright's services. So Mankiewicz began to fiddle with an outline himself.

He hit on the idea of taking the character of Tracy Lord's brother virtually out of the script and combining his early scenes with the ex-husband's, one C. K. Dexter Haven, building up the ex-husband's part. Mankiewicz wrote a fifty-page treatment—beginning with the preface of the film, the drumroll and the golf clubs and Dexter's roughhousing with Tracy Lord.

Back in California, Mankiewicz took his treatment to Howard Hughes. For some reason, they had to meet at the top of Mulholland Drive; Mankiewicz had to walk from his car to Hughes's limousine, where a guard stood by while Hughes pored over the pages. "Very mysterious," said Mankiewicz, "like Howard always was." Hughes liked what he read. Mankiewicz's outline was approved, and the sale went to MGM.

Donald Ogden Stewart was a natural to develop the screenplay, adding a couple of original scenes "very much in the manner of Barry himself," in Cukor's words. Along with Hepburn and Donald Ogden Stewart—well after all of this was settled and in motion—Cukor became the obvious choice as director.

In Philip Barry's play, it was Tracy's brother who brings the two

reporters to the wedding. In Stewart's screenplay, C. K. Dexter Haven has invited the two snoops in exchange for a vow, from a tabloid publisher, to keep hush-hush the extramarital philandering of Tracy's absentee father. However, Dexter has an ulterior motive for being there: Even though she divorced him for drunkenness, he still carries a torch for Tracy Lord.

One of the snoops—a high-minded novelist named Macaulay Connor, who is moonlighting as a gossip hound—decides he is in love with the irresistible Tracy Lord, too, even though in general he has contempt for rich people. In the comic free-for-all that ensues, Tracy Lord gets wise to a few things about herself, loses her fiancé (a social climber anyway) and rejects Macaulay Connor, then—just as the wedding march sounds—is propelled back into the arms of her ex.

Although it was Hepburn's spotlight, Cary Grant and James Stewart had the other key parts, as C. K. Dexter Haven and Macaulay Connor, respectively. Ruth Hussey got to play the wisecracking dame reporter, and John Howard (the spurned groom), Roland Young (a lecherous uncle), John Halliday (Tracy's unapologetic father), Mary Nash (her noble mother), Virginia Weidler (her brat sister), and Henry Daniell (the disreputable publisher) had democratic screen time in featured parts.

Stewart's role as a love-struck reporter was a particular change of pace for someone just finding his career niche as a man of the people, and Cukor had to fight the actor's "aw shucks" mannerisms.

Katharine Hepburn remembered that Stewart struggled with his love scenes. One day, the actor was having such trouble with his showcase speech—"You've got fires banked down in you, hearth-fires and holocausts"—that Cukor had to stop the cameras and have a word with him. Noël Coward just happened to be visiting the set, and almost as if by prearrangement, Cukor's friend—a consummate smoothy of stage and screen—stepped up to Stewart and told him how *devastating* he was in the part.* Cukor took advantage of that moment of flattery to roll the cameras again. This time, he got a good take.

Again Cukor's strategy was to keep Cary Grant close to his actual self: charming but exasperating, a mite empty at the heart. C. K. Dexter Haven's contempt is not only for Tracy Lord but himself. The twist ending, when it comes, seems a revelation of actor as well

*Cukor and Noël Coward were longtime friends. Around this time, too, in August of 1940, Cukor was involved in staging *The Astonished Heart* from Coward's *Tonight at Eight* at El Capitan in Hollywood. Cukor's rare theater stint was part of a benefit for a British war-relief fund.

as character, a burst of optimism that is not only gallant but foolhardy, the two qualities Cukor liked in combination.

Cast perfectly, Grant responded with one of his quintessential performances. Only for directors Howard Hawks and Leo McCarey would he ever be as recklessly romantic.

The challenge in Hepburn's case was to recreate a performance that perhaps had already grown stale on the stage, a challenge Cukor faced often—usually well—in his career. Under such circumstances, when an actor or actress was overly familiar with a scene, the director said he liked to "throw" them a little bit just before filming with some small comment that jostled the interpretation. The actor would endeavor to incorporate the director's suggestion. The *value* of the scene would come out then, but the execution would seem fresh to them both.

Cukor realized that Hepburn's actressy excesses were sometimes overbearing, but he liked that in a performer. He preferred the problem of toning down excesses to turning everything up a notch. "Less" was one of his favorite directions, quoting Professor Strunk, the editing and Shakespeare expert he met during the filming of *Romeo and Juliet*. According to producer Mankiewicz, both Hepburn and Cukor had learned some lessons since their earlier films.

"Kate, in her early years, was on the verge of being very mannered," said Mankiewicz. "Cukor wasn't going to call her on that—because those were his early years, too. I think he had as much to do with her being 'box-office poison' as she did. So when they came together on *The Philadelphia Story*, they were both older and wiser, and they worked together very well. George put her at her ease, and Kate needed to relax."

With Cukor, Hepburn was more comfortable "playing herself." Not for this director did she don the crown of Scotland or slap on Oriental makeup. Cukor knew Hepburn too well for that nonsense, and part of the fascination of *The Philadelphia Story*—the sensation is uncomfortable when the text criticizes her character so strenuously—is that Hepburn was being presented by people who knew her inside and out, writers Barry and Stewart, and director Cukor.

With the possible exception of *Adam's Rib, The Philadelphia Story* may be the best Cukor comedy. As raucous as it is at times, it is also civilized in a way that keeps it fresh today. The values are grown-up. And if the characters and situations are dated, the acting is not. The people seem spontaneous, the interactions so natural and nuanced that it seems no longer acting but behavior—Cukor's favorite kind of acting.

Among its Oscar nominations in 1940 were Best Picture, Best Director, Best Actor (James Stewart), Best Actress (Hepburn), and Best

Supporting Actress (Ruth Hussey). The two Stewarts, James (his only Oscar) and Donald (his only Oscar) won. In his autobiography, Donald Ogden Stewart, ever modest, wrote that it was the easiest job he ever had in Hollywood, so perfect was Philip Barry's play.

A Woman's Face, Two-Faced Woman, and *Her Cardboard Lover* were all glossy studio bundles directed within the span of the next year, 1941. From the outside, such an energetic burst might have seemed like a run of productivity, but in fact Cukor was working at a faster pace than he preferred, directing scripts that could have used revision, doing films that at another time he might have flatly refused.

A Woman's Face was precisely the kind of film they specialized in and did better at Warner Brothers—a hard-edged suspense thriller about a beautiful scar-faced lady with a shady past; radical cosmetic surgery repairs her disfigurement, but criminal associations from her past haunt her. Warner Brothers would have played it to the hilt. MGM pulled its punches with all sorts of cop-outs. (Lady Scarface, for example, plays classical piano!)

The script was based on a French play that had already been made into a Swedish film starring Ingrid Bergman. There were at least thirteen writers on the American adaptation, among them Christopher Isherwood, the British poet and writer who was on the fringe of the Cukor circle. The final credit went to Donald Ogden Stewart and Elliot Paul. However, Stewart's polish was not enough for this, the least distinguished film among his collaborations with Cukor.

The British expatriate Victor Saville was producer. Melvyn Douglas was the male lead, playing the doctor who performs facial surgery on the Crawford character. The star of *The Cabinet of Dr. Caligari*, Conrad Veidt, took the only memorable turn, as the fiend of the piece.

Joan Crawford liked to say that she really won her Academy Award as Best Actress not for *Mildred Pierce* a few years later but for her performance in *A Woman's Face*. She and Cukor liked to kid themselves about the quality of their work together. Her acting is solid, especially in the first half of the picture. In the second half, though, the story collapses into pure melodrama, climaxing with a ludicrous sled chase to abort the villainy.

Much of the effect of her performance, in any case, depends on the evocative manner in which Crawford was photographed. Indeed, when one is praising any of these more dubious Cukor films—and many film critics do—usually what is being praised, in some vague fashion, is the lighting and camera work, the pictorial embroidery of studio craftsmen.

Two cameramen whose careers dated back to the silent era, Robert Planck (*Susan and God, A Woman's Face, Her Cardboard Lover*) and

Joseph Ruttenberg (*The Women, The Philadelphia Story, Two-Faced Woman, Gaslight*), were Cukor's mainstays at MGM during the 1940s. Their technical virtuosity was much admired in Hollywood. They photographed many films that, however middling in other ways, were visually hypnotic.

Her Cardboard Lover was another morsel, costarring Norma Shearer and Robert Taylor. A phalanx of writers labored on revamping the French boulevard farce that had been one of Cukor's Broadway productions, about a lady who employs a gigolo to impersonate her lover. The lifelessness of the film only served to underline how far the director had drifted in his own emotions from such vapid silliness.

Although he was tenderly convincing in Cukor's *Camille*, Robert Taylor is wasted here. Suffice it to say of Shearer's painfully sincere effort that, after two decades in movies, *Her Cardboard Lover* proved her final screen appearance.

Two-Faced Woman, with Greta Garbo, was likewise based on a play, one that had been filmed twice before: *Die Zwillingschwester* or *The Twin Sister* by Ludwig Fulda. Garbo's trusted writers, Salka Viertel and S. N. Behrman, had been laboring for some time to update the story, before George Oppenheimer joined the team. Cukor was of little help in the story sessions—he seemed more interested in what Garbo was going to wear—and the script was still being revised as filming began.

Against Garbo and Cukor's wishes (they both thought he was inferior as a romantic lead), and against his own (he preferred to devote his time to the war effort), Melvyn Douglas was held to his MGM contract and cast as Garbo's foil. The comedy, such as it was, revolved around the antics of a ski instructress who pretends to be her own identical cousin in order to spy on her husband.

Producer Gottfried Reinhardt had an ambivalent relationship with the director, dating back to the time of *Camille*. "We certainly didn't get on professionally, at all," said Reinhardt. "He [Cukor] was a type of man that I didn't really go for. His homosexuality—even though I have had many good friends who were homosexuals—his homosexuality bothered me. Perhaps, above all, because he was so ugly, and that made it ludicrous."

Cukor wore Reinhardt down with his insistence on casting old friends Constance Bennett and Ruth Gordon in featured parts. Their inadequacies, in Reinhardt's opinion, hurt the picture. Reinhardt got his own back by insisting that second-unit maestro Andrew Marton be available to supervise the downhill skiing that was filmed at Sugar Bowl Lodge in Norden, California, up near Donner Summit—some

of the outdoors scenes were cut, and some were spliced into the beginning of the story.

"We [Reinhardt and Cukor] had too many fights on that film from the very beginning, from the script, from the way he shot," said Reinhardt.

Some of the worst fights were over Garbo's wardrobe. Cukor announced to Hedda Hopper, in her column, that he wanted Garbo to look "as she does in reality." So he permitted the actress to dress in "bulky, ugly clothes," in the words of cameraman Joseph Ruttenberg, outfits that wouldn't photograph well under any conditions. The wardrobe department came to a standoff with the director. Cukor's outright rejection of multiple designs and fittings, for Garbo, was a factor in MGM costume designer Adrian's eventual decision to quit the studio and open his own establishment.

The resulting picture is so mild that it is hard to imagine all this behind-the-scenes fuss—hard to imagine, too, that after filming was completed censorship wardens would get so exercised over the relaxed morality of *Two-Faced Woman*. That is what happened, however.

After *Two-Faced Woman* was previewed, the Legion of Decency slapped the film with a condemnation for having an "immoral and un-Christian attitude toward marriage and its obligations; impudently suggestive scenes, dialogue and situations; suggestive costumes."

Archbishop Spellman personally flew out to Hollywood to view Cukor's film in the MGM screening room. He deplored what he saw as indecent. According to Reinhardt, Spellman was insistent that the hero of the picture appeared to be making love to "another woman," even if in the story line it was really the *same* woman. Spellman wrote a letter to be read in the churches of the New York diocese publicly excoriating *Two-Faced Woman* for its "sinister" moral influence.

Even if Spellman had not been Mayer's good friend—"totally under Spellman's spell," in Reinhardt's words, "he [Mayer] gave him [Spellman] ten million dollars in his will, you know"—the studio would have feared losing the national audience of Catholic filmgoers.

At Spellman's behest, there were "massive rewrites" and "massive retakes" and in the process the film was "completely butchered," said Reinhardt. Cukor did his disappearing act sometime during the turmoil and moved on to his next assignment. When Spellman returned to see the new version the studio had patched together, he gave it his seal of approval. Reinhardt does not claim that the film was *ever* any good, but *Two-Faced Woman* ended up an insufferable mishmash.

If *Camille* is Garbo's best performance, her best film, *Two-Faced Woman* may be her worst. Nobody could blame Cukor, but there had to be moments when he blamed himself. Although no one could have

predicted that *Two-Faced Woman* would be the last film of this screen immortal, the director had a premonition about it.

One day during the filming, Cukor said he came upon Garbo sitting in front of her dressing table and mirror. She looked very sad. She gazed up and said to him, "I am old!" He said, "No, you are beautiful!" She said, "No, look! . . ." There were two or three almost invisible lines that ran from her mouth upward. "Those lines will get deeper," she told him. "I must quit."

It's true, Cukor thought, she should quit. She is in a private hell.

Cukor's last film before World War II was the politically relevant *Keeper of the Flame*, about a public figure, mysteriously killed, who is revealed by an investigative reporter to have been the leader of an American fascist movement. Katharine Hepburn was to play the great man's widow, and Spencer Tracy the newsman digging beneath the public facade.

By now, the world was in the grip of dramatic political events: Germany had conquered much of Europe and was bombing England. The Axis alliance had invaded the Soviet Union. With the bombing of Pearl Harbor on December 7, 1941, America had finally entered World War II.

Even before the outbreak of hostilities, however, there had been tremendous political ferment in Hollywood over labor, race, migrant, anti-fascist, and California campaign issues. Many of the director's acquaintances had grown increasingly politically aware: Many celebrities, such as Katharine Hepburn, were stalwart supporters of liberal issues, while others, such as Donald Ogden Stewart, who had become a spokesman for the Hollywood Anti-Nazi League, had embraced more radical political views, and given over much of their spare time to left-wing causes.

Although Cukor was a registered Democrat, he could not have been less interested in politics per se. "He never uttered a political conviction," friends say.

Yet Cukor gave in to the general air of political consciousness in small ways. Privately, he was helpful to the European refugees streaming into Hollywood, especially those from Hungary. He might lend his name to the letterhead of one of the anti-fascist committees, especially if coaxed by the fact that they were headed by Bea Buchman, the wife of *Holiday* coscriptwriter Sidney Buchman.

He put limits on his gestures, however. Once, Cukor bought a painting from Stella Bloch, knowing full well that the proceeds were going to a left-wing cause. Like Donald Ogden Stewart, the Eliscus had become politically radicalized; they believed that fundamental change was necessary in the American economic system, and this

commitment put a strain on their relationship with Cukor. Stella Bloch tried to talk to Cukor about her beliefs. The director didn't want to know which cause his money was going to, and he put his longtime friend off.

"He said that capitalism had been very good to him, thank you," said Bloch.

Thus it must have seemed somewhat astonishing when a parable about American fascism was directed by Cukor, especially at a point in time when many Hollywood films were taking a turn toward war-alertness themes. After all, the United States had already entered the war against the Axis militarists, and foreign dictators were more to the point than homegrown ones. The high tide of Hollywood films of social consciousness, dating back to the early 1930s, was over.

Yet, like Cukor's other social-conscience gestures, this one was on behalf of a friend, Donald Ogden Stewart. Stewart fought to adapt I. A. R. (the *I* for Ida) Wylie's novel, which had been purchased in unpublished form by MGM, as a kind of testament to Stewart's own sincere political convictions. The novel was willfully oblique, but Stewart had shaped his film script into a pointed political drama, underplaying the love story.

However, there was resistance to Stewart's uncharacteristically meaningful script from, of all people, Katharine Hepburn. She wanted more romance, and to return to the sense of the book, where the male character was an "impotent eunuch," according to Stewart, "who plays sad love scenes." Stewart wrote to his wife, the journalist Ella Winter, to complain that Hepburn was undercutting his script. "I created an intelligent male with action as his keynote. . . . Is it not interesting that Miss H., not being an active character in the story, is Goddamned if there will be an active male in the same story?"

Hepburn had a showdown with producer Victor Saville, and when Saville backed Stewart, she took her complaints over his head to studio executives.

Although Stewart felt that Hepburn's stand was not really about the script ("it is for control"), he felt she had betrayed him "dirtily" by appealing to her "real enemies," the "Top Bosses." And he wrote his wife that he believed Cukor had acted cowardly by not speaking up against Hepburn in favor of the more hard-hitting version.

"Cukor has turned yellow completely," Stewart wrote his wife in June of 1942, "[and] with two bad pictures on his heels (they say *Cardboard Lover* is unbelievable) is afraid to tackle something that is hard and not lush (Remember that David Selznick took him off *Gone With the Wind*, presumably at the insistence of Gable that a fairy shouldn't direct a picture with any guts).

"I shall not resign as long as there is a chance to save the 'message'

(not my face)," Stewart continued. "Is it not humiliating that all the discussion now takes place without my being allowed to participate. . . ?"

In the final analysis, Hepburn was more influential with Cukor and MGM than was Donald Ogden Stewart. After *Woman of the Year*, earlier in 1941, Hepburn had gone under contract to the studio, and was no longer considered to be "box-office poison" but box-office pay dirt. Hepburn applied her star leverage. She got her way, and Zoë Akins was brought on the picture by Cukor, to make some uncredited revisions.

The picture turned out to be a disappointment to all—smoky and fiery in spurts, but at crucial moments, either souped up or watered down. In Cukor's career it is an intriguing oddity.

Neither Hepburn nor her director could much credit the female character who spent her life in the great man's shadow. The love story between the dogged reporter and the famous man's widow seems as trite and tacked on now as it must have seemed to scriptwriter Stewart back in 1941.

Many years later, Cukor said that the acting—especially Hepburn's—was as artificial as the fir forests, prop-room thunderstorm and soundstage mansion. He said he never really believed in the story (it was "pure hokeypokey") and Hepburn's part was just plain "phony."

With wartime preparedness sweeping the United States, Cukor had more than one reason to ponder losing weight. He had tried to do so before, many times, but it was not until the early 1940s that he embraced the rigorous regimen that finally did the job.

There had long been wisecracks about his cheating on diets and his protuberant behind. Back in the early days of talkies, people told about the time a Paramount sound man heard a strange noise coming over the microphone. It took several minutes for people to realize it was the director's stomach grumbling, already, only one hour after lunch.

Cukor's conspicuous eating habits (he loved Hungarian iced cakes, crystalline fruit, salami) and "hugely fat" (Katharine Hepburn's words) profile made his weight a topic of conversation and good-natured jokes in Hollywood.

No matter what measures he tried, Cukor stayed fat. The fact that he was unattractive physically was a disaster for him for one reason: he could never be totally comfortable with his homosexuality. For in that world, especially, a premium is put on looks.

"Naturally he would be self-conscious about his looks," said the actor David Manners, "because he was not an attractive guy. Big,

round, a rather prominent nose, black hair and all—not a physical beauty by any means. And maybe that had an effect on him."

All of a sudden, with the onset of World War II, Cukor, "the least sports-loving person in the world," according to one of his friends, turned a spare room into a gymnasium and hired a French physical instructor. He was joined by Greta Garbo and others, and they began a schedule of regular workouts. Also, Cukor began to take early-morning laps in his swimming pool, which he always kept unheated.

His weight-loss aids were extreme and, to some, horrific—he enlisted all kinds of dubious measures, including regular doses of NuJol, a kind of mineral oil that was tasteless and colorless but decidedly potent.

Cukor still served sumptuously at his own table. But he began to eat more sparingly, albeit with terrifying speed, all the while encouraging others to have seconds or thirds. He began to carry a paper sack of his own dietary preparations to other people's houses for dinner. His own prepared lunch was taken every day from the house to the motion-picture set.

Though Cukor had gone through many cycles of dieting before, this time he was startlingly successful. People were fascinated by his almost symbolic act of transformation, this self-discipline and self-denial, by a man who so loved to eat. Many people commented in interviews on the change in the director's appearance that took place around the time of the outbreak of the war.

Stella Bloch is one who thought that Cukor lost a lot of the character in his face. "He lost his flawless olive complexion and his youthful bloom," said Bloch. "His drawn face acquired a grim expression."

In years to come, Cukor would have to be vigilant against poundage, but the rotundity that people had associated with him was gone forever. When the transformation was complete, the director sought out Bloch and confided to her proudly, "You know, now I'm really thinner than Morty!"

When Pearl Harbor was bombed on December 7, 1941, Cukor was forty-two years of age. Among his immediate peers, director George Stevens was not quite thirty-seven, William Wyler was thirty-nine, Frank Capra was forty-four, John Ford was forty-six.

Stevens, Wyler, Capra, Ford, and many other Hollywood figures quickly joined the military. Why Cukor refrained from enlisting for almost a year is unclear. When Pearl Harbor was bombed, *Two-Faced Woman* was being recut and *Keeper of the Flame* was in development, true. Other film directors left behind projects to join the war effort, however.

Stevens, Wyler, Capra, and Ford—and others—quickly received

special appointments or commissions. Cukor's belated enlistment, in the fall of 1942, brought him the status of a private in the Signal Corps.

The director traveled east by train and by late October was a cog in the basic-training machine at Fort Monmouth, New Jersey. His salary as a private was set at fifty dollars weekly, as compared to roughly four thousand dollars a week as a motion-picture director. However, Cukor was patriotic and, along with everything else he did in his life, upbeat about the prospects.

To Elsa Schroeder, who was supervising his house and obligations during his absence, he wrote after the first week of military regimentation that he was enjoying himself and didn't mind the discomforts. The only complainers, added Cukor, were "ex-shipping clerks."

There was drill and study, long hikes and heavy exercise, Army mess, KP, and latrine duty. He spent a week on the rifle range. The hours were long, from 6:30 A.M. till 5:30 P.M., very strenuous, but the experience fascinating.

Gottfried Reinhardt, in the same group coming out from Hollywood, recalled that the gentleman director went through the arduous training with a lot of spunk, but to people who knew him, he looked weakened and dispirited.

"He looked just terrible, physically, arriving in the barracks [on Long Island], I remember," commented Reinhardt. "He had been in basic training, as we all had. That must have been quite hard for him. He was actually too old to go through this and then to be a private. He looked beaten, pathetic."

Back in California, some of his friends and household staff members had qualms about Cukor going through it all. He didn't have to; he was old enough to have refrained from enlisting. As much as it seems to have been a matter of self-esteem to the director, to them the thought of Cukor in the army was unseemly. When she told her mother about Cukor's guard duty, Schroeder wrote Cukor that her mother had broken down and sobbed.

Of course, Cukor was no "ex-shipping clerk," and consistent with his self-image his one desire was to serve his country in some higher capacity—like Somerset Maugham, who was functioning for British intelligence; or, like some of his directorial colleagues, as an officer. Twentieth Century–Fox executive Darryl Zanuck, a lieutenant colonel in charge of Hollywood's war effort, and MGM executives were working through proper channels for Cukor: They informed him that there was a temporary hold on commissions for Hollywood people, that he had to go through basic training in the meantime, and that he must be patient.

After the three weeks at Fort Monmouth, Cukor was transferred to

the old Paramount studios at Astoria, New York, idle since 1935, where the Signal Corps was stationed and where Cukor had filmed *The Virtuous Sin*, *The Royal Family of Broadway*, and *Tarnished Lady*. Cukor was amused to be back at the old soundstages and cutting rooms, where he saw unit managers and other people who remembered him and were pleased to see him.

A unique regiment of show business and literary people, the Signal Corps was expected to produce training and education films in conjunction with the Office of War Information. Apart from Cukor and Reinhardt, the ranks included such notables as writers Irwin Shaw, John Cheever, and William Saroyan; the publicist Arthur Mayer and playwright Arnaud D'Usseau; screenwriters Robert Lord and Robert Presnell.

Cukor went right to work. MGM's highest-paid director toiled without rank on an instructional film about the building and placement of latrines. He worked hard on another short at the Merchant Seamen Canteen. His most important assignment brought him to Washington, D.C., to make a film of a speech by Secretary of War Robert Patterson.

When they went into his office to set up the equipment, Cukor instructed Patterson as to the proper line reading, although Patterson didn't have the slightest idea who Cukor was. The director treated him as he would any actor. After Patterson tried his speech, Cukor told him, "That's fine, but look, we don't want acting, we want you. Your personality. When you say your lines, I want you to believe every word." Cukor even tilted Patterson's chin for the best camera angle.

Everyone else in the room seemed terrified. An aide pulled Cukor aside and asked him, "How can you speak to Secretary Patterson that way?" Cukor said, "How else would I talk to him?" When finally Patterson discovered that Cukor was a prominent motion-picture director, they all began asking him for autographs.

Ironically, most of the best-known people in the Signal Corps were enlisted men, while their superior officers, who had been in the reserves, were "fourth-rate Hollywood people," in Reinhardt's words. In Cukor's case, the captain in charge of his company had been his second-unit director in Hollywood, and that officer, everyone knew, enjoyed lording it over Cukor, ordering him around.

Without an officer's commission, Cukor complained to Schroeder, he was at a distinct disadvantage, unable to give orders to superior officers who happened to be the camera and sound men.

Cukor was discouraged. He wrote to Frank Capra, who was heading up his own wartime documentary unit, and asked to work directly

under him. He wanted to be designated a captain. He wouldn't go below a captaincy, he informed Capra. Capra replied enthusiastically that he would be pleased to have Cukor under his command, adding that he already had several worthwhile projects in mind for his colleague.

Cukor wrote to Zanuck, to Spencer Tracy, and to the Selznicks, requesting them to write letters of recommendation on his behalf to Colonel Melvin E. Gillette, the commander of the Signal Corps.

Cukor even wrote to MGM vice president Eddie Mannix, asking Mannix to telephone Colonel Gillette personally. May first was the deadline for application of release of overage (over thirty-eight) soldiers, and Cukor advised Mannix that he would be forced to quit if he didn't have a commission by then. Mannix wrote back that the Truman investigation into Hollywood commissions had slowed things, so Cukor had to remain patient.

To Elsa Schroeder, Cukor wrote that the whole subject of negotiations over his captaincy was fragile, the issue of Hollywood commissions murky.

Cukor was permitted to lodge at his favorite hotel, Manhattan's St. Regis Hotel at $4.50 a day, where he left every morning at 6 A.M. for the Astoria headquarters.

Elsa Schroeder kept him stocked with items that were lacking in the commissary—soaps, toiletries, perfumes—which, he wrote her, he used stingily, as he didn't want to strut around in his uniform smelling pretty like Geraldine Farrar in *Zaza*.

When Hedda Hopper reported in her column that the film director was spending his army term in a hotel suite, implying that he was having a soft time of it, Cukor was hurt. He prided himself on the fact that he was serving his country without any particular privileges.

Writing to Hopper, Cukor said he was greatly upset. Considering their long friendship, she should have been more sympathetic about where he was billetted, he pointed out. Other Hollywood people were bunking at the St. Regis Hotel, and in any event he did *not* have such a big suite.

It was true, he admitted to Hopper, that he had not experienced anything life-threatening, though there had been minor hardships. However, Cukor added, awkward details of his army life were nobody's business but his own.

Hopper replied to Cukor that she had gotten her news tip from Andy Lawler, so she thought the director had approved of the item. She was only doing her job, she said, apologizing that she had "a column to fill. . . ."

The army had its comic, "discombobulating" (one of his favorite words) element, Cukor liked to say.

The writer William Saroyan was one of the lowly privates in the Signal Corps, kind of the company oddball—he used to write his service films in his digressive Saroyanesque style. Cukor liked to tell amusing stories about Saroyan.

An obscure screenwriter was giving a series of lectures on some prosaic military subject, and everyone was compelled to attend. Saroyan would insist upon asking the self-important scriptwriter all sorts of irrelevant questions: Why this, why that? Cukor finally asked him, "Dammit, why do you prolong the torture?" Saroyan replied, "Why should he bore me? I'll bore him!"

They had another class in map reading, attended by members of the company. Map reading completely mystified all the Broadway and Hollywood folk. A fellow sat up front who knew all the answers, and usually got 100 on the tests. Cukor said he sat next to him and scored 99, the man next to Cukor got 98, and so on down the line. The farther away you sat from the smart fellow, the lower your marks, Cukor liked to embroider the anecdote. The only man who refused point-blank to have anything to do with the subject of map reading was Saroyan, who sat away in a corner and got 22.

Mornings, Cukor and Saroyan would trek from Manhattan to Long Island and eat breakfast together at 6:30 A.M. in one of the local diners. Cukor always remembered watching the snow trickling down under the electric lights outside in the morning darkness. The grandfather who ran the café was straight out of a Saroyan play. Factory workers and housepainters came in and played the jukebox. Everybody talked as if Saroyan were scripting their lives. Not for the first time did Cukor have the strange feeling, as he sat there with Saroyan, that he was watching his life unfold as if it was taking place on a stage.

Cukor liked the esprit de corps of the Signal Corps, the feeling that everybody was in the fight together.

By late winter he was weary of the trivial assignments and frustrated by his lowly status, however. Despite assurances from everyone that his commission was forthcoming, still he had not received it.

To Elsa Schroeder, he wrote that he yearned to head right home, yet he couldn't quite reconcile that with his desire to prove himself as an officer.

Eddie Mannix informed him that he had spoken to Colonel Gillette on his behalf, and had been told that some big shot was forestalling Cukor's application for a commission. Gillette claimed he was

trying to make inroads, but the whole matter puzzled Cukor, who blamed the morass of army bureaucracy.

Still he waited.

Meantime, Cukor finished up a training film about electricity ("Not that I'm a genius on the subject," he liked to say), called *Resistance and Ohm's Law*, written by a young Signal Corps confrere by the name of Arthur Laurents.*

By April, there was still no word, and Cukor gave up hope. He decided to apply for a discharge; perhaps the commission would arrive before the discharge did. The May deadline came and went—no commission. So Cukor was discharged, having served a mere six months and without having satisfied his goal of becoming an officer.

By late May, he was back in California. Hollywood columnists reported that Cukor was resting at Fanny Brice's home because the military stint had "debilitated" him.

To the end of his life, it was painful to Cukor that he had not received that sought-after officer's status. Other directors—Stevens, Wyler, Capra, Ford, Huston—earned awards and distinction for their wartime contributions to military documentaries. Hollywood people made an impressive contribution to the documentary form—for example, John Huston's film on the psychiatric treatment for stress, *Let There Be Light* (on which Mortimer Offner worked). To some extent, the war was a phase of their lives and careers that ennobled them.

Not for Cukor—who was acutely aware that he and his Signals Corps worthies were toiling on instructional films that, in the main, were dull and insignificant.

There is no confirmation in available army files as to why Cukor was stalled and rejected. But there is some indication in files obtained through the Freedom of Information Act that the Federal Bureau of Investigation had Cukor's fingerprints on file, and kept a report of some of his activities.

Decades later, it became known that FBI director J. Edgar Hoover hoarded information about people's sex lives, which interested Hoover almost as much as their politics. To Hoover, homosexuality was as much of a bugaboo as Communism. If Cukor did not necessarily think so at the time, later on it might have occurred to him that his officer's commission was denied because the army had been alerted to his arrest and the open secret of his homosexuality.

*Arthur Laurents's Hollywood scriptwriting career was several years away. His long list of eventual writing credits for stage and screen includes the scripts for Max Ophuls's *Caught* and Alfred Hitchcock's *Rope*, the novel and film *The Way We Were*, and collaboration on the Broadway musicals *West Side Story* and *Gypsy*.

If the army was ambivalent about Cukor, MGM was not. His four-year contract was torn up, and the director signed to another seven-year pact with MGM. That did not mean the studio understood him, though, and most of his MGM films over the course of the coming decade would be his lesser ones.

Cukor's touch in these films could become mechanical and cold. One felt an exclusion from characters. Everything on the surface would become too immaculate, too lacquered, too perfect—like his own personality sometimes, too meticulous and controlled.

There were to be undeniable triumphs such as *Gaslight*, but they were outnumbered by humdrum items like *Winged Victory, Desire Me, Edward, My Son*, and *A Life of Her Own*.

Gaslight, in 1944, was based on the play *Angel Street* by Patrick Hamilton, which had chalked up 1,295 performances on Broadway and had served as the basis of a rather excellent British film. Vincente Minnelli was originally on tap to direct the MGM version, but writers Walter Reisch and John Van Druten, who were brought on to revamp the script, argued for Cukor, their mutual friend.

Ingrid Bergman had seen *Angel Street* on the stage, and she coveted the leading part of Paula Alquist. David O. Selznick, to whom she was under long-term contract, engineered another of his bargains with Louis B. Mayer, which netted him three times her normal salary for the duration of her loan-out. Regardless that she herself was "a powerful woman with enormous shoulders, strong, healthy," in scriptwriter Reisch's words, Bergman would be playing the fragile, neurotic newlywed who is nearly driven mad by her depraved husband.

Not only Bergman but the debonair, Virginia-born Joseph Cotten, another Selznick contractee, was attached to the bill as the most un–Scotland Yardish of detectives in Victorian England. Finally, the casting of the dreamy Frenchman Charles Boyer, as the killer Gregory Anton, gave the writers a conniption.

"John Van Druten, who was a wonderful man, very sensitive and tender, was just out of his mind at the prospect," recalled scriptwriter Reisch in an interview. "'What's the difference?'" I said. This was a challenge! Van Druten went for a whole week to his ranch—his 'runch' as he called it—at Indio south of Palm Springs, and sulked and sulked. But he came back and we took the bull by the horns."

Cukor was amused by the disparities. He gave the writers a pep talk: "What's the difference? What if we do have a powerful woman? It will be twice as interesting to see whether she will be able to fight back, whether he will be able to really ruin her, or break her. . . ."

With Reisch and Van Druten, Cukor was able to work closely on

the adaptation of a play whose solid framework was to be enhanced in their screenplay.

According to scriptwriter Reisch, Cukor gave the ending particular emphasis: where Gregory Anton is strapped to a chair and Paula Alquist becomes for a passing moment, "a goddess of vengeance" (Reisch's words).

There were other signature touches from the director, like the one that evoked Cukor's stagestruck youth. As a little boy, overcome with admiration, the Scotland Yard detective had collected a backstage souvenir from a resplendent stage star. At the film's riveting climax, this long-ago memento identifies him to the paranoid Paula Alquist as an admirer of her mother's who can be trusted.

After finishing the shooting script, Van Druten had to return east for a play, but Reisch was on the set every day, something common for Cukor and uncommon in Hollywood. "Cukor would never shoot a scene without the author being present," Reisch commented. "Cukor always compared notes, asking me, 'How did you like it?' When he wanted a word changed for Ingrid, you had to change it right there on the set."

The richness of character detail is one of the things that sets *Gaslight* a notch above others of its type, such as Alfred Hitchcock's more mechanical *Suspicion*. Cukor was able to set off emotional depth charges in what was otherwise, with its jewels-in-the-attic denouement, an implausible murder melodrama. The heroine's torment was deeply felt: her terror psychological, her predicament real.

Gaslight is unlike any other Cukor film, except that other baroque murder mystery of the same period, *A Double Life*. They were almost back-to-back with their taut atmosphere and baroque pictorial values—perhaps they showed the director, beneath his controlled surface, in a mood of churning desperation.

As usual, in good or bad Cukor films, the acting is a strong point: not only Bergman (never better) and Boyer (against type, eerie and sinister) but, in smaller yet important parts, Dame May Whitty—as one of those elderly busybodies that crop up in unexpected ways in Cukor films—and Angela Lansbury, who makes a sex-charged screen debut as a voluptuous chambermaid. Only Joseph Cotten is disappointing.

Bergman's quivering presence dominates the film—not that she and the director were in complete accord. Cukor had to talk the Swedish actress out of staying up late nights brewing strong coffee to cultivate the deep dark circles under her eyes. Illogically, he wanted her to stay beautiful under duress, not look haggard—another inconsistency that did not interfere with the jittery suspense.

On her part, Bergman said in an interview that she was sometimes

disoriented by the director's overintellectualization of the character. "Cukor explains everything in such detail," Bergman said, "that sometimes you feel like saying, 'Please don't say any more because my mind is so full of explanations. I used to tease him by saying if it were a little line like 'Have a cup of tea,' he would say what kind of a cup it was and what kind of tea it was until you got so worried you couldn't say the line."

There was no arguing with the verdict: For her performance in *Gaslight*, Bergman won the Best Actress Academy Award for 1944.

Cukor's next two projects have to be considered among the least of his career.

Winged Victory, also in 1944, was produced from a Moss Hart play about the sacrificing lives and loves of a young bomber crew. William Wyler was supposed to direct, but at the last minute Wyler was called to Washington, D.C., to make war documentaries. In his stead, Cukor was loaned to Twentieth Century–Fox to direct this "gosh and golly" show.

Except for the Lon McCallister role, the multifarious cast of the film version was the same as the Broadway ensemble, including Edmond O'Brien, Don Taylor, Lee J. Cobb, Peter Lind Hayes, Red Buttons, Barry Nelson, Karl Malden, Gary Merrill, George Reeves, and Martin Ritt. The females who crop up in the story to provide welcome respite from the heroic posturing include two future stars—and stars of Cukor films—who were getting their feet wet in motion pictures, Jeanne Crain and Judy Holliday.

Fox wanted McCallister for box-office insurance, and to keep his name alive for the years he was going to be off the screen. At the request of Twentieth Century–Fox and on orders from General "Hap" Arnold, the young actor was transferred from cryptography school in the Signal Corps to the cast of *Winged Victory*.

McCallister had an interesting history with Cukor: As a teenager, he had been given a pageboy close-up in *Romeo and Juliet*, as a young man he starred in *Winged Victory*, and after retiring from the screen he became, in the 1960s and 1970s, one of the director's closest confidants.

"I was thirteen when I met George Dewey [Cukor] on the set of *Romeo and Juliet,*" said McCallister. "It was my first day as an extra in movies. I remember him as a gentleman on the set, and I remember Miss Shearer as a beautiful and caring woman. When one of the other choirboys accidentally fell, after an establishing shot, and began crying, Miss Shearer held him in her arms and I remember thinking how lucky he was to have stumbled.

"He [Cukor] always joked about my brief close-up in the final cut

[of *Romeo and Juliet*]. Said it was due to Oliver Messel's request, not something he himself wanted. Yet the shot remained in the released version and, as you know, George supervised every frame during the editing process."

Although home-front propaganda such as *Winged Victory* may have served the nation well during its critical hour, Cukor's film looks decidedly ingenuous in retrospect. Much of it is straightaway documentary footage—tests and drills—that added up to an extension of Cukor's own basic training. Yet the general air is one of unreality. The hysterically sobbing men, the high jinks in the showers, the surfeit of patriotic songs, the scrupulous girlfriends and idealized mothers—these story elements are laughably cornball by today's standards.

Most other major directors were able to avoid this kind of artistic embarrassment during World War II, while using their skills to make more momentous wartime films—in Washington, D.C., or overseas, away from Hollywood.

Desire Me was a peculiarity. According to fellow MGM director Mervyn LeRoy, Cukor was the "one who first conceived and set up the pattern of the picture," which was based on the novel *Karl and Anna* by Leonhard Frank. But the script never jelled, and Cukor tried to wriggle out of responsibility.

So did a couple of the scriptwriters. There were a raft of them, but Casey Robinson received the adaptation credit, and three women persevered with screen credit: Marguerite Roberts, Sonya Levien, and Zoë Akins. However, Roberts and Levien realized the film was substandard, and they tried—not as successfully as Cukor—to have their names removed.

It's hard to figure out what Cukor saw in the material in the first place. The story is a purplish psychodrama about a brain-warped prisoner-of-war survivor (played by a Broadway actor named Richard Hart) who steals the memories of a friend (Robert Mitchum) he has abandoned for dead during an escape attempt. He arrives at an English coastal village to woo the friend's lady (Greer Garson) with his spooky prescience about her. When the friend turns up, very much alive, there is a vengeful—and melodramatic—climax.

On top of the feeble script, Cukor had trouble working with Mitchum, whose part was actually secondary in screen time. "It [the filming] was a fiasco altogether," said Elliott Morgan, Cukor's friend and a production adviser on *Desire Me*. "I think George couldn't get on with Mitchum. That is where the trouble was. And then one day he was gone. He was naughty about that sometimes. He wasn't beyond pretending he was ill."

It is hard to pin down exactly when Cukor left the film, which

179

began filming in March and finally consummated in August of 1946—or why. However, when it became clear the film was a muddle and that the director and Mitchum were a mismatch, Cukor demanded to be relieved of duties.

Both Jack Conway and Mervyn LeRoy, MGM contract directors, helped to finish and refilm scenes. Cukor fought to disassociate himself entirely, saying his scenes were all but wiped out, asking that his name be omitted from the credits. Conway and LeRoy, embarrassed by the film, felt likewise.

In the end, *Desire Me* became one of the few films in all Hollywood history to be released without *any* director's credit. Around MGM, its failure became part of Cukor's reputation.

"Cukor was one of those directors," said scriptwriter Marguerite Roberts, "who was usually quite good. But when he went bad, he went very bad."

Interesting prospects came and went unpredictably, as they tend to do in Hollywood.

Cukor spent some time in the summer of 1945 working on a version of Somerset Maugham's *The Razor's Edge* for Zanuck and Fox. The book appealed to him; the snobbish expatriate American aesthete, Elliott Templeton, was the closest Maugham ever came to writing an explicit homosexual character. Cukor told Zanuck that Maugham ought to write the script. Zanuck was skeptical. He already had an acceptable draft from Lamar Trotti.

Cukor persuaded his novelist friend to pen a complete script without any charge at all to the studio. It turned out to be a superb script—at least Maugham and Cukor thought so.

A grateful Zanuck asked Cukor what Maugham might like as a gift by way of compensation. Cukor suggested a work of art. "Anything up to fifteen thousand dollars," Zanuck told Maugham. With the money, Maugham purchased a snow scene by Matisse.

Preproduction and casting hurdles kept postponing *The Razor's Edge*, however, and Cukor chose to move on to something more imminent. Edmund Goulding was assigned to take over the directing. In the end, Zanuck threw out the Maugham script and went back to the original one by Lamar Trotti, so that both Cukor and Maugham found the experience—not to mention the film—disillusioning.

"The original script, you see, had what the studio called entertainment, which means dancing and country clubs and all that crap," Cukor recollected. "Nothing to indicate you were supposed to sit down and listen to what was being said. Whatever important things [from the book] this script retained were sandwiched between all kinds of nonsense."

Also in 1945, Cukor had a few pleasant conferences with silent-era director D. W. Griffith, who was floating around Hollywood. Griffith's plight—like the director of *What Price Hollywood?* he was out of work, alcoholic, largely forgotten—must have moved Cukor, who so admired him. Griffith had an idea for a film about a touring theatrical troupe, and he had put together an outline that drew on his own road-company days, and portions of *Good Troupers All,* the autobiography of America's "First Actor," Joseph Jefferson.

Although Griffith's treatment was inadequate, Cukor was not simply humoring the great man with his enthusiasm. He was an aficionado of Jefferson's; in his Rochester stock company, he had known some old-timers who had toured with Jefferson, so he had his own collection of hand-me-down stories about him. He took Griffith's synopsis to an old acquaintance, playwright Maxwell Anderson, who fleshed out a script called *Troupers West,* which took off from Griffith's version.

Anderson talked with composer Kurt Weill about turning *Troupers West* into a musical, but alas, nothing came of all the work, so Cukor filed the script away for future consideration.

Ideas for Garbo films came and went. Sometime in the spring of 1946, Walter Wanger "accosted" Salka Viertel at a Beverly Hills restaurant and implored her to suggest something for a Garbo comeback. Viertel had written a script based on George Sand's life story, which she offered to Wanger. She and Garbo went to Wanger's studio for a meeting—"there was a lot of chat and bantering"—but Wanger appeared to cool on the idea after his bankers told him a costume picture would be too expensive.

Wanger's German-born partner, Eugene Frenke, had seen them on the lot, and he began to bombard Viertel with phone calls ("five times a day"). Frenke's enthusiasm revived Wanger's. Cukor was contacted, and he agreed to direct any picture that Frenke and Wanger (whom Cukor knew dating back to Astoria days) could arrange with Garbo. Cukor advised Wanger that MGM would agree to loan him out with uncomplimentary speed when the film was ready.

Cukor liked the idea of Garbo as the French lady writer who donned men's clothes and assumed a man's pen name. However, he was even more keen on Garbo in a film of Daudet's *Sappho.* It could be a two-picture deal. True, there would be budget considerations with *Sand,* and censorship barriers with *Sappho,* but optimism reigned among them all.

Cukor certainly took the talk seriously. On two occasions of several hours each, he discussed *Sappho* in St. Jean Cap Ferrat with Maugham, Maugham dissecting it scene by scene, making pointed

suggestions and comments. Cukor took pages of notes from their conversations.

An elaborate dinner was held at Frenke's house, where everything was talked up. Garbo was made available to Wanger—he could have her, her agent Leland Hayward told Salka Viertel: "Nobody else wants her!"—and was seemingly happy about the arrangements. Champagne glasses were clinked.

Suddenly, Garbo became "enigmatic." She and Viertel went for their usual long walks, swam in the ocean, shared teas and dinners, but Garbo would not discuss her pending comeback. Cukor was very patient, and shared Viertel's tolerance of as well as appreciation for the strange ways of "our charming and imaginative ostrich" (Viertel's words).

When Garbo's close friend Georges Schlee arrived from Paris, it became apparent that he was counseling her against the George Sand film. Instead, Schlee wanted to bring over playwright Sacha Guitry from France to collaborate with Viertel on a substitute—a romantic comedy that centered around the Parisian salon of Mme. Récamier and her love for the writer Chateaubriand.

Viertel refused to enlist in the scheme on the grounds that Guitry had been a fascist sympathizer during World War II. "As Mr. Guitry's previous collaborators from 1940 make it impossible for me to collaborate with him, I refused," wrote Viertel to Cukor, explaining her position in the matter. *Sappho, George Sand,* and the Récamier-Chateaubriand story were added to the list of unmade Garbo films.

Both Cukor and Viertel knew in their hearts that Garbo would have found some excuse to kill any chance to resume her career. "Greta is impatient to work and on the other side she is afraid of it," wrote Viertel to Cukor. "I understand this very well after all these years of idleness. Work is a habit and she lost it. . . ."

CHAPTER EIGHT

B y 1945 and the end of World War II, the "woman's director" had learned some hard lessons and was beginning to reorganize his life to be strategically, almost brilliantly, compartmentalized. The lines had to be more strictly drawn. Cukor had to exercise more caution on the one hand and more controlling initiative on the other, in both personal and professional areas—both halves of his "double life."

Of course, double lives have always existed, and many people find them valuable and creative, even psychically necessary. That may be especially so among actors, and acting was one of Cukor's most personal subjects as a director. Certainly part of what made Cukor such a fascinating person was that he had these levels, these clashing forces within him, these mixed-up depths of personality, character, and feeling.

But he was also forced into behaving secretively by the Victorian double standards that prevailed in that generation. His private life, his homosexuality, could be considered criminal or "sick," according to law, religion and prevailing attitudes. It was important that the public image overcompensate. Cukor could go to elegant houses in the afternoons and sip high tea with titled ladies—and he could live an active homosexual life behind closed doors—as long as the two worlds never intersected. If they did, there might be scandal, damage to his career, revelation, and humiliation.

His acquaintances and friends became as categorized as his schedule. They surrounded him in concentric circles. In the outermost ring were the famous and important people, who visited him and stayed with him at intervals (by some they were dubbed "the Olympians"). Closer to Cukor in most ways were the professional friends who passed in and out of his sphere with his films. As distinct from all of the others were the tight-knit circle of male friends, almost all homosexual, who had known Cukor over many years, and who felt, although he was difficult to know, that they knew Cukor best. They called themselves the "chief unit." There were so many of them—they did not always know each other—that there even seemed to be circles within circles of the "chief unit."

In the 1930s, all of the circles overlapped—family and professional, and the homosexual men. Less so, now, did the circles intermingle, except for the "Olympian" who also happened to be homosexual.

After having undergone various mid-life crises, the Thirties group had settled into new lives. John Darrow became an independent talent agent and was sharing a house in Malibu with the choreographer turned director of musicals Charles (Chuck) Walters. Tom Douglas and Bill Haines were now flourishing interior decorators with many prominent Hollywood personalities as clients, and Haines had settled down into domesticity with Jimmie Shields, his partner in interior decoration.

Andy Lawler had been squiring various executives' wives around town. One of them was Virginia Zanuck, keeping busy at parties while Darryl Zanuck stayed at the studio late into the night viewing dailies and using his high position to seduce lowly starlets. Virginia Zanuck asked her husband to repay Lawler by giving him some work, so in 1945, Lawler was made the producer of one of Joseph L. Mankiewicz's early directorial efforts, *Somewhere in the Night*. "Funny thing about it," commented Mankiewicz, "but he [Lawler] was a very good producer."

While on the Twentieth Century–Fox payroll, according to sources, Lawler was arrested in New York City for soliciting a young undercover policeman and attempting to ply him with cocaine. (Lawler always seemed to have a supply of cocaine, but he never flaunted it around Cukor, who frowned on excessive drinking and any drugs—unless they were diet pills.) Zanuck had to pull strings to get the charges dropped, but Lawler's Hollywood climb was effectively terminated.

The resilient Lawler moved on to Broadway, where his career was reborn, surprisingly, as a producer of notable plays. He coproduced Jerome Chodorov's *Oh Men, Oh Women!* and later on was listed as associate producer of Tennessee Williams's *Camino Real*, directed by

Elia Kazan. Lawler was hardly ever in California anymore. Stories were told of his extravagant exploits, however, and his name persisted in the Cukor circle.

Among the newcomers were Clifton Webb, who had come to Hollywood for *Laura* in 1944, along with Sholto Bailie (another crossover from Noël Coward's circle). Irving Rapper, who knew Cukor from his Rochester period and whose own career as a director of superior Bette Davis vehicles at Warner Brothers was in ascendancy, was an old acquaintance who periodically visited Cukor's house for dinners. Jack Gage was another director among the regulars, though less established than Rapper (Gage's best-known feature film, *The Velvet Touch* with Rosalind Russell, was released in 1948).

In general, there was an influx of people who were ten or twenty years younger than the director—fresh arrivals to California from all over the world, people discharged from the military, up-and-coming stage and screen names, young behind-the-scenes art and design people, agents and publicists.

Most of Cukor's social activity revolved around the group. In the 1930s, he had been very much a man-about-town. He had met young men at parties and nightclubs, and at the beaches. Now he went out less, and he avoided nightclubs and public places. He shied away even from accepting very many dinner invitations.

"For many years you couldn't get him to go out," said Robert Wheaton, an ex-Navy man who became one of the director's close friends. "He simply wouldn't accept a dinner invitation, or he'd accept and not go."

Yet Cukor "was basically a lonesome man," in the words of a friend, "easily bored." He *hated* to be alone, to dine alone. That was the impetus behind the crowded calendar of lunches and dinners at his house, to surround himself with guests and friends. "He never ever had dinner alone in his life," said another friend. "He entertained every night."

Even on days when he had been working at the studio, Cukor liked to gather the group around him and *do something*. If he chose to leave the house, to go to another friend's house, the group would simply tag along. The dermatologist Hans Kohler remembered how Cukor would come home from the studio exhausted, take a shower, and don his pajamas; then they would hop in a car and ride together to Fanny Brice's—a car crammed with men, Cukor in his pajamas—where they all would play an evening of gin rummy.

Sunday, as it had been during his childhood, became the extra-special day at the Cukor residence. Sundays were more for the surrogate family now. Though Victor was still alive, few people met Cu-

kor's, father, and the director was more likely to visit his father at the latter's house than to entertain him at his own.

As for Cukor's sister, Elsie, he and she had a permanently troubled relationship. From childhood, Cukor recollected his older sister as a murky presence, rather a tyrant toward him. No doubt she resented her younger brother's usurpation of "first" status in the family hierarchy. Her marriages had failed, and she was preoccupied by care of her spastic daughter. Elsie lived in California, too, at a house provided by Cukor, but she was never around Cukor's own house for long without their voices being raised.

(Cukor was extremely fond of Evelyn, Elsie's tragically fated daughter, and the young girl would be brought down at some expense from Santa Barbara, where she was under nursing care, to quiet occasions around the pool at his house. Cukor wrote to Evelyn regularly, and paid to have a book of her poetry privately published. Her nursing companion translated Evelyn's eye blinks and facial gestures into words.)

Beginning after World War II, there was a distinct shift in the nature of the director's Sundays. Elegance and formality, the usual hallmark of Cukor occasions, were set aside for casual late-afternoon Sunday galas that brought together friends and an ever-changing list of handsome young men for poolside buffet parties that became famous throughout Hollywood as the time and place to meet the newest, most ravishing men in town.

The food was typically lavish, but perhaps left over from Sunday brunch or the previous Saturday night. Drinks were notoriously hard to come by, as Cukor did not stock much liquor. The household staff would be off for the day, so Cukor and the friends who would reassemble each Sunday brought the food out from the kitchen themselves and arranged it at poolside.

The guests would meet and munch as the sun went down. Afterward, the friends would pitch in and wash the dishes, and some of the circle would congregate in the suede-walled oval room, with its old-fashioned radio that never functioned, for an after-dinner salon. There would be witty, sparkling conversation about art, literature, theater, and films. There would also be brisk gossip. There would be assessment of the new young men who had been dotted among the guests.

These were the "famous Cukor Sundays," in Garson Kanin's words—famous in an open-secret kind of way. This aspect of Cukor's life was of course unknown to many: So innocent of Cukor's homosexuality was one young actress making her screen debut under his direction, she asked him whether he ever had been married. When the director replied with a straight face that he hadn't yet met the

"right girl," the actress—who was Shelley Winters—believed him.

In general, however, knowledge of the famous Cukor Sundays was widespread, even if details were hard to come by.

Dorothy Kilgallen is said to have made a distinct allusion to Cukor's Sundays in her column. Often cited is the remark of Baroness d'Erlanger, who went to a Sunday brunch and teased Cukor's other guests with this parting shot—"Mr. Cukor has all these wonderful parties for ladies in the afternoon. Then in the evening naughty men come around to eat the crumbs!" And when the pianist Vladimir Horowitz was asked to a more formal Saturday-night occasion at Cukor's, he is said to have accepted the invitation but joked, "However, I would much rather come on Sunday. . . ."

These famous Cukor Sundays were "sacrosanct," according to Garson Kanin. "We [Kanin and his wife Ruth Gordon] were never there on a Sunday, nor was Kate." Although the crowd might be flecked with some women (Tallulah Bankhead was not averse to being present), in general it was the coming together of a global network of almost exclusively homosexual men who in Cukor's changed life formed a nurturing family—and substituted for the cruising and nightlife of the 1930s.

Indeed, it was global, in the sense that people came from all over the world, and that the people who were regulars traveled themselves all over the world and brought into Cukor's life their own acquaintances and friends. People were constantly arriving in Hollywood with a letter of introduction to Cukor from someone overseas. Cukor himself wrote dozens of letters every time a friend was set for a foreign vacation. These letters were one entree into this secret society, not unlike wearing a green carnation in the days of Oscar Wilde.

The regulars included the most eligible and attractive, the most renowned and prosperous homosexual men for miles around.

The fresh faces were encountered in bars and on movie sets. They were picked up at gymnasiums and at other parties. One day, they might be hitchhiking, the next day lolling at a poolside party at George Cukor's house, mingling with important and influential people. The homosexual equivalent of being discovered behind the counter at Schwab's, it was a Hollywood dream come true.

Rarely, among the Sunday crowd, were there any bona fide film stars or other directors. Cukor's taste was for young unknowns. His screen tests were one renewable source. He had friends who published pornography and muscle-building magazines, and he would pick out a model and ask to meet him. He was extremely cautious about getting involved, closely, with any prominent Hollywood figure. Yet some of the people who came to various occasions went on to have substantial careers, and part of the titillation of Cukor's Sun-

days was watching some vaguely recognizable and well-endowed actor—Forrest Tucker, say—taking laps in the director's pool.

"He was the mecca" is how one longtime Cukor friend put it. "You met everybody through Cukor."

Invitations were screened, of course—for a long time James Vincent was an informal majordomo in charge of Cukor's parties—because Cukor had to be concerned about the possible theft of valuables from his house. However, there was also a lot of "Who do you know?" and "Just bring him along." There was sometimes a sprinkling of hustlers and hopefuls, dubious characters, and tricks at the Sunday parties.

Among the regulars, it seemed that there were altogether too many yes-men—"cronies, hangers-on, and freeloaders," in the words of Cukor's longtime friend and production assistant Michael Pearman. If some of the yes-men came for the free meal, others had a more specific function. "Some people were there for the purpose of getting tricks for George," said Pearman, "because George wouldn't and couldn't go to bars."

In this secret society, it was an act of friendship to take someone to meet Cukor—someone who might appeal to him—because everyone close to the director knew he was afraid to go out and look for people, and that he had a fear of being recognized. People also knew that Cukor was notoriously inept—a notoriously poor judge of tricks—when picking people up.

"There was always a little sharing here and there," said Bob Raison. "It was the least someone could do, after all his [Cukor's] entertaining, to bring up a cute thing once in a while, reciprocally."

"If George liked someone, he might have them back and sleep with them himself," explained Bob Wheaton. "A very nice operation all around, and I met some very nice people that way myself."

The sex was usually in exchange for money. Sex for money was customary, and in most ways preferable to an emotional commitment. Nowadays there would be the occasional "kept man," for the director was not averse to paying someone's living expenses or tuition costs. One young man, who endeared himself to Cukor, was put through college at the director's behest and in time became a prominent, sophisticated New York literary agent. He was eternally grateful to his benefactor.

Such arrangements were always short-lived, however. Cukor was not interested in domesticity, nor in the inevitable problems a "housekeeping" relationship would bring to his "double life." His Sunday parties helped provide a turnover in sex partners.

"George was mainly interested in 'trade,'" noted Michael Pearman, "someone he knew he wouldn't have to put up with."

"The boys were always given a few dollars and a lovely dinner," said Bob Raison.

Naturally, there was some outrageous behavior behind Cukor's walls at his parties. There might be an occasional "quick trip to the garden house," in the words of one of Cukor's friends, with one of the irresistible guests. The host disapproved of conspicuous bad manners, however, and consequently such activity was not only furtive but rare. Anyone caught would not likely be invited again.

Cukor's rules, in small as well as large matters, were to be obeyed. If not, there was the risk of a blowup. These parties were meant as relaxation for Cukor, but, even on Sundays, he could not always let down his formidable front. He was sometimes high-strung and preoccupied, even then. Someone might disagree with him about something, even something trivial. All of a sudden, he would gush with venom. Seemingly out of nowhere, he would shock people with his outbursts of violent language.

His friends liked him so much that they always ascribed his temper tantrums to outside pressures—to the fact, in the opinion of some, that he had to keep up such an ebullient front, always, in order to cloak his homosexuality in Hollywood. "The fact that he was a homosexual meant that he had to play games," as one of them put it.

In the years after World War II, a Hollywood rivalry began to develop between Cukor's circle and another clique of homosexual men that gathered, also on Sundays, at the home of the celebrated composer and songwriter Cole Porter.

Cukor and Porter were not intimate, but professionally they were best of friends. They worked together twice: Porter supplied the theme song for *Adam's Rib* (without charge—all the proceeds went to the Damon Runyon Cancer Fund), and it was Cole Porter's score that formed the spine (such as it was) of Cukor's *Les Girls* in 1957.*

An unspoken competition went on between these two world-class egos with their magnificent houses and friends in common, however, for each saw himself as the center of this unique homosexual universe. Behind their backs (no one would have dared say it to Cukor's face), some referred to them as the rival Queens of Hollywood. There was some competition, especially, over the handsome young soldiers and sailors who were abundant in postwar Hollywood, and jockeying,

*One other, small gesture of their professional friendship was Cukor's casting of Monty Woolley, Porter's former Yale classmate and longtime friend, in a cameo as a reporter at the end of *Zaza*.

moreover, for the loyalty of those regulars who managed to divide attendance on Sundays between both houses.

Porter's was perhaps the more privileged invitation, although the atmosphere there could be surprisingly informal, with Password or parlor games among the activities. Cukor the director set a more formal agenda as host. There was always ambient music chez Porter, never any music at Cukor's. Porter was more democratic—"he would serve the same thing to everyone, sailors or royalty," according to one of his friends. Cukor, by contrast, was famous for his double standard—French wine for Miss Hepburn, California for cronies.

Bob Raison, Bob Wheaton, the publicist Stanley Musgrove, the writer Frank Chapman, and others managed to sup at both houses. They knew that it irked Cukor to be told that they also had bestowed their presences on Cole Porter. "I had lunch at Cole's and dinner at George's," commented Bob Wheaton, "but you never told one about the other."

One of the key new people in Cukor's life was not a man but, rather, a woman employed by Cukor as his secretary.

When Dorothy Dawson, his secretary since the Paramount years, left his employ, Cukor was forced to look around for someone else to handle his correspondence, schedule, and household management—all extremely complicated and central parts of his life.

Irene Burns had been Hunt Stromberg's assistant for many years, until she got married and retired. She knew Cukor well from those prewar years—when Stromberg produced *The Women* and *Susan and God*—and she always remembered the time when she was walking on the lot with Stromberg, and Cukor came up and started toying with her hair. She needed a new hairdo, Cukor told her, and would look much more attractive if her hair was cut shorter. She thought about it and decided he was right.

"I think that's what actresses liked about him, too," said Burns, "because he took a great personal interest in their appearance. They had kind of feminine secrets about things."

Cukor surprised Burns by phoning her out of the blue one day and asking her whether she would take over for Dorothy Dawson. Elsa Schroeder would continue to handle his financial affairs, but in all other matters Burns would be his personal assistant, operating out of a small office in the house. She liked Cukor so much that she decided to go back to work. Her first day on the job was V.J. Day, 1945.

Her efficiency was remarkable, she was consistently good-humored, and Cukor always admired the fact that she was so dutiful to her mother.

For her part, she thought he was the kindest man she ever met.

He could be awfully funny, and always took an interest in her personally. He always had a perceptive comment about her outfit when she came to work in the morning.

After World War II, a handful of the best and most important directors in Hollywood stepped out on their own, forming their own production companies. Over the years, they had learned that producing was vital to both artistic and budget control. In part on the strength of their World War II credentials, these directors had risen in professional stature, while acquiring a more sobering view of life, newly charged aspirations, and a desire for more independence from the studios.

Wyler, Stevens, and Capra formed the short-lived Liberty Films. John Ford joined producer Merian Cooper (who also had combat film experience) to form Argosy Pictures. Their examples inspired others.

Those who remained under studio contract were more completely creatures of the system, whether it treated them well or occasionally humiliated them with "idiotic" (as Cukor characterized them) assignments. Incapable of forging alliances with financiers, they did not seem to have the vision or courage to break away from the studios.

Though Cukor groused about his situation, the MGM contract meant tremendous security for him. He did not have the executive ability, the story originality, or the sheer drive to produce a film from his own resources as Wyler, Capra, Stevens, or Ford did. But he needed to escape from MGM and to get out of the same old soundstage surroundings as much as the others did, just as in a way he needed to get out of his own house more. In a creative sense, he needed fresh air.

The person who arrived to bolster Cukor at this crucial juncture, the man who temporarily liberated him from studio confines, was one of stage and screen's perennial overachievers—Garson Kanin.

Kanin had met Cukor for the first time in 1939 when the director invited him to dinner. Kanin had been born and raised in Rochester, and although he had not known Cukor during his stock company days—he was younger than Cukor by more than a decade—Cukor mentioned Rochester as something they had in common.

"We were great friends at once," noted Kanin. "We had many, many common interests, of course, and we talked some about Rochester."

Cukor might have known of Kanin from Broadway, for Kanin had had a colorful New York career (after a false start as a saxophone player) as an actor and assistant to George Abbott. When he first went to Hollywood, Kanin worked as an assistant to Sam Goldwyn, whose wife, Frances, probably made the Rochester connection. By the time

he met Cukor, Kanin had already left Goldwyn and begun his career as a wunderkind director of RKO pictures—seven precocious features between 1938 and 1941, before he had turned thirty.

Cukor played matchmaker by inviting Kanin and Ruth Gordon to dinner together at his house in 1939. Their marriage, in 1942, was serendipitous.

Of course, Gordon knew Cukor dating back to Rochester and Broadway (although it was many years before she knew what to think of him; "I didn't like him," she wrote in one of her memoirs, "because he said 'shit.'") She had been in the cast of the ill-conceived *Two-Faced Woman*. Over time, her relationship with Cukor, like Kanin's, had grown to be one of "mutual admiration, adoration and love," in Kanin's words.

For several years, the paths of Cukor and the Kanins diverged. Garson Kanin chalked up a long military service and, unlike Cukor, rose in rank, directing outstanding war documentaries. Indeed, he shared a Best Documentary Oscar with British director Carol Reed for *The True Glory*, their definitive record of Operation Overlord, the last phase of the war in Europe. Meanwhile, Ruth Gordon spent time on the East Coast, acting in plays.

Toward the end of his army stint, Kanin began to write for the first time—working on a serious play about influence peddling in Washington, D.C. In the course of writing, his natural inclinations turned to comedy, and the serious play became *Born Yesterday*. His changeover from directing, and his niche as a writer, was assured by *Born Yesterday*'s phenomenal success. Although Kanin himself directed the stage production, starring Judy Holliday, henceforth he would limit his screen directing to two quirky films, *Where It's At* and *Some Kind of a Nut*, both a quarter-century later, in 1969.

After *Born Yesterday*, Kanin began to work on a film script, a thriller about a Shakespearean actor whose role brings on a homicidal delirium. It occurred to him that it would be more fun to write it in partnership with his wife. Gordon, who by this time had written a number of magazine essays and an autobiographical play, became his collaborator.

They wrote the screenplay in New York City, and handed it over to Kanin's older brother, Michael (coscriptwriter of *Woman of the Year*), as their producer. He offered it to Edie Mayer's husband, William Goetz, then an executive at Universal. Cukor was everyone's choice as director. After all, he was everyone's friend.

"We were very anxious to have someone with whom we had a personal rapport," said Kanin, "and who wouldn't, in the way of some important Hollywood directors, move in and immediately take over."

There is no reason to believe that Cukor saw *A Double Life* as a

harbinger of the next several years. Indeed, it was one of several scripts being proffered to him (an entertaining murder mystery was how he described it in a letter), and initially he seemed more interested in the conversations at Twentieth Century–Fox about directing the lurid *Nightmare Alley*.

Yet friendship was always part of the appeal for Cukor. Mayer had no objection to loaning Cukor to Goetz, his *other* son-in-law. So it happened that Cukor went over to Universal in late 1946 to direct the Kanins' *A Double Life*.

A Double Life set the pattern. In all but name the Kanins became a sort of husband-wife studio for several years, lone eagles operating outside the mainstream. They sought out Cukor as a partner, and he treated them as equals. For seven years and seven films, beginning with *A Double Life*, they gave him his own unique form of directorial independence.

A Double Life, Adam's Rib, Born Yesterday, The Marrying Kind, Pat and Mike, The Actress, and *It Should Happen to You* comprise the high middle period of Cukor's oeuvre.

The Kanins never did take up residence in Hollywood, or sign a studio contract, or sell a script before they had finished writing it. Everything they wrote, they wrote on speculation. All of their filmed scripts were originals—no adaptations, except of their own works. Any one of these elements would have made them unusual in Hollywood. Together, they made the team unique.

In addition, they were "terribly secretive about [their] work," according to Kanin. "We never told the story to anyone . . . until after the screenplay was finished." Not until they were finished, then, did they consult with Cukor—or with Hepburn on the Hepburn-Tracy films. (In the case of the films starring only Tracy—*Edward, My Son* and *The Actress*—Hepburn was usually around to watch over Tracy's interests.) Hepburn always contributed a great deal extemporaneously. Cukor had some say, but his script contribution, because the Kanins were so accomplished and proprietary, was modest.

"We were all great pals, in addition to being coworkers," said Kanin. "He [Cukor] was certainly a great respecter of the text, once it had been set. And we used to have a lot of conferences and talk about the script. . . ."

"I don't think the stories they film today have the charm and intimacy that comes from a knowing, tightly knit relationship," echoed Hepburn in a published interview. "Like the ones in *Adam's Rib* and *Pat and Mike*, where we all knew each other, and knew what everybody could do well.

"It was all very ensemble in spirit. And things we didn't like, or

which irritated one, or you didn't understand, you were able to state it, which one doesn't always get an opportunity to do in this business. It was not just friendship, but an artistic collaboration."

The Kanin films prodded Cukor away from artificiality and Hollywood clichés, toward a naturalism and verisimilitude that were more in keeping with postwar trends and realities. At the same time, and sometimes in the same scene, the Kanin scripts introduced elements of camera subjectivism (point-of-view distortion) and comic surrealism (dream sequences) into Cukor's work, touches that suggested the influence of René Clair, a French *auteur* of sometimes fantastical bent whom the Kanins greatly admired.

Literally as well as figuratively, the Kanins were to sweep Cukor out of MGM confines—taking him to other studios, Universal and Columbia; taking him outdoors, to New York City and other "real" locations; taking him away from high-society comedy and costume melodrama, back to theater environs, street life, public places, and the living rooms of middle-class people.

Their stories dealt with issues of marriage and sexual equality, and featured more acutely developed relationships. There was more than a tinge of Capraesque populism and idealism in the eccentric people and situations. Somehow, when all of the ideas and influences of the Kanins were working, the blend was magnificent.

For *A Double Life*, the Kanins took as their premise a seasoned actor playing Othello who gets into his role not wisely but too well. The actor, Anthony John, becomes so carried away by his murderous identification with the role that he strangles a pretty waitress. A press agent in love with the actor's ex-wife, who is playing Desdemona, has a hunch that helps solve the crime, trapping the killer onstage during the climactic Shakespearean soliloquy.

The script was originally meant for Laurence Olivier, who proved unavailable for the part. Therefore, the dulcet-toned Englishman Ronald Colman was approached by Cukor and the Kanins and asked to play the lead role. Colman was insecure about performing Shakespeare. To convince him, Cukor told him, "Gar and Ruth Gordon have written an Academy Award–winning part. We think you would be marvelous in it, and we're going to design the entire production around that target."

Realizing that Cukor was at his best when he was freed up to concentrate on performances, the Kanins brought in editor Robert Parrish to join production designer Harry Horner as part of the team. Horner was in on every stage of the production.* "He [Horner] arrived in

*Beginning with *Winged Victory*, production designer Harry Horner worked on several Cukor films, not always credited.

early mornings," said editor Robert Parrish, "and proposed setups for every shot. Cukor came in—approved or disapproved—then disappeared into Coleman's dressing room to work with him."

Parrish was also present on the set, and after Cukor approved (or changed) Horner's setup, Parrish would suggest to Cukor just how much of each scene should be covered in each setup. Cukor was therefore "cutting in the camera," according to Parrish. Just like in the early codirecting days of sound: The Kanins and team were active in all phases, but all decisions were Cukor's.

In real life, Colman was the prototypical English gentleman, so Cukor had to work hard to help mold his performance. To put the actor in a homicidal mood, the director talked to Colman at length about his struggling early days as an actor in the United States, kindling the memory of hardship and bitterness, bringing out the Jekyll-Hyde transformation.

For his *Othello* scenes, the leading man was coached by the noted classical actor Walter Hampden. The Shakespearean interludes were carefully rehearsed and filmed in continuity, apart from the rest of the scenes, and later interwoven.

In addition to Colman, *A Double Life* was blessed with two strong actresses in rewarding supporting roles: Swedish actress Signe Hasso, as Anthony John's refined leading lady; and, more in the category of earthy sexuality, Shelley Winters—another of those performers Cukor graduated from screen tests—as the doomed waitress.

Cukor had seen Winters as a teenager dating back to the *Gone With the Wind* talent search, and Kanin had recommended her after meeting her in a Walgreen's drugstore.

Before testing her, Cukor advised Winters to take off her bra and girdle, unpeel her false eyelashes, let her hair down, and scrape off her makeup. Without alerting her, he filmed her rehearsal. "I know those magic words *Roll 'em* terrify actors," Cukor told Winters, "so I synchronize the sound and camera without the actors being aware of it. It makes for more spontaneous performances."

Her test was good enough to get her a long-term contract at Universal. "But he [Cukor] felt bad that I had signed that piece of paper after I tested for him," Winters said, "because he knew Universal did mostly junk in those days. He told me once, 'If you're going to do junk, don't fool yourself that it isn't. Know you're just doing it for the money, grit your teeth, and go through it. But make sure that you also look for good things and fight to do them.' And I did. All the good things I did were on loan-out. He gave me that sense of not kidding yourself, which is good."

Patiently, Cukor coaxed Winters through her first major screen role. In her first scene, she had upward of ninety-six takes with Ron-

ald Colman. Colman himself took her to lunch in the studio commissary and soothed her with assurances; then she came back after lunch and went through another dozen or so takes. Cukor kept saying, "That's okay . . . let's do it again."

"To me, he was the kindest man I ever met," recalled Winters. "I remember he said to me, 'This girl [her character] is doomed. She is very pretty and open and ingenuous, but I want the audience to know she is doomed right from the first time they see her. Go and watch the pretty call girls at Schwab's. Try to get the sense of being one. . . .' And I did.

"I shouldn't say this, but when he said the girl was 'doomed,' it made me think of Marilyn, who was my roommate at the time—Marilyn Monroe."

Despite all the words that have been written about Cukor's attachment to elegant high-society females, one might also note his keen feeling for the low types—the Angela Lansbury and Shelley Winters characters—who trade on sex in their misspent lives.

For many years his hand was restrained by censorship, but in later films such as *Bhowani Junction, Wild Is the Wind, The Chapman Report, Travels With My Aunt,* and *Rich and Famous,* the director made clear his approval of the need for sex and his understanding of women's pleasure in it. He was always sympathetic to female characters—who, not unlike himself, found the pursuit of sex vital.

The Kanins were always pushing the director to be "as cinematic as possible." The expressionistic glare of the theatrical scenes, set against the ordinary tones of the offstage material; the voice-overs and harsh close-ups; the point-of-view camerawork when Anthony John's psychology disintegrates—these were all part of the rich visual tapestry of *A Double Life* that had not been seen in the director's work since similarly amicable teamwork produced *David Copperfield.*

Thematically, too, the film was a departure for Cukor—a stark thriller, not in the least comic, not in the least hopeful at the end.

Comedy helped Cukor disappear into material. This was the role he preferred, the detached observer, in some ways a removal of himself from his work. While watching a film directed by Rouben Mamoulian once, Cukor complained to Stella Bloch, who had accompanied him, that Mamoulian had injected himself too obviously, too self-seriously. A director's hand, Cukor told Bloch, ought to be invisible. At the least, not obvious. In his films, as in his life, he tried to blend himself in.

Drama, handled seriously, has a tendency to force issues. And *A Double Life* was, for its director, a signature film about the double life of a divided self. Anthony John could not live one life on the stage

and a completely separate one offstage—nor could Cukor. Art and life overlap. *A Double Life* is about the tightrope act of pretending otherwise.

The Kanins' script is clever, the suspense taut—the atmosphere of the film high-strung, much like Cukor's own personality. The performances shine. Ultimately, it is Colman's deeply etched, gripping star turn that dominates. His descent into madness is hypnotic and takes *A Double Life* beyond its gimmick into brave territory.

Keeping their promise to Colman, the Kanins and Cukor arranged screenings at the Universal projection room every night for two weeks. "One of them, *personally*, called every voting member of the Motion Picture Academy of Arts and Sciences and invited him (or her) to a screening," said editor Robert Parrish. "As the members arrived, one of the Kanins or Cukor greeted him (or her) and said something like 'I'm glad you could come. I think you'll agree that Ronald Colman gives one of the best performances of his career.' As the Academy members left the screening, ninety-six minutes later, either one of the Kanins or Cukor (or all three) stood at the projection room door and said something like this, 'Don't you agree that that's one of Ronald Colman's best performances?'"*

All of Hollywood seemed to applaud when Colman picked up his Best Actor Academy Award, the only Oscar of a long, superlative career that stretched back to silent films.

When Kanin went to that dinner at Cukor's house in 1939, the other guests were Laurence Olivier and Vivien Leigh, whom Kanin was also meeting for the first time. Kanin, Ruth Gordon, Olivier, Leigh, Somerset Maugham, Spencer Tracy, and Katharine Hepburn—for many years these people formed the privileged epicenter of the circle of Olympians in Cukor's life.

There were to be many such dinners among them over the years—not only at Cukor's home in Hollywood but in New York City, Paris, and London, and at Maugham's in St. Jean-Cap Ferrat.

Ever since they had met on the set of *Woman of the Year* in 1941, Tracy and Hepburn had been involved in a heart-and-soul love affair that has been much chronicled in such books as Garson Kanin's *Tracy and Hepburn: An Intimate Memoir* (a controversial book with Cukor and among his circle). Cukor, as Hepburn's confidant, played go-between for the two of them after Tracy moved into one of the houses on Cukor's estate in order to distance himself from his wife, and to be

Variety puts the running time of the release print at 103 minutes.

nearer to Hepburn when she was working in California (and usually staying, herself, at Cukor's house).

One tends to forget that Cukor directed Spencer Tracy more—five times—than any other film director did. He directed Tracy more often than he did any other male star. Capping that professional association, the effervescent, sociable, Jewish "woman's director" from New York City and the enigmatic, stoical Irish Catholic loner from Milwaukee, became, off camera, the most unlikely best of friends.

Cukor was endlessly fascinated by the sensitive and peculiar Tracy. He was endlessly sympathetic to Tracy's drinking and family problems, his appalling routine of coffee, Dexedrine, booze, and sleeping pills. Like Hepburn, Cukor was endlessly admiring of Tracy's acting muse.

They coordinated trips. They traveled to Europe together more than once. And during the years that Tracy lived on the estate, when Cukor could hunt him up, they were company for each other at dinner, just the two of them.

Edward, My Son was an excuse for everyone to escape the Hollywood soundstages momentarily and flee to England—Cukor and star Spencer Tracy, scriptwriter Donald Ogden Stewart, and Cukor's old friend from Rochester days, producer Edwin Knopf. The Kanins were in Europe, so there could be dinners and story conferences; there were weekends in the country with Laurence Olivier and Vivien Leigh; and Hepburn was in London doing a play.

(Indeed, Cukor tried without success to figure out some way of putting Hepburn into the film without upsetting the first-billed status of leading lady Deborah Kerr.)

Feeling at home in London, Cukor stayed on the top floor of the Savoy, with a view of the Thames and Waterloo Bridge, which gave him delight and reminded him of Whistler's painting.

The screenplay, based on the play by Robert Morley and Noel Langley, traced the rise of a Napoleon of finance whose love for his son motivates his unscrupulous methods and ultimate downfall. The gimmick of the play was that Edward is never glimpsed, only spoken of incessantly, by the other characters.

Cukor wrote to Elsa Schroeder that Tracy was in a rare happy state. For the first time in years, the actor was working throughout a picture without a layoff of days or weeks because of nerves or illness. Tracy was extremely helpful to the other actors, and did his long takes (over six minutes) without cuts or difficulty. Cukor said he was able to ask for fewer takes than usual as a result of Tracy's buoyant mood.

He also wrote to Signe Hasso from England. The benefits of filming there far outweighed the disadvantages, he informed her. He said

he felt relieved being out from under the long shadow of MGM, the business orientation of Hollywood, and prying gossip columnists. The director told Hasso that he was trying not to think about what would happen to *Edward, My Son* when he took the film back to the United States and had to confront the usual studio second-guessing.

Alas, *Edward, My Son* did not benefit from its "Christmasy" atmosphere on the set and Cukor could not blame anything on MGM.

Though Tracy gave his part some shading, it was a stretch for him as an actor, and he never made the father-love (atypical for Cukor—fleshed-out fathers of any sort were rare in his films) or the villainy credible within the context of the synoptic script. Despite the director's enthusiasm of the moment, *Edward, My Son* proved an ambitious dud.

The Kanins had no thought of continuing to write motion pictures together until the ground swell of acclaim for *A Double Life* and the nomination of their script for an Academy Award. Quickly, they went to work and came up with a vehicle for Tracy and Hepburn—about married lawyers who represent opposing sides in a domestic crime case—called *Adam's Rib*.

Filming began in May of 1949, with Hepburn playing feminist lawyer Amanda Bonner, who takes up the cause of a lamebrain blonde (Judy Holliday) accused of attempting to murder her no-good philandering husband (Tom Ewell). Tracy was cast as Hepburn's husband, Adam Bonner, the public prosecutor who must suffer his wife's canny courtroom defense of all womanhood, as well as an obnoxious neighbor (David Wayne) who professes to worship her.

As with John Barrymore and the novice Hepburn more than fifteen years earlier, Cukor had to negotiate the "common ground" between Tracy and Hepburn.

They had antithetical approaches. Tracy, for example, paid no attention to the script in progress, while the others—Hepburn, Cukor, and the Kanins—held read-throughs and conferences. Tracy abjured rehearsal, so the costars never rehearsed their scenes together. "Never," said Hepburn. "Not once. Ever." Tracy preferred to deliver his performance in a single take, whereas Hepburn liked to do as many takes as could be wrung out of the director (Cukor was not averse to twenty or thirty). She liked to psych up for a scene and then try endless variations on it.

In scenes together, Tracy and Hepburn could be so deferential to each other that it was maddening for the director. They would underplay the dialogue, and twist and turn to give each other the advantage of the camera angle. Once when they were doing a scene together,

Cukor remembered, he had to call out in frustration: "I can't see either of you. I really can't!"

Tracy was another, like Garbo, who rarely talked with the director about his characterization or about line readings. "Cukor never gave him one word of direction," said Kanin. "He didn't have to." Cukor liked to photograph that craggy face with its grudging expression, and then be surprised by the subtlety of emotion revealed in the dailies. "He [Cukor] said he thought of things to say to Spence, didn't, then he went to the rushes and it was all there," commented Hepburn. "But he had never seen him [do it]."

Most Hollywood "man and wife" comedies have as their premise a kind of artificial one-upmanship that propels the plot. The Kanins teased audience expectations: their love story sprang from the equality between hero and heroine. The script reverses the usual sex roles when Adam Bonner loses the courtroom verdict—and his wife. In order to save face and his marriage, the husband must put on a "feminine" act, sulking and weeping (fake tears).

The script is the Kanins' best: the playful, low-key intimacy of the Hepburn-Tracy scenes is leavened with physical high jinks, memorable minor characters, and quotable one-liners. Beneath the comedy was a serious look at the bias of laws, and the rigid expectations of sex roles—a theme about which the Kanins, Hepburn, and Cukor could be adamant. The message is clear, yet communicated with panache and hilarity.

Even more than *A Double Life, Adam's Rib* demonstrated how ill-used Cukor had been for most of the decade. Comedy more than murder melodrama was his normal purview. Cukor was most at ease and keenly observant with rondeaux of love and friendship, and the shifting sands of relationships. *Adam's Rib* put the crime on the fringe, reminded the directors of lawyers and the middle class, and let the interaction between Tracy and Hepburn, whom he knew so well, take precedence.

Tracy and Hepburn were never more relaxed with the audience or each other. It was as if the camera was peeking through a keyhole into their hideaway on Cukor's grounds. Cukor did not force the point: He let them be themselves. Their scenes together are marvelously supple.

Some other Cukor films could have been directed with similar results by other directors. But it is hard to imagine any other Hollywood director so adroitly managing the comic exchange of humanity of *Adam's Rib*. One of the most perfectly rounded comedies of the Golden Age, as time passes it seems only more modern, loving, and wise.

It was no foregone conclusion that Judy Holliday would recreate her Broadway triumph in the screen version of *Born Yesterday*. Harry Cohn, notorious as Hollywood's most profane and despotic production head, referred to her sneeringly as "that fat Jewish broad." The Columbia studio boss refused even to look at a screen test of Holliday in the part of the dim-witted ex-chorus girl Billie Dawn, who blossoms into a lady through edification and love. Cohn had paid a record $1 million for the screen rights, and he balked at risking his dough on a box-office long shot. He preferred one of his contract dependables—Rita Hayworth, Alice Faye, Barbara Stanwyck, or Lucille Ball, who owed him a picture.

For some time, Cukor had conspired with the Kanins and Katharine Hepburn to put Holliday in the best possible light in order to convince Cohn. She has some affecting moments in *Winged Victory*, her first movie appearance. And her first big role was as Doris Attinger, a blond cookie kindred to Billie Dawn in *Adam's Rib*.

During the filming of *Adam's Rib*, everyone had worked to put Holliday at ease. The director liked to tell the story of when they photographed her first scenes: They were shooting in Bowling Green in New York City, the scene where Holliday waits outside her husband's office in nervous desperation, hiding a gun in her purse while eating candy bars to ease her tension.

Repeated takes were necessary. The actress was scared to death, and fumbling her lines and movements. Later on, Cukor discovered that during the breaks between setups, Holliday was handing out invitations to the crew to see her in *Born Yesterday*, which was still playing to sell-out audiences on Broadway. She wanted them to know she was not totally incompetent.

Holliday had one crucial scene—basically, a very long single take—in a jail, where her lawyer, played by Hepburn, interviews her for a deposition. Although most of the dialogue was Hepburn's, the more experienced film actress insisted that Cukor train his camera over her shoulder on Holliday's visage, so that as Hepburn spoke the audience would focus on the newcomer.

Holliday flowered under Cukor's direction. When *Adam's Rib* was released at Christmas 1949, critics unanimously applauded her supporting role. The Broadway production of *Born Yesterday* closed, in fact, on New Year's Eve—after 1,642 performances; and less than two weeks later, Cohn announced to the press that Holliday would be starring in the part that she had made famous. Cohn was sold.

Cohn did insist on a Columbia contract player as her leading man, however. Broderick Crawford, who made a career out of playing burly bullies, was put in the part that Paul Douglas had played on Broad-

way, the crooked junk dealer who tyrannizes and adores Billie Dawn. According to Cohn's thinking, the hangdog Douglas was too sympathetic an actor, while the repugnant Crawford would encourage the audience to root for William Holden, cast as the reporter who takes on the job of refining Billie Dawn.

Cukor tended to agree with Cohn. As a matter of fact, he often tended to agree with Cohn—whom he discovered he liked. He was won over by these tough-talking studio dictators with their shrewd attitudes learned from life.

The screenplay was a problem, as it so often was for Cukor. Kanin had refused to adapt his play without additional compensation, so Cohn hired Albert Mannheimer to execute a draft. When Mannheimer's version failed to satisfy anyone—ironically, since he was the only one credited and later was nominated for an Oscar—Cohn hired the clever Epstein twins, Julius and Philip, to touch up the draft.

The script problems aggravated the long-standing antagonistic relationship between Kanin and Cohn, meanwhile, so it fell to Cukor to serve as intermediary for the production decisions. When the director read the Epsteins' rewrite, he rebelled, and practically begged Kanin to come back and work "under the table" on opening up the play for film. Finally, Kanin relented and finished off the script, unpaid and uncredited.

The cast rehearsed for two weeks, then gave six performances of *Born Yesterday* for Columbia employees. The picture was shot on studio soundstages, except for two weeks of exteriors filmed in Washington, D.C., at national landmark sites.

In Cukor's filmography, *Born Yesterday* rates near the top: beautifully directed, full of vitality and nuance, true to a script that saw light and grace in the crass character of a "dumb broad."

Kanin's populism—if it can be called that—might be presumed to clash with Cukor's elitism. However, one of the ways in which Kanin stimulated the director was by reminding him of his roots; after that, Cukor's humanism took over, a quality that overlapped with Kanin's folk-comedy.

Cukor was like Henry Higgins, in that he treated a flower girl like a duchess and a duchess like a flower girl. Cukor didn't always direct the sweeping canvasses; he did portraits of people. He may have treated Tracy Lord with more awe, but he had genuine affection for people, and a kindly way of seeing Billie Dawn. In his films as in his private life, he was generous with character flaws.

The *Pygmalion*-like theme of *Born Yesterday*—of a woman uplifted by tutorial love—was one the director felt strongly about, one that he acted out in real life with actresses and friends. In films ranging from *What Price Hollywood?* to *A Star Is Born*, from *Wild Is the Wind* to *My*

Fair Lady, Cukor's female characters get diction lessons, undergo wardrobe changes, and are transformed by new hairdos; they become glamorized, just as his mother did once when she donned a costume at a family party. His film females may be covered with surface grime. Their voices may be slurred with cockney accents, or dripping with street slang. They may seem, at first, like grotesqueries. Yet Cukor's women are inevitably beautiful butterflies inside, waiting for the director to awaken them from their cocoons.

Holliday, on- and offcamera, was one of Cukor's Elizas. She was anything but dumb herself. Highly intelligent—"between takes she could do a *Saturday Review* double crostic while listening to Bach," in producer Bert Granet's words—she was also nervous and emotional, a compulsive eater who loathed being overweight. Cukor was as consoling about her weight problems as Kanin was driven to desperation.

Even though Cukor lost the Best Director Oscar—for the third time—he was proud of his friend, his star, when she won the Best Actress Academy Award against what film writer David Shipman has called "the stiffest competition in its history" (including Bette Davis in *All About Eve*, and Gloria Swanson in *Sunset Boulevard*).

After she collected her gold-plated statuette, Cukor knew what Holliday wanted to do most. The press was monopolizing the phones backstage; it was pouring rain outside. So Cukor draped his coat around her, and together they slipped next door to a Chinese restaurant, where the Best Actress of 1950 called her mother with the good news.

This was the busiest phase of Cukor's long career. After *Born Yesterday*, the director had to sandwich in another MGM project and one at Twentieth Century–Fox as a favor to old friends.

Louis B. Mayer had begun to lose his footing at MGM, and in 1948 was forced to turn over his day-to-day power to producer Dore Schary. Nowhere in Cukor's correspondence is there any indication of how the director reacted to L.B.'s downfall; in any event, Mayer was around the lot in various executive capacities for years afterward, until his death. Cukor might have gotten along personally with the more chummy Schary, but professionally he fared no better.

A Life of Her Own was a humdrum sob story that Cukor agreed to do to demonstrate to the newly appointed production chief that he was a good soldier in MGM's army. Glamour queen Lana Turner was coming off a long suspension for contract insubordination. Leading man Wendell Corey didn't think highly of Turner, and during photography of initial scenes, he said something impolite to her that caused a blow-out. She used her prestige to have Corey dismissed.

So Ray Milland, approved by Turner—Cukor had no say in the matter—stepped in.

Rewrites of the Isobel Lennart script went right up through production. The story was a mess of folderol about a small-town girl turned top fashion model (Turner) falling hopelessly in love with a business tycoon (Ray Milland) who is saddled with a crippled wife (Margaret Phillips). Guilt and bathos reigned, and Cukor had to struggle against the material. The director's only comfort may have been the presence of his old friend Louis Calhern, although Calhern is wasted in a secondary part as Lana's steadfast friend.

Ill at ease with such assignments, Cukor took out his frustrations in various ways. He could be adversarial not only with producers but with the MGM departments—particularly the sound and wardrobe heads. He had a running argument with the sound department over the most natural possible rendering of dialogue and sound effects. They were always taking the "crud" out; he was always insisting on the subtleties of pitch and variance. There would be screaming matches, and reediting. Usually, there would be compromises that satisfied no one.

One of his worst bêtes noires was MGM costume designer Helen Rose, who dictated Lana Turner's look in *A Life of Her Own*. Cukor regarded Rose as "bereft of talent," as he one day made the mistake of telling production head Dore Schary. Cukor learned, to his amusement, that Rose was highly regarded by Schary, and in fact, designed some of his wife's apparel. At least Cukor was amused; not so, Schary.

Friends like George Hoyningen-Huene wondered why Cukor just didn't put his foot down and say no to films like *A Life of Her Own*, which was the director's studio rock bottom. Many years later, to a French journal, Cukor would echo the sentiment himself, confessing with uncharacteristic candor, "This was a horrible film, and the last one which I was forced to make against my better judgment."

Nobody forced Cukor to make *The Model and the Marriage Broker*, however. It was a nod of friendship toward Charles Brackett and Walter Reisch. Brackett had separated painfully from his screenwriting partner Billy Wilder and was ensconced as a producer at Twentieth Century–Fox. Reisch was collaborating with Brackett and Richard Breen on a script about a middle-aged matchmaker who brokers a romance between a fashion model and an X-ray technician.

From Brackett's point of view, *The Model and the Marriage Broker* made a vehicle for wisecracking Thelma Ritter, who was having a remarkable mid-life resurgence as a character lead in films. Jeanne Crain (under Fox contract) played the lovelorn model, and Scott

Brady (Cukor's casting) the handsome young man—another of those idealized physical types, like Richard Hart in *Desire Me*, William Ching in *Pat and Mike*, Jacques Bergerac in *Les Girls*, whose blandness did not improve matters.

"I just think George may have had a fantasy in his own mind about what constituted male attractiveness," said Bert Granet, the producer of *The Marrying Kind*. "It was like 'bad insurance' on a picture when there were certainly much more available and better actors."

Cukor may have been attracted to the notion of a story about lonely and shy people sensibly orchestrating their love lives. And *The Model and the Marriage Broker* was not so very different from what the Kanins were turning out at the time—a populist romantic fable reminiscent of 1930s comedies—except that the film was just not very enthralling.

For the first time in several years, the director was feeling personally as well as professionally expansive. In 1951, Cukor, who hadn't vacationed in ten years, began a custom of taking an annual vacation in Europe—usually a month a year, including two weeks of motoring.

For ten years, his European traveling companion was Bob Wheaton. Wheaton had been living at the Hollywood Athletic Club in 1944 when he was invited to lunch at Cukor's by Jack Gage. He hesitated ("I was just experiencing my sexual coming out, and I just got scared") and ended up being introduced into Cole Porter's group instead. In one of the ways that the circles intersected, however, Porter called Cukor one day and asked a favor. As a gesture to Porter, at Cukor's request, Wheaton's mother and aunt were invited to visit the set of *Mrs. Parkington* and to have tea with Greer Garson.

"Typical of George, he went all out," recollected Wheaton. "He was so nice about that. He knew the effect of Hollywood on people from the Midwest. I was terribly indebted to him, though we had still not met."

Wheaton finally met the director in 1946, when he was brought by Clifton Webb to Cukor's house to an afternoon tea for British actress Gladys Cooper. "From the first there was love at first sight, without sex. We just had wonderful rapport. He was so interesting, and so interested in people."

In the late 1940s, Wheaton relocated to Europe to attend the Sorbonne on the G.I. Bill, then chose to stay overseas as a management consultant. He was a little surprised when Cukor wrote to him about accompanying him on his European jaunts, but he was flattered. "I couldn't have been more honored," said Wheaton. He knew that it was partly because he owned a nice expensive car, a Hillman-Minx, and Cukor preferred not to drive.

For several weeks, they toured through southern Europe. George

Hoyningen-Huene joined up with them in Madrid and they did Franco's Spain—the great houses and museums of Madrid, Granada, and Seville. There were stopovers at the European hideaways of "Olympians."

Cukor usually had some professional excuse to scout foreign locales and write off expenses. (The director developed a brief enthusiasm for filming the Frank Harris story "Montes the Matador"—set in Spain—which was owned by MGM. Like most of his would-be ideas without a viable script or producer, it went nowhere.)

Mostly, there was just recreation and anonymity. Wheaton remembered the long, stimulating conversations they would have while driving between cities. They never turned on the radio; they just talked. "Everything. Sex, art, history, books, people. We covered everything."

Friends have commented on how different Cukor could seem overseas, how relaxed and open. He would behave differently, do things in Europe he wouldn't do in the United States, where he carried the weight of his importance. One of Cukor's favorite stories for intimates was of the times he and Maugham cruised sailor boys in Nice. Cukor wouldn't have dared to be so flagrant in Hollywood in the 1940s.

"In Europe he [Cukor] could be an ordinary person, not a great and famous man," said Wheaton.

"There was a bit of sex mixed in with it all," continued Wheaton. "For example, he was always afraid to do things in an automobile. That was too frightening for him. That didn't inhibit me, if I happened to meet someone in the Italian Navy. George wouldn't do anything himself. But he was relaxed enough to drive the car while I did."

Another reason why Wheaton was Cukor's ideal companion is that he was good at making introductions to men. "George wasn't great at picking up. That's why he liked traveling with me, or someone else."

In their conversations together, Wheaton remembered being struck by something: Cukor made a lot of jokes about his homosexuality, almost compulsively. "He always made jokes that a good Jewish boy shouldn't be doing this. There must have been some shame. But remorse? No."

Others commented similarly in interviews. "Oh yes, he [Cukor] was ashamed," said writer Frank Chapman, part of the "chief unit" for many years. "That was the basis of his whole attitude. 'He's one of your kind.' Put it off on everyone else."

"His relationship to being homosexual and Jewish," remarked Gerald Ayres, the screenwriter of Cukor's last film, *Rich and Famous*, "was something that he constantly made jokes about. Yet I guess it

was an ambivalence he had himself. He hated the clichés of homosexuality, he hated the clichés of Jewishness, joked about them. Yet had to feel he was deeply both."

Wheaton was also struck by how sweet and philosophical Cukor could be about his fleeting romances—tricks. Once, outside Palermo, Wheaton remembered, they picked up two stunning men—Wheaton had an Adonis tennis player, and Cukor a sailor from New Zealand just off the boat. The sailor happened to be married.

For twenty years afterward, Wheaton recalled, Cukor stayed in touch with this particular sailor and sent him letters and toys for his children. "Whenever I came to visit [Cukor]," said Wheaton, "he would always show me the Xmas card from [him]."

Back in the United States, Cukor spent a couple of months cooling his heels, waiting for MGM to decide what it wanted him to do next.

Writing to George Hoyningen-Huene, the director complained that MGM was totally indifferent to his inactivity. For a while, he felt unhappy about the studio's attitude, he confessed, but now he was getting used to it. No matter what happened, he vowed to Hoyningen-Huene, he wouldn't be lulled into doing any more pictures that he could barely stomach, such as *A Life of Her Own*.

The Kanins were writing at such a feverish pace that *The Marrying Kind*, *Pat and Mike*, and the adaptation of Ruth Gordon's play *Years Ago* were all completed by 1951. MGM could not make up its mind about either *Pat and Mike* or *Years Ago*, so Cukor went back to Columbia and Harry Cohn.

The pattern had been established for the working relationship between the Kanins and Cukor. Even when they were not in the same city or country, the collaboration between them was exceedingly close in all areas of production. As is made clear from the cache of telegrams and letters in the Cukor archives, the Kanins had ideas about everything, from costumes to camera angles. Cukor dutifully sent them reports of every stage of production, still photographs of each scene, and regular assessments of the dailies.

After *Born Yesterday*, Harry Cohn had given Kanin and Gordon a blank check of $100,000 to write "any script they wanted." However, they had opted for a striking change of pace in *The Marrying Kind*—nothing as theatrical and comic—and they wanted to make sure that Cukor understood how atypical their marriage-on-the-rocks tragicomedy was. "Its aim is realism, its tone is documentary rather than arty, its medium is photography rather than caricature. I think it is the closest we have ever come to 'holding the mirror up to nature,'" Kanin wrote Cukor.

When John Meehan was chosen as the film's art director, Kanin said he was pleased. Meehan had just finished *Sunset Boulevard* with Billy Wilder. Now he would work with production designer and second-unit director Harry Horner as part of the team.

"John Meehan sounds absolutely fine to me and I do not see how he can go far wrong," Kanin wrote to Cukor. "Did I ever tell you about the discussion I had with a fifteen-year-old high school boy in Tampa, Florida, one time? He claimed that he liked all foreign movies better than all American movies and when I pressed him for a reason, he said, 'Well, all American movies are too shiny.' I knew instantly what he meant, and so do you, and I hope Mr. Meehan will do us the favor of not having this one 'shiny.'"

The casting, Kanin urged in another letter, ought not to be "shiny," either. The actors had to be "extremely real. The trouble with most actors is that they look and sound and behave like actors, even the good ones."

Cukor had a notion to cast his friend Ina Claire as Judge Kroll, who handles the divorce case of the two main characters, Florence (Judy Holliday) and Chet Keefer (Aldo Ray). Kanin objected. He opined that Claire's casting would throw the picture into "a strange and make-believe key," because her whole style was "artificial acting." Cukor disagreed, but they compromised on another longtime Cukor friend—actress Madge Kennedy.

As for Judy Holliday, Kanin was adamant that she should play her part differently from *Born Yesterday*, less theatrically, more naturally. She should endeavor to deliver "the performance of a real person who does real things," Kanin advised Cukor, applying herself to the character as written "without any thought of career or artistic evolution."

The lead actor chosen in part for his average good looks, Aldo Ray, had played only inconspicuous parts before. The director believed in Ray's future, however, and worked long hours, in screen tests and throughout the filming, to put the gravelly voiced former town constable at ease, and to convey his offbeat personality.

The staging of *The Marrying Kind* was assured, with Cukor exploiting real locations: Times Square and Central Park, the city post office and bus terminal. The dream sequences (Aldo Ray has a memorable post-office nightmare) were especially inventive. The script demanded a lot of the two leads, who responded with virtuoso performances.

In its blend of comedy, fantasy, and pathos, *The Marrying Kind* was certainly the most audacious of the Cukor-Kanin films: a love story about the impossibility of marriage, rife with bitterness and pain. The "happy" ending did not alleviate the aftertaste of another Cukor

film—his toughest on the subject—that dared to be skeptical of romance.

Pat and Mike augured a change of pace for Tracy and Hepburn. Mainly an excuse to show off Hepburn's athletic prowess, as well as a bunch of celebrity sports cameos, this story of a female all-sports athlete managed by a dese-dem-dose promoter plunged into Damon Runyon territory. "There ain't much meat on her, but what there is is cherce!" goes one of its widely quoted lines, uttered by Mike Conovan (Tracy) in the act of appraising the physical attributes of Pat Pemberton (Hepburn).

Because of a long prelude showcasing Hepburn's golf and tennis skills, it seems to take forever for the story to get going, though. The scenes between her and Tracy, who continued his run of oddball roles under Cukor's direction, are predictably the highlight. However, Hepburn's physically robust/emotionally fragile character—though an interesting idea—dilutes her force as a personality, leaving her a helpless victim of the tame plotting.

Cukor showed no documentary flair at filming sports events, and one must wait patiently for the film to be enlivened by digressions (a surreal tennis match) and colorful supporting characters—a pea-brained boxer (Aldo Ray), personable gangsters (including a youthful Charles Bronson), and a briskly authoritative police officer (Chuck Connors).

Although *Pat and Mike* certainly has its memorable moments, and its share of admirers (Gavin Lambert, for one, proclaimed it "a comic masterpiece"), it is sheer whimsy—not Cukor's strong suit.

Years Ago—whose title evolved into *The Actress*—was a watershed.

Despite their success together, the Kanins had actually stopped writing together after *The Marrying Kind*. They discovered that they quarreled so much while they were writing that the partnership wasn't fun anymore. They established separate writing rooms—at home and at the studios. According to Kanin, they even stopped reading each other's individual works in progress.

Once, the studio had been eager to film Ruth Gordon's autobiographical play about her New England stagestruck adolescence. That was before *Adam's Rib*, which was only a modest box-office success, and *Pat and Mike*, which actually showed a loss on studio ledgers. Now MGM was losing confidence in the "small" pictures of Cukor and the Kanins.

In the wake of television and the Supreme Court divestiture of theater chains, the studio was consumed with grandiose plans to lure audiences—Cinerama, "third dimension," and all-star spectacle pic-

tures such as Paramount's *The Greatest Show on Earth*. The business was depressed, revolutionary things were happening in the industry, and nothing would ever be the same.

Dore Schary remained committed to *Years Ago*, if only as an artistic corrective to the usual MGM fare. When the rest of the executive board evinced little enthusiasm, Schary had to stake his personal prestige on the film. However, Schary worried that the *Years Ago* script was too talky, so Ruth Gordon patiently suffered through re-writes, while Kanin, realizing full well that *Years Ago* went against the trend of spectacles and big budgets, telegraphed Cukor: "Picture needs all cinematic devices, shot angles and effects possible."

Perhaps, it was reasoned, appealingly casting the role of the young Ruth Gordon character would help critical and box-office possibilities. MGM expressed a preference for Debbie Reynolds, and going along with the studio, so did Cukor. He tested her and tested her, and tested her some more. He brought in John Gielgud, on the lot in his Cassius makeup for *Julius Caesar*, to coach Reynolds for the brief Shakespeare passages. Reynolds did rather admirably. For weeks, the director maintained his enthusiasm for the bouncy actress, writing to the skeptical Kanins that she could be genuinely affecting in the role.

The Kanins wore him down with their objections, however, and MGM's attention got distracted by other, bigger pictures.

In the end, for reasons never quite made clear—perhaps it was just attrition—the crucial role went to Jean Simmons, the ethereal English actress who had been nominated for an Academy Award for her Ophelia in Laurence Olivier's *Hamlet*, and who had just arrived in Hollywood in the company of her husband, Stewart Granger.

Spencer Tracy was cast as her gruff seagoing father, who doesn't understand young stagestruck girls or modern-day contrivances such as the telephone. (A showy but moving characterization—and another rare papa in Cukor's films.) The ensemble was filled out by Teresa Wright as Ruth Gordon's sympathetic mother, and young, spindly Anthony Perkins in his screen debut as her spurned suitor.

Much research went into the flavor and detail of the early twenti-eth-century period during which Gordon (and Cukor) had grown up, and there was some intention of atmospheric location photography in Gordon's native Wollaston, Massachusetts.

While Columbia had permitted Cukor to venture out of doors and out of state, MGM kept tight reins and cut back on the budget of *Years Ago*. Cukor had to make do with filming entirely on studio soundstages. At one point, the director even had to borrow and re-vamp a theater set, complete with backstage and auditorium, that had been erected next door for a more lavish Stanley Donen musical.

MGM, in its anxiety, forced all kinds of postproduction alterations.

Someone thought Simmons's voice was grating whenever she spoke in a higher register. The dubbing crews were given instructions that the "highs" in her voice be modulated in the dubbing, resulting, to Cukor's chagrin, in a loss of texture. Teresa Wright's raspy voice was also smoothed out. Meanwhile, Tracy's lines were hiked up, so there could be no question the audience would hear the voice of the one star they might recognize.

The title was changed by MGM to *Fame and Fortune* without anyone consulting the Kanins. The Bronislau Kaper pastiche score was imposed on the Kanins and Cukor. (Kanin referred to it, disparagingly, as "Balaban and Katz.") And as the last straw, the studio chose to preview *Fame and Fortune* on a Friday night in the San Fernando Valley to a houseful of teenagers. The reaction cards were predictably negative. MGM and producer Lawrence Weingarten ordered drastic editing.

Cukor argued with producer Weingarten to no avail. The audience happened to be "stupid," he told Weingarten, and MGM ought not to kowtow before the preview cards. Hundreds of people had just been fired at MGM, the theaters were barren of moviegoers, and it was apparent that the studio had learned nothing, Cukor declared.

Cukor took his arguments over Weingarten's head to Schary. At a decisive meeting that included Schary, Weingarten, studio manager Joe Cohn, the film's editor, and representatives from the sound department, Cukor "exploded" and angrily allowed as how he was "goddamned sick and tired" of the sound department intimidating directors, and everyone ignoring his advice about restoring cuts.

Schary averred that Cukor was being too finicky, but under pressure from the director, the production chief agreed to salvage some of the cuts. He also authorized some expensive redubbing.

The nasty infighting was still fresh in mind when the film was released in a compromised form. Although the reviews were generally favorable, *The Actress*—as it was finally called, much to the Kanins's displeasure—was considered one of the worst box-office disappointments of MGM's fiscal year.

In his autobiography, Schary singled out *The Actress* as one of the key failures of his regime—indeed, one that undermined his authority and helped hasten his removal as head of the studio. Schary wrote that the film was "beautifully played, written and directed," yet was "one of those failures that depress you. . . . It's like pitching a no-hitter but losing one to zero."

The selection of Jean Simmons was crucial miscasting, perhaps. She was about as Yankee as Vivien Leigh was Dixie belle, too elegant and beautiful to play an ugly duckling whose homely looks are referred to

211

over and over again in the script. At times, her characterization borders on the fanciful, and is part of the sentimentalized drift away from the candor of Ruth Gordon's play.

However, from the opening shot—Ruth Gordon as a young girl perched in the upper balcony, mesmerized by Hazel Dawn's performance in *The Pink Lady*—it is clear that *The Actress* was also an allegory of the director's stagestruck youth. Perhaps the film is overly nostalgic; no doubt it suffered from MGM's tampering. There is, however, tremendous style to it, charm, and, beneath it all, the heartbeat of the writer—and director.

Perhaps the Kanins, shuttling between New York, London, and Paris, hurt themselves by their aloofness from Hollywood. Without Garson's brother as a surrogate, the Kanins had to fall back on people such as producer Lawrence Weingarten (*Adam's Rib*, *Pat and Mike*, *The Actress*), whom Cukor knew dating back to his tenure as one of Thalberg's assistants. Increasingly, though, Cukor—as well as Tracy and Hepburn and the Kanins—regarded Weingarten as a toady of the studio, although his vehemence on this issue may have been complicated by the fact that Weingarten, for many years, rented one of the houses on the director's estate.

Possibly Kanin was having second thoughts about relying entirely upon Cukor as director. Maybe another director could have played the studio politics angle differently and won more of the fights. Maybe the director ought to have been Kanin himself. In fact, Kanin proposed himself as director of his next script, *A Name for Herself*.

Kanin had been driving past Columbus Circle in New York City one day, when, trying to cheer up his wife, he asked how she would like to have her name posted on a giant billboard in full view of the passing public. His offhand comment blossomed into a script idea about a young man who fails big in New York. As a desperation gesture, he rents a sign and puts his name on an empty billboard. His name becomes famous and his life goes into a spin.

Ruth Gordon didn't like that it was going to be a male protagonist. "It feels like Judy Holliday to me," she told Kanin. "Fine," he replied, "but it's going to be Danny Kaye."

As he wrote the script, Kanin realized she was right—*A Name for Herself* made perfect sense as another vehicle for Judy Holliday. Columbia was the contract base for Holliday, but Harry Cohn wouldn't accept Kanin's terms as director (especially his demand to have a guarantee of final cut of the film, over Cohn, after it was finished). There were "belligerent" negotiations, according to Will Holtzman's authoritative biography *Judy Holliday*, and Kanin ended up washing

his hands of Cohn, Hollywood, and the United States, sailing to Europe to begin work on a novel.

By the time Cukor had turned his attention to *A Name for Herself*, Kanin had calmed down and was willing to counsel the director in telegrams and letters. All of his initial joy in the project was gone, however, and he displayed a wary attitude toward Columbia and staff producer Fred Kohlmar, whom Kanin knew and disliked ("he never struck me as much of a creative ball of fire . . .") dating back to 1937, when they both had worked for Sam Goldwyn.

What is more, Kanin had become progressively disenchanted with Judy Holliday, to the point that he was fed up with her. He had patiently waited out her crises during the long run of the play *Born Yesterday*, and had endured her ups and downs during the two Cukor films. He had had enough of her crash diets, her mannerisms, and her annoying script demands. He found her bored and apathetic, and "highly replaceable" in the part of Gladys Glover. To Cukor, by post, he recommended a list of suitable replacements.

Cukor took a trip to New York to judge for himself. Dutifully, he reported to Kanin that Holliday had ballooned up to 160 pounds, but that her agent and Harry Cohn were going to throw a scare into her about breaching her contract.

Although, when face-to-face with Holliday, Cukor was sympathetic about her weight problems (he commiserated with her about ladies' glands after childbirth), privately he thought otherwise; the bottom line, he wrote Kanin, was that Holliday was hooked on sauces and sugary sweets. Cukor told Kanin he was beginning to feel he was getting too old for such mollycoddling.

On the other hand, Cukor felt loyal to Holliday—and he *liked* her. Moreover, according to Cohn, the director was going to be stuck with her in the picture no matter what. Eventually, scriptwriter Kanin would have to accept that about the picture along with all of the other things that stuck in his craw.

With John Bagley, who was working with John Meehan and Harry Horner, Cukor scouted locations in New York. They walked through every setup in Columbus Circle, and visited a huge advertising agency for real-life inspiration. Cukor wrote Kanin that seeing the actual setting was edifying as usual. He thought that the atmosphere of importance and agency trappings masked a phony operation.

They visited the *Look* magazine offices to get amusing ideas for advertising photographs. They found an excellent boardinghouse for the two principal characters to live in—a brownstone of 1895 vintage, with a church opposite. For the cameo scene in the picture that featured Constance Bennett and Ilka Chase, they visited "What's My Line" backstage and Cukor observed the run-through of a program.

For the fade-out shot, they discovered a road on the New Jersey side of the Lincoln Tunnel that circled around and yielded a spectacular view of the New York skyline.

Jack Lemmon, who had had some limited Broadway exposure, was picked to make his screen debut as Pete, the young documentary filmmaker who is attracted to Gladys but scornful of her quest for fame. Peter Lawford was going to play the debonair soap-company tycoon who covets Gladys's particular billboard and flatters her with romance.

The filming took place in the summer of 1953, including two weeks of arduous location work in New York City. The city was miserably hot, Cukor wrote Kanin, but the grueling location work was worth it. He predicted that it would give space and a sense of reality to the picture.

In Paris, Kanin was hungry for crumbs of information as to how everything was turning out. The first shock was that his title had been changed. The film was now called *It Should Happen to You*, even though "a name for myself" is trumpeted several times in the script. A dismayed Kanin wrote a letter to Cukor, saying his title might not have been the best in the world, "but it [*A Name for Herself*] is approximately one hundred times better than the one they have put on it. . . ."

Then Kanin was chagrined to learn that Columbia had changed the ending of his script without his knowledge. Columbia filmed a new ending. Then Jerry Wald, the production boss, decided the alternative was no better than the original. Kanin voluntarily dashed off a third ending, but word came back from Wald that Columbia would not authorize the expenses to shoot it. Even then, Kanin would not give up. He offered to pay *out of his own pocket* for filming of the new version.

He waited a long time for an answer. When he got one, it was from producer Kohlmar, saying Kanin's new scene was not deemed any better, and that Cohn would not authorize reopening the production unit for any refilming. Kohlmar's letter also informed Kanin, rather matter-of-factly, that the studio had instituted some cuts over Cukor's objections.

Kanin wrote a furious dispatch to Cukor, saying he had read Kohlmar's letter "through a mist of tears," and was heartsick over "the heartless and brainless injustice of the whole situation . . . the system is so arranged that a Johnny-come-lately can step in and take charge, vetoing and overriding. . . . On the basis of this letter I have practically decided to retire from the motion picture business."

Cukor tried to play the diplomat; he told Kanin that Charles Lang (one of Cukor's favorite cameramen) had managed to make Judy Holli-

day look slim with his photography; he tried to soften the various blows with humor, even though he didn't always agree with Kanin, and some of what was happening was happening behind his back, too.

He joked with Kanin that he and Cohn had their disagreements about cutting the film. Cohn, who imagined himself a nonpareil comedy constructionist, wanted scenes to be speeded up. Cukor protested that every time he saw a picture that had been through such a "slicking-up process," he fell asleep, and apparently the audience had been doing that, too, since they weren't showing up at the theaters anymore.

The letters to Kanin fell off momentarily. Cukor's attention was diverted by plans and preparations for his most expensive and ambitious production, a musical version of *A Star Is Born* at Warner Brothers.

Writing from London and Paris, Kanin must have felt this lapse. He felt alienated and left out of the process. In Hollywood, the first thing producers change is the title, and the second thing is the ending. Other writers accept this—and worse—as a matter of course. Kanin was unusual, however: He could not accept it.

When Kanin finally saw the picture, he made the belated gesture of writing to Cukor and complimenting the director, but he also allowed as how he found the opening flat, the ending a disaster, the cuts incomprehensible, and Holliday's looks and playing uneven.

"I am still bitter and sore over the way in which I was treated by Cohn and Wald . . ." wrote Kanin.

For all that, *It Should Happen to You* is quirky and amusing, with bright performances and ingenious moments, if somehow intermittent and slack on the whole.

In Europe, though, influential young critics were beginning to take notice of the arc of Cukor's career. It was always solace to Cukor, who for a long time felt unappreciated by the Motion Picture Academy and U.S. film critics, that early on the Europeans noticed him. In France particularly, *It Should Happen to You* commanded favorable notice.

"This is why we can say in all seriousness," François Truffaut wrote in *Cahiers du Cinema*, "that *It Should Happen to You* is a masterpiece. To keep up the rhythm for ninety minutes with no letup, to keep the smiles constant even between laughs, to direct people that way . . . that takes a *master*."

CHAPTER NINE

\mathcal{T}he sheer pace of Cukor's activity proves that, regardless of his slow reputation, he often worked as fast as the fastest—and the most important—directors. Beginning with *A Double Life*, Cukor had turned out ten films in seven years. That was fewer than John Ford during the same time frame, but more, for example, than Hawks or Hitchcock.

For seven years, the Kanins had had a virtual monopoly on Cukor. By now, he was besieged with offers from the other studios, even if at MGM he sometimes seemed to be persona non grata.

If Cukor never quite hit it off with Louis B. Mayer or Dore Schary, he was courted, especially in the 1950s, by three other "wise showmen" he admired—studio heads Darryl F. Zanuck of Twentieth Century–Fox, Harry Cohn at Columbia, and Jack L. Warner at Warner Brothers.

One day in December of 1952, while Cukor was still working on postproduction of *It Should Happen to You*, Sid Luft, the husband of actress Judy Garland, arranged to meet him at Romanoff's, the Beverly Hills restaurant perhaps more famous for its clientele than its cuisine. Before Cukor even sat down, he told Luft, "If you want me to do a picture with Judy, I will."

Once one of MGM's most popular, puppy-fat child stars, Garland had personal demons that kept her from graduating into more mature

217

roles, and after a series of setbacks, she had been fired from the studio in 1950. Out of pictures for a couple of years, she was widely considered to be washed up as a movie star. Reports of her manic-depressive and suicidal behavior had circulated widely.

However, her third marriage, to Luft, had given an unpredictable lift to her career. Acting as her personal manager, Luft had arranged Garland's triumphant concert engagements at the London Palladium, and New York's Palace Theatre, in 1951 and 1952.

Now Luft and Garland had an independent, multipicture contract at Warner Brothers. They were planning to revamp the vintage Selznick picture *A Star Is Born* into a musical to herald Garland's screen comeback. Playwright Moss Hart was already sequestered in Palm Springs, reworking the original 1937 script. Garland was going to play the Janet Gaynor part of the aspiring young actress who marries a fading matinee idol.

Cukor had turned down the original picture, which was eventually directed by William Wellman. At the time, he had insisted it was too close—in story and chronology—to the earlier Selznick-Cukor film *What Price Hollywood?* Everything about the remake sounded good, though: the chance to work at Warner Brothers, scriptwriter Hart, and Judy Garland as the star pressured by fame.

Especially Garland—probably the main consideration. Cukor had never directed her—he came closest in his one week of duty on *The Wizard of Oz*—but he had always *liked* her, and he admired the talent she could not always bring under control. She had been a guest at his house, and often he told the story of the seventieth birthday party he gave for Ethel Barrymore, when Garland, at the height of her own troubles, sang an a capella rendition of "Happy Birthday!" that moved him almost to tears.

Like him, Garland was a creature of the system—not unlike the character of Esther Blodgett that she would play in *A Star Is Born*, a prisoner of fame. He felt deeply for her. An incident Cukor recalled with uncommon rancor had Louis B. Mayer pointing to Garland on a motion-picture set one time and saying in a loud voice, "When she first came here, she was a hunchback!" And of Garland hanging her head and responding woefully, "Yes, I was!"

Cukor was on the short list of directors deemed acceptable to Jack Warner. As usual, there was a hole in his directing schedule at MGM, which asked for and received $6,250 weekly against Cukor's $4,000 salary for loan-out of the director's services.

In a sense, the Kanin films had prepared him—prodded his instincts, sharpened his sensibilities—for his first color picture, his first musical, the most expensive and ambitious production of his career to date.

218

*　　*　　*

Casting the right male costar was essential. Cary Grant was everyone's first choice to play Norman Maine, and even before Cukor agreed to do the picture, producer Luft had been wooing Hollywood's most romantic leading man by accompanying him to the races at Hollywood Park every day, while trying to convince him. Stubbornly, Grant would not commit himself, and it became incumbent upon Cukor to sell him on the project.

In all of their conversations on the subject, Grant was strangely resistant. The director suspected the actor wouldn't act the part because he was afraid of depicting the obsessive, self-destructive personality of an alcoholic. That dark side was too close to Grant himself, and Grant, Cukor believed, preferred to disguise, not reveal, himself in his film roles.

Cukor pleaded with Grant: If only he would do an open-minded read-through of the script for Cukor, alone at Cukor's house, then perhaps Grant would be able to decide once and for all whether to accept the part. Either way, the director would agree to stop pressuring him. Grant agreed to that.

The actor went to Cukor's house for the private reading: Grant played Norman Maine, Cukor all of the other characters. The reading went on for several hours. Grant's interpretation was riveting, his identification with the role absolute. Afterward, it was clear to Cukor that this was the part of a lifetime for the actor.

"Can there be any doubt?" the director asked Grant. "This is the part you were born to play!"

"Of course," Grant agreed. "That is why I won't."

It was never brought up between them again. But Cukor couldn't understand such a denial of self from an actor—even if he thought it was mandatory for a director—and it became a lamentable gulf between them. Cukor never quite forgave Grant, whose career he had given such a boost in *Sylvia Scarlett*, *Holiday*, and *The Philadelphia Story*.

At meetings with Sid Luft, Judy Garland, Moss Hart, and Jack Warner, Cukor brought up the names of Humphrey Bogart and Frank Sinatra—intriguing ideas, both—but the studio chief, who had casting say-so, vetoed each of them for a different reason.

Stewart Granger, the swashbuckling British actor who was under contract to MGM, was recommended by Spencer Tracy, and tested with Garland. Tracy warned Granger not to let Cukor tell him how to say his lines: "Don't let him . . . it's fatal. Whenever he tries it with me I just tell him to play the part and I'll direct the film." Granger listened, but Cukor's style unnerved him just the same.

In his autobiography, *Sparks Fly Upward*, Granger told of an excru-

ciating day of rehearsal with Garland in Cukor's garden ("to my consternation"), where the auditioning actor's confidence was shattered by "several yapping dogs who didn't help one's concentration much. . . ."

"The afternoon wore on," wrote Granger, "with George giving me every bloody inflection and I began playing the part like a New York Jew, which George was. He also had a habit of jabbing his forefinger to emphasize his words. . . . The next day was just the same. I couldn't get a word out without George correcting me and pointing that bloody stubby finger. It didn't seem to affect Judy at all as she would listen to his corrections with a faraway look in her eyes and then say the line exactly as she'd said it before. But he was absolutely demoralizing me. . . ."

One night, after having had some drinks to bolster his courage, "furious and rather drunk," Granger went to see Cukor and demanded that the director sit down while he played a key scene from beginning to end. Afterward, Cukor applauded him vigorously, asking the actor why he hadn't done it like that in rehearsals.

"'Because you won't give me the chance, George,'" Granger replied. "'If you think I'm going through this kindergarten lesson in acting from you every day, you're mad. Take the script and shove it.' And I walked out. What a shame. I could have played that part on my head."

In the end, the introspective British leading man James Mason was picked to play the crucial role. Why precisely he was cast has never been made clear. However, there was a gap to be filled and—as with Jean Simmons in *The Actress*—Cukor had a not-always-wise tendency to opt for British distinction as a last resort, even in these peculiarly American stories.

The able cast that would support Mason and Garland included Tommy Noonan as band member Danny McGuire, Charles Bickford as the studio chief Oliver Niles, and Jack Carson as the studio publicist Matt Libby.

Nothing in Moss Hart's intermittent career as a screenwriter stands up, really, to his work for *A Star is Born*. Most of the scripts he wrote directly for Hollywood, as opposed to the movies he wrote that were based on his successful plays (usually in collaboration with George Kaufman)—even prestige pictures such as the Oscar-winning Best Picture of 1947, *Gentleman's Agreement*—are lumbering and unwatchable by today's standards.

Of course, Hart had the advantage of a first-rate script to begin with—the Oscar-nominated original screenplay by Dorothy Parker, her husband Alan Campbell, and Robert Carson, based on the story

by Carson and director Wellman. All the principal characters and situations of Cukor's *A Star Is Born* were borrowed from the 1937 version.

Hart had the advantage of superb musical construction to wrap around his story: the songs of Harold Arlen and Ira Gershwin, the additional material by Leonard Gershe (and, uncredited, MGM's musical arranger Roger Edens), and the dance direction of Richard Barstow.

Hart, like Cukor, knew the subject. Like Esther Blodgett, the writer was a child of show business, someone who had hoped and dreamed and clawed his way to the top, who knew the clichés as well as the verities. His version was perhaps more vehement than the original, more florid—there was more of an "insider's" flavor—especially with characters such as Matt Libby, a type the writer knew firsthand (he had been a press agent himself), these were written with his pen dipped in venom.

They were also directed with venom: Typical of Cukor, the worst villain of his *A Star Is Born* is a press agent. Cukor didn't want the black and white portrayal of Lionel Stander in the original; he wanted a "petty Lucifer." The studio magnate, meanwhile, is a fatherly type whose goodheartedness Cukor wanted to believe in, and who is probably the least credible character of the film.

As with many of Cukor's best projects, the writer had finished at least one draft before the director came along. But there is ample evidence that Cukor, more than ever, closely influenced the final form.

His suggestions, though hardly radical, added up: modifications of scenes, dialogue suggestions, details of setting or character behavior, transitional moments that were consistent with the overall script. If the blank page stymied him, Cukor's involvement in a script was most beneficial at this level. There was a great deal of his precise fine-tuning and contribution of nuances.

Hart seemed to welcome the input. Both he and Cukor made career virtues out of collaboration. When the writer was not in California, there were many letters and telegrams between them—an average of two weekly over the one-and-a-half-year course of the production.

Cukor was deferential about his script advice, as usual. He would preface his letters to Moss Hart with the hope that his suggestions were cogent, and not too tiresome. And he would sign his script memos "Gregory Ratoff," an in-joke in the Cukor circle at the expense of the well-known, somewhat hammy actor-director who played the producer in *What Price Hollywood?*

Often Hart would adopt Cukor's scribbled scene changes wholesale. In one letter, seconding a brief scene insert that had been proposed by

Cukor, Hart averred that he was delighted with the director's tinkering. The new version was "excellent and infinitely better visually" than the original, Hart admitted, enclosing Cukor's letter back to him in case the director didn't keep a copy. "I see no point in just transcribing your deathless prose and sending it back to you," wrote Hart. "It's fine as it is."

Although Hart stayed close to the filming—he visited the set, watched dailies whenever possible, and advised on cuts when the film grew to cumbersome length—the dozens of loose ends and daily script emendations fell to Cukor. This production was to prove more beleaguered and complex than any Cukor had faced since *Gone With the Wind*.

The director had seen *Life* photographer Eliot Elisofon's work as a color consultant on John Huston's film *Moulin Rouge* and was impressed by its evocation of the Toulouse-Lautrec era. (Huston—with his artistic pretensions and his precision as a writer—was one of the few Hollywood filmmakers to whom Cukor paid some attention.)

Now, to initiate his own use of color, Cukor called on another noted still photographer, a friend who, like Elisofon, had never worked in motion pictures, though he had lived in Hollywood off and on since the 1930s: George Hoyningen-Huene.

The son of a Baltic nobleman in the service of the czar and an American mother, Huene had been born in St. Petersburg, Russia, and carried the bona fide title as well as the regal presence of a baron. When his family escaped from Russia during the 1917 revolution, Huene had settled in Paris, worked as an extra in silent films, and done odd jobs while studying art under Cubist master André Lhote. He began his career as a fashion illustrator, and in time became a leading *Vogue* photographer, acclaimed for a style of elegance and simplicity.

In the early 1930s, Huene received an assignment to Hollywood, where he became part of the Cukor circle. He did some noteworthy photography of film celebrities, including Katharine Hepburn, whom he first photographed in 1934, dressed in an old shirt and pants, against unassuming backgrounds.

After World War II, Huene renounced fashion photography and began a series of semi-archaeological and travel books: about Greece, Africa, and Mexico, about temples in Syria and Egypt. He directed cultural and historical documentaries: one about the eleventh-century mosaics of the church of Daphni in Attica, Greece (with text by Aldous Huxley); one about Hieronymous Bosch; one about Philip II; one about the lives of fishermen in the Balearic Islands. In Los

Angeles after World War II, he began to teach innovative film classes at the Art Center School.

Nobody was closer to Cukor. The director looked up to Huene, who was at home anyplace in the world; he knew all the great hidden restaurants of Paris; he counted among his friends royalty and many international figures.

The photographer's aesthetic influence extended to Cukor's private life. It was Huene, for example, who oversaw the redesign of Cukor's lower garden in 1951—the patio, the trees, the pavement and lanterns (à la the Córdoba Cathedral). And it was Huene who conceived the director's annual Christmas cards—famous for their humor and elegant design. One year, the card might be an ostentatious proscenium frame with Cukor winking a Merry Christmas from his theaterbox seat. Another year might be something simple: just Cukor and his dogs, grinning a hello.

(Huene and Cukor always tried to come up with a motif that suited the director's latest film, and the volume of correspondence between them attests to the fact that they deliberated as lengthily and exactingly on this annual question as if the Christmas card were a film—as if there were nothing more important to either of them.)

Huene had a notorious wanderlust—on his travels, he purchased many of the foreign curios that were distributed among those on the director's long Christmas gift list—and Cukor often lost track of him as he roamed faraway capitals. In early 1953, however, Huene was located in Mexico, and agreed to return to Hollywood to work on *A Star Is Born* as "special visual and color consultant."

The moody and quixotic Huene's forbidding presence was tempered by another person recruited by Cukor for major responsibility—not only on *A Star Is Born* but as the director's chief lieutenant for the next two decades.

Gene Allen had been a child extra (he can be spotted in William Wellman's *Wild Boys of the Road* in 1933) and for six months a Los Angeles policeman before he began to work in the sketch department of Warner Brothers. He was chosen to sit in on morning meetings to assist Lem Ayres, the Broadway scenic designer who was involved in preproduction of *A Star Is Born*. That is where he first met Cukor.

Allen recalled how, when he was first introduced to Cukor, the director gasped, "My God, I get to talk personally with a sketch artist!"—a joke that indicated to the young artist the director's prevailing sense of humor. (At MGM, Cukor had not been allowed to work with artists or designers; everyone functioned through Cedric Gibbons, who more often than not took screen credit, regardless of any individual's contribution.)

223

After one morning's conference, where Allen had made a knowl-
edgeable comment about the script, he found himself being ad-
dressed more and more by the director. Then, over the course of
weeks, he was given further power and duties, until, in the span of
just one production, Allen managed to rise from sketch artist to (his
eventual *A Star Is Born* screen credit) "production design."

Working with Huene, Allen became responsible for executing the
scenic sketches and the storyboarding—translating into more func-
tional terms Huene's often fanciful notions.

As an innovative photographer, Huene had been known for in-
jecting realism into fashion poses through movement and emotion.
Now, for *A Star Is Born*, he became a kind of painter for movies
(Cukor called him an editor of color), mixing strange and dark colors
to infuse scenes with emotion and vitality. Huene had an exhaustive
collection of art books, and would bring them in to show the camera-
men or department heads his models for color or lighting. The pho-
tographer had extreme ideas for the use of shadows and backgrounds,
smoke and gauze, flash and shine. His novice standing in Hollywood
was something of an advantage: He tried things that others swore
wouldn't work.

Cukor called Huene and Allen his two "art boys." There was al-
most a Laurel and Hardy contrast in their appearance: Huene, to
quote *The New York Times*, was "tall, broad-shouldered and elegant,
and he kept in shape with gymnastics," while Allen was built squat
and wide like a football player. As down-to-earth as Huene could be
mystical, Allen was the communicator and the enforcer—someone
who could pave the way in the studio for the "color specialist," one
of those Cukor outsiders whose presence might threaten unions and
established department heads.

Allen could also pave the way for Cukor, as a go-between for the
director and the production departments, with all their myriad needs.
Once they were on the same wavelength, and people knew that Cu-
kor would back Allen up, it was a shortcut for them to go to Allen,
and it made the director's job, especially on enormously complicated
films like *A Star Is Born*, all the easier.

Filming started smoothly and pleasantly in early October of 1953.
Cukor predicted, in a letter to Katharine Hepburn—dictated on the
set to Irene Burns, as was his custom—that the picture would go
without a hitch.

There was tremendous pressure on Garland to succeed, however,
and the stress took a toll that mounted. At first, little things caused
small delays, but as fall dragged into winter, Garland became more

and more difficult, and the production veered out of control. The leading lady had wardrobe complaints, mysterious weight fluctuations, real or imagined illnesses, and unfortunate chemical and alcohol dependencies. Cukor had directed fragile actresses before, but never one this tortured. She seemed to be fighting for her life as well as her career.

By February, the film was still not finished, and there was some question whether it ever would be. Writing again to Katharine Hepburn, to whom he was unusually candid, Cukor said that the production had been exciting most of the time, but Garland's unpredictable behavior had deteriorated to the point where Cukor and the studio felt powerless and betrayed.

Only a few musical numbers were left, but they had not gone beyond the rehearsal stage, Cukor confided. One dance number was supposed to take a week for rehearsal, and three days for filming; yet after six weeks of photographing the chorus, sans the star, the studio felt compelled to pull the plug and mop up scenes with a look-alike.

Whenever Cukor or the studio gave Garland time off for rest, she returned in even worse shape. Cukor suspected domestic tribulations, and more drinking than rest. On days when Garland reported, she'd materialize for an hour, then leave to go to the horse races. Or she'd call in sick, and the next morning they'd all read in Louella Parson's column about her charming serenading of audiences at the Mocambo.

Cukor told Hepburn that he no longer trusted Garland. She had stiffed him too many times with her unprofessional deportment. Yet he was at a loss as to what to do. So was the studio.

The remaining musical routines, it was decided, would be postponed until summer. In March, the studio assembled its first rough cut. By now, Cukor was so battle-weary that he was not sure what to think.

His reaction to the screening of the rough cut was "clouded," he wrote to Moss Hart. He had the feeling that scene after scene was inadequate, and that the cutting was bad. Yet producer Luft and Warners executives were thrilled by the preview of the rough cut, Cukor informed Hart, and assured the director that they had a winner.

Never mind that there were key production numbers yet to be filmed. Dating back to *The Dagger and the Rose*, Cukor had the habit of deputizing someone else to do the musical scenes. In any case, the director was being taken off salary at Warner Brothers, and he had made up his mind to leave production headaches behind and take his annual European vacation. Cukor had slotted two months for his vacation, beginning in early June, and he was determined to depart on schedule.

No motion picture that Cukor directed would take longer to finish—over nine months. The filming that began on October 12, 1953, did not officially end until July 28, 1954, when the last retakes of musical numbers were finished at 2:55 A.M. with Cukor still in Europe.

A Star Is Born would become the second most expensive picture in Hollywood history up to that point. Its official cost of $5,019,777 made it second only to Selznick's 1946 film, *Duel in the Sun*, recorded at $5,225,000.

The marriage of Technicolor and the wide-screen CinemaScope (a process still in its infancy) was partly responsible for the delay and cost. Color-test scenes had been filmed and refilmed until everyone was satisfied. Several cameramen came and went during the course of the production—some, for innocent scheduling reasons; others, after dissenting with Cukor.

Some of the blame for the protracted production fell on Cukor, whose "leisurely" style, according to the definitive chronicle of the production, *A Star Is Born* by Ronald Haver, consisted of "long takes, complex staging and blocking, with the emphasis on the actors and their reactions to the script and to each other. A scene that might take two and a half minutes to play under Raoul Walsh or William Wellman might take three and a half to four minutes under Cukor."*

But Cukor had always favored rehearsals, long and multiple takes, and unhurried development of the acting in scenes. Only now he had turned a corner in his career and in his thinking; he was digging deeper. In the grip of a dictatorial impulse, the director drove people to distraction with his unusual lighting and color demands. Some of the voluptuous effects were arrived at after much argument and costly experimentation.

As one example, James Mason described part of a day (thirty-five takes) when Cukor had a "strange-looking girl" dressed up in a "bizarre red" curtain for a scene in which the drunken Norman Maine experiences a distorted nightmare in the manner of the Swiss painter Henry Fuseli. That indulgence—like several other scenes—never made it into the final film.

The director's entrenched custom was to photograph many, many takes, which was time-consuming and expensive enough. To make matters worse, from the studio point of view, he insisted on *printing*

*In his book *A Star Is Born*, Ronald Haver offers this kicker: When asked by *Variety* why the filming went on so long, Cukor's reply, shouldering the blame, was a gentlemanly "I really don't know; maybe it's because I'm a slow director."

as many takes as he could get away with in order to have the best possible selection in dailies. This "exorbitance" caused repeated run-ins with Sid Luft and Jack Warner.

"But that is what important directors did," Gene Allen said, defending Cukor. "They printed more than one take because they really were great directors who were working with nuances that other people might not care about, and they wouldn't be sure until they saw what they were looking for in a print. I think important directors were always accused of printing too many prints."

Under the pressured circumstances, it might be considered a sort of miracle that what emerged from Judy Garland was one of Hollywood's definitive and transcendent performances.

Cukor knew full well, writing as a guest columnist for Dorothy Kilgallen after filming was completed, that "it was hard to know where Frances Gumm left off and Esther Blodgett began. . . . I'm sure that even for our star, the lines of demarcation were blurred."

Hers was the director's favorite kind of performance, a blurring of role and actress studded with "curious movements" of the heart.

At her best, Garland reminded him of his boyhood idol and friend Laurette Taylor, whose life had spiraled downhill in alcoholism and self-pity, but who conquered her private tragedy with public greatness. When he informed her of this comparison, Garland thanked him, although she had to admit she wasn't very familiar with Laurette Taylor.

While consistently sympathetic to Garland offcamera, and a supportive friend to her throughout her lifetime, what Cukor exploited on the screen was the tragic affinity between Frances Gumm and Esther Blodgett. Though he could be kindness itself off the set, at work the director pulled no punches. "Because of his particular lifestyle," said *A Star Is Born* makeup artist Del Armstrong, "he knew how to hurt a woman, and he used it several times to get them into a mood for a crying scene. Usually, it's in the quietude of their little rehearsals. . . ."

The director seemed almost to revel in taking Garland to the brink for scenes where she had to bare her emotions. Already nerve-ridden and hooked on pills, Garland would be reminded by Cukor of her own joyless childhood (she once described her mother as "the real-life Wicked Witch of the West") and career low points, her marital failures (barely thirty, she was on her third marriage) and chronic insecurity (at times she would lock herself in the dressing room and refuse to come out). Cukor would speak to her in hushed tones. He would ask her, "Do you understand the unhappiness and desperation of the character you are playing?"—knowing full well that she under-

stood. He would work her into a fevered state. Then they would do the scene . . . again and again.

In many of the director's films, there were scenes—or memorable moments—that seemed to obsess Cukor. They were there in the script from the beginning, as something to goad him on and to revitalize his enthusiasm in a long preproduction. Sometimes it was an exchange of dialogue, gone over and over in story conferences to such an inexplicable degree that the scriptwriter would be dazed, or it might be an entire scene that was somehow symbolic of what was impelling the director.

In *Gaslight*, it was the postscript to the climax: when Ingrid Bergman faces her persecutor, now caught and strapped to a chair, and becomes—for just a cruel moment—a "goddess of vengeance." The dialogue had to be right in that scene, the look on her face perfect.

In *Bhowani Junction*, it was just a vignette that took place in the house of the half-caste family, when the sultry breezes stirred some flimsy curtains erotically across Ava Gardner's face. Cukor spent more time on that scene than he did on any other.

In *Heller in Pink Tights*, it was the sequence in which the Indians raid the theatrical troupe's trunk—when the worlds of Old West and vaudeville meet. As the Indians don the costumes, there is a glorious explosion of color and emotion. "Sometimes I think that [scene] was the only reason he was interested in *Heller*," said screenwriter Walter Bernstein.

In *A Star Is Born* the moment comes when Esther Blodgett, putting on her makeup, suddenly loses her composure and unravels into hysteria. "I know that he was fascinated by that scene from the beginning all the way up through doing it," said Gene Allen. Cukor had Garland so worked up beforehand that she was sick, was physically throwing up. And after she had done the scene beautifully, he made the actress do it over and over, repeatedly.

Part of Cukor's ability was that he also had unique ways of bringing actresses down from these emotional eruptions. He might have been rough on Garland, but it was for a purpose, and when the purpose was over, the gentleness and the humor took over. After the last take of the breakdown scene, Garland was still sobbing, despite the fact that the director had said "Cut." Cukor walked up softly behind her, put his hand on her shoulder, and told her, "Judy, Marjorie Main couldn't have done that any better!"

If Garland gave the performance of a lifetime, it may be that James Mason—directed in more Arthur Hopkins, laissez-faire fashion—fell in her shadow. In interviews, Cukor himself tended to refer to Mason, with an interesting choice of language, as a "foil" for Garland.

Although Mason gave a vivid, intelligent performance, and was nominated for an Oscar, he did not quite convey either the man of action (the Errol Flynn–type fading star seen in cameo scenes) or the man of inner turmoil called for by the script.

Mason himself said he was "disappointed and depressed" by the film for these reasons, explaining in an unusually frank interview years later that he thought "Wellman's *A Star Is Born* is a much better picture because it tells the story more simply and correctly, because really the emphasis should be on the man rather than the girl. It's more his story. . . ."

The mellifluous British actor said he found it difficult to adjust to Cukor's "nonstop flow of talk . . . he was leaning over me all day with his chin thrust out. He had a funny way of directing, of translating the lines into vivid modern terms—'this shit.' 'What the fuck.' He had a keen image of what he wanted, the way he wanted Norman Maine to behave. I believe what he really wanted was a sort of mimicry of John Barrymore; the only actor he ever talked about was John Barrymore.

"In the long run I regret that I could not do just what he wanted. The image I was creating was not Barrymore-esque at all—it was based on some of my own drunken friends. In fact this was the best that I could offer him."

The remaining musical numbers became the province of dance director Richard Barstow, while George Hoyningen-Huene and Gene Allen stayed on salary to protect Cukor's point of view. Ironically, the director of two of Hollywood's all-time best musicals had very little interest in music itself.

"One thing I always missed [at Cukor's house] was the total absence of music," his longtime friend Lon McCallister reminisced. "George did not like any distractions during conversation. I grew up listening to the classics about eighteen hours a day. I suppose that's why the complete absence of music on Cordell Drive is something I still think about. There were no musical instruments in the house. No tape players and only one ancient record player built in to the wall and seldom used.

"Curious, too, when you remember his productions of *A Star Is Born* and *My Fair Lady* and what an important role music played in those pictures. He knew how to 'use' music in films, but it was completely excluded from his personal life.

"And yet he could quote lyrics from many Broadway musicals and the popular songs of the Thirties and Forties. On the many trips he made with me in my land yacht, he 'suffered' the sounds of Mozart

and Bach and Sinatra and Glenn Miller. In point of fact, I believe he rather enjoyed the music on the road."

Cukor had always delegated liberally, but in this case it was a mistake: The filming of the production numbers in *A Star Is Born* went no more smoothly than the dialogue scenes. There were significant decisions that had to be made, and Garland to be coped with and sugared along.

The production numbers themselves, uniformly good, sometimes fit jaggedly into the story. Indeed, the overlong "Born in a Trunk" number, concocted while Cukor was away, was an impromptu addition, not in the script—written by Roger Edens, at the behest of Luft, Garland, and Jack Warner, and filmed at some cost and duress. (As songwriter Ira Gershwin complained of the new number: "It added fifteen minutes to [the] film, held up the show, and cost three hundred thousand dollars. Big mistake. . . .")

That so major a scene could be inserted without Cukor's knowledge suggests great casualness on the part of the studio—as well as powerlessness on the part of the director. When Cukor returned from Europe, he objected but was overruled, and "Born in a Trunk" was inserted into the film. That was just one of the editing and postproduction decisions that contributed to the unmanageable length of the film, and to the momentum of anxiety that was snowballing during Cukor's absence.

The summer of 1954 proved a critical transition period for Cukor. The director was flowering professionally. His Metro contract was up in May of 1955, and for the first time ever he toyed with the idea of breaking away from his parent studio.

In May of 1954, before leaving for Europe, he wrote a long letter to his agent, Bert Allenberg at the William Morris Agency, detailing his personal itinerary and professional goals.

In New York, he was going to meet with Marlon Brando, Mary Martin, and Richard Rodgers to discuss *Pal Joey*, which had been offered to him tentatively by Columbia's Harry Cohn. In London, he would be sure to see the productions of *Pal Joey* and *The Seven Year Itch*, which had been mentioned to him by Warner Brothers as possible film projects. Sandwiched in would be interviews and radio appearances to promote the forthcoming *A Star Is Born*.

In New York City, he would meet with Irene Selznick, who was now divorced from David O. Selznick and emerging in her own right as a producer of important plays. In London, he would talk with author Enid Bagnold, whose play *The Chalk Garden* Irene Selznick wanted him to direct on Broadway.

Also in New York, Cukor planned to meet with Walter Reisch

about the script for *Fanfare for Elizabeth*, based on an Edith Sitwell novel. He planned to visit the eccentric, aristocratic poet at her family estate in Montagna, outside Florence. With Spencer Tracy, who was going to rendezvous with him abroad, he was planning to visit the Kanins in Europe and to scout possible locations in France and Italy for one of their scripts—an expensively budgeted European chase picture intended for Tracy and Hepburn. He anticipated taking the decisive step of setting up a producing partnership with Tracy and Hepburn and the Kanins.

It was time, Cukor wrote Allenberg, he became a free agent, capitalizing on his friendships with writers, especially those overseas. Since the script was the vital element of any picture, he would have a distinct advantage over other directors making similar independent moves, owing to his extensive contacts with so many prominent authors and playwrights.

Yet while Cukor had extremely good personal relationships with writers, he was fatally inadequate when it came to developing his own properties, and unlucky and unwise in the studio projects with which he aligned himself.

He wasted a lot of time on pipe-dream films that never came to pass—*indeed, there is no Cukor idea for a film, from inception, that ever came to pass*—and at no time was this more hurtful to him than in the 1950s.

Illustrative of Cukor's problems were three important projects that he labored on for long stretches of time. Each represented flight from MGM. All were properties that stirred his interest but eventually floundered.

For Twentieth Century–Fox, in 1952, Cukor had agreed to direct another British suspense story, *My Cousin Rachel*, a Daphne du Maurier novel with a period setting and murder-mystery plot, à la *Gaslight*. Darryl Zanuck was interested in Vivien Leigh for the lead, while writer-producer Nunnally Johnson was set on Garbo. Either would have been a coup: Leigh had just won her Oscar for *A Streetcar Named Desire*, and Garbo was continuing the enigmatic absence from the screen she had maintained since *Two-Faced Woman*. Cukor was the conduit to both.

The director was exuberant about the prospects—he said he loved the book—and on his own time and money, while on trips abroad, he scouted locations. He boned up enthusiastically on Cornish history. As was his custom, he met with the author for her advice and suggestions, and while in England interviewed and tested Richard Burton for the male lead.

No doubt Cukor was skeptical about the chance of Garbo's involve-

ment, but he gave Zanuck his quota of salesmanship. In New York over a period of four days, he had long talks with the elusive screen star in an attempt to persuade her. He diagnosed her particular ailment as Swedish stubbornness, but advised Nunnally Johnson that the door remained open to her participation.

Nunnally Johnson flew to New York to see Garbo himself, but only got to speak to her on the telephone. He poured out his reasoning, and felt the actress was tempted as she listened. "But," Johnson remembered, "as she went on talking, it was almost as if she were arguing with herself. She began to think of how she looked, in her last pictures, which meant that she was about as beautiful as a woman can be, and she was disturbed about what the camera would do for her, at her present age. . . ."

That was fine with Cukor, who preferred Vivien Leigh. Leigh was also proving an illusion, however. She had said no before Cukor decided to direct; then she had reversed herself and agreed, on the proviso that the picture would be shot in England so she would not be separated from husband Laurence Olivier.

Zanuck had no desire to inflate production costs by filming in England, and without informing Cukor, he engaged another *Gone With the Wind* alumna, Olivia de Havilland, for the leading role. That was calamitous from Cukor's point of view. He liked de Havilland well enough, but he didn't think she was right for the part—she held no allure for him.

But the director was even more aghast at Nunnally Johnson's freely adapted script. Shown the script by Cukor, du Maurier herself complained that it was banal and volunteered her own substitute treatment. Cukor usually sided with the author, and did so in this instance. He and Johnson, who was also acting as producer, had a complete divergence of opinion; the director withdrew his participation.*

The Edith Sitwell project was a more personal, more prolonged lapse, reflecting Cukor's intense preoccupation with literary celebrity and British aristocracy.

Cukor had met the Sitwells casually through Somerset Maugham. She and her brother Osbert went to California in early 1951 for public poetry readings. The sixty-three-year-old Sitwell was at the height of her fame, and audiences, including many Hollywood personalities, flocked to see her. Cukor attended one session, accompanied by the unlikely duo of Aldous Huxley and Ethel Barrymore.

My Cousin Rachel was eventually directed by Twentieth Century–Fox contract director Henry Koster, in 1952, starring Olivia de Havilland and Richard Burton.

The Sitwells lacked the professional touch, Cukor wrote to a friend. Osbert Sitwell did sound effects for the reading by tapping a stick on the table. When Edith Sitwell, turbaned and tented, performed the sleepwalking scene from *Macbeth*, however, Cukor was duly impressed. As he liked to say, "I was knocked on my ass."

Cukor invited the Sitwells to lunch, and Edith (not Dame Edith until 1954) rhapsodized about his house. She loved his big black poodle Sascha, a gift from the Kanins, which she dubbed "King of the Fiji Islanders."

Cukor hit on the idea of filming her novel *Fanfare for Elizabeth*, about the romance between Henry VIII and Anne Boleyn (the mother of Queen Elizabeth I), as a vehicle tailor-made for Vivien Leigh and Laurence Olivier—or perhaps for Audrey Hepburn, who was just then rising to the fore. Cukor had met the young actress and was thoroughly enchanted with the "other" Hepburn.

At Columbia, Harry Cohn was likewise taken with Audrey Hepburn. So it transpired that Sitwell returned to Hollywood at Columbia's expense to reside at the Sunset Tower Hotel, and to work in collaboration with the veteran Walter Reisch, recruited by Cukor to tutor Sitwell in scriptwriting.

For a period of time, Reisch met daily with Sitwell, who looked "like a Queen of Sheba with all her jewels and makeup, a wonderful, majestic woman towering over me and totally unused to Hollywood."

The trouble, from Reisch's point of view, was that the skeleton of the story was very elusive—told in flashback, all from the point of view of Boleyn. Sitwell proved a "total stranger to motion pictures" who did not know what the scriptwriter was talking about when he used camera terms such as *dissolve* or *long shot*. "I think the last picture she'd seen was *Birth of a Nation*," commented Reisch. "So when they ran tests of Audrey Hepburn for her, it closed a hiatus of thirty years in her moviegoing life."

Here was the hurdle that Cukor, champion of the best writing and writers, never could leap: He might know instinctually that something was wrong with a script, but he might not know *what* was amiss or how to set it right. He was good with embroidery, but clumsy and sometimes counterproductive on the larger scale.

Sitwell did her draft. Then Cukor asked Reisch to revise it, preserving Sitwell's high-flown style. The writer tried hard, but he regarded Sitwell's draft as "a bird of peculiar plumage" that was really more "a collection of material and notes for a picture. . . ." His changes did not please Sitwell, Cukor sided with the poetess, and Reisch came out the "heavy" (in Reisch's account).

When Audrey Hepburn moved on to more viable film projects, Cukor returned to the idea of Leigh and Olivier. Once again, Leigh

stymied him with her standoffishness, her insistence that she would do the film only if it was photographed in England. When Olivier was shown Sitwell's draft, he admitted he did not share Leigh's polite enthusiasm. He said he would not commit to *Fanfare for Elizabeth* because it was so "airy-fairy" in the author's treatment.

Cukor stayed close to Sitwell (she dedicated her book *The Queens and the Hive* to him) and enamored of *Fanfare for Elizabeth*, beating the drum for the proposed film fitfully into the late 1950s. Somehow it was typical of this director that he would expend so much time and motion on this illusory goal while other film offers, more plausible and tangible, went by the boards.

Columbia was, of all the movie studios, the most likely candidate to be Cukor's home away from MGM. The director had an auspicious track record of Judy Holliday films there, and a curious affection for Harry Cohn. Cukor's correspondence indicates the extent to which he placed his hopes in the generally unloved Cohn, who under the best of circumstances could be something of a bully.

When, for example, feelers were put out to Cukor about directing a motion-picture adaptation of George Bernard Shaw's *The Millionairess*—which Katharine Hepburn had performed on the stage in New York and London—the director sidestepped the offer. The script was by writer-director Preston Sturges (significantly improved by Hepburn, according to Cukor). But Sturges had had a series of reversals in Hollywood, and Cukor was thought to be the person who might work better with Hepburn.

Yet strangely, Cukor was more interested in Harry Cohn than George Bernard Shaw. In a letter to his agent, Bert Allenberg, the director declined the *The Millionairess*, saying confidentially that he preferred Columbia and the possibility there of filming the John O'Hara/Rodgers and Hart musical, *Pal Joey*. For one thing, Cukor did not want to spend an extended period of time filming in England; for another, he did not want to exacerbate relations with his good friend Harry Cohn.

(More than once Cukor used his agency to let friends down rather than reject their overtures himself. When Frederick Brisson approached him about a Rosalind Russell musical—though Russell was his friend, he had little desire to work with her—Cukor asked his agent to tell Brisson that Metro had him fully committed. He advised his agent to be tactful and dress up the turndown by choking back some tears.)

Pal Joey was the Columbia picture that intrigued Cukor the most, and the one on which he spent the most fruitless time. Toward the end of the filming of *A Star Is Born*, he began to meet regularly with Cohn to discuss the casting and script, but with each, one linked to

the other, there were seemingly insurmountable problems.

Moss Hart was Cukor's first choice to adapt the script, but in May of 1954, Hart turned down the opportunity (calling *Pal Joey* thoroughly "overrated" and a "thankless job" for whoever scripted it); and when Cukor went east in the summer of 1954, author John O'Hara refused even to meet with him preparatorily without receiving a consultation fee. Any free advice is worth nothing, explained O'Hara to producer Jerry Wald. O'Hara's attitude sharply contrasted with most of the writers Cukor had known, and the director was left with the opinion that O'Hara had acted "idiotically."

The *Pal Joey* problems were unresolved when the William Morris Agency began to talk to Harry Cohn about a long-term contract for Cukor. In the air, that summer of 1954, was the fact that Cukor's agreement with MGM was nearly up, and Cukor was looking for a new deal somewhere. But in order to switch to Columbia, the director felt he needed improved contract guarantees.

Cohn hedged. He wanted to be able to transfer Cukor to any picture of his choosing if something happened to *Pal Joey*. In effect, he wanted Cukor on the same assignment relationship as any other contract director. In the end, the Columbia pact offered no more privileges and security than his MGM one, and *Pal Joey* passed on to another Columbia director, George Sidney.

In his May 1954 letter to Bert Allenberg, Cukor had cited his pivotal relationships with Tracy and Hepburn and with the Kanins, but here too he badly misjudged. The director would never make another film with Tracy, who was to quit MGM within the year, and his friend Katharine Hepburn he would not direct again for another twenty years—and then for television, not motion pictures.

As for the Kanins, they were terminally alienated from Hollywood, and Cukor had misgauged the depth of their disaffection.

Garson Kanin had two other films targeted for direction by Cukor, but both were deep-sixed by MGM; the demise of these scripts was every bit as bitter a pill for Kanin as the experience of *It Should Happen to You*.

One More Time was a love story that Kanin thought modern and daring, "the most important piece of work I have ever done for the screen," as he wrote in a letter to Cukor. But Dore Schary would not approve the script, and a year went by before the production head informed Kanin that his "most important piece of work" needed a title change and wholesale revision.

Somewhere along the line, the Kanins also finished *Flight to the Islands*, the big-budget chase comedy-thriller set in Europe and intended for Tracy and Hepburn. MGM was more enthusiastic about

this one, but Dore Schary threw everyone by calling in Gottfried Reinhardt and assigning him to direct the film. "It was completely out of the blue," said Reinhardt. "I couldn't have been more surprised."

Even though Cukor had directed the Kanins' last seven scripts—to much acclaim—this was the studio's way of clamping down on budget and the autonomy of Cukor and the Kanins. *Flight to the Islands* was ultimately deemed too expensive; the film was never made, and Cukor and the Kanins, his most compatible writers, never worked together again.

By the time Cukor returned from Europe in late summer of 1954, it was obvious that while Twentieth Century–Fox or Columbia might offer him individual picture deals, neither studio would extend any attractive long-term package. His agency began renegotiating Cukor's contract with MGM.

A Star Is Born still had unresolved problems. At the first preview, in August at Huntington Park, the picture ran three and a half hours. Preview audiences were ecstatic, but even the director admitted to scriptwriter Hart that the picture ought to be shorter. Neither one's brain nor posterior, Cukor opined, could stand the three and a half hours.

There was furious debate over how much should be cut, and Cukor conferred and conspired with Hart about how to attack the arguments of the producers. Cukor and editor Folmar Blangsted worked hard to get the length down to three hours and two minutes. Even then, there was tremendous resistance to the lengthy running time from the Warners sales and executive departments, since it meant there would be fewer performances in theaters, adding to the financial gamble.

After the New York opening in October, the reviews were unequivocally favorable, the best Cukor had ever had—would ever have.*

"A socko candidate for anyone's must-see list," declared *Variety*.

"A stunning achievement," opined Bosley Crowther of *The New York Times*.

Look: "The greatest one-woman show on earth."

*Zoë Akins's review was perhaps the most inclusive. She wrote Cukor a letter calling the film "almost more than genius . . . I can imagine what a politician, statesman, psychiatrist, magician, painter, writer, animal-trainer, nurse, elocutionist, mathematician, dancer, musician, cameraman, dressmaker, and papa you had to be to bring it all off. Everything but Judy Garland's husband . . ."

Life: "A brilliantly staged, scored and photographed film, worth all the effort."

Yet the Warners sales and exhibition hierarchy were immune to the reaction. Between them, Benjamin Kalmenson, president of distribution, and Harry Warner, the president of the company, orchestrated pressure on Jack Warner to institute drastic cuts for exhibition purposes.

Again, Cukor's absence proved crucial—the director's new contract with MGM meant that he was already at work on his next picture, *Bhowani Junction*, and off in India with camera and crew people scouting locations.

Sid Luft always insisted that Cukor himself authorized the specific cuts entailed in the final shortening of *A Star Is Born*. Editor Folmar Blangsted's wife told Ronald Haver that the editor repeatedly cabled Cukor in India for advice but received no reply. Cukor himself said more than once that the postpremiere editing was done entirely without his cooperation or consent. (Cukor held Blangsted responsible and never spoke to the editor again.)

Who truly ordered the excisions, and who stipulated the precise cuts, is one mystery about *A Star Is Born* that persists to intrigue film buffs.

Twenty-seven minutes were eliminated. "They just hacked into it," said Cukor in an interview. "It was very painful. . . . Neither of us [Judy Garland] could bear to see the final version." Songs and scenes and subtleties were omitted "that added considerably to the understanding of the motivations and development of the two central characters," wrote Ronald Haver in his book.

All of the existing prints, and the original negative, were shortened to 154 minutes, and the snipped scenes lost or destroyed, so that in a very short time only the condensed version existed, while the cherished Cukor cut of *A Star Is Born*, for all intents and purposes, vanished into the mists of memory.

Although an Oscar nomination had been hoped for, the director's name was conspicuously absent from the Academy Award finalists for 1954. Cukor could take some consolation in the fact that Mason and Garland were in the running for Best Actor and Actress, and in the several other nominations: (Color) Art Direction (Malcolm Bert, Gene Allen, Irene Sharaff, and George James Hopkins), Song ("The Man That Got Away"), Scoring (Ray Heindorf), and (Color) Costume Design (Jean Louis, Mary Ann Nyberg, and Irene Sharaff). Yet the film did not win in a single category.

"The loss of any Academy recognition more or less sealed the commercial fate of *A Star Is Born*," wrote Ronald Haver in his book.

Hollywood in general regarded the production (according to Haver) as "overdone, over-rated and exhausting."

Fans and critics kept the reputation of the film alive, however, and nearly thirty years later Haver, subsidized by the American Film Institute, set out to find as much as possible of the original footage, and restore (with the aid of stills, sketches, and other material) Cukor's preferred three-hour-and-two-minute version.

Haver's effort produced a reconstituted *A Star Is Born,* which Cukor never saw—for the director died just a few days before the first private screening of it, in 1983. When Warner Brothers rereleased the augmented version later that year, there were gala, celebrity-attended premieres and a new flood tide of critical acclaim for the film that, in either form, many consider Cukor's most passionate and most accomplished—the flawed monument of his career.

Perhaps Hollywood can be forgiven for treating *A Star Is Born* shabbily in 1954. The film studios had learned to expect champagne comedy from Cukor, and maybe people hadn't noticed the trend of the Kanin films. Now, all of a sudden, Hollywood had to have been startled—perhaps Cukor startled himself—to be served by this director a forbidding wine, with clots of sediment and dirt.

The American musical had been the refuge of innocence, of June-moon rhyming and mechanical dance numbers. Moss Hart had tried to invest some psychologizing in *Lady in the Dark,* but that was a lame experiment. Cukor's film was a gut chuck of nerves and misery—a musical *noir.* Was there any musical in Hollywood history, before the deviations of the 1960s, with quite the shock value?

The Wellman-Selznick version, as powerful as it is, could not escape the romanticism of its era. Cukor's version of *A Star Is Born* was relentless—not only dark, but scarlet and purple; not so hard on the subject of Hollywood (the fans and the press get worse treatment than the studio machinery), really, but brutal on the happiness that is trampled by the blood, sweat, and tears of personal ambition.

Cukor—and Moss Hart, and Judy Garland—had dropped the mask, and not to all tastes was the staring soul revealed.

CHAPTER TEN

The competition of television, the divestiture of theater chains by order of the Supreme Court, the blacklist of accused Communists and sympathizers from the ranks of the motion-picture industry—all these shattering events in the 1950s threatened the very existence of the once-omnipotent studios.

The panicky production chiefs were relying more and more on technological and publicity gimmicks (wide-screen and 3-D), inflated budgets and "safe" genres (Westerns, Bible epics, musicals). Armed with their statistical studies and marketing estimates, they tried in vain to revive dwindling profits and vanishing audiences. Yet it was a losing battle, and the average weekly attendance was to drop by more than half, from 87,500,000 in 1949, to 42,000,000 ten years later.

By 1956, Zanuck had lost power at Twentieth Century–Fox, and moved into autonomous production. Warner Brothers, perhaps the most farsighted of the studios, was gearing up for television. RKO had ceased production. Paramount had cut back. By the spring of 1958, Columbia's Harry Cohn and MGM's Louis B. Mayer would be in their graves.

At MGM, the situation was no different than elsewhere—perhaps worse. Losses had to be curtailed, profits maximized, production slashed. MGM went from an output of forty-one films in 1951, to

twenty-one in 1961, from a solid year of $7.8 million profit in 1951 to the lean one of a $500,000 loss on the books six years later.

The decision was made during Dore Schary's regime to counteract television with a wide-screen image, grandiosely budgeted epics, splashy musicals, and adaptations of proven best-sellers with durable stars.

At MGM, writers—Cukor's lifeblood—were cut from an average of fifty-four in 1951 to thirty-two in 1953. In 1953, when addressing the membership of the Screen Writer's Guild, Schary had announced that at MGM in the future there would be an emphasis on big, provocative subjects. "I would say that what we know as the 'nice, little picture' will become a thing of the past," he declared. "Size and wallop preferred." Cukor had been involved with few pictures, ever, of "size and wallop"—*Gone With the Wind* was one, *A Star Is Born* another. Everyone in Hollywood with half a brain knew the conventional wisdom about Cukor and those films.

The "nice, little picture" *Pat and Mike* had shown a loss on the MGM books—after distribution—of $137,000. (The same year, by comparison, *An American in Paris* turned a $865,000 profit.) The loss on another, *The Actress*, was estimated at $967,000. *Edward, My Son* showed the largest loss, $1,160,000, perhaps as a result of the largest budget ($2.4 million). Of the MGM films directed by Cukor since the end of World War II, only *Adam's Rib* showed a tidy profit on the books, nearly $1 million ($843,000).

One didn't have to be a swami gazing into a crystal ball to glimpse the future, and Cukor was more aware than most in Hollywood of what was happening. Already, in the early 1950s, he was telling Selznick, in a letter, that all signs pointed to the twilight of one era and the dawn of another. Publicly, in trade newspapers, he espoused the radical opinion that the turnover in personnel and film styles was "healthy" and "stimulating."

But the trouble, Cukor reflected more privately in letters, was that the studios, in their general disarray, were retrenching around old ideas and slick packaging. Cukor detested the slavish reaction to audience preview cards, and was skeptical about the bold claims made for the envelope-shaped wide screen. Early on, in the 1950s, he wrote Edith Sitwell that he had gone to a demonstration of CinemaScope and was impressed by the grandeur of the process. Unfortunately, he added, the scenes so vividly photographed added up to the same old clichés.

MGM directors like Cukor were an endangered species. Many of the contract directors chose this interval of disorder to retire, leaving the toil and trouble to younger men with grit and ambition. Clarence

Brown (Garbo's most frequent director), Robert Z. Leonard, Jack Conway, Sam Wood, Mervyn LeRoy, Victor Fleming—these studio dependables of Cukor's era—were all dead, or gone from the MGM lot, by the mid-1950s.

However, Cukor could boast a new, four-year contract dating from 1955. At an average of four thousand dollars weekly, with seniority on the lot, he was now compelled to make pictures for the studio with a higher profit outlook.

For the last decade, MGM had been able to bear the burden of Cukor's salary by charging other studios substantially higher sums for the privilege of borrowing his services. When the director was loaned to Columbia at $6,250 weekly—more than his MGM paycheck—MGM pocketed the difference of $2,250 weekly. For Cukor's twenty weeks directing Judy Holliday, MGM received roughly $55,916, plus whatever the publicity value.

Only now there were to be markedly fewer films, not only at MGM but all around Hollywood. Salaries had to be strictly accounted for, and the reins were being pulled tight on costs.

In a sense, directors of the Golden Age had been spoiled. In the heyday of the studios, they had an office, a secretary, assistants; they had top camera and design people at their beck and call; they could deploy squadrons of researchers for authenticity or legal questions; they had a projection room standing at the ready. All they had to do was press a button and say, "I want a room at four o'clock," and they had it.

Under that system, some directors were able to make two or more pictures a year. There was constant activity of some sort. Contract employees took home fifty-two paychecks a year. Every Friday night, an MGM employee could go to the office and pick up his paycheck—whether or not he was assigned at the moment.

Those paychecks paid for sumptuous houses and leisure lifestyles. And, though Cukor liked to joke about it, he was someone who valued his studio pension and benefits. The studios provided a feathered nest, and only a very few of the most resolute and resourceful directors chose to risk the perks and privileges for a measure of independence.

When the volume of pictures dropped in the 1950s, when the time came that a director had picked up thirteen or fourteen paychecks and hadn't done anything, when the newest studio head called a director in and said, "We'd like to start shooting next Tuesday," even the toughest of the veterans were hardly in a position to say they did not like the script or lead actor. They had no choice but to show up on the set and say, "Roll 'em" and "Cut."

* * *

Directors were not alone in being affected by the changes. Because of the blacklist, a climate of political fear pervaded Hollywood. Practically overnight, a sizable number of people became unemployable, and many in the industry were hurriedly grinding out anti-Communist and patriotic potboilers.

For Cukor, the blacklist meant the loss of his longtime collaborator Donald Ogden Stewart. Rather than endure the political repercussions in the United States, Stewart, who had been conspicuous as a left-wing activist while in Hollywood, settled in London after *Edward, My Son*. He was denied a passport to return to the United States, which he fought in court. His screen credits dwindled, and so did Cukor's comedies.

Not only Stewart but Mortimer Offner and Edward Eliscu— Cukor's friends from boyhood—were blacklisted.

Mention of the word *blacklist* seemed to terrify Cukor, as if he was worried about being tinged with guilt by association. And though Cukor visited London often, his contacts with Stewart were superficial during the next decade and a half when the writer was living under a cloud and struggling to keep up his livelihood.

If Cukor was quiet about the political blacklist that was destroying the lives and careers of old friends, he had no qualms about attacking publicly the "blacklist" that descended on Ingrid Bergman after his *Gaslight* star left her husband to go to Italy to live and cohabit with the father of Italian neorealist film, Roberto Rossellini. "I think it's morally reprehensible what they have done to her," he told Rochester newspaperman Henry Clune, whom he knew dating back to the 1920s. He added that Bergman had been "subjected to the most scurrilous attacks by people whose own lives might not stand very close scrutiny." Clune published Cukor's remarks in his regular Rochester column.

Cukor made a point of visiting Bergman in Italy and acting as a go-between for her and her daughter, whom she had left behind in the United States. Bergman's situation was a moral issue, however, and that was different from a political one that did not concern Cukor.

Ironic, therefore, that Cukor's first film under his renewed MGM contract was an improbable, exotic, anti-Communist potboiler of the type that proliferated in Hollywood in the 1950s.

Bhowani Junction was based on a novel by John Masters that pitted the dastardly Communist Party in India against the high-minded British army during the period of the British military abandonment after 1947. The Communist terrorists in the story are anxious to undermine the social order in order to subvert Gandhi and his pacifist followers

before they have an opportunity to consolidate control of the new nation.

That was the festering background, while the simmering foreground was taken up by the surreptitious love affair between a glamorous half-caste woman (Ava Gardner), spurned by the British and her own prejudiced countrymen, and a stiff-upper-lipped British officer (Stewart Granger) trying to keep the peace.

Perhaps it did not occur to MGM that Cukor was the last director in the world to evince interest in the political troubles of the far subcontinent. Under the circumstances, it was understandable that Cukor chose to focus on the love story. The big spectacle scenes are certainly well done, but the politics and history lessons of *Bhowani Junction* are silly and simplistic.

Robert Ardrey had done the first script, but Cukor was not satisfied, and the offcamera subplot of many Cukor films—the quest for an acceptable script—became, again, the problem of problems.

Typically, Cukor sent an early draft, under the table, to author John Masters, complaining that the latter's novel had been conventionalized, the humor lost, the relationships rendered ineffective, at times incomprehensible. Did Masters have any script suggestions? (Cukor realized, as he put it to his agent, Bert Allenberg, that he had to communicate confidentially with Masters, because to consult with the author of the original work was considered worse than stupid in Hollywood.)

Ivan Moffatt, the Australian-born scriptwriter of *Giant*, was put on the film, along with the veteran MGM contract writer Sonya Levien. Moffatt had met Cukor at Salka Viertel's salon in the 1940s, and Levien was an old friend of Cukor's. By the time they were set to work on the script, the schedule was already racing ahead of them, and over in England and in India, they had to write scenes out of continuity in order to keep up with the filming.

Working with Cukor for the first time, Moffatt noticed that the director had a habit of carrying the novel around with him and going over and over the same page or the same paragraphs that he had marked—even after the scenes had been written—as if searching for some elusive significance.

"He [Cukor] would repeat the passages to me," said Moffatt, "read them out, again and again and again. I remember a scene in which a British officer tries to rape Ava Gardner and gets killed. There's a paragraph in the book that describes how this man was preparing for the evening. George was constantly reading that aloud to Sonya and myself. I couldn't understand what we were supposed to glean from it, whereas usually his comments were extremely relevant."

Moffatt also noticed that Cukor had a personal acquisitiveness that

was carried over as one of the visual tenets of his directorial style. The director loved to go to the flea markets in London on Saturdays. According to Moffat, Cukor would take very nice things back to his hotel room, array them and gaze fondly at them.

"You'd perhaps praise one of them, and he'd open his mouth, widely—with a startled look—and you'd begin to wonder, really, if he would so much like it after all—whether it was quite as good as he thought in the shop window."

In a similar way on the set, Cukor, very much under the thrall of Huene and his color experimentation, would be beguiled by pretty objects and fabrics and materials and light. "He was seduced by things like that," said Moffatt. "Even in the middle of the making of a film, something would occur on the set—perhaps the way a curtain was blowing, or the unexpected combination in the pattern of some dress—it sort of pleased him and seemed to give him pause. As it were, for the moment, the rest would be forgotten by whatever forced his attention at the time.

"He would emphasize that and go after it—it probably looked very nice in the rushes. I even thought, occasionally—it's a purely subjective view based on *Bhowani Junction*—that he was sometimes sort of seduced away from the essential story line itself into a lovely picturesque irrelevancy."

Pandro Berman, who had once vowed never to work with Cukor again, was assigned by the studio to act as producer. The MGM acting coach Lillian Sidney (director George Sidney's wife) was called in to instruct Ava Gardner in the proper dialect. And a well-known second-unit man was brought on as part of the team to plan and assist in the massive crowd scenes and strenuous location work in England and India.

(Cukor was amused by the second-unit man. "'He's here because the studio's afraid I'll get tired,' he joked," remembered Gene Allen. "Cukor was far more rugged than anybody else. . . ." Less amused was Cukor by the studio's second-guessing of Ava Gardner's performance.)

Cukor preferred to look on the bright side of things. He was not keen on the heat and rigors of India, but he became reconciled to the trip. He remembered Stella Bloch's remark, after she returned from her first trip to India in the 1920s, that some Indians she met had borne a remarkable resemblance to his father and his uncle. On location, he would have an opportunity to observe firsthand and maybe collect some data on the Jews of India and west Pakistan—to tramp his ancestral ground, that part of the world where the Cukors, as a clan, were thought to have originated.

Ava Gardner was another reason to be cheerful, from the director's

At one of the costume parties that had such a vogue in Hollywood in the 1930s. Judging by the garb, the theme must have been *Romeo and Juliet*. A fat and Friarish Cukor talks with actor Fredric March and his wife, actress Florence Eldridge, whom Cukor knew (and disliked) from Rochester summer stock days.

Garbo's finest performance and Cukor's consummate screen romance was *Camille*. The director, Garbo, and co-star Robert Taylor mustered some lighter moments off-camera.

A rare swim in his own pool with William Haines, a good friend. The former silent screen star became one of Hollywood's premiere interior decorators. Photograph by Mortimer Offner.

Poolside: Cukor crony Anderson Lawler preening for the camera with Katharine Hepburn, probably on a Sunday, when friends gathered and mingled at Cukor's. Photograph by Mortimer Offner.

A tableau of family and friends from the Thirties, including (peeking out, third from left) Victor Cukor, Rowland Leigh with his arms around Stella Bloch, Cukor, Edward Eliscu, John Darrow, Louis Mason, and James Vincent. Seated in the modified lotus position: the photographer George Hoynigen-Huene. Photograph by Mortimer Offner.

In Cukor's sanctum sanctorum, the oval room walled in suede: the novelist who came to help on *David Copperfield*, Hugh Walpole, fellow Englishman Rowland Leigh, and Katharine Hepburn. Photograph by Mortimer Offner.

Cukor with one of his favorite writers, Zoe Akins, the tragically fated Rosamond Pinchot, and a bemused Lewis Milestone. Photograph by Mortimer Offner.

A publicity angle that became, to some extent, a career millstone: Cukor, strutting on the MGM lot, arm-in-arm with the all-female cast of *The Women*. From left to right: Hedda Hopper, Phyllis Povah, Rosalind Russell, Joan Crawford, Norma Shearer, Paulette Goddard, Mary Boland, and Joan Fontaine.

On the set of *Sylvia Scarlett:* Cary Grant burst into late bloom in his con-man part, and Hepburn played the sexually dichotomous title role. One of Cukor's most audacious and personal films, it was a notorious box-office flop.

Ill matched: Cukor and Clark Gable, seen here during costume and makeup tests, proved incompatible during early filming of *Gone With the Wind*. Cukor never blamed Gable for his firing, but he never quite shrugged off the onus either.

The well-liked and admired Donald Ogden Stewart, Cukor's most frequent writer, with his Oscar for adaptation of *The Philadelphia Story*.

Hunt Stromberg, an ex–sports reporter, was one of the MGM producers congenial to Cukor, even if their films together were among his least "distinguished." Anita Loos cropped up as a contributing scriptwriter of both of them, *The Women* and *Susan and God*.

All-white day on the set: Katharine Hepburn, co-owner of the stage property, listens intently to Cukor, as does aw-shucks leading man James Stewart, whose only Best Actor Oscar came for his performance in this film, *The Philadelphia Story*.

Even after Irving Thalberg's death, Cukor remained loyal to Norma Shearer. Here, on the set of *Her Cardboard Lover*, destined to be Shearer's last motion picture, Cukor looks every bit as svelte and well-dressed as his leading lady.

Intensely communing with Joan Crawford during the filming of *Susan and God*. Their films together were not the highlights of his career.

point of view. On location in the spring and early summer of 1955, Cukor felt that the sex goddess was coming gloriously alive in her role, while before, in other films, she had behaved as if she were a beautiful statue. Cukor wrote to Irene Burns that he was moved by Gardner's exultation at discovering herself as an actress.

In India, Cukor seemed to luxuriate in the logistically complicated crowd scenes, narrowing in on faces and descriptive details. The street riots of Bhowani involved thousands of people running rampant through the streets, and took several days to shoot—"really spectacular footage that impressed them in Hollywood," according to Ivan Moffatt.

"The trouble of it was," continued Moffatt, "the principals weren't involved in the action at all. The flamboyance, the details, the extraordinary quality of that sequence, it was really not germane to the story itself, unfortunately. And it was too late to interlace the people storywise. That often happens in a movie. But it was a kind of typical example of George being, in my view, beguiled by something that attracted him, while he was unable to incorporate it into the story itself."

Back in Hollywood, the MGM board grew alarmed at the expensive overshooting of *Bhowani*. At an executive meeting in May 1955, Cukor's overspending was discussed. It was decided that Dore Schary would speak sharply to him about it, and in a stroke of *Alice in Wonderland* logic, that the picture would be assembled all the more hastily in order to limit postproduction costs and rush the film into the theaters.

As it turned out, Cukor was not around for much of the postproduction; he had taken a ten-week leave of absence in order to direct his first play on Broadway in a quarter of a century. And postproduction censorship, which had hurt *Zaza* and *Two-Faced Woman*, also became a factor in the editing decisions that affected *Bhowani Junction*.

Cukor thought he had invested a lot of boldness in the love scenes. It was fuzzy thinking on MGM's part not to realize that the director would stress this aspect of the story line. Yet in this, the first Cukor film in which sex was foremost—almost *palpable*—all the erotic implications were trimmed back in order to adhere to 1950s conventions, and to accommodate fears about reaction in some foreign markets to a film concerning miscegenation.

There was a scene where the Ava Gardner character is taking a shower; she uses her lover's toothbrush and washes her mouth out with whiskey. Gone.

And according to Cukor: "You know the scene in *Les Amants* where the man is making love to Jeanne Moreau . . . he is on [top of] her and then all of a sudden his head disappears [out of the frame] and

the camera remains on her face, her ecstasy. I did exactly the same thing in *Bhowani Junction* with Ava and Bill Travers . . . [some] years before [French *nouvelle vague* director] Louis Malle. But it all went onto the cutting-room floor. . . ."

The love story was convincing regardless, and when *Bhowani Junction* was released in 1956 it earned some modest praise for its modest attributes before dying a box-office death. It was Cukor's last assignment from the Dore Schary regime, and one of Schary's last miscalculations. Schary was dismissed early in 1956, shortly after the film's release—stripped of power overnight, just like Louis B. Mayer before him.

Whether or not Cukor had any real hankering to go back to the stage, he was urged to do so now and then by people anxious for his marquee value. He had come closest in 1951, with Anita Loos's script for Colette's *Gigi*, to be produced by his old boss Gilbert Miller. That is when Cukor first met Audrey Hepburn, interviewing her for the title role of the Parisian coquette who comes of age at the end of the nineteenth century. However, after some publicity, the director had backed out of *Gigi*, pleading a too-crowded calendar.

Now Cukor's schedule was less crowded. He had admired the English novelist and playwright Enid Bagnold since days of young manhood, when he and Stella Bloch had discussed her pseudonymously written treatise "The Technique of the Love Affair" and her scandalous novel, *Serena Blandish* (authored by "a woman of quality"). After reading Bagnold's new play about a teenager and her governess, Cukor declared *The Chalk Garden* a beguiling piece of work, and yielded to Irene Selznick's entreaties that he be the director. In his new MGM contract, time had been set aside for this purpose, beginning in mid-August 1955.

Partly, Irene Selznick had pursued Cukor, thinking she might entice Katharine Hepburn into playing a part. But Hepburn didn't like the play, and she was busy with her own pursuits. So, ultimately, the Abbey Theatre stage star Siobhan McKenna was engaged to play the governess, with formidable British actress Gladys Cooper as Mrs. St. Maugham, her employer.

The play was set to open at the Ethel Barrymore Theatre on October 26. Yet the editing and postproduction of *Bhowani* dragged on over the summer of 1955, and Cukor found he was not free to head east until September.

Indeed, according to correspondence in his archives, it appears that Cukor was in no particular hurry to leave *Bhowani* behind, and that he may have been having second thoughts about his Broadway commitment. At one point, he asked MGM higher-ups Benny Thau and

Pandro Berman to be extra-tough with their language to him in a letter holding him to MGM obligations, so that he could impress Irene Selznick—who was fuming over the delay—with the fact that he had no choice.

By the time Cukor arrived, it is possible that all the original good-will had already deteriorated. What transpired next does not differ very much factually in the three principal accounts—Selznick and Bagnold in their respective autobiographies, Cukor in various sources—but the experience was a sore point for each person, gone over and over again, rationalized, in memory and interviews.

What happened was that Bagnold did an initial reading for the cast, pointing out meanings and inflections, which somehow got her and Gladys Cooper off on the wrong foot. Bagnold felt that Cooper was treating her, a fledgling playwright, with contempt, while Cukor deferred almost abjectly to the distinguished actress. Nobody seems to have anticipated that this is precisely what Cukor was bound to do. When Cooper starred in *The Astonished Heart*, which Cukor staged as a war-relief benefit in 1940, she also received program credit as director, according to *The New York Times* review, "under the supervision of George Cukor."

"George was in a difficult position," wrote Bagnold in her memoir *Enid Bagnold's Autobiography*. "He hadn't directed on the stage for twenty-five years, and his film-habit was to concentrate on the Star."

"He was still behind schedule when he got to New York," remembered Irene Selznick in her autobiography, *A Private View*, "and hadn't yet caught up with our script, so to help him along I had a scale model of the set ready for him in his suite. 'Whatever for?' So he could block his scenes for heaven's sake! A tiny doubt crossed my mind."

Selznick's version agrees with Bagnold's that Gladys Cooper "got the major part of his [Cukor's] attention, and Siobhan suffered benign neglect without a murmur. It was all I could do to keep Enid in her seat. . . ."

Louis B. Mayer's youngest daughter thought that Cukor, "alas, was no longer stage-wise by 1955." Amazingly—from Irene Selznick's point of view—the film director had forgotten what theater sight lines were; to make matters worse, Cukor had to excuse himself constantly to talk on the phone to Culver City about retakes for *Bhowani Junction*.

For one crucial interval, Cukor actually had to suspend work and go to California to attend to *Bhowani Junction* decisions. Bagnold took over as director and "unblocked" Cukor's scenes, "to the relief of everybody but Gladys." Now Bagnold and Cooper were at sword's points.

When Cukor returned east, he was flustered by what Bagnold had done, but he seemed to accept her restaging. However, his seeming lack of preparation and focus were beginning to gnaw at the producer. "He still didn't really know the script," wrote Irene Selznick in her memoir. "The tension was awful."

At last, before the New Haven preview, she decided to let Cukor go. "I've mercifully forgotten the details, but I fired him at the back of the theatre in the middle of a rehearsal. To his credit, he carried on as though nothing had happened—and magnanimously offered to stay on until I found someone or, if need be, even till New Haven, which he did. It was very stylish of him. If he had hard feelings, he contained them. The day he left we had a sentimental breakfast. In other words, I wept."

Later on, Cukor himself admitted that he was "discombobulated" by the job of directing for the stage, and after some time had passed he could be funny—if somewhat ingenuous—about the second, widely publicized time he was fired by a Selznick.

Privately, the director complained that Selznick and Bagnold were gross amateurs when it came to the theater. He liked to tell a story about Ethel Barrymore's reaction when he recapped his dismal experience to her. When Cukor informed his old friend and idol, the first lady of the American theater, that Irene Selznick thought him ignorant of "playing areas" on the stage, Barrymore's bewildered response delighted him. "What is a playing area?"

The firing was a definite blow to his professional pride, for in this case there was no question that Cukor had not mastered the situation.

Meeting with writer John Patrick in New York City, Cukor seemed unusually somber and downcast. To the Pulitzer Prize–winning playwright, he confessed, "I'd forgotten the problems involved in directing a play. Here, I tell actors what to do, when to cross the stage, and they stop and ask why. I've been used to Hollywood where I say, 'Because I told you to'. . . ."

When he had lunch with actress Shelley Winters shortly after, Cukor—this director who never never expressed any vulnerability—surprised her by saying that for the first time in his life he had lost confidence in himself.

Producer Sol Siegel, who was the heir apparent to Schary (although he didn't officially take over as head of production until 1958), had asked John Patrick to write the script for a Cole Porter musical comedy to be called *Les Girls*. Cukor had never directed an MGM musical, but he did have *A Star Is Born* under his belt. So Siegel assigned his highest-salaried director to the film, which at $2.5 million (Cine-

maScope, European locations) was also one of the studio's most expensively budgeted of the year.

The script was based on a property owned by MGM, a story by Vera Caspary, the author of *Laura*. With studio sagacity, Siegel told Patrick not to read or follow the original story. "Oddly enough, to this day I've never read it," remembered Patrick. "When the Queen chose it [the film] for her command performance in England, the original author, a woman [Caspary], said that she was the highest-paid writer in the world because she got eighty thousand dollars for two words: *Les Girls*."

Following a long-standing habit, Patrick wrote the initial draft from his farm in upstate New York. Cole Porter's songs were cued into the script after it was already finished. "I never discussed with him [Porter] what they should be," said Patrick. "He just picked them out from what he read. He did say to me once, 'The leading lady's name is Samantha, what the hell rhymes with Samantha?' I said, 'Lovely as a panther?' He said, 'Get out of my house.'"

Consequently, the script was largely completed by the time Cukor came on the picture. Patrick recalled that he and the director only had a few story conferences, and that Cukor objected to just a couple of things. "The girls in the screenplay lived in an attic. George said, 'Oh my God, I can't direct a play where zey live in ze Attic.' But I talked him out of that. Another scene he thought he couldn't handle was a love scene in a canoe. He said it would always remind him of Groucho Marx in a takeoff of *An American Tragedy*. However, both were beautifully done and important points in the picture."

In the story line there were similarities to the bitchy comedy of *The Women*: the publication of a tell-all memoir prompts a libel lawsuit, and the appearance of three women, ex-showgirls, before a judge. The three ex-friends relate highly divergent accounts of what happened in their love lives when they performed in a troupe with a handsome song-and-dance man many years earlier in Paris.

MGM picked the cast: Finnish ballerina Taina Elg, the gifted English comedienne Kay Kendall, the singer-dancer Mitzi Gaynor, Gene Kelly as the song-and-dance Romeo, and Henry Daniell as the judge.

Actually, Gaynor was cast over Cukor's vigorous objections. A friend of choreographer Jack Cole, Gaynor was regarded by Cukor as less than adequate. What was worse, she was engaged by MGM after the director had already been assigned. Cukor may have had little to do with casting decisions in the 1930s and 1940s, but now—especially with all the studio mismanagement—he felt he should be listened to.

When Cukor threatened to quit the film the studio called his bluff, informing his agent that as a result of precarious financial conditions in the industry, MGM had to be firm with its people. Cukor could

take it or leave it. Rather than risk a suspension, the director backed down.

Cukor was stuck with Gaynor. It did not help matters either that there was between Cukor and Gene Kelly a coolness unusual for two such thoroughly professional animals. Kelly may have resented Cukor's invading the genre Kelly usually "owned" with directors Stanley Donen or Vincente Minnelli (with Kelly usually contributing to the direction). At a transitional period of his own career—*Les Girls* was to be Kelly's last full-fledged musical—the singer-dancer needed an infusion of ideas rather than Cukor's characteristic blanket enthusiasm, which Kelly perceived as a kind of insincerity.

Kelly told Kenneth Tynan that he tolerated his director's "endless chatter" and enjoyed working with him but felt "basically Cukor is a theater man who neither cares about nor understands the camera." (An ironic assessment of the director who had just been fired from Broadway for being too much of a "movie man.")

In part because of this friction with the cast, Cukor devoted most of his attention to the decor and stylization of the picture—a task sure to pique his interest, even if nothing else in the production did. George Hoyningen-Huene and Gene Allen were at his side throughout filming in London and Paris, to contribute their ideas to the look of the film.

Huene blew a puff of cigarette smoke and said, "The whole thing [*Les Girls*] should be in *this* color—the background, the set, the girls' clothes." Cukor asked, "Won't that be drab?" Huene replied, "No, no." Cukor's éminence grise explained that it would be a discipline: the removal of color.

Huene was a one-man art and research department. His memos covered script, authenticity of European details, the title sequence, the extras, makeup (lipstick shiny and glossy), and precise descriptions of light and colors (the Daumier–type drab courtroom), many elements that might be outside the normal purview of an art director.

Befitting a picture in which the director was more intrigued by the visual design than by anything else, *Les Girls* turned out stunningly beautiful but empty, its innocence fatuous, its story without any cleverness or depth of characterization. The performers, even Gene Kelly, seem strangely enervated. It was more typical of an era clamoring for big-budget artifice than of Cukor.

But *Les Girls* did have its ardent admirers. John Patrick and (ironically) Vera Caspary won a Writers Guild award for Best-Written American Musical. And François Truffaut, trailblazing for *auteurism* in *Cahiers du Cinema*, was eloquent in his appreciation: "To give an account of *Les Girls* is a task which by no means can be compared to that required from seventh grade pupils when made to write a theme

250

in French on the following subject: 'You have spent Sunday in the country; the weather was fine, the sun brilliant, you picked some flowers. Describe your impressions.'"

Cukor and MGM could not agree on what, if anything, he should film next for the studio. One titillating possibility was Tennessee Williams's *Cat on a Hot Tin Roof*, an explosive play about a neurotic Southern family dynasty (with an obvious homoerotic subtext).

The studio was trying to figure out how to launder the Pulitzer Prize–winning drama for mass consumption, and Cukor was one candidate to steer the adaptation toward audience acceptability. Again there was the hope that Vivien Leigh might be persuaded by her good friend to lend her luminous presence to the film.

But there were problems. Although Lawrence Weingarten was producing, Pandro Berman had a big hand in discussions. Berman—who had been known to grumble about the director's budget overruns on the recent *Bhowani Junction;* who, moreover, had a good memory for the box-office thud of Cukor's cross-sexual allegory, *Sylvia Scarlett*—was adamantly opposed to Cukor directing, because Cukor would treat it more as a "homosexual piece." Script disagreements led to Cukor's withdrawal from the project.

Ironically, Cukor was destined never to direct Vivien Leigh, after casting her for *Gone With the Wind*, and despite so many spirited campaigns in ensuing years to woo her to star in one of his own films.

Cukor told Hollywood columnist Louella Parsons that he would not commit himself to directing *Cat* because of censorship misgivings. "I am not sure the public will like this play or understand it," he was quoted as saying, somewhat ambiguously. "I couldn't do an emasculated version, and I don't see how the movie itself could be properly presented."

With the director and MGM management at a temporary stand-off—with the studio in crisis, and the number of available assignments plummeting—Cukor was loaned out for his next two pictures to his old studio Paramount, where Hal Wallis had taken up residence and, in effect, was keeping the studio afloat.

Wallis, a tasteful, no-nonsense producer who had headed up the Warner Brothers assembly line for years, had a volatile star and an unusual property in need of a sensible director.

Wallis had just completed *The Rose Tattoo* with Anna Magnani. Now the earthy Italian actress, who was under contract to the producer, wanted to do a remake of a vintage Italian film, *Furia*, in part as a rebuff to director Roberto Rossellini, who had thrown her over for Ingrid Bergman. Anthony Quinn would costar, with Tony Franciosa

and Dolores Hart filling out the cast of *Wild Is the Wind*.

Director John Sturges had been working with the young playwright Arnold Schulman, whose first play, *Hole in the Head*, was a current hit on Broadway, in developing the American version of the *Furia* screen story by Vittorio Nino Novarese. When it became clear that a love story was evolving rather than an action picture, Sturges bowed out, however, and Cukor—as was too often the pattern of his career after *A Star Is Born*—was asked to come in on the project and pick up the momentum.

Although he was only in his twenties then, Schulman recalled that Cukor treated him as an equal. They met at Cukor's house almost every day, and talked and *talked* about the story of a middle-aged rancher who brings home a bride from Italy, only to have her fall in love with his hired hand, a surrogate son. Beginning at a civilized hour, say ten or eleven, they would work until lunch, break, and then work for a few hours more in the afternoon. Cukor served lunch on his most exquisite china, with his best silver and glasses.

"There was never any pressure, never any screaming or hysteria, there was just exploration [of the ideas]," Schulman said. "Being a young filmmaker, I was very conscious of visual metaphors and symbols, and he was very receptive. When I got too ambitious, he would gently lead me away from my excess. If I went overboard in some way he would pull it back to reality or reduce it to its crucial elements.

"Once it was on the page, it was frozen. Once it was on paper, nobody changed a line, and if it had to be changed, I was right there on the set. If we needed an extra three lines to cover a 'cross,' whatever it was, there were no improvs, no ad-libs."

It was Schulman who set the story on a sheep ranch in Nevada, where eventually they all went on location. Cast and crew stayed at a hotel outside Carson City. Because Schulman was on the spot, they were able to incorporate details of the location (a fortune-telling machine in a Reno airport) and some of Magnani's personal mannerisms into the script.

Altogether, the sixteen weeks of filming *Wild Is the Wind* were an ordeal—the accommodations were grubby, Magnani an impossible star. She quarreled constantly with the script and caused delays. "She stayed in bed for two days because she was displeased with her wardrobe," according to producer Wallis in his autobiography, *Starmaker*. "In a perpetual state of fury," she tossed food around her room "in fits of rage and the walls were streaked with spaghetti sauce and pasta." The weather turned bitter cold, the wind never let up, and neither did Magnani.

There was no love lost between Quinn and Magnani, while be-

tween Franciosa and Magnani there was only love gained: They were in the midst of an obvious, torrid love affair. One hitch: Franciosa had promised to marry Shelley Winters, and Winters showed up on location to collect on his promise. Filming, and other diversions, were interrupted while the two of them went off to be wed and to have their pictures taken for the newspapers.

Filming resumed: more tension and bad behavior off-camera, more love affair between Franciosa and Magnani. On-camera, meanwhile, there was jockeying for vantage, with all three principals—Quinn, Magnani, and Franciosa—competing for Cukor's close-ups.

One doesn't hear about these kinds of sidelights, over and over again, in the case histories of other directors. But off-camera Sturm und Drang sometimes seemed inseparable from Cukor and his career. Was it that his very presence somehow encouraged such openness, such angst on the one hand and amour on the other? Was it all part of his patience and tolerance of people?

Now every one of his films seemed to be overshadowed by script troubles, or gossip-column excitement, or untenable behavior from untameable actresses. Too often, producers seemed to think of Cukor "second," as an eleventh-hour replacement for a dropout director. Though publicly good-humored, more than once in letters to friends and associates, during this period, the director admitted he was feeling too old for the perpetual crises that seemed to afflict every one of his films.

That may be one of the reasons why Cukor's concentration in these films seems more focused on the visual elements. Where once Cukor's films had been visually conservative, now there was a restlessness in the camera movement. The visual verve of these 1950s films—of *Wild Is the Wind* especially—was one of their strong points, even when other things were going awry.

To some extent, this was a shift in Cukor's own sensibility, to some extent the result of his long experience with actors who told him that sometimes he *did* talk too much. Too often now, the director who could discuss acting ad infinitum simply had less interest in his characters—and his actors—and turned his attention to "picturesque irrelevancies."

"Cukor never talked about acting theory, was not interested in inner motivation," said Schulman, speaking of the uncharacteristic 1950s Cukor. "He was more concerned with the technical aspects of directing. The most he would say to an actor: 'a little lower, a little higher, a little more energy.' He was not any more interested in the psychology of his characters than he was in his own psychology.

"One time he yelled at Dolores Hart, the actress, 'Cut, cut! You

must not, absolutely *must not*, blink your eyes, because this is a close-up. . . .'"

One of the things that impressed the young scriptwriter was how the veteran director fortified himself for the job. Cukor took a short nap in his trailer during the lunch break, as he always had. The director, Schulman noticed on the airplane flight to Nevada, made a point of bringing his own down pillow along to location. After the day's filming, when the rest of the cast and crew went off to Carson City for food and nightlife, Cukor disappeared into his cabin to enjoy an early bedtime. "I felt that wasn't his style—to go out and mingle," said Schulman.

Sometimes the story behind a film is more compelling than the film itself. *Wild Is the Wind* is not uninteresting—it is precisely the sort of film one calls "interesting," but more as a backhanded compliment.

There is a mustang roundup scene, complete with Magnani pleading for the liberty of the wild horses, that Arthur Miller must have remembered later when writing *The Misfits*. Of course, *Misfits* director John Huston filmed that scene magnificently, while in Cukor's version it was filmed to less thrilling effect by the second-unit man, acting on instructions from Cukor.

There is one other notable story element: In *Furia*, the adulterous woman dies at the end of the story. Schulman felt that was a cliché and Cukor supported him staunchly. They thought it was the husband who should plead with her for forgiveness ("that was revolutionary at the time," noted Schulman) and there was a lot of discussion about such a departure. Wallis supported Schulman and Cukor against the studio's wishes, and their more modern, more feminist ending prevailed.

Magnani was not the ideal of beauty Cukor doted on—in real life or on the screen. ("Magnani by any standard is not good-looking," wrote Wallis). Nor did the shouting, screaming ethnic mismatch between Magnani and Quinn—who does one of his patented "crude peasant" routines in the film—add up to the director's idea of a good marriage or stirring love story. The film's ludicrously repressed lust-guilt, as in the case of his two previous films, *Bhowani Junction* and *Les Girls*, is more representative of bad 1950s moviemaking than of true Cukor.

Hollywood liked the picture enough, incredibly, to nominate Quinn and Magnani as Best Actor and Actress. Critics and audiences responded with indifference to *Wild Is the Wind*, "this most difficult of motion pictures" in producer Wallis's long experience. "There was nothing to do but shrug and go on to the next one," Wallis wrote. That was also the motto his director lived by.

*　　*　　*

It had been several years since Cukor had a film he considered his own, a subject he coveted, an assignment he truly prized.

While at Paramount, Cukor discovered the studio owned a book called *Heller With a Gun* by, of all people, the prolific Western writer Louis L'Amour. The book was typical "shoot 'em up" L'Amour, but with a twist that appealed to Cukor—a colorful subplot about a theatrical troupe stumping the frontier. The idea of a theatrical troupe venturing into a danger zone had always intrigued him. Although he may have been deluded to tackle a Western—hardly his forte—the prospect of *Heller* excited him more than any other film he had done in recent years.

Paramount had an ongoing contract with Italian producer Carlo Ponti and his wife, actress Sophia Loren, and *Heller With a Gun* could be shaped as a vehicle for her. Things moved quickly after Cukor's commitment, and the fortuitous availability of the "art boys," Huene and Allen. A first-draft script had already been written by the Oscar-winning writer Dudley Nichols. But Nichols was terminally ill with cancer (he was to die in 1960), and by the time Walter Bernstein was hired to rewrite the script, the production already had a start date.

Bernstein was a dapper and witty ex-newspaperman whose nascent Hollywood career after World War II had been interrupted by the HUAC targeting of Hollywood Communists and left-liberal activists. His first credit off the blacklist was a picture he had just finished for Ponti and Loren and Paramount, directed by Sidney Lumet, called *That Kind of Woman*.

"The situation [on *Heller*] was so hectic," Bernstein recalled, "sometimes they would catch up to me, and I'd bring the pages in in the morning they were supposed to shoot. It was both a good and a terrible position to be in—if you could bring them something they could shoot, you were a hero."

L'Amour's book was blended in the script with D. W. Griffith's treatment from the 1940s—another story of a theatrical troupe braving the Wild West—and chunks of Joseph Jefferson's life story. The Indian raid on the wardrobe trunk, always Cukor's favorite scene, was inspired by a scene in the Joseph Jefferson autobiography and exhumed intact from the script Cukor had nurtured in the 1940s. The Sophia Loren character emerged more and more prominently in the writing, so *Heller With a Gun* became, improbably, *Heller in Pink Tights*.

The supporting cast was exceptional: Edmund Lowe, Eileen Heckart, Margaret O'Brien, and Steve Forrest. Loren was very easy to work with, and Cukor behaved in "courtly" fashion toward her,

Bernstein recalled. But the director and Anthony Quinn, her costar, had a more frictional chemistry.

Originally, for the part of the dashing impresario of the troupe, Cukor had fought to cast a handsome, broad-shouldered young English actor by the name of Roger Moore. But nobody at Paramount was willing to bet on the future James Bond, so Cukor had taken Quinn, out of convenience and because Quinn was under Paramount contract.

"In fairness to Quinn," remembered Bernstein, "he was dreadfully miscast in the part. Also, he didn't have the pages. He couldn't go home and read the script and work on his character. Nobody knew what they were getting the next day. That was very tough on everybody.

"I remember one point where there was a script conference with Quinn, Sophia, George, and I don't know who else. George got so angry that he got down on his knees and started to *salaam* in front of Tony. He was so angry, he didn't know what else to do. That defused the situation. It also defused his own anger."

Quinn was left largely to his own devices, while Cukor hustled about, trying to keep everybody calm and happy as the script was being plumped up. The charm of *Heller in Pink Tights* is this slapdash quality: The script never does jell. Cukor was more absorbed in the style and atmosphere of his first and only film set in the West.

"It was not his kind of movie really, a Western," noted Bernstein. "He was much more involved with George Hoyningen-Huene and Gene Allen, and the style of the picture really. I was just entranced by that trio of Cukor, Huene, and Allen—Huene was very elegant; Gene Allen was an ex-L.A. cop of a considerably developed aesthetic sensibility. Looks like a cop, talks like a cop, but Cukor was able to see what he had and he was very, very valuable. Allen did all the camera setups; he walked through them and laid them out.

"Cukor was very smart that way. He didn't have an ego in that sense. He used whatever he could in a situation."

Adding to the *Heller*-skelter, when the picture was finished, the studio decided the film was not enough a conventional Western—which should hardly have come as a surprise. Additional action scenes were ordered filmed and tossed in.

"I wrote a lot of scenes that were shot," said Bernstein, "but cut out of the movie because when Cukor finished it Paramount didn't know what to do with it. It wasn't the typical Western. So they cut it their way—which was to cut out all the quality of the characterizations, and go to plot—the plot was ridiculous!

"I know they made him [Cukor] shoot a couple of action scenes that weren't in the original script. He had no interest in doing that,

but he was very much a company guy; he knew he didn't have control; that was it and on to the next thing."

Audiences and critics didn't quite get it. Cukor bemoaned the "idiotic" cuts. But *Heller in Pink Tights* was too pleasant a film to kill off entirely: It has an avid cult, this colorful Wild West comedy done as if a handshake between Toulouse-Lautrec and Fredric Remington.

Along with *Sylvia Scarlett* and *Travels With My Aunt*, *Heller* forms part of a Cukor road-show trilogy. These are not his best nor his most important films by any means, yet they are among his most personal. In each he was able to re-create his early road-company days and depict the "strange creatures" of the theater he first met, goggle-eyed, as an assistant stage manager. He was able to imagine the screen stories as equivalents to his own life.

But he wasn't too analytical about it. Although the director realized he had an emotional attachment to *Heller* that ran deeper than usual, Cukor had to admit, in a letter to George Hoyningen-Huene, that he also didn't have the foggiest notion why.

At Twentieth Century–Fox, the redoubtable Jerry Wald had taken over the reins of production, and he was trying to figure out what to do with Marilyn Monroe. Though she was the studio's major box-office attraction, Monroe, completely under the spell of the Method and its self-hypnotic techniques, was becoming increasingly withdrawn and contrary, resistant to Hollywood rules and packaging. Wald thought Cukor was the man to cajole her through her next picture, *Let's Make Love*.

Let's Make Love had come to Wald via Oscar-winning comedy scriptwriter Norman Krasna, who had once been the producer's partner in a short-lived production unit at Columbia. Wald had written a blithe comedy—originally and more appropriately titled *The Billionaire*—about a rich and powerful stuffed shirt who learns of a Greenwich Village revue whose satirical songs and jokes hold him up to ridicule. When the billionaire heads down to the cabaret to investigate for himself, he falls in love-at-first-sight with a chorine in the act. She detests the ruling class, so he has to pretend to be a budding song-and-dance man in order to join the show and get to know her. Being rich, he is able to arrange for three famous entertainers— Milton Berle (who, with the longest screen time, is hilarious), Bing Crosby, and Gene Kelly—to teach him how to crack jokes, sing, and dance.

All along, Krasna's idea was that the billionaire ought to be played by an actor with the audience image of a "shit-kicker"—a Gary Cooper, Jimmy Stewart, or Gregory Peck—so that his wooden inability to perform would be all the funnier. In that vein, Gregory Peck was

cast as the billionaire before either Monroe or Cukor was on the film. There were satisfactory script conferences with Peck, and everything was set.

When Wald decided to ask Monroe to play the female lead, Krasna was dispatched to pitch the story to her. She pronounced herself thrilled with his oral rendition. "Krasna had a genius for selling a story to actors," in coscriptwriter Hal Kanter's words. After finishing a first draft, which had not yet been shown to Monroe, Krasna flew off to Switzerland, where he kept a home.

Meanwhile, Cukor went to New York with Lionel Newman, the studio's director of music, and the songwriters Sammy Cahn and Jimmy Van Heusen. They were to demonstrate to Monroe and her husband, playwright Arthur Miller, the score they'd written for the film.

"The day after they arrived there," said writer Hal Kanter, "I got a summons to Jerry Wald's office. He asked if I had any ideas on how to fatten Marilyn's part! Seems she (and/or Miller) had read the screenplay for the first time shortly before Cukor arrived and she was distressed, to understate her reaction. So Jerry called her and mollified them with the promise that another writer was being put on the project. He also put in a call to Krasna and asked him to make suggestions. Krasna's suggestion—now that the studio's check was safely deposited in his Swiss bank—was to let me do any rewriting that seemed appropriate and send the pages to him for approval."

Peck bowed out when he learned that Monroe had demanded script changes to make it more of an "evenhanded costarring vehicle," in Kanter's words. Cukor and Wald settled on Rock Hudson, who could play comedy, but that ideal casting hit a snag when Universal refused to release Hudson to Fox. That was fine with Monroe, who much preferred someone else, the masculine continental (Italianborn, French-bred) star with a music-hall background, Yves Montand. So Montand, no "shit-kicker" he, got the part.

"It entailed another rewrite to accommodate the Frenchman," recalled Kanter. "Cukor was talking to both Mr. and Mrs. Miller, who were back in New York, and getting suggestions on the script from Mr. Miller. One day he said Arthur had suggested a great joke for the scene where the billionaire and the showgirl—Monroe—are walking past a nightclub where a doorman is sweeping the sidewalk. The billionaire says to the doorman, 'Call me a cab,' and the doorman says, 'All right—you're a cab.' While George chuckled at that, I stared at him.

"'You're not serious about putting that in the script,' I said. 'That joke is ancient.' Cukor said he never heard it before. No, I supposed, his friend Willie Maugham never told jokes like that—but everybody

else in the world has. How could they, he argued, when Arthur Miller just told it to him?

"Footnote to that: When, finally, my wife and I saw the finished film, in a Hollywood theater at a poorly attended matinee, I cringed as I saw a doorman sweeping the sidewalk as Monroe and Montand approached. He didn't dare do that, did he? By God, he did. And, by God, it got a huge laugh from even that small audience."

Filming proceeded with the usual Cukor quota of rewrites, delays, and duress—Monroe was in her exasperating pattern of lateness, sickness, and not showing up—behind-the-scenes romance, and ancillary developments.

One of the offcamera subplots was the steamy rapport between the two principals, apposite sex symbols. Gossip columnists swarmed to report evidence of M and M's fling with each other. Surely, something must have happened between Cukor's two sexy leads, but who could be sure what?

Another distraction was the visit to the studio of the Soviet premier Nikita Khrushchev and the big media event made of lunch with the Russian leader in the Twentieth Century–Fox commissary. Cukor escorted Marilyn Monroe and Judy Garland for the occasion. (Afterward, for Khrushchev's benefit, there was a soundstage presentation of scenes from the forthcoming Twentieth Century–Fox musical gala, Can Can. Strictly for show: There was no film in the cameras.)*

The director rarely said much about Let's Make Love in interviews. Perhaps it was too much of a "sprightly concoction" for his taste, without a molecule of reality.

Yet the picture turned out stylish, the least assuming, the least subservient, and in some ways the most appealing of Monroe's late-career vehicles. She was rarely so unaffected. The musical numbers are most entertaining—she does a killer "My Heart Belongs to Daddy"—even if they were staged by choreographer Jack Cole, and too many of them shared with the truly dreadful Frankie Vaughan.

*"Khrushchev's patience was tried on all occasions," Cukor said bemusedly in On Cukor. "It began when he arrived here and the dumb mayor of Los Angeles insulted him by saying, 'You think you're going to wipe us off the face of the earth, but you're not,' and then at the lunch, Spyros Skouras kept on challenging him and said, 'I was just a poor boy and now I'm head of a studio.' And Khrushchev said, 'I was just a poor boy and now I'm head of Russia.'

"But finally he [Khrushchev] got quite angry and said, 'You won't let me go to Disneyland, I'll send the hydrogen bomb over,' and frankly I wondered why he didn't."

Now, perhaps too late, Cukor began to reexamine his professional options, and to try to adjust to the swiftly deterioriating condition of the motion-picture industry. He began by looking closely at the quality of his representation.

Over the years, Cukor's agents had been successful in getting him the best possible financial terms. However, in other ways they had failed him: First Myron Selznick and then the William Morris Agency had stopped short of pushing him toward more independent or creative options.

The William Morris Agency had represented him since the death of Myron Selznick in 1944. But Cukor felt a surprising bitterness toward the agency for negotiating the plush contracts on his behalf while putting less effort into more risky career moves—for failing to help him bridge, in some fashion, the difficult transition between the studio heyday and the unforeseeable future. He felt stuck professionally. Sensing that he had not done as well as he might, Cukor moved to pry himself away from the all-powerful firm in the spring of 1957.*

Cukor's choice for an agent was expeditious. He signed with Irving Paul Lazar, whose nickname "Swifty" came from his reputation for procuring swift deals and cushy terms. (Lazar was also reputed never to read any of the properties for which he made such big, quick deals.) In those frantic times, with so many abortive productions and executive shuffles, the swift arrangement might be an advantage, even if it did not guarantee any other distinction. Cukor's need to be busy was great, though, and "Swifty" Lazar was a man in motion—one of the most hyperactive agents in the business, whose clients of the moment included many of the people whom Cukor would be tied to professionally in the future—Walter Bernstein, Alan Jay Lerner, Audrey Hepburn, and Cecil Beaton, among them.

With Cukor all but divorced from current studio thinking, Lazar was able to renegotiate his studio contract downward and to obtain for the director a "nonexclusive" pact with MGM stretching for five years, from 1958 through 1963. While tying him loosely to the studio for mutually agreed upon motion picture projects, the contract per-

*Years later, Cukor had an arrangement with a writer to write his authorized biography, which blew up when the writer remarked in passing that he was represented by the old and established agency. Cukor seemed to rage and fume at the very mention of the William Morris Agency. It was just an excuse—he probably would have found some excuse no matter what—but the author was astonished when Cukor, citing his antipathy to the William Morris Agency, summarily canceled the book and their collaboration.

mitted Cukor to direct elsewhere at his own volition. His strong suits were to be called upon in a retainer fee for "advising MGM as to suitability of literary properties, and writers, casting of other films, etc."

Yielding to friends' pleas, Cukor also went to the extraordinary lengths of hiring a personal publicist—Stanley Musgrove, one of Cole Porter's friends and a stalwart of Cukor's Sunday parties. The generally well liked Musgrove would begin to arrange the interviews and testimonials that seemed to occupy Cukor's life increasingly from the 1960s onward. Musgrove would also arrange for the first Cukor biographer to come in and begin writing the director's life story.

Cukor felt strange about hiring a publicist, but times had changed. (Notice the difference between the helpful and intelligent press agent played by Tony Randall in *Let's Make Love,* and the "petty Lucifer" of *A Star Is Born.*) The director was at a professional crossroads, and he rationalized the move as purely an act of self-preservation.

He liked to quote Lillian Gish: "It's the work that matters." Not the publicity: He prided himself on never having had a publicist. However, he told Musgrove that he was fed up with doing all the work, and then seeing all the "personality Joes" get the credit. He was tired of being overlooked and underappreciated.

With Lazar in his corner, things were sure to perk up, and Cukor was hardly at such a low point that he would have considered going back to work for David O. Selznick.

His old friend was at a bleaker state in his career: After producing only two middling pictures since 1950 (*Indiscretion of an American Wife* in 1954, and *A Farewell to Arms* in 1957)—both vanity shows for his second wife, actress Jennifer Jones—Selznick had floundered. It was ironic, but Cukor believed that Selznick had been immobilized by the spectacular success of *Gone With the Wind.* The producer could not figure out how to top himself.

Selznick had been pestering Cukor for much of the decade with proposals for films of classic literature: screen versions of Thomas Hardy's *Tess of the d'Urbervilles,* William Thackeray's *Vanity Fair,* or, as early as 1950, a favorite Selznick idea, an adaptation of F. Scott Fitzgerald's *Tender Is the Night,* to be scripted by John O'Hara.

In his letters, Selznick used various ploys to persuade Cukor, calling on the bonds of their longtime friendship as well as the director's professional pride. The producer lived abroad much of the time; writing Cukor from the Grand Hotel in Rome, for example, Selznick would taunt him with his unseemly devotion to Hollywood and MGM, referring to the studio system as "the salt mines," asking why

Cukor didn't do something more elevated and artistic with his consummate talent.

Despite the exchanges of Christmas gifts and outward signs of friendship, Cukor still harbored resentment toward Selznick. A commitment from Cukor might have made a difference for Selznick, but the director staved Selznick off repeatedly with evasions and politesse, even when Selznick's film ideas were more auspicious than whatever Cukor had going.

By the late 1950s, Selznick was desperately clinging to his dream to film *Tender Is the Night*. Glenn Ford had agreed to star in the picture, and Selznick felt he could go to Sol Siegel at MGM with the director/lead actor combination of Cukor and Ford. Selznick sent Cukor wires and telegrams asking him for his frank commitment.

However, Lazar had Cukor lined up to direct two lightweight vehicles—a version of the Broadway play *Goodbye Charlie* at Twentieth Century–Fox (intended, originally, as another vehicle for Marilyn Monroe), and an adaptation of Romain Gary's novel *Lady L* for MGM. Both projects were tentative, but nonetheless, somewhat coldly, Cukor asked Lazar to pass the word to his old friend that his schedule, as usual, was too crowded to consider a Selznick commitment.

Selznick was particularly hurt that Cukor would turn down F. Scott Fitzgerald for the likes of *Goodbye Charlie*, a comedy about reincarnation that Selznick had seen on Broadway and judged as badly written, badly acted froth—"that all-time low in smoking car jokes." In Selznick's eyes, Cukor was abandoning art for commerce.

Selznick wrote Cukor: "It seems a pity that your talent will be wasted on junk like *Lady L* and *Goodbye Charlie* which are placed on production schedules solely through the salesmanship of Lazar, while a masterpiece like Fitzgerald's *Tender Is the Night* is available to you. . . ."

Cukor was unmoved by Selznick's predicament. He sailed the Hollywood seas, and he intended to ride out the present choppy waters. Privately, he fumed that the producer would dare to lecture him about living in Europe and devoting himself to art.

Cukor would not yield to Selznick, but he felt different about helping William Goetz, husband of L.B.'s *other* daughter, and he flew off not to Paris but Vienna when the Hungarian-born director Charles Vidor dropped dead of a heart attack on the set of the Columbia production of *Song Without End*, the musical life story of composer Franz Liszt.

Before Vidor's body was cold on the set, Goetz was on the phone to Lazar, talking to him about Cukor coming to the rescue of the

expensive international coproduction, which starred Dirk Bogarde, Capucine, and Genevieve Page.

"Almost as soon as Mr. Vidor was freighted aboard a K.L.M. flight to Los Angeles," wrote Bogarde in his memoir *Snakes and Ladders*, "another flight arrived bearing a tired, but encouraging, George Cukor who arrived determined to hold the sagging epic together, bearing Osbert Sitwell's *Life of Liszt* firmly clutched for us all to see in his hand."

In Vienna, Cukor encountered an "idiotic" script, dull sets, costumes and furniture whose awfulness he could not believe, and an inflexible cameraman (James Wong Howe), who had to be dispatched in favor of one more compatible with Cukor (Charles Lang).

Fortunately, in one of those almost-too-good-to-be-true coincidences, Gene Allen and Walter Bernstein were also in Vienna at the time, toiling in their different capacities on director Michael Curtiz's equally chaotic filming of Molnar's play *Olympia* (another Carlo Ponti/Sophia Loren production, entitled *A Breath of Scandal*).*

Allen helped Cukor with his impromptu redesign and camera strategy, while Bernstein was asked by the director to ponder revisions in the screenplay. After reading it, however, Bernstein, already anxious to flee Vienna, begged to be counted out.

"I remember I said to him [Cukor], 'My best advice to you is to get rid of Dirk Bogarde and get Sid Caesar. Then, just film the script.' The script was terrible, like a parody."

Bernstein flew off to Paris to keep a rendezvous with his fiancée. Cukor told Charles Feldman, a leading Hollywood agent whose mistress was Capucine, a former top model making her screen debut in *Song Without End*, that he couldn't proceed without the reluctant writer. In Paris, therefore, Bernstein was hunted down by the relentless Charles Feldman.

"For the first and only time in my life I was subjected to this great Hollywood wooing," recalled Bernstein. "He [Feldman] found out where I was staying. It turns out he was an old friend of the lady I was going to marry, and every night he was taking us out to the best restaurants, and saying things like, 'Just do two weeks for me, I'll get you twice your pay'—the whole schmeer. What's fascinating about it is ninety-nine percent of you is laughing at it, but there's another one

*Curtiz was "kind of in his dotage," recalled scriptwriter Bernstein, and when the director would depart the soundstage, the Italian neorealist pioneer Vittorio de Sica would be ushered in to redirect scenes behind his back. "And de Sica had to be paid in cash at the end of every day for his gambling."

percent in the back there that is saying, 'Well, maybe, who knows. . . .' So I said yes to the two weeks."

Back in Vienna, Bernstein began morning meetings with Cukor in his hotel room, plied with helpings of ham and fruitcake ("George would eat all of his, and take mine"). The writer advised the director that, because the script could not be salvaged in its entirety, they ought to go through the pages on the basis of the immediate schedule, and then just fix the scenes as best as possible, to make them "less egregiously awful."

"I remember the first scene I started on was a scene between Wagner and Liszt," said Bernstein. "I rewrote the scene and brought it to him [Cukor]. He said, 'It's not right.' I said, 'I know it's not right, but it's better, isn't it?' He said, 'It's better but it's not right.' I said, 'But it's better; let's keep going. . . .'

"I spent two weeks on that one scene really. In this terrible picture, there is only one very well-written scene. He couldn't let it go. He was fascinated by it. It hurt him to let it go.

"Maybe one reason why actors liked him so much is that he was marvelous with a scene—getting all the values out of that scene—though he was not great in the overall conception or arc of the script. That may be one of the reasons, too, why he was best in the studio setup."

The filming was rigorous: From chronic miscommunication with the European crew to the constant night shooting (6:30 P.M. to 6:00 A.M.), *Song Without End* sometimes seemed as if it should be retitled *Movie Without End*. However, the director wrote George Hoyningen-Huene that he didn't find the trials of the production too taxing, because he did not feel emotionally attached to the film.

Wrote Bogarde admiringly in his book: "He [Cukor] was a working professional from the tip of his fingers to the crown of his splendid head, and he expected and demanded no less from us. He rallied our forlorn band together swiftly; giving each one of us a private pep talk outlining the way that he would now steer our drifting barque. He was rightly appalled by my own performance, 'a mincing tailor's dummy,' he cried furiously, and sent my heart soaring by the detailed ideas he had for a complete re-working of Lovable Liszt. . . .

"Under his determined authority we all began to come alive, costumes were altered to the correct period, actors re-cast where needed, sets modified, a general feeling of enthusiasm began to flow. . . .

"The only thing he couldn't do much about was the script, although he did manage to clear up quite a number of 'Hi! Liszt . . . meet my friend Schubert, he's a pal of Chopin's.' Which was a relief. However, none of us was under any illusion that we were making anything more than a big Hollywood standard."

When the picture came out, although he had refilmed all scenes in their entirety, Cukor graciously—wisely—refused directorial credit, and *Song Without End* went down as Charles Vidor's last picture.

Back in Hollywood, "Swifty" Lazar's agenda for Cukor was altered by unforeseen circumstances.

Despite laborious efforts, Cukor felt unable to proceed with his production of *Lady L,* a chic continental comedy set in turn-of-the-century London and Paris.

There were producer problems—and there was a producer replacement. Cukor clashed with the female lead, Gina Lollobrigida, whom he found unpleasant and untalented, especially after she went public in the press with her gripes about the script. The script bothered Cukor, too: S. N. Behrman's draft had been reworked by Robert Kaufman, but Cukor was not satisfied. Once again, MGM overruled the director's objections, saying in effect that his job was to direct, not to worry about the script. Cukor was incensed at such treatment, from a studio where he had worked for nearly thirty years.

In an inter-office memo of early April 1961 to Sol Siegel, Cukor declared that he had never been faced with such a dismaying prospect as *Lady L,* and that his morale was "completely shaken" by the experience. He told Siegel that he adamantly opposed the present script, with "its lack of style and wit," unclear story line, and bewildering characters.

"If questioned by an actor about certain vital, important points of story or character, I would not be able to give either an intelligent or even common-sense answer," Cukor wrote to Siegel, adding that in recent story conferences with stars Tony Curtis and Lollobrigida he was "put in the awkward position of sitting by silently while the script, about which I had expressed a strong disapproval, was being discussed. This could not help but put me in an ineffective and perhaps unfavorable light with the people with whom I have to work."

While conceding that his contract stipulated "no script approval," he insisted that under the circumstances he could not promise "even a passable picture." Though filming was to begin the following Monday, Cukor asked to be relieved of directing *Lady L.*

Yet Siegel would not consent to release him from his obligations, resulting in an extraordinary climax to Cukor's three decades of MGM service: The sets for *Lady L* had been built, the first scenes (a Parisian riverbank) were set up on the backlot, the extras were milling around and waiting, the clock ran down—and no director showed up.

It was announced that Cukor was suffering from an ulcer; if so, it would have been the first day in his life he had missed work because

of illness. And, of course, he had a history of bailing out of untenable situations. According to Gene Allen, the start date of *Lady L* "was pushed to the limit for legal reasons." The production was canceled.

MGM threatened to sue, of course. Lawyers had to resolve Cukor's role in the matter, and the director did not make another MGM picture for ten years.

(*Lady L* would be filmed five years later, with a different script and cast, by a different studio.)

Because of the *Lady L* delays, Marilyn Monroe had dropped out of *Goodbye Charlie*, and that pending Cukor production had to be taken off the schedule at Twentieth Century–Fox. (*Goodbye Charlie* would be made in 1964 by Vincente Minnelli.) Now, Cukor was in bad odor not only at MGM but at Twentieth Century–Fox, too. To fend off another lawsuit over *Goodbye Charlie*, "Swifty" Lazar agreed that Cukor owed Twentieth Century–Fox a future film of the studio's choice.

The Chapman Report was a radical departure—something highly dramatic and ultracontemporary, based on a book by Irving Wallace, about a Kinsey-style team of sex fact finders who peek into upper-income-bracket bedrooms, exposing nymphomania and frigidity.

How the project originated is unclear. However, Cukor himself had read the best-selling book and was intrigued by its subject matter ("the point here was a rather freshly written insight into the sexual problems of 'respectable' women at that time"). And at the time, there was a vogue for books and films exploring the relatively new world of suburbia.

The script rights wound up at Twentieth Century–Fox, where Darryl F. Zanuck, now operating from France as an independent producer, expressed an interest in filming a book that, from the get-go, was daring—unusually prurient.* There were frank references to intercourse and sexual attitudes; one character suffered a gang rape, then committed suicide.

A few too many scriptwriters converged on the script. Sonya Levien, the first, proved hopelessly old-fashioned in her approach; she was followed by the *New Yorker* scribe Arthur Sheekman (who eventually adopted the pseudonym of Grant Stuart for his screen credit) and Don Mankiewicz, one of the two sons of Herman J. Mankiewicz (and his widow Sara, Cukor's close friend). *Esquire* writer Wyatt Cooper was one of the finishing writers, if the script was ever really finished.

*However, if the book *The Zanucks of Hollywood* by Marlys J. Harris is to be even half-believed, the Zanuck clan was hardly prudish, and the semi-porn aspect may well have been, at least initially, part of *The Chapman Report*'s appeal for Zanuck.

"He [Cukor] gave me the book to read, and later he gave me a huge script, maybe four hundred pages," recalled one of the film's stars, actress Shelley Winters. "In order to get screen credit, the writer had to change 51 percent or something. Every time I got a new script, the good stuff was taken out of it. By the time we got to the shooting script, there was no relation to the original script I had read! All the good things had been taken out. . . ."

The flurry of rewrites worried Twentieth Century–Fox, whose management thought it over and decided not to make the film. In one of Hollywood's historical ironies, *The Chapman Report* was then farmed out to Warner Brothers, where Jack Warner had agreed, almost as a personal favor to his onetime production boss, Zanuck, to handle distribution of the film (with a share of any profits to go to Twentieth Century–Fox).

From Cukor's point of view, the script problems had less to do with racy content than with the fact that the scriptwriters had strayed from the source material. Therefore, Gene Allen, who had never written a script—but who, after all, had been Cukor's right-hand man for so long—spent some time on the final draft, returning to the guideposts of the book whenever possible. His contribution was made hastily as the film went into production in the fall of 1961, with new pages delivered simultaneously to the set and the Production Code office for approval.*

The elder Zanuck was embroiled in the European megaproduction of *The Longest Day*, so his son Richard Zanuck acted as home-front producer. All along, the younger Zanuck trusted that Cukor's good taste would ensure "an entertaining and even moral film" to overcome the trepidations of the Production Code and its arbiter of screen morality, Geoffrey Shurlock. Just in case, there would be extra close-ups for coverage in the editing room, and some retakes with milder language in the more risqué scenes.

Apart from the reliable Gene Allen, Cukor had Huene and Orry-Kelly (the costume designer who had been Cary Grant's roommate back in New York salad days) arranging the decor and clothing of the women. He had a top-flight cast of actresses, including Winters, Claire Bloom, Jane Fonda, and Glynis Johns; mandated as part of the Warners tie-in were some relatively deadweight actors with television credentials, including Efrem Zimbalist, Jr., Ray Danton, and Ty Har-

*Allen and Grant Stuart were eventually cocredited with the adaptation. It was the only script of Allen's career, and Allen's co-credit made Wyatt Cooper so mad that he did line counts on every version of the script as he fought, in vain, to limit the number of writers' names on the screen.

din (who has the best comedy scenes, garbed in beachwear and ogled by Glynis Johns).

Although there was a lot of script and censorship negotiation behind the scenes, Cukor thought he had cleared the hurdles. The documentary-style interviews with the women were compelling, particularly so the uncommonly dark and erotic scenes featuring the Claire Bloom character, the pathetic nymphomaniac. An enthusiastic preview in San Francisco seemed to augur a box-office sensation.

But the finished picture had to be sent to Paris for Zanuck's approval. Zanuck had a reputation for radical postproduction surgery on films, often editing savagely for plot briskness and running time. When Zanuck *père* got hold of *The Chapman Report*, he cut twenty to twenty-five minutes without, in his opinion, "affecting any dramatic or comedy values."

The director was furious, left feeling that Zanuck had "mutilated the picture with his egomaniacal cutting." Those are Cukor's words, from a transcript that survives of his agitated twenty-minute phone call to executives at Warner Brothers. "The picture was delicate enough," Cukor warned the studio. "Now [it] has been hurt with the sledgehammer, ruthless and brutal treatment; these cuts will be fatal and disastrous to the picture."

Solomon-like, Jack Warner had to rule the dispute.* There was never any question with whom he would side. These two "wise showmen" whom Cukor admired kibitzed now behind his back about the man with whom both had had their differences. Warner telegraphed Zanuck that the director was an "obstinate putz" and he should edit accordingly. Zanuck replied to Warner in a telegram that Cukor had a "great talent" and although he liked him "immensely" and appreciated his films—Cukor could "drive [him] to the bughouse. . . ."

The Zanuck version was approved. No question that it resulted in a truncated film with confused continuity, few subtleties, punch lines without jokes, and vice versa. The scenes of sustained adult content were chopped up into acceptable homogenized bits.

Cukor threatened to take his name off the film, though in the end he didn't. On many an occasion, he spoke up with fondness for the

*Cukor may have exhausted Warner's goodwill early in the filming by overphotographing a scene with muscled beachboys playing football on the sands. It was a trivial scene in the script, but it stretched out in the filming. After observing dailies, Warner had complained to Dick Zanuck that "Cukor shot enough football for the complete schedule of USC, UCLA, Notre Dame and the University of Oregon. . . . You can tell George I am disappointed."

film that never was: "I know one always talks this way when a picture doesn't turn out, but in this case it was definitely so! Everything original in the picture was really hurt," Cukor told Gavin Lambert in *On Cukor*.

But there was often a dichotomy between the film that existed in Cukor's mind and the one that materialized on the screen. And, of course, the trouble with these cutting-room-floor memories is that they can never be disproved.

On the evidence of the version that can be seen (mostly on late-night television) nowadays, *The Chapman Report* is an unbecoming and in some ways downright ludicrous film. The intelligent theme that sex is a perfectly natural appetite—very Cukor—is lost in the alternately lurid and simplistic presentation.

In his own life, sex was clandestine. Here, uncharacteristically, Cukor tried to address the subject head-on, in serious—one might say starkly dramatic—terms. The effort was clearly a strain, the effect solemn and muddled. The film cried out for more of the director's trademark humor.

Scriptwriter Don Mankiewicz is one who felt *The Chapman Report* was a dubious achievement, no matter what. "It was a dreadful concept, a shabby concept. It should have been done as a semi-porno picture, which, in fact, it almost was. I just didn't understand why any reputable director who didn't have to work would have gone into this particular project.

"My feeling at the time was that they had destroyed my script, and made a very bad picture out of it. Later on, I read my script and realized they hadn't destroyed it—there was nothing there anyhow—but there was nothing there in the original material. There was nothing of value to anybody."

That such botched jobs were at all worthwhile up on the screen was a testament to Cukor's craftsmanship and artistry—his ability to stay calm and bemused despite nightmare circumstances, his determination to keep working and to see things through.

On the heels of *The Chapman Report* came the Marilyn Monroe picture for Twentieth Century–Fox that both Monroe and Cukor owed the studio.

Something's Got to Give would be a kind of reunion of Cukor with Garson Kanin. It was intended as a remake of a film Kanin had directed (but not written) in 1940, called *My Favorite Wife*, a vintage marital mixup comedy about a wife whose sudden reappearance, after years of being presumed dead, wreaks havoc on her husband's second marriage.

Dean Martin and Cyd Charisse would star with Monroe—now di-

vorced from Arthur Miller, and in the final unstoppable tailspin of her tragic life.

Walter Bernstein was the last in a long line of writers laboring on the script as filming progressed in the spring of 1962, and George Hoyningen-Huene and Gene Allen were around for pictorial embroidery (one of their sets was a facsimile of Cukor's home, with its famous patio and swimming pool.) Practically from the outset, however, it was clear to the director, if not the studio, that this was going to be a disaster of the first magnitude.

Twentieth Century–Fox was in a tailspin of its own. After losing $22 million the previous year, studio management was frantic for Monroe's name on a picture; because of her earlier renege, she was obligated to the studio at a low salary. Except for *Something's Got to Give*, there was a definite "atmosphere of siesta" on the lot, in the words of scriptwriter Walter Bernstein.

When Bernstein came on the picture, there was a Nunnally Johnson screenplay to be overhauled. After sitting down and watching the masterful Garson Kanin version, Bernstein wondered why anyone would have worked so hard, as Johnson did, to change a perfect film. Cukor agreed and "was in favor of restoring as much of the old movie [script] as possible, on the theory that no one had yet managed to improve on it, and, in any case, there was no time to try," according to Bernstein.

Monroe had approved the Nunnally Johnson draft, however, and she resisted any script changes. Of course, she had plenty of script ideas of her own. Indeed, as the production progressed, her script demands were to become increasingly intuitive, contrary, or inscrutable—change this, change that, first approving, then disapproving of entire scenes "with an appealing ambivalence," in Bernstein's words.

She made other completely irrational demands (she was upset that Cyd Charisse's hair coloring might upstage hers), but her worst transgression was not showing up on the set. For days at a time, plagued by mysterious colds and fevers and flu attacks, she just wouldn't report for work.

Yet she seemed healthy enough to fly off to New York of a weekend to consult with her acting guru Lee Strasberg—or, another time, to attend the Madison Square Garden birthday party of President John F. Kennedy, publicly serenading him with a sexy rendition of "Happy Birthday!"

Like Judy Garland's during the filming of *A Star Is Born*, Monroe's nightlife seemed more important to her than her day life. If she came in to the studio at all, she came in late and went home early. Weeks went by while Cukor filmed cutaways and contrived to shoot scenes around her character.

"It was another impossible situation," said Bernstein. "What was interesting is that nobody really liked her, except Cukor. I didn't like her particularly. The one I liked was Dean Martin, who I thought behaved terribly well, very professional. He was there swinging his golf clubs, but when he had to do something he was there. He wasn't an actor in the way that Cukor was used to dealing with Cary Grant and Jimmy Stewart, people like that. But I liked him [Martin], and she was totally unreliable."

When Monroe did go to work, there were maddening distractions. On the soundstage, there was obvious competition for her attention. A reporter visiting the set described her as "a Trilby pawed over by a contingent of Svengalis" after noticing that she seemed to confer more with choreographer Jack Cole and her acting coach Paula Strasberg than with the director.

Strasberg stood behind the camera for every one of Monroe's scenes, coaxing and advising her. After each take, Cukor might signal "Cut," but it fell to Strasberg to signal her approval to Monroe. "Between scenes, the two [Monroe and Strasberg] would consult together, both very serious," according to Bernstein. "And then Miss Monroe would carry this seriousness back into the scene, where, since the picture was a comedy, it did not always fit."

Although Cukor was used to Lubitsches and Selznicks breathing down his neck, Strasberg had to be the worst possible irritant to him, since he considered the entire Method school "pretentious maundering."

Meanwhile, terrified of the inevitable, the studio went along with Monroe's erratic behavior until it was too late. The staff producer, Henry Weinstein, a friend of the star's psychoanalyst, seemingly bowed to her every complaint.

However, nothing seemed to faze Cukor. "It's gonna work," he kept telling Bernstein optimistically. "We're gonna do it." Cukor "worked with humor and invention, a captain fighting a gallant rearguard action in a battle already lost by the generals," the screenwriter recalled.

In spite of everything, Cukor remained determinedly nice and courteous to Monroe.

"George Cukor was her greatest fan—he saw things in her that to this day I would argue with him about," said Gene Allen. "He leaned over backwards not to hurt her. I remember one time when Marilyn kept saying, 'Let's do it one more time. . . .' We finally shot five or six scenes without any film in the camera. He didn't want to hurt her. He wanted to be kind."

On June first, Twentieth Century–Fox celebrated Monroe's thirty-sixth birthday on the set with a big press party, and her famous swim-

ming pool nude scene provided another media-made ripple. The truth of it, however, was that in the small amount of footage Cukor had on her, Monroe was acting "in a kind of slow motion that was hypnotic," in Bernstein's words.

Every day, Gene Allen would view the rushes on Cukor's behalf. The first person waiting for him when he got back was Monroe, who wanted to know how she was ("mainly she wanted to know how she looked"). "'Gee, you were terrific,' Allen would tell her. "But I had to tell George Cukor that it was strange . . . she had no focus. . . ."

"There was talk of replacing her, but the studio seemed paralyzed," according to Bernstein. "No one seemed able to make a decision."

Finally, it was Cukor who stopped the charade. There came a point after seven weeks when he refused to photograph any more scenes without Monroe. There was nothing left to do without her. In early June, Cukor went into a screening room and viewed everything they had filmed so far. He decided they had "about five days' work" from Monroe.

"He [Cukor] emerged shaken," remembered Bernstein. "A meeting was called with [acting studio chief Peter] Levathes and other executives. And what some had said should have happened long ago and others claimed would never happen at all finally did happen. Miss Monroe was fired."

When Lee Remick was hired to replace Monroe, Dean Martin quit (his contract stipulated Monroe as his costar) and the production was shut down.

Even at the time, Cukor could not find it in his heart to blame Monroe, whom he thought a pathological creature. He felt that he had been betrayed by the producer, and the "idiotic" and supine Twentieth Century–Fox management. When Fox called it quits, Cukor was relieved.

He knew that it was a lost cause. After Monroe was fired, columnist Hedda Hopper telephoned Cukor for the inside scoop, and he spoke at length to his old acquaintance on the proviso that their candid conversation (recorded, transcribed, and duly preserved by Hopper in her archives) remain unattributed in print.

Cukor told Hopper that Monroe had driven people crazy with her behavior during filming and had finally gone "round the bend."

"We have shot for seven weeks and we have five days' work. And the sad thing is that the five days' work are no good. She's no good and she can't remember her lines. It's as though she were underwater. She's intelligent enough to know it's no good. And there's a certain ruthlessness, too.

"The studio has given into her on everything. She's tough about

272

everything. She's so very sweet with me. I am enormously sorry for her. Even her lawyer is baffled. She's accusing him of being against her.

"I think it's the end of her career. . . ."

Of course, it was worse than that. On August 5, 1962, less than two months after she was dismissed from *Something's Got to Give*, Marilyn Monroe's body was discovered nude and lifeless, her death declared the result of an overdose of barbiturates.

The Cukor scorecard for the years following *A Star Is Born* offered a mixed record: two uncompleted films (*Lady L, Something's Got to Give*), one rescue job (*Song Without End*), two studio-gilded productions (*Bhowani Junction, Les Girls*), two respectable loan-outs (*Wild Is the Wind, Let's Make Love*), and, arguably, only two films (*Heller in Pink Tights, The Chapman Report*) that interested the director on some interior level—both, sadly, chopped up in postproduction.

Cukor was not a scorekeeper—in any case, he lived more by the averages—and one of his secrets of longevity was that he endeavored to find pleasure in the experience of the failures as well as the successes.

But Cukor knew that he was living through the end of an era, that his career as a director was winding down, that it was time to take stock.

He had lived a lucky life. He had experienced the beginnings and middles of great things, he told friends, and now he was witnessing the ends.

In more ways than one, the life and world that he had known was vanishing: Now there were funerals to go to, one after the another. James Vincent had drowned in 1953.* Zoë Akins died of cancer in October of 1958. Bert Allenberg, too, died in 1958. Louis Mason, Ethel Barrymore, and Andy Lawler (suddenly, of a heart attack) died in 1959.

Unlike many people, Cukor did not seem troubled by the notion of death; he was not afraid to look it in the face. When Humphrey Bogart lay dying in the hospital in March of 1956, after his operation for cancer of the esophagus, some of Bogart's friends could not bear to visit him and cast their eyes upon his horribly mottled condition. Cukor wrote the actor amusing letters and visited him at death's door, trying to cheer him up.

*Vincent was found dead floating in the Hudson River. Cukor had no compunction about being identified in the newspapers as the man who claimed the corpse of his friend, like him a "confirmed bachelor."

When, much later, John Ford was in deteriorating health, Cukor was one of the people who wrote and telephoned regularly, for the director of Westerns and Americana had a poetic sensibility like D. W. Griffith that made him one of his few peers Cukor truly admired. (Typical of their kidding relationship, Cukor sent the convalescing Ford a copy of Leo Rosten's *The Joys of Yiddish*.)

Cole Porter was terribly ill by 1962. He'd had a leg amputated, and Cukor was at his bedside twice a week, chatting with him as if nothing were the matter. He went to the effort once of taking along Vivien Leigh—dressed to the teeth, her fingers covered with rings, "like a gypsy fortune-teller"—because the composer still enjoyed the company of famous and beautiful people. Leigh entertained Porter with jokes and stories, although by that time the composer could barely move and was lying there in pain. On the way home, Leigh chose to sit in the front seat next to Cukor's driver. Her silence was unbearable. "Then she turned around," said the director in *On Cukor*, "and I saw she'd been weeping, her eyes filled with tears."

Leigh could not grit her teeth as Cukor did. Cukor could make jokes about death and dying. Early on, he considered calling his autobiography *A Funeral Every Saturday*. Still, the deaths of friends affected him.

He told Stanley Musgrove that he felt it deeply when he experienced something memorable and wanted to call one of them up and tell them. He was watching "The Jack Paar Show" one day, and suddenly he had an urge to call Ethel Barrymore and tell her to tune it in. Then he realized she was dead. Zoë Akins, too. He used to complain when she called him up and talked endlessly on the phone, "Zoë, I cannot listen any longer. . . ." Now he wished she would call up and he could listen to her again.

Cukor admitted to feeling somewhat weary and ambivalent about work these days. He couldn't take the grind with as much good humor as he used to. He detested night shooting. He couldn't work six days a week as he had back in the early days. He didn't want to be away from home too much, filming some damned thing overseas.

Vacation time, and time spent with friends, was not only more abundant but more welcome. Cukor admitted that he had stopped reading the novels that he felt he ought to read ("Nobody over the age of fifty reads novels," Maugham once had told Kanin), and nowadays was concentrating on reading biographies, travel books, and books about art and architecture, purely for enjoyment.

There was no thought of quitting or retirement. Maugham, whom he quoted often, had told Cukor that what he missed most about writing—once he was too old and rich to bother with it—was the company of his characters. The company of Cukor's characters had

enriched the director's other life, the life of the imagination, and he could not conceive of a life without those characters, without the actors who played the characters, without the plays and films populated by them all. He had been living that double life of the imagination, one way or another, since just after World War I.

However, he knew he was slowing down.

He was thinking back over his career, reviewing his life, and he and Musgrove had long talks about the book he ought to write about himself. In this formative stage of a fruitless enterprise that was to persist almost twenty years, Cukor was reflective about how his life overlapped his art, and how, in some ways, they were indistinguishable from each other. Sometimes he wondered whether they were truly separable.

When an actress came to him, at his home, and wept in private about her philandering husband or her faltering career, Cukor wondered whether she was acting it up just for him. He had seen actresses cry on cue in movie scenes, and now he wasn't sure whether they were truly crying.

He mused that, without ever quite knowing why, he had done scenes in old-fashioned filmed plays such as *Grumpy*, where the avuncular Grumpy came home from work and was rewarded with his slippers. Now, in real life, the director found himself returning home from the studio, and strangely, almost subconsciously, taking off his shoes and replacing them with a pair of slippers.

He said that when he was on a speedboat or a yacht (which, he would add, wasn't all that often), he would look back and observe the swell and the wake, and all of a sudden it would occur to him that the scene looked exactly like a soundstage process shot.

He recollected that when he went to Milan for the first time and stayed in a hotel on the fourth floor, he opened the curtains and saw opposite him a great, ornate cathedral. Cukor had the oddest sensation that he had seen this edifice before, and then it dawned on him where: In *Gaslight*, Ingrid Bergman had had a brief scene in Milan when she was a singing student, and that was the studio backdrop.

He had a similar sensation when staying in a Paris hotel: When he drew the drapes, he saw the Eiffel Tower framed in his window, just as in all those film clichés.

So he had been to these places, though he had never been to these places before.

He and Musgrove and a succession of writers worked on Cukor's autobiography, tape-recording interviews and working up pages upon pages of disconnected material. There was no consistent theme of poverty or deprivation (Cukor thought Moss Hart overdid it in *Act One*, and, as for himself, he was inclined to joke about setbacks) and

he didn't feel like discussing his own private emotions (he said he had no great desire to bare his soul).

All they had, finally, was a series of show-business anecdotes, and the book was put aside.

Cukor's father, Victor, had died in Los Angeles, at the age of eighty-five, in June of 1951. Uncle Morris, who stayed close to the director and often came for prolonged visits, died at age eighty-eight at Cukor's sister's home in 1957. The director's niece, Evelyn, had died at an early age, but his sister Elsie still lived nearby. She had remarried, and Cukor had set her and her husband up in a candy-making firm; later on, they operated a small talent agency. She and her younger brother still had a volatile relationship, however, and they did not see each other often.

Cukor's real family was the "chief unit" of the Sunday group.

The 1950s had been the heyday of the poolside parties. If anything, in the sanguine atmosphere of the Eisenhower era the gatherings had grown larger and even more special, the invitations more coveted. It was still here, in safety and privacy, that the most handsome, available young men could meet illustrious people over a cocktail and a sandwich, and exchange pleasantries and phone numbers.

Cukor's own sex life was still active. Ingrained habits prevailed: He preferred the straight types and the no-names (no celebrities). The sex was still frequent and paid. The young men who entered his life stayed only for a few nights, or a few weeks. They were usually introduced, often "passed on" by the friends who came to dinner.

"George and I shared a few tricks," said one longtime friend. "I remember a boy at a party once—a very handsome boy, a hustler. He talked a lot; they all talk a lot; they always talk. He said he knew George. He thought he was a poet. We both had to suffer his stream-of-consciousness poetry. George and I both had to read it. We used to call each other on the phone and laugh about it."

(Cukor was always uncomfortable with unabashed earnestness, and made fun of it.)

However, with everything else that was happening in Hollywood—and with his advancing age—Cukor's appetite for the teeming soirees began to diminish. The Sunday-afternoon occasions began to fall off in regularity also, until by the early 1960s they became altogether a thing of the past.

In time, these big parties came to be supplanted by smaller, more quiet Sunday-evening get-togethers of the close circle. This was the Sunday group that, to some extent, existed dating back to the early 1930s, but it was more cohesive now, more mellowed: just Cukor's oldest and best friends, predominantly homosexual, joined intermit-

tently by new acquaintances and notables—playwrights William Inge, Terence Rattigan, and others. This group, consisting only of the "chief unit," continued to gather on holidays, special occasions, and most Sundays.

All of these changes coincided, somewhat, with meeting a young man who became the most important man, ever, in Cukor's life.

Sometime in the late 1950s, two of the regulars of the Sunday group came to dinner. They brought with them, to show him off, a handsome, muscular newcomer. Cukor was not the only one of the Sunday group who thought the young man (younger than Cukor by some thirty years) a stunning beauty—a beachboy type, with rugged good looks, a vibrant smile, and sensuous mien.

Everything about the young man seemed to be mysterious. He had no apparent connection to the motion-picture industry, and, unlike most of the regulars, he was neither prosperous nor well known. People knew only vaguely that he was from Canada and had been in the military.

Because the two men were longtime Sunday participants, the last thing in the world they expected was to lose their young find to Cukor. Cukor himself was always respectful of other people's friends, and at his house there was a kind of unwritten rule that if a member of the group brought a "girl" to those Sunday-night dinners, the person who brought "her" was entitled to the last dance, at evening's end.

But this time, as in one of those romantic screen stories that Cukor would have found difficult to believe, it was chemistry at first sight. Cukor was smitten, and for the first time that anyone could remember, he broke his own rules. "It was a Queen passional," in the words of Bob Wheaton.

Furious, the two gentlemen never again returned to the Sunday gatherings. The young man, whose name was George Towers, became Cukor's frequent companion and friend.

According to friends, Towers was the type Cukor had always fallen for—a strapping "real" man who kept his own sexual proclivities ambiguous. Towers seemed to play those ambiguities to the hilt—in front of others, copycatting the older man's quips and sayings, his mannerisms; obvious, even in front of straight friends, in his warmth and affection for the Hollywood director.

In the wholehearted way that he had always disdained, Cukor became attached to Towers, emotionally and psychologically. In turn, Towers seemed to latch on to Cukor, and to be at the house constantly.

In the beginning, it was a relationship of tremendous inequality, one Cukor might have recognized from his own films. It was as if

Cukor were enacting scenes from *Born Yesterday*. Or, as if he were playing Norman Maine to the younger man's Esther Blodgett—Henry Higgins to his Eliza Doolittle—molding Towers, improving him, giving him a boost in life, making him over in his own image as he might have preferred to be—handsome and virile, smooth and secure, one of life's perfect specimens.

Cukor helped Towers out financially. He helped put him through college at the Los Angeles State College of Applied Arts and Sciences (graduated, 1964); then through law school at the University of Southern California (graduated, 1967). When Towers was looking for placement, Cukor was helpful in arranging work downtown in the offices of Cukor's longtime lawyer, Lloyd Wright. Later, Cukor found a spot for him in the offices of the director's Beverly Hills accountant.

Towers was the perfect "beard"—charming, presentable, able to attend premieres, industry functions, and dinner parties at Cukor's side, introduced variously as the director's good friend or legal adviser.

In 1962, Cukor stopped taking his European vacations with Bob Wheaton. Now, Cukor and Towers occasionally travelled together—whether to San Francisco for a weekend with Cukor's well-heeled friend from Broadway days, Whitney Warren, Jr., or overseas on vacations with a stopover at Somerset Maugham's. When Alan Searle, Maugham's companion, met the personable young man, he, too, became smitten with him, and asked after him in letters and communications.

For a time, especially in the late 1950s and early 1960s, Cukor and Towers seemed inseparable. They even signed some telegrams "Two Georges."

Not everyone liked Towers; Cukor occasionally had to make excuses for what people perceived as his brusqueness, his boorishness, his self-centeredness. In the Sunday group, there was general skepticism about Cukor's infatuation. "We all thought he [Towers] was an opportunist," said longtime friend Elliott Morgan, "but of course we didn't say so. We knew what side our bread was buttered on."

Yet everyone had to admit that Towers was exceedingly good-looking. Even those who were cynical-minded had to concede that the young man made Cukor genuinely happy. The director seemed to dote on him.

CHAPTER ELEVEN

*T*he system had been good to Cukor, not always but often enough, and he was loyal to the system. The 1950s and the 1960s had tested everyone. Now, at the end of the Golden Age, for a few like him who had shown their good faith, there was a welcome payback.

My Fair Lady was a last gasp of the studio machinery. George Bernard Shaw's play about a guttersnipe flower girl and a professorial Pygmalion, transformed into the Alan Jay Lerner–Frederick Loewe musical, was logical territory for a director who had climbed the rungs of the social ladder himself. Although Cukor did not regard himself as a director of musicals, he had proven, late in his career, that he could follow the notes—even if he finessed them, much as Rex Harrison did in delivering his patter. ("Most musicals are silly damned things," Cukor told *The New York Times* adamantly. ". . . To me, *My Fair Lady* is a play with music. . . . If I thought of *My Fair Lady* as a musical, I would not bother with it.")

This last great studio movie was produced by the last great studio mogul: Jack Warner. Warner Brothers had limped into the 1960s, enjoying an edge of prosperity as a result of its television division. Jack Warner was determined to recapture the studio's glory as well as his own. For Warner, again, Cukor would direct one of the most important and expensive films of his career.

Not that Cukor, who had clashed vigorously with Warner over *A*

Star Is Born and *The Chapman Report*, was the studio boss's favorite director. Even as production was in full swing, Warner grumbled to *The Motion Picture Herald* that "he [Cukor] wasn't exactly my first choice" but was selected "after elimination" mainly because of his reliable work on *A Star Is Born*.

"Like all great artists there are times when he's [Cukor is] temperamental—aren't we all?" Warner was quoted as saying. "If you have a cigarette to light and it doesn't light you take it out on the match *and* the cigarette—so you're a great artist too. I think that about covers why the director was chosen. I turned everyone else down."

Only two alternatives to Cukor were discussed at the highest levels: Jerome Robbins and Vincente Minnelli. However, Robbins, the inventive Broadway choreographer, had never directed a film by himself; he shared an Oscar with Robert Wise for codirecting *West Side Story*, but Warner wouldn't take the leap of faith on him alone. Minnelli, everyone's inside favorite, demanded a profit percentage, which, unlike Cukor, he was allowed in his MGM contract. Ironically, Minnelli was also hampered by his exclusive ties to MGM.

Cukor's hiring was a vindication for "Swifty" Lazar (Minnelli was being aggressively represented by Abe Lastfogel of the William Morris Agency), and patched over a certain awkwardness that existed between the director and his agent as a result of the scrambling of recent years. Lazar had badgered Warner about Cukor, until finally one day the mogul and the director found themselves seated next to each other in an airplane—what an amazing coincidence!—and Warner popped the question: "How'd you like to do *My Fair Lady*?" "Yes," replied Cukor without hesitation. "I'd love to—and you're making a very intelligent choice."

Unlike Minnelli, Cukor came relatively cheap—no "points," and $300,000 for the length of the production (a minimum of fifty-two weeks, beginning in January of 1963 and ending in February of 1964). Lazar's effectiveness may have been enhanced by the fact that he also represented Audrey Hepburn (whose desire to work with Cukor was used as a wedge in the bargaining), Alan Jay Lerner, and production designer Cecil Beaton.

Jack Warner had attended the opening night of *My Fair Lady* on Broadway in March of 1956. He had wooed lyricist and writer Alan Jay Lerner—whose *Camelot* was also on the back burner at Warner Brothers—and bulldoggedly pursued the screen rights to *My Fair Lady* ever since.

CBS owned the musical through a $400,000 investment, and a buyout of Lerner and Loewe, as well as of original stage director Moss

Hart.* As a condition of the film rights, CBS stipulated that it had to receive 50 percent of any gross revenue above $20 million. Warner's record $5.5 million bid meant that before one frame of the film was exposed, *My Fair Lady* was destined to become the studio's biggest financial gamble ever.

Warner announced—astonishing thing—that he would personally act as producer.

It was Warner who engineered the casting. Lerner, much to his ire, and Cukor—who was more used to it—could propose, but Warner disposed. Lerner was fiercely attached to the idea of Julie Andrews recreating her stage triumph as Eliza Doolittle. Lerner expressed reservations about Audrey Hepburn: He didn't trust her singing voice. But Warner wouldn't even think of Julie Andrews, who had captivated stage audiences in London (2,281 performances) and on Broadway (2,715). Who had ever heard of Julie Andrews? Whereas Audrey Hepburn was considered a strong box-office draw, and she bewitched every Warner or Cohn she ever met.

(The displeased Lerner was alienated from the production from that point on. He devoted all of three desultory paragraphs to the film in his autobiography, *The Street Where I Live*. And no mention of Cukor.)

The question of who would play the part of Henry Higgins was more up in the air. Six years had elapsed since the Broadway opening, and Rex Harrison, the cool embodiment of English arrogance, was no younger. Added to that was the fact that Harrison, who had a spotty, albeit interesting, career in films, was not considered a film-audience enticement.

Lerner and Cukor both seemed to prefer a newcomer such as Peter O'Toole—whose *Lawrence of Arabia* was in postproduction and all the industry buzz. In Europe, Cukor met with O'Toole, saw rushes of *Lawrence*, and reported back that O'Toole was "crazy" to do the part. The role was offered to him. However, Warner was aghast when O'Toole's manager-partner demanded what Warner regarded as an "excessive" salary plus a percentage of the profits, and just as quickly as he was in, O'Toole was out.

Cary Grant was Jack Warner's brainstorm, with James Cagney in a supporting capacity as Alfred P. Doolittle, an elusive tandem that has

*Moss Hart's name does not appear at all among the credits of Cukor's film of *My Fair Lady*—a surprising lapse of mention for someone so crucial to Cukor's two screen musical successes. In an interview for this book, Kitty Carlisle Hart, his wife, said she resented that omission and attributed it to Cukor's need to claim all the credit.

intrigued film buffs ever since. At parties, Cagney was known for getting up and performing the Doolittle show-stoppers. But the pugnacious screen star had retired, and though he was tempted he said no.

Cukor was said to be horrified at the thought of Cary Grant, with his roustabout background and cockney English, playing the aristocratic, phonetically pure Professor Higgins. The director wanted "no sham golfing English" in the film, though he hadn't registered any complaints about authenticity over any of Grant's roles as well-dressed Americans. More to the point may have been Cukor's lingering displeasure over Grant's refusal to appear in *A Star Is Born*, a resentment that was stoked in later years by Grant's eventual retirement into the perfume business. Cukor couldn't get over Grant's abandonment of his God-given talent in order to make money and do frivolous things with his time.

In any case, Grant was not even tempted. He told Jack Warner to stop being silly and to go hire Rex Harrison. Cukor had the ignominious task of telephoning overseas, to Harrison's hideaway in Portofino, Italy, and asking the distinguished actor to do a screen test for Warner's benefit. Harrison refused, and instead sent the director a couple of "happy snaps" of himself on his boat, "stark naked, in one of them holding a Chianti bottle in front of me, in the other reading a strategically placed copy of the *New Statesman*. . . .

"I don't know why it was—perhaps because I was very thin at the time, and George may have been expecting to find me quite decrepit—but for whatever reason, those pictures appealed to him. The studios telephoned and said I had the part. . . ."

Harrison was good-natured about what had transpired, but his value to the studio was indicated by his contract for $200,000, while Audrey Hepburn received a $1 million sum for *My Fair Lady*, payable, for tax purposes, over seven years.

Cukor campaigned for his friend the Welsh actor-playwright Emlyn Williams to essay the supporting role of Doolittle. He had never forgotten Williams's performance in an Edgar Wallace play in the late 1920s; Cukor had gotten goose pimples watching Williams perform a mad ballet with a red scarf. But in the end Stanley Holloway—the only original member of the cast besides Rex Harrison—was signed to repeat his stage alchemy. The cast was filled out by a couple of veterans, Gladys Cooper as Mrs. Higgins and Wilfrid Hyde-White (also in *Let's Make Love*) as Colonel Pickering.

Almost as an afterthought, CBS Chairman William Paley had tacked the British production designer Cecil Beaton on to the production, telling Warner, "I want Beaton to do the designs." Of course, Beaton—the royal photographer, set and costume artist, author, and

illustrator whose designs for the Broadway show had been a triumph—had a tremendous cachet. Yet he was a novice in film, and in any case, Cukor would have preferred working with his old-shoe team of George Hoyningen-Huene and Gene Allen.

Beaton made the suggestion that the visual scheme of the picture emulate the monochrome soft effect of *East of Eden* and of the last two reels of *War and Peace*, particularly in the Covent Garden, Ascot, and ballroom scenes. To this end, British-born Harry Stradling, an indisputable master of color cinematography whose career had initially gained momentum in England and France, was engaged as the film's cameraman.*

At first, the studio intended to do some filming in England. That was important to Rex Harrison for tax purposes, and although Alan Jay Lerner had not yet delivered his screenplay everybody presumed that the play would be opened up somewhat for British sites and scenery.

Cukor and Beaton—and Gene Allen, who was on the film as art director—spent much of their preparation time in England touring Covent Garden, churches, and racecourses. Beaton spoke up emphatically for English authenticity; though he tried hard to arouse Cukor's enthusiasm for real backgrounds, in his view the director seemed distinctly "to be in need of extra conviction" when it came to working away from Hollywood.

Whereas Cukor had once, in the time of *Edward, My Son*, waxed rhapsodic about filming in England, in the intervening time he had come to dread British location work. "They're always breaking for cups of tea," he complained to Cecil Beaton. Moreover, Cukor had come to dislike the British press intensely, which had given sour reviews to some of his 1950s films, particularly *Bhowani Junction* and *Les Girls*. Nowadays, the director preferred to stay in California. The bloom was certainly off his longtime Anglophilia.

Since the budget was elevating fast, Jack Warner resolved the issue by deciding that costs could be trimmed if everything was confined to the Burbank soundstages. That decision was perfectly amenable to Cukor. So Beaton—ambivalent about spending almost a year in the United States—decamped to Hollywood, where, in February of 1963, preproduction began in earnest.

For one of the last times, all of the great studio departments swung into concerted action. Beaton, for one, was struck by the vast integrated network. "'Research' was like a University library. I wondered

*Stradling did have at least one prior association with Cukor, having photographed some scenes in *Her Cardboard Lover* in 1942.

why, with all this brilliant documentation and with solicitous scholars at hand, most moving-pictures ignore authenticity."

The most effective studio directors knew how and when to utilize the many departments, and how and when to sidestep them. (As a corollary, the absence of such departments, when the studios failed, was one more reason why most of the contract directors could not get going on their own.) For any question, Cukor was able—as was his wont—to call upon the services of literally hundreds of salaried people to whom his problem was their problem, and he the ultimate taskmaster.

Were there bells on St. Paul's Cathedral? Church bells or chimes? Did they ring during the period of 1912? Did they strike every quarter hour, in addition to the hour?

When Cukor wanted to know the answers to such questions for *My Fair Lady* or any of his other films, he had only to ask. If he queried advice for "Things People Do at Ascot and Some Who Might Have Been at Ascot in 1913," he received a long list back, which included:

1. Lots of cutting.
2. Raucous gaiety and hearty laughter when two couples meet and make jolly jokes.
3. Men flexing their calves backward and backslapping.
4. Women roaring with double chins and heads thrown back.
5. Same women irritated with their veils tickling their nose and lips.

When he requested ideas for things "Servants Might Be Caught Doing at Higgins's Home," he was supplied with an abundant itemization ("filling a hot-water bottle, plucking a pheasant, a kitchen maid with a face like a codfish decorating with radishes and cucumbers a large cold salmon, etc. . . ."). When he asked for a description of people who might be attending the ball, he received from some anonymous person in the appropriate department thirty detailed tintypes of chorus characterization.

One of the things that had already changed about Hollywood was the tone of the press coverage—always vaguely snickering, but now, on occasion, openly hostile.

There was a June 4, 1962, gala press conference, hosted by Jack Warner on a Burbank soundstage, attended by one hundred newspaper and magazine and other media representatives from around the globe, with worldwide transmission. Harrison and Hepburn were in attendance, along with Cukor and Beaton, and studio manager Steve Trilling.

The budget was already high, and the press, alert to the *Cleopatra* syndrome—that film was a calamity in progress at Twentieth Century–Fox—already had an attitude. Apart from anything else there was general indignation that Julie Andrews had been passed over in favor of Audrey Hepburn (not that Hepburn was to blame; indeed, she was rather well-liked by the press).

"A platform was set up at one end of the stage," wrote Charles Higham in his biography *Audrey*, "with food of indifferent quality supplied by Chasen's and plastic flowers from the same source. A photographer screamed at Cukor when he accidentally moved in front of Rex Harrison, and Cukor, who hated the press, screamed back. Beaton cringed, only to be told by the grand old actress Gladys Cooper, 'Don't sink into the mud with them.' Audrey barely tolerated the whole occasion, realizing that worse would come when she finished the movie and had to go through this ordeal again on a national tour."

The event, described by all as a horrific low point, was not the best emotional lift-off for a picture with so much riding on its success and with more than its share already of behind-the-scenes ego clashes and worn nerves. Partly as a result of this publicity misfire, the decision was made to close the set to the press.

Cukor and Beaton's prickly collaboration is one of the storied aspects of *My Fair Lady*. If the two seemed, at least at the outset, to have a mutual admiration, behind the polite facade a long-standing antipathy simmered.

They had met at Rosamond Pinchot's early in the preproduction period of *Gone With the Wind*. According to Beaton's biographer Hugo Vickers, "In the early days he [Beaton] had gone to parties that Cukor gave, but was sickened by the obscene language amongst the Impressionist paintings, and a scene when 'a fair young Adonis massaged the back of George's shoulders so violently that his grey-haired-covered breasts wobbled like jellies.'" Beaton found himself disturbed by "Cukor's paradoxes," namely "his love-hate relationship with Britain, with homosexuals and with intellectuals."

As for Cukor, he would have been aware of Beaton's notorious anti-Semitic transgression in 1938 (Beaton had hidden scurrilous comments in a *Vogue* illustration), and though he was not much of an avowing Jew, Cukor was anything but anti-Semitic.* Then there was Beaton's claim that he had made love to Greta Garbo—after photographing

*Was Beaton anti-Semitic? He "resented the power that the Jews had over Hollywood," wrote Hugo Vickers in *Cecil Beaton,* "equating this with a lack of artistic taste."

her—which, to put it kindly, the director viewed with skepticism. After all, Beaton was an effeminate dandy who, in Charles Higham's words, "affected Edwardian suits, enormous broad-brimmed panamas, and floppy fin-de-siècle hats." That type of flamboyant homosexual Cukor had always disdained and used as a target for nasty comments.

By the time they went to work on *My Fair Lady*, "Cecil was ready to take offense," in Vickers's words. Working closely with Cukor for the first time, the production designer felt "alarmed" by this director who spoke "in a stream of of bad language and badinage. He began talking before entering a room and seldom completed a sentence." Moreover, the stressful preproduction of *My Fair Lady* unnerved him. He felt himself in the constant grip of a "gut-grinding pain."

According to Hugo Vickers, Beaton made matters worse by mentioning to Cukor a mutual friend (implicitly, a mutual lover) in San Francisco, which aggravated their rivalry. "The homosexual side of both men was in competition and their respective vanities were at stake," wrote Vickers in his book *Cecil Beaton*. There was competition over mutual friends, the pretense of competition over Garbo, and the actual, on-site competition over Audrey Hepburn on the set.

Tension between Cukor and Beaton began to get out of hand as the laborious preproduction stretched out through the summer of 1962. Filming was set to begin in August. Beaton, perhaps because his principal tasks were completed, seemed to hover around Hepburn, fussing with her hair and costumes, and photographing her—as part of his obligation—for production stills.

Hepburn, though she professed to adore Beaton and his gorgeous work on her behalf, was stretched thin, taut and fatigued. Beaton felt unable to establish an emotional connection with her. Used to being treated like a prima donna, he now felt he was being treated by Cukor "like an IBM machine," and he admitted in his diaries to a growing rancor.

A series of skirmishes took place between Cukor and Beaton during early filming, but in October there was a confrontation that, though itself trivial, was ultimately climactic. One day, as Beaton was trying to photograph a weary Hepburn, Cukor ordered him through an assistant to stay away from her while she was working on the set. Beaton was outraged, but of course Cukor was director—the ultimate boss—and had to be obeyed.

Several weeks later, his contract having lapsed, Beaton left the production. His diaries indicate that he was contrite about what had happened between them: He liked the director's sense of humor (Cukor was "exceptionally witty and so accustomed to being funny that he is only slightly amused at his own jokes"); he thought the director's advice about costumes and sets was "positive and constructive."

Hoping to close the episode graciously, Beaton wrote Cukor a note regretting the contretemps. The director, now that Beaton's work was done, had no interest in salving the wound, however, and Cukor did not respond in kind.

Many times later on in interviews, Beaton spoke disparagingly of Cukor, feeding a press appetite for the unattractive feuding between them. It must also be said that Cukor did not restrain himself on the subject of Beaton. "Although the sets were supposed to be done in collaboration with Cecil Beaton," Cukor said in an ungenerous published interview at the time of the release of *My Fair Lady,* "he [Gene Allen] in fact, did most of the work while Beaton concentrated on the clothes. I don't like Beaton. He was the only sour note in the picture. . . . I think he's publicity seeking and ungenerous . . . and terribly pretentious."

(*Pretentious* was one of Cukor's most grievous put-downs—as in "pretentious crap.")

Ironically—for both Jack Warner (who had paid the price) and Cukor (with his reputation as a "woman's director")—the $1 million fair lady struggled with her performance, while the $200,000 leading man locked into rhythm. Ironically, it was Hepburn who would give the stagy performance, while Harrison, the stage veteran, would give the completely assured, almost nonchalant one.

Although Hepburn had sung "How Long Has This Been Going On?" in *Funny Face* and "Moon River" in *Breakfast at Tiffany's,* the big suspense was whether she could handle the full, more demanding score of *My Fair Lady.* The actress herself badly wanted to give the singing a try, and for a long time her coaching and rehearsals were keyed to that pipe dream.

Well into the filming, Hepburn was still meticulously rehearsing and singing—recording and rerecording—songs. But the production's musical experts were of the growing opinion that her voice was simply not up to standard. No one in all fairness could disagree with them. Finally, the decision was made, and Hepburn was informed that her voice in musical sequences would be entirely "duped" by noted voice double Marni Nixon.

The decision to "double" Hepburn's voice was devastating to her. Her nerves were already frayed by seemingly endless coiffure and wardrobe adjustments, by niggling over the cockney accent and mannerisms that would emphasize her metamorphosis from smudge-faced flower girl to regal woman. Added to this was the fact that her marriage to Mel Ferrer was in a bad state. Yet the actress carried on with her dignity intact, her chin up.

Even so, she was unsteady in the street-waif half of the picture,

which is the acting stretch, and more credible—one suspects more comfortable—when she emerges from her cocoon, one of Cukor's lady butterflies.

Rex Harrison, meanwhile, had the different problem of reinventing his signature performance from the stage and revitalizing it on film. "Though I was trying to adapt the material from stage terms to film terms," he said forthrightly in his autobiography, *Rex*, "I did at least know it, whereas Audrey was feeling her way through a show she didn't know. . . .

"It was some years since I had played *My Fair Lady* at Drury Lane, a long enough period in which to disassociate myself from the play, but still I found the whole pattern of the show coming back to me as a theatrical performance. I was always conscious of this, and fought it continuously. The intimacy of the screen requires quite different acting techniques from those of the theatre. I had to think out the performance in front of the cameras and not, as in the theatre, project it."

Cukor sensibly accommodated himself to Harrison's methods. One of the unusual aspects of Harrison's performance, in fact, was that the British actor insisted on singing his musical numbers live on camera instead of mouthing them to playback, which was the time-honored practice in musicals (and Cukor's experience on *A Star Is Born*). Harrison wore a shortwave radio microphone so he could tear through his songs without stopping for sound adjustments. Cukor used a two-camera techinque for maximum flexibility, and to provide both long shots and close-ups of Harrison as he moved.

"George Cukor still works in front of the camera, much more like a stage director," Harrison wrote in his autobiography. "I know film directors who only look through the camera and hardly ever look anywhere else. They frame a performance and see it as film. Cukor never looks through the camera, nor is he a man to let things go. He stretches actors to their limits and will not let them rely on technique or take the easy way out. He also knew when we were working a scene into the ground, when to make us break off and come back again the next morning.

"The things he did for me were quite remarkable. I had a lot of trouble, for instance, with the last number, 'I've Grown Accustomed to Her Face.' On the stage the whole show leads up to this number, but for the film I was doing it cold, and this I found very difficult, as indeed it has been whenever I have had to do 'Accustomed to Her Face' on its own, for charity shows or royal performances. I think that number needs the whole weight of the show behind it to give proper significance to the moment when Higgins suddenly realizes that he has fallen in love with Liza.

"We spent a morning trying, and failing, to get it right and I retired to my dressing room for lunch feeling pretty desperate. I stood at the window and watched the gang in their golf carts whizzing past, singing and laughing without a care in the world. I decided I was trying too hard, and that we had set the number rather too firmly in my moves and the camera moves.

"Whereupon George simply dispensed with further rehearsal and said, 'Feel totally free. Whatever you do, the camera will follow you, so do what you like.' And that was what happened. . . ."

As he had done so many times before with costars—with Hepburn and Tracy, for instance—Cukor had to marry disparate approaches and achieve a common ground in the scenes between Harrison and the "other" Hepburn.

Hepburn got better as she rehearsed and redid scenes; Harrison peaked on his first takes. For a two-shot, for example, the normal procedure would be to photograph the woman first so that her carefully arranged beauty does not wilt. Cukor reversed the normal procedure so that Harrison could deliver his lines while Hepburn had time to work up her feelings. "That was just one of those nuances that showed how Cukor really knew how to work with actors and actresses," noted Gene Allen.

Harrison, especially, soared under Cukor's laissez-faire direction, and there are some who think he acted Henry Higgins better, more freely and more deeply, in the film than he ever had onstage.

Cukor could take pride in the craftsmanship, joy in the highlights, but there was too much tension and pressure for *My Fair Lady* to have been a very happy experience.

Not that Cukor was ever morbid, but one cannot read his letters and interviews from this period without being struck by how he took cognizance of death, and how death seemed to hover around the set of *My Fair Lady*. As in the case of *Camille*, there were two particular deaths that affected the director, one personal and one political.

The personal death was that of a cast member, and it was symbolic of the end of the studio era for Cukor, certainly the end of one tradition of filmmaking. Character actor Henry Daniell, a longtime friend, had been in more Cukor movies (*Camille*, *Holiday*, *The Philadelphia Story*, and so on) than anyone besides Katharine Hepburn—invariably as the heel, the villain, or the authority figure. He was a kind of lucky charm for the director. The London-born Daniell was playing the relatively small role of the Queen's chamberlain when one day on the set he keeled over dead.

As had happened in the case of director Charles Vidor on the set of *Song Without End*, before Daniell's body was cold the director was

faced with the problem of how to proceed without him. Cukor found it eerie but unavoidable to be grieving for his old friend at the same time that he was considering how to get around him in the filming. In the end, the director simply cut back his part in the script so that the character only appears on the screen in glimpses that were filmed before he died.

The death of President John Fitzgerald Kennedy was another blow, for Kennedy was a sort of political Thalberg—young and princely, heroic and ill-fated—his death a premature closure of a hopeful new era. Cukor and his crew were shooting a Covent Garden scene in Burbank with dozens of extras and the stars when word filtered on the set, on November 22, that the President had been shot and killed in Dallas.

People were shocked. The feeling was that the news must be some kind of horrible jest. Cukor had met President Kennedy once, and had been struck by his personality and charisma. He admired the youthful President enormously, and now he couldn't bring himself to say anything to the cast and crew, who milled around, wondering whether the bulletins were true.

Audrey Hepburn thought something had to be said immediately, so she grabbed a hand microphone. The head electricians stood next to the actress as she gathered her resolve, wearing her apricot-colored dress, hat in hand. Cukor could not see her face, but he never forgot Hepburn's clear voice coming over the public-address system with the awful words.

"The President of the United States is dead. Let us have a few moments of prayer."

Moments passed, people wept softly, and then Hepburn's voice again: "May God have mercy on his soul."

Work had to continue, Jack Warner tried to insist, but cast and crew drifted away.

The four months of principal photography were completed by Christmas. Cukor impressed everyone—as in the best of times—with his energy and good humor, his ability to organize and accomplish. The budget had soared to $17 million, however, and Cukor's perfectionism in some scenes finally took Jack Warner to the brink. When Cukor threatened more retakes of the Ascot sequence, the last of the moguls hit on a unique expedient.

"Warner settled the issue one night by ordering a bulldozer to raze the Ascot set," wrote Bob Thomas in his book *Clown Prince of Hollywood*.

* * *

It is impossible now—it was impossible then—to see *My Fair Lady* without being prejudiced by expectations: all of the negative publicity surrounding Hepburn and her doubled voice; all of the familiarity and mystique of Harrison's hallmark role. Expectations which, no doubt, are unfair to both performers. And to the director.

"Always hanging there," said Gene Allen, "was the success of *My Fair Lady* on the stage and a worldwide audience waiting to pounce on you if you didn't do it right."

With all its polish and professionalism, especially its wardrobe and design perfection, *My Fair Lady* seemed to exemplify the best of the studio system. In another light, though, given all the cautious deliberation and second-guessing that went into it, it is clear there was little genuine creativity involved. Certainly there was little of the cinematic ingenuity that Garson Kanin always was urging upon Cukor.

The stage musical had scenes that were famously stylized: the stop-freeze of the early-morning Covent Garden; the Ascot Gavotte; the dream interlude of "Just You Wait, Henry Higgins." In the film, these scenes were staged, blocked, and photographed just as they had been presented on stage in thousands of performances over the years. All the concessions to cinema were minimal—the actual horses, racing between the camera and the chorus of the Ascot Gavotte, a kind of blurred special effect. All of the opening up was in the exits and entrances.

The director's preoccupation with the two stars meant that everyone else in the cast suffered a benign neglect. The chorus and small parts, among the delights of the stage musical, are barely glimpsed except as background.* The Freddy Eynsford-Hill character is a simpering one (although, to be fair, he simpers nearly as much on the stage). The whimsical Colonel Pickering is given so little focus as to become almost irrelevant. Revisionist directors of the musical have spotted the homosexual subcurrent between Pickering and Higgins; none of that for the homosexual director Cukor. Their relationship is flattened, much of the affection and comedy between them stepped on.

Cukor relentlessly trained his camera on the two stars, and there was common sense in that. The lens work seems to be all medium shot, however. There is no intimacy, no intensity, as there was with

*For once, Cukor filmed the musical numbers himself, so that ironically the dance scenes lacked the spontaneity and camera inventiveness that had been brought to other Cukor films by a more music-wise secondary, a Richard Barstow or Jack Cole.

Cukor's other musical, *A Star Is Born*. The entire picture has an impersonal, oddly perfunctory quality, as if Cukor, stuck with Lerner's rigidly adherent adaptation and all the production difficulties, simply shrugged it off.

Jack Warner made his profit, however, and the film's pictorial virtues were much acclaimed. The New York Film Critics awarded it Best Motion Picture of the year. Cukor won the Directors Guild's annual Director Award, a prize that had always eluded him. The film was nominated for eleven Oscars, winning eight: Best Costume Design (Cecil Beaton), Best Musical Scoring (André Previn), Best Sound (George R. Groves, Warner Brothers' sound director), Best Color Art Direction (Gene Allen, Cecil Beaton, George James Hopkins), Best Color Cinematography (Harry Stradling), Best Actor (Rex Harrison), Best Picture, and Best Director.

It was George Cukor's only Academy Award for Best Director. He displayed it high on a shelf in Irene Burns's office.

Cukor was happy with his Oscar—ecstatic, really—although he never made great claims for *My Fair Lady*. One suspects he would have been prouder to have received an Oscar for one of his other films for which he was nominated as Best Director—*Little Women, The Philadelphia Story, A Double Life*, or *Born Yesterday*, or even one of his films, ignored in the directing category, but Oscar-nominated as Best Picture—*David Copperfield, Romeo and Juliet*, or *Gaslight*.

The director felt bad too for his leading actress, Audrey Hepburn, who was not even nominated in her category. "I'm just sick about it," the director told the press. Hepburn showed her mettle by appearing at the ceremonies as presenter of the Best Actor statuette to Rex Harrison. The Best Actress award that year—an irony that escaped no one—went to Julie Andrews for her magical nanny in *Mary Poppins*. In her acceptance speech, Andrews thanked "Jack Warner for making it all possible." Warner, undeterred, told newspapers that he himself had voted for her.

In 1963, Cukor had finally severed all his MGM contractual obligations. To take their place, he formed his own production company, which was called (after his initials) G-D-C productions.

Gene Allen turned down a producer's job at Warners to become affiliated with G-D-C, and George Hoyningen-Huene was around for art and design consultation. Various other people came and went on the payroll (Mia Farrow, one of Cukor's many godchildren, is one who earned wages for "research" duties while working for G-D-C during a career low point before her breakthrough in TV's "Peyton Place").

During the next ten years, roughly from 1963 to 1973, G-D-C

pinned its hopes on three films that consumed most of Cukor's time and energy.

- *Peter Pan*, J. M. Barrie's enduring children's fantasy, was a film that Cukor had mulled over for many years. He had once envisioned it as a vehicle for the young Katharine Hepburn. In the 1960s, his version aimed to star the "other" Hepburn, fresh from *My Fair Lady*, as the androgynous flying Pan.
- Gene Allen was to produce and Robert Shaw to star in Cukor's ambitious adaptation of *Nine-Tiger Man* (a novel by Lesley Blanch, the ex-wife of Romain Gary, the author of *Lady L*). It had tiger hunting, riots, grand house parties, and interracial lovemaking during a mutiny of 1857 in India. Terence Rattigan produced a 504-page script that Allen trimmed to 155 pages.
- *The Bloomer Girl*—the story of Mrs. Amelia Bloomer, the nineteenth-century inventor of bloomers, who was also a campaigner for temperance, women's suffrage, and feminist reform—was the first of several projected films about "remarkable women" that occupied Cukor's imagination after 1960. It was set in Seneca Falls, New York (near Rochester). One role was intended for Katharine Hepburn, but her commitment vacillated; Shirley MacLaine and Harry Belafonte agreed to the script by John Patrick, with songs by Harold Arlen.

Freed of studio constraints, Cukor was nevertheless in lockstep with old habits he couldn't shake off—working up big-budgeted star-decorated films with expensive period or foreign settings. According to Gene Allen, G-D-C Productions never considered developing anything on a smaller scale. For the next decade, Cukor was optimistic about *Peter Pan*, *The Nine-Tiger Man*, and *The Bloomer Girl*. . . .

There were many, many—too many—other projects, some of them vaguely autobiographical. But the more autobiographical they were, the more trouble Cukor had approaching them.

When he tried to work on an Isadora Duncan movie, he just couldn't get the right perspective on that borrowed enthusiasm of his youth. Cukor discouraged proposed film biographies of Tallulah Bankhead or Laurette Taylor, because, he admitted, he was especially stymied when he himself had known the people.

He had a brief, itching desire to do a behind-the-scenes film about Marilyn Monroe and the abortive filming of her last picture, *Some-*

thing's Got to Give. It would be the ultimate Hollywood inside story, with the cold-blooded studio machinery and the insanity of the omnipotent star. It would be a tragedy, of course, but it ought to be scathingly funny besides. Cukor himself would be a character. There was even a title: *It's What's on the Screen That Counts*. The idea was too close to him, however, and it never went beyond the speculative stage.

Cukor returned to the idea of D. W. Griffith, still in his eyes a heroic artist who had expressed himself soulfully and indelibly in his films. A "D. W. Griffith Project" was again set in motion in the mid-1960s, with Gregory Peck to play Griffith and Katharine Hepburn to play some unspecified costarring role. A screenwriter was set to work.

Cukor read up on Lillian Gish's book *The Movies, Mr. Griffith and Me* (he thought it was humorless and a little too reverential); Anita Loos's *A Girl Like I* (which depicted more humorous sides of his character); Mrs. Griffith's *When the Movies Were Young* (which Cukor thought the best book, full of nuggets about Griffith's secretiveness and perversities); and Iris Barry and Eileen Bowser's book, *D. W. Griffith, American Film Master* (which he liked for its portrait of Griffith's road-show adventures and extravagant, self-destructive lifestyle).

Over time, Cukor had come to the belief that film was the most important American art form, and D. W. Griffith one of the most authentic and original American filmmakers. A movie about Griffith ought to array his full tarnished genius, all his mystery and sadness.

But the time was not ripe for a retrospective on D. W. Griffith and the silent film era, and the "D. W. Griffith Project" took the back burner to other projects where the "personal" was more subsumed, more disguised—*Peter Pan, The Nine-Tiger Man, The Bloomer Girl*, and all the rest.

A written autobiography was the never-ending project. The first ghostwriters had come and gone before 1960, but there were a dozen other writers over the years. There was no end, though, to the list of New York editors and publishers who expressed interest and offered contracts for a book about Cukor's life and career.

Other motion-picture directors—even some who astounded people by being able to set pen to paper, such as Raoul Walsh and William Wellman—were at work on lively autobiographies. Although Cukor militantly averred that he himself was not a writer—not an *auteur*, not a "hyphenate"—everyone was impressed by the intelligence of his interviews and the prose style of his multitudinous letters.

Friends dubbed his letters "Cukor specials," because they could be so funny and charming. Cukor's letters were not necessarily about

work—they might, for example, be all about his dogs. The director was perfectly capable of dictating and polishing five single-spaced pages of exuberant reportage on his beloved pets' health, appearance, and newly acquired dog tricks. His dogs meant a lot to him; his insistence on their importance in his life was one of the drags on the prospects of an autobiography, because it was hard for each new ghostwriter who came along to figure out how to work them into his life story.

He worked hard on his letterwriting. But if he was relatively casual when formulating a letter about his dogs, he could be extraordinarily self-conscious when writing about himself or his films. Especially when writing *serious* letters, he fretted about his writing; he corrected and polished his phraseology—he overly polished, as he did with some of his films—until, like some women never seen without full makeup, his face was wiped away.

"There were many drafts of his letters, all of them," said his secretary of almost forty years, Irene Burns. "It didn't matter how simple they were or to whom they were going to be sent. Even a thank-you letter to somebody, a two-paged single-spaced reply, a thank-you for a Sunday invitation. . . ."*

"I would do the first draft as he dictated it, then he would take the draft and correct it in great detail. Sometimes there were two or three drafts, especially to important people, particularly when he was writing to Somerset Maugham, who was a great friend of his. He would very kiddingly say, 'I have to be very literary now. We are writing to Somerset Maugham.' That sometimes took as long as a week to get the final draft. Quite often [at the end] I would say, 'Mr. Cukor, I think your first version is most interesting.'"

The writers who appeared on the scene—well-known writers, as well as up-and-coming writers whom Cukor happened to meet at Hollywood parties—were confronted with a veritable slag heap of letters and memorabilia, and, what was more tricky, with pages and pages of hand-scribbled notes and barely legible reminders to himself that Cukor had filed away. The organization of the material was challeng-

*His letter writing, like his hospitality, could be compulsive. When Cukor invited Don Mankiewicz and his wife Carol to "a little backyard picnic" with Don's mother, Sara, they arrived to discover a scene "like it was out of *My Fair Lady*," in the words of Carol Mankiewicz. "It was set up by a fountain, with all of the orchids from the greenhouse—three hundred blooming orchids—backing this fountain. A fabulous dinner served by his maid and cook. Finger bowls with floating flowers in them. Gorgeous china and crystal. A chocolate soufflé for dessert. Just your standard family fare." When Carol Mankiewicz sent him a note and flowers, she received a two-page note back thanking her for her thank-you note.

ing, and the writer would be swamped by the unwieldy size of the task.

"That went on and on and on," said Burns. "That was rather disastrous. I always contended, and I told him, too, 'There's no one, Mr. Cukor, who can write what *you* feel and what you express.' He had several people who attempted. Oh, there were such conglomerate notes that he'd write down on little slips of paper, as incidents would occur to him. They were all over the place. Voluminous. In the office, in his room. I had to keep a kind of file folder to stuff all of that into, and then the poor writer would come along and try to put the pieces together."

The pieces never seemed to fit together, because too many of the anecdotes were about someone else and the subject of the autobiography had religiously removed himself from his own life story. This, too, was exaggerated modesty—but more than that, it was Cukor's deep sense of privacy at war with the public impulse.

When Cukor did tell an anecdote, he would want to clean it up afterward, in part to tone down his vernacular (the "cunt and kike" vocabulary that startled anyone's expectations of the gentleman director) or to sanitize stories so they would not offend anyone. A repository of all Hollywood gossip, Cukor would tell the most marvelous, revealing, sensational story about Garbo—then turn around and insist it be deleted or trimmed, so that all of its impact was diluted.

When, in 1966, author Charles Higham, then working as a Hollywood correspondent for *The New York Times*, interviewed Cukor for his book (with coauthor Joel Greenberg) *The Celluloid Muse*—the first significant book of transcribed interviews with Hollywood directors—Higham realized the director had an almost palpable dread of tape recorders. He kept on reaching over and turning Higham's off.

Cukor was extremely considerate—"with an orderly mind, one that has made up its mind in advance what it is going to say," in Higham's words. However, the interview (Cukor's first in book form) was "drastically restricted by the fact that Cukor was living and made a lot of things off the record," said Higham. "He was a very strongly opinionated gentleman and would give random statements about all kinds of people which might or might not be correct—but they were seen through his very special vision."

Cukor, Higham realized, still lived in a world in which press agentry was part of the gigantic curtain against the outside world, the world that is performed to but which must not know anything real or injurious about the performers. That curtain must always be in place, made of steel, never pierced.

Although in private Cukor could be incisive about Hollywood, in interviews for public consumption he subscribed to a more diplo-

matic, nostalgic, and ultimately fairy-tale image of Hollywood, the kind MGM luminaries evoked from the screen in *That's Entertainment*, speaking of the Golden Age of studio picture-making as a by-gone world of sweet innocence and fantasy. (So complete a self-delusion this was that by that time much of the audience had passed them by in comprehension and knew it was nothing of the sort.)

By the mid-1960s, ironically, Cukor was not only the maker of the film of that title but indeed a Keeper of the Flame for all Hollywood—eloquent and sentimental on the merits of the Golden Age. The moguls were geysers of wisdom, the great screen ladies at once deeply human and gloriously divine, Hollywood itself like some fabulous medieval enclave with artisans working together to create exquisite works of art.

(About those *nouveau* horror films starring such ex-glamour queens as Joan Crawford and Bette Davis and Olivia de Havilland, Cukor told Hedda Hopper adamantly: "I don't like it. It's not very graceful. People have certain illusions, certain memories about them, and it's a pity that they should be destroyed. But there are lean years and fat years for actors and sometimes these are the only things at hand. . . .")

Cukor had to know that as time went on, the media—and the public, of which he was wary—was closing in, and that Hollywood's secrets would be revealed. He didn't want that. It was all right for people in Hollywood to know, to a certain extent. Everyone in Hollywood, Cukor included, had a passion for knowing. However, outsiders, the public, must never know.

Cukor was upset with Garson Kanin over Kanin's books about Maugham (*Remembering Mr. Maugham*) and, later on, about Katharine Hepburn and Spencer Tracy's intimate relationship (the best-selling *Tracy and Hepburn*).

In Maugham's case, Cukor felt that Kanin did not know Maugham even as well as he did, and he was particularly offended that Kanin had mentioned Alan Searle, Maugham's devoted homosexual companion. In the case of *Tracy and Hepburn*, Cukor was even more irate—it was an invasion of privacy from his point of view. After *Tracy and Hepburn* was published in 1971, he and Kanin had a long lunch at the Beverly Hills Hotel to talk about it.

"Almost halfway through the lunch I said to him, 'George, I think I'm beginning to understand,'" related Kanin. "'You have two objections. One is that I should not have written the book. And the second objection is that you're not mentioned in it enough.' He laughed and I laughed—because there isn't very much about Cukor in the book."

("All the dinner parties [in the book] are at my place," Cukor griped to friends, "but I never get any lines.")

Cukor stayed angry, however, and there was a rupture between him and his most agreeable screenwriter after the publication of *Tracy and Hepburn* that never really healed. Indeed, some people in his circle think Cukor fueled Hepburn's own outrage (although she claimed never to have read Kanin's book).

More and more from the 1960s on, Cukor was encircled by columnists and critics with whom he was not familiar. They and their tape recorders made him nervous. Most, like Higham, were respectful of his privacy, but occasionally he was burned by someone he trusted, someone he had invited to the house for lunch or dinner. Someone like John Rechy, whose path-breaking novel about the nation's homosexual subculture, *City of Night* (1963), contained a thinly disguised and contemptuous depiction of Cukor ("a tight, skinny wiry old man with alert determined eyes") as a hoary old queen, fawned over by his male "discoveries." This passage wounded the director and made him all the more suspicious of inquisitive writers.

Naturally, when Cukor was working on his autobiography with one of the parade of writers, there was never any mention of his homosexuality or of homosexuality in general. That taboo was a nagging obstacle in telling the story of his life, right through to the end of his days, when Cukor still entertained notions of having it ghostwritten. The director would not acknowledge for the record this central fact and compulsion of his life.

Author, film critic, and documentarist Richard Schickel, whose public television series *The Men Who Made the Movies* included a nearly perfect capsule segment on Cukor, was one of the last of the potential biographers—in the late 1970s—to spend a good deal of time with Cukor preparing such a book. But Schickel realized there was a gap in their conversations, and that the book would never add up without that gap being bridged.

"I could kick myself now," recalled Schickel. "I should have stopped the tape recorder and leaned over and said, 'Mr. Cukor, I know that you are a homosexual. It's common knowledge. And it doesn't matter to me in the slightest. But I think it would make our job easier, and the book more interesting, if we were to talk about it a little.'"*

*Schickel elaborated in a letter about the author: "He [Cukor] would start out on a promising tack—say a visit from Somerset Maugham, or a conversation with Noël Coward. But somehow the punch line was always pulled. I came to think that after building up the habit of discretion over the course of a lifetime he simply could not abandon it now—even if the people he was talking about were dead and his memories would have made an invaluable contribution to history. *(continued)*

Like many others before him, and a few after him, Schickel could not bring himself to say those words. The writers Cukor drafted (because they liked the director so much, and, of course, because they were under obligation to him) felt unable to push him on the subject.

Over the years, some of these would-be books ended badly (with letters from Cukor's lawyers threatening to sue if the writer persisted), but most tapered off quietly and disappointingly.

Ironically, during this late-life transition of his career, the Keeper of the Hollywood Flame often felt unappreciated in his own homeland.

Abroad, particularly in France, by the mid-1960s, Cukor's films were being saluted by film historians and scholars. The influential *Cahiers du Cinema* thoroughly admired his work. When Henri Langlois, the director of the Cinémathèque Française in Paris, praised his oeuvre—Langlois declared, "Elegance exists still today in the films of George Cukor"—Cukor wrote Langlois that it was "heartening" to be treated so kindly in Europe, especially when Hollywood directors were not given the same respectful attention in the United States.

Just as he liked to believe himself descended from Hungarian nobility, Cukor felt part of the global aristocracy of filmmaking. No Hollywood director was as genuinely cosmopolitan. When foreign directors went to Hollywood, they invariably sought Cukor out for advice and hospitality. In his correspondence, there are poignant let-

"Several times I was tempted to turn off the tape recorder, and make the point to him that—as to most people not raised in the tradition of silence about one's sexuality—it would make no difference [to me]. I thought perhaps such a tactic might jar him out of his silence and open him up on all the other more interesting and important matters about which he was maintaining radio silence.

"But a tone of gentlemanly discretion had been established between us and that was hard to break. Moreover, I have a principled belief that well-known people have a right to their silences. And so I never—as it were—broke the ice—as I think, looking back, George may well have wanted me to do. I gather he had asked other writers to take the same kind of shot. . . .

"In other words, in his later years, he was searching for someone who would encourage him to do something he was mightily tempted to do—and perhaps stand by him later in case there was any scandalous fallout.

"I should have been intuitive enough to realize this and attentive enough to guide and ease him through a passage that scared him. This is especially so since I was so fond of the man and had learned so much from him. . . .

"He was a wise old owl, and I think his reflections on being, if you will, a premature homosexual in what was, in his day, a job for men's men—a fact that a lot of them protested rather too volubly—might have been not merely informative, but salutary."

ters, asking for work in Hollywood, from the best, most artistic of them, the French filmmaker Robert Bresson or the revered Danish director Carl Dreyer (please let producers know he was a "methodical worker," Dreyer pleaded). They could not have known that Cukor himself was having trouble securing work.

For many years, beginning in the mid-1960s, Cukor was on the foreign films committee of the Academy of Motion Picture Arts and Sciences, and at his own volition hosted an impressive annual affair bringing together Hollywood and foreign directors for a ceremonial lunch at his house.

While the Europeans seemed appreciative of Hollywood, Americans tended to favor European filmmakers. It irked Cukor, for example, that the New York Film Festival seemed to militate against American representation. In a 1963 newspaper article, Cukor aired his grievance that that year's festival had only one U.S. picture on the schedule. "This snobbery of young Americans who rave about second-rate foreign pictures is disgusting," Cukor was quoted as saying.

When snobbish young Americans did deign to rave about an American director, it would be about "auteurs" such as Howard Hawks or Alfred Hitchcock, whose particular geniuses Cukor could not endorse. Whereas the articles, the books, the film festivals in *his* honor seemed, at least to him, slow to materialize. Part of the strategy of retaining a press agent was to promote himself in that regard.

On the one hand, Cukor was old-fashioned. On the other, he desperately wanted to be up-to-the-minute, detesting anyone who referred to him as being from another era or the past. In Hollywood, it was professional death to be perceived as old-fashioned, especially in the swiftly moving 1960s.

Yet there were plenty of things about contemporary society that Cukor didn't like at all. He had reached the age where certain trends were offensive to him.

Cukor had seen the end of the Victorian era and vaudeville; he had experienced the heyday of Broadway. He had arrived in Hollywood at the birth of talkies, and survived the inception of television. He had outlasted most of his contemporaries in the studio system, and here he was in the 1960s—with its long hair and drug culture, its social upheaval—trying to get a fresh start and foothold as an independent filmmaker.

Inevitably, there were time warps. When writing scripts for Cukor in the 1960s, Gene Allen would use the word *boyfriend* in a dialogue exchange. Cukor would stop him and say, "No, the correct word is *beau*." Allen would argue: "Mr. Cukor, nobody uses the word *beau*

anymore." Cukor would hesitate and appear to consider the objection, before saying firmly, "Put in the word *beau*."

He thought the Sixties had their pros as well as cons. He was not as upset as Katharine Hepburn about sex and nudity on the screen; in fact, he rather *liked* it, although he thought it would behoove actors who were not as beautiful as they thought they were to keep their clothes on. He didn't mind hippie regalia, which he thought looked okay—not on the girls (he confessed he didn't even like to see women sitting in bars or smoking in public), but on the men, who looked more "picturesque" nowadays. He himself, interviewers were surprised to discover, dressed in rather snappy California-style outfits.

Of course, he did no recreational drugs (though some of his friends did), but nowadays he took an occasional Dubonnet at his dinner parties. He didn't understand Lon McCallister's vegetarianism, or Christopher Isherwood's interest in swamis and yoga, but he was amused by these lifestyle trends and indulgent with friends. And, in tune with the times, Cukor was dabbling a little in politics—giving a donation to Cesar Chavez, or to the presidential campaign of Robert F. Kennedy. Even so, when he read the newspapers, he preferred to skip the headlines and read the astrology forecasts, the gossip, Art Buchwald, or try the crosswords.

He didn't see that many current movies—he preferred a night out at the theater, or a good book—but someone took him to Andy Warhol's *Flesh* and he pronounced himself enchanted by it. Here was another paradox: this man who made films that were so utterly tasteful rhapsodizing about the bold camp sensibility of Andy Warhol (a sensibility Cukor had privately enjoyed from the days of his youth).

Warhol used Cukor's quote in advertising: "*Flesh* is an authentic whiff from the gutter." The director became friends with Warhol star Joe Dallesandro and "Factory" director Paul Morrissey, another who worked with Cukor on his sporadic fits of autobiography.

If *Flesh* was unusually attuned to Cukor's secret self, much of the "youthquake" culture, the more contemporary modes, Cukor just didn't understand. In the early 1970s, Christopher Isherwood and Don Bachardy took him to see Charles Ludlam's Ridiculous Theatrical Company drag travesty of *Camille*. Isherwood and Bachardy sat back with anticipation. Here was the director of Hollywood's classic *Camille* watching an avant-garde cross-dressing road company from New York. Yet Cukor was disoriented by the show. He was, if anything, horrified. He just didn't get it.

Cukor went to one of the first screenings of *Fellini Satyricon* with Charles Higham, and sat through the Italian director's phantasmagoria of ancient Rome. Cukor kept nudging Higham and saying, "Oh, this is fascinating . . . this is strange . . . but what is going on?"

"I suddenly realized that, although the film was an intensely heterosexual film about bisexuality, it could only have been made by an aggressively heterosexual imagination," remembered Higham. "I think he [Cukor] was completely confused by it. He thought the boys were very beautiful, very pretty, but I realized he could not deal with a nonlinear or an unconstructed story, mentally. He didn't have the capacity to reach out to something that was done in nontraditional terms."

(On the other hand, can one imagine John Ford, Howard Hawks, Alfred Hitchcock, or any of the others even venturing to that screening room? Such was Cukor's intrepid curiosity.)

The gay liberation movement—such a part of the Sixties—was at once fascinating and repellent to Cukor. He had lived to a time when homosexuality was more open, if not acceptable. Certain of his circle (Christopher Isherwood and some of his literary friends and acquaintances) went public with their sexual preferences, and gave speeches at rallies. Coming out of the closet was not for Cukor, however, for he had lived too long with the specter of arrests and scandal—the opposite mentality.

"I think he [Cukor] might really have disapproved of gay liberation," said artist Don Bachardy, who lived with Christopher Isherwood, "but he wouldn't say so, in front of us, for fear of upsetting us."

Cukor couldn't drop his defenses. He could be especially coy around liberated homosexuals, whose openness might taint him by association. Bachardy, for one, was never quite sure to what extent Cukor *practiced* his homosexuality. "When he [Cukor] came to the house [for an occasion]," Bachardy said, "if there was some rowdy stuff or 'queer talk,' he would pretend to be scandalized like a great maiden aunt. . . . Any details of his sex life we learned, not from George, but from other people by way of gossip."*

"George wouldn't answer those kinds of questions about himself," agreed writer Frank Chapman. "He was terrific about turning aside the subject. Suddenly you'd find yourself talking about something else, the weather, and you wouldn't know how it happened. He was so seductive, so quick."

With his lifelong scorn for effeminate men, a lot of the openness and parading of lifestyle was difficult for Cukor to take. Bob Wheaton

*"The only conversations I remember, where George talked about sleeping with another human being, were about his close friend Fanny Brice," said James Donaldson (a pseudonym). "She and George would talk away the night, in her bed (they even ate there), until she went to sleep from sheer exhaustion. Only then could George slip off to sleep himself."

remembered talking Cukor into going to a New Year's Eve party in Pasadena one year where the guests were predominantly gay men and were supposed to be dressed in gold lamé. Everyone was—except for Wheaton, Cukor's longtime neighbor Harris Woods, and Cukor. It was a fun party. "But after twenty minutes George began to fidget and insisted we go," recalled Wheaton.

As with everything else, Cukor became more accepting and indulgent of open homosexuality, even if it was not for him. (He became friends with the editors of alternative gay newspapers and occasionally accompanied them to events.) However, only among his very closest friends—not all of the "chief unit"; usually the discreet middle-aged men who, like him, had their secrets to keep—would there be any revelation at all.

Deaths—the death of the past—seemed one benchmark of the 1960s.

His onetime close friend, his best producer, David O. Selznick, died in 1965. The friendship had waned, and Cukor was weary of the *Gone With the Wind* connection on which the press always harped. His friends found it significant that Cukor, when asked, refused to write anything on his own for Selznick's funeral service. He agreed only to utter the speech Truman Capote wrote.

Not only Selznick but Moss Hart, Elsa Schroeder, Clifton Webb, Cole Porter, Rowland Leigh, Spencer Tracy, Viven Leigh, Tallulah Bankhead, William Goetz, and Rex Evans all died in the 1960s.

In September of 1968, his good friend and color consultant George Hoyningen-Huene died—at night in his nearby home, while having a massage. (The masseuse, who had been recommended by the director, woke Cukor with the terrible news.) Huene had been weakened by a bad heart and had recently been depressed because of failing health. Eyes streaming with tears, Katharine Hepburn spoke a few words at Huene's funeral. With Huene's death went Cukor's tradition of lavish Christmas cards, which the director could never again bring himself to resurrect.

Somerset Maugham, perhaps Cukor's truest exemplar, died at the age of ninety-one in 1965.

Cukor was practical in his grief. He was one of the few people who did not forget Alan Searle, who was abjectly crippled by sorrow and spoke incessantly of Maugham's passing. Quite apart from Maugham, Cukor had always liked Searle, and could rhapsodize about his youthful beauty (his doelike eyes and his camellia complexion), although by now Maugham's longtime companion was almost grossly fat, and given to complaining constantly of ailments.

Cukor insisted that Searle come to Hollywood and recuperate at his house. His kindness and generosity seemed to rekindle Searle's

desire to live. Soon, like Maugham before him, Searle became an accepted adjunct to the Cukor household, arriving, usually in low spirits, for extended periods of rest and recreation at Cukor's house.

Because of his inheritance from Maugham, Searle had money to burn and a voracious appetite for sexual adventure. With all of his money, Searle would do outrageous things—hire a big place in Santa Monica and pay forty hookers to do it with each other while he watched. A steady stream of young tricks arrived to pay court to Searle at Cukor's house.

The director was greatly amused. Young men continued to race through his own life, as well—always paid and fleeting. It was Cukor's opinion that an interest in sex was healthy and kept an older gentleman young.

As it had been for two decades, the Sunday group of the 1960s was a tremendous solace for Cukor, not only on Sundays—for the group went on dozens of extracurricular outings (they had a penchant for packing lunches and taking off down the highway in recreational vehicles or land yachts, for traveling dinner parties)—but especially on Sunday evenings when "the chief unit" assembled as a family.

"The relationship that best describes George's interaction with his closest friends was parenting," said Cukor's friend James Donaldson (a psuedonym). "Every Sunday his brood or family came together to share what had happened the previous week."

When Lon McCallister, not part of the original nucleus, renewed his friendship with Cukor in the early 1960s, he introduced Cukor and his friends to his own younger acquaintances, invigorating a group that had thinned out to leave mostly the old-timers.

Cukor's schedule on a Sunday was typically ordered, nearly the same Sunday after Sunday for twenty-five years.

"Harry Beatty [a pseudonym], an old friend who was I think on the staff payroll, would arrive each Sunday around 7:00 A.M.," recalled Donaldson. "[Beatty], who had keys to 9166 Cordell, would let himself in, turn off the burglar alarm, and then would prepare and serve breakfast to himself and George. George then worked on scripts or read manuscripts till around 1:00 or 2:00 P.M.

"George worked in bed propped up on his pillows. He had a caddy that he kept beside his bed that held writing materials, scripts, and any books or folders he might be currently using for research.

"The cook arrived at mid-morning on Sunday to prepare the evening meal. She served lunch to George and [Harry] at 12:00 P.M., consisting of leftovers and cold cuts. George generally had this meal from a tray in his bedroom, where he continued the reading, ate and

napped. George performed his most serious and uninterrupted work during these Sunday work sessions.

"Sometimes, we would hear the sounds of George reading lines aloud coming through the blinds of his bedroom. George needed to hear the words spoken aloud.

"Sometime in the early 1960s I was pressed into service, because of my Southern accent, to read chapters from Robert Gover's book *One Hundred Dollar Misunderstanding*. George would arrive at the pool house in pajamas, with book in hand, and say, 'Start reading at the paper clip.' He would sit in a big garden armchair, eyes closed, playing with a ring he wore on his little finger, while he listened. The paper clip would be at the beginning of a chapter where the black prostitute would be telling her side of the misunderstanding in her deep Southern whorehouse slang. If I paused to catch my breath, George would say, 'Keep reading, kid,' without opening his eyes. I must have read the book on three or four occasions. While he worked on *Misunderstanding* for months, I don't think anything ever came of it.

"George would bathe and dress in mid-afternoon after the Sunday work was done. Sunday dinner guests would start arriving around 4:00 P.M., even though dinner was served at 6:30.

"Occasionally, some of us were invited to bring our lady friends or wives for Sunday lunch and then volleyball in the swimming pool. On these days, George always had lunch at the pool house and then disappeared for a nap. On these days the lunch guests cleared out by 4:30 P.M. to make way for the Sunday-night regulars; however, there was usually some overlapping of guests. Frank Horn always came early, his house was within earshot of the volleyball shouts and laughter, so he would arrive around 4:00 P.M. to see who had been there for lunch."

Christmases were the highlight of the year—the Sunday of Sundays, as it were. The "chief unit" would gather at Cukor's house: all the regulars and occasional regulars, a sprinkling of big names but mostly low-profile friends, people in show business as well as people like Whitney Warren, Jr.—who always came down from San Francisco to spend a lively Christmas and a more peaceful New Year's Eve with Cukor. His friendship with the director spanned most of his life.

Cukor at Christmas was like Big Daddy, his friends' expectations like kiddies'.

"It was a big production, Christmas," recalled one friend. "Being Jewish, this was almost funny."

"He [Cukor] was so generous," remembered another friend. "Gay people don't have families and this gave them a family. He would

305

have twenty-five people over, a beautiful tree, great food, a wonderful atmosphere. It was always a very nice Christmas."

The presents were something to see, piled high under a tree. Cukor was famous for his gift giving. There would be big fancy presents (one prosperous Christmas in the 1930s, each guest received a Picasso pencil drawing) and sometimes erotic stocking stuffers (the surprise nude or drag photos of handsome young men). All of the "chief unit" were expected to bring presents for all the others, but Cukor always gave most bountifully of all.

Even with the Christmas gift giving, there was the curious compartmentalization of Cukor's life. There was an *A* list and *B* list. Many of the gifts were picked out and purchased by someone other than Cukor, then sealed and wrapped by someone in Cukor's employ. There was a caste system in the wrappings, too: the most "distinguished" presents had to be for people such as Irene Selznick and Edie Goetz; other gifts might be wrapped tastefully but, on orders from Cukor, less expensively.

Every year, moreover, Cukor kept a room downstairs of presents he had received and didn't need, or already had. These he would set aside and meticulously label to give back to someone else the next year. Such gifts were stored on special shelves and tagged with the name of the giver. Long lists of givers and recipients were made, so that a television set from Frank Sinatra one year, say, would not inadvertently be bestowed on some associate of Sinatra's the next, thus betraying the musical-chairs game of gift giving.

The occasional gaffe would occur—one year a forgetful Cukor gave back to George Towers the present he had been given by him the year before; it became one of those Cukor anecdotes that everyone treasured. The Byzantine nature of the gift giving was part of the fun, and the reapportionment an open secret among the "chief unit."

"I think of him [Cukor] as a Kwakiutl chief," said writer Frank Chapman, "a redistributor of wealth."

Cukor could be truly thoughtful, especially about some in the "chief unit" who meant the most to him. Cukor took great pleasure in figuring out just the right gifts for closest friends. Over a lunch at Twentieth Century–Fox, the director asked one Sunday group member, who was living with another member of the circle, what his companion would like best. The friend said his companion was an avid movie buff who would appreciate any memorabilia connected with the film *King Kong*. Christmas Eve at the big party, a messenger arrived bearing an autographed copy—courtesy of Cukor's old friend, producer Merian Cooper—of an artist's first sketch of the climactic scene of the movie, King Kong straddling the Empire State Building.

When Alan Searle was in Hollywood, Searle and Cukor occasionally dined with George Towers, whose mere presence Searle seemed to enjoy almost as much as Cukor did.

Cukor had no seething jealousies, and he had always promoted Towers's friendship with his friends. He even promoted "dates" for Towers with certain well-known actresses in film productions on which he was working. And when Towers chose to marry in the fall of 1967, Cukor seemed to approve wholeheartedly.

Towers was still the most important person in Cukor's life, although the nature of the relationship had subtly changed.

"It turned into a father-son relationship, and as George [Cukor] grew older, he grew less interested in the personal attraction and more interested in the father part of it," explained Bob Wheaton. "George Towers played up to it—called him Dad—and George rather liked that."

After he had obtained his law degree, Towers seemed to be busy all the time, and he drifted away from the Cukor house. The talk about him was always muted, because among the group Towers (like Hepburn) was exempt from any real "cutting." Cukor continued to think the best of his friend—wasn't he proving himself by rising up in the world?—and in Towers's presence could be reduced almost to fawning.

In any case, Towers never seemed comfortable around some of Cukor's longtime friends, recalled members of the "chief unit," nor were they around him. "George Towers was very, let's put it this way, *shy* about being connected with gay people," said one of Cukor's longtime friends.

Some of the "chief unit" defended Towers as being the person who brought the most happiness to Cukor. "I always liked George Towers," insisted Michael Pearman. "I think a lot of people were just jealous of him. He was one of the few people who gave George [Cukor] pleasure."

However, others believed that as Towers became entrenched in Cukor's life, winning the director's total confidence and trust—as he shone all the more in Cukor's eyes—his presence contributed to a discontent in the circle that may have been there as an undercurrent on Sundays all along.

When people began to disappear from Cukor's life, inevitably there were rumors that they had said something unfair about George Towers that had reached George Cukor's ears. Indeed, there were mysterious defections: Character actor Grady Sutton was one who stopped coming to the house. While nothing ever really seemed to bother Cukor, one thing that plainly did bother the director was when

a good friend he had known for half a century stopped coming by without explanation.

However much they were grateful for Cukor's hospitality, some of the Sunday group did resent his rules and decorum: the scurrying and scrounging for aperitifs; Cukor's fury if a guest dared to arrive late (dinner always started promptly at ten to seven); Cukor's gulping down of food, and his insistence that everyone else hurry up and clean their plates.

Even more: His bias about people. The wearisome old cronies with their predictable stories and jokes. The director's own unpredictability—his mood swings of arrogance and irritability.

"He [Cukor] was too difficult sometimes," said one of Cukor's friends, a member of the "chief unit." "Informed, exciting, yet you had to put up with things. He was a bully. He liked yes-men around him. He made up his mind about something, or someone, in the first three minutes and he never changed it."

The kidding at Cukor's house was always supposed to be kept in check. But Cukor could be acute in his observations of people, as with the characters in his films, and he might be very truthful with his sarcastic remarks. He could cut through to people and hurt them. For some of the "chief unit," being at his house was always "nervous time."

"I had become a little bit successful," explained Bob Raison, "but my opinions meant nothing. Once he said to me, 'What do you know? You're a piddling little agent.' I never felt happy leaving there. It was not good for my self-esteem."

Even Christmases—especially Christmases—tensions were heightened. David Manners, who had known Cukor since the 1920s, thought that although Cukor was "full of good cheer and quips for everybody, the 'show' was always a 'show,' it was never from [deep inside], I felt. I'm sorry, but that's the way I felt. That he lacked something; it was all this outward expression, there was no *inner*.

"I never really understood a man like that. Because he seemed to have so many friends, yet none very close. At Christmas everyone loaded him with presents, but I felt that he was still alone. And with all of his friends around him . . . he was lonely."

This was certainly a paradox: This man who always surrounded himself with a cast of characters, figuratively and literally, in life and work; who thrived on dinners and parties and group activities; who hated solitude; this man was at his best, his most genuine, at ease, when there was no flock of guests or friends around.

No family. No image to uphold. No "performance."

"The most wonderful times were when he and I were alone," noted Bob Raison. "A couple of times we ate alone on trays in his bedroom. That was beautiful."

"The nicest time to see George was when he was alone," agreed director Irving Rapper. "When he would have the dogs and say, 'Irving, let's take a walk in the woods!' That's when I liked George as a person. Because he would tell me things that he would never discuss in the house. Things that were really true."

Cukor got the call from Twentieth Century–Fox about *Justine* in 1969, just when he desperately needed something to revive his optimism about his career. Five years had gone by since *My Fair Lady* and his Oscar for Best Director.

The struggle to transform Lawrence Durrell's labyrinthine Alexandria Quartet (*Justine, Balthazar, Mountolive,* and *Clea*) into a movie had begun long before, in 1957. The four interwoven novels had been wrestled with by many scriptwriters, including Ivan Moffatt and Joseph L. Mankiewicz, before being finally tamed—perhaps too tamed—into a workable adaptation by Lawrence B. Marcus.

Early filming had taken place in Tunis, where cast and crew were dogged by eye irritation from the constantly blowing dust, general suffering from "Tunis stomach," rampant boredom, and "gravest misgivings," according to actor Dirk Bogarde, who had the distinction of being in his second Cukor "salvage" operation.

Director Joseph Strick had been fired on location and the producer, Pandro Berman, had been ordered by Twentieth Century–Fox to retreat to Hollywood. By the time Berman had hired Cukor, the budget had been slashed, the script was in need of overhaul, and the director—"perhaps the most cultured and erudite of all Hollywood directors," in Bogarde's words—had no choice but to re-create the forbidden city of Alexandria, circa 1938, on studio soundstages.

The international cast that had been assembled included Anouk Aimée (as the contradictory Justine), Michael York (as the boyish poet-narrator), Dirk Bogarde (as the morally fatigued British diplomat), French director Jean-Luc Godard's ex-wife and leading lady Anna Karina (a belly dancer), French character actor Philippe Noiret (a diplomatic attaché) and Cliff Gorman (as a hapless homosexual character).

Cukor had to spend much of his time fighting the casting of the two leads. He found York bland—as, indeed, he comes off in the finished film—and he acted snappishly toward the actor on the set. And nobody could fathom Aimée. She suffered from hives and

strange skin conditions. Worse, her professional comportment was—like Marilyn Monroe's—difficult.*

"Forbidden, because of the Decency Laws or something, to use real children in the Children's Brothel, we were forced to employ elderly dwarfs instead, swathed in veils or strategically placed back to camera," wrote Bogarde in his memoir *Snakes and Ladders*. "Most of the sets looked like the Coffee Shop in the Tunis Hilton; everything was clean and neat; and even wretched Michael York was forced to wear a flesh-coloured pair of briefs for his seduction scene on a beach, and striped flannel pyjamas when he was in bed. Hollywood's decadent, fabled Alexandria had all the mystery, allure and sin of Derry and Tom's roof garden.

"None of this was Mr. Cukor's fault. . . ."

The only actual glimpses of the city Durrell had called "the winepress of love" were handled by a second unit in Egypt. The second-unit work was excruciatingly obvious—especially the romantic beach interlude that the studio insisted on inserting into the picture.

These are certainly strikes against the film: the script bastardization, the soundstage Alexandria, the budget exigencies, the two leading-character duds, with zero chemistry between them.

Yet why is it that *Justine* looks pretty good after all these years?

It was as if Cukor had stood back and tossed shimmering colors and jagged emotions and these exotic people on the screen—a little rococo in their effect but with all the strong points of his expertise. Some of his later films were like this, an almost gaudy clutter of things that somehow added up to a strange harmony, like the interior decoration of his house. This Golden Age director had mellowed, was more comfortable with himself, and seemed completely at home here—with these tales of promiscuity and death.

Some favorable reviews greeted *Justine*, released in the summer of 1969: Kevin Thomas called it "a triumph" in the Los Angeles *Times*. The majority of them were unkind, however: across town at the Los Angeles *Herald-Examiner*, a reviewer said Cukor's film of *Justine* was a "crime," a butchery of great literature.

Whichever, *Justine* proved no impetus to further work for the director.

*Aimée was just coming off her Oscar nomination for *A Man and a Woman*. Cukor loathed her. Producer Berman, in published interviews at the time of the film's release, averred that "She [Aimée] doesn't care about career. All she is interested in is being with her lover of the moment."

Three years elapsed between *Justine* and Cukor's film of *Travels with My Aunt*.

After much anticipation, *Peter Pan* had been blocked in court by the Walt Disney corporation, which proved claim to the screen rights. *The Nine-Tiger Man* had come close—really close—before it was canceled as being too expensive ($12 million budgeted) with its British and India locations. *The Bloomer Girl* had come even closer, and both Cukor and scriptwriter John Patrick as well as the two stars had to be paid off for commitment dates that a studio, at the last minute, failed to honor.

In the nearly ten years since its inception, G-D-C Productions—basically Cukor and Gene Allen—had failed to launch a single picture. In 1971, Gene Allen left Cukor's employ and chose to move on. To some extent, he blamed himself. "Maybe because I'm not a screenwriter," Allen said.

Was the failure because of Cukor's incompetence as a producer? That would be unfair.

Mostly, the times were to blame. Ford, Hawks, Capra, Wyler, Stevens, Mamoulian, King Vidor, Lewis Milestone, Walsh, Wellman, Henry King—all of these men and others who were in Hollywood when Cukor first arrived in 1929 had directed their last films by 1970.

Partly because she knew Cukor was desperate to go to work, Katharine Hepburn had agreed to star in a film of Graham Greene's entertaining, darkly comic novel about a priggish banker swept into dangerous itinerant adventures by his long-lost eccentric aunt (who may be his mother). Greene himself supposedly recommended it to Hepburn, in galleys, as "a book made for films."*

The two Cukor friends who agreed to produce the film were James Cresson and Robert Fryer (the managing director of Center Theater Group at L.A.'s Ahmanson Theater).

But when, according to coscriptwriter Jay Presson Allen, Hepburn's career stumbled with her portrayal of an eccentric old woman in the

*Cukor never read the book or even met Greene, however. In fact, the film is very different from the book; the "third act" of the novel is chock full of political and historical intrigue, ugly incidents (the killing of Wordsworth), and takes place in Latin America. The ending is far from comic. All of that was scotched in favor of Cukor's more picaresque version. "I very much disliked his [Cukor's] adaptation of *Travels With My Aunt*," wrote Greene to this author, "but then I have not found any of the American adaptations of my books other than bad. Sometimes as in the case of Ford and *The Power and the Glory*, a complete betrayal."

1969 film of *The Madwoman of Chaillot*, her willingness to portray another grande dame on the screen was affected.

"She would never admit it," Jay Presson Allen recalled, "but I know she didn't want to play another crazy old lady, not an unreasonable position—but she was in for a penny and a pound with George.

"As she began to withdraw and find problems, he became frantic—like a boiling pot. I rewrote and rewrote but I knew it was not going to work. She didn't know what she wanted, when what she wanted was to get the hell out of the project, and was unable to articulate that, maybe even to herself."

British playwright Hugh Wheeler had done the first draft of the script. Allen was struggling through revisions and Hepburn's suggestions for changes. After a time, it occurred to Allen—who had had reservations about the material in the first place—that she had run her course. You should write the script yourself, she told Hepburn.

Months passed. "Kate wrote and wrote." said Allen, "My guess is she was happy writing, but she [still] didn't want to play it."

Cukor asked Kanin to meet with Hepburn (this was still before publication of *Tracy and Hepburn*) to prod her along. There was progress but still no completion. Hepburn's refusal to say "It's done and I'm ready" drove everyone up a wall. Cukor would not push her, but he was "panicked," in Allen's words.

Finally, MGM President James Aubrey telephoned Hepburn and, in effect, informed her that filming was to begin in ten days and told her to report to work. He tape-recorded the conversation, to protect MGM from legal repercussions. Predictably, Hepburn said no and quit.

Waiting in the wings was Maggie Smith, who had worked with producer Fryer for her Oscar-winning performance in *The Prime of Miss Jean Brodie* (also with a script by Jay Presson Allen). Smith was substituted as Aunt Augusta, and according to Allen, "they gave George about thirty-seven dollars and sent him to Spain and said make a movie."

Cukor was terribly distressed about Hepburn—he urged her to file a damage suit—but she told him to go ahead and make the movie, which is what he sorely wanted to do, anyway. He knew the studio era was over. The soundstage days were over. Therefore, this seventy-two-year-old director, practical above all, packed his bags and went overseas to make a low-budget movie.

Ironically, for all of Cukor's mystique as the great studio craftsman, some of his best films were the reckless ones—not the fussed-over ones, but those done outside the studios, or one day ahead of crisis.

Travels With My Aunt falls rapturously into that category. Although it was shot almost entirely in Spain, Cukor made beautiful use of

glimpsed locales, interspersed with the places he knew well from his own life—planes, trains, taxis, cafés, and hotel rooms. Lyrically designed and costumed (Anthony Powell won an Oscar for his costume design), the movie was all dash and blur, the scenery as liquid as the story line.

It is one of Cukor's most personal movies, about a restless theatrical spirit such as he liked to imagine himself. This time, however, the story gave him an excuse to flaunt both selves on the screen: He is the stuffy banker, Henry (played by Alec McCowen), who potters in the garden and raises dahlias. And Cukor is also the nonconformist Aunt Augusta (Maggie Smith), whose resolve to rescue a favorite old lover sets in motion the trans-European quest.

The old-fashioned younger man has a secret lust for life, and Cukor's treatment of him is compassionate as well as comical. When Henry makes love on a train to a marijuana-puffing pickup (a cute performance by Cindy Williams, later of television's "Laverne and Shirley") who spouts all kinds of nonsense, the view is decidedly approving.

Aunt Augusta was more the exterior Cukor (as he imagined himself): an elder adventuress of love, scoffing at death, intrigued by pot and superstition, haunted by flashbacks of triumphs and failure. Her mysterious tarot card–playing squire, Wordsworth (drolly played by Lou Gossett), is even more appealing than Henry's pixieish pickup, despite the fact that he has substituted marijuana for the ashes in Henry's mother's funeral urn.

At the end of the story, the banker must decide his future by a (freeze-frame) coin toss. In *Travels With My Aunt*, this director, who lived such a carefully ordered and determined life, tosses up a valedictory paean to chance and fate, impulse and wanderlust. It is more the point of the story, however, that Henry was part of Aunt Augusta all along, and now he has *become* Aunt Augusta. One is the other.

The picaresque humor and manic zest of *Travels With My Aunt* must have caught some film critics by surprise ("no real zing," complained an uncomprehending Pauline Kael). Yet others wrote rave reviews (Cukor had to laugh at the double entendre quote in the newspaper advertisements: "His talent shows through in beautiful snatches . . ."). The Academy of Motion Picture Arts and Sciences honored Cukor's forty-ninth film with four nominations, for photography, art direction, costuming, and a Best Actress nod to Maggie Smith for her elaborately contrived performance.

The final script, credited solely to Hugh Wheeler and Jay Presson Allen, was mostly Katharine Hepburn's. Hepburn got "screwed" on the screen credit, according to Allen, who was dissuaded by Wheeler

and producer Fryer from taking her own name off the screen. The Writers Guild refused even to consider Hepburn's name because she wasn't a guild member.

"But I've never made any bones about writing that movie," said Allen. "That script had one big speech of mine. It had nothing of Hugh's. It was Kate's script."

Nineteen seventy-two was also the year of publication of *On Cukor*, a series of edited conversations about Cukor's career, between Cukor and a friend, the author and screenwriter Gavin Lambert. The "official" transcript of the director's public life, it is an indispensable guide to his experiences and technique, full of anecdotage and insight, if, as deliberately presented, a little stiff and self-conscious.

Cukor was dismayed by its reception. The publisher found minimal interest from the talk shows and publicity columnists, and sales were low for the book, which scarcely made it into stores. Even though the director never quite gave up hope for a further book about himself, with his memory receding, *On Cukor* marked the real end of Cukor's autobiography project.

When Charles Higham reviewed *On Cukor* for *The New York Times*, he was surprised by Cukor's reaction when, in discussing the director's career contribution to films, he made the mistake of drawing too fine a distinction, in Cukor's case, between artist and craftsman.

"Although the review was quite favorable both to him and the book, he was furious about that," recalled Higham. "I might not be so arrogant today. The line is too finely drawn. Yet he had gone out of his way repeatedly to tell me he was not an artist, that he hated the term, and that it didn't apply to him."

While on location for *Travels With My Aunt*—a film with a comic view of death and funeral urns—Cukor received a letter from George Towers urging him to finalize and sign his last will and testament.

None of the "chief unit" paid much attention to vague references to the will; Cukor, after all, was in excellent health. Some were upset that Towers was to be named executor, however.

Cukor pacified these friends by giving them the impression that Towers's toddler son was to be named the beneficiary of a trust. The little boy called Cukor Grandfather, just as Towers called him Dad. A few of the "chief unit" chuckled aloud at that, but others thought Cukor's affection for the boy a nice, sentimental touch. They thought it wouldn't be so bad if Cukor left all his money to George Towers, if it was all really going to the little boy.

CHAPTER TWELVE

*T*he *Blue Bird* was his absolute nadir, ten times worse than *A Life of Her Own*. At least *A Life of Her Own* might be pardoned as a studio junk product. *The Blue Bird* was a classic travestied, a financial and publicity catastrophe, and for a seventy-five-year-old director anxious to keep working, seemingly the end of the long road. Who would hire Cukor after that mess of a film?

This unusual U.S.–U.S.S.R. coproduction was much ballyhooed in the preproduction stages, in late 1974, yet by the time filming began, the press was already aware of the slide toward debacle. To reread the clippings and review the unfortunate history of this film is to become as depressed as Cukor must have been at the time.

The problems began with miscommunication, differences in work habits, and cultural discrepancies between the Americans and the Russians. The situation deteriorated with producer inadequacy and shuffling, cameraman and equipment problems, cast illness and changes, and general on-location disgruntlement.

Even before the film's release, Elizabeth Taylor was saying *The Blue Bird* was going to be a "disaster" (she told the *Ladies' Home Journal:* "In five months I did about a week's work . . .") and Cicely Tyson's accumulation of blunt quotes ("Don't tell me what a great director Cukor is . . .") was damning.

In all, there were eight months of tortured filming, from January

315

to September of 1975, at Lenfilm Studios in Leningrad. The budget soared to between $6 and $8 million, not inconsiderable in those days (the film earned back less than $1 million in rentals). No one seemed in charge—no studio, no single producer, not the Russians, not the Americans—least of all Cukor, who found himself in the middle of a nightmare.

As always, Cukor tried to put a good face on reality. In interviews, he said he had seen and enjoyed the Winthrop Ames production as a child in New York. Although the fairy-tale preciousness of *The Blue Bird* couldn't have been further from his own more decidedly adult sensibility, he expressed fondness for the 1908 play by the Nobel Prize–winning Belgian Maurice Maeterlinck. In the symbolistic text, where two woodcutter's children search for the Blue Bird of Happiness, he found ideas that he could claim as his own. "It's about mother love and respect for grandparents. . . ."

Whatever connection Cukor had to the material, real or imagined, was not apparent on the screen, however. What was apparent was an elephantine attempt to be precious, the strain and confusion—the lack of energy—shocking and without precedent in the director's long career.

Critics and commentators did not overly fault the cast, however tiresome they might have been on the screen. Cukor had assembled old friends and reputable professionals—including kindred MGM spirit Elizabeth Taylor, who had ten songs and the four roles of Light, the Witch, Mother, and Maternal Love; Jane Fonda as Night (Cukor was godfather to Fonda's daughter Vanessa); Ava Gardner as Luxury (he had stayed friends with the actress after *Bhowani Junction*); and Cicely Tyson as Cat (on location she and Cukor agreed on only one thing—they detested each other). A host of notable Russian actors, ballet stars, and musicians were relegated to the status of local color.

The reviews tended to target the director. "Senile and interminable," wrote John Simon about *The Blue Bird*, a barb with an obvious target. Simon, the critic for *New York* magazine, was often sharp-tongued, but many reviewers went out of their way to echo his tone.

It hurt Cukor terribly that critics seemed to blame him personally—especially those who had championed him in the past, who, in some cases, had been guests of his for dinner. Critics who had written about him as though he were one of the central figures of American civilization now were saying that the director no longer knew what he was doing, that his latest movie was dumb, appalling, grotesque. Cukor was distraught over the attacks.

He seemed to have lost confidence. To close friends, Cukor would murmur, half to himself, "I don't know if the movie is any good,

anyway. I don't know. I usually *know*. In the past I've known whether it was good or not. This time I don't know. I don't have a feeling for it."

Cukor tried to take solace in Kevin Thomas's positive notice in the Los Angeles *Times*. Thomas, a Cukor partisan who had also praised *Bhowani Junction* and *Travels With My Aunt* in print, was almost alone in hailing *The Blue Bird* as "exquisite," "contemplative . . . this rich yet delicate musical fantasy [with] much charm and poignance. . . ." Thomas went on to offer such flattering adjectives as "deft," "sophisticated," "radiant," "shimmering," "ethereal," "dazzling," "radiant," "ravishing," "irresistible," and a "landmark" in discussing the film's doubtful merits.

"Well, Kevin Thomas thought it was wonderful," Cukor would say. "And I *like* Kevin Thomas better than the others. He writes much better than any of the others. And he's smarter than any of the others."

Friends who listened to him were struck at how sad it was that this fine director, down on his luck and at the end of his career, seemed unable to convince himself.

Once again, Katharine Hepburn came to the rescue. If the septuagenarian director was adrift, Hepburn still seemed able to *will* a project into existence. Her retreat from motion pictures had already begun, however, so her final work with Cukor, two small-scale films in 1975 and 1979, was for television.

The first, the exquisitely mounted *Love Among the Ruins,* was filmed in England, quickly and quietly, actually before Cukor's unfortunate experience on *The Blue Bird*.

Cukor finally got his wish to direct Laurence Olivier in a role well suited to that ingenious actor: as an aging barrister who takes on the case of a society figure, a onetime actress (played by Hepburn) being sued for breach of promise by a young gigolo (Leigh Lawson). It turns out that the lawyer and his client have a shared past; as a young man, when he was a seaman on shore leave and she a stage beauty in the midst of a road-company tour, they had a romantic fling. She left him behind. All the rest of his life, he has carried a torch for her. Now, even as he is defending her honor in a situation reminiscent of his own betrayal, she professes not to remember him in the slightest.

Cukor's self was always channeled through Hepburn in his films with her. In the studio age, she had been a stand-in, for him, of poetic yearning and sexual ambiguity (*Sylvia Scarlett*), of haughtiness and foolish romance (*The Philadelphia Story*), of brash independence (*Holiday*), staunch character (*Adam's Rib*), and athletic pulchritude (*Pat and Mike*). However, in this, his most unapologetically sentimen-

317

tal romance, his most poignant and philosophical comedy, Hepburn became for the director a medium for regretful ruminations about aging, friendship, love, and loss.

But she was not his only projection; Cukor was also represented by the older gentleman who had once pined after a road-show leading lady. A mark of Cukor's maturity and of his more personal films was the presence of both selves—both lives, as it were—represented thematically (as in *A Double Life*), or as two characters who are like halves of each other (as in *Travels With My Aunt*). The Olivier character was like the director, a professional who has sacrificed himself to career, a "disappointed romantic" who keeps the secret fires of youth burning in his heart.

This most rueful of the director's final films was shot in six weeks in England. The time "passed like a lovely pink shooting-star," wrote Laurence Olivier in his memoirs *Confessions of an Actor*, "so memorable but quickly gone."

The reception for *Love Among the Ruins* when it was aired in 1975 must have cheered the director. A year later, Cukor's television film was honored at the annual awards. Emmys went to the writer (James Costigan) of the pinpoint script, and to both of the stars, who inhabited their roles with such flair, Laurence Olivier and Katharine Hepburn.

Even as the abysmal reviews for *The Blue Bird* were logging in, Cukor himself won a Best Directing Emmy—to go with his Oscar.

Cukor stayed busy. However, it was an artificial busyness, not the everyday forced busyness of the contract years. Most of the projects came together at the last minute. In between, there were vast stretches of time when Cukor worked on films that never came to fruition.

One of the things that occupied his life was his newfound stature as the First Citizen of Hollywood. Cukor had always been popular at events and parties, but now he was no longer one among equals. Now—with so many colleagues of the Golden Age dead, reclusive, or reluctant about personal appearances—Cukor was one of the last of the conspicuous survivors, someone who seemed to revel in the attention and occasions involving public-spirited causes.

The director was always willing to lend his name and enthusiasm to a film-preservation drive, to college programs, and to film events. He was available to show up at special screenings to answer questions. He established a fellowship in his name at the University of Southern California, and helped organize and fund the Ethel Barrymore Memorial Collection of theater and film memorabilia there. He became a "founding father" of FILMEX, the annual Los Angeles

Film Festival. He was one of the true friends of the American Film Institute.

Tribute evenings, to Hollywood people alive or dead, seemed to proliferate in the 1970s, and Cukor was often a gracious presence at such festivities. (One night, he directed scenes from two Moss Hart plays at a USC memorial to the man who had scripted *A Star Is Born* and directed *My Fair Lady* onstage: highlights from *Once in a Lifetime* with Jack Lemmon and Felicia Farr; and *The Man Who Came to Dinner* with Debbie Reynolds, and Truman Capote as the Alexander Woollcott character. Capote was very funny, too, according to Cukor, and not too amateurish an actor.

If Cukor had felt unappreciated by American film critics in the early 1960s, now he could have no such grievance. Film acolytes streamed to his house for advice and fellowship. Journalists lined up for interviews. (He still didn't like tape recorders, but he was getting used to them.) Numerous gala tributes were held in his honor—Dan Talbot had scheduled the first significant retrospective of his films at his New Yorker theater in 1964; the Museum of Modern Art added its imprimatur with a five-week festival of Cukor films in the fall of 1970; many more followed.

Cukor complained about the embarrassing, the fatuous, the interminable speeches of these special evenings. He hated the questions about Mae West and Garbo, and would have preferred the broader ones about the film or the director. (He hated that when his old friend Billie Burke appeared on the screen at a revival of *A Bill of Divorcement* the audience tittered expectantly, recognizing her primarily as the Good Witch of *The Wizard of Oz*.) At such affairs, he encountered some people he usually avoided, some he privately detested, some he had to admit had grown awfully rickety and ancient-looking. The habit of audiences rising to their feet in standing ovation, cheers and tears at the slightest urging, he detested. The unabashed sentimentality of it all embarrassed him.

But Cukor had to admit that he did not *really* hate these love-ins. The tributes and festivals, the student screenings and public appearances, the honorary college degrees, these were part of the compensation for having lived so long. Such celebrations of himself and of Hollywood took up more and more of his time.

"He needed that," said Katharine Hepburn. "He couldn't get enough of that."

"You would see more dinners and celebrations of the legend [of Cukor]," commented Joseph L. Mankiewicz, "than any two directors I know of, and I know he loved those."

Few of the other alive-and-well old-timers were as ready to show up as Cukor. Few were as witty and personable, as up-to-date, as

319

Cukor. Cukor could tolerate the young people, banter with them, and call bullshit *bullshit*.

Old acquaintances who encountered him in public thought he was more mellow, still feisty and funny but less sarcastic. For too many years, he had suffered needlessly from looking more Jewish (in his own eyes) than he really was, and had wrapped himself in a dream world of famous people and chic. Now, to some, Cukor seemed more thoughtful, at peace with himself, eager to listen and mingle.

Now people remarked on how handsome and distinguished-looking he was—with those gold wire-rims (which had replaced the Golden Age horn-rims), sparkling brown eyes, and a nimbus of fine white hair. For such an elderly man, he cut a fashionable figure.

"I liked him better," said Gottfried Reinhardt. "He was much less flamboyant in his later years, and more thoughtful, yes."

"He got better looking as he got older somehow," noted Bob Wheaton. "I was struck by that."

"He had great pride," mused Don Bachardy. "He was certain about himself and what he had done. And I think though he had regarded himself as physically unattractive once, he had dealt with it so long ago that it became a tower of strength to him."

No matter the dry spell in directing jobs, no matter the unkind reviews for *The Blue Bird*, Cukor preferred to look on the bright side of life; and in the mid-1970s, he found much to be happy about.

"One of the keys to his whole personality was just this joy in being alive," stated writer-director James Toback. "He [Cukor] used to look out at the garden on a sunny day and say, 'Aren't we just the luckiest people in the world to be in a house like this, on a day like this, to be doing exactly what we want to do in life?' And he meant it. There was no sardonic detachment whatsoever. He was somebody who really loved being alive and felt that, of all the possible ways of being alive, he had somehow managed to get the best."

Between 1975 and 1977, Toback, then getting a foothold in Hollywood as a scriptwriter (his first credit was *The Gambler*), spent "probably five hundred hours" with Cukor, developing a script about Victoria Woodhull, a turn-of-the-century "free love" activist who was the first woman to campaign for President of the United States. If all went well, Faye Dunaway was going to play the lead role.

At first, there were no time pressures. They spent a lot of time just sitting at poolside and talking. Cukor would open a package from a clipping service and pore over the positive reviews for a play that Katharine Hepburn was touring in around the country. He seemed to get a vicarious thrill out of what was being said about her perfor-

320

mance, exclaiming as he read each of them, "Isn't this wonderful? Isn't this just *wonderful*?"

Indeed, a lot of their conversation was not about work. At least half was about sex, Toback remembered, and while the director stubbornly refused to talk about his own sex life (no matter how much Toback prodded him), he had an insatiable appetite for hearing all about Toback's, "everything in graphic detail." Cukor seemed paradoxical to Toback in his insistence on good taste in discussing scenes of the script, while in ordinary conversation he evinced an insatiable curiosity about sex.

Not to mention the paradoxes of his language. "In terms of vocabulary, the two words that he favored about all others were 'distinguished' and 'distinctive,'" remembered Toback. "Every three or four sentences, something was 'distinguished' or 'distinctive.' In a way, you could say that there was a part of his personality that looked for everything to be 'distinguished' or 'distinctive,' which is to say 'clean' or 'high-minded' ('high-minded' is another phrase he used all the time). On the other hand, he also loved words like 'cunt.'

"His language was very explicit and obscene. It's interesting— because he's known as a women's director, and there is no word which women detest as much as 'cunt.' There are women who won't speak to you again if you use the word—in *any* context. Cukor referred to everybody as a cunt, not even disparagingly. It was the most common word in his vocabulary. 'Silly cunt,' 'dumb cunt,' 'a foolish cunt,' 'oh, he's just a cunt,' 'she's a cunt.' It was overused the way 'fuck' is overused by some people, and yet it was never personal, it was anything but.

"'Kike' was a very definite part of his vocabulary, too, although he didn't use it so often as 'cunt.' I'm sure he never used it with non-Jews, the way a lot of people only refer to 'niggers' around other black people. He and [some of] his friends used to refer to Anatole Litvak as 'Anatole Kike.' Like sex, there was a sense of Jewishness being something low, and the Wasp word as being something high."

Toback—a boxing fan—was struck by Cukor's own unlikely interest in spectator sports. (As with stage highlights, Cukor could remember amazing details—for example, the name and precise physical description of a handsome long-distance runner dating back to the 1932 Olympics.) One day they were taking a break from script sessions, both lying on Cukor's bed, Cukor with his slippers and bathrobe on, Toback in a bathing suit, watching the Ron Lyle–George Forman fight.

"It was one of the great 'bomb' fights of all time, where these two huge muscular guys knocked each other down for several rounds," recalled Toback. "Each of them was just about out on his feet at the

end. Foreman finally won by a knockout. Cukor was agape at the sight of these two guys. He kept commenting on their bodies and their muscles. I've never been with anybody who got into a fight with quite such an odd and personal fervor as he did with that fight."

Weeks went by while revisions were made on the *Vicky* script. The work dragged on. Toback, like others before him, got the idea that Cukor was "fetishistic" about some parts of the script. The director had the writer read certain passages over and over again, obsessing on "moments" or certain lines of dialogue.

"At first I thought it was senility," remembered Toback. "Then I realized he was putting me on the spot. He made me read a scene over and over and over again, out loud. He'd make me tell what the scene was doing, where it was, and why, and where it was going. The same questions over and over again. At first I thought it was because he didn't remember he had asked before. Then I realized he kept asking because he didn't really feel I had answered it satisfactorily either for him or for me."

When they went through the motions of casting the secondary parts, Toback learned there was a visual correlative to that obsessive approach to the script in Cukor's physical appreciation of certain actors.

"There was an actor I suggested to him for the male lead that he had never heard of. Then he went and saw him and got very excited about him, and talked about him a great deal. He didn't want to meet him yet; he just wanted to think about him and watch him and run everything he'd done over and over again. Jon Finch—who, oddly enough, played Macbeth in Polanski's *Macbeth,* and the lead in Hitchcock's *Frenzy.*

"His comments were always very detailed observations about the physical presence. In fact, it's interesting, it made me as a director aware of the importance of specific physical details of actors. His obsession with a mouth, or with eyes, or with a walk—in particular, Jon Finch's—started getting me more conscious of just the physicality of both actors and actresses."

After the notices for *The Blue Bird* began to pile up, however, it became clear to Toback that the director was fighting depression. Though Cukor spoke of bouncing back, Toback began to wonder. Cukor was also beginning to experience health problems, especially severe back pain, and taking more Percodan than he was supposed to. For the first time, he began to talk (not to whine—he had no patience for whiners and complainers) about feeling old and finished.

Again and again, Cukor asked for changes in the *Vicky* script, which caused delay. It occurred to Toback that—as had been the case with Hepburn and *Travels With My Aunt*—the director didn't *want* to finish

the script because he no longer felt confident about making the movie. Finally, in part because Cukor refused to get started, producer George Barrie stopped the financing, and Toback reluctantly moved on to another project.

"He [Cukor] was not ready emotionally to do another movie. The critics were able to convince him that perhaps he should never make another movie. He could dismiss the critics as morons and ignoramuses, yet on more than just a practical level, he needed them."

Two anecdotes: In 1978 Toback went on to direct his first film, *Fingers*—an unusual brutal and sexually frank story about an aspiring concert pianist who also collects gambling debts. It starred Harvey Keitel, James Brown, and Mia Farrow's sister, Tisa Farrow. Toback mentioned to Cukor that François Truffaut (the former *Cahiers* champion of Cukor's work who had become a leading French filmmaker, and someone Cukor regarded as "a man of great taste and distinction") had proselytized for the film. Partly on the strength of Truffaut's recommendation, Cukor agreed to attend a small invitation-only screening of *Fingers*.

Throughout the screening, Toback could hear Cukor's audible mumbling and uncomfortable responses: "Oh, this is awful! . . . What can you be doing? . . . How dare you put this on the screen!"

"When it was over," recalled Toback, "he [Cukor] said, 'The only reason that I was polite enough to sit here and watch this appalling movie to the end is that you are my friend, and I am going to keep you as my friend even though you should be chastised for making such a horrible movie.' He was furious about the sex and violence on the screen, even though in terms of minutes it was really very little. It was something that he simply did not feel should be in movies.

"And he [Cukor] added, 'As for your friend Truffaut'—whom I had never met; actually Truffaut was *his* friend—'he can go fuck himself if he thinks this is a good movie!' He was even angry at Truffaut for having liked it!"

Cukor and Toback stayed in touch. When in 1980 Toback was getting ready to direct a film called *Love and Money*, he approached Cukor about playing the small part of a doddering grandfather. Cukor told him, "I'm not going to do it because I spent my whole life behind the camera to avoid being in front of it, so I wouldn't make a fool out of myself. . . ."

Toback argued with him, "You'll be terrific. Just read the script and see. . . ."

Cukor told Toback, "I'll do what Cary Grant did for me on *A Star Is Born*. I'll read it for you. But if I say no, you can't ask me about it anymore."

Cukor did perform the scene for Toback, and indeed he was terrific. When he had finished, he put down the script and told Toback that he had made his decision: He wouldn't play the part. An exasperated Toback asked, "Why not?" Cukor told him, "I just won't. And you promised not to nag me if I said I wouldn't."

About three or four months later, fellow director King Vidor went to Hollywood to play the part that Cukor had informally auditioned for, and as it happened, he had dinner one night with Cukor. Vidor started to tell Cukor, 'I'm in this movie *Love and Money* that Jim Toback is directing . . .'' but before he could say another word, Cukor cut him off: 'Oh, Jim offered me that part and I turned it down. . . .'''

The Corn Is Green, in 1979, was the tenth and final teaming of Cukor and Katharine Hepburn. Perhaps the choice of material was unwise. Who could forget the classic Warner Brothers version, starring Bette Davis as the old-maidish schoolmarm who brings education to Welsh miners, directed by Irving Rapper? And Davis was in her late thirties then; Hepburn was in her early seventies at the time Cukor approached this project.

Yet Ethel Barrymore had played the original role on Broadway at an advanced age. And the playwright Emlyn Williams was an old and dear friend of Cukor's. These were all pleasurable resonances.

To hark back—to see themselves in a younger context—perhaps this was understandable. Scriptwriter Jay Presson Allen said in an interview that Cukor had a wrongheaded idea about Hepburn when first working on *Travels With My Aunt*. He wanted there to be flashback scenes in that script in which Aunt Augusta would be glimpsed—alluringly—in the prime of youth.

"George wanted to show Kate as a young woman," explained Allen, "and this is where we locked horns from day one. I really didn't. I thought it was a disservice to her and the film. In the end they showed Maggie as a young woman—which is more reasonable—but I desperately thought Kate shouldn't, and he was very, very, very determined to do that."

(There are "youth flashback" effects in *Love Among the Ruins*, too.)

In respects other than the age of the starring actress, the Cukor version was antithetical to the Warner Brothers film. Cukor's interpretation was skimpy on the milieu, more of a gloss, an evasion of the reality of that harsh world, which was given grime and authenticity in the 1945 film.

"I would love to spend a short holiday on the grounds around that town, which is supposed to be a mining town," said Irving Rapper, director of the original version of *The Corn Is Green*, and a Cukor ac-

quaintance since the 1920s. "The boy who appeared as the young miner looks like he just came from Oxford. He wore beautiful clothes! There was nothing of the mines, just stock shots. And the miners were awfully good-looking guys—you know, George's casting. I picked ugly people. I tried to make it as real as possible. . . ."

But from Cukor's point of view, this was a variation on *My Fair Lady* with the environment changed and the sex roles reversed. The female character was played by the actress Cukor adored and who symbolized himself. This time, it was Hepburn as the tutorial uplifter of a young man whose crude exterior belies his innate intelligence. So sacrificing of him is her character that she adopts his illegitimate child so he can escape his deprived circumstances to go to Oxford! Cukor was primarily interested in the relationship between the two main characters, and about as fascinated by miners' rotten lives as he was about the London squalor that spawned Eliza Doolittle.

More than the relationship, Cukor was interested in Hepburn. His camera is nearly always on her. Her performance starts in a low key and builds with cumulative intent, ending as a tour de force of shuddering emotion. Her portrait of the fiercely determined schoolteacher, a marvel of optimism and survival, was a way for the director to look into the mirror, and provided Cukor with one of his most eloquent testimonials on behalf of civilized values.

When work seemed to dry up in the mid-1970s, Cukor began to experience serious financial problems.

Although he was never really out of work, none of the films he directed after *My Fair Lady* made much of a profit; in any case they were never G-D-C productions, and he never had profit participation.

Money had always been a vexation. Elsa Schroeder had sold off Cukor's choice Beverly Hills lots during World War II in order to meet back taxes (the Internal Revenue had refused to honor all of Cukor's dinner party and travel itemizations as business exemptions). That hasty decision always rankled, and was thought ill advised, especially in hindsight when California real estate values soared.

Ill advised, too, was the decision to donate some of Cukor's valuable artworks to colleges and museums, taking advantage of tax breaks established in the 1960s and 1970s for such purposes. For example, in 1963, Cukor bestowed a Georges Braque still life, valued in publicity at $85,000, on the University of Southern California. When USC sold that painting after his death, the campus received several hundred thousand dollars in booster funds. The most valuable pieces in his collection were pledged to institutions. Although the director was strapped for cash, he could not sell them to benefit himself.

After Elsa Schroeder died, Cukor's financial management was even more catch-as-catch-can. Cukor had always lived profligately, and he continued to travel widely, to acquire objets d'art, and to entertain lavishly as he had practically every night of his life. He wouldn't give up the high standard of living. He kept the full-time secretary, the cook and gardener (who doubled as handyman), two maids always, a valet and laundress, and a part-time librarian. Nobody was fired.

George Towers dabbled in real estate, and it was he who urged Cukor to sell off the houses on his estate in the late 1970s. These were the fabled houses in which famous people had lived—Hollywood producers and friends—including Spencer Tracy's house, now Hepburn's. Some members of the "chief unit" thought Towers ought not to sell them; thought the rent (ridiculously low for ages) ought to be raised; thought at least that the selling price should be high. Cukor followed Towers's advice, however, and the estate was carved up, the three houses going quickly to buyers.

One of the unfortunate side effects of this decision was that it caused a rift in the fifty-year friendship between Hepburn and Cukor. Hepburn had rented her house—the Tracy house—for years and years, and she had come to regard it as her domicile. When Cukor offered it to her for sale, Hepburn, a notorious pinch penny, balked, and indeed was offended by the ultimatum to buy or move. She didn't understand (few outside the "chief unit" realized that Cukor perceived himself to be in such rough financial straits) why she couldn't just stay on as before. It ended up that she vacated in a huff and moved to New York.

Cukor's collectibles were pawed over for market value. He had a veritable mother lode of theatrical memorabilia and inscribed photographs and letters, not only his own but those that had belonged to other famous people. (And whenever one of his friends had died—James Vincent, George Hoyningen-Huene, and others—Cukor was invariably the major inheritor.)

Now, in the late 1970s, there seemed to be a congestion of visitors to the Cukor house, picking over the correspondence and photographs and mementos. Rare-book dealers, private collectors, friends of friends—at times they would pass each other in the corridors as they appraised Cukor's belongings for their respective reasons.

The more public-minded archivists wanted Cukor's papers and memorabilia for historical purposes. They found Cukor, with his autobiographical life trove, just as he had always been—torn between revealing and not revealing. They would solicit his collection. He would invite them over to the house and to the room above the garage where most of it was kept, tantalize them with peeks at the contents, and then dismiss their interest. Then he would invite them

over again, tantalize them once more, while the people could not help but notice that some of the items were mysteriously missing this time—presumed by friends to have been sold piecemeal.

One curator described the visits to Cukor's house as one of the great frustrations of his professional life, because try as he might he could not establish an accord with Cukor on the disposition of his material. When one day the famous director asked him how much money he was willing to *pay* for some of the items, the archivist was taken aback, dumbfounded. In the end, the library of the Academy of Motion Picture Arts and Sciences received the apparent bulk of Cukor's voluminous collection of scripts, photographs, memoranda, and letters—a collection that was nevertheless obvious as picked over and incomplete.

All the quick-sell money went to Cukor's cash flow. He had always been dependent on others for investment counsel, and now the counsel came primarily from George Towers. It was cautious and conservative, so opportunities came and went. The cash flow dwindled.

Toward the end, there was talk of selling the main house, *his* house, the house that he loved so much.

All of the problems with money added to Cukor's growing sense of isolation and frustration. To some, he seemed irascible about money. To other people, it seemed as if he was desperately economizing. "There were times when we used to go to the house and have meat loaf," remembered Bob Wheaton. "With someone like George, who cared so much about food, you knew things had to be tight. He was so worried about finances that we all felt sorry for him."

Partly because of the financial uncertainties, partly because of his age, Cukor did not encourage big parties, and the "chief" unit, like the work and the money, had dwindled away. Many of Cukor's acquaintances had died by the late 1970s. Some had moved to other cities. The few who gathered were the old-timers such as Harris Woods, who had been a hillside neighbor since the 1930s, elderly men in their seventies and eighties, their circle augmented by the occasional youthful newcomer.

When in the summer of 1980 Cukor got the call to direct *Rich and Famous,* he had just turned eighty-one. Producer William Allyn was concerned enough to ask screenwriter Gerald Ayres how old Cukor really was. Ayres got out a reference book, looked up Cukor's birth date, and reported that the leading candidate for director of their exceedingly contemporary comedy about female friendship had been born in the nineteenth century.

Another (loose) remake of an old Bette Davis vehicle, which itself was based on John Van Druten's play *Old Acquaintance, Rich and Fa-*

mous was about the roller-coaster relationship between two wo-
men—unalike literary lionesses—spanning twenty years.

The film had one of those complicated studio histories that was
completely independent of Cukor's involvement. Several years ear-
lier, Gerald Ayres had written the script expressly for Universal,
where, after a change in executives, it went into "turnaround." Then
actress Jacqueline Bisset discovered the script nesting in a pile on her
agent's desk and took it to studio chief David Begelman at MGM.

In one of those uniquely Hollywood situations, her timing was
good: Begelman was looking for "go" projects, Bisset was made co-
producer, and studio executives called in Ayres and told him he had
to rewrite the script but fast in order to accommodate sets that were
already being built.

Ayres—whose background included Yale, the Living Theatre,
lower-level studio jobs, producing (*The Last Detail*), and one other
filmed script, *Foxes*—rewrote his screenplay "four times in two and a
half weeks."

Robert Mulligan had been operating as director for all of one week
before an industry-wide actors' strike shut down production in the
spring of 1980. For scheduling reasons, as well as for vague reasons
of artistic disagreement, Mulligan asked to be released from his com-
mitment as director. Therefore, by the summer, they had to find a
new director—or even a new "old" one.

Gottfried Reinhardt was working at MGM during this time and
remembered hearing an MGM executive brag about having boosted
Cukor's chances by mentioning his name during the crucial impasse.
"I helped bring Cukor back!" The studio that had succored him
longest was paying him back in the twilight of his career by giving
him a last chance to direct.*

Long before Cukor took the job, many of the production deci-
sions—most of the artistic decisions that were assailed by critics as
being of Cukor's devise—had already been made. According to
screenwriter Ayres, a lot of the "giganticism" and "glossy overproduc-
tion" of the film emanated from the producer, "and it was not my
idea, or George's, of what it [the film] should look like." Originally,
there was to be a lot of location work instead of shooting on overly

*His contract stipulated $300,000 for his services—no increase since *My Fair Lady*
more than fifteen years earlier, though he would receive 5 percent of the net profits.
Contractually, *Rich and Famous* was to be credited as "A George Cukor Film," the
first and only time that this particular *auteur* took such, the kind of billing Louis
Calhern had urged upon him sixty years earlier in summer stock.

ornamented soundstages. Some of the secondary casting, too, had altered the tone of the picture.

Although Ayres thought he had written a film with some documentary authenticity, more of a drama really, the shift toward comedy had already been made. Cukor preferred to emphasize the comedy, anyway, as he always had.

The first thing Cukor did was to ask Ayres, who knew him well from social occasions, to come over to the house and read the entire script aloud to him. It took two afternoons. "He would stop me and correct my performance," said Ayres. "He'd say, no, no, *less.* . . ." Later on, before the filming of a tricky scene, Cukor would ask Ayres to come to his trailer, and would have him read the particular scene again.

The next thing was to view Mulligan's one week of footage. Cukor was horrified and ordered, "Get that wig off her head," meaning costar Candice Bergen's head. "He [Cukor] wanted her to look more natural," said Ayres. "He realized that Candice was going large [in her performance] anyway and he wanted to keep it from looking like too broad a work. He encouraged her toward a naturalness."

By the time filming was to resume in November, Cukor's appointment had been announced and was proving publicity rich. *Variety* ransacked its files for another example of a film director working over age eighty, and wrote an article declaring that Cukor was "the only octogenarian who is spending his time on a soundstage instead of writing his memoirs."

While Cukor enjoyed that distinction, he was sensitive about it. He had recently slipped on a wax floor in his house, and his sprained ribs were wrapped in adhesive. It was painful for him to go up and down stairs, yet if someone reached out a hand to help him, he'd utter "No, no, no," and bat the helping hand away.

At the same time, he was highly amused by people's worries about him—particularly the producer, who was nervous as a sparrow. On the first day of shooting, Allyn noticed Cukor nodding off in his director's chair. Allyn approached him timorously and announced gently, "We're ready to shoot, Mr. Cukor. . . ." The director popped his eyes open, looked up at Allyn, and asked playfully, "Did you think I was dead?"

The director was rumored not to have the strength he used to have, and as evidence of that—look, he was taking catnaps in his trailer during lunchtime. Of course, he had been doing that for years—and after napping, fastidiously changing his shirt, brushing his teeth, and combing his hair before starting the afternoon's work.

The filming *was* exhausting, and he *didn't* have the strength he used to have. He would slump in his director's chair. Then, when

the camera was ready, he'd spring up, filled with with seemingly inexhaustible energy.

The old man was ebullient—back in the saddle with the kind of comedy of manners that he had directed in his heyday—working at the very site of his heyday, Soundstage 28 at MGM.

In some ways, *Rich and Famous* was to be a compendium of all those Cukor films from those years: the seriousness underlying the comedy, the counterpoint between private happiness and public careerism, the jaundiced view of marriage and the extra-curricular sex, the responsibilities of friendship (a subject close to the director's heart).

(As a footnote to his own friendships, he filmed key scenes at Lon McCallister's house in Malibu, and put people such as Christopher Isherwood in party scenes. "Of all the places that he'd wind up working," commented Frank Chapman, "it was out there at this house which we all knew so well. Watching that film was just a groove, because I'd see the camera sitting where I had often sat. . . .''

Not that filming was idyllic. The obvious vanity strife between star (Bisset) and producer (Allyn)—squabbling over screen credit, furnishings of offices—spilled over onto the set and was disrupting to Cukor. Ultimately, the director found himself more in agreement (expeditiously perhaps) with the producer than with Bisset, who was feeling her way as coproducer. Bisset dug in and fought back. While in the past Cukor had been a master of patience, now his nerves were frayed and his patience seemingly at an end.

"There certainly was a struggle for control between Jackie and George," said Ayres. "I think George thought his authority was in question and he got unrelenting with her . . . and in some ways overbearing. He lost his sense of humor about it."

Perhaps there was a method to his irascibility, as there often had been for fifty years of films. Director Paul Morrissey, visiting the set, observed that Cukor used to throw Bisset by making her do a scene over and over again, without turning off the camera or giving her time to collect her thoughts. "Remember, personality! Personality!" Cukor would practically shout at her as she tried to hit her marks. "Let's go!"

"She couldn't think about her acting," remembered Morrissey, "and he knew she had a problem with thinking about her acting. He totally disoriented her, so that as she went about her work, odds and ends of flickering life came out. He tricked people into having life, and other directors can't do that."

Bisset said in interviews afterward that Cukor had resented her as a producer, because he was used to men in that capacity. "Sometimes I hated his guts," she admitted. Yet Cukor was supremely used to

330

female scriptwriters and headstrong female stars. And the bottom line is that under Cukor's direction, Bisset's character came across as pensive and smoky, more varied and interesting, far deeper—with the exception of François Truffaut's *Day for Night*—than anything else she had done.

Candice Bergen's more freewheeling part, as Bisset's competitive Smith College chum who spews out a best-seller, furthered the actress on the road that had begun with *Starting Over*, establishing her comic persona as someone who made light of her own husky beauty. It was a delicious scenery-chewing job.

Rich and Famous also had that in common with some famous Cukor films of the past: these two bright, bitchy, luminous female performances.

Hopes for a popular and critical hit were high when the rich and famous, many of them studio alumni whom Cukor had directed (Cary Grant, Gene Kelly, Elizabeth Taylor, and other contract stars), assembled at MGM for gala previews.

Audiences saw a modern and funny and compassionate "character" picture, quite as sturdy as any of the last pictures directed by others of Cukor's generation—Ford, Hawks, Hitchcock, Wyler, and so on—every bit the intelligent and entertaining summing up of a career.

Yet Cukor had lived into an era of skepticism and liberation, and *Rich and Famous*, a hip Hollywood comedy about women's interrelationships and sexuality, directed by a male octogenarian, was ripe for assault from critics.

While there were some patently good reviews (*Newsweek* hailed the film as "an outrageously entertaining event"), the more cultured publications, *The New York Times*, *The Village Voice*, and *The New Yorker* in particular, excoriated it, or had mixed reactions.

One of the side effects of homosexual liberation was that it also brought antihomosexuality—gay bashing—out of the closet. When researching the attitudes of the Golden Age by interviewing people who were close to the top Hollywood moguls, one is hard-pressed to find a snide comment about Cukor's homosexuality out of the mouths of Darryl F. Zanuck, Jack Warner, Harry Cohn, or Louis B. Mayer. They knew better, even if they didn't pretend to understand homosexuality.

It isn't until the 1960s and the new age of openness that one encounters vague reports of Hollywood people who, in the words of Gerald Ayres—positioned as a lower-echelon executive at Columbia at the time—"laughed about Cukor being a fag."

Similarly, with critics, it was now okay to allude to Cukor's sexual

tendencies, even if *he* never did. Pauline Kael was and is one of the most respected and influential film critics in the nation. Although she sometimes praised vintage 1930s and 1940s Cukor films in *The New Yorker*, she had been ungenerous to other films made in the dusk of his career. (*My Fair Lady*, she found "rotting on the screen.") Her review of *Rich and Famous* condemned Cukor's film as as "a tawdry self-parody" and complained that "it's more like homosexual fantasy." Her point was that the female characters were unreal figments of a twisted male psyche.

Kael might have gone all the way back to John Van Druten (and much of the history of Hollywood) for that simplistic analysis of male-originated female characters. She was answered, fiercely and articulately, by Stuart Byron in *The Village Voice*, who reviewed Kael's unfortunate history of such comments as "tiredest homophobic myths." But the "despicable" (Gerald Ayres's word) damage had been done.

As proud as he was of the film, Cukor, who knew that he would never have the stamina to direct again, felt mortally wounded by Kael's and other negative reviews.

"After we had been knocked down by [Vincent] Canby, Pauline [Kael] and a few others," said Gerald Ayres, "he looked at me with a moment of total vulnerability that I didn't associate with him—we were alone in his library—and he said, 'Is the picture any good?' I said, 'I think it is, George.' He said, 'Goddamn right,' and went on as before."

Some of Cukor's colleagues from MGM days were taken aback by the frank language and sexuality of *Rich and Famous*. Some of the reports from the set indicated the director was embarrassed to be filming such a risqué script.

The *Hollywood Reporter* quoted the producer as saying "the dialogue is so Eighties it occasionally makes Cukor wince a bit."

Jacqueline Bisset told one interviewer, "He [Cukor] dislikes vulgarity. He tends to pull away from it. We had one scene in the picture which I thought quite funny, where Candy [Bergen] has to tell her young daughter to stop doing something rather intimate. Mr. Cukor would only shoot that in long shot. I sensed he wasn't happy about it."

Perhaps the most notorious scene in the picture is the sex act that takes place between the Jacqueline Bisset character and a passenger (the uncredited Michael Brandon) in the upstairs lavatory of the sky lounge of a 747. "I wasn't there the day he shot it [the 747 scene]," said Ayres. "But I understand George wouldn't watch it. I was told by others that he said, 'Go ahead and do it,' and had to look away."

There was something of the charlatan in these reports, however, more of the old-maid act that Cukor put on for Don Bachardy. He couldn't have been embarrassed by *any* kind of language, or depiction of sex.

Parts of the movie are as direct on the subject as anything Cukor had ever done. One scene in *Rich and Famous* seemed almost confessional: where the young male pickup played by Matt Lattanzi (Cukor's casting) unbuttons himself before Jacqueline Bisset and plays with his own nipples seductively. Ayres scripted their scenes together as accidental "meet-cute." Cukor directed them more provocatively. In the script, the bedroom scene was supposed to be one quick shot. In the film, it became a lingering camera shot.

Cukor's own language remained perforated with expletives. His own sex life, even in his seventies and eighties, remained surprisingly healthy. Even among the "chief unit," few knew of the young men who were brought to the house to service the elderly director. They were scheduled so that few would glimpse their surreptitious comings and goings.

"There was one morning when I got there early," said writer-director James Toback, speaking of the time in the mid-1970s when he worked with Cukor. "I was supposed to be there at 8:30 A.M., and I got there at 8:10 A.M., although I had always been coming late. He [Cukor] came out of the bedroom in his bathrobe. Lo and behold, after him, to his surprise and upset, was a young man. He [Cukor] was flustered. He fumbled around and said, 'Do you remember [so and so]? This is his nephew.' To me it made no difference whatsoever. He could do whatever he wanted. But he did not want to reveal . . ."

Indeed, in the final year of the director's life, two of Cukor's neighbors opened the door to his pool dressing room and discovered the eighty-three-year-old director in suggestive circumstances with a younger man. He might have quoted to them from the aging heroine of *Travels with My Aunt*, who is proud of her active sex life. "Age may modify our emotions—it does not destroy them." Like Aunt Augusta, George Cukor had not lost interest in sex.

"Some people thought he [Cukor] should not have attempted [*Rich and Famous*]," said Irene Burns. "That it taxed his energy too much. Because being the trouper he was, he never stopped giving it all. He would come home at night afterwards, sometimes just drained. He would go straight to bed and have dinner on a tray in his room. I think he wanted to conserve himself totally for what he was doing."

Gallant—a word Cukor would have loved to hear used in connection with himself—is a word that crops up over and over again when

people describe him in his final months. He was gallant and upbeat, never (at least at parties and occasions, publicly) down or depressed.

"He wouldn't give into any kind of depression," said Irene Burns. "If he felt depressed in any way, no one ever knew it. He didn't tolerate people who did give in to that, either."

In the year and a half following the release of *Rich and Famous*, Cukor steadily lost vigor. Partly because of his medications, he was often tired and vague. People who saw him remarked at how his suits hung on him, how thin and frail he looked, how unsteady on his legs.

George Towers had divorced and remarried, and he seemed to be busier than ever with his burgeoning client list. Close friends say that Cukor was saddened by his absences and silences, as a father would be saddened by a son who does not pay him enough attention. At first, friends assumed Towers would be managing the household and watching over Cukor, but increasingly it became clear to them that no one was doing that. It fell to Irene Burns to do her best.

There were still nights of sand dabs and scintillating conversation, but more often, the dinner was on trays, and after dinner, when the "chief unit" retired to the oval room, Cukor rapidly nodded off to sleep in his chair. Other times, he would be *too* awake—sniping; the quips bitter, the atmosphere sour.

"It was really depressing there toward the end, to be honest," said one of Cukor's longtime friends. "It had lost its spark, its magic. And all of the worst qualities of George predominated."

His household staff, Irene Burns, his neighbors of many years' standing, and friends who dated back to the 1920s and 1930s—these people became his support network. There was no illusion of future films; there were more phone calls from Cukor and fewer letters as he retreated more and more to his bedroom. Irene Burns still came to work every morning, however. Over time, Cukor had grown very fond of his secretary, and because they did not have much to talk about professionally, they talked about other things.

"He came to look upon me as—not as confidante, but as someone he could express his feelings to and he knew they would go no further."

One of the last times the director went out, to a neighbor's house for tea, he took Irene Burns with him. She had observed him and his friends gather in the oval room, pour rum in their tea, laughing and talking through many winter afternoons. She had never been to any of their houses, even though this one was only a couple of blocks away. To them, it was symbolic of Cukor's feelings for her that he wanted her to see and share that house and garden where he had spent so many pleasant times.

Mornings were best for the director. That's when friends and the

occasional interviewer still came over. Cukor would stay in bed (as he might all day). There was a phone next to his bed and one in his bathroom. He liked to work the crossword puzzles, and he enjoyed watching television. Frank Chapman always remembered the great "woman's director" of classic MGM films lying in bed watching the Three Stooges, chuckling aloud. "You don't think of the Three Stooges when you think of George Cukor," said Chapman, "but he loved them. Every time I see the Three Stooges now, I think of him."

Afternoons, he would read and doze and maybe putter around the house.

Evenings, Cukor might have a few of his closest friends over, and occasionally people that he wanted to meet. However, such dinners would be less frequent and formal, frugalities had to be observed, and hanging over the evening would be the issue of his health.

Cukor didn't believe in the supernatural, but was intrigued by all kinds of otherworldly phenomena that seemed at odds with his public image of commonsense practicality—ESP, astrology, tarot cards, reincarnation, flying saucers. While Cukor and Gene Allen were working to develop a picture about spiritualism in the 1960s, Allen was always professing skepticism, but Cukor kept saying to him, "There's something in all of this. . . ."

The director didn't believe in an afterlife, but he didn't rule out the possibility. He certainly wasn't religious, but toward the end he spoke occasionally with a rabbi. (He had surprised everyone late in life by traveling to Israel with Sara Mankiewicz, then in her eighties, whose expenses he picked up. "According to my mother," said Frank Mankiewicz, one of her sons, "Cukor did not enjoy Israel partly because, to her amusement, he thought there were 'too many Jews.'")

These days, he might forget the title of one of his pictures, but the memories of his boyhood came flooding back. "Towards the end," said his longtime friend Leslie Wallwork, "one goes back to childhood, and George used to talk a lot about his childhood, and when he was seven or eight years old. That was a very revealing thing."

Some days, Cukor did not feel well at all, he did not want any visitors, and he would only go to the window and wave to friends who stopped by.

In the summer of 1982, Cukor went east with a traveling companion to celebrate his birthday, with a private dinner with Katharine Hepburn. They had repaired any ill feelings, and remained close.

In the fall, he journeyed to San Francisco to toast Ina Claire's ninetieth birthday party at the San Francisco Press Club. Actress Helen Hayes was there, and she remembered that Cukor felt a little

insecure in his mind and couldn't be persuaded to make a speech. Afterward, the two veteran show people waited together for their respective flights at the San Francisco airport. Hayes happened to mention John Gielgud, and Cukor commented, "It's too bad we've lost him." When she informed him that Gielgud was very much among the living, Cukor got firm with her and told her that no, Gielgud was gone, gone.

"I could tell that he [Cukor] was rattled," recalled Hayes, "and that he was slipping away."

Always in the past, in the midst of illness or production troubles, Cukor had looked to the future. He hated spite, resentment, regret, looking backward. When someone would ask him how he could be so upbeat about everything, he would say he just looked forward to when it was all over. "I project six months ahead."

Time had been a friend, but now time was really the enemy.

The famous house seemed to be standing still, waiting for something to happen. Objects were in the same place; paintings had been in the same place for fifty years. The stove in the kitchen was antidiluvian. Weeds were growing in the garden.

There was no big tree, no communal gift giving, no Christmas with the "chief unit" in 1982.

On January 23, 1983, Cukor was visited by a number of his closest friends—among them, Lon McCallister, Harris Woods, and Tucker Fleming. Woods and Fleming stayed for dinner.

They had the sense that it was an exceptional evening, almost a formal good-bye. Cukor requested a different fine set of china on which to dine, and for the first time ever, they ate their dinners in the oval room, on trays.

Cukor ate little, and he retired for his nap around 7:30 P.M. In bed, he clasped hands weakly with both of them, and in turn they gave him a kiss on the forehead.

"I never saw him sad or melancholy, not even on the last day of his life when I visited him a few hours before his death," remembered Lon McCallister. "When we said good-bye, I leaned over and kissed him on his forehead (even though any kind of physical display between men was rather embarrassing to him). He smiled at me and said, 'Give my love to Mary Madaline, Lenzo.' (My mother and George were the same age. Someone once told me one of the reasons he liked me so much was because I was a good son. He had been a good son, too.) Maybe that comes with the territory of being an only son, and unmarried."

His two friends went home, leaving Cukor in the care of Robin Thorne, a young student who was employed to assist him. When the film director woke later, he and Thorne watched *The Graduate* on tele-

vision. "I was surprised that he [Cukor] had never seen it before," recalled Thorne. "He thought Dustin Hoffman's performance was excellent but that the film dragged in some places."

Around 10 P.M., Cukor uttered a gasp. Thorne realized he was having a heart attack, eased the director to the floor, and administered CPR. The paramedics were dialed. Tucker Fleming, Harris Woods, Irene Burns, and others were immediately telephoned. Around 11 P.M., at Cedars-Sinai Hospital, George Cukor was pronounced dead.

"I would not like to have any sermon of any kind. All music shall be of a traditional nature, and shall be brief. My coffin shall remain closed at all times."

Cukor's dictates in his will were that there be no speeches or glamour or fussing over his death. Even so, members of the "chief unit" felt afterward that his funeral needed a director—or, like some of his films, one more rewrite. George Towers made some of the arrangements and chose the pallbearers. Harris Woods had made some phone calls and generally acted as senior member of the circle of friends. But nobody rallied people to the graveside or orchestrated the occasion.

His death made the gossip columns, an irony he would have enjoyed. Nationally syndicated columnist Liz Smith wrote: "Where were all the great big beautiful stars George Cukor directed through the years when it came time for his funeral?"

No prominent Hollywood personage went. Katharine Hepburn did not go. Cary Grant was rumored to have begged off because he had accepted a free "Love Boat" cruise with his wife. Aside from some of the "chief unit," friends, household staff, and neighbors, the only show people present were those who represented the long ago: Ethel Barrymore's son Samuel Blythe Colt, actor Lew Ayres, and the ninety-year-old Ina Claire, the director's boyhood idol, who made the trip down from San Francisco with Cukor's old friend Whitney Warren, Jr.

His pallbearers were Harris Woods, Sam Goldwyn, Jr., Gene Allen, producer Michael Viner, George Towers, and Tucker Fleming.

The will had contained at least one "shocker" (in Irene Burns's words): the provision that the director was to be buried in the Goldwyn family crypt, alongside Sam and Frances, and Frances's mother. Frances Goldwyn had preceded Cukor in death on July 2, 1976. No one in the "chief unit" had been informed that Cukor would be buried next to her, however, and that decision invited a lot of speculation among them.

In his book *Goldwyn*, author Scott Berg makes much of this post-

337

script to Cukor's life, postulating that Cukor and Frances Goldwyn "fell in love" on the day they met in 1921 when Cukor was a "lonely outcast" (highly unlikely!) in summer stock; and that this love endured for nearly sixty years—"their feelings for each other were profound—it was the greatest love of their lives." However, the fact that Cukor was homosexual, wrote Berg, meant that he was not the answer to Frances Goldwyn's prayers. These ringing declarations emerged from interviews by the author with Cukor toward the end of his life.

Most of the "chief unit" are skeptical of such claims. These people who knew Cukor best do not believe that Cukor was leading Berg on; but they do suspect that this version of Cukor's love for Frances Goldwyn was the author's own idealized projection. "Several of his friends later insisted that Frances was the only woman he ever truly loved," states the *Goldwyn* book. "He even asked her to marry him."

The response to this marriage-proposal revelation among some of the people who knew Cukor best, way back in the 1920s, as well as people who knew him at the very end of his life, is amazement and denial.

"Bullshit," said Curt Gerling.

Gerling dated Frances Howard before her marriage to Goldwyn in the 1920s—never advancing beyond the kissing stage, for Frances was a virginal Catholic, so devoutly religious that, as Cukor liked to recall, one Friday night in Rochester she bought a hot dog and held it in her hands until after midnight, when she could eat it without sinning. (In his book *Never a Dull Moment*, Curt Gerling relates his courtship of Frances Howard—although, for chivalric reasons, her real name is not given in the book.)

"Ridiculous," agreed Stella Bloch.

Cukor certainly never proposed marriage to Frances Goldwyn, said Bloch. "His fondness for Frances Howard [Goldwyn] was that of a patron to a protégée. When Goldwyn started courting her, Cukor strongly and persistently urged her to overcome her girlish reluctance to marry a much older and far from romantic figure of a man (a striking contrast to the young Curt Gerling). Cukor, doubting Howard's ability to achieve stardom as an actress, wanted to make sure she had lifelong financial security—a real obsession of his regarding many women friends. His worst bugaboo was that this lovely young thing would eventually lose her looks, become destitute and lonely, and end up in the Old Actors Home.

"Frances Howard sacrificed her life to Cukor's neurosis. Little wonder she wanted to be near him in death. In acceding to her wish,

338

he not only affirmed his magnanimity but sent the world a parting denial of his homosexuality."

Everyone in the "chief unit" knew that Cukor did not want to be buried back east in the Cukor family plot. He was not a New Yorker anymore, and he wanted to be buried where he had lived out his life—in California—he said so many times. Frances Goldwyn, too, had heard Cukor utter that sentiment aloud, and had told him not to worry, he would be buried in her family plot, next to her. Don Bachardy said that Frances Goldwyn probably took advantage of Cukor's anxiety on the subject and of his common sense in the matter.

"George might have taken the position that if she took the trouble to worry about his remains, 'Why not go along with it?' I'm sure no one else offered, so why not? George was very sensible that way, and very susceptible to kindness."

Author Berg makes a point of saying that Frances Goldwyn's picture was on Cukor's bed table and that he called her every Sunday for years. However, there were several pictures in the director's all-white bedroom, which encompassed a series of smaller, connecting rooms. Among them were his mother's, Hugh Walpole's, and George Towers's; and the list of women Cukor called practically every Sunday for years—a partial list of the women for whom he had a special affection, each in a different context—was a long one, which included Sara Mankiewicz, Madge Kennedy, Ina Claire, Irene Selznick, Signe Hasso, and Katharine Hepburn.

Indicative of the compartmentalization of Cukor's life, Lon McCallister—the man universally considered by everyone to have been the director's closest friend for the last twenty years of his life—never saw that picture of Frances Goldwyn, and never met her.

The will bestowed a generous amount of money to Irene Burns, and set aside allotments for members of the household staff. There were also sums set aside for a number of elderly female friends, including Madge Kennedy and Sara Mankiewicz.

The entire remainder of the estate—the house, the furnishings, the memorabilia, the savings, and the Cukor name as it applied to rights and ownership—went to George Towers; if Towers had predeceased Cukor, it would have gone to Towers's son from his first marriage. Members of the "chief unit" were surprised to learn that the trust fund that they believed had been set up for Towers's son did not exist formally in the will.

The famous house was put on the market right away, and there was an effort to sell it with its furnishings intact. The months

stretched on, however, and it did not sell, adding to the impression that it was a white elephant.

When the people who knew him the longest and the best are asked to recollect George Cukor, invariably they do not think to mention his films. Perhaps his work, taken for granted, does not need mentioning. Perhaps, to someone like Somerset Maugham, never much of a filmgoer, they were almost beside the point.

Maugham, when asked once what he would inscribe on the tombstone of his friend the Hollywood director, is said to have thought a moment and replied, "He had a sense of humor."

That is the first thing everyone mentions: Cukor's prevailing sense of good humor, his kidding and sarcasm, his quips and stories that were so often an antidote for, or highlight of, many a remembered time. The sense of humor that was in part a mask, not unlike the one of "humorous resignation" Maugham himself wore to armor himself against the world.

Maugham's picture was in Cukor's bedroom, too. Maugham—the artist, the gentleman, the *raisonneur*, one of Cukor's pure heroes—personified achievement and worldliness. His life was a model for Cukor, in the way that D. W. Griffith was an exemplar in the field of motion pictures.

Cukor's student nurse, Robin Thorne, told the story of an incident that occurred in the director's dressing room, adjacent to his bedroom, less than two weeks before Cukor's death. Out of a jewelry box Cukor produced "a worn Chinese pattern silk eyeglass case." The director showed Thorne a typed note that indicated the case contained the last pair of eyeglasses worn by Somerset Maugham, and the last words Maugham ever wrote, as certified by Alan Searle (October 2, 1966).

"George handed me the case," wrote Thorne. "On the inside flap was written a scrawl quite indecipherable to me—'Frere Mumck.' I asked George what it meant, but he merely smiled a Mona Lisa smile. Was the inscription French? Frere—brother someone? Or a Latin motto? George seems to have given me my own 'rosebud' to ponder."

The other thing people mention is, simply, Cukor's generosity. To research Cukor's life, to interview his friends and associates, to pore over his correspondence and notes, is to affirm this aspect of his reputation.

He put them in his films—the old friends who could not find work, the stage veterans out of their element in Hollywood, the silent-screen stars whom time had eclipsed (not unlike Norman Maine).

Cukor worked intermittently for Twentieth Century-Fox producer Darryl Zanuck (second from left), whom he respected, but the resulting films were usually mediocre. Here, on the set of his World War II preparedness picture *Winged Victory*, Cukor chats with actor Don Taylor and (hatted) columnist Walter Winchell.

His best screenwriters and closest collaborators: the married team Ruth Gordon and Garson Kanin, with Cukor and Ronald Colman on the set of *A Double Life*—the film that launched a productive phase of all their careers, and won a Best Actor Oscar for Colman.

A friend and tenant: Spencer Tracy, the actor Cukor liked best and directed more often than any other director, on the set of *Pat and Mike*.

Below: One of Cukor's high points of the forties: with Ingrid Bergman and adaptor Walter Reisch during *Gaslight*. Reisch was nominated (with two others) for a Best Screenplay Oscar; Bergman won an Academy Award as Best Actress.

Another soda break, this time on the set of *The Marrying Kind*. Actress Judy Holliday was perfectly attuned to Cukor, her best director, who knew that off- as well as on-camera her dumb-blonde act concealed a keen intelligence.

"He had a great pride, but no vanity," said writer John Patrick. "I've seen him kneeling down in front of a star who is sitting in a chair, and giving directions." Here, Cukor genuflects before Jeanne Crain on the set of *The Model and the Marriage Broker*.

Judy Garland, Moss Hart, and Cukor mull the script of the film that was a career peak for each of them—the screen remake of *A Star Is Born*. The original, long "Cukor cut" was destroyed by Warner Brothers, but critics regard it as the director's flawed masterwork.

One of Cukor's famous Christmas cards, this one from 1957, designed by George Hoyningen-Heune. His three dogs, from left, include the two dachshunds Amanda (at left) and Solo (at right). In the middle is Sasha, a standard poodle that was a gift from the Kanins.

A project that Cukor liked better than most: the road-show Western *Heller in Pink Tights*, based on a Louis L'Amour novel and starring Sophia Loren.

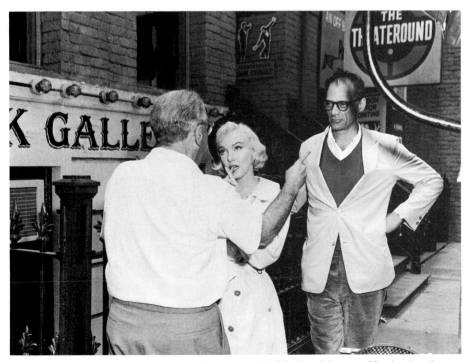

During *Let's Make Love*, Cukor learned to cope with Marilyn Monroe. Her husband, playwright Arthur Miller, kept a watchful eye on the script.

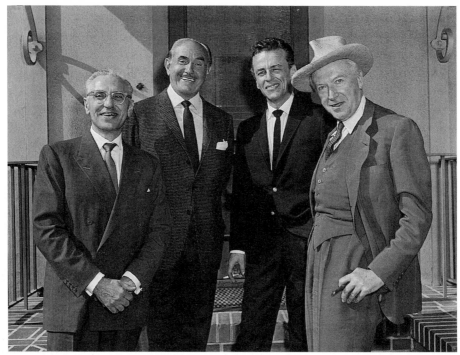

All smiles, for publicity purposes: director Cukor, Jack Warner, *My Fair Lady* playwright-lyricist-screenwriter Alan Jay Lerner, and production designer Cecil Beaton.

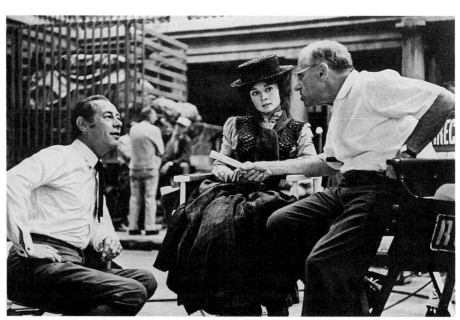

A smooth, almost perfect performance from Rex Harrison, a striving one from Audrey Hepburn, and a director at his crowning moment of studio achievement, on the set of *My Fair Lady*.

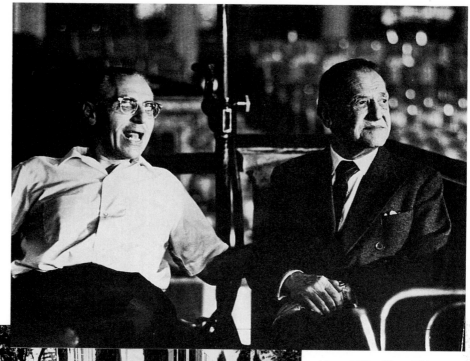

Above: "The Very Old
Party," as 85-year-old
author Somerset
Maugham dubbed
himself, visiting his friend
the Hollywood director on
the Vienna set of the
Franz Liszt "biopic,"
Song Without End.

The heir apparent,
handsome and youthful
George Towers, poolside
at Cukor's house in the
early 1960s. Towers's
appreciative treatment of
Cukor's beloved pets was
one of the things that
endeared him to the
director.

Above: A luncheon of luminarie
One of Cukor's directors' get-
togethers, this one, in the earl
1970s, in honor of visiting
filmmaker Luis Bunuel. From
left: Robert Mulligan, William
Wyler, Cukor, Robert Wise,
unidentified person, and Fren
director Louis Malle. Seated:
Billy Wilder, George Stevens,
Bunuel, Alfred Hitchcock, and
Cukor's old Rochester
colleague, Rouben Mamoulian

With *Rich and Famous* in 1981
Cukor went into *Variety*'s reco
books as the oldest active
director alive. Cukor is flanke
by co-stars Candice Bergen an
Jacqueline Bisset.

Whenever Cukor started a film, the director would draw up a list of the people he might be able to help out, then see whether he could fit them into small parts.

The letters in his files bespeak his kindness: the remembered birthdays, anniversaries, opening nights—the small gestures of flowers, soaps and perfumes, hankies, chocolates. (When people such as Vivien Leigh came to town for extended stays, he not only helped to arrange a rented house but decorated the premises with flowers, paintings, and his own furnishings.) The autographed photographs of glamorous leading ladies sent to switchboard operators and hotel clerks. The godfather gifts (Cukor had so many Hollywood godchildren that inevitably he lost track of many of them). The unusual thank-you gestures: "He's the only director who ever gave me a signed Bonnard drawing after I cut a picture for him," said the editor of *A Double Life*, Robert Parrish.

The letter from a onetime Griffith leading man thanking Cukor for his kindness during the period when he was reduced to selling fire extinguishers. A note from a destitute Billie Burke, toward the end of her life, asking for any kind of job at all from Cukor, holding script or coaching young people. (The director made sure she was provided for.) The extraordinary pains Cukor took to set Ethel Barrymore up in an apartment, to raise money for her to live on (chipping in with the Kanins, Tracy, Hepburn, and Whitney Warren, Jr., to provide a cost-of-living fund), to find meaningful work for her, to keep her hopes alive.

He would wage a letter-writing campaign on behalf of scriptwriters who did not have enough formal credits to get into the Motion Picture Country Home. He would make regular phone calls to the lonely and unfortunate. Cukor was one of the few in Hollywood to keep vigils for the "ghosts who linger on in obscure hospitals," in Lesley Blanch's words. He faithfully attended other people's funerals or tributes, and composed or recited many eulogies.

Nobody can be sure how happy he truly was. There is mixed testimony on that score.

"I think he was the happiest professional who ever lived in Hollywood," insisted Joseph L. Mankiewicz.

"He had a lot of friends," noted Michael Pearman, "but I don't think he ever had a truly close friend. I don't think he wanted anyone to get close to him in some ways."

"He was not a happy person," said Katharine Hepburn unequivocally. "He couldn't possibly be. His life was too complicated. Complicated to such an extent, so many layers, that he did not really know himself."

341

He gave and gives pleasure to millions, however. Some fifty films directed by Cukor, full of the humor and the generosity of spirit that was his life, are seen on television and video, in theaters, and at museums and film festivals. They will endure as his legacy.

The panoramic, quintessentially filmed Dickens, *David Copperfield*. The full-force tragedy of *A Star Is Born*. *Travels With My Aunt*, with its road-show lessons of life. The blistering set piece comedy of *Dinner at Eight*. The psychological crisscross of *A Double Life*.

Ingrid Bergman, uncharacteristically cowering, then transformed into a pillar of vengeance, in *Gaslight*. Judy Garland, her makeup running. Judy Holliday, blowing a gum bubble. Garbo, foolhardy unto death, giving more of herself in Cukor's *Camille* than in any other film.

A flower girl treated like a duchess.

Cary Grant or Spencer Tracy in the kindest possible light.

Above all, Katharine Hepburn.

Idealist. Freethinker. Trousered or dressed for society. Batting a tennis ball or arguing a court case. Taking a chance on love.

Ten films over fifty years. In which future audiences will always see Hepburn as Cukor saw her, the purest of the pure, noble and defiant and—something else—holding her sides for fear she'll burst with laughter.

Almost overnight, the "chief unit" fell out of contact with one another. Several of the men who were getting on in years died soon after Cukor. Some others traveled more, or moved away from California. They ran into each other now and then, but there was no longer one person as a magnet to bring them all together. "I miss him very much" is the comment heard over and over from the group that no longer exists as a group, and many others who knew Cukor well.

"I only got to know him [Cukor] well in his last three years," said Gerald Ayres. "But there was something about George's character—about his enfant terrible, bad boy character—his wanting to tweak everyone, therefore protecting himself against pain in that way, but turning a lot of things into jokes—I felt that I had met a double, in a sense. I felt as if he were an extension of myself.

"We had a type of communication going that was extrasensory. I felt enormously close to George. I felt that George and I were almost like nonsexual lovers. I felt there was almost a lover intensity between us. He was the sort of approving father—for he was certainly very approving—that I never had. I loved the man with a passion. I can't tell you what a void his death leaves. It was like an entire family died, not just one man."

* * *

The Cukor residence was on the market for a year and a half before it sold. It had been appraised at $1,100,000. Eventually, it sold for $1,455,000.

The furniture and furnishings had been appraised at $83,160 and sold, through Butterfield & Butterfield in San Francisco, for $159,150.

Members of the "chief unit" believed that Cukor had drawn up a handwritten twenty-page list, on a legal pad of paper, of cherished belongings that he wanted bequeathed to his many friends. That pad of paper was never found, and almost everything that had been collected for years was sold at auction.

Records in probate court indicate Cukor's total net worth after his death to have been $2,377,720.16—hardly the encroaching meat-loaf poverty that everyone believed. For two years, George Towers paid himself thousands of dollars in trustee and executor fees, then inherited the rest. Among the items not sold was Cukor's Oscar for *My Fair Lady*, which Towers kept.

About two months after Cukor's house was sold, in August of 1985, Alan Searle died in Monaco, at the age of eighty. Court records in London indicate that Searle bequeathed a substantial sum—over one hundred thousand dollars—to George Towers.

Almost eight years later—to the surprise of former members of the "chief unit" who tried to visit the site—there was no marker on Cukor's grave, no formal identification of the burial place.

The new owners of the Cukor house were Lynn von Kersting, an interior decorator, and her husband, Richard Irving, a prominent Los Angeles restaurateur. They refurbished the house, incorporating some of Cukor's furniture and ornamentation, and the famous house was featured, as it has been so many times over the years, in a layout in *House and Garden* magazine.

The owners told the magazines that the very first night they stayed in the house they heard the echo of footsteps in one of the rooms—a man's footsteps, walking up and down, in the room that had been Cukor's study.

Von Kersting got up and went to the door and shouted, "Get out of here, Mr. Cukor, you dear old Hungarian! This is our house now!"

The footsteps ceased. Nor did they return.

AFTERWORD

*W*riting a biography of George Cukor has proven a tremendous challenge. I knew it would be difficult; that was half the appeal. But I couldn't have guessed *how* difficult it would be to probe his life story, to try to find the arc and drama of it, and to tell it within bounds.

People tried to encourage as well as discourage me. Sometimes I wasn't sure which they were doing. "I feel sorry for you, in a way," Garson Kanin said, "because I don't think there *is* a book in George." Katharine Hepburn put it in a different, if equally daunting, way. "A book about George," she told me, "would be hundreds and hundreds of pages. Very thin, fine paper. Very small black type."

I met Cukor only once. This was just before the release of *The Blue Bird*, when I interviewed him at one of those posh Beverly Hills hotels. He was in a cranky mood. I couldn't have impressed him with my long hair, informal clothes, and nasal Wisconsin questions. Though he treated me contemptuously, I remember feeling as sorry for him as for me, thinking that here was a great director at the sad end of his long career. I'm not sure I wrote up the interview. Certainly I didn't use a word of it for this book.

Cukor's name came up again when St. Martin's Press asked me to do a biography of another motion-picture director, to follow up my book about Robert Altman—this time, someone from Hollywood's Golden Age. Names were bandied about. When trying to decide on

whom to focus, I telephoned Todd McCarthy, who was working on a biography of Howard Hawks. Todd reminded me of Cukor, who had eluded biographers. In some ways Altman and Cukor were opposites. The more I thought about Cukor as a possible subject, the more I was intrigued.

I knew that Cukor's private life—that is, his life off the set—was, except for anecdotes about elegant dinner parties, a blank page. (One might say that of all the famous directors; it was as if they did not exist off the set.) In his lifetime, there had been a lot of rumors about Cukor's lifestyle. In recent years, especially after his death in 1983, some of that speculation had crept into print in various books.

In a sense, the new labels (Bruce Babington and Peter William Evans, the authors of the recent *Affairs to Remember: The Hollywood Comedy of the Sexes*, categorize Cukor's films as "products of a homosexual sensibility") seemed to be versions of the old one—Cukor as the woman's director—just drawn forth out of the closet. Even though both variations can be interpreted richly and complexly, they can also be construed narrowly and to exclude richness of meaning.

My credo, with a book such as this, is that a deeper knowledge of a man's life facilitates a deeper appreciation of his work. Understanding Cukor the human being would put me in a better position to understand Cukor the filmmaker.

At the outset I knew my job was going to be tough. I knew little about Cukor that had not been fed to the press. I had little real understanding of his pre-Hollywood years—the all-important formative period of his youth and early stage career. I had no idea whether his life was any more or less than the wonderful success story that, on the surface, it appeared to be.

To be honest, I had no inside track on his homosexuality. I could hardly say with certainty that Cukor was homosexual; interestingly, that's the first bit of juicy gossip you hear about *everyone* in Hollywood. All facets of his life interested me; but obviously, his homosexuality loomed as something that set him apart, at least among the first-echelon studio directors. I felt, instinctively, that it must have figured into the pattern and themes of his life.

Unlike the Altman book, I spent almost as much time in libraries—reading clippings, correspondence, oral histories, and studio production files—as I did talking to people. But I did talk to many people, not only those listed on the following pages but many more who chose to remain anonymous or off the record.

There was a lot of luck involved in my task, and I was lucky to discover that an old friend—whose wife I had never met—was married to Stella Bloch, and that both knew Cukor from boyhood. I was lucky, too, in the new friends I met in Hollywood and New York,

who not only introduced me into Cukor's close circle but spoke up for me and championed me as someone who would try to be fair and accurate—without being bloodless. The old and new friends formed the bookends of what I set out to do, roughly three years ago.

Long after I have forgotten the specifics of some bit of research, I am quite certain I will recall my time spent with the people. George Cukor would have liked the fact that often the interviews were conducted over meals, and so I fondly recall the exquisite borscht, cold sandwiches, and ice cream served to me by Katharine Hepburn. An evening of Chinese takeout (or deliver-in, as it happened) with Shelley Winters. A sunny day on the terrace of the Beverly Hills Tennis Club with Gilbert Roland, and MGM old-timers Joe Cohn and Jack Cummings. A Palm Springs lunch with Bob Wheaton. Marvelous full-course family dinners with Eddie and Stella, with Stella doing most of the cooking.

One of the many things that I did not know, starting out, was that there existed an exhaustive (and exhausting) collection of Cukor's letters, production files, and career memorabilia at the Margaret Herrick Library of the Academy of Motion Pictures Arts and Sciences. This collection made my work easier and harder. Easier, because it was one-stop shopping for many names and dates. Harder, because prevailing court decisions have made it clear that virtually no unpublished words or letters of a person can be quoted without appropriate copyright permissions.

I read scores of Cukor's letters, including some not in the Academy collection but given to me by people I had gone to interview. Most were lively and amusing, not uninteresting, but in my opinion they were also highly repetitive and full of gaps. One of the unfulfilled projects of Cukor's late life was to collect his letters into a book. Director (and Cukor friend) Paul Morrissey worked on just such a project for a while. While publishers were perpetually interested in a candid Cukor autobiography, no publisher was as enthusiastic about a book of his letters. The gaps were professional and personal, but the worst gap may have been the personal one. All of the more intimate letters (it is hard to say how intimate or how many there ever were) had been weeded out of the Academy collection before Cukor passed it on.

I did not quote the Cukor letters. I could not. Appropriate copyright permission meant, in Cukor's case, the approval of his executor. As readers of the book will understand, the executor was not willing to grant permission without first reading and approving the manuscript. I was unwilling to let publication hinge on George Tower's permission, as he figures (in the book) importantly in the last twenty-five years of Cukor's life. I did try to speak to him. For a long time,

my letters and phone calls to him went without response. People who knew him acted as go-betweens for us. I was told that he did not want to speak to me—or any Cukor biographer—under any circumstances.

Finally, one day by prearrangement, I managed to get Towers on the phone. I had schemed to be only several blocks away from his Beverly Hills law office, so that I could quickly walk over to see him, if possible. The pretext of the conversation was to talk about quotation permissions, but I told him that, just as important, what I really wanted to do was to speak to him about his role in Cukor's life and his activity as Cukor's executor.

Towers told me that he would not extend any copyright permissions without approving of the book as a whole. He told me that he certainly didn't want to be in a book about Cukor's life and that in general he didn't want to encourage any such book. "Biography is a scummy profession," he told me.

I couldn't begrudge him his point of view (some days I feel that way about lawyers, myself). But I offered to hasten right over to his office and read to him part of my work-in-progress, which I was carrying under my arm—those portions particularly that covered his relationship with Cukor. On or off the record, it was all the same to me simply to have the benefit of his reaction. He said no, no again, adamantly no. Although he spoke with me on the phone for approximately forty-five minutes, he refused to see me ("I'm just too busy") and to say anything other than no interview, no copyright permissions without text approval.

My experience with Katharine Hepburn was likewise frustrating, and out of fairness (since she is quoted, sparingly, from my interview with her) I feel that I should mention it. I knew that I had an obligation to try to see Cukor's great friend and the leading lady of ten of his films, even though she had said so much—everything she intended to, I suspected—about him in interviews and other books.

I wrote to her. She wrote back that she had no interest in sitting for an interview about Cukor, as she would write about her favorite director in a book of her own, someday. I wrote back, telling her I felt certain my book would not compromise or compete with her book in any way, and that I was more interested in her insights into Cukor's personal life than in behind-the-scenes film anecdotes. Again she said no.

When I sent her a copy of one of my previous books, she relented somewhat, sending me a short, glowing, and ultimately fatuous preface about Cukor for my biography. After long internal debate (how nice it would look on the cover!—Preface by Katharine Hepburn), I

decided not to use her contribution. It was hardly in keeping with what I was doing.

Months went by. I persisted with my correspondence to her. I began to send her drafts of my chapters. To my surprise, she responded, making small comments and criticisms, and occasionally adding touches (usually about herself). Always, she made the point in her letters of complaining that I ought not to be writing about Cukor's sexuality. What was the point?

By this time—after a year and a half of research and interviews—I felt on solid ground arguing back that Cukor's homosexuality was at least partly the point. Certainly not the be-all and end-all of his life, but a significant impulse, and a window offering a fresh light on him and his career. I also realized that no matter how much I cared to downplay this aspect of the book, it loomed in other peoples' psychologies, setting off alarm bells.

Finally, at one point, frustrated, I wrote to Hepburn and asked her to please stop treating me at arm's length and let me come and interview her. She sent me her phone number. I flew to New York and called her from the airport. She told me to come right over.

The next two hours were genuinely astonishing. I expected her to try to lecture me about what I was doing, and to try to dissuade me. I was prepared for that.

Instead, she was very welcoming. She served me a delightful lunch, and seemed as interested in hearing what I had learned, in my interviews with people, as in telling me what she knew about Cukor. She made a point of declaring that she knew very little about Cukor's homosexuality and indeed not so very much about homosexuality in general. But that is virtually all we talked about, in terms of Cukor: his private life. We talked very little about the famous films, and as I say, she could not have been more warm and gracious.

The postscript should not have surprised me (although everything does surprise me; that may be a good requisite for a biographer, the capacity to be surprised). I returned to Wisconsin and continued to send her chapters. It so happens the next one up was the chapter about *Sylvia Scarlett*, leading into the upshot of *Gone With the Wind*, in which some of the earlier themes of the book rise to the fore. Although the drift of the book had never been disguised, this new chapter offended her. She returned it to me with a sharp note saying she would never have invited me to lunch if she knew what I was planning to write about. But—this still puzzles me—she knew!

Not only did I have to travel back into the past, into another time and another world, in order to try to comprehend Cukor, but, as was the case with Hepburn, other people had to be convinced to move forward with me into a more contemporary way of thinking in order

to feel comfortable talking about some subjects that Cukor wouldn't have countenanced during his lifetime.

Nowhere was the dichotomy of encouragement/discouragement more dramatic than within Cukor's circle, the "chief unit." Few of the men from the remote years of the Thirties were still alive, but even the homosexual gentlemen who knew Cukor dating back to the Forties and Fifties had lived their lives discreetly and without sacrificing their own privacy. First I had to learn their identities, then track them down (as they were not usually public figures)—and then coax them into talking to me.

The dichotomy in Cukor's circle was not unlike the dichotomy in Cukor's own psychology. There were some who wanted a revealing book—if not a tell-all and sensational one—in part so that they themselves could learn all about their mysterious friend who was like a father to many of them. There were others, many more, who did not feel that a biography of Cukor could be either honest or honorable, who felt his sexuality should be either minimized or nonexistent in a book, and who simply wanted me to go away.

Some of the "chief unit" showed bravery by speaking to me despite their misgivings, and by trusting me to give proper emphasis to their observations about Cukor. These portions of the book, the sections about Cukor's lifestyle, were the hardest to come by, the reader might rightly suspect. Because people in the "chief unit" sometimes spoke to me on the condition they not be identified, these sections are necessarily replete with anonymous quotes and material presented without attribution.

As anyone who has already read my book knows, Cukor labored strenuously to produce a book about his life. His ambivalence about revealing himself became one of the obstacles to completing that task. If this book is at all successful in piercing his double life, it is owed to the old friends and new friends—the ambivalent as well as wholehearted—who helped guide it along.

ACKNOWLEDGMENTS

Sources and letters: Alan H. Anderson, Erik Barnouw, Ralph Bellamy, Whit Bissell, Wanda Burgan, Henry W. Clune, Philip Dunne, Arnaud D'Usseau, Jerry Epstein, Sidney L. Fineman, Graham Greene, Rose Hobart, Paul Jarrico, Michael Kanin, Hal Kanter, Harry Kisver, Ring Lardner, Arthur Laurents, Robert Longenecker, Richard Maibaum, Lon McCallister, Frank Mankiewicz, Arthur Miller, Jacob J. Miller, Robert Parrish, David Peck, Buddy Pepper, Charles Pogue, A. L. Sainer, Irene Selznick, Alfred Shivers, Pete Steffens, and Peter Viertel.

Interviews: Gene Allen, Jay Presson Allen, Gerald Ayres, Lew Ayres, Don Bachardy, Benny Baker, Pandro Berman, Walter Bernstein, Stella Bloch, Mary Brian, Irene Burns, Frank D. Chapman, Joe Cohn, Jack Cummings, Edward Dmytryk, Edward Eliscu, Sally Erskine, Esther Fairchild, Curt Gerling, Bert Granet, Robert E. Gross, Ruth Hammond, Kitty Carlisle Hart, Helen Hayes, Katharine Hepburn, Ruth Hussey, Garson Kanin, Mildred Knopf, Hans Kohler, Winona Kondolf, Howard Kuh, Don M. Mankiewicz, Joseph L. Mankiewicz, Sam Marx, Elliott Morgan, Paul Morrissey, James Newcombe, John Patrick, Michael Pearman, Marcella Rabwin, Bob Raison, Irving Rapper, Gottfried Reinhardt, Martin Ritt, Gilbert Roland, Arnold Schulman, Donald Stewart, Irma Templer, James Toback, Leslie Wallwork, Robert Wheaton, and Shelley Winters.

My deepest gratitude to Marian Seldes for her help, to Charles

Williamson and Tucker Fleming for extending many courtesies, and to Frank D. Chapman for opening doors and being good company.

Advice and assistance: Authors and colleagues who generously contributed insights and observations, background, or material from their own Cukor files include Scott Berg, Matthew Bernstein, Robert Calder, Bernadette Fay, Michael Fellner, Jack Garner, David Grafton, Lawrence Grobel, Charles Higham, Kevin Kelly, Otile McManus, Ken Mate, Roy Moseley, Vito Russo, Richard Schickel, Henry Schipper, Kevin Thomas, and Tise Vahimagi.

Especially: Nat Segaloff, for use of his premises, David Thomson, for his counsel and criticism, and Todd McCarthy, for giving me the idea and being a friend not just on this book but over the years.

Hospitality and friendship: Thomasine Lewis, Joan Scott, Barry Brown and Marty Spanninger, Mark Rowland and Rosemary Aguayo, Joan Scott, Regula Ehrlich and Will Winburn, and Alison Morley.

Extracurricular activity: My thanks to those editors who have helped keep me afloat with newspaper and magazine assignments, Ernest Callenbach of *Film Quarterly*, James Greenberg of *American Film*, Gavin Smith and Harlan Jacobson of *Film Comment*, John Pym and Penelope Houston of *Sight & Sound*, Robert Taylor and Mike Feeney of *The Boston Globe*.

Archives and organizations: Diana R. Brown, Turner Entertainment Company; Oral History Research Office, Butler Library, Columbia University; Pauline Claffey, for her scrapbooks; Ned Comstock, Leith Adams, and Anne G. Schlosser, Cinema-Television Library and Archives of Performing Arts, the University Library, University of Southern California; Mary Corliss and Terry Geesken, Stills Archives, Museum of Modern Art; Ronald L. Davis, director, Southern Methodist University Oral History Program; Patricia Finley, Local History/Special Collections, Onondaga County Public Library (Syracuse, New York); Peter Ford, library manager, Gannett Rochester Newspapers (Rochester, New York); Sam Gill and Howard Prouty, Special Collections, Margaret Herrick Library, Academy of Motion Picture Arts and Sciences; Howard B. Gottlieb, Special Collections, Boston University; Frederick Grand, Alumni Association, De Witt Clinton High School, New York City; Dr. Bonnie Hardwick, Manuscripts Division, the Bancroft Library, University of California, Berkeley; Sarah I. Hartwell, Local History Division, Rochester Public Library; Susan J. Huber, Interlibrary Services, Milwaukee Public Library; Lincoln Center Library of the Performing Arts; Daniel Luckenbill, Manuscripts Division, University of California at Los Angeles; Ron Mandelbaum and Photofest; Mrs. Scotty MacCrae, Actors Home, Englewood, New Jersey; Alex D. Mestes, Discovery Unit, Los Angeles Police Department; Cynthia Wall, Special Collec-

tions, the Newberry Library, Chicago; Patricia C. Willis, curator of American Literature, the Beinecke Rare Book and Manuscript Library, Yale University; Wisconsin Center for Film and Theatre Research, University of Wisconsin, Madison.

Especially: The Milwaukee Public Library, whose fine resources and excellent reference librarians were a boon at every stage of the work.

Portions of manuscript drafts were read and corrected or criticized by Stella Bloch, Frank D. Chapman, Edward Eliscu, Katharine Hepburn, Garson Kanin, and David Thomson. I am tremendously grateful for their comments and suggestions. Of course, only the author is responsible for the book in its final form.

My original editor, Toni Lopopolo, who contracted this book, was the soul of support. Calvert Morgan, Jr., who succeeded her, was instrumental to the final result; his editing was always an improvement, and I appreciate that he was gracious about difficult decisions. My agent, Gloria Loomis, has been staunch. Above all, my wife and children—Tina, Clancy, and Bowie—were tolerant of my moods and protracted absences.

353

NOTES

━━━━━━

*A*ll quotes, unless otherwise noted, are from interviews with or letters to the author. Key books are cited, but I have spared the reader a long bibliography. Cukor had literally hundreds of books in his personal library that acknowledged him as a source, or mentioned him in some context.

CHAPTER ONE

Cukor's genealogy is drawn from an untitled document in the Stanley Musgrove papers in the Cinema-Television Archives at the University of Southern California (USC), and from similar material in the Cukor collection at the Academy of Motion Picture Arts and Sciences. Additional family background was elicited in a conversation with Clarence Cukor, and from letters and an interview with Robert E. Gross.

Cukor's boyhood is detailed in his extensive reminiscences on the subject, early abortive efforts of autobiography, on deposit at the Motion Picture Academy and USC. Stella Bloch and Edward Eliscu filled in important details.

A day trip to Cukor's high school, De Witt Clinton, now relocated in the Bronx, produced yearbooks and school newspapers and records of his high school era. A computer printout of his graduation classmates was provided by the Alumni Association. Letters to all surviv-

ing classmates produced only one or two sources who remembered Cukor, and who could recollect anything—tidbits—about him.

Cukor's World War I service record was obtained from the National Personnel Records Center.

Significant background on Cukor's theatergoing years is contained in unpublished letters to Alex Tiers, reminiscing about that time, on deposit in the Cukor collection at the Academy of Motion Picture Arts and Sciences.

Frank D. Chapman was my authority on the derivations of "chukor," "schwel," and other exotic questions of vernacular.

The quotation from Katharine Hepburn at the end of the chapter is taken from an August 30, 1989, letter to the author.

Neal Gabler's *An Empire of Their Own* (New York: Crown, 1988) provided a valuable framework.

CHAPTER TWO

Details of Cukor's early road-show life, his ambitions to write and direct, and his double-edged view of actors come from his unpublished letters at the Motion Picture Academy.

"The prettiest girl I had ever seen . . ." is from *Goldwyn* by A. Scott Berg (New York: Alfred A. Knopf, 1989).

"A small city, very American . . ." is from "Cukor Remembers Rochester," an August 17, 1969, article by Bernard Drew in the Rochester *Democrat and Chronicle*.

Louis Calhern's letters to Cukor of February 18, 1924, and March 27, 1924, are in the Cukor collection at the Motion Picture Academy.

Material about Cukor's dismissal from the Lyceum Players, and the founding of the Cukor-Kondolf Stock Company, is drawn from letters to Stella Bloch and Walter Folmer's father made available to the author by Stella Bloch.

A train trip to Rochester produced a theatrical scrapbook of that era—lovingly kept by Pauline Claffey, and passed on, for safekeeping, to Jack Garner of the Gannett News Service—helpful clippings from the newspaper and local public library, and several interview contacts.

Anyone who knew Cukor in Rochester in the early 1920s would have had to be at least eighty-five years old by 1989, yet I was fortunate indeed to make the acquaintance of two vigorous old-timers, Curt Gerling (in person) and Henry W. Clune (by correspondence). Both writers themselves, they were crucial sources with keen memories. Both wrote many letters to me, and in Gerling's case, I augmented this with an interview. Clune's memoir *The Rochester I Know* (Garden City, New York: Doubleday, 1972) and Gerling's books

Smugtown, U.S.A. (Webster, New York: Plaza Publishers, 1957) and *Never a Dull Moment* (Webster, New York: Plaza Publishers, 1974) were vital to my research, as well as enjoyable to read.

The anecdote about Edward G. Robinson comes from his autobiography (cowritten with Leonard Spigelgass), *All My Yesterdays* (New York: Hawthorn Books, 1973).

In this chapter and throughout the book, my key sources on W. Somerset Maugham were Robert Calder's *Willie: The Life of W. Somerset Maugham* (New York: St. Martin's Press, 1989), Garson Kanin's *Remembering Mr. Maugham* (New York: Atheneum, 1966), and Ted Morgan's *Maugham* (New York: Simon & Schuster, 1980). Cukor's unpublished letters were another source of information about his friendship with Maugham.

Other books I read that touched on this period in Cukor's life include Ethel Barrymore's *Memories* (New York: Harper, 1955), Ilka Chase's *Past Imperfect* (Garden City, New York: Doubleday, Duran & Co, 1942), George Eells's *Ginger, Loretta and Irene Who?* (New York: Putnam's, 1976), James Kotsilibas-Davis's *The Barrymores* (New York: Crown, 1981), and Howard Taubman's *The Making of the American Theatre* (New York: Coward-McCann, 1967).

CHAPTER THREE

Cukor's stage career, including Broadway, was difficult to reconstruct, but at least most of the work could be done within the hospitable confines of the Lincoln Center Library of the Performing Arts. However, it must be said that even the best sources there do not seem to resolve the differing versions of events that plague accounts of some of Cukor's plays—*The Constant Wife, Her Cardboard Lover,* and *Coquette.*

"Mad and fraught . . ." is from "Conversations with George Cukor," a major interview with Cukor by John Gillett and David Robinson, in *Sight & Sound,* Autumn 1964.

"Comic, distraught, light as a feather . . ." is from Marguerite Courtney's biography of her mother, *Laurette* (New York: Rinehart and Co., 1955).

The Hedda Hopper citation is from a December, 1965, newspaper clipping—paper of origin unattributed—in the files of the Rochester public library.

All of the information and quotes from Cukor about his early film work at Paramount, and the clash with Ernst Lubitsch over *One Hour With You,* come from court documents pertaining to Cukor's lawsuit in the Cukor collection at the Motion Picture Academy.

Adela Rogers St. John's reminiscences ("To watch him work . . .")

are excerpted from her interview in the Special Collections of Butler Library at Columbia University.

The Dagger and the Rose was resurrected for me, with great reluctance, by Edward Eliscu.

I interviewed Lew Ayres, but patched into my interview with him is kindred material from an oral history conducted by Ronald L. Davis, on August 8, 1981, for Southern Methodist University, and used here with permission.

Books that I have drawn on for this chapter include George Abbott's *Mister Abbott* (New York: Random House, 1967), Tallulah Bankhead's *Tallulah* (New York: Harper and Brothers, 1952), Kenneth Barrow's *Helen Hayes: First Lady of the American Theater* (Garden City, New York: Doubleday, 1985), *Memo from David O. Selznick*, edited by Rudy Behlmer (New York: Viking, 1972), Edward Dmytryk's *It's a Hell of a Life, But Not a Bad Living* (New York: Times Books, 1978), Martin Gottfried's *Jed Harris: The Curse of Genius* (Boston: Little, Brown & Co., 1984), Jed Harris's *A Dance on the High Wire* (New York: Crown, 1979), Jesse L. Lasky's (with Don Weldon) *I Blow My Own Horn* (Garden City, New York: Doubleday, 1957), Emlyn Williams's *George* (New York: Random House, 1961), and Adolph Zukor's (and Dale Kramer) *The Public Is Never Wrong: The Autobiography of Adolph Zukor* (New York: Putnam's, 1953).

CHAPTER FOUR

The portrait of Cukor, newly arrived in Hollywood, comes from *Memo from David O. Selznick*, Ilka Chase's *Past Imperfect*, and Cukor's own unpublished letters.

Earl Bellamy's anecdote ("There's a great bit . . .") is from Ronald Haver's essential book *A Star Is Born: The Making of the 1954 Movie and Its 1983 Restoration* (New York: Alfred A. Knopf, 1988).

"Baubles and bibelots" is from Kenneth Tynan's important article on Cukor, "The Genius and the Girls," *Holiday*, February 1960, reprinted in his book *Tynan Right & Left* (New York: Atheneum, 1967).

Sidney Howard's appraisal of Cukor's domicile is from a July 20, 1937, letter to his wife in the Sidney Coe Howard correspondence at the Bancroft Library, University of California, Berkeley.

There were dozens of articles about Cukor's house in newspapers and magazines over the years. I have relied upon several in particular: "In Seven Living Rooms and One Bedroom," *Country Life*, June 1937; "*Architectural Digest* Visits George Cukor," January 1978; and "Cukor House a Vestige of Gentility" by Charles Lockwood, the Los Angeles *Times*, September 4, 1983. *Landscaping the American Dream: The Gardens and Film Sets of Florence Yoch, 1890–1972* by James J.

Yoch (New York: Abrams, 1989) provided additional reference.

Many letters to and from Elsa Schroeder, in the Cukor collection at the Motion Picture Academy, attest to the unusual closeness of their relationship over a period of nearly thirty-five years.

Cukor's comment about Constance Bennett is part of a longer (presumably ghosted) essay by him that was published in *Glamour*, July 1963, under the heading "My Fair Ladies—A Dissertation by Hollywood's George Cukor on the Beauties He Has Directed from Garbo to Audrey Hepburn."

Cukor's recollections about *What Price Hollywood?* spring from the indispensable *On Cukor*, the director's "official" interview book by Gavin Lambert (New York: Putnam's, 1972).

"A very romantic view of Hollywood . . ." is from *On Cukor*.

"Idiotic suggestion" is from *On Cukor*.

"A slightly odious quality" is from *On Cukor*.

"A mixed bag" is from *On Cukor*.

Selznick's remark about his physical similarity to Cukor comes from the introduction to *Memo From David O. Selznick*.

There are many, many versions of Cukor's discovery of Katharine Hepburn and her going to Hollywood for *A Bill of Divorcement*. The excellent books on which I drew included Charles Higham's *Kate* (New York: W. W. Norton, 1975) and Hepburn's own interview in John Kobal's *People Will Talk* (New York: Alfred A. Knopf, 1985). Adela Rogers St. John offered a convincing account in her oral history in the Columbia University archives. Hepburn herself read and corrected the version in this book, which differs from the others in slight details.

Cukor's recollection of Hepburn's screen test and of filming *A Bill of Divorcement* is quoted from a British Broadcasting Corporation (BBC) interview transcript with him, which is in the Cukor collection at the Motion Picture Academy.

"Too high" is from the BBC transcript.

"A sad lyric moment" is from the BBC transcript.

"When in a scene . . ." is from the BBC transcript.

King Vidor's letter to Cukor, dated February 24, 1933, is in the Cukor collection at the Motion Picture Academy.

Selznick's "could think of twenty different permutations . . ." is from *A Child of the Century* by Ben Hecht (New York: Simon & Schuster, 1954).

Charles Brackett's words ("I got no clue from him . . .") are cited from his oral history on deposit in Special Collections, Columbia University.

For background and perspective on Zoë Akins, I am indebted to

Anthony Slide's article about Akins in volume 26 of the *Dictionary of Literary Biography*.

For background and perspective on Donald Ogden Stewart, I am indebted to Edward Eliscu and Donald Stewart, his son.

Philip Barry's telegram of May 26, 1940, is in the Cukor collection of the Motion Picture Academy.

Cukor's assessment of George S. Kaufman ("quite an astringent writer . . .") is from *On Cukor*.

"To drive him crazy by insisting . . ." is from *Memo From David O. Selznick*.

"Tight" and "sweet and funny" are from *On Cukor*.

Kenneth MacGowan's papers in Special Collections at the University of California at Los Angeles (UCLA) offer background on one of Cukor's plays, *Young Love*, as well as on *Little Women*. Selznick's memo disclaiming producer credit for *Little Women*, dated July 8, 1935, and addressed to Hal Horne at United Artists, is in MacGowan's archives.

All of Cukor's MGM contracts were perused at Turner Entertainment Company's offices in Culver City.

S. N. Behrman's complimentary words about Salka Viertel are to be found on the dust jacket of her autobiography, *The Kindness of Strangers* (New York: Holt, Rinehart & Winston, 1969).

Cukor's unpublished letters to Hugh Walpole, dated December 25, 1934, and January 21, 1935, in the Cukor collection at the Motion Picture Academy, offer his unvarnished initial reaction to Greta Garbo.

James Hilton's letter of February 14, 1937, is in the Cukor collection of the Motion Picture Academy.

Cukor's reflections on working with Garbo are contained in the *Glamour* article of 1963.

"The beginnings of taste" is from the *Sight & Sound* article.

"In his own way he [Thalberg] was . . ." is from *On Cukor*.

Irene Mayer Selznick spoke to me off the record, confirming some details of the Thirties period, on condition that she not be quoted.

Books I read that are pertinent to this chapter include Billie Burke's (with Cameron Shipp) *With a Feather on My Nose* (New York: Appleton-Century-Crofts, 1949), Gloria Swanson's *Swanson on Swanson* (New York: Random House, 1980), Joseph Patrick Roppolo's *Philip Barry* (New York: Twayne 1965), Irene Mayer Selznick's *A Private View* (New York: Alfred A. Knopf, 1983), and King Vidor's *A Tree Is a Tree* (New York: Garland Publishing, 1977).

CHAPTER FIVE

To trace the roots of Cukor's publicity as a "woman's director," I read early Paramount, RKO, and MGM press releases on file at the

Motion Picture Academy. The April 1933 *Screenland* article by Ida Zeitlin is in the Cukor collection there. Mary Moffitt's May 31, 1936, piece for the Kansas City *Star*, entitled "Problems in Producing Classic Plays as a Screen Director Finds Them," is in the Norma Shearer collection in the Cinema-Television Archives of USC. Paul Harrison's NEA Service Staff newspaper column of 1936 is pasted into the Shearer scrapbooks in that collection.

"I feed 'em dope!" is from the *Hollywood Reporter*, January 23, 1961.

Ben Hecht's comment ("He didn't know anything, except one thing . . .") is from his oral history in Special Collections at Columbia University.

The production of *Sylvia Scarlett* is well documented in the many Katharine Hepburn books and in *On Cukor*.

"Every day was Christmas . . ." comes from Cukor's interview with Richard Overstreet in *Film Culture*, no. 34, Fall 1964, which is reprinted in Andrew Sarris's seminal *Interviews With Film Directors* (New York: Bobbs-Merrill, 1967).

Pandro Berman's words are quoted from *Kate*. Cukor's comment about Cary Grant bursting into bloom comes from the *Film Culture* interview. The *Sylvia Scarlett* production costs, which vary in accounts, were confirmed in Pandro Berman's production files in the Center for Film and Theatre Research at the University of Wisconsin in Madison. Hepburn's diary citation from that period is quoted in her November 24, 1973, interview with David Robinson in the London *Times*.

CHAPTER SIX

Cukor's arrest—the time, place, and circumstances—could not be verified in police files. I was told by local police that records on the incident, if they ever existed, would have been destroyed long ago. There was nothing in the MGM files to corroborate the reports of his arrest. However, my sources on the incident are impeccable, and no one close to Cukor (some of Cukor's friends have their own arrest anecdotes) doubted that the story probably was true.

The film of *Gone With the Wind* continues to be the subject of innumerable books. Chief among those I consulted were Gavin Lambert's *GWTW: The Making of Gone With the Wind* (Boston: Little, Brown & Co., 1973), Roland Flamini's *Scarlett, Rhett and a Cast of Thousands* (New York: Macmillan, 1975), and *Margaret Mitchell's Gone With the Wind Letters, 1936–1949*, edited by Richard Harwell (New York: Macmillan, 1976).

The Turner Entertainment Company documentary *The Making of a*

Legend: Gone With the Wind, written by David Thomson and directed by David Hinton, was an important reference.

All Selznick quotations, unless otherwise stipulated, are from *Memo From David O. Selznick*.

Anita Loos ("He had that taste . . .") is quoted from her oral history in Special Collections at Columbia University.

B. R. Crisler's undated article for *The New York Times*, entitled "General Cukor's Expeditionary Force Threatens Richmond—Director Talks," is in the Cukor collection at the Motion Picture Academy.

Sidney Howard's *Prisoner of Zenda* anecdote is from an April 17, 1937, letter to his wife. "I had so much rather be eaten . . ." is from a May 1, 1937, letter to his wife. "Cukor talks as though his mind were made up . . ." is from a July 20, 1937, letter to his wife. His correspondence is on deposit in the Bancroft Library, University of California, Berkeley.

Detail as to Cukor's directorial fling with *The Wizard of Oz* is from Aljean Harmetz's authoritative *The Making of the Wizard of Oz* (New York: Alfred A. Knopf, 1977).

Olivia de Havilland's words are from a transcribed television interview in the Cukor collection at the Motion Picture Academy.

Kenneth Tynan's interview with Frances Goldwyn regarding Cukor and *Gone With the Wind* is in his *Holiday* article.

The Jean Negulesco anecdote comes from his autobiography, with its marvelous title, *Things I Did and Things I Think I Did* (New York: Linden Press/Simon & Schuster, 1984).

Ronald Neame was interviewed on July 18, 1985, by Ronald L. Davis for the Southern Methodist University Oral History Program.

Fredric March's missive regarding Cukor's *Gone With the Wind* firing is in the Cukor collection at the Motion Picture Academy.

Books that I found relevant include Felix Barker's *The Oliviers* (Philadelphia/New York: J. B. Lippincott, 1953), David King Dunaway's *Huxley in Hollywood* (New York: Harper & Row, 1989), Charles Higham's *Hollywood Cameramen: Sources of Light* (Bloomington, Indiana: Indiana University Press, 1970), John Lahr's *Notes on a Cowardly Lion: The Biography of Bert Lahr* (New York: Alfred A. Knopf, 1969), Joshua Logan's *Josh: My Up and Down, In and Out Life* (New York: Delacorte, 1976), Aaron Latham's *Crazy Sundays: F. Scott Fitzgerald in Hollywood* (New York: Viking Press, 1970), Rosa Ponselle and James A. Drake's *Ponselle: A Singer's Life* (Garden City, New York: Doubleday, 1982), and Sidney Howard White's *Sidney Howard* (Boston: Twayne Publishers, 1977).

CHAPTER SEVEN

The Anita Loos quotation ("putting the laughs in . . .") is from her oral history, on deposit at Columbia University.

William Haines called Louis B. Mayer "a liar, a cheat, despicable" in the first-rate book *The Moguls* by Norman Zierold (New York: Coward-McCann, 1969), which contains a good deal of other interesting conversation with Haines.

"Very much in the manner of Barry himself" is from *On Cukor*.

The discussion of Cukor's personal and professional relationship with Joan Crawford is culled from an extensive tape-recorded conversation between them ("Joan Crawford and George Cukor Discuss Hollywood Past, Present, Future") for the 37th Anniversary Edition of *Daily Variety*, as well as several books—particularly *A Portrait of Joan* by Joan Crawford with Jane Kesner Ardmore (New York: Doubleday, 1962) and *Conversations With Joan Crawford* by Roy Newquist (Secaucus, New Jersey: The Citadel Press, 1980)—and the director's unpublished letters.

Joseph Ruttenberg was interviewed by Scott Eyman in *Focus on Film*, Spring 1976.

The author was permitted by Turner Entertainment Company to review individual production files of Cukor's films for the studio during the span of his contract years.

Donald Ogden Stewart's correspondence was provided by Donald Stewart, his son and executor.

Cukor's World War II misadventures are extensively chronicled in the Stanley Musgrove papers at USC and in the Cukor collection at the Motion Picture Academy—especially his unpublished letters of the time to Elsa Schroeder. My effort to obtain his service file was rebuffed by the National Personnel Records Center on the grounds that his WWII records—unlike his World War I data—were missing or lost. Memoranda obtained through the Freedom of Information Act (FOIA) indicate that there was a Federal Bureau of Investigation and security file on Cukor, dating back at least to the Forties. I could not pinpoint why Cukor was denied an officer's commission, or whether the FBI kept track of him because of his homosexuality. That this was the case is my surmise.

Further information on the Hollywood contingent of the Signal Corps can be found in many Hollywood memoirs, notably Arthur Mayer's *Merely Colossal* (New York: Simon & Schuster, 1953) and Gottfried Reinhardt's *The Genius: A Memoir of Max Reinhardt by His Son* (New York: Alfred A. Knopf, 1979). William Saroyan touched on the experience in several of his books.

Cukor's correspondence with Hedda Hopper of February 1943, regarding his military stint, is in the Hedda Hopper collection at the Motion Picture Academy.

The Walter Reisch interview was conducted by Joel Greenberg as part of the American Film Institute's oral history program, and a large

portion of it was published in *Backstory 2: Interviews With Screenwriters of the 1940s and 1950s*, edited by Pat McGilligan (Berkeley, California: University of California Press, 1991).

The best Ingrid Bergman books are *Ingrid Bergman, My Story* by Ingrid Bergman and Alan Burgess (New York: Delacorte, 1980) and Laurence Leamer's *As Time Goes By: The Life of Ingrid Bergman* (New York: Harper & Row, 1986), although in both there is precious little mention of Cukor. Bergman's words here ("Cukor explains everything . . .") are from her interview in Kobal's *People Will Talk*.

Marguerite Roberts's remark ("Cukor was one of those directors . . .") is from an unpublished 1983 interview with Tina Daniell.

Mervyn LeRoy's comment ("one who first conceived . . .") about *Desire Me* comes from his autobiography, *Mervyn LeRoy: Take One* (New York: Hawthorn, 1974).

The tale of Maugham's abortive participation in the film version of his novel *The Razor's Edge* is covered in the Maugham biographies and many Hollywood histories. I also read the Twentieth Century–Fox production files for *The Razor's Edge* on deposit at USC. Cukor's words on the subject come from *On Cukor*.

Lillian Gish's *The Movies, Mr. Griffith and Me* (Englewood Cliffs, New Jersey: Prentice-Hall, 1969) and Richard Schickel's *D. W. Griffith: An American Life* (New York: Simon & Schuster, 1984) are my sources for Cukor's meetings with Griffith in the Forties. Cukor's script files at the Motion Picture Academy indicate the additional involvement of a Hollywood scriptwriter and, later on, Maxwell Anderson.

Salka Viertel's letters about *Sappho* and *Sand* are in the Cukor collection at the Motion Picture Academy. Matthew Bernstein took time from writing the life story of Walter Wanger to help me clear up some points of accuracy in the chronology of those intertwined projects.

Books that I read for this chapter include David Brown's *Let Me Entertain You* (New York: William Morrow, 1990), *The Noël Coward Diaries*, edited by Graham Payn and Sheridan Morley (Boston: Little, Brown & Co., 1982), Melvyn Douglas and Tom Arthur's *See You at the Movies: The Autobiography of Melvyn Douglas* (New York: University Press of America, 1986), *Dramatist in America: Letters of Maxwell Anderson, 1912–1958*, edited by Laurence G. Avery (Chapel Hill, North Carolina: University of North Carolina Press, 1977), Kenneth L. Geist's *Pictures Will Talk: The Life and Films of Joseph L. Mankiewicz* (New York: Scribner's, 1978), Charles Higham and Roy Moseley's *Cary Grant: The Lonely Heart* (San Diego: Harcourt Brace Jovanovich, 1989), George Oppenheimer's *The View From the Sixties: Memories of a Spent Life* (New York: D. McKay Co., 1966), Elliot Paul's *Film Flam* (London: Fredrick Muller, 1956), Rosalind Russell and Chris Chase's

Life Is a Banquet (New York: Random House, 1977), and Mike Steen's *A Look at Tennessee Williams* (New York: Hawthorn, 1969).

CHAPTER EIGHT

Cukor's production files at the Motion Picture Academy really begin with the Gordon-Kanin films. The memos and letters pertaining to each project are extensive, flowing in both directions, roughly from 1947 to 1954. Most quotes from Kanin here are from those files. Kanin was also interviewed by the author. Material on Kanin's background and career come from those interviews, and from his own books—*Tracy and Hepburn: An Intimate Memoir* (New York: Viking, 1971) and *Hollywood* (New York: Viking, 1974).

Ruth Gordon's relationship with Cukor is covered in separate letters to her, in the Cukor collection, and in mentions of him in her own books, particularly *Myself Among Others* (New York: Atheneum, 1971) and *Ruth Gordon, An Open Book* (Garden City, New York: Doubleday, 1980). "I didn't like him . . ." is from *An Open Book*.

"I don't think the stories they film today . . ." is from the Hepburn interview in *People Will Talk*.

Julia Benita Colman's biography of her father, *Ronald Colman: A Very Private Person* (New York: William Morrow, 1975), was useful for background in writing about *A Double Life*.

"This was a horrible film . . ." is from *Cinemond*, no. 1482, January 1, 1963.

Will Holtzman's *Judy Holliday* (New York: Putnam's, 1982) was an invaluable guide to Holliday's life and her films directed by Cukor.

Dore Schary's regrets about *The Actress* ("beautifully played . . .") are expressed in his *Heyday, An Autobiography* (Boston: Little, Brown & Co., 1979).

Shelley Winters's first installment of her memoirs, *Shelley: Also Known as Shirley* (New York: William Morrow, 1980), augmented my own interview with the actress about working with Cukor on *A Double Life* and *The Chapman Report*.

Gavin Lambert proclaimed *Pat and Mike* "a comic masterpiece" in *On Cukor*.

Truffaut's praise of *It Should Happen to You* is preserved in his book *The Films in My Life* (New York: Simon & Schuster, 1975).

Other books that informed my writing of this chapter were Lana Turner's *Lana* (New York: E. P. Dutton, 1982) and David Grafton's *Red, Hot and Rich! An Oral History of Cole Porter* (New York: Stein and Day, 1987).

CHAPTER NINE

Ronald Haver's book about the filming and reconstruction of *A Star Is Born*, although it does not focus on Cukor, is the bible of information about that motion picture. The material that I have drawn on or cited, and would like to credit, includes:

- All Moss Hart and Cukor memos and correspondence, including a Cukor letter that Haver uses but does not identify as being written to Katharine Hepburn
- Haver's footnote—repeated here—about Cukor's reply to *Variety:* "I really don't know; maybe it's because . . ."
- Haver's analysis of Cukor's "leisurely" directorial style
- The anecdote about Cukor trying to film a drunken Norman Maine nightmare in the style of painter Henry Fuseli
- Makeup artist Del Armstrong's interview ("Because of his particular lifestyle . . .") about Cukor's technique with women
- Ira Gershwin's complaint about the tacked-on "Born in a Trunk" sequence
- "They just hacked into it . . ."
- "That added considerably to the understanding . . ." quoting Haver's assessment of the effect of the elimination of key scenes
- "The loss of any Academy recognition . . ." quoting Haver's assessment of Hollywood's attitude toward the film

Stewart Granger's autobiography, *Sparks Fly Upward* (New York: Putnam's, 1981), recounts his audition for Cukor and *A Star Is Born*.

James Mason's comments regarding Cukor and *A Star Is Born* come from his interview with Rui Nogueira for *Focus on Film*, March/April 1970. Sheridan Morley's *Odd Man Out: James Mason* (New York: Harper & Row, 1989) also proved enlightening.

Cukor's interest in *My Cousin Rachel* is documented in the Cukor collection at the Motion Picture Academy. Nunnally Johnson's side of the story is touched on in Tom Stempel's *Screenwriter: The Life and Times of Nunnally Johnson* (San Diego/London: A. S. Barnes/Tantivy Press, 1980) and *The Letters of Nunnally Johnson*, edited by Dorris Johnson and Ellen Leventhal (New York: Alfred A. Knopf, 1981). Johnson's recollection here of his telephone conversation with Greta Garbo ("But as she went on talking . . .") is contained in his oral history on deposit in Special Collections of Columbia University.

The Edith Sitwell project is fully chronicled in the Cukor collec-

tion of the Motion Picture Academy. I have quoted the Walter Reisch transcribed interview with Joel Greenberg, and read Sitwell's autobiography, *Taking Care Of: The Autobiography of Edith Sitwell* (New York: Atheneum, 1965), as well as Victoria Glendinning's *Edith Sitwell: A Unicorn Among Lions* (New York: Alfred A. Knopf, 1981).

Zoë Akins's letter of October 22, 1954, is in the Cukor collection of the Motion Picture Academy.

Laurence Olivier's letter of August 6, 1954, is in the Cukor collection of the Motion Picture Academy.

Dore Schary's memos and correspondence relating to the two unmade Kanin scripts, *One More Time* and *Flight to the Islands*, are on deposit in his collection at the Center for Film and Theatre Research at the University of Wisconsin, Madison.

CHAPTER TEN

Dore Schary's speech to the Writers Guild ("I would say that what we know . . .") is preserved in his files at the Center for Film and Theatre Research. Profit and loss figures for individual Cukor films made for MGM during the Schary era are set down in studio financial records for that period, also on deposit in Schary's collection at the University of Wisconsin.

My statistics on the general decline in film production, studio profits, and audience attendance during the Fifties are taken from *Reel Facts: The Movie Book of Records* by Cobbett Steinberg (New York: Vintage, 1978).

Cukor's undated (probably 1957) interview with Henry W. Clune on the subject of Ingrid Bergman's "moral blacklisting" was published in his regular Rochester newspaper column, "Seen and Heard," provided to me by Mr. Clune.

Cukor's comments about Louis Malle and *Les Amants* are from his *Film Culture* interview.

Crucial to relating the saga of *The Chalk Garden* were *Enid Bagnold's Autobiography* (Boston: Little Brown & Co, 1969) and Irene Mayer Selznick's *A Private View*. The subject is broached in many Cukor letters in the Cukor collection at the Motion Picture Academy.

Gene Kelly's coolness toward Cukor was mentioned in Kenneth Tynan's article for *Holiday*, and confirmed by some correspondence in the Cukor collection at the Motion Picture Academy.

The discussion of George Hoyningen-Huene's design strategy for *Les Girls* is taken from an American Film Institute transcribed interview with Cukor, dated October 5, 1977.

Pandro Berman's qualms about Cukor directing *Cat on a Hot Tin Roof* come up in Berman's oral history for the American Film Insti-

tute, dated August 4, 1972. A copy of the interview, done by Mike Steen, is on deposit in Berman's archives in the Center for Film and Theatre Research at the University of Wisconsin, Madison.

Hedda Hopper wrote about Cukor and *Cat on a Hot Tin Roof* in a December 1957 clipping of her column—paper of origin unattributed—in the files of the Rochester Public Library.

Hal Wallis's (and Charles Higham's) *Starmaker* (New York: Macmillan, 1980) and volume two of Shelley Winters's autobiography, *Shelley II: The Middle of My Century* (New York: Simon & Schuster, 1980), augmented my interview with Arnold Schulman on the subject of *Wild Is the Wind*.

Cukor's unusual affection for *Heller in Pink Tights* is expressed in several unpublished letters in his collection.

Regarding the not entirely amicable collaborations between choreographer Jack Cole and Cukor, I read the Jack Cole interview in *People Will Talk* and Glenn Loney's *Unsung Genius: The Passion of Dancer-Choreographer Jack Cole* (New York and London: Franklin Watts, 1984).

I cannot pinpoint the date when François Truffaut's rhapsodic review of *Les Girls* was published in *Cahiers du Cinema*. A copy of it was saved by Cukor and is in his collection at the Motion Picture Academy.

Stanley Musgrove's collection in the Cinema-Television Archives at the University of Southern California was an invaluable source of notes and transcripts as to Cukor's state of mind at the end of the Fifties and into the Sixties.

Selznick's letter to Cukor of May 4, 1960, regarding *Tender Is the Night*, is in the Cukor collection at the Motion Picture Academy.

Dirk Bogarde's autobiography *Snakes and Ladders* (New York: Holt, Rinehart & Winston, 1978) described the troubled production of *Song Without End*, augmenting my interviews with Walter Bernstein and Gene Allen.

Cukor's memos to Sol Siegel, regarding *Lady L*, dated April 11, 1961, and May 23, 1961, are in MGM production files.

The story of *The Chapman Report* is told from the material in extensive studio production files in the Warners collection in the Cinema-Television Archives at the University of Southern California. Jack Warner's memo complaining about Cukor's overshooting of football scenes on the beach is dated October 13, 1961. Jack Warner's telegram to Darryl F. Zanuck calling Cukor "an obstinate putz" is dated February 15, 1962. Zanuck's reply to Warner ("has great talent and personally . . .") is dated February 20, 1962. Cukor's twenty-minute transcribed phone call of February 28, 1962, complaining about Darryl Zanuck's editing, is in the Warners-USC collection.

"The point here was a rather freshly written . . ." is from *On Cukor*.

"I know one always talks this way . . ." is from *On Cukor*.

Something's Got to Give has been written about almost as much as *Gone With the Wind*, and Marilyn Monroe has been the subject of more books than perhaps any other Hollywood star. Walter Bernstein's edifying article ("Marilyn Monroe's Last Picture Show") for *Esquire* (July 1983) affected my viewpoint and dovetailed with my interview with Bernstein. At the time Cukor wrote about the experience in unpublished letters to Irene Selznick, Whitney Warren, Jr., and Dirk Bogarde, in the Cukor collection at the Motion Picture Academy.

Cukor's phone call about Marilyn Monroe to Hedda Hopper, of June 6, 1962, is transcribed verbatim in Hopper's papers on deposit at the Academy of Motion Picture Arts and Sciences.

The anecdote about Vivien Leigh visiting the gravely ill Cole Porter is from *On Cukor*.

Other books that I have consulted include Simone Signoret's *Nostalgia Isn't What It Used to Be* (New York: Harper & Row, 1978) and Arthur Miller's *Timebends: A Life* (New York: Grove Press, 1987).

CHAPTER ELEVEN

The voluminous *My Fair Lady* production files are in the Warner Brothers collection in the Cinema-Television Archives of the University of Southern California.

Jack Warner talked about Cukor in the *Motion Picture Herald*, November 21, 1963.

Two books about Cecil Beaton were crucial to my section about his rivalrous relationship with Cukor: *Self Portrait with Friends: The Selected Diaries of Cecil Beaton, 1922–1974*, edited by Richard Buckle (New York: Times Books, 1979) and *Cecil Beaton: A Biography* by Hugo Vickers (Boston: Little, Brown & Co., 1985). All quotations from Beaton himself come from his *Diaries*, while Hugo Vickers's book is separately noted.

"Although the sets were supposed to be done . . ." is from a newspaper clipping in the Cukor collection at the Motion Picture Academy.

Charles Higham's *Audrey: A Biography of Audrey Hepburn* (New York: Macmillan, 1984) offered significant insights into Hepburn and the filming of *My Fair Lady*, while Rex Harrison's delightful autobiography *Rex* (New York: William Morrow, 1975) covered the experience from his point of view.

The description of how Beaton characteristically dressed is from *Audrey*.

The hopes and failures of G-D-C Productions are well documented in the Cukor collection at the Motion Picture Academy.

Charles Higham was particularly illuminating in an interview on the subject of Cukor during the Sixties.

Richard Schickel was generous with his insights. His letter to this author, dated September 10, 1990, is used with permission.

Cukor complained about the snobbery of the New York Film Festival in "Cukor Remembers Rochester" (the headline of more than one Cukor article in Rochester papers) by Jean Walrath, the Rochester *Democrat and Chronicle*, November 24, 1963.

Dirk Bogarde's autobiography *Snakes and Ladders* is quoted apropos of *Justine*.

Graham Greene's letter to this author is dated November 8, 1988.

Cukor's disappointment about the reception for *On Cukor* crops up in letters in the Cukor collection at the Motion Picture Academy.

Other reading included Quentin Falk's *Travels in Greeneland: The Cinema of Graham Greene* (London: Quartet Books, 1984), *The Andy Warhol Diaries*, edited by Pat Hackett (New York: Warner Books, 1989), Marlys J. Harris's *The Zanucks of Hollywood* (New York: Crown, 1989), Charles Higham and Joel Greenberg's *The Celluloid Muse: Hollywood Directors Speak* (New York: New American Library, 1972), Alan Jay Lerner's *The Street Where I Live* (New York: W. W. Norton, 1978), Axel Madsen's *William Wyler: The Authorized Biography* (New York: Thomas V. Crowell Co., 1973), and Bob Thomas's *Clown Prince of Hollywood: The Antic Life and Times of Jack L. Warner* (New York: McGraw-Hill, 1990).

CHAPTER TWELVE

Jacqueline Bisset's quote ("Sometimes, I hated his guts . . .") is from "Risque Bisset" by Gregg Kilday, *Vanity Fair*, July 1989.

Pauline Kael's attack on *Rich and Famous* was published in *The New Yorker*, October 26, 1981, and reprinted in her collection *Taking It All In* (New York: Holt, Rinehart & Winston, 1984).

Stuart Byron's reply is from *The Village Voice*, November 11–17, 1981.

The article in *Variety* about Cukor's age record, when directing *Rich and Famous*, is dated October 17, 1980.

The letter from Frank Mankiewicz to this author is dated May 31, 1989.

Cukor's final hours were recorded in "His Fair Ladies" by Robin Thorne in *California*, July 1983.

Cukor's will and disposition of estate are a matter of public record at the Los Angeles County courthouse.

The material about Frances Goldwyn is cited from A. Scott Berg's *Goldwyn*.

Lesley Blanche's words ("ghosts who linger on . . .") come from the Kenneth Tynan article in *Holiday*.

The article about the new owners of Cukor's house was published in *House and Garden*, January 1990.

Other books that I read for this chapter include Laurence Olivier's autobiography, *Confessions of an Actor* (New York: Simon & Schuster, 1982) and Boze Hadleigh's *Conversations With My Elders* (New York: St. Martin's Press, 1986).

My principal reference books, always close at hand, were Leonard Maltin's *TV Movies and Video Guide*, 1990 Edition (New York: New American Library, 1989), Ephraim Katz's *The Film Encyclopedia* (New York: Perigee, 1979), Mason Wiley and Damien Bona's *Inside Oscar: The Unofficial History of the Academy Awards* (New York: Ballantine, 1986), Andrew Sarris's *The American Cinema: Directors and Directions, 1929–1968* (New York: Dutton, 1968), and David Thomson's *A Biographical Dictionary of Film*, Second Edition, Revised (New York: William Morrow, 1981).

FILMOGRAPHY

Key: Sc: Screenwriter; Ph: Photography
Producer and approximate running time appear in parentheses.
Cast listings are partial.

1 9 3 0

Grumpy. Codirector: Cyril Gardner. Sc: Doris Anderson, from a play by Horace Hodges and Thomas Wigney. Ph: David Abel. Cast: Cyril Maude, Phillips Holmes, Paul Cavanagh, Paul Lukas, Frances Dade, Halliwell Hobbes, Dorris Luray, Olaf Hytten, Robert Bolder, Colin Kenny. (Paramount, 74 mins.)

> *"Direction is legit and intelligent; casting superb; technic without fault."*
>
> Abel, Variety

The Virtuous Sin. Codirector: Louis Gasnier. Sc: Martin Brown and Louise Long, from a play by Lajos Zilahay. Ph: David Abel. Cast: Walter Huston, Kay Francis, Paul Cavanagh, Kenneth MacKenna, Eric Kalkhurst, Oscar Apfel, Gordon McLeod, Victor Potel, Youcca Troubetzkoy, Jobyna Howland. (Paramount, 80 mins.)

> *"The one remarkable feature of the film is that [Kay] Francis wears beautifully accurate 1914 gowns, hats and hairdos."*

373

The Royal Family of Broadway. Codirector: Cyril Gardner. Sc: Herman J. Mankiewicz and Gertrude Purcell, from the play by Edna Ferber and George S. Kaufman. Ph: George Folsey. Cast: Ina Claire, Fredric March, Mary Brian, Henrietta Crosman, Arnold Korff, Frank Conroy, Charles Starrett, Royal G. Stout, Elsie Edmonds, Murray Alper, Wesley Stark, Herschel Mayall. (Paramount, 82 mins.)

"*. . . a neat jest at the expense of the Barrymore family . . . Cukor's flair brilliantly shows through. . . .*"
Charles Higham, The London Magazine

1 9 3 1

Tarnished Lady. Sc: Donald Ogden Stewart. Ph: Larry Williams. Cast: Tallulah Bankhead, Clive Brook, Phoebe Foster, Alexander Kirkland, Osgood Perkins, Elizabeth Patterson. (Paramount, 83 mins.)

"*Bankhead acquits herself with considerable distinction, but the vehicle to which she lends her talent is no masterpiece.*"
Mordaunt Hall, The New York Times

Girls About Town. Sc: Raymond Griffith and Brian Marlow, from a story by Zoë Akins. Ph: Ernest Haller. Cast: Kay Francis, Joel McCrea, Lilyan Tashman, Eugene Pallette, Alan Dinehart, Lucille Webster Gleason, Anderson Lawler, Lucille Browne, George Barbier, Robert McWade, Louise Beavers, Adrienne Ames, Hazel Howard, Claire Dodd, Patricia Caron, Judith Wood. (Paramount, 90 mins.)

"*. . . a low-brow farce full of Babbitts and gold-diggers which displays a generous amount of flesh and lingerie incompatible with high comedy, but also a cheerful carnality synonymous with film vigor.*"

Carlos Clarens, Cukor

1 9 3 2

What Price Hollywood? Sc: Jane Murfin and Ben Markson, adaptation by Gene Fowler and Rowland Brown of a story by Adela Rogers

374

St. John. Ph: Charles Rosher. Cast: Constance Bennett, Lowell Sherman, Neil Hamilton, Gregory Ratoff, Brooks Benedict, Louise Beavers, Eddie Anderson. (David O. Selznick for RKO, 87 mins.)

"... a witty and biting parody of the film colony which parallels in some ways Wellman's A Star Is Born and Cukor's Fifties remake, the latter arguably his greatest film. As the waitress who rises to fame with the assistance of an alcoholic director (Lowell Sherman), Constance Bennett is engagingly tough and unsentimental. Although the ending descends to melodrama, Cukor's assured handling of the crisp Adela Rogers St. John dialogue gives the film a uniformity rare among RKO productions of this period."
John Baxter, Hollywood in the Thirties

A Bill of Divorcement. Sc: Howard Estabrook and Harry Wagstaff Gribble, from the play by Clemence Dane. Ph: Sid Hickox. Cast: John Barrymore, Billie Burke, Katharine Hepburn, David Manners, Henry Stephenson, Elizabeth Patterson, Paul Cavanagh, Gayle Evers, Bramwell Fletcher. (David O. Selznick for RKO, 80 mins.)

"A young and new actress, Katharine Hepburn, has the luck to have been given the part of the daughter for her first appearance in films, and the gift to make that part glow with life and beauty, a life and beauty that does not come from mere appearance but from the direct projection of an inner nature. The playing of [the] actors rounds itself into a whole that the director has made harmonious and convincing. And the picture being so serious and sincere in its material and so ably handled, belongs definitely among the films that are more than just good entertainment."
James Shelley Hamilton, National Board of Review

Rockabye. Sc: Jane Murfin and Kubec Glasmon, from the play by Lucia Bronder. Ph: Charles Rosher. Cast: Constance Bennett, Joel McCrea, Paul Lukas, Walter Pidgeon, Jobyna Howland, Virginia Hammond, Walter Catlett, June Filmer, J. M. Kerrigan, Clara Blandick. (David O. Selznick for RKO, 71 mins.)

"It emerges finally as a first-grade program picture, lachrymose but reasonable, brightened by Jobyna Howland's expert characterization of Judy's [Constance Bennett] tippling mother."
Time

1 9 3 3

Our Betters. Sc: Jane Murfin and Henry Wagstaff Gribble, from the play by Somerset Maugham. Ph: Charles Rosher. Cast: Constance

Bennett, Violet Kemble Cooper, Phoebe Foster, Charles Starrett, Grant Mitchell, Gilbert Roland, Anita Louise, Minor Watson, Hugh Sinclair, Alan Mowbray, Harold Entwhistle. (David O. Selznick for RKO, 85 mins.)

> *"In his deft direction of [Constance] Bennett, and the fine supporting cast headed by Violet Kemble-Cooper as Minnie, Cukor proved as never before his skill in handling high comedy."*
> *Gene D. Phillips*, George Cukor

Dinner at Eight. Sc: Herman J. Mankiewicz and Frances Marion, from the play by Edna Ferber and George S. Kaufman, additional dialogue by Donald Ogden Stewart. Ph: William Daniels. Cast: Marie Dressler, John Barrymore, Wallace Beery, Jean Harlow, Lionel Barrymore, Lee Tracy, Edmund Lowe, Billie Burke, Madge Evans, Jean Hersholt, Karen Morley, Louise Closser Hale, Phillips Holmes, May Robson, Phoebe Foster, Grant Mitchell, Elizabeth Patterson, Hilda Vaughn, Harry Beresford, Edwin Maxwell, Anna Duncan. (David O. Selznick for MGM, 110 mins.)

> *"With the setting and story of a Waldorf operetta, Cukor was able to get inflections and tones from the departments that professional cinematicians always class as uncinematic: Make-up, setting, costumes, voices. Marie Dressler's matronly bulldog face and Lee Tracy's scarecrow, gigolo features and body are almost like separate characters interchangeable with the hotel corridors and bathtubs and gardens of Cukor's ritzy and resilient imagination. Cukor, a lighter, less sentiment-logged Ernst Lubitsch, could convert an obsession or peculiarity like Jean Harlow's nasal sexuality, or Wallace Beery's line-chewing, into a quick and animating caricature—much as Disney used mice and pigs in his 1930s cartoons."*
> *Manny Farber*, Negative Space

Little Women. Sc: Sarah Y. Mason and Victor Heerman, from the novel by Louisa May Alcott. Ph: Henry Gerrard. Cast: Katharine Hepburn, Joan Bennett, Paul Lukas, Edna May Oliver, Jean Parker, Frances Dee, Henry Stephenson, Douglass Montgomery, John Davis Lodge, Spring Byington, Samuel S. Hinds, Mabel Colcord, Marion Ballou, Nydia Westman, Harry Beresford. (RKO, 117 mins.)

> *"Film offers endless pleasure no matter how many times you've seen it; a faithful, beautiful adaptation of Alcott's book by Victor*

Heerman and Sarah Y. Mason, *who deservedly received Oscars.*
The cast is uniformly superb."
Leonard Maltin, Leonard Maltin's TV Movies
and Video Guide

1 9 3 5

David Copperfield. Sc: Howard Estabrook, adaptation by Hugh Wal-
pole of the novel by Charles Dickens. Ph: Oliver Marsh. Cast:
W. C. Fields, Lionel Barrymore, Maureen O'Sullivan, Madge Evans,
Edna May Oliver, Lewis Stone, Frank Lawton, Freddie Bartholo-
mew, Elizabeth Allan, Roland Young, Basil Rathbone, Elsa Lanches-
ter, Jessie Ralph, Violet Kemble Cooper, Harry Beresford, Hugh
Walpole, Herbert Mundin, John Buckler, Una O'Connor, Lennox
Pawle, Renee Gadd, Jean Cadell, Fay Chaldecott, Marilyn Knowl-
den, Florine McKinney, Hugh Williams, Mabel Colcord, Ivan Simp-
son. (David O. Selznick for MGM, 135 mins.)

> *"The most profoundly satisfying screen manipulation of a great*
> *novel that the camera has ever given us."*
> Andre Sennwald, The New York Times

Sylvia Scarlett. Sc: Gladys Unger, John Collier, and Mortimer Off-
ner, from a novel by Compton MacKenzie. Ph: Joseph August. Cast:
Katharine Hepburn, Cary Grant, Brian Aherne, Edmund Gwenn,
Natalie Paley, Dennie Moore, Lennox Pawle. (Pandro S. Berman for
RKO, 90 mins.)

> *"The milieu and story of* Sylvia Scarlett *have a Shakespearian*
> *feel to them, harking back to an age and a theatrical convention*
> *in which sex-exchange was permissible. This is Cukor's first film*
> *(and last for a while) in which he dared to challenge, in a lyrical*
> *stage whisper, our traditional assumptions about male-female*
> *roles."*
> Molly Haskell, From Reverence to Rape

1 9 3 6

Romeo and Juliet. Sc: Talbot Jennings, from the play by William
Shakespeare. Ph: William Daniels. Cast: Norma Shearer, Leslie
Howard, John Barrymore, Edna May Oliver, Basil Rathbone, Andy

Devine, Henry Kolker, Reginald Denny, C. Aubrey Smith, Violet Kemble Cooper, Robert Warwick, Virginia Hammond, Ralph Forbes, Conway Tearle, Maurice Murphy. (Irving Thalberg for MGM, 130 mins.)

> *"To intelligent cinema addicts, it will be no great shock to learn that the best actors currently functioning in the U.S. act the play as well as it can be acted; that the most expensive sets ever used for* Romeo and Juliet *are by far the most realistic and hence the most satisfactory; and that the camera—which can see Juliet as Romeo saw her and vice-versa—greatly facilitates the story. As for the play itself, which is by far the best part of the production, it remains what it has always been, the best version ever written of Hollywood's favorite theme,* Boy Meets Girl.*"*
> Time

Camille. Sc: Zoë Akins, Frances Marion, and James Hilton, from a play and novel by Alexandre Dumas. Ph: William Daniels. Cast: Greta Garbo, Robert Taylor, Lionel Barrymore, Elizabeth Allan, Jessie Ralph, Henry Daniell, Lenore Ulric, Laura Hope Crews, Rex O'Malley, Russell Hardie, E. E. Clive, Douglas Walton, Jean Brodel, Marion Ballou, June Wilkins, Elsie Edmonds, Fritz Leiber, Jr. (Irving Thalberg for MGM, 108 mins.)

> *"Garbo in* Camille *shows up Dietrich in anything as a smooth mask with interesting hollows in her cheeks and a low voice that reads 'yes' with a rising inflection. Garbo in* Camille *has character and shading and, surprisingly, warmth. You don't just admire her in* Camille*—you like her. You find her human at last. You are actually, actively, sorry for her—nor does she sacrifice any of her natural dignity to win your sympathy. It's that, in* Camille*, she realizes her potentialities as a great actress. She no longer need depend upon a provocative personality; now every nuance has meaning, is felt, is true."*
> *Cecilia Ager,* Garbo and the Night Watchmen

1 9 3 8

Holiday. Sc: Donald Ogden Stewart and Sidney Buchman, from the play by Philip Barry. Ph: Franz Planer. Cast: Katharine Hepburn, Cary Grant, Doris Nolan, Lew Ayres, Edward Everett Horton, Henry Kolker, Binnie Barnes, Jean Dixon, Henry Daniell. (Everett Riskin for Columbia, 93 mins.)

> "*Of course, Grant and Hepburn fall in love. Story is predictable, but writing is first-rate and stars, especially Hepburn, are excellent. It's odd that the images I always remember from this film are those that express freedom: Grant doing backflips, and Hepburn running (something actresses never did in the old days).*"
> *Danny Peary*, Guide for the Film Fanatic

Zaza. Sc: Zoë Akins, from the play by Pierre Berton and Charles Simon. Ph: Charles Lang, Jr. Cast: Claudette Colbert, Herbert Marshall, Bert Lahr, Genevieve Tobin, Constance Collier, Rex O'Malley, Helen Westley, Rex Evans, Robert C. Fischer, Ernest Cossart, Dorothy Tree, Monty Woolley, Maurice Murphy, Ann Todd, Frank Puglia, Janet Waldo, Alexander Leftwich, Fredrika Brown, Olive Tell, John Sutton, Michael Brooks, Philip Warren, Maud Hume, Alice Keating. (Albert Lewin for Paramount, 80 mins.)

> "*Claudette Colbert, who looks very well indeed in those big, feathered hats and sweeping dustcatchers of the prewar era, works herself up into an occasional tantrum or spasm of nobility as the plot demands, and is also nice in the occasional musical outbursts.*"
> *John Mosher*, The New Yorker

1 9 3 9

The Women. Sc: Anita Loos and Jane Murfin, from the play by Clare Boothe. Ph: Oliver T. Marsh and Joseph Ruttenberg. Cast: Joan Crawford, Rosalind Russell, Mary Boland, Paulette Goddard, Phyllis Povah, Joan Fontaine, Virginia Weidler, Lucile Watson, Marjorie Main, Virginia Grey, Ruth Hussey, Muriel Hutchison, Florence Nash, Hedda Hopper, Dennie Moore, Cora Witherspoon, Mary Cecil, Mary Beth Hughes, Ann Morriss. (Hunt Stromberg for MGM, 134 mins.)

> "*. . . a surprisingly jaundiced and bitter-flavored look at one slice of life. . . . The Women can still be regarded as one of MGM's most diverting films of the period in its lavishly appointed production and cluster of star performances, as well as its often funny dialogue. Its ladies may not be ladies at all, but they are certainly enjoyable to visit.*"
> *Ted Sennett*, Hollywood's Golden Year: 1939

1 9 4 0

Susan and God. Sc: Anita Loos, from the play by Rachel Crothers. Ph: Robert Planck. Cast: Joan Crawford, Fredric March, Ruth Hus-

sey, John Carroll, Rita Hayworth, Nigel Bruce, Bruce Cabot, Rose Hobart, Constance Collier, Rita Quigley, Gloria De Haven, Richard O. Carne, Norma Mitchell, Marjorie Main, Aldrich Bowker. (Hunt Stromberg for MGM, 115 mins.)

> *"Cukor's justified reputation as a 'woman's director' nowhere was more evident than in his work with [Joan] Crawford. . . . Susan and God [showed] one of her rarely displayed talents: a real sense of comic timing. When Susan and God was first released Crawford's performance was compared unfavorably to Gertrude Lawrence's. Today we can see her performance for what she gave to it: character not caricature."*
> *Jeanine Basinger*, University of Connecticut
> Film Society notes

The Philadelphia Story. Sc: Donald Ogden Stewart, from the play by Philip Barry. Ph: Joseph Ruttenberg. Cast: Katharine Hepburn, Cary Grant, James Stewart, Ruth Hussey, John Howard, Roland Young, John Halliday, Mary Nash, Virginia Weidler, Henry Daniell, Lionel Pape, Rex Evans. (Joseph L. Mankiewicz for MGM, 112 mins.)

> *"Hollywood's most wise and sparkling comedy, with a script which is even an improvement on the original play. Cukor's direction is so discreet you can hardly sense it, and all the performances are just perfect."*
> *Leslie Halliwell*, Halliwell's Film and Video Guide

1 9 4 1

A Woman's Face. Sc: Donald Ogden Stewart and Elliot Paul, from a play by Francis de Croisset. Ph: Robert Planck. Cast: Joan Crawford, Melvyn Douglas, Conrad Veidt, Osa Massen, Reginald Owen, Albert Basserman, Marjorie Main, Connie Gilchrist, Donald Meek, Richard Nichols, Henry Daniell, Charles Quigley, Gwili Andre, Clifford Brooks, George Zucco, Henry Kolker, Robert Warwick, Gilbert Emery, William Farnum, Sarah Padden. (Victor Saville for MGM, 105 mins.)

> *"***1/2 . . . hard-edged and suspenseful . . ."*
> *Steven H. Scheuer*, Movies on TV and Videocassette

Two-Faced Woman. Sc: S. N. Behrman, Salka Viertel, and George Oppenheimer, suggested by the Ludwig Fulda play. Ph: Joseph Rut-

tenberg. Cast: Greta Garbo, Melvyn Douglas, Constance Bennett, Roland Young, Robert Sterling, Ruth Gordon, Frances Carson. (Gottfried Reinhardt for MGM, 95 mins.)

> *"Garbo's last film is better than its reputation. She has an infectious sense of humor as the woman who tests her husband's faithfulness by posing as her own seductive twin sister. Fast-moving, full of clever dialogue, and professionally acted by the entire cast."*
>
> Mick Martin & Marsha Porter, Video Movie Guide 1991

1 9 4 2

Her Cardboard Lover. Sc: John Collier, Anthony Veiller, William H. Wright, and Jacques Deval, from the play by Deval as adapted by Valerie Wyngate and revised by P. G. Wodehouse. Ph: Harry Stradling and Robert Planck. Cast: Norma Shearer, Robert Taylor, George Sanders, Frank McHugh, Elizabeth Patterson, Chill Wills. (J. Walter Ruben for MGM, 90 mins.)

> *"If this be Miss Shearer's movie swan song, as has been intimated, she leaves us with a very fine performance to remember her by. True, at times Miss Shearer spreads on the histrionics a bit too thick, but the role is difficult and why shouldn't a love-frustrated woman be a bit hysterical at times? Anyway, we liked her and think you will too."*
>
> Photoplay

Keeper of the Flame. Sc: Donald Ogden Stewart, from the novel by I. A. R. Wylie. Ph: William Daniels. Cast: Spencer Tracy, Katharine Hepburn, Richard Whorf, Margaret Wycherly, Forrest Tucker, Horace McNally, Percy Kilbride, Audrey Christie, Darryl Hickman, Frank Craven, Donald Meek, Howard Da Silva, William Newell. (Victor Saville for MGM, 100 mins.)

> *"In* Keeper of the Flame, *George Cukor has made a psychological thriller with a sociological message. The new MGM film is unorthodox and, on the whole, absorbing drama. . . . Mr. Cukor has not Alfred Hitchcock's facility with psychological thrills but he has turned out an important and arresting film."*
>
> Christian Science Monitor

1 9 4 4

Gaslight. Sc: John Van Druten, Walter Reisch, and John L. Balderston, from a play by Patrick Hamilton. Ph: Joseph Ruttenberg. Cast: Charles Boyer, Ingrid Bergman, Joseph Cotten, Angela Lansbury, Dame May Whitty, Barbara Everest, Emil Rameau, Edmund Breon, Halliwell Hobbes, Tom Stevenson, Heather Thatcher, Lawrence Grossmith, Jakob Gimpel. (Arthur Hornblow, Jr., for MGM, 114 mins.)

> *"Gaslight is George Cukor's classic Victorian melodrama . . . a study in induced madness, and, paradoxically, the film sustains our interest because Cukor's direction intentionally subverts the traditional elements of mystery in the plot."*
> *Robert Mitchell,* MaGill's Survey of Cinema *(First Series)*

Winged Victory. Sc: Moss Hart, from his play. Ph: Glen MacWilliams. Cast: Lon McCallister, Jeanne Crain, Edmond O'Brien, Judy Holliday, Mark Daniels, Jo-Carroll Dennison, Don Taylor, Lee J. Cobb, Peter Lind Hayes, Alan Baxter, Red Buttons, Barry Nelson, Rune Hultman, Gary Merrill, Karl Malden, George Humbert, Richard Hogan, George Reeves, George Petrie, Alfred Ryder, Martin Ritt. (Darryl F. Zanuck for Twentieth Century–Fox, 130 mins.)

> *"It gives every promise of being one of the most successful films about this war. . . . George Cukor, the director, has kept all the poignancy and zeal that was tightly compacted in the episodes of Moss Hart's original play. Only now the continuity flows easily and fast in a natural scenic pattern that carries great conviction on the screen."*
> *Bosley Crowther,* The New York Times

1 9 4 7

A Double Life. Sc: Ruth Gordon and Garson Kanin. Ph: Milton Krasner. Cast: Ronald Colman, Signe Hasso, Edmond O'Brien, Shelley Winters, Ray Collins, Philip Loeb, Millard Mitchell, Joe Sawyer, Charles La Torre, Whit Bissell, John Drew Colt, Peter Thompson, Elizabeth Dunne, Alan Emiston, Art Smith, Sid Tomack, Wilton Graff, Harlan Briggs, Claire Carleton, Betsy Blair, Janet Warren, Marjory Woodworth. (Michael Kanin for Universal, 103 mins.)

> *"Terrific was the word for* A Double Life, *whose highly theatrical premise was that if an actor plays a part for too long, or with*

too much intensity, he is psychologically in danger of continuing the performance into private life. . . . Colman's central performance was a brillant and mesmeric study of a man obsessed."
Clive Hirschhorn, The Universal Story

1 9 4 8

Edward, My Son. Sc: Donald Ogden Stewart, from the play by Robert Morley and Noel Langley. Ph: Frederick A. Young. Cast: Spencer Tracy, Deborah Kerr, Ian Hunter, James Donald, Mervyn Johns, Leueen McGrath, Felix Aylmer, Walter Fitzgerald, Harriette Johns, Clement McCallin, Tilsa Page, Ernest Jay, Colin Gordon. (Edwin H. Knopf for MGM, 112 mins.)

"Skillful direction has brought this play to the screen with full dramatic force. There is no letup in its intensity and it moves surely and swiftly from one dramatic phase to another."
Myro, Variety

1 9 4 9

Adam's Rib. Sc: Ruth Gordon and Garson Kanin. Ph: George J. Folsey. Cast: Spencer Tracy, Katharine Hepburn, Judy Holliday, Tom Ewell, David Wayne, Jean Hagen, Hope Emerson, Clarence Kolb, Will Wright, Elizabeth Flournoy, Polly Moran, Emerson Treacy. (Lawrence Weingarten for MGM, 102 mins.)

". . . Tracy and Hepburn's Adam and Amanda Bonner brought more camaraderie and humor into married life than any couple since Nick and Nora Charles of the Thirties Thin Man *series. The Garson Kanin-Ruth Gordon script for* Adam's Rib *is one of the handful of American comedy masterpieces written for the screen or stage, and George Cukor's smart, svelte movie is a banner raised for sexual equality, waving in the air decades before Betty Friedan."*
Gerald Peary, American Film

1 9 5 0

A Life of Her Own. Sc: Isobel Lennart. Ph: George Folsey. Cast: Lana Turner, Ray Milland, Tom Ewell, Ann Dvorak, Barry Sullivan,

Louis Calhern, Jean Hagen, Margaret Phillips, Phyllis Kirk, Sara Hayden, Hermes Pan. (Voldemar Vetluguin for MGM, 108 mins.)

> "... one of the more maligned of Cukor's repertoire, yet, I think, one of the most powerful film noirs ..."
> Allen Estrin, The Hollywood Professionals, *Volume 6*

Born Yesterday. Sc: Albert Mannheimer (and uncredited, Garson Kanin), from the play by Kanin. Ph: Joseph Walker. Cast: Judy Holliday, William Holden, Broderick Crawford, Howard St. John, Frank Otto, Larry Oliver, Barbara Brown, Grandon Rhodes, Claire Carleton. (S. Sylvan Simon for Columbia, 103 mins.)

> "*Miss Holliday makes a good job of Billie with a high, rasping, scarcely understandable accent that has the characteristics of a human jukebox. Her moronic expression of utter idiocy occasionally softens into a glimmering understanding as that under-developed mind grasps a point or two. Her high-heeled, peahen strut is affected to that degree of incredibility that makes it only too real. She gets almost everything out of the part that is possible. ...*"
> Paul Rotha, Rotha on the Film

1951

The Model and the Marriage Broker. Sc: Charles Brackett, Walter Reisch, and Richard Breen. Ph: Milton Krasner. Cast: Jeanne Crain, Scott Brady, Thelma Ritter, Zero Mostel, Michael O'Shea, Helen Ford, Frank Fontaine, Dennie Moore, John Alexander, Jay C. Flippen, Maude Prickett, Ken Christey, Jacqueline French, Edna Mae Wonacott, June Hedin, Shirley Mills, Athalie Daniell, Nancy Kulp, Bunny Bishop, Dennis Ross, Tommy Noonan, Eve March. (Charles Brackett for Twentieth Century–Fox, 103 mins.)

> "*... There's nothing terribly new or original about the story, and no dominating star performances—nothing to get the picture talked about. It's entertaining, though. Thelma Ritter, who plays the marriage broker, doesn't show any new sides, but she's awfully good at her hard-bitten specialty, and Jeanne Crain is very likeable as the model.*"
> Pauline Kael, 5001 Nights at the Movies

1952

The Marrying Kind. Sc: Ruth Gordon and Garson Kanin. Ph: Joseph Walker. Cast: Judy Holliday, Aldo Ray, Madge Kennedy, Sheila

Bond, John Alexander, Rex Williams, Phyllis Povah, Mickey Shaughnessy, Peggy Cass, Griff Barnett, Susan Hallaran, Wallace Acton, Elsie Homes, Christie Olsen, Barry Curtis. (Bert Granet for Columbia, 108 mins.)

"*. . . The underrated* The Marrying Kind *will rank alongside [Billy] Wilder's and [Paddy] Chayefsky's intimate glimpses of American realities.*"

Raymond Durgnat, The Crazy Mirror:
Hollywood Comedy and the American Image

Pat and Mike. Sc: Ruth Gordon and Garson Kanin. Ph: William Daniels. Cast: Spencer Tracy, Katharine Hepburn, Aldo Ray, William Ching, Sammy White, George Matthews, Loring Smith, Phyllis Povah, Charles Buchinski (Charles Bronson), Jim Backus, Frank Richards, Chuck Connors, Owen McGiveney, Joseph E. Bernard, Lou Lubin, Carl Switzer, William Self, Gussie Moran, Don Budge, Frank Parker, Beverly Hanson, Babe Didrikson Zaharias, Alice Marble, Betty Hicks, Helen Dettweiler. (Lawrence Weingarten for MGM, 95 mins.)

"*I do not know of a more courteous bouquet of thanks from a director to his star. And yet even here Cukor has allowed himself a justifiable pride. While the camera spends in the film a disproportionate amount of time on Hepburn's physical accomplishments, a disproportionate brilliance of acting in the film is Tracy's, the good director's surrogate.*"

Stanley Cavell, Pursuits of Happiness

1 9 5 3

The Actress. Sc: Ruth Gordon, from her play. Ph: Harold Rosson. Cast: Spencer Tracy, Jean Simmons, Teresa Wright, Anthony Perkins, Ian Wolfe, Kay Williams, Mary Wickes, Norma Jean Nilsson, Dawn Bender. (Lawrence Weingarten for MGM, 90 mins.)

"*Gentle, nostalgic, affectionate,* The Actress *sought and achieved a mood of unhurried intimacy without the saccharine exaggerations of [Vincente] Minnelli's* Meet Me in St. Louis *or [George] Steven's* I Remember Mama. . . . *The playing was pleasantly in keeping with the quiet, turn-of-the-century tone. One remembers the final shot, through the window of the Jones' kitchen,*

of Ruth walking away to her destiny as the cat sits calmly on the
sill staring after her."
 Joel Greenberg, Film Journal

1 9 5 4

It Should Happen to You. Sc: Garson Kanin. Ph: Charles Lang. Cast:
Judy Holliday, Peter Lawford, Jack Lemmon, Michael O'Shea,
Vaughn Taylor, Connie Gilchrist, Walter Klavun, Whit Bissell, Ar-
thur Gilmore, Rex Evans, Heywood Hale Broun, Constance Bennett,
Ilka Chase, Wendy Barrie, Melville Cooper. (Fred Kohlmar for Co-
lumbia, 100 mins.)

> *"Of all the films Cukor made with one or both of the Kanins, this*
> *is my favorite, if only because of the delightful performances of*
> *Judy Holliday and Jack Lemmon."*
> Gary Carey, Cukor & Co.

A Star Is Born. Sc: Moss Hart, based on the screenplay of the
1937 film by Dorothy Parker, Alan Campbell, and Robert Carson,
based on the story by William Wellman and Robert Carson. Ph:
Sam Leavitt. Cast: Judy Garland, James Mason, Charles Bickford,
Jack Carson, Tommy Noonan, Irving Bacon, Lucy Marlow,
Amanda Blake, James Brown, Hazel Shermet, Lotus Bobb. (Sidney
Luft for Warner Brothers, 182 mins. cut to 140 mins.) (Restored
version, 176 mins.)

> "A Star Is Born *is one of the rare films that successfully integrate*
> *music with drama; it's not exactly a musical, but it has more*
> *music than most musicals. It's also not exactly a serious*
> *drama—it's too broad and predictable for that—but it's the sort*
> *of exaggerated, wide-gauge melodrama that Rainer Werner Fass-*
> *binder would experiment with twenty years later; a movie in which*
> *larger-than-life characters are used to help us see the melodramatic*
> *clichés that we do, indeed, sometimes pattern our own lives*
> *after. . . ."*
> Roger Ebert, Roger Ebert's Movie Home Companion

1 9 5 6

Bhowani Junction. Sc: Sonya Levien and Ivan Moffat, from the
novel by John Masters. Ph: Frederick A. Young. Cast: Ava Gard-

ner, Stewart Granger, Bill Travers, Lionel Jeffries, Abraham Sofaer, Francis Matthews, Peter Illing, Freda Jackson, Edward Chapman, Alan Tilvera, Marne Maitland. (Pandro S. Berman for MGM, 109 mins.)

> *"The director of this swirling, crowded picture is, surprisingly enough, George Cukor. Cukor has more often been associated with Judy Holliday and Katharine Hepburn comedies than large-scale adventure and action films. And yet in this picture he not only keeps the vast CinemaScope screen constantly alive and interesting but also achieves a rare degree of intimacy upon it. Perceiving that the effectiveness of his story rested on the believeability of his characters, he created them as people, not symbols, through the strong characterizations he drew from every member of his cast."*
> *Arthur Knight*, Saturday Review

1 9 5 7

Les Girls. Sc: John Patrick, based on a story by Vera Caspary. Ph: Robert Surtees. Cast: Gene Kelly, Mitzi Gaynor, Kay Kendall, Taina Elg, Jacques Bergerac, Leslie Phillips, Henry Daniell, Patrick MacNee. (Sol C. Siegel for MGM, 114 mins.)

> *"Les Girls is just about the brightest, wittiest, tunefullest, danciest and by all odds the most entertaining mirth-and-melody mixture of just about any movie season within recent memory."*
> Cue

Wild Is the Wind. Sc: Arnold Schulman, based on a story by Vittorio Nino Novarese. Ph: Charles Lang. Cast: Anna Magnani, Anthony Quinn, Anthony Franciosa, Dolores Hart, Joseph Calleia, Lili Valenty. (Hal B. Wallis for Paramount, 110 mins.)

> *". . . As furious in intensity and gathering volume as a whirlwind, stripping the spectator of his resistance and laying bare the emotions as the demonic wind whips the green from a tree and leaves bare its skeleton. . . . And lest the impression arise that all is stark and relentless about* Wild Is the Wind, *the point should be made that it is also rich in humor and happiness, as merrily sun-lit as a glass of Strega."*
> *James Powers*, Hollywood Reporter

1 9 6 0

Heller in Pink Tights. Sc: Dudley Nichols and Walter Bernstein, adapted from the novel by Louis L'Amour. Ph: Harold Lipstein. Cast: Anthony Quinn, Sophia Loren, Eileen Heckart, Margaret O'Brien, Ramon Navarro, Steve Forrest, Edmund Lowe, George Matthews, Frank Cordell. (Carlo Ponti and Marcello Girosi for Paramount, 100 mins.)

> "*A salutary and entertaining reactionary movie . . . a joyful reconstruction of the way things were—give or take the concomitant levity—among members of a theatrical troupe in the old American west, touring the settlements from Cheyenne to Virginia City in the days of Wyatt Earp and Jesse James. . . .* Heller *evoked the birth pangs of American showbiz, in high style. . . .*"
> Gordon Gow, Hollywood in the Fifties

Let's Make Love. Sc: Norman Krasna, additional material by Hal Kanter. Ph: Daniel L. Fapp. Cast: Marilyn Monroe, Yves Montand, Tony Randall, Frankie Vaughn, Wilfred Hyde-White, David Burns, Michael David, Mara Lynn, Dennis King, Jr., Milton Berle, Gene Kelly, Bing Crosby. (Jerry Wald for Twentieth Century–Fox, 119 mins.)

> "*If it is not a preternaturally light musical souffle in the Astaire-Rogers tradition, it most certainly is a rich musical treat in the George Cukor tradition.*"
> James Bernardoni, George Cukor

1 9 6 2

The Chapman Report. Sc: Wyatt Cooper and Don M. Mankiewicz, from the adaptation by Grant Stuart and Gene Allen of the novel by Irving Wallace. Ph: Harold Lipstein. Cast: Efrem Zimbalist, Jr., Shelley Winters, Jane Fonda, Claire Bloom, Glynis Johns, Ray Danton, Ty Hardin, Andrew Duggan, John Dehner, Harold J. Stone, Corey Allen, Jennifer Howard, Chad Everett, Henry Daniell, Cloris Leachman. (Richard D. Zanuck for Warner Brothers, 125 mins.)

> "*. . . One of this auteur's masterpiece . . .*"
> Jean-Andre Fieschi, Cahiers du Cinema

1 9 6 4

My Fair Lady. Sc: Alan Jay Lerner, based on the musical comedy by Alan Jay Lerner and Frederick Loewe, from a play by George Bernard Shaw. Ph: Harry Stradling. Cast: Audrey Hepburn, Rex Harrison, Stanley Holloway, Wilfred Hyde-White, Gladys Cooper, Jeremy Brett, Theodore Bikel, Mona Washbourne, Isobel Elsom, John Holland, Henry Daniell, John Alderson, John McLiam. (Jack L. Warner for Warner Brothers, 170 mins.)

> *"It is humorous, cinematic, and in no way jars our expectations of a beloved and familiar work—one which we would not wish to see tampered with by movie people. . . . The film turned out to be one of the few aesthetically satisfying screen adaptations of a Broadway success. . . ."*
> *Richard Schickel*, The Platinum Years

1 9 6 9

Justine. Sc: Lawrence B. Marcus, from the four novels of *The Alexandria Quartet* by Lawrence Durrell. Ph: Leon Shamroy. Cast: Anouk Aimée, Dirk Bogarde, Robert Forster, Anna Karina, Philippe Noiret, Michael York, John Vernon, Jack Albertson, Cliff Gorman, George Baker, Elaine Church, Michael Constantine, Marcel Dalio, Michael Dunn, Barry Morse, Severn Darden, Anapola Del Vando, Abraham Sofaer, Peter Mamakos, Stanley Waxman. (Pandro S. Berman for Twentieth Century–Fox, 116 mins.)

> *". . . Cukor has created his own kind of stylish masquerade. Justine is a movie of such opulence that the eye and ear are constantly persuading the mind to take a rest. Scene after scene is inlaid with shiny, and admittedly fake details, like furniture set with mother-of-pearl. It's a movie of sexual confusion (a woman might look like a transvestite, and vice versa) and dark humor."*
> *Vincent Canby*, The New York Times

1 9 7 2

Travels With My Aunt. Sc: Jay Presson Allen and Hugh Wheeler, based on the novel by Graham Greene. Ph: Douglas Slocombe. Cast: Maggie Smith, Alec McCowen, Lou Gossett, Robert Stephens, Cindy Williams, José Luis Lopez Vásquez, Valerie White, Corinne

Marchand, Raymond Gerone, Daniel Emilfork, Robert Flemyng, Aldo Sanbrell, David Swift, Charlie Bravo, Cass Martin, Olive Behrend, Javier Escriva. (Robert Fryer and James Cresson for MGM, 109 mins.)

> *"Working from a lean and utterly delicious screenplay by Jay Presson Allen and Hugh Wheeler, director George Cukor demonstrates that even at age seventy-four his talent is as firm and juicy as a pippin apple. . . . It is a film of pure pleasure, a simple and uncomplicated joy shot with grace and wit and intelligence, and I do not think you will pillory me for urging you to see it at your earliest convenience."*
> Harlan Ellison, Harlan Ellison's Watching

1 9 7 5

Love Among the Ruins. Sc: James Costigan. Ph: Douglas Slocombe. Cast: Katharine Hepburn, Laurence Olivier, Colin Blakely, Richard Pearson, Joan Sims, Leigh Lawson, Gwen Nelson, Robert Harris, Peter Reeves, John Blythe, Arthur Hewlett, John Dunbar, Ian Sinclair. (Allan Davis for ABC Entertainment, 120 mins.)

> *"Set in post-Edwardian London, it's a stylish, witty and romantic comedy of manners, with Miss Hepburn playing a feisty, independent widow of means and Lord Olivier the gentlemanly barrister who defends her in a breach-of-promise suit. This inspired casting presents two of the world's best actors in scenes of flawless timing, lyrical delivery and repartee that's alternately spirited and touching."*
> TV Guide

1 9 7 6

The Blue Bird. Sc: Hugh Whitemore, Alfred Hayes, and Alexei Kapler, based on the play by Maurice Maeterlinck. Ph: Ionas Gritzus, Frederick Young. Cast: Elizabeth Taylor, Jane Fonda, Cicely Tyson, Ava Gardner, Todd Lookinland, Patsy Kensit, Will Geer, Mona Washbourne, Robert Morley, Harry Andrews, George Cole, Richard Pearson, Nadejeda Pavlova, Margaret Terechova, Oleg Popov, Georgi Vitzin, Leonid Nevedomsky, Valentine Ganilaee Ganibalova, Yevgeny Scherbakov, Steven Warner, Monique Kaufman, Russell Lewis, Grant Bardsley, Ann Mannion, Pheona McLellan. (Edward

Lewis and Paul Maslansky for Lenfilm Studios/Twentieth Century–Fox, 100 mins.)

> *"Miraculously, after forty-five years of prizewinning film credits, George Cukor's work continues to amaze in its ingenuity and spontanaeity. . . .* The Blue Bird *will perch in your memory as a happy treasure."*
> DeWitt Bodeen, Films in Review

1 9 7 9

The Corn Is Green. Sc: Ivan Davis, based on the play by Emlyn Williams. Ph: Ted Scaife. Cast: Katharine Hepburn, Ian Saynor, Bill Fraser, Toyah Wilcox, Patricia Hayes, Anna Massey, Artro Morris, Bryn Fon. (Neil Hartley for Warner Brothers/CBS, 100 mins.)

> *". . . A joyous, yet humble, homage to a minor drama . . . Hepburn, almost constantly on the move as Miss Moffat, breezes through the property as a prodding catalyst. . . . Cukor's control of the ensemble acting is effortlessly masterful."*
> Tom Allen, The Village Voice

1 9 8 1

Rich and Famous. Sc: Gerald Ayres, based on a play by John Van Druten. Ph: Don Peterman. Cast: Jacqueline Bisset, Candice Bergen, David Selby, Hart Bochner, Steven Hill, Meg Ryan, Matt Lattanzi, Daniel Faraldo. (William Allyn for MGM, 117 mins.)

> *"This swiftly paced comedy is a deliciously impure compound of old-fashioned 'women's film' formulas and up-to-the-minute sexual mores. It is, from moment to moment, trashy and touching, literate and ludicrous, bitchily funny and as full of sharp, sophisticated insights as it is of appalling blind spots. Part soap opera, part comedy of manners, it refurbishes shopworn cliches into a gloriously unrespectable entertainment."*
> David Ansen, Newsweek

Cukor made significant contributions to these films without sole director's credit: *River of Romance*, 1929, where his work is uncredited and Richard Wallace is credited as director.

All Quiet on the Western Front, 1930, where he is credited as dialogue director and Lewis Milestone is credited as director.

One Hour With You, 1932, where he is credited as dialogue director and Ernst Lubitsch is credited as director.

No More Ladies, 1935, where his work is not credited and Edward H. Griffith is credited as director.

Gone With the Wind, 1939, where his work is not credited and Victor Fleming is credited as director.

Desire Me, 1947, where his work is not credited and no director receives screen credit.

Song Without End, 1960, where his work is not credited and Charles Vidor is credited as director.

> *"It is a body of work that will improve with age, overshadowing many directors more highly rated today."*
> *David Thomson*, A Biographical Dictionary of Film

INDEX

404